DESIGNED FOR PLEASURE

THE WORLD OF EDO JAPAN IN PRINTS AND PAINTINGS, 1680–1860

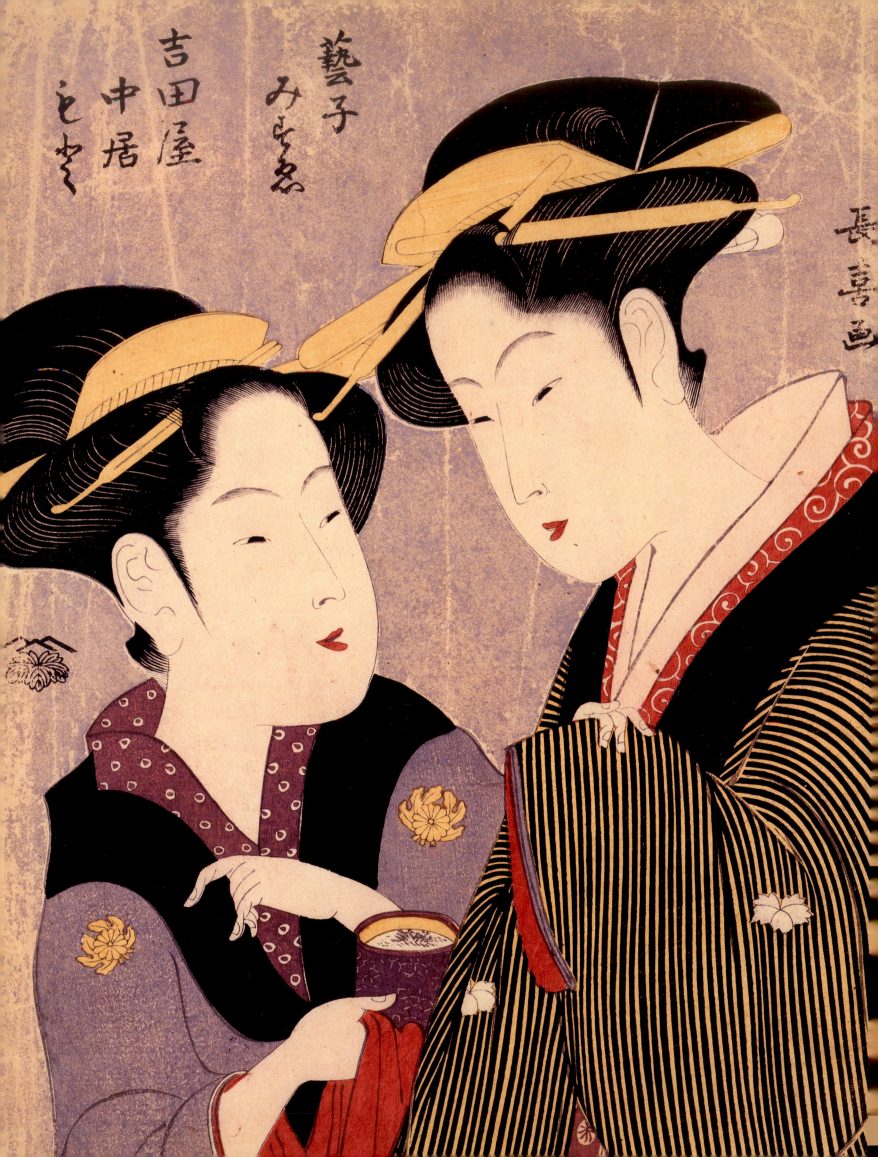

DESIGNED FOR PLEASURE

THE WORLD OF EDO JAPAN IN PRINTS AND PAINTINGS, 1680–1860

EDITED BY

Julia Meech and Jane Oliver

WITH ESSAYS BY

John T. Carpenter

Timothy Clark

Julie Nelson Davis

Allen Hockley

Donald Jenkins

David Pollack

Sarah E. Thompson

David Waterhouse

Asia Society and Japanese Art Society of America in association with
University of Washington Press, Seattle and London

Published on the occasion of the exhibition *Designed for Pleasure: The World of Edo Japan in Prints and Paintings, 1680–1860* organized by Asia Society and Japanese Art Society of America

Asia Society and Museum
New York, New York
February 27–May 4, 2008

Printed in Singapore

Published by Asia Society, New York, and Japanese Art Society of America, in association with the University of Washington Press, Seattle and London

University of Washington Press
PO Box 50096
Seattle, WA 98145-5096
www.washington.edu/uwpress

Support for *Designed for Pleasure: The World of Edo Japan in Prints and Paintings, 1680–1860* has been provided by John C. Weber, The Blakemore Foundation, Mary Livingston Griggs and Mary Griggs Burke Foundation, The Ellen Bayard Weedon Foundation, Peggy and Dick Danziger and The Japan Foundation New York Office.

We also appreciate the support of the National Endowment for the Arts.

NATIONAL
ENDOWMENT
FOR THE ARTS
A great nation
deserves great art.

We appreciate the support provided for this catalogue from The Estate of Doris Lang Thomas, Roger L. Weston, Tajima Mitsuru, Scholten Japanese Art, Nagano Masaharu, Joan B. Mirviss, Sebastian and Miki Izzard, Richard Fishbein and Estelle Bender, Klaus Naumann, Roberta and George Mann, Hara Shobō and Marguerite and Walter Bopp.

Exhibition Curators: Sebastian Izzard, H. George Mann, Julia Meech, Jane Oliver, Allison Tolman
Project Manager: Marion Kocot
In-house Coordinator and Curator, Asia Society: Adriana Proser
Copy Editor: Robbie Capp
Index Editor: David Waterhouse
Designers: Miko McGinty and Rita Jules
Japanese checklist typesetter: Miyuki Nagai-Gubser

Cover: Chōkyōsai Eiri. *Flowers of Edo: The Master of Kyōbashi* (*Edo no hana Kyōbashi natori*) (fig. 110, detail)
Frontispiece: Eishōsai Chōki. *Moto, Maidservant of the Yoshidaya in Shinmachi, Osaka, and Mizue, a Geisha* (exh. no. 5, detail)
Back Cover: Hishikawa Moronobu. *A Visit to the Yoshiwara* (exh. no. 80, detail)

Library of Congress Cataloging-in-Publication Data

Designed for pleasure : the world of Edo Japan in prints and paintings, 1680–1860 / edited by Julia Meech and Jane Oliver ; with essays by John T. Carpenter ... [et al.]. — 1st ed.
 p. cm.
 Issued in connection with an exhibition held Feb. 27–May 4, 2008, Asia Society and Museum, New York, New York.
 Includes bibliographical references and index.
 ISBN 978-0-295-98786-6 (pbk. : alk. paper)
 1. Art, Japanese—Edo period, 1600–1868—Exhibitions. 2. Ukiyoe—Exhibitions. 3. Japan—Social life and customs—1600–1868—Exhibitions. I. Meech, Julia. II. Oliver, Jane (Jane W.) III. Carpenter, John T. IV. Asia Society. V. Japanese Art Society of America.
 N7353.6.U35D47 2008
 760.0952074747′1—dc22 2007039628

CONTENTS

Lenders to the Exhibition 6

Preface from Asia Society 7
VISHAKHA DESAI

Foreword from Asia Society 8
MELISSA CHIU

Foreword from Japanese Art Society of America 10
ALLISON TOLMAN

Notes to the Reader 13

A Mirror on the Floating World 15
DONALD JENKINS

Hishikawa Moronobu: Tracking Down an Elusive Master 33
DAVID WATERHOUSE

The Original Source (Accept No Substitutes!): Okumura Masanobu 57
SARAH E. THOMPSON

Suzuki Harunobu: The Cult and Culture of Color 83
ALLEN HOCKLEY

Katsukawa Shunshō: Ukiyo-e Paintings for the Samurai Elite 101
TIMOTHY CLARK

Tsutaya Jūzaburō: Master Publisher 115
JULIE NELSON DAVIS

The Literary Network: Private Commissions for Hokusai and His Circle 143
JOHN T. CARPENTER

Designed for Pleasure: Ukiyo-e as Material Culture 169
DAVID POLLACK

WORKS IN THE EXHIBITION 191
JAPANESE CHECKLIST 236
INDEX 243
PHOTOGRAPHY CREDITS 256

Lenders to the Exhibition

The Art Institute of Chicago
Asian Art Museum of San Francisco
Asia Society, New York
Becker Family
Brooklyn Museum
Mary and Jackson Burke Foundation
Robert and Betsy Feinberg
Richard Fishbein and Estelle Bender
Gitter-Yelen Collection
Peter Grilli and Diana Grilli
Harlow N. Higinbotham
Dr. and Mrs. Martin Levitz
Los Angeles County Museum of Art
The Mann Collection
Merlin C. Dailey & Associates, Inc.
The Metropolitan Museum of Art, New York
Minneapolis Institute of Arts
Museum of Art, Rhode Island School of Design, Providence
Museum of Fine Arts, Boston
The New York Public Library
Geoffrey Oliver
Stephen W. Rozan and Marie Rozan
Joanna H. Schoff
Seattle Art Museum
Cecilia Segawa Seigle
Arthur Vershbow
John C. Weber
David R. Weinberg
Roger L. Weston
Worcester Art Museum, Massachusetts

We also acknowledge with gratitude those lenders
who prefer to remain anonymous.

Preface

ASIA SOCIETY

Asia Society is proud to present *Designed for Pleasure: The World of Edo Japan in Prints and Paintings, 1680–1860*. This exciting collaboration between our museum and the Japanese Art Society of America began four years ago, when members of that outstanding organization—formerly the Ukiyo-e Society of America—approached Asia Society with an ambitious exhibition and catalogue proposal. As the curators stated, despite the general popularity of Japanese prints, ukiyo-e still proves to be something of an enigma to most Americans, partly because recent exhibitions on the subject have concentrated on prints and books by individual artists, specific periods or on selections from a single collection.

The exceptional paintings, prints and illustrated books in the present exhibition—all drawn from the collections of members and supporters of the Japanese Art Society of America—give viewers the opportunity to experience and appreciate the breadth of the ukiyo-e tradition in a new light. The exhibition and catalogue explore the intertwined worlds of art, popular culture, commerce and society of Edo Japan in a focused examination by a team of renowned experts.

We are grateful to the Japanese Art Society of America for organizing the exhibition and catalogue. Our thanks go to many individuals and organizations for their continued involvement with the mission of Asia Society, and whose support of the project is acknowledged elsewhere.

Last spring, Asia Society held its annual corporate conference in Tokyo, drawing major business delegations from China, India, Australia, Singapore, Malaysia, Vietnam and the United States. Among other topics, the conference explored Japan's economic expansion and commitment to foster regional ties and growth, key factors in Asia's economic future. We hope that this exhibition and catalogue, along with other Asia Society programs, will lead to a greater awareness of the history and culture of Japan, and will contribute to a deeper understanding of Japan's role in the world of today as well as in the world of the future.

Vishakha N. Desai
President
Asia Society

Foreword

ASIA SOCIETY

Designed for Pleasure: The World of Edo Japan in Prints and Paintings, 1680–1860 brings together approximately one hundred fifty paintings, woodblock prints and illustrated books, with images known as ukiyo-e, or pictures of the floating world. The floating world was a new leisure industry of popular entertainment centered in the shogunal capital of Edo (modern Tokyo). The carefully selected images in the exhibition not only present the principals of that realm—the actor, the artist, the courtesan, the poet, the publisher, the patron— they also examine the confluences and contradictions in a time of enormous social, cultural and economic change in Japan.

The appreciation and collecting of art from this period in Japan's history has a long tradition, especially in the United States. The first ukiyo-e exhibition in this country took place in New York City in 1896. Museum and private collections in the United States have substantial holdings of this material, and all but one of the works shown here are from collections in this country. An aim of the Japanese Art Society of America, in organizing this exhibition, was to point to the quality and breadth of these collections, many represented by works never previously displayed. *Designed for Pleasure* builds on the existing body of ukiyo-e scholarship and presents a new perspective on the subject. Through a focus not only on woodblock prints, but also on paintings and illustrated books, an expanded view is offered of the visual culture of Edo Japan and the way in which art became more accessible to a new class beyond the ruling elite. The exhibition and catalogue explore the connections among painting, prints and book illustration, noting the broader industry of visual cultural production and technical achievements in the media, and setting the better-known prints in a more interrelated context.

In its fifty-two-year history, Asia Society has presented numerous exhibitions of Japanese art, including those featuring ukiyo-e. Two of the most notable were *Masters of the Japanese Print: Moronobu to Utamaro* (1964) and *Undercurrents in the Floating World: Censorship and Japanese Prints* (1992); both exhibitions reappraised ukiyo-e art. The former, curated by Gordon Bailey Washburn, the director of Asia House Gallery, as it was then known, addressed the lapse of public interest in Japanese prints during the years immediately after World War II. *Undercurrents* was conceived decades later, when the art world was consumed with debates on censorship stemming from the controversy surrounding an Andres Serrano exhibition funded by the National Endowment for the Arts. Vishakha N. Desai, then the museum director and current Asia Society president, encouraged curator Denise Patry Leidy and guest curator Sarah E. Thompson (a contributor to this catalogue) to use the example of ukiyo-e and the censorship laws of the ruling Tokugawa shogunate as a way of discussing the relationship between government and artist. With *Designed for Pleasure*, Asia Society continues its interest in Japanese art, bringing to light a new reading of works

of art in relation to their times. The exhibition and catalogue focus on individuals—adding to the already substantial scholarship on Hokusai, Hiroshige and Utamaro—including the father of ukiyo-e, Hishikawa Moronobu, the artist and publisher Okumura Masanobu, the color innovator Suzuki Harunobu, the master publisher Tsutaya Jūzaburō and the brilliant painter Katsukawa Shunshō.

This exhibition was conceived by the Japanese Art Society of America in collaboration with Asia Society. It has been a delight to work with so many passionate devotees of this art form. JASA's President, Allison Tolman, should be acknowledged for her leadership in galvanizing her board and membership's support for this important and extensive project. Special thanks to Christine Guth, who proposed the exhibition on behalf of JASA, and to the curatorial team Jane Oliver, Julia Meech, Sebastian Izzard and H. George Mann, as well as members of the board of JASA. We are grateful to Jane Oliver and Julia Meech, the editors of this volume, for their dedication to the project, and thanks also go to the catalogue essayists for their insights: John T. Carpenter, Timothy Clark, Julie Nelson Davis, Allen Hockley, Donald Jenkins, David Pollack, Sarah E. Thompson and David Waterhouse. Miko McGinty, with the assistance of Rita Jules, has done a superb job of design. John C. Weber offered critical support for this project from its inception. And I thank Helen Abbott, former Deputy Director of Asia Society Museum, and Ann Yonemura, former president of the Ukiyo-e Society of America, for their contributions during the early stages of the project.

The artworks in this exhibition have been drawn from many public and private collections listed elsewhere in this publication. We appreciate their support.

At Asia Society I would like to thank Marion Kocot, Assistant Director, for managing this project; Dr. Adriana Proser, John H. Foster Curator of Traditional Asian Art; Clare McGowan, Collections Manager and Registrar; Clayton Vogel, Installation Manager and exhibition designer; Dr. Kristy Phillips, Museum Fellow; Elizabeth Bell, Museum Associate; Nancy Blume, Head of Museum Education Programs; and Hannah Pritchard, Administrative Assistant, all of whom have worked in various capacities on the exhibition. Others at Asia Society who should be thanked for their continued support include Dr. Vishakha Desai, President; Jamie Metzl, Executive Vice President; Tom Moore, Senior Vice President, Operations; Rachel Cooper, Director, Cultural Programs; Helen Koh, Associate Director, Cultural Programs; Todd Galitz, Julie Lang, Alice Hunsberger and Emily Moqtaderi for their fundraising efforts; and Deanna Lee, Jennifer Suh, Elaine Merguerian and Ashley Eiler for publicity and marketing.

It is with great enthusiasm that we present this twenty-first-century scholarship on ukiyo-e, raising issues of consumer culture, fashion and celebrity that are still relevant today.

Melissa Chiu
Director
Asia Society Museum

Foreword

JAPANESE ART SOCIETY OF AMERICA

Designed for Pleasure: The World of Edo Japan in Prints and Paintings, 1680–1860 commemorates the thirty-fifth anniversary of the Japanese Art Society of America (JASA), founded as the Ukiyo-e Society of America in 1973. We have grown into an international organization with the mission of promoting the culture of Japan through a lecture series, an annual peer-reviewed journal, *Impressions*, a quarterly Newsletter and escorted tours to private and institutional collections throughout the United States. We are especially honored that Asia Society, with its international reach and commitment, is our host in this historic endeavor.

Rather than focus on one artist, one school or one artistic medium, the exhibition seeks to present the best of the "images of the floating world," known as ukiyo-e, in their three primary manifestations: paintings, woodblock prints and illustrated books. Loaned from private and institutional collections, many of the works are on public display for the first time.

Designed for Pleasure examines the popular culture of the period between 1680 and 1860, when Japan transformed itself from an agrarian to a booming commercial economy. By 1710, Edo (modern Tokyo) was the largest city in the world, with a population of over a million. We know so much about this time in part because of the vast body of imagery created and treasured by succeeding generations. The artists and writers we discuss in the exhibition and catalogue held a looking glass up to their heady world, and in the process, to themselves. Fads and fashions proliferated, and this highly literate, consumer-driven society insisted on being up to date. For those not wealthy enough to frequent the pleasure quarters or theater districts, a panoply of images described the activities of the latest courtesans and just about every activity and trade in the city. Innovative color and printing techniques fed the demand for ever-new information. Print publishers, mindful of a business opportunity, also responded to the clamor for representations of the public's cherished heroes. Their stables of artists not only produced mass-market prints and books, but used their connections in the literary salons of the day to secure commissions for luxury paintings and printed works from the wealthy and elite.

The original name of the Japanese Art Society of America—the Ukiyo-e Society of America—implies that the organization was founded with the intent to serve (and therefore draw members from) the entire nation. These aspirations were clearly reflected in its certificate of incorporation, which set forth six goals, one of which was "to foster interest in and appreciation for ukiyo-e in communities at large by extending the resources and special events of the society to said communities through a program of public education and relations." Such lofty goals notwithstanding, the society's membership expanded only slowly beyond the New York metropolitan area, where most of its activities were centered. This was hardly surprising, given that the founders were essentially a group of like-minded New York

print lovers and print collectors. Many of their early meetings focused on "show-and-tell" sessions put on by themselves.

But the society had been formed at an auspicious time. Though only a handful of dealers were then active in the city, Sotheby Parke Bernet (later renamed Sotheby's) was already beginning to hold enough important auctions to put New York on its way to succeeding London as the world's leading center of Japanese print sales. And though no collector of the caliber of the legendary Louis Ledoux (1880–1948) had yet emerged in the city to take his place, it should be pointed out that collectors of Japanese prints were still few and far between anywhere at the time. During the 1960s, the number of major American collectors—such as Edwin and Marjorie Grabhorn, James Michener and Richard Gale—could be counted on one hand. By the 1970s, however, the Japanese print world was beginning to show new life: the pace of major sales was picking up in both London and New York; museums were scheduling more frequent shows; and popular writers like Jack Hillier were attracting new attention to the field. With its base in New York, the society was well positioned to take advantage of these developments. Scholars, curators and collectors visiting the city were invited to make presentations, and tours were arranged for members to see exhibitions and view collections in other East Coast locations. (For an extensive review of the society's history, see Julia Meech and Ann Yonemura, "The Ukiyo-e Society of America, Approaching Thirty five," *Impressions* 27 [2005–2006]: 99–109. See also Julia Meech, "Ukiyo-e Print Collecting in America," in Amy Reigle Newland, ed., *The Hotei Encyclopedia of Japanese Woodblock Prints* [Amsterdam: Hotei Publishing, 2005], 402–11; Meech, "The Early Years of Japanese Print Collecting in North America," *Impressions* 25 [2003]: 15–53.)

By 1975, the society's membership had grown to over one hundred. It began a monthly *Notes from the President*, which included informative accounts of each society program or lecture. Also in 1975, its research committee compiled the small annotated bibliography *Selected Readings on the Art and Times of Ukiyo-e*. The next year, the society launched a modest forerunner of its current professional journal, *Impressions*, to serve as a vehicle for presenting longer articles connected with the society's interests.

Soon the society began branching out in other ways. In 1978, it presented its first exhibition, *The Life and Customs of Edo*, in collaboration with the Pratt Graphics Center. Five years later, in 1983, the society again collaborated with the Pratt Graphics Center on *Hiroshige: An Exhibition of Selected Prints and Illustrated Books*, accompanied by a scholarly catalogue by Sebastian Izzard. In 1993, in commemoration of the twentieth year of its founding, the society took on an even more ambitious project, *Kunisada's World*, in collaboration with Japan Society Gallery. The catalogue of one hundred seventy prints, illustrated books and paintings, written by Izzard, with essays by J. Thomas Rimer and John T. Carpenter, persuasively challenged the traditional view that saw the work of Utagawa Kunisada (1786–1865) as a primary example of the decadence that overtook ukiyo-e in the nineteenth century.

The society was now well on its way to becoming a recognized voice in the world of ukiyo-e scholarship. A final step in this development took place in 1997, when the society decided to expand and transform *Impressions* into a peer-reviewed journal publishing articles by leading scholars in the field. It is now recognized as one of the world's foremost English-language publications devoted to Japanese art.

———

There can be no art exhibition without works to display. Our utmost gratitude is to the lenders, all members and supporters of JASA, who shared their masterworks in this landmark exhibition. My deepest thanks go to Jane Oliver and Julia Meech, editors of the catalogue and organizers of the exhibition, along with Sebastian Izzard and George Mann, all past or present members of the board of JASA. Their expertise and indefatigable efforts resulted in the superb selection that constitutes the exhibition. We owe our cumulative thanks to Christine M. E. Guth, former president of the Ukiyo-e Society of America, who conceived of the exhibition and proposed it to Asia Society, and to Ann Yonemura, who succeeded her as president, for their crucial advice and support. Joan D. Baekeland, Treasurer of JASA, managed the financial intricacies of our participation with perfection and steadfastly endorsed our efforts.

JASA was able to fund the exhibition catalogue thanks to the generous support of Marguerite and Walter Bopp, Hara Shobō, Roberta and George Mann, Klaus Naumann, Richard Fishbein and Estelle Bender, Sebastian and Miki Izzard, Joan B. Mirviss, Nagano Masaharu, Scholten Japanese Art, Tajima Mitsuru, Roger L. Weston and the Estate of Doris Lang Thomas. Additional funding was provided by many members of our society.

We offer our deep appreciation to the distinguished scholars who contributed essays to the catalogue. The volume opens with an introduction and overview of ukiyo-e studies by Donald Jenkins, Curator Emeritus of Asian Art and Director Emeritus of the Portland Art Museum. David Waterhouse, Professor Emeritus of East Asian Studies at the University of Toronto, discloses important new research on the life and patrons of Hishikawa Moronobu, the acknowledged father of ukiyo-e. The third essay, by Sarah E. Thompson, Assistant Curator for Japanese Prints at the Museum of Fine Arts, Boston, shifts critical attention to Okumura Masanobu, who showed the way toward diversification in format, subject and technique that was essential to securing a mass audience. Allen Hockley, Chair, Department of Art History at Dartmouth College, examines the cult and culture of color through Suzuki Harunobu. Timothy Clark, Head of the Japanese Section at The British Museum, focuses on luxury paintings for the elite through Katsukawa Shunshō. Julie Nelson Davis, Assistant Professor in the Department of the History of Art, University of Pennsylvania, reconsiders the place of the publisher in ukiyo-e by demonstrating how Tsutaya Jūzaburō exploited the commercial and cultural dimensions of celebrity. John T. Carpenter is Lecturer in the History of Japanese Art at the School of Oriental and African Studies, University of London, and Head of the London Office of the Sainsbury Institute for the Study of Japanese Arts and Cultures. His essay shows how Katsushika Hokusai and his circle used their literary connections to secure commissions for deluxe paintings and *surimono*. David Pollack, Professor of Japanese Culture, Department of Modern Languages and Cultures, University of Rochester, New York, takes the commercial pulse of ukiyo-e by describing the intertwined worlds of fashion, marketing and aesthetics. We also are indebted to Katsura Yamaguchi, Senior Vice President and International Director, Japanese and Korean Art, Christie's, for compiling the list of works in the exhibition in Japanese, and to David Waterhouse, our Father Athanasius, for correcting many details of the catalogue manuscript and for enhancing both the volume and exhibition with his erudition and advice. Roger Keyes graciously made himself available for consultation. The catalogue would not be the evidence of all our expectations without the mastery of the book's designers, Miko McGinty and Rita Jules, and the photographers of the works of art.

Many others made sure that our project came together and stayed on track. To you we offer our heartfelt appreciation: Helen Abbot, Mary Ruth Albert, Robbie Capp, Sondra Castile, Carol Conover, Charles T. Danziger, Thomas C. Danziger, Geoffrey Dunn, Barbara Brennan Ford, Margaret Glover, Hollis Goodall, Lori van Houten, Janice Katz, Masae Kurahashi, Susan G. Lewis, Miroslav Matusek, Yoshinori Munemura, Geoffrey Oliver, Robert Poster, Mary Richie Smith, Elizabeth de Sabato Swinton, Melinda Takeuchi, Masako Watanabe, John C. Weber, Katherine Williamson, Nancy Wolff and Huei-Ling Yeh-Lewis.

Asia Society, our partner in this exhibition, shares our commitment to further knowledge of Asian art and culture. Our profound thanks go to our colleagues there, many working hard behind the scenes, who welcomed our exhibition and accommodated our vision. We purposely end our acknowledgments by extending our special gratitude to Dr. Vishakha N. Desai, President; Melissa Chiu, Director of the Museum; Marion Kocot, Assistant Director of the Museum, who guided us with unfailing grace and generosity; Clare McGowan, Collections Manager and Registrar, whose indulgence and diligence were indispensable; Adriana Proser, John H. Foster Curator for Traditional Asian Art; Todd M. Galitz, Vice President, External Affairs; Rachel Cooper, Director, Cultural Programs; Helen Koh, Associate Director, Cultural Programs; Kristy K. Phillips, Museum Fellow 2006–2007; Elizabeth Bell, Museum Associate; and Clayton Vogel, who conceived the installation of the exhibition.

Allison Tolman
President
Japanese Art Society of America

Notes to the Reader

Personal names: For Japanese and Chinese names, the surname is cited first, followed by the given or the artist's name. This does not apply, however, to those who publish in the West and/or who have opted to use the Western order of their names. In discussion, Japanese artists are referred to in the form most commonly cited, usually by the given or art name. Katsushika Hokusai, for example, is known as Hokusai.

Diacritical mark: The macron is used to indicate a long vowel in Japanese (Shunshō), except where the Japanese name or term has entered the English lexicon (Tokyo, shogun, kimono).

Measurements: Measurements are given in centimeters, height before width. For paintings, measurements apply only to the perimeter of the image, exclusive of the mounting.

Illustrations and cross-references: Most figure illustrations are of works in the exhibition. For full citations of these and, in some cases, for extra notations, please refer to Works in the Exhibition, beginning on page 191. Cross-references in the essays to illustrations in Works in the Exhibition are cited as "exh. no."

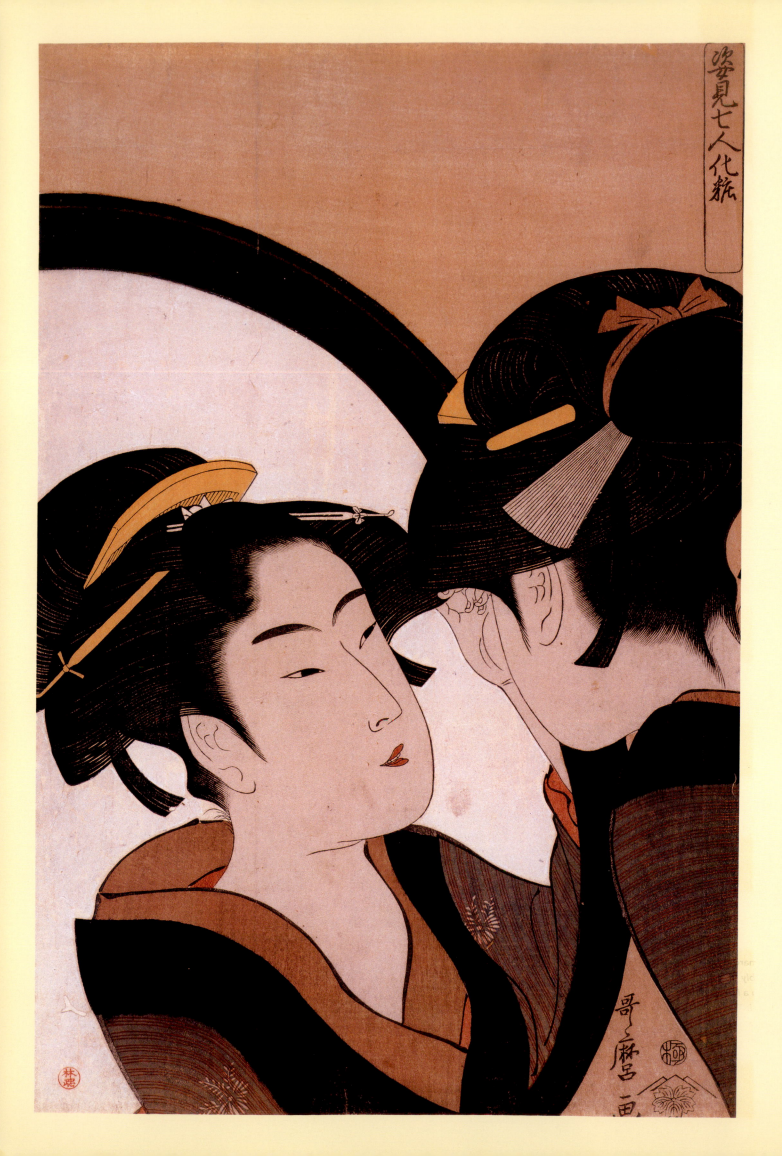

A Mirror on the Floating World

DONALD JENKINS

Designed for Pleasure: The World of Edo Japan in Prints and Paintings, 1680–1860 is the Japanese Art Society of America's most ambitious undertaking since its founding in 1973 as the Ukiyo-e Society of America. Much has happened in the past thirty-five years. Not only has the society itself grown and evolved in ways that its founders could hardly have imagined but—more surprisingly—the same years have seen dramatic changes in the ways in which ukiyo-e, the images of the floating world, are defined, studied and collected. As a result, the exhibition hosted by the Asia Society and Museum, New York, differs markedly in content from one that would have been organized even a generation ago, and the catalogue essays largely concern issues that would have been foreign to earlier scholars.

In its narrowest sense, the term "ukiyo-e" is used to describe the Japanese woodblock prints produced for popular consumption from the late seventeenth century until well into the later nineteenth century. Published primarily in Edo (present-day Tokyo), these include some of the best known and best loved works of art in the world, such as prints of celebrated courtesans and kabuki actors and Hokusai's "*Red Fuji*" (figs. 1, 2). The literal meaning of "ukiyo-e" is "pictures" (*e*) of the "floating world" (*ukiyo*), a name given to a lifestyle devoted to the pursuit of pleasure, especially the pleasure to be found in the theater district and the brothels of the licensed prostitution quarter, the Yoshiwara.

Looking into the Mirror

To provide some context for *Designed for Pleasure*, let us briefly look back at how ukiyo-e was seen in North America until quite recently. No early writer was more influential than Ernest Francisco Fenollosa (1853–1908). The history of ukiyo-e set forth in *The Masters of Ukioye* [sic]: *A Complete Historical Description* of *Japanese Paintings and Color Prints of the Genre School*, the catalogue he wrote for an exhibition shown in New York in early 1896, remained widely accepted, at least in its general outlines, well into the twentieth century, as Allen Hockley discusses in his essay on Harunobu in this volume.[1]

Figure 1
Kitagawa Utamaro (1753?–1806)
Woman, Possibly Naniwaya Okita, Adjusting Her Coiffure in a Mirror,** from the series Seven Women at Their Toilettes in Front of **Sugatami Mirrors (Sugatami shichinin keshō)
c. 1792–93. Color woodcut with mica on mirror glass. 37.1 x 24.4 cm. Private Collection

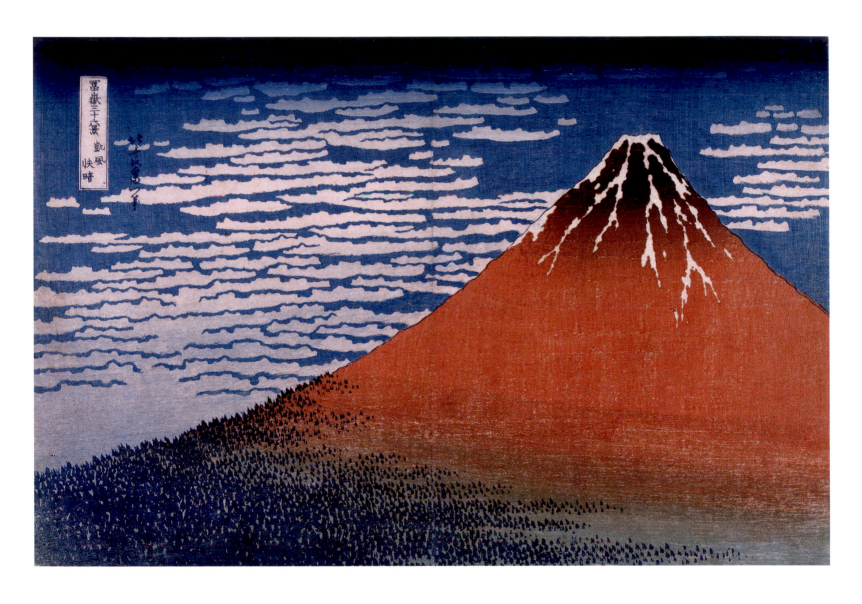

Figure 2
Katsushika Hokusai (1760–1849)
Fine Wind, Clear Weather (Gaifū kaisei)
["*Red Fuji*"], from the series *Thirty-six Views
of Mount Fuji (Fugaku sanjūrokkei)*
1830s. Color woodcut. 25.5 x 38.1 cm.
Private Collection, New York

Roger Keyes has identified this as the sixth of
eleven known states and has assigned it a date
in the second half of the 1830s.

Fenollosa divided the history of ukiyo-e into ten periods, beginning in the seventeenth century with the work of Iwasa Matabei (1578–1650) and his successors, to afford "a sort of introduction to Ukioye," and ending with a final period, from around 1830 to about 1850, which provided "a temporary renaissance through landscape work."[2] Three of the intervening periods were linked to stages in the development of print technology: the fourth, for instance, with the invention, in the early 1740s, of "color printing in two blocks," and the fifth, around 1760, with "complete color printing." Fenollosa saw the seventh to last periods as little more than phases of a gradual decline. The ninth, from about 1805 to 1830, represented by several spectacular examples in this exhibition, he dismissed as one of "utter degradation."

Fenollosa maintained that his conclusions were based solely on his study of the prints and paintings which, in his words, classified "themselves into periods more or less clearly marked by the broader differences between their qualities." Several of his groupings do seem to support this claim. The later ones, however, come across as highly subjective. When looked at as a whole, his periodization reflects what might be called an organic model of history, that is, the belief that historic movements go through phases analogous to infancy,

youth, maturity and decline. Though Fenollosa never said as much, this belief, which was shared by many art historians at the time, is implicit in virtually everything he states in the 1896 catalogue. Given Fenollosa's reputation as an authority on East Asian art, it did not take long for his opinion of ukiyo-e to become dogma, however much later writers might enlarge upon or modify some of his pronouncements.

The poet and collector Arthur Davison Ficke (1883–1945) mirrored Fenollosa's views almost to the letter in his widely read *Chats on Japanese Prints* of 1915. Though Ficke brought a refined aesthetic sense—a poetic sensibility one might say—to his appreciation of prints, he can never be described as a scholar. Many later writers with more impressive credentials continued to apply Fenollosa's term "primitives" to the earliest print artists, dismissed most early nineteenth-century figure artists like Utagawa Kunisada (1786–1865) (fig. 3) as decadents, and ignored anyone working in the second half of the century—presumably because by then, ukiyo-e as such had ceased to exist. Even Richard Lane (1926–2002), a specialist on erotic prints who wrote extensively on ukiyo-e and was notorious for finding fault with the conclusions of others, apparently saw no reason to challenge this accepted view.

Only recently has ukiyo-e become recognized as a legitimate field for art-historical research. Not only in the West but even (if not more so) in Japan, the commercial aspects of the art and its "vulgar" associations worked against it in an academic world dominated by conservative scholars interested primarily in older, more aristocratic, art. Despite this marginalization, collectors, such as Louis Ledoux (1880–1948), and a handful of museum curators in England and the United States, inspired by their love of the art, made important discoveries. Most of this knowledge was limited to prints, however; paintings and illustrated books were rarely mentioned. This is understandable, since prints were more available, more actively collected and more likely to be exhibited in museums and libraries.

Though it is the prints that first captured the attention of the Western world—and there is no denying their graphic brilliance—they were almost always the work of artists who thought of themselves primarily as painters (fig. 4). It is no accident that they so often chose to sign their prints as being "from my brush" (*fude* or *hitsu* in Japanese). Nor is it

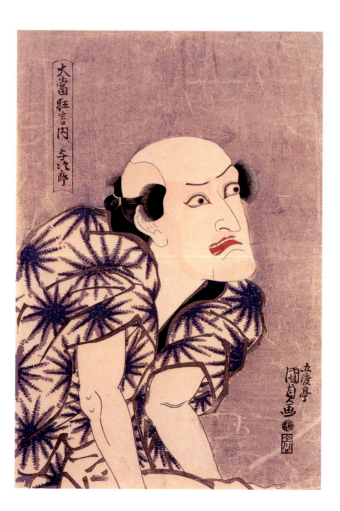

Figure 3
Utagawa Kunisada
Nakamura Utaemon III as the Monkey Trainer Yojirō (Yojirō), from the series Great Performances (Ōatari kyōgen)
c. 1815. Color woodcut with mica ground. 39.3 x 26.8 cm. The Mann Collection, Highland Park, IL

The *Great Performances* series of seven mica-ground portraits of actors in major roles may have been Kunisada's tribute to Sharaku. Kunisada's designs appeared some twenty years after Sharaku vanished from the Edo scene. Unlike Sharaku, who created designs of actors performing in plays presented almost contemporaneously with the issuance of his prints, Kunisada issued "retrospective" prints commemorating particular "great performances" over the preceding eight years.

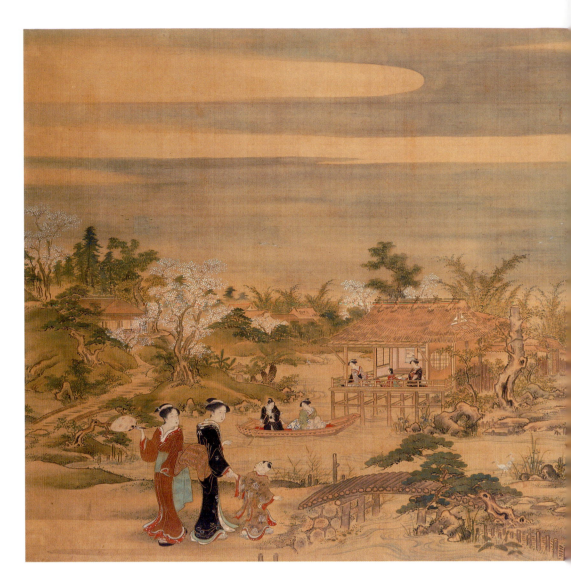

Figure 4
Keisai Eisen (1790–1848)
Geisha
Early 1830s. Hanging scroll; ink, color, gold and silver on silk. 95.4 x 39.3 cm.
Collection of Roger L. Weston

surprising that Isoda Koryūsai (1735–1790) and Katsukawa Shunshō (d. 1792), to name just two examples, gave up designing prints entirely in favor of painting once their reputations were well established, as Timothy Clark explains in the present catalogue. In ignoring the paintings of these artists, we not only ignore a major aspect of their creative life but also run the danger of misreading the very history of ukiyo-e.

By concentrating on the prints to the near exclusion of the paintings, most earlier writers (even Fenollosa, who, however, did include paintings—one of which was the *Spring Concert* by Utagawa Toyoharu [1735–1814] in the present exhibition [fig. 5]—in his 1896 catalogue) tended to see the history of ukiyo-e as inextricably linked to the evolution of printing technology, a point examined by Allen Hockley in his essay. It led to describing the highly sophisticated illustrations of Moronobu as "primitive," merely because they were not printed in color, and concentrating on the use of color in Harunobu's prints to the neglect of some of his other, equally expressive innovations, such as a more evocative use of settings and poetic allusions.

Focusing exclusively on the prints had other drawbacks. Perhaps the most damaging was that it encouraged one to treat the prints as a world without any connection with other forms of art and only limited connections with Japanese society and culture. Collectors tended to concentrate on the aesthetic aspects of their activity, seeking out superior impressions of well-known images, say, rather than trying to discover examples of less familiar work. Whole categories of prints, such as the lavish privately commissioned prints called *surimono*, or prints made by artists in Osaka (fig. 6), were overlooked. More crippling, intellectually, was the failure to see—even to be aware of—the connections between the prints and paintings by the same artists.

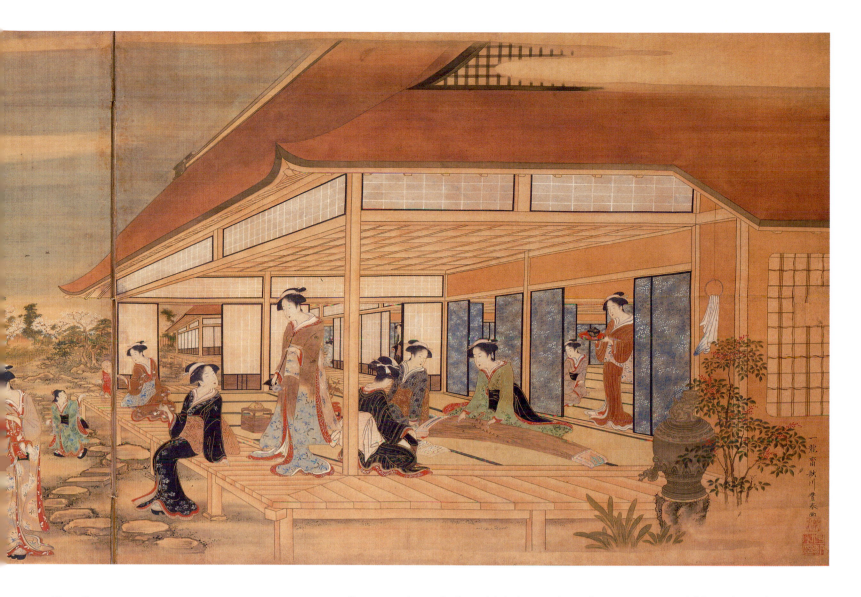

Figure 5
Utagawa Toyoharu
Spring Concert
1780s. Two-panel folding screen; ink and
color on silk. 67.4 x 178.8 cm. Collection of
Robert and Betsy Feinberg

Because prints exist in multiple impressions, they are more available and—perhaps of even greater importance to the collector—their different impressions can be compared and gauged as to quality and authenticity. Authenticity concerns have been particularly troublesome with ukiyo-e paintings. Naitō Masato has described the long-term dampening effect that the sale of a number of notorious fakes in the early 1930s had on the Japanese ukiyo-e painting market.[3] In this country, collectors were hampered not only by their unfamiliarity with ukiyo-e paintings in particular but also their limited connoisseurship of Japanese paintings in general. It was only with our nation's rediscovery of all things Japanese after the end of World War II that interest began to pick up again. Among the earliest postwar American collectors of ukiyo-e painting were Richard Gale in Minnesota and Mary and Jackson Burke in New York (figures 7 and 78 are from their collections). The 1966 exhibition *Japanese Painters of the Floating World*, organized by Martie W. Young and Robert J. Smith for the Andrew Dickson White Museum of Art at Cornell University included works from both the Gale and the Burke collections; their catalogue broke new ground at the time. Harold Stern's 1973 exhibition of ukiyo-e paintings from the collection of the Freer Gallery of Art also played an important role in reacquainting Americans with this all-but-forgotten aspect of ukiyo-e.[4]

By the late 1980s, the study of ukiyo-e had finally begun to acquire some academic respectability. Ukiyo-e could no longer be talked about in isolation from the broader context of Edo-period culture. More than a few of the new discoveries required a radical rethinking of earlier assumptions. It used to be maintained, for example, that ukiyo-e was a popular art, patronized almost exclusively by the urban middle classes and frowned upon by the shogunate, the daimyo and the upper classes generally. To a degree this was true. But as scholars became more familiar with the *kyōka* ("mad verse") movement, to which

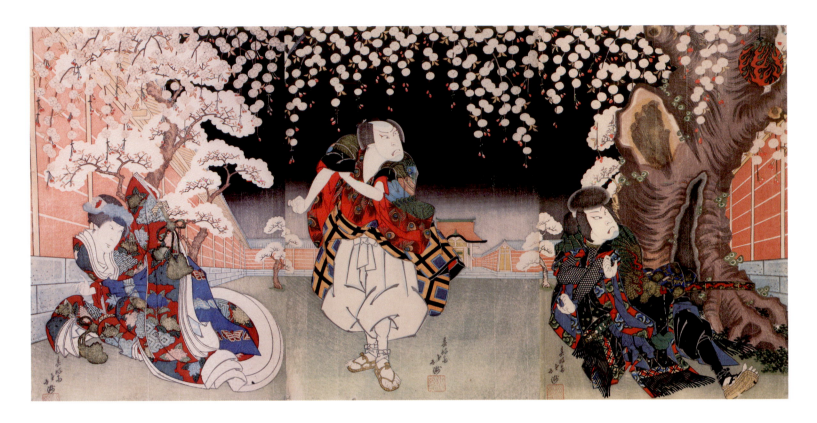

Figure 6
Shunkōsai Hokushū (act. 1802–32)
Ichikawa Ebijūrō II as Ki no Haseo, Nakamura Utaemon III as Kujaku Saburō and Fujikawa Tomokichi II as Kōbai hime, in the Kabuki Play Tenmangū aiju no meiboku
1828. Color woodcut triptych with metallic powders and embossing. 37.2 x 76.2 cm. Collection of Dr. and Mrs. Martin Levitz

many of our catalogue authors refer, they discovered the extent to which minor officials from the shogunate and habitués of the floating world regularly socialized together in poetry clubs. As David Waterhouse and Timothy Clark reveal in their essays, scholars have now discovered that contact also took place between ukiyo-e artists and more elevated members of the Edo-period elite. Several important daimyo are now known to have commissioned paintings from the artists.[5]

Changes in the discipline of art history in general, such as the prominence of gender studies and the growing interest in popular visual arts like film and even comic strips, have opened up previously unconsidered avenues of inquiry. Research into the business side of printmaking and painting has resulted in a number of influential monographs reassessing and giving new importance to the key role played by publishers at certain junctures in its history, such as the findings presented by Julie Nelson Davis in this volume.

New Reflections

Now let's turn our mirror back to *Designed for Pleasure* to ask, how does it reflect or respond to the changes described above?

One is immediately struck by several things. The most noticeable is how many paintings and illustrated books are included, genres that have only rarely been part of ukiyo-e exhibitions in the past. One of the exhibition's seven sections, that devoted to Katsukawa Shunshō, purposely concerns only the master's paintings, even though he was highly influential in the print field where he was a leading exponent, perhaps even the inventor, of a new, more realistic approach to depicting actors.

One of the primary goals of the organizing committee—Christine Guth, initially, Sebastian Izzard, H. George Mann, Julia Meech and Jane Oliver—was to draw attention to

ukiyo-e that were made to order for the elite market by including luxury paintings. Another, less obvious feature of the exhibition relates to this same goal, that is, the number of *prints* that were either directly commissioned or designed to appeal to this same elite market, which largely consisted of samurai officials and retainers. Among the best-known examples of this kind are Harunobu's *Eight Parlor Views* (*Zashiki hakkei*), which are represented in the exhibition by a rare first-state set from the collection of The Art Institute of Chicago (see fig. 57a–h). The set was commissioned by the leaders of a samurai poetry club for private circulation among the club's members. Allen Hockley discusses the impact that it and other prints commissioned at about the same time by samurai patrons had on the subsequent course of ukiyo-e print publishing. *Surimono*, another, later type of print well represented in the exhibition by Katsushika Hokusai (1760–1849) and members of his circle, were also commissioned beginning around 1810 by poetry clubs for private circulation to their members, who included samurai along with cultivated commoners.

A major challenge facing the organizing committee was how to produce a catalogue that would do justice to the exhibition and present, in a scholarly but approachable fashion, new discoveries and current knowledge regarding ukiyo-e. The committee decided to invite eight scholars, each a specialist in one or more aspects of the art, to contribute essays concerning the artists or themes into which the exhibition had been divided. The scholars were given considerable latitude as to how to approach their work, the only request being that they should address the issues embodied in the brief titles given to their respective sections in the original exhibition proposal: "Okumura Masanobu: Artist as Entrepreneur," for example, or "Tsutaya Jūzaburō: The Impact of the Publisher." The resulting diversity of approaches gives some idea of the wide range of topics ukiyo-e scholars are now dealing with, and the variety of the conceptual tools they are employing in their investigations.

In the first essay, David Waterhouse concentrates on a specific work, Hishikawa Moronobu's splendid handscroll, *A Visit to the Yoshiwara*, from the John C. Weber Collection. Making use of his wide-ranging familiarity with early Edo-period literary and historical texts he comes up with a plausible candidate for the "missing" patron who might have commissioned it. He expands our appreciation of a given work by sharing the implications of individual details he has discovered within it. Allen Hockley, on the other hand, concerns himself with larger issues regarding his subject, Suzuki Harunobu: primarily, the artist's role, previously much emphasized, in the development of full-color printing, and he pays relatively little attention to aspects of the artist's work that have nothing to do with this issue. For all their differences, the essays of both scholars help underscore one of the major theses of the exhibition, the importance of elite patronage in the course of ukiyo-e history.

The same point is made less directly by Sarah E. Thompson in her essay on Okumura Masanobu. Though her assignment was to address the entrepreneurial character and many innovations of Masanobu, she also draws attention to his activity as a poet (he was a pupil of a prominent *haikai* master) and his amusing parodies of stories drawn from classical literature. He was one of the first to popularize the appropriation of classical material for use in prints, in the process creating a new genre of transpositional imagery now referred to as *mitate-e*. There has been considerable debate in scholarly circles recently about the proper use of this term, which is generally applied to pictures involving a witty transformation or parody of classical subject matter through its placement in a "modern" setting (fig. 8).[6]

Several of the other essays also help underscore the various ways in which ukiyo-e artists drew on classical literary traditions. Julie Nelson Davis and John Carpenter speak of *kyōka*, a type of witty verse that incorporated allusions to *waka*, a form of lyrical poetry that had been favored by the court and aristocrats for centuries. While Davis concentrates on the deluxe *kyōka* albums published by Tsutaya Jūzaburō (1750–1797) around 1790, when prominent samurai writers like Ōta Nanpo (1749–1823) were still active in the *kyōka* movement, Carpenter discusses the later *surimono*, which provided a superb vehicle for the ingenious interplay of images and poetry. Carpenter has acquired a deserved reputation for his translations of *kyōka*, which have been notoriously difficult to translate because of their allusiveness and fondness for double (if not triple) entendres.

As the reader will note, the final essay by David Pollack differs rather markedly from the others. Whereas each of his fellow authors was asked to focus on an individual figure

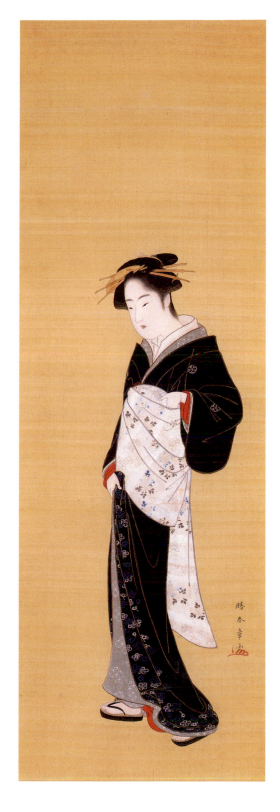

Figure 7
Katsukawa Shunshō (d. 1792)
Woman in Black Robe
1783–89. Hanging scroll; ink, color and gold on silk. 85.1 x 28.5 cm. Mary and Jackson Burke Foundation

Mary and Jackson Burke purchased this painting in 1965.

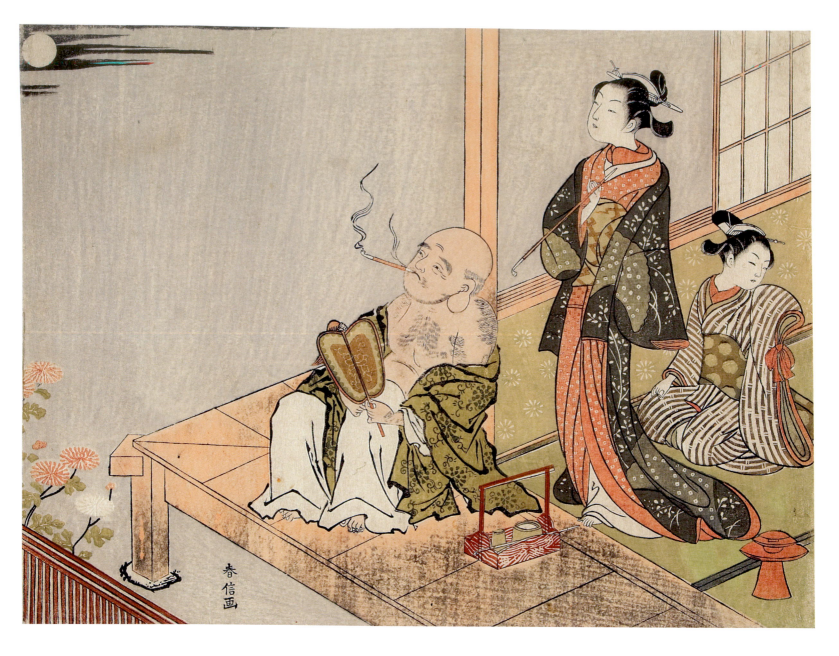

Figure 8
Suzuki Harunobu
Courtesan and Hotei Smoking
on a Veranda in Moonlight
c. late 1760s. Color woodcut. 20 x 27 cm.
Collection of Harlow N. Higinbotham

crucial to the history of ukiyo-e, Pollack was charged with examining the commercial developments that took place over a larger period of time and are impossible to relate to the influence of a single person. He provides a corrective to earlier views of the art, which tended to neglect the role played by fashion, especially fashion in dress.

A Gathering Stream: Tributaries to the Floating World

The approach I have taken to my assignment to provide background for the exhibition as well as the contributions of my fellow essayists has been to describe the genesis of the exhibition and how it fits within the evolving world of ukiyo-e studies. I also wish to give the reader a sense of the immense richness and variety of the works of art embraced by the term "ukiyo-e." Probably no other genre of Japanese art better reflects the extent of the creative energies that found expression in Edo-period Japan, at a time when—and this is all the more remarkable—the nation was almost entirely isolated from the outside world.

The beginnings of ukiyo-e can be traced back to the earliest years of the Edo period (1615–1868), when the newly established Tokugawa shogunate was still consolidating its power. Much of the preceding century had been characterized by turmoil and social ferment as rival leaders struggled for supremacy, but it was also a time of positive change. Agricultural production increased, the economy expanded and the first-ever contact with Westerners, along with a partial breakdown of traditional class barriers, released energies that would come into play as soon as order and peace took hold under the Tokugawa clan. Urban life

quickened and prosperity began to spread, resulting in the rise of a new, literate merchant class interested in art forms that appealed to its own tastes and experience.

One of these was an early form of kabuki that was flourishing already in the 1620s, "women's kabuki," so called because the performers were mainly women, unlike later kabuki where the actors, regardless of their roles, were exclusively men. Manuscript picture books, called *Nara ehon*, illustrating traditional stories and literary classics also began circulating in greater numbers and, as the market grew, were soon followed by printed versions. Paintings of beautiful women and handsome young men garbed in fashionable kimonos and shown standing alone against blank backgrounds became immensely popular. These so-called Kanbun paintings—Kanbun being the name of the era (1661–73) when they were most popular—provided the prototype for the earliest known single-sheet ukiyo-e prints, which began appearing in the 1680s, but all of these developments fed into ukiyo-e.

For much of the seventeenth century, the old imperial capital, Kyoto, remained the cultural center of Japan, and it is there that most of the developments just mentioned first occurred. Yet ukiyo-e soon became almost exclusively associated with Edo. This was particularly true of ukiyo-e prints, which were referred to elsewhere in Japan as *Edo-e*, "Edo pictures," or, after the development of full-color prints in 1765, as *azuma nishiki-e*, literally, "brocade pictures of the East," the East referring to the Kantō area of Japan with Edo as its metropolitan center.

By the end of the seventeenth century, Edo, which had already surpassed Kyoto in population, began to come into its own culturally. It was a new city in Japanese terms, having been nothing more than the seat of a minor regional lord when Ieyasu (1542–1616), the first Tokugawa shogun, chose it as his administrative and military capital in 1603. By 1700, it was well on its way to becoming one of the largest cities in the world, and nearly half of its population consisted of samurai serving the shogun or forming the retinues of regional daimyo during their periods of obligatory residence in Edo. To provide food, clothing, lodging and entertainment for such a huge number of functionaries, enterprising craftsmen, merchants, artists and performers streamed into the city from all over the country, giving it a bolder, less conservative character than was typical of the nation's more settled metropolitan centers.

By the 1690s, this distinctive character was already beginning to find expression in the arts. A prime example is the *aragoto* ("rough stuff") style of acting developed by Edo's first great kabuki actor, Ichikawa Danjūrō I (1660–1704), which contrasted with the softer *wagoto* style favored in Kyoto and Osaka. Danjūrō's forceful gestures and bombastic postures quickly found their graphic expression in the vigorous brushwork displayed in the prints and playbook illustrations of Torii Kiyonobu (1664–1729), the earliest of which are datable to 1697.

The earliest prints seem to have been created as inexpensive substitutes for paintings, not as distinct art objects in their own right. Many early prints, especially the larger ones, were actually mounted as hanging scrolls. It was not until around 1718, when the small, narrow *hosoban* format came into vogue, that printed pictures began to be considered as worthwhile commodities in themselves. From this point on, an entirely new dynamic begins to set in, one that would have enormous implications for the future course of ukiyo-e.

Enterprising publishers with a flair for marketing strove to come up with features that would distinguish their products from those of their competitors. Decorative enhancements—an expanded palette of hand-painted colors, metallic chips sprinkled over parts of the print surface and a lacquerlike gloss of deer glue applied over areas of black—were some of the innovations they developed. In her essay in this catalogue, Sarah Thompson describes those that the artist-publisher Masanobu devised in his efforts to gain an edge in this evolving market. The competitive drive that emerges during these years led to the introduction of two-color printing shortly after 1740, and then, in 1765, of full-color printing. (Until 1740, any color appearing in ukiyo-e prints was applied by hand.)

This might be the place to explain for those less familiar with ukiyo-e prints that the artists whose signatures appear on them had no hand in the physical production of the prints. Their role was to provide the designs, usually at the behest of a publisher. The carving of the blocks was entrusted to specialized engravers, and the printing was the responsibility of yet another group of specialized craftsmen. A *surimono* by Hokusai recasts these

Figure 9

Katsushika Hokusai

Printer and Engraver

c. 1825. Color woodcut, *surimono* with brass and
silver powders and embossing. 21.4 x 18.7 cm.
Surimono Collection of the Becker Family

For the poems, see exh. no. 40.

skilled artisans as an old block carver gazing at his lovely assistant absorbed in the task of rubbing the paper onto the inked block with a round *baren* (fig. 9). The role of the publisher was akin in many ways to that of the producer of a modern film.

Given the greater influence wielded by publishers on developments in ukiyo-e after 1718, one might have assumed that the influence of well-to-do patrons would have diminished correspondingly. This was not the case, however. One of the most dramatic turning points in the history of ukiyo-e—the sudden appearance of full-color printing in 1765—would not have occurred, or at least not have occurred as early as it did, had it not been for the patronage of a small group of samurai literati who underwrote the publication in that year of a number of full-color prints for private circulation (see fig. 57a–h). Another innovative feature of these prints, their squarer format and quieter, more poetic subject matter, set them apart from contemporary commercial publications. Their appeal soon attracted imitators. Within a few years, the whole ukiyo-e print world was transformed: images seemed more refined, and the squarer so-called *chūban*, or medium format, which gave scope for including atmospheric background elements and settings, became standard, except for actor prints, but even in these the treatment changed. Previously, an actor's face and other physical characteristics had been virtually interchangeable from one picture to another, with the actor identifiable only by the crest displayed on his costume. Afterward, however, features were so carefully delineated that it is often possible to recognize an actor even if he is not shown with a crest.

Aristocratic patrons, many of whom were samurai, influenced the direction taken by ukiyo-e through much of the eighteenth century. Timothy Clark relates the discovery of the association between the lord of Kōriyama, Yanagisawa Nobutoki (1724–1792), to Shunshō's painting *Peony* of the late 1770s (see fig. 73). The influence of the aristocracy was especially important in painting but also made itself felt in prints and illustrated books. It is perhaps most evident during the 1780s, when several of the most sumptuous works in the entire history of ukiyo-e were created. One of these was *New Mirror Comparing the Handwriting of the Courtesans of the Yoshiwara* (*Yoshiwara keisei shin bijin awase jihitsu kagami*), an album designed by Kitao Masanobu (the popular writer Santō Kyōden, 1761–1816) and published by Tsutaya Jūzaburō, which came out in 1784 with a preface by the charismatic samurai scholar-poet, Ōta Nanpo (figs. 10, 85). It depicts fourteen of the most celebrated courtesans of the day engaged in a variety of cultivated pursuits and surrounded by elegant furnishings of the sort one would expect to find in a scholar's study.

Works like these may well mark the highpoint of aristocratic involvement in ukiyo-e. Only a few years later, the shogunate began instituting a series of "reform" measures that included the reinforcement of sumptuary laws and efforts to restore "appropriate" samurai behavior. This forced some of the more prominent samurai, such as Nanpo, to withdraw, at least for a while, from any too visible participation in the floating world. At the same time, other changes in society were beginning to take place, changes that would also affect the future course of ukiyo-e. Growing literacy and more frequent travel introduced Edo's big-city culture to other areas of the country. Even Edo-style *kyōka* clubs began springing up elsewhere, and publishers soon began to exploit the larger market these developments made possible. Where prints, albums and illustrated books of the 1780s and 1790s were largely aimed at a relatively small circle of sophisticates—or would-be sophisticates—whose lives centered on the Yoshiwara pleasure quarters, later prints were designed to appeal to a broader public with less inside knowledge and different interests and aspirations.

Similar changes occurred in literature. *Sharebon*, slender storybooks set almost exclusively in the licensed quarters and presuming an insider's familiarity with its customs and personalities, flourished between 1764 and 1788 but then fell out of favor. By the early 1800s, much longer books, most of which were adventure, romance and humorous travel books, had become popular, and they were published in much larger editions.

The nineteenth century saw the parameters of ukiyo-e expand in all kinds of directions. The sudden appearance of landscape prints around 1830 represented the greatest departure. Yet tentative experiments with landscape subjects had been made earlier, notably by Utagawa Toyoharu and as backgrounds for figure prints by a number of late eighteenth-century artists. Ukiyo-e artists had always shown a great capacity for experiment and

Following pages: Figure 10
Kitao Masanobu
The Courtesans Hinazuru and Chōzan of the Chōjiya (*Chōjiya Hinazuru, Chōzan*), from the album *New Mirror Comparing the Handwriting of the Courtesans of the Yoshiwara* (*Yoshiwara keisei shin bijin awase jihitsu kagami*)
1784. Color woodcut album, diptych. 37.8 x 51 cm. Private Collection

This album presents pairs of women from seven houses in the Yoshiwara, each with calligraphy said to reproduce her handwriting style. The courtesans were accomplished poets and calligraphers. Here, they have transcribed classical poems; Hinazuru, standing on the right, selected a verse that describes the hazy daybreak moon, while Chōzan, seated, chose one about wild geese forsaking the rising mists of spring.

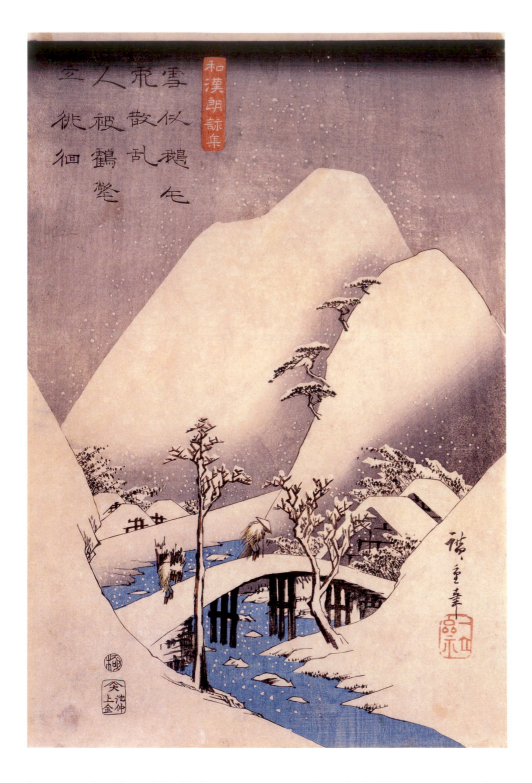

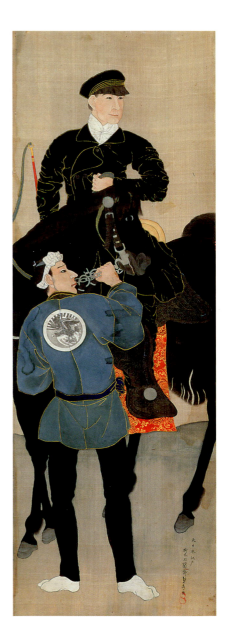

Left: Figure 11
Utagawa Hiroshige
Poem by Bai Juyi, from the series *Chinese and Japanese Verses for Recitation* (*Wakan rōeishū*)
c. 1840–41. Color woodcut. 37.5 x 25.8 cm.
The Mann Collection, Highland Park, IL

borrowing ideas from all kinds of sources. It is a mistake to think of ukiyo-e—even earlier ukiyo-e—as consisting solely of "pictures of the floating world" in the narrowest sense of the term "floating world."

We have seen how artists throughout its history drew on classical stories; but in doing so, they also sometimes even employed styles and techniques associated with medieval court painters. Hokusai's landscapes clearly owe something to the earlier work of *bunjinga* (Chinese-style literati painting) artists like Ike Taiga (1723–1776), and several scholars have shown how certain elements in prints by Utagawa Hiroshige (1797–1858)—especially their atmospheric effects and asymmetric "one-corner" compositions—reveal the artist's familiarity with contemporary Kyoto-based Shijō-school painting.[7] In another example, Hiroshige transcribes the first two lines of a verse by Tang-dynasty poet Bai Juyi (772–846) in a Chinese-inspired snow scene (fig. 11).

As I recounted earlier, Fenollosa placed landscape prints in his tenth and final period, which he described as "a temporary renaissance." Many others shared this view, as we have

Figure 12
Hashimoto Sadahide (1807–1878/79)
The American Merchant Eugene Van Reed
1860s. Framed painting; ink and color on silk.
102.9 x 35.6 cm. Asian Art Museum of San Francisco, Transfer from the Fine Arts Museums of San Francisco, Gift of Mrs. Noble T. Biddle, 2001.8

Eugene Van Reed, a native of Reading, Pennsylvania, lived in Japan from 1859 through 1872, first as a clerk to the American consul, then as a trader working for Heard and Company. He died in 1873 at the age of about thirty-six aboard ship returning to the United States.

seen, especially as it coincided with the more widespread perception, common until quite recently, that "authentic" Japanese art disappeared after the beginning of the Meiji period (1868–1912) when the nationwide push for modernization seemed to devalue, at least for a time, so many aspects of traditional Japanese culture.

This is not a perception that I share, and I definitely don't think that it can be applied to ukiyo-e. Ukiyo-e prints and paintings continued to be produced after 1868, many still dealing with traditional subjects, such as kabuki actors and beautiful women, along with others exploiting the novel subject matter provided by the arrival of Westerners with their exotic clothing and strange inventions (figs. 12, 130; exh. no. 91). Depictions of Westerners seem to have enjoyed only a passing vogue, but actor prints remained popular at least until the end of the century; and portraits of the kabuki stars from the 1880s and 1890s by Toyohara Kunichika (1835–1900) and Utagawa Toshihide (1863–1925) rival in graphic terms and in the finesse of their printing anything in the actor print tradition (fig. 13).

Other kinds of prints by these and their fellow artists also seemed to have had no trouble in finding a market. Battle scenes were published in huge numbers, for example, during both the Sino-Japanese and the Russo-Japanese wars (1894–95 and 1904–05, respectively). Many artists also found work designing woodblock frontispieces (kuchi-e) for the popular romantic novels that were published in installments during these same years. Moreover, the infrastructure that supported all this—the publishing system, the block carvers and printers, and, above all, the consumers—seems to have remained intact at least through the end of the century.

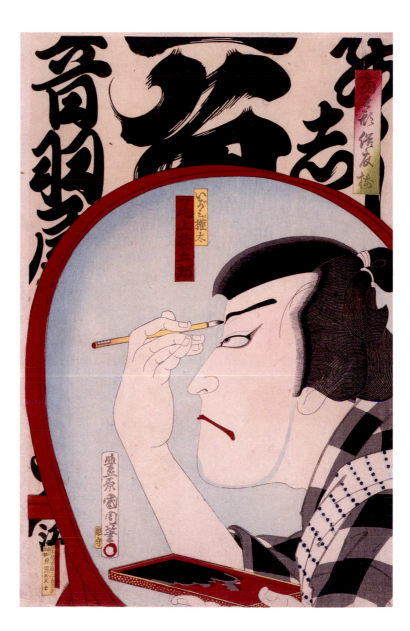

Figure 13
Toyohara Kunichika
Onoe Kikugorō V as Igami no Gonta (Igami no Gonta Onoe Kikugorō), from the series *Fashionable Modern Clothing (Tōseigata zokuizoroi)*
1885. Color woodcut. 38.1 x 24.9 cm.
Private Collection

Onoe Kikugorō V (1844–1903) was one of the most popular kabuki actors of the late Meiji period. The bold lettering in the upper left background reads *Otowaya*, the shop name (*yagō*) of the Onoe Kikugorō line.

But the times were changing. The days when artists could continue to work unself-consciously within the ukiyo-e tradition were gone. In the later 1910s, the publisher Watanabe Shōzaburō (1885–1962) attempted to revive what he considered a dead or lost art, the ukiyo-e tradition of figures and native landscapes with his so-called *shin-hanga* (new prints). Others began to turn the looking glass beyond Japan. *Yanagibashi*, from the series *Twelve Views of Tokyo* (*Tōkyō jūnikei*) by Ishii Hakutei (1882–1959) gives us a woman of the world even as her clothes and backdrop fix her nationality (fig. 14). A man of parts, much like his predecessors in the floating world, Hakutei was a poet, essayist, painter and print-maker and member of various groups of artists and writers. But he had crossed a divide and could no longer work with an ukiyo-e vocabulary and sensibility without irony. He studied Western-style painting at the Tokyo Art School and became one of Japan's best-known Impressionists. His treatment of the pensive geisha here, off-handedly holding a cigarette to her lips, seems curiously detached. And yet, in spite of its air of sophisticated modernity, we cannot mistake the evocation of a long lineage of beauties pictured in their own here and now, evidence that the grand stream of ukiyo-e continued to flow.

———

With this brief discussion of the two-hundred-odd-year history of ukiyo-e behind me, I would now like to turn my attention back to *Designed for Pleasure* for a few final comments. Westerners have admired ukiyo-e prints and paintings ever since they first discovered them in the nineteenth century, but much about them has remained mysterious or misunderstood, for many reasons I have already mentioned. Much of the art has disappeared in fires, earthquakes and other disasters so that the lives of many of the artists are poorly documented, if documented at all. Yet much continues to be learned about this great art, as the essays that follow will demonstrate. Meanwhile, the beauty and expressive power of these works of art will be clear to anyone who visits the exhibition.

Over the past fifteen years or so, the Japanese Art Society of America has moved increasingly into the forefront of ukiyo-e studies, providing a forum for redefining the very nature of ukiyo-e and its place in Edo-period Japanese culture. This development does not represent a change in its original goals so much as a natural progression from them and the culmination of its thirty-five-year history. The significance of what the society has achieved during its relatively brief existence can be measured by the fact that 112 years have now passed since the 1896 publication of Ernest Fenollosa's landmark catalogue. Now, with this exhibition and catalogue, the society shows how much that basic framework has been changed. What better way could it have chosen to celebrate its thirty-fifth anniversary?

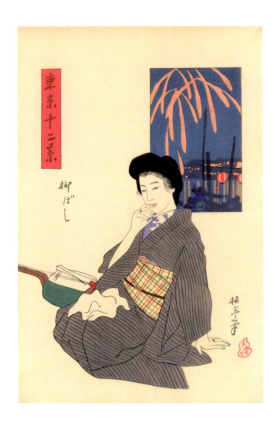

Figure 14
Ishii Hakutei
Yanagibashi, **from the series** *Twelve Views of Tokyo* (*Tōkyō jūnikei*)
1910. Color woodcut. 38.4 x 25.4. Portland Art Museum, Portland, OR, Gift of the Asian Art Council in honor of Donald Jenkins

The cartouche shows fireworks over the Yanagibashi district of Tokyo.

Notes

1. Ernest Francisco Fenollosa, *The Masters of Ukioye: A Complete Historical Description of Japanese Paintings and Color Prints of the Genre School* (New York: W. H. Ketcham, 1896).

2. Fenollosa, *The Masters of Ukioye*, wherein he describes his ten periods in the last two pages of the catalogue, 114–15.

3. Naitō Masato, "The Origins of Ukiyo-e," in *Drama and Desire: Japanese Paintings from the Floating World, 1690–1850*, ed. Anne Nishimura Morse, exh. cat. (Boston: Museum of Fine Arts, 2007), 34–39.

4. Harold P. Stern, *Ukiyo-e Painting*, vol. 1 of *Freer Gallery of Art, Fiftieth Anniversary Exhibition*, exh. cat. (Washington, D.C.: Smithsonian Institution, 1973).

5. What has made discoveries of this sort possible is the mastery of the Japanese language and the ability to read early texts and manuscripts that only a generation ago was restricted to a very few. Today, all scholars are required to decipher inscriptions on prints and paintings that were ignored in the past, and they routinely collaborate with their Japanese colleagues.

6. The term was apparently not used in this sense during the 18th century.

7. Timothy T. Clark, "Utagawa Hiroshige and the Maruyama–Shijō School," in *The Commercial and Cultural Climate of Japanese Printmaking*, ed. Amy Reigle Newland (Amsterdam: Hotei Publishing, 2004), 143–64.

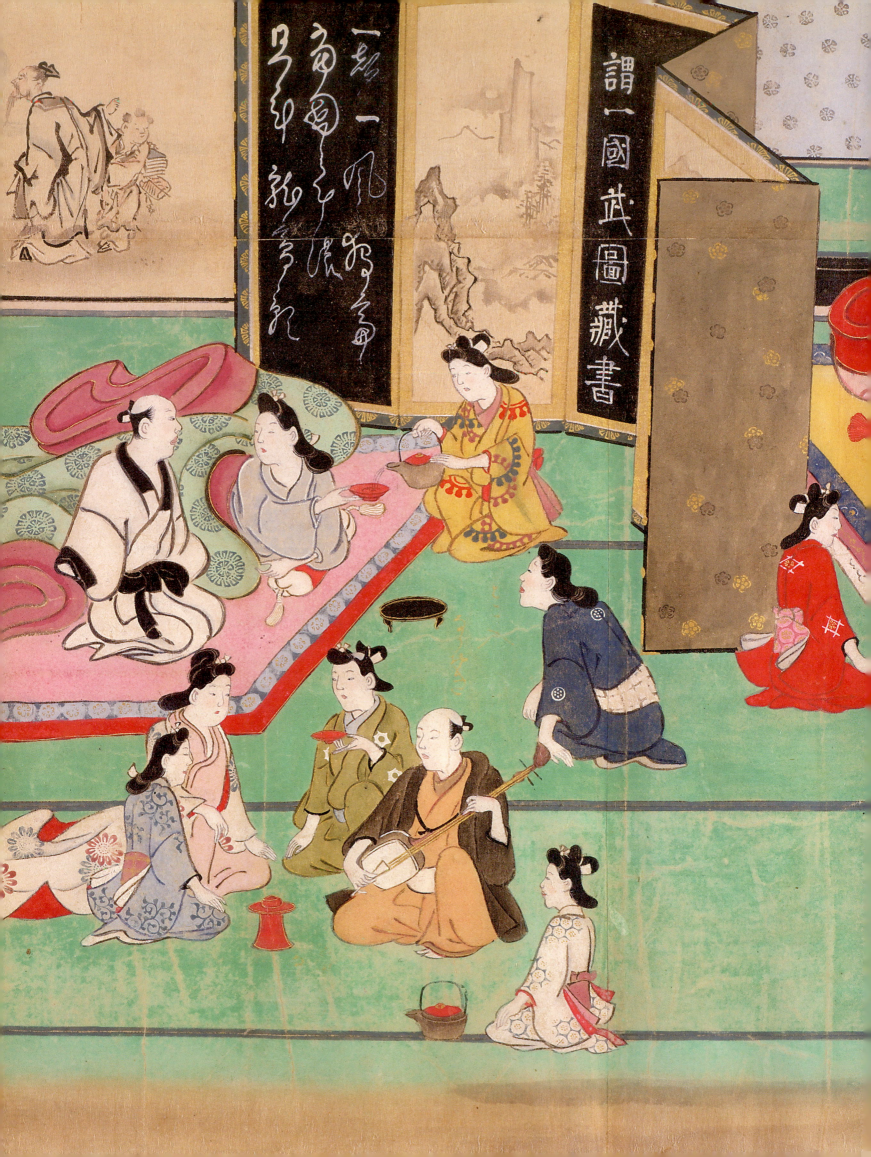

Hishikawa Moronobu
Tracking Down an Elusive Master

DAVID WATERHOUSE

By common consent, Hishikawa Moronobu is a seminal figure in the history of ukiyo-e, or "pictures of the floating world."[1] Misleadingly described as the "founder" of ukiyo-e, and with more legitimacy as its "father," Moronobu was also the first artist to be called an *ukiyo-eshi,* "master of ukiyo-e." He was to be an enduring influence on all later ukiyo-e artists, through his creation of a distinctive brand for Edo ukiyo-e: in style, in subject matter and in range of techniques and formats. Exact details of Moronobu's life and artistic background are hard to disentangle, and much has to be inferred from the work itself. In this essay, I present new evidence and propose new solutions, in particular concerning an important handscroll painting by Moronobu in the John C. Weber Collection (figs. 15, 30–32). It and the other works by him in the present exhibition draw attention to the Yoshiwara pleasure quarter in Edo, as well as to Moronobu's evident delight in the depiction of beautiful women and their clothes.[2]

In Chinese, the expression "floating world" was originally Daoist. In Japanese, *ukiyo* could mean either "floating world" or "sad, troublesome world," especially in Buddhist contexts. In the early seventeenth century, more cheerful interpretations made their way into *kanazōshi,* or "leaves written with kana syllables": printed collections of lighthearted tales, miscellanies, guidebooks and so on, often illustrated with black-and-white woodcuts. The most influential of these was *Tale of the Floating World* (*Ukiyo monogatari*), written in 1665 or 1666 by Asai Ryōi (1612?–1691), a Pure Land monk in Kyoto and the author of some seventy titles, including commentaries on Buddhist and other texts, as well as popular fiction and guidebooks. Its introductory section contrasts two interpretations of *ukiyo* and recommends what one might call "going with the flow." In practice, this implied disporting oneself in the pleasure quarters and theater districts of Edo, Kyoto and Osaka, as depicted in countless ukiyo-e prints and paintings. By the late seventeenth century, a major category of *kanazōshi* was *ukiyozōshi* (leaves written about the floating world), especially those by the Osaka author Ihara Saikaku (1642–1693).

After its establishment in 1603 as the seat of government, Edo (modern Tokyo) grew into a bustling metropolis where feudal lords maintained grand mansions. Despite catastrophic

Figure 32 (detail)

33

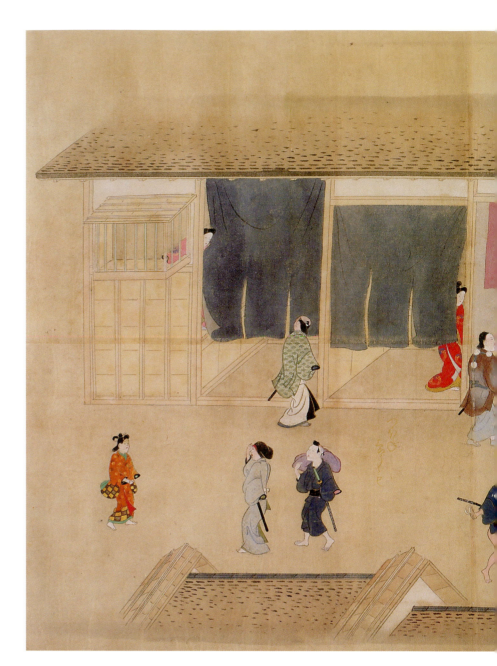

Figure 15
Hishikawa Moronobu
Display Room of a Brothel, from *A Visit to the Yoshiwara*
Late 1680s. Handscroll; ink, color and gold on paper. 54.1 x 1,761.4 cm. John C. Weber Collection

This section features the latticed display room of second-rank courtesans at the House of Miura, a popular brothel on Kyōmachi, the last of the three main lateral streets crossing the Yoshiwara. It also shows the Takashima, a bordello for low-class prostitutes run by Takashima Kiyozaemon. A woman at the Takashima gives money to an itinerant priest, probably an exorcist. Takashima must have had special meaning for Moronobu, who shows it in several paintings and in his set of twelve single-sheet prints of the Yoshiwara. A label reads "*tsubone agarau to mo,*" referring to the low-class prostitutes called *tsubone* (literally "small room") who are shown peeking out of the doorways of a series of very small bordellos.

fires in 1657, 1658, 1682 and 1698, it flourished through the century and became a magnet for literati, artists, craftsmen, entertainers, merchants and others ministering to the needs of both samurai and leisured townsmen. Many of the newcomers were from Kyoto or Osaka, and the cultural history of the following 250 years is largely a tale of these three cities, at a time when Japan was almost isolated from the outside world.

Recent research indicates that Moronobu was born in about 1631, and it is known that he died in 1694.[3] The name Hishikawa comes from a village in the Fushimi district of Kyoto, where Moronobu's grandfather Hishikawa Shichiemon apparently had an indigo dyeing business (*kon'ya*). *Kon'ya* not only dyed cloth but also printed designs on it, using stencils.[4] Shichiemon's son Kichizaemon Dōmo (d. 1662) expanded the family business to include silk embroidery (*nuihaku*), which involved both stitching and the printing from stencils of designs in gold or silver foil (*surihaku*) with the support of a wooden frame.[5]

From their study of local genealogies, Nishina Yūsuke and Kawasaki Yoshirō conclude that Kichizaemon came to Hoda, in the Heguri district of Awa province (in the southwest of modern Chiba Prefecture) in the early 1620s; that he married in about 1624 (aged twenty-five or twenty-six); and that his fourth child, Kichibei (later known as Moronobu), was born in 1630 or 1631.[6] Hoda, one of two adjacent fishing villages on the east side of Tokyo Bay, was within easy reach of the Edo market, and perhaps Kichizaemon was invited by the local

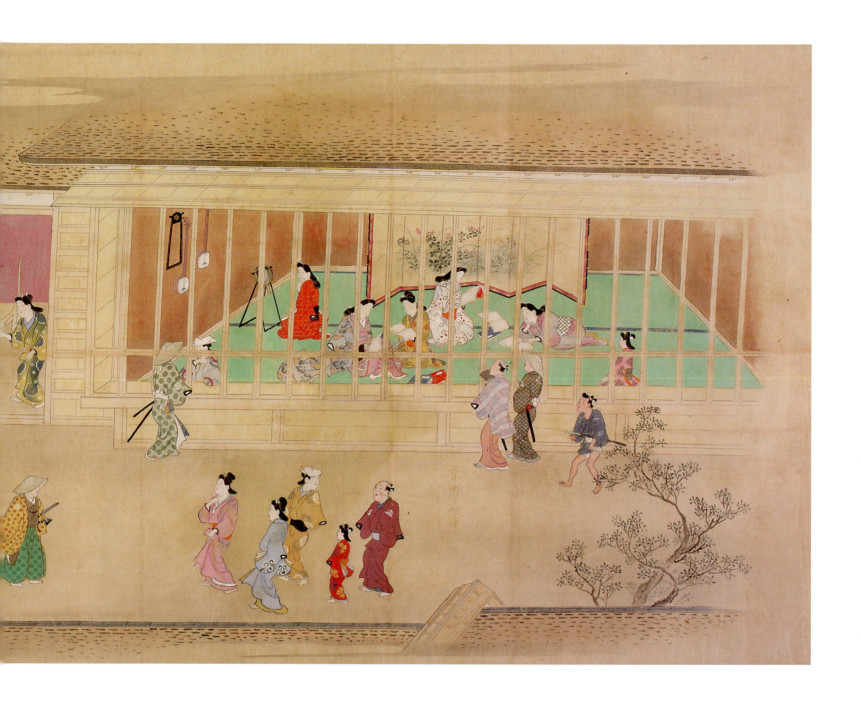

daimyo, Yashiro Tadamasa (1594–1662). Moronobu's mother, Otama, was from the Iwasaki family, fishermen in Hoda for many generations. The waters off Hoda attracted fishing boats from Kii, Ise and Izumi provinces.

Buddhism also flourished in the region, and Pacific Awa was famous as the birthplace of the Buddhist teacher Nichiren (1222–1282). At a monastery in Futtsu City near Hoda is an embroidered hanging by Kichizaemon of the Buddha on his deathbed, surrounded by mourners.[7] This very large piece, inscribed and dated 1658, suggests that he specialized in Buddhist subjects; it is said to have taken him over three years to complete, and his sons Moronobu and Masanojō could have helped with the underdrawing.

There are large gaps in Moronobu's early life. It is unclear when or how he came to work in Edo, and it is often assumed that he did so only after his father's death in Hoda in 1662. He began using the name Moronobu and became successful as a woodcut print artist and painter after 1672. Tanaka Kisaku was the first to suggest that he studied in Kyoto,[8] and Nishina Yūsuke suggested that he had come to Edo as early as the age of sixteen, before going to study in Kyoto, where he might have been exposed to the family textile business.[9]

Some clues come from the prefaces and colophons to Moronobu's books. For example, from his *One Poem Each by a Hundred Poets on Mount Ogura* (*Ogurayama hyakunin isshu*, 1680), illustrating a classic anthology edited by Fujiwara Teika (1162–1241), we learn that

originally this painting master of the Hishikawa clan (*uji*) is from a family business (*kagyō*) in Awa province (Bōshū), but from his youth he has been extremely fond of this Path [i.e., of painting]. Skilled with words, and applying his mind, he differentiates samurai and farmers, and delineates the forms of each. Grasping his brush in his fist, he copies on paper the taking up of a bow and wipes clean the ink. When, mingled in with these, he begins depicting the exertions of people of the soil, one's immediate feeling just on seeing them is that one can distinguish men of low degree and assign them to their estate; and they are drawn in a fascinating way. In conception his works surpass those of other men. At the present time the renown of [this] *yamato-e* [Japanese-painting] master is proclaimed in the Four Directions; prosperity rewards him; and, when one combines these pictures into a single volume, they constitute a diversion in pictures for people to use as practice.[10]

The author of the above preface, using the pen-name Anke, describes himself as a resident of Suita, in Settsu province (north of Osaka). In the same year, Moronobu published at least four other illustrated books, two of which have prefaces by Anke. In 1683, in the preface to a three-volume collection entitled *Compendium of Yamato-e* (*Yamato-e zukushi*), Anke describes Moronobu as having taken a ship from the shore of Awa and come to live "below the Castle" in Edo.[11] Anke adds that Moronobu has taken the title *ukiyo-eshi*—a very early instance of this term, which appears thereafter in the colophons of several of Moronobu's books.[12]

Moronobu's earliest exactly dated work is the 1672 *One Poem Each by a Hundred Samurai* (*Buke hyakunin isshu*), illustrating one hundred poems by one hundred samurai, along with their portraits. The colophon names the calligrapher as one Tōgetsu Nanchō and the artist as Eshi Hishikawa Kichibei. In a 1678 collection, *Portrait Eulogies of One Poem Each by One Hundred Poets* (*Hyakunin isshu zō sanshō*), he appears as "*Yamato-eshi* Hishikawa Kichibei Moronobu from below Edo Castle in Musashi province."[13] This is possibly the earliest datable instance of the name Moronobu, literally meaning something like "leader in expression."

Despite evidence to the contrary, Moronobu was still described as resident in Awa province in the colophon of his 1680 *Hundred Poets on Mount Ogura*.[14] He evidently retained strong ties there. In the fifth month of Genroku 7 (1694), he presented an inscribed bronze bell to Rinkaisan Betsugan-in, site of the Hishikawa family graves in Hoda. Betsugan-in was attached to Shōryūji, a Sōtō Zen monastery founded in 1613. Unfortunately, this bell was requisitioned during World War II for its metal, and may no longer exist; but there is a photograph of it, and a rubbing of the inscription. On the fourth day of the sixth month that same year, Moronobu died in Edo. Funeral rites were conducted at Tokuju-in, a nearby Pure Land monastery, where his daughter and grandchildren were interred, but soon afterward his remains were transferred to the gravesite in Hoda.

On the twenty-second day, eleventh month of Genroku 16 (1703), a violent earthquake and tsunami struck the peninsula, wiping out Hoda village and much of the surrounding district. Saitō Gesshin (1804–1878), drawing on contemporary records, says that houses were tossed like small boats, there were fires, and many men and horses perished. Other earthquakes and fires followed, in Edo as well. In Awa alone, supposedly one hundred thousand people died.[15] Betsugan-in, set on a low promontory, was destroyed, and the graves of Moronobu and his father would have been washed out to sea. Further damage was caused by a flood tide in 1791 and a fire along the shore in 1907, not to mention the last recorded eruption of Mount Fuji, in 1707, which deposited ash over a wide area.[16]

Moronobu had five children, but the identity of his wife, who is not mentioned in the Shōryūji genealogy or anywhere else, is unknown. The silence of the records suggests that she was a courtesan. His direct followers included his younger brother, Masanojō; his eldest son, Morofusa; his second son, Moroyoshi; his son-in-law, Moronaga; and his pupils Masanobu, Tomofusa, Moroshige and Morohira, all using the family name Hishikawa.[17]

Figure 16
Hishikawa Moronobu
Thread Makers and Embroiderers, from
*The Various Occupations of Japan, Exhaustively
Portrayed: A Picture Book Mirror of the Various
Occupations (Wakoku shoshoku ezukushi:
shoshoku ehon kagami)*
1685. Woodblock-printed book. Vol. 4 of 4 bound
as 3, fols. 7v–8r. 26.7 x 18.5 cm each page.
Collection of Arthur Vershbow

Moronobu the Master Illustrator and Painter

The main center of publishing in seventeenth-century Japan was Kyoto, distantly followed by Edo and Osaka. Printing had been monopolized by the great Buddhist monasteries, but now commercial publishers put out editions of Chinese classics and Buddhist texts; Japanese classics; poetry in both languages; and miscellaneous manuals of instruction, for women as well as men. There was also the *kanazōshi* fiction referred to earlier. By the late seventeenth century, publishing in the three cities was on a vast scale, and publishers' printed trade catalogues ran to hundreds of pages, elaborately classified according to subject. One Edo catalogue of 1696 was 674 pages long and listed 7,800 titles.[18] Most of Moronobu's woodblocks and original stock seem to have been destroyed in 1682 in a fire started by Yaoya Oshichi, the star-crossed girl who literally set Edo ablaze,[19] but within a few years his publishers reissued several books in recut editions, in Kyoto or Osaka as well as in Edo. A case in point, from the present exhibition, is *The Various Occupations of Japan, Exhaustively Portrayed: A Picture Book Mirror of the Various Occupations (Wakoku shoshoku ezukushi: shoshoku ehon kagami)*, first published in four volumes in 1681, and reissued with slight variants in 1685, in both a four-volume and a three-volume edition (fig. 16).[20] Though much will have been lost altogether, Moronobu's corpus of illustrated books and albums between 1672 and 1694 has been estimated at over 150, including some 120 single-sheet prints in sets.[21]

In preindustrial cities worldwide, handicrafts and trade were controlled by guilds and families.[22] In seventeenth-century Japan, the guilds (*nakama*) were self-regulating, though the government might step in unexpectedly.[23] Family groups (*kumi*) operated an apprentice system, with succession going to the eldest son or an adopted apprentice. There were separate guilds for block cutters, printers, publishers, booksellers and countless other trades. These fraternal organizations developed strong loyalties, rivaling those of the samurai class. With the switch to a money economy, the rising merchant class prospered, though it had no political power. The four-class system instituted in the late sixteenth century, with samurai at the top of the hierarchy and merchants at the bottom, was always notional; some of the most successful merchants were former samurai, and the Edo townsman (*chōnin*) gradually developed his own highly literate culture which transcended class barriers.

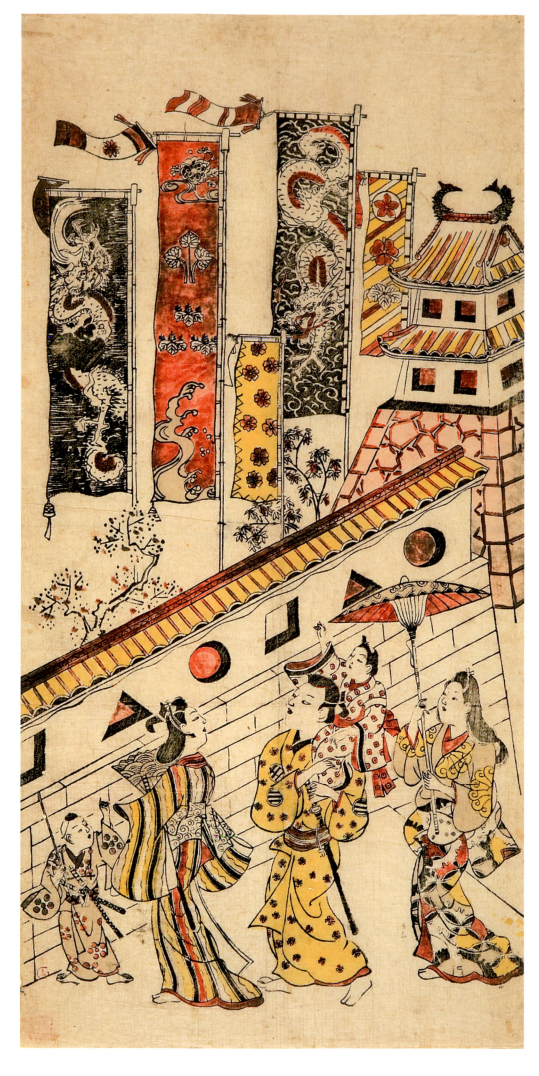

Figure 17
Attributed to Sugimura Jihei
Family Outing on Boy's Day
1680s. Woodcut, handcolored. 59.7 x 29.8 cm.
Asian Art Museum of San Francisco, Gift of the
Grabhorn Ukiyo-e Collection, 2005.100.1

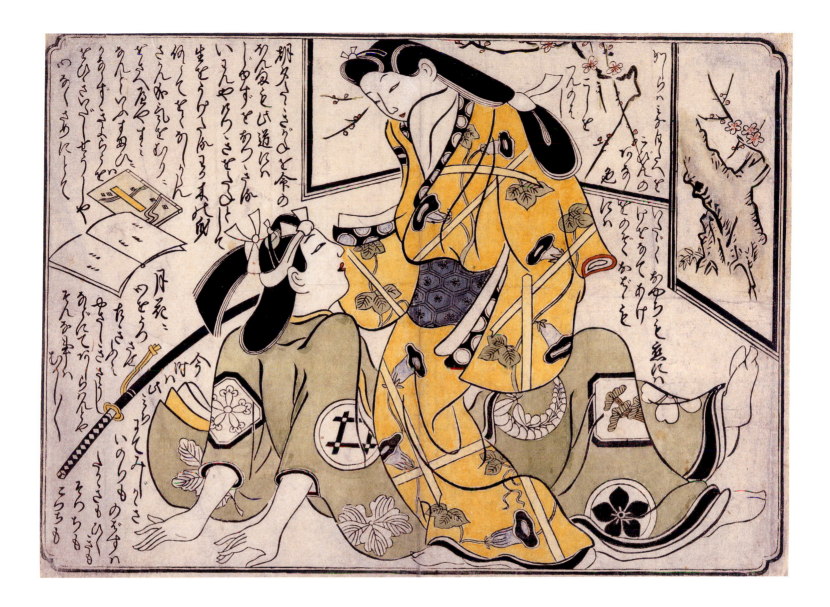

Figure 18
Attributed to Sugimura Jihei
Lovers
1690s. Woodcut, handcolored. 26.6 x 36.2 cm.
The Mann Collection, Highland Park, IL

The text, an ironic commentary on the activities
shown here, may be summarized more or less
as follows:

> Even white-haired old men and elderly ladies
> are excited by the thought of love, so how
> much more so is it true for young people. In
> the past, neglected younger sons relieved their
> boredom by viewing the moon and the cherry
> blossoms or reading easy books. But now
> everyone, high and low, far and near, spends
> his or her time in amorous play.

Moronobu's books, prints and paintings spring from this background, and catered to all
classes. His books, varying in style and format as well as topic, and in the quantity and place-
ment of text, were put out by at least six different Edo publishers.[24] His pair of handscroll
paintings of various occupations includes a scene in a publisher's workshop, with a block cut-
ter, printer and binder at work side by side, while a porter in the street bears away a load of
finished books.[25] Clients could specify the quality of paper they wanted, and might ask to
have album prints colored by hand. However, the last sentence in Anke's 1680 preface implies
that owners might practice applying their own coloring.[26] Two prints by Moronobu's pupil
Sugimura Jihei (act. c. 1681–98) in the present exhibition have carefully applied handcoloring,
and it is difficult to say whether this was done at source or by an early owner (figs. 17, 18).

Besides the one-hundred-poem collections mentioned previously, Moronobu's subject
matter embraced illustrations for classic, folk and popular tales; other poem collections;
stories about military heroes of the past; play texts; stories or texts on Buddhist themes;
histories; guides to Edo, the Yoshiwara and other pleasure spots; depictions of artisans at
work; portraits of beautiful women (especially of the Yoshiwara) and handsome men (espe-
cially kabuki actors); design books for paintings, fans or kimonos; birds and flowers; erotic
albums; and so on. Many of these productions were single volumes, but others were in two
to five, or as many as twelve volumes. The erotic albums and other single-sheet prints usu-
ally comprised a set of twelve sheets (figs. 19–22).

In later life, Moronobu came into his own as a painter. He must have maintained his
own studio at one of the successive Edo addresses we have for him between the Sumida
River and Edo Castle, close to the theater district and to his main publishers. Some of his
pupils and family members lived under the same roof, and they helped with major works.[27]

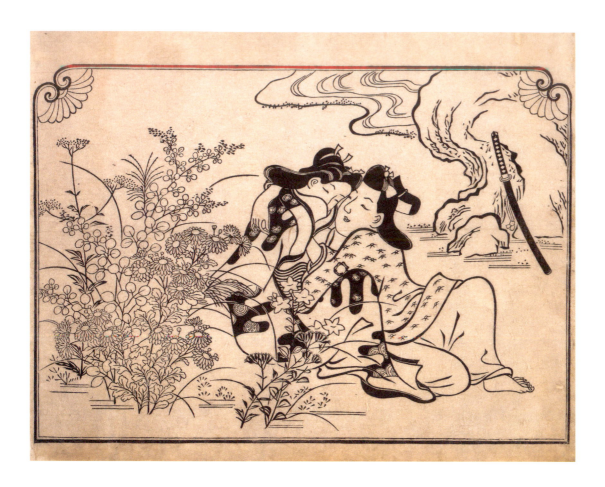

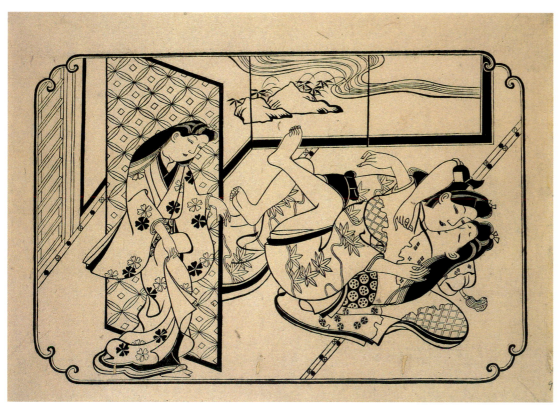

Top: Figure 19
Hishikawa Moronobu
Couple Seated by Autumn Flowers
1680s. Woodcut. 29.2 x 34.3 cm. The Metropolitan
Museum of Art, Harris Brisbane Dick Fund and
Rogers Fund, 1949, JP 3069

Above: Figure 20
Hishikawa Moronobu
Watching a Courtesan and Her
Client from Behind a Screen
c. 1680. Woodcut. 27.2 x 38.3 cm.
Kate S. Buckingham Endowment, The Art
Institute of Chicago, 1973.645.9

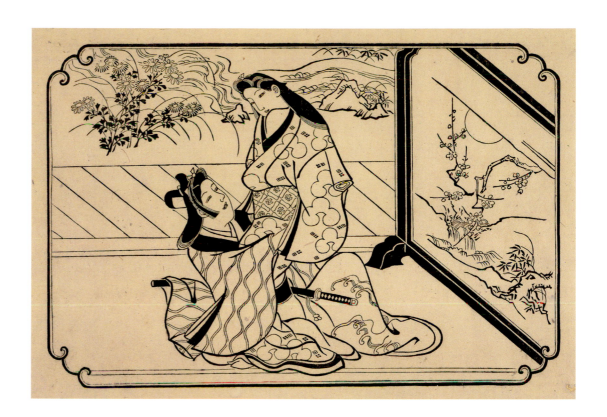

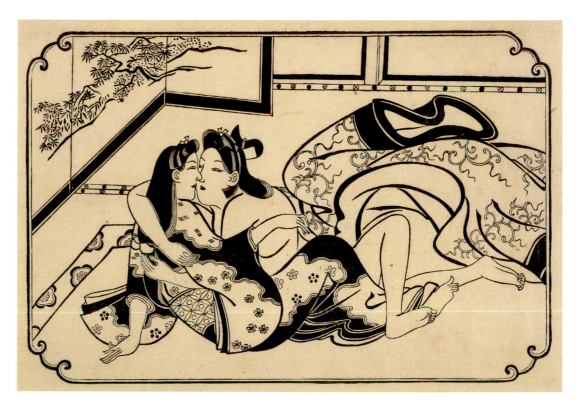

Top: Figure 21
Hishikawa Moronobu
Lovers Beside a Screen
c. 1680. Woodcut. 27.2 x 38.4 cm.
Kate S. Buckingham Endowment, The Art
Institute of Chicago, 1973.645.1

Above: Figure 22
Hishikawa Moronobu
Lovers By a Screen
c. 1680. Woodcut. 27.1 x 38.4 cm.
Kate S. Buckingham Endowment, The Art
Institute of Chicago, 1973.645.4

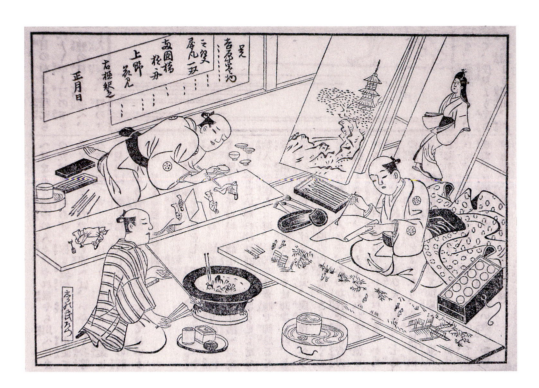

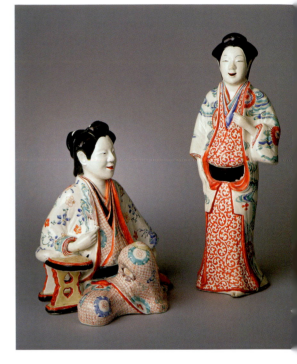

The frontispiece of *Shika's Paper-Wrapped Brush* (*Shika no makifude*), published in 1686, depicts an artist's studio in which two men are working on ukiyo-e handscroll paintings (the silk is stretched on frames), while a client watches (fig. 23). Leaning against the rear wall are an ink landscape hanging scroll in the Chinese manner and a female beauty in the style of Moronobu. The client is identified as Shikano Buzaemon (1649–1699), the author of this book and the main creator of *rakugo* ("chipped speech," a type of comic monologue still popular today).[28]

Artistic training and transmission in feudal Japan differed considerably from those in seventeenth-century Europe or Renaissance Italy. Teaching was secretive, might last many years and was by imitation, with a minimum of oral instruction. Painting was dominated by the Kano and Tosa lineages, which received official support and had their own transmission. In performing, martial and decorative arts, the *iemoto* (house source) system, by which masters of a traditional art certified successors, was taking shape in varying ways. Ukiyo-e, new at the time, never developed a full-blown *iemoto* structure, though artists often took their teacher's family name as well as part of his art name.[29]

Even without formal instruction, an abundance of models was available to Moronobu.[30] By the 1660s there were the immediate forerunners of the *ukiyo-e* style established by Moronobu during the following decades: anonymous black-and-white albums containing especially erotic prints; paintings of the so-called "Kanbun beauties" (after the Kanbun era, 1661–73); and screen paintings of Edo festivities. Some of these works may even have been by Moronobu himself. A single figure in the "Kanbun beauty" tradition demonstrates Moronobu's fascination with kimono patterns and with the flowing lines created by this garment when it is in use (fig. 24).[31] A demure beauty trips lightly across the silk surface, her gorgeous red robe patterned with small gold roundels and a prominent motif of painted clam shells, each bearing a different design, an allusion to the *kai-awase*, a shell-matching parlor game sometimes depicted in ukiyo-e and with a long history in Japan. The Moronobu figure type carried over into other luxury items, including porcelain figurines (fig. 25).

Left: Figure 23
Furuyama Moroshige
Artist's Studio, from Shikano Buzaemon, *Shika's Paper-Wrapped Brush* (*Shika no makifude*)
1686. Woodblock-printed book. From *Kono hana* 6 (June 1910): 8

Two artists paint on silk that has been stretched on frames. Each artist has multiple brushes, small dishes for color and water for cleaning brushes. There are an inkstone and ink stick on the floor between them. The artist on the right tests his color on a blank sheet of paper; the one on the left holds two brushes in his hand.

Right: Figure 25
Seated and Standing Beauties
c. 1670–90. Arita ware, Kakiemon style, porcelain with enamels and traces of gilt. H. 26.7 cm (seated); 39.4 cm (standing). Asia Society, Mr. and Mrs. John D. Rockefeller 3rd Collection of Asian Art, 1979.241, 1979.239

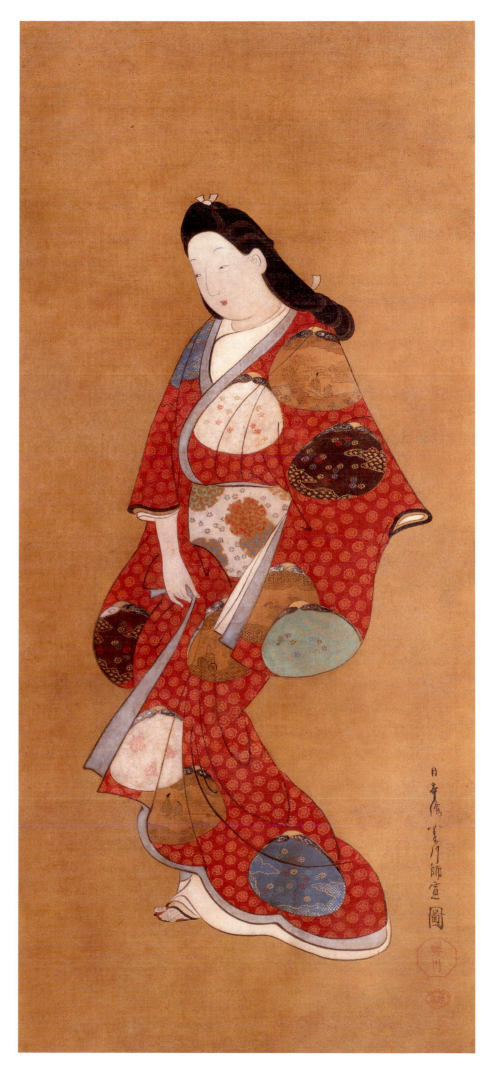

Figure 24
Hishikawa Moronobu
Standing Beauty
c. 1690. Hanging scroll; ink and color on silk.
68.6 x 31.2 cm. Collection of Richard Fishbein
and Estelle Bender

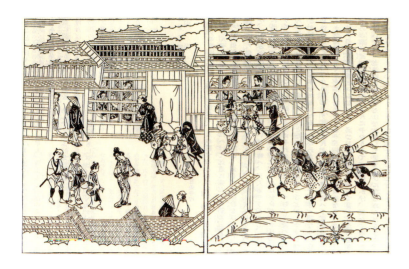

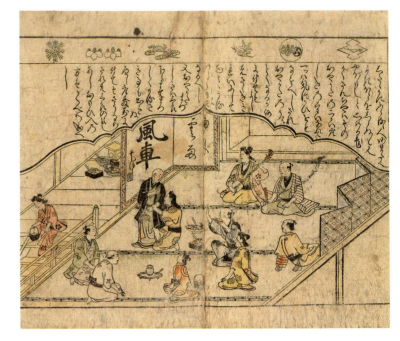

Moronobu and the Yoshiwara

The original Yoshiwara, literally, "Plain of Reeds," opened south of Edo Castle in 1618, on reclaimed land granted by the government. Inspired by licensed quarters in Kyoto, Osaka and elsewhere, it was a rectangular enclosure divided into several streets. The courtesans were virtual prisoners unless rich clients bought them out. Perhaps regretting the decision to allow its establishment, and concerned about the proliferation of illegal brothels and disreputable bathhouses, in 1656 the authorities ordered the Yoshiwara to move out of town. After the great fire of 1657, it was reestablished on virgin land north of the city, beyond Asakusa. The new site was laid out more spaciously but on the same plan, and a new character for *Yoshi* was chosen, so that the name meant "Plain of Good Fortune." The main street was Nakanochō, while assignation houses (*ageya*), small brothels and living quarters for the courtesans were in side streets.[32]

A short description of the Yoshiwara appears at the end of Asai Ryōi's *Record of Famous Places in Edo (Edo meishoki)*, published in Kyoto in 1662.[33] The single illustration shows two men on horses trotting toward the Great Gate of the Yoshiwara, while earlier arrivals are already inspecting the merchandise on display behind lattices along the main street (fig. 26). The view from above, repeated in other woodcuts and paintings, including the Weber scroll, is a reminder that the Yoshiwara lay at the foot of a slope. Later in the century Saikaku, writing from Osaka, makes references to the Yoshiwara, as do other authors of *ukiyozōshi*. However, the most vivid evocations of the Yoshiwara as it existed in the last quarter of the century are contained in Moronobu's woodcuts, in the Weber scroll and in other Hishikawa paintings.

Much of the New Yoshiwara had burned down in 1676, but it was evidently soon rebuilt.[34] *Guide to Love in the Yoshiwara (Yoshiwara koi no michibiki)*, published on "a clear, bright day" in 1678, is a cross between a guidebook and an illustrated storybook, combining practical information with whimsical allusions to classical literature and Buddhist doctrine.[35] Its unnamed author, an educated man, was probably a samurai. It introduces a pictorial scheme later refined by Moronobu, as in the Weber scroll. The first portion of the text, reminiscent of the *michiyuki* (journeying) section of a Noh play, begins at Ryōgoku Bridge over the Sumida River and takes the reader first to Asakusadera. By the seventeenth century, the latter was the largest Buddhist monastery complex in Edo, and it undoubtedly benefited from being a rest stop on the way to the Yoshiwara.[36]

The text lists return fares by boat or packhorse from central points in the city to Kinryūzan (near Asakusadera). At night, or if it was raining, more was charged; and tipping was recommended. For the final stage one took local transportation (horse, palanquin or

boat) or walked to the Yoshiwara. Particular boatmen (and more tipping) were recommended. Some of the paths were dangerous; and Moronobu's images show that Asakusa and the Yoshiwara were surrounded by open country. Brief descriptions are given of Doromachi ("Mud Street") and the Emonzaka ("Smartening-Up Slope") just outside the Great Gate, where one tidied up after the rigors of the journey. The gate itself looks modest, and there is only a glimpse of Nakanochō.

During this period, there were four main grades of courtesan. In ascending order, *Guide to Love in the Yoshiwara* mockingly describes and illustrates the experience of meeting *tsubone*, *sancha* and *kōshi*, the three lowest grades. We are then taken to an *ageya*, where more ambitious visitors made appointments to meet a top-grade courtesan, or *tayū*. Already by this date there were few *tayū*, and soon they priced themselves out of the market altogether. The *ageya* (fig. 27) would have been on Ageyachō, a side street added to the plan of the New Yoshiwara and, as we see from the Weber scroll and elsewhere, might be luxuriously appointed, with banquet kitchens and gardens. The text advises how to behave (and tip). Moronobu's illustrations depict entertainment beside a veranda and the preparation of food. The concluding scene takes us onto the street again; and a postscript encourages the reader to seek enlightenment through the Way of Love.

The publisher of *Guide to Love in the Yoshiwara* was one Hontoiya, who between 1660 and 1678 put out some twenty-one titles, including six illustrated by Moronobu.[37] The twelve black-and-white album prints of *Aspects of the Yoshiwara* (*Yoshiwara no tei*), datable to 1682 or 1683, were published by Yamagataya Ichirōemon, perhaps the successor firm to Hontoiya (figs. 28, 29).[38] There is a title but no text, and the pictorial scheme is a simplified version of that for *Guide to Love in the Yoshiwara*, some elements being common to both. The journey starts in the countryside near the Yoshiwara, and by sheet 4 we are already at the Great Gate.

There is a close correspondence between several sheets of *Aspects of the Yoshiwara* and the Weber scroll, which can be assigned stylistically to the late 1680s.[39] Dispensing completely with the earlier stages of the journey, it starts above the Yoshiwara on the Nihon-zutsumi ("Japan Embankment") and the Emonzaka, where samurai, attendants and porters are coming or going. The samurai wear basket hats to maintain their anonymity (see figs. 15, 28). Entering the enclosure with them, we encounter a busy scene, with shops and street vendors as well as teahouses, and low-class prostitutes soliciting customers (see fig. 15). At this period, there were many kinds of shops on Nakanochō; the restriction to teahouses came later.[40]

On the Weber scroll many figures and scenes are identified in gold ink; and some houses are named on storefront awnings. From Nakanochō we visit *sancha* establishments on two side streets, and a *tsubone* house on another street, before turning down Ageyachō to arrive at the entrance of a large *ageya*. A representative of the proprietor obsequiously greets a samurai client who has arrived with two attendants; and the second half of the scroll takes us inside. We see a crowded reception room (*ageya ōyose*) overlooking a garden with spring blossoms, and view the kitchen, where staff are preparing for an elaborate banquet (fig. 30). Beyond, servants carrying trays scurry to and fro past a room where bedding is stowed. We make a diversion to the upper room of a *sancha* house, where food and

Left: Figure 28
Hishikawa Moronobu
Yoshiwara Street Scene, from the series
Aspects of the Yoshiwara (*Yoshiwara no tei*)
1682–83. Woodcut. 25.7 x 38.6 cm. The
Metropolitan Museum of Art, Gift of the Estate
of Samuel Isham, 1914, JP 809

Right: Figure 29
Hishikawa Moronobu
Entertainers in a House of Assignation, from the
series *Aspects of the Yoshiwara* (*Yoshiwara no tei*)
1682–83. Woodcut. 25.7 x 38.6 cm. The
Metropolitan Museum of Art, Gift of the Estate
of Samuel Isham, 1914, JP 812

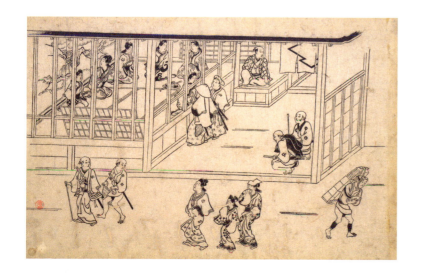

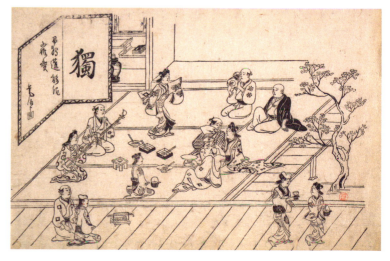

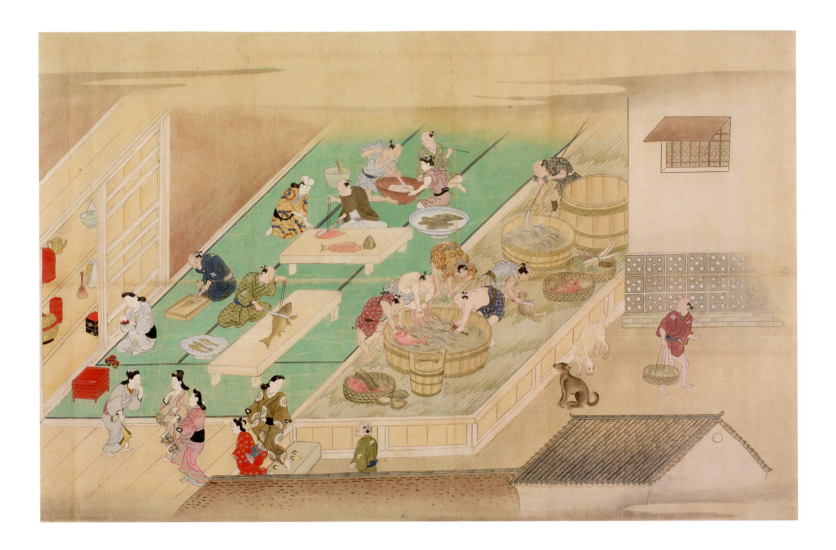

entertainment are being provided to a group of samurai, and to the *tomobeya*, where another group of samurai is served *sake*. Returning to the *ageya*, we look into a room where the proprietor, seated at a table with bags of money, is overseeing operations (fig. 31, upper center). In neighboring rooms parties are in progress, with music and dancing, and there is a view into the garden, with a running brook.

For the climax of the scroll, we cross a footbridge and pass another food station. Behind it a servant bears a huge trunk of bedding toward a screened room, where a couple, attended by more servants, lies together under wadded bedding kimono of the type known as *yogi* (fig. 32). In an adjacent screened area another couple, also with attendants, converses beside their bed; in a third bedroom the couple is sitting inside a huge mosquito net. In the final scene, clients are shown paying the bill, while behind them courtesans finally enjoy their own meal.

The Case of the Missing Art Patron

The unusual height and length of the Weber scroll, and the overall quality of the work, leave the viewer in no doubt that it is the work of a master. Though the signature was probably added later, and assistants may have helped, the only artist who would qualify is Moronobu himself. In this painting, as in his woodcuts, he demonstrates sureness of line, attention to detail, versatility in style, imaginativeness in composition and an overall softness and lightness of touch. Like Moronobu's other depictions of the Yoshiwara, it must be based on firsthand knowledge. It will be recalled that his wife may have been a courtesan and that his work includes many uninhibited erotica.

Even with the gold writing, it is hard to identify everything that is going on. One feels that the scroll contains private allusions for the client who commissioned it, plus a select group of his friends. It is natural, therefore, to wonder who this person was. The rich Edo

Figure 30
Hishikawa Moronobu
Kitchen of a House of Assignation,
from *A Visit to the Yoshiwara*
Late 1680s. Handscroll; ink, color and gold on paper. 54.1 x 1,761.4 cm. John C. Weber Collection

merchant Kinokuniya Bunzaemon (?–1734), who was famous for his wild spending and became a friend of the *haikai* poet Kikaku (1661–1707), might seem to be a candidate, but in the later 1680s would have been too young to contemplate such a commission. Moreover, as we see from the scroll itself, serious visitors to the Yoshiwara, and especially to an *ageya*, were then mostly samurai.

In the 1680s, the daimyo of Awa was Yashiro Tadataka (1647–1714), with a stipend of 10,000 *koku* (stones) of rice.[41] Entering the service of Tokugawa Tsunayoshi (1646–1709), the fifth shogun, in 1662, he succeeded as the third and last Yashiro daimyo the following year, at the age of sixteen or seventeen. In addition to lands in Awa (where his castle was at Kachiyama, north of Hoda), he had a mansion in Edo, in Takashōchō ("Falconers' Quarter"), where many daimyo had their mansions. In 1671, he was granted Minakuchi Castle in Ōmi province; in 1677 and 1689, he was additionally granted title to Osaka Castle; and in 1692 and 1693, he received further honors. Presumably these gifts came from Tsunayoshi, who was notorious for rewarding his favorites.[42]

In 1682, Tadataka was one of two daimyo granted leave to supervise ceremonies in Nikkō for a proxy visit by the emperor. In the same year a peasant revolt erupted in Tadataka's domain in Awa, but in 1711 there was a far more serious revolt. Over a period of ten years his steward Kawai Tōzaemon had increased taxes, appropriated timber from shrines and monasteries and used forced labor for new irrigation canals. A delegation of village headmen brought their grievances to Edo, and, ultimately, there was a demonstration involving some six hundred farmers outside Tadataka's mansion. Tōzaemon seized the leaders and beheaded three of them, but the farmers appealed directly to the government. Tsunayoshi had died in 1709 so he could no longer protect Tadataka, and the government sided with the farmers. Tōzaemon and his children were put to death. Tadataka was deprived of his domain in Awa, was fined heavily, was demoted to the rank of bannerman (*hatamoto*) and died in disgrace. The affair came to be known as the *Mangoku sōdō*, "the 10,000-*koku* disturbance," and was among the first of many peasant rebellions during the Tokugawa period.[43]

This, then, was Moronobu's daimyo. If one reads between the lines it is apparent that over many years he mismanaged and neglected his domain, and that he ran into financial difficulties, perhaps as a result of visits to the Yoshiwara. By the late 1680s, Moronobu was famous in Edo and beyond, and was frequently advertised as being from Awa. Moronobu was not from the samurai class, but it is tempting to suppose that, at least indirectly, he owed his commission for the Weber scroll, and perhaps for other paintings, to Yashiro Tadataka.

The shogun had countless retainers with time on their hands, and many daimyo in Edo would have had the means and possibly the inclination to order such a painting. Another whose name springs to mind is Makino Narisada (1634–1713). His domain was not far from that of Tadataka and of similar size, in part of Shimōsa province (now in Chiba Prefecture). He too was promoted to high office by Tsunayoshi, he entertained him in his compound, and after the shogun's death he thought it wise to take Buddhist ordination.[44]

Examining the Weber scroll for further clues, we find that at the entrance of the *ageya* its proprietor is named in gold ink as "Fucha Tarōemon." This individual does not appear in *Great Mirror of the Way of Love* (*Shikidō ōkagami*, 1678), a guide to courtesan quarters throughout Japan compiled by Hatakeyama Kizan (c. 1628–1704). We can presume that Tarōemon's establishment in the Yoshiwara dates from the early 1680s, since it is depicted also in Moronobu's *Aspects of the Yoshiwara* series and seems to have been a real place. However, "Fucha" must be a nickname referring to *fucha ryōri*, also called *fusa ryōri*, a type of cuisine associated especially with the Ōbaku school of Zen Buddhism. It was introduced to Nagasaki from China in the early seventeenth century, and documentary sources indicate that it might then have included meat, poultry and fish along with the vegetables. The word *fucha* means "tea for all." A distinctive feature of *fucha ryōri* was that the food was served on tables, and in larger dishes from which diners helped themselves, as opposed to the small individual trays and dishes typically favored in Japanese cuisine. In the Weber scroll we see in the kitchen the preparation of just this kind of meal, using large blue-and-white serving dishes, so that it provides us with both an early instance of the word *fucha*, and iconographic evidence for *fucha ryōri*.[45]

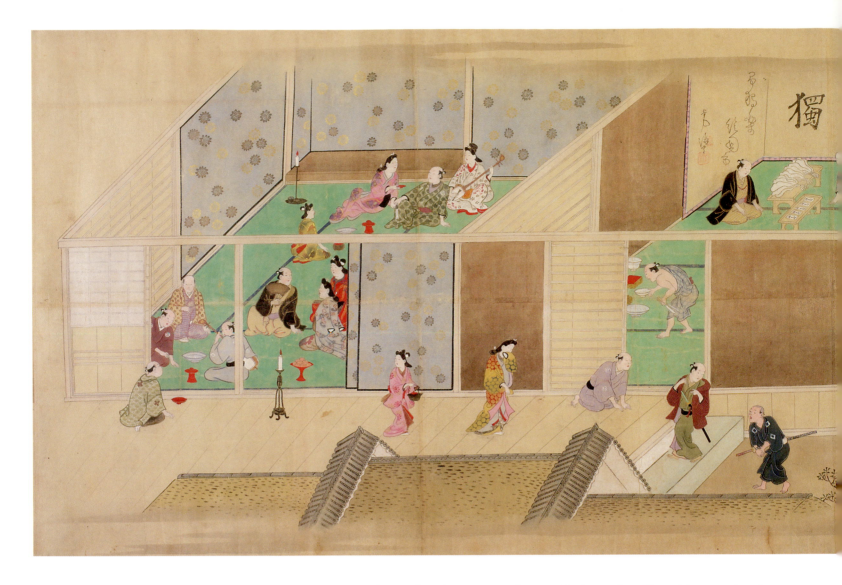

Figure 31

Hishikawa Moronobu
Proprietor of a House of Assignation,
from A Visit to the Yoshiwara

Late 1680s. Handscroll; ink, color and gold on
paper. 54.1 x 1,761.4 cm. John C. Weber Collection

At the lower right is a waiting room for retainers
(*tomobeya*) who accompany samurai clients.
They, too, are wined and dined with sake and
good food. The proprietor (top center) is seated
at a table with bags of money. To the left, various
evening scenes include more sake and music
by candlelight.

Later in the scroll Fucha Tarōemon is seated in front of a calligraphic screen bearing the signature *Longhu* (J. Ryūko) and including the large character *doku* (solitude), followed by a cursive seven-character Chinese inscription which speaks of a man as a solitary lotus (emblematic of the Chinese Buddhist scholar) (fig. 31). Exactly the same screen is portrayed in *Aspects of the Yoshiwara* (see fig. 29); and it was probably a prized possession of Fucha Tarōemon, who despite his Japanese name may have been a Chinese immigrant. Another calligraphic screen with the signature *Longhu* and an inscription including the large characters *fūsha* ("wind carriage" or "windmill") is depicted in Moronobu's *Guide to Love in the Yoshiwara* (see fig. 27). Still another, with the same signature and an inscription beginning with the large characters *dokuryū*, "solitary dragon," is depicted on a small screen in the Nara Prefectural Museum.[46]

Longhu, "Dragon Lake," can be identified as a brush-name of Li Zhuowu (Li Zhi, 1527–1602), who in later life lived for a while at the Cloister of the Iris Buddha (Zhifuo Yuan) beside Dragon Lake, in Huguang province (modern Hubei and Hunan). Li Zhuowu was an eccentric and controversial figure, who espoused the Neo-Confucian philosophy of Wang Yangming (1472–1528) but also sympathized with Chan (J. Zen) Buddhism and with Daoism, while castigating the followers of all three paths. For a while he openly consorted with prostitutes; he was eventually imprisoned and committed suicide in jail. He was a prolific author, whose writings were banned after his death but were widely circulated. They include a commentary on the theory of karma, in which he discusses the Buddhist precept on releasing animals; Confucian polemic; and attributed commentaries on the *Romance of the Three Kingdoms* (*Sanguozhi yanyi*; J. *Sangokushi engi*), the *Journey to the West* (*Xiyuji*; J. *Saiyūki*) and the *Water Margin Classic* (*Shuihu zhuan*; J. *Suikoden*). These enormously long Ming novels of action and adventure were admired in Edo Japan and provided subject matter for ukiyo-e and kabuki theater (see fig. 132).[47] Immersing himself in the "pleasures of the market

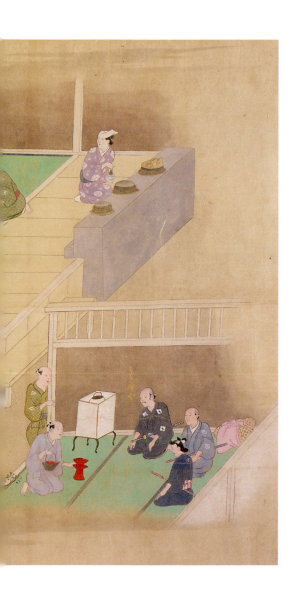

place," Li Zhuowu remarked that "It was only after I came to Macheng and began to frequent the brothels that I was able to breathe the dust of this world along with commoners."[48] The admission was later used against him, but it would make him an apt role model for the Way of Love.

In the Weber scroll the Chinese connection is reinforced in other details of the *ageya*. The first bedroom is decorated with a Chinese table and a bronze Chinese lion incense burner (also seen in *Aspects of the Yoshiwara*). In the second bedroom the paintings on the rear wall, in Chinese style, depict several of the Seven Sages of the Bamboo Grove (fig. 32). Moronobu may not have been aware that the phrase "floating world" first appears in an essay by one of these third-century worthies. Most conspicuous, however, is a large six-panel screen that is partially visible in the second bedroom scene. It alternates Chinese "stone rubbing" calligraphy in white on black with a Chinese landscape painting in the Northern style, and its overall composition resembles that of a Chinese folding album, magnified greatly in size.[49] The characters on the panel to the right of the landscape form a title, of which one possible Japanese reading is *Iwaku ikkoku buzu zōsho*, "So-called Book Collection of Military Images of the One Country." This apparently alludes to the *Cangshu* (J. *Zōsho*), a huge anthology compiled by Li Zhuowu, and one wonders if Moronobu was playfully turning an actual Chinese album into a screen painting.

The cursive characters on the left panel are in a style known in Japan as *O-ie-ryū*, "Honorable House School," an old aristocratic form of calligraphy which by the Edo period was being taught in monastery schools. It was particularly associated with the Ōbaku school, and gradually filtered down to the townsmen class.[50] A provisional Japanese reading of the inscription is:

issei ippū hitori ni hitoshiku
tōgoku no sokuryū
katsu sunawachi ryōga no omokage

One voice, one wind alone is like
the very line of this country:
indeed, it is the very image of the
 imperial palanquin.

Li Zhuowu, for all his unorthodox opinions, was fiercely loyal to the emperor. Indeed, *Cangshu* and its sequel *Xu Cangshu* are huge compilations of anecdotes about dutiful emperors, loyal feudal lords, generals, scholars, officials and others, elaborately classified according to rank. The characters in question are resistant to reading, but if the interpretation proposed above is on the right lines, the saying could be taken as affirming the Tokugawa ruling house's relationship with the throne in Kyoto.[51]

Ōbaku Zen, introduced from China in 1654, quickly spread as an upper-class intellectual fashion in the later seventeenth century.[52] Japanese interest in Chinese culture was by no means confined to Tang poetry and the classic Confucian texts, but embraced fiction, food, the latest developments in Chinese Buddhism and art, too. The color scheme and overall conception of the Weber scroll seem to owe something to Ming banquet painting, and it has been shown that elsewhere Moronobu borrowed from an erotic book attributed to Tang Yin (1470–1523).[53]

In the late 1680s and 1690s, a wealthy samurai gentleman with a taste for Chinese culture and fine Chinese food, who wished also for a night out with the ladies, might betake himself incognito to Tarōemon's *ageya*. Such a person was Yanagisawa Yoshiyasu (1658–1714), protégé of that colorful character, the shogun Tokugawa Tsunayoshi. Tsunayoshi is best known to posterity for his protection of dogs, but he encouraged education, the publishing of Confucian texts and the pursuit of literature generally. He also spent lavishly, and he shamelessly promoted Yoshiyasu, who gradually assumed control of the treasury. The prevailing ethos of the period was relaxed, and culture and the arts flourished, even if government coffers were drained and the coinage debased.

Yoshiyasu, Tsunayoshi and Makino Narisada were all born in a Dog year, and this undoubtedly helped to draw the three men together; but Yoshiyasu was twelve years younger, being a near contemporary of Yashiro Tadataka (who died in the same year). Singled out in his youth for preferment, Yoshiyasu rose rapidly in favor, was showered with additional stipends, estates and honors, and at the end of 1694 was appointed as one of

the shogun's chief advisers, or *rōjū* (elders). The other *rōjū* were all considerably older. Until Tsunayoshi's sudden death from illness in 1709 Yoshiyasu consolidated and augmented his power, afterward retiring to Rikugien, his garden estate in the Hon Komagome district of Edo, where he died in 1714.

If Tsunayoshi and Yoshiyasu did see the Weber scroll, they would have liked the two dogs hovering around the kitchen (see fig. 30).[54] The dogs could even be a joke at the expense of both men. The shogun's only son was lost to him as a child and he had been told by the Shingon Buddhist monk Ryūkō (1649–1724) that he must have been born as an animal in a previous life. He should therefore show compassion to animals, especially dogs, since (like Yoshiyasu) he had been born in the Year of the Dog. In 1681, Tsunayoshi's mother, Otama, under her Buddhist name, Keishōin, established in the Ōtsuka district of Edo what later became the Shingon monastery of Gokokuji, and Tsunayoshi rewarded Ryūkō with a series of important clerical positions. In the later 1680s, he passed a series of ordinances to protect successively oxen and horses, birds, fish, dogs and other animals. The ordinances concerning dogs were the most far-reaching, and earned him the nickname *Inu-kubō*, "Dog shogun." Dogs had to be registered, it was prohibited to kill them, and large kennels for strays were constructed in the Nakano district of the city. Much inconvenience was caused, and many people were imprisoned, banished, or even executed for violating the laws regarding compassion, but the daimyo Tokugawa Mitsukuni, who was too powerful to be punished, pointedly sent a gift of dressed dog hides to the shogun and to Yanagisawa Yoshiyasu.

In his lifetime Yoshiyasu aroused jealousy and later, like Li Zhuowu, he was vilified by Confucian opponents. The attack was led by Muro Kyūsō (1658–1734), who wrote in a letter that "Yanagisawa Yoshiyasu was a philanderer, who consorted with over twenty women." [55] This may well have been true. In addition to his principal wife, Sadako, Yoshiyasu had two secondary wives (*sokushitsu*, literally, "side rooms"), and he is known to have had children by five other women. Altogether he had twenty children, of whom five were adopted girls. Among his many residences was one in Asakusa, conveniently near the Yoshiwara, though it burned down in 1700.[56]

Though Yoshiyasu was a social climber and had an adventurous private life, he was fundamentally a serious and extremely cultivated man, with strong interests in Zen as well as in Confucian teaching. Already, in his twenties, he was earnestly studying and exchanging letters with the Rinzai Zen monk Jikudō Sobon, at the Edo branch of Myōshinji; after Jikudō's death in 1684, he consulted and corresponded with a succession of Ōbaku monks, one of whom, Gaoquan Xingdong (J. Kōsen Shōton, 1633–1695), lectured to Tsunayoshi at his instigation. Throughout his life Yoshiyasu retained his interest in Ōbaku, and he donated to several Buddhist monasteries and Shinto shrines.

There is direct evidence that Yanagisawa Yoshiyasu patronized the arts. He shared with Tsunayoshi an interest in Noh drama, in 1706 organizing a performance at his residence in Edo. In 1703, he commissioned three portraits of himself from Kano Tsunenobu (1636–1713).[57] In addition to his diaries and surviving correspondence, a fascinating document about Yoshiyasu is *Diary in the Shadow of the Pine* (*Matsukage nikki*), covering the period from 1685 to 1710 and purporting to have been kept by one of his secondary wives, Ōgi-machi Machiko (1676–1723). Like his other two wives, she came from an educated upper-class family, but he was probably to some extent the ghostwriter.[58]

The diary contains many details of social life, particularly concerning the shogun Tsunayoshi, who early in 1691 paid the first of many visits to Yoshiyasu's mansion. Machiko describes the elaborate preparations that were entailed. New pavilions were constructed, and everything was dusted and polished. In the North Pavilion there was a painting of ponies by the shogun himself, on cherry wood, with two silver flower vases in front of it, containing cherry blossoms. On a shelf was an inkstone with a lacquered decoration of scattered autumn leaves. In the place for paintings was a presentation handscroll painting, together with a "Jar of Celebration" (*Iwai no tsubo*) that depicted the picking of tea in Uji. This jar had been brought back by the shogun himself. In addition, there was provision to hang swords and other equipment. Machiko further describes the decorations in the West Pavilion, which included a painted triptych of Jurōjin, the god of longevity, flanked by pines and bamboo; and those in the East Pavilion, which included screen paintings.[59]

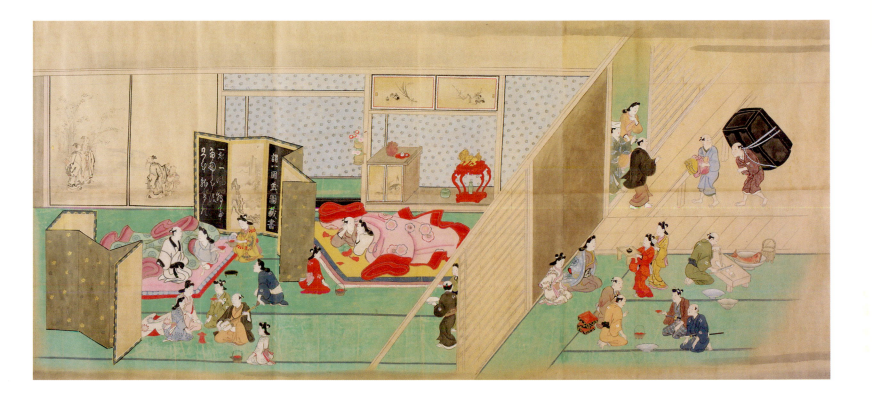

Figure 32
Hishikawa Moronobu
Bedroom Scenes, from *A Visit to the Yoshiwara*
Late 1680s. Handscroll; ink, color and gold
on paper. 54.1 x 1,761.4 cm. John C. Weber
Collection

At last, clients and courtesans are under the
bedcovers. The silk bed quilts or *yogi,* as they
are called, take the form of oversize robes that
are stuffed with light cotton wadding. Luxurious
bedding, usually a prestigious gift from a patron,
was a status symbol for a courtesan. (See also
detail, p. 32)

Tsunayoshi shared many interests with Yoshiyasu, including not only Ōbaku but also
Yoshiyasu's other secondary wife, Iizuka Someko. The shogun was rumored to have had liai-
sons with her in a boat (perhaps on the grounds of Edo Castle, where there was more than
one lake). *The Boat at Asazuma (Asazumabune)* by Hanabusa Itchō (1652–1724), depicting
a prostitute from Asazuma on Lake Biwa wearing the costume of a dancer and sitting in a
boat, was assumed to be a reference to this, since the word *asazuma* can mean "fickle wife"
(see fig. 71). It was rumored that Someko had a son by him, though the evidence is unclear.

In recent years the received opinion of Tsunayoshi, as of Yoshiyasu, has changed. Despite
his foibles, the shogun was dedicated to the well-being of his subjects, and the financial
troubles endured under his rule were more the product of natural disasters than of carefree
spending. He was profoundly influenced by his commoner mother, Otama, with whom he
was very close, and it is clear that she made her views known.[60]

One wishes that Machiko had provided more detail about the paintings, particularly
the handscroll. For such an occasion it is unlikely that it was the Weber scroll, but the evidence
presented above strongly points to Yoshiyasu as patron of the latter. Tsunayoshi would have
appreciated the quality and details of this Yoshiwara scroll, and relations between the two
men were close enough to permit the showing of such a work to him in private. Julia
Meech has observed that "This luxury scroll was probably made to order for a member of
the court or military aristocracy, someone who may never have had the chance to make the
visit it records so vividly."[61] After 1691, and perhaps sooner, Yoshiyasu would have become
too important and easily recognized to visit the Yoshiwara in person, but it is most likely
that he had earlier acquaintance with it. The Weber scroll can thus be read as an exercise in
nostalgia and fantasy: a decorous, idealized remembrance of times past.

Notes

1. The term "ukiyo-e" first appeared in 1682 in Ihara Saikaku, *A Man with an Amorous Life* (*Kōshoku ichidai otoko*), illustrated by the author, and re-issued in 1686 in an Edo pirated edition, *Origins of Yamato-e* (*Yamato-e no kongen*), with illustrations by Moronobu. See Teruoka Yasutaka and Higashi Akimasa, eds., *Ihara Saikaku shū* (*Collected works of Ihara Saikaku*), vol. 1, in *Nihon koten bungaku zenshū* 38, 445. The latter passage has been translated by Ivan Morris in *The Life of an Amorous Woman and Other Writings by Ihara Saikaku* (New York: New Directions, 1963), 135.

2. In the present exhibition, it is possible to consider only a handful of Moronobu's varied works and themes. A special exhibition at the Chiba City Museum of Art in 2000 identified previously unknown works by Moronobu in both Japanese and foreign collections: see Chiba City Museum of Art, ed., *Hishikawa Moronobu ten* (Hishikawa Moronobu exhibition) (Chiba: Chiba City Museum of Art, 2000), hereafter abbreviated as *Hishikawa Moronobu ten*.

3. The writer and artist Santō Kyōden (1761–1816) asserted that Moronobu was born in the Shōhō era (1644–47) and died in Edo in the middle of the Shōtoku era (1711–15), aged over seventy. See his additions to *Ukiyo-e ruikō* (Some considerations of ukiyo-e), the compilation of biographies of ukiyo-e artists started by Ōta Nanpo (1749–1823), in Yura Tetsuji, *Sōgō Nihon Ukiyo-e ruikō* (Synoptic Japan *Ukiyo-e ruikō*) (Tokyo: Gabundō, 1979), 59, 60. Combining Kyōden's date, the corrected death date of 1694 and an unsupported statement in 1894 by Sekine Shisei that Moronobu was seventy-seven when he died, Inoue Kazuo proposed a birth date of 1618; see Inoue Kazuo, *Ukiyo-eshi den* (Biographies of ukiyo-e masters) (Tokyo: Watanabe Hangaten, 1931), 197, 198–200. The print publisher Watanabe Shōzaburō (1885–1962) accepted this 1618 date in his own annotations to *Ukiyo-e ruikō*. Over a hundred years ago, Asaoka Okisada and Miyatake Gaikotsu correctly stated that Moronobu died in 1694. See Asaoka Okisada, *Zōtei koga bikō* (Remarks on old paintings, enlarged and revised) (Tokyo: Yoshikawa Kōbunkan, 1905), vol. 2, 1371; Miyatake Gaikotsu, "Hishikawa Magobei: Hishikawa Moronobu zen no ukiyo-eshi" (Hishikawa Magobei: An ukiyo-e master before Hishikawa Moronobu), *Kono hana* (These flowers) 14 (March 1911): 14. Miyatake Gaikotsu (Miyatake Tobone, 1867–1955), a learned and engaging commentator on ukiyo-e, wrote the first monograph on Moronobu: *Hishikawa Moronobu gafu* (Hishikawa Moronobu picture book) (Osaka: Gabundō, 1909). Through the painstaking research of Kawasaki Yoshirō and others, much new information has emerged: in particular a genealogy (*kakochō*) kept at Shōryūji, the Hishikawa family monastery in

Hoda. See Kawasaki Yoshirō, "Hishikawa Moronobu kaimyō no shin hakken: Shōryūji kakochō ni tsuite" (New discoveries about the posthumous Buddhist name of Hishikawa Moronobu: On the genealogy at Shōryūji), *Ukiyo-e geijutsu/Ukiyo-e Art* 69 (Aug. 1981): 3–13; Nishina Yūsuke and Kawasaki Yoshirō, "Kenkyū shiryō: Shin hakken Hishikawa Moronobu no kakochō ni tsuite/Materials of Art Research: The Recently Discovered Necrology of Hishikawa Moronobu," *Kokka* 1054 (Aug. 1982): 32–40; and Kawasaki Yoshirō, "Hishikawa-ke keifu" (Hishikawa family genealogy), in Narazaki Muneshige, ed., *Moronobu*, vol. 2 of Nikuhitsu ukiyo-e (Ukiyo-e painting) (Tokyo: Shūeisha, 1982), 141–43. The Shōryūji genealogy contains several copyist's errors, which are corrected by Kawasaki.

4. Miyatake Gaikotsu discovered a relative, Hishikawa Magobei, who was active as a painter in Kyoto and Osaka in the later 1640s; and it is now generally accepted that Shichiemon lived in Kyoto. Miyatake Gaikotsu, "Shōsetsu-teki seikō dan" (A story of novelistic achievement), *Kono hana* 13 (Jan. 1911): 8; Miyatake, "Hishikawa Magobei," 14.

5. Such a frame is depicted in a painting of various trades by Kano Yoshinobu (1552–1640), in the Suntory Museum of Art, Tokyo: see Jane Turner, ed., *The Dictionary of Art* (London: Macmillan Publishers; and New York: Grove's Dictionaries, 1996), vol. 17, 309, fig. 186. *Kon'ya* and *nuihaku* processes are depicted also in anonymous screen paintings of the 16th century. See Kyoto National Museum, ed., *Rakuchū Rakugai zu/Pictures of Sights in and Around Kyoto* (Tokyo: Kadokawa Shoten, 1966), unnumbered black-and-white photograph section.

6. Nishina and Kawasaki, "Kenkyū shiryō: Shin hakken," 33.

7. Nishina and Kawasaki, "Kenkyū shiryō: Shin hakken," 37. Hoda was also called Hodamura and Hodachō, and was subsequently renamed Hongō. The embroidered Buddhist hanging (*shūbutsu*) for the Shōōin of Muryōkōji, in Hyakushu village, Amawa, Shimōsa province (now part of Chiba Prefecture), measures 3.636 by 2.424 meters; a long inscription records that Kichizaemon was sixty-two at the time of its completion.

8. Tanaka Kisaku, *Ukiyo-e gaisetsu* (General explanation of ukiyo-e) (Tokyo: Iwanami Shoten, 1929; reprinted, 1971), 94. This suggestion was followed by Louise Norton Brown, *Block Printing and Book Illustration in Japan* (London: George Routledge and Sons, Ltd.; and New York: E. P. Dutton, 1924; reprinted, Geneva: Minkoff Reprint, 1973), 41.

9. Nishina Yūsuke, "Ukiyo-e no shiso Hishikawa Moronobu" (Hishikawa Moronobu, founder of ukiyo-e), in Chiba Nisshinsha, ed., *Chiba dai hyakka jiten* (Great encyclopedia of Chiba) (Chiba City: Chiba Nisshinsha, 1982), 783.

10. Translated here from Matsudaira Susumu, *Moronobu Sukenobu ehon shoshi* (Bibliography of illustrated books by Moronobu and Sukenobu), vol. 57 of *Nihon shoshigaku taikei* (Japanese bibliographic compendia) (Musashi Murayama: Seishōdō Shoten, 1988), 22. Matsudaira gives detailed bibliographic descriptions of thirty-eight of Moronobu's *ehon*, and shorter descriptions of seven others.

11. Matsudaira, *Moronobu Sukenobu ehon shoshi*, 28. A 1687 map of Japan by Moronobu's pupil Ishikawa Tomonobu, which includes sea routes, does not indicate a direct sea-lane from Awa to Edo, but Moronobu could have obtained a ride across the bay in a fishing boat belonging to his mother's family, or in a boat belonging to the local daimyo. The publication history of Moronobu's books is complicated. *Yamato-ezu-kushi* was in fact the reprint of an undated album of warrior pictures, *Portraits of Warriors of Yamato* (*Yamato musha-e*), which survives in a single copy in the Museum of Fine Arts, Boston.

12. Yura, *Ukiyo-e ruikō*, 61. In his earliest work Moronobu is described simply as *eshi*, "master of painting," but his illustrated books and paintings mostly call him *Yamato-eshi*, "master of *yamato-e* (Japanese-style painting)," or, less commonly, *Nihon-eshi*, using characters for "Japan" which are normally pronounced *Nihon* or *Nippon* but may also be read *yamato*. In the early eighteenth century, ukiyo-e artists of the Miyagawa line almost all preferred the description *Nihon-e*, while the Kaigetsudō artists called their works *Nihon giga*, "Japanese playful paintings." See Nakata Katsunosuke, *Ukiyo-e zakki* (Ukiyo-e miscellany) (Tokyo: Niken Shobō, 1943), 59. Until after the time of Suzuki Harunobu (1725?–1770), ukiyo-e artists tended to refer to themselves as *Yamato-eshi*.

13. Matsudaira, *Moronobu Sukenobu ehon shoshi*, 8–9.

14. For example, the colophon of Moronobu's *Edo suzume* (Edo sparrow, 1677) describes him as living in Edo. See Shibui Kiyoshi, *Edo no hanga: yomigaeru bi* (Edo prints: Beauty come to life) (Tokyo: Tōgensha, 1965), 65.

15. Saitō Gesshin, *Zōtei Bukō nenpyō* (Chronicle of Edo in Musashi province, enlarged and corrected), ed. Kaneko Mitsuharu (Tokyo: Heibonsha, 1968), vol. 1, 103.

16. The ravaged coastline of Hoda, with Mount Fuji in the background across the bay, is depicted in one of the prints from Hiroshige's 1858 series *Thirty-six Views of Mount Fuji* (*Fuji sanjūrokkei*). A further possibility for the loss of the gravesite, not hitherto considered in this connection, is suggested by the 1996 finding of Japanese geophysicists that a major earthquake in 1700 along the Cascadia fault extending from Vancouver to California created a giant tsunami that crossed the Pacific Ocean and slammed into the coast of Japan. Although Hoda was on the leeward side of the Bōsō Peninsula, it was probably affected. The 1703 earthquake is estimated to have had a magnitude of 8.2 on the Richter scale, the 1700 North American earthquake a magnitude of 9. For the 1700 earthquake, inferred from Japanese documentary evidence but since confirmed from North American sources, see Brian F. Atwater et al., *The Orphan Tsunami of 1700: Japanese Clues to a Parent Earthquake in North America* (Reston, VA: U.S. Geological Survey, in association with the University of Washington Press, 2005); also Atwater, *The 1700 Orphan Tsunami* (DVD video. Coos Bay, OR: Southwestern Oregon Community College, 2007).

17. Outside the family were such notable pupils as Ishikawa Tomonobu (also known as Ryūsen; act. 1680s–1710s) and Sugimura Jihei, the latter being one of the first to produce true single-sheet prints, in the late 1680s. The next generation of Hishikawa artists included Moroshige's son Moromasa and his pupils Morotane and Tomonaga. After 1694, the Hishikawa enterprise was continued for a while by Furuyama Moroshige and his pupils Morotane and Tomonaga; Moroshige changed his name to Hishikawa, implying some kind of formal adoption. Moronobu's immediate heir, Morofusa, apparently opted to concentrate on the original family business of dyeing, while turning out painting or calligraphy on the side, but there is no evidence that he moved back to Hoda. (Exact dates are not forthcoming for any of these men.) In the first two decades of the 18th century, the Hishikawa line was soon superseded in ukiyo-e by the Torii and other lines. There were new styles and a renewed emphasis on sheet prints though, in painting, the short-lived Kaigetsudō group, Hanabusa Itchō (1652–1724) and Miyagawa Chōshun (1682–1752) all show the strong influence of Moronobu.

18. See Peter Kornicki, *The Book in Japan: A Cultural History from the Beginnings to the Nineteenth Century* (Leiden: E. J. Brill, 1998), 430f.

19. Satō Satoru, "Hishikawa ehon no sho mondai" (Various problems of the Hishikawa illustrated books), in *Hishikawa Moronobu ten*, 25; Asano Shūgo, "Hishikawa Moronobu: Thoughts on the Publication and the Distribution of His Work," in Amy Reigle Newland, ed., *The Commercial and Cultural Climate of Japanese Printmaking* (Amsterdam: Hotei Publishing, 2004), 23. For the story of Yaoya Oshichi and its early transfer to the kabuki stage, see David Waterhouse, *Early Japanese Prints in the Philadelphia Museum of Art* (Toronto: University of Toronto–York University Joint Centre on Modern East Asia, 1983), 18–22.

20. The sole authority for the existence of the 1681 edition is Brown, *Printing and Book Illustration*, 47. For a detailed description of the 1685 versions, see Matsudaira, *Moronobu Sukenobu ehon shoshi*, 86–89.

21. The figure of 150 books comes originally from Miyatake Gaikotsu. It is repeated, without acknowledgment, by Richard Lane, *Images from the Floating World: The Japanese Print, Including an Illustrated Dictionary of Ukiyo-e* (New York: G. P. Putnam's Sons, 1978), 304, and followed by Jack Hillier, *The Art of the Japanese Book* (London: Sotheby's Publications, 1987), vol. 1, 92. The figure for the single-sheet prints is from Timothy Clark, Anne Nishimura Morse and Louise E. Virgin, with Allen Hockley, in *The Dawn of the Floating World, 1650–1765: Early Ukiyo-e Treasures from the Museum of Fine Arts, Boston*, exh. cat. (London: Royal Academy of Arts, 2001), 23. The count for books was presumably of titles, rather than volumes. The most convenient list is still that of Brown, *Printing and Book Illustration*, 45–49, but it requires revision in light of more recent research. Lane has estimated that erotic albums constitute one quarter of the total.

22. See Gideon Sjoberg, *The Preindustrial City, Past and Present* (Glencoe, IL: The Free Press, 1960), 187ff.

23. During the 18th century, the old *nakama* system gave way to one with wholesale distributors (*ton'ya*), subject to ever-increasing government control. See Charles D. Sheldon, *The Rise of the Merchant Class in Tokugawa Japan, 1600–1868: An Introductory Survey* (Locust Valley, NY: J. J. Augustin, 1958).

24. Undoubtedly Moronobu worked with a team of assistants, as the colophons sometimes indicate (see Yura, *Ukiyo-e ruikō*, 61); in addition to expert calligraphers, block cutters and printers were employed by the publishers.

25. Illustrated in *Hishikawa Moronobu ten*, no. 14 and p. 61. These handscrolls in the British Museum (1923.11.14.02 [1–2]) have been dated to the later 1680s. The many other occupations depicted include indigo dyeing.

26. For example, *Hishikawa Moronobu ten*, nos. 105, 107, 110, 113, 116, 121, 124, 128, 142, 145.

27. A pair of handscroll paintings in the Museum of Fine Arts, Boston (21.262, 21.263), was jointly created with several of them, in 1685. The significance of these paintings has emerged only within the past twenty years. See Tsuji Nobuo, "Hishikawa Moronobu to sono monjin ni yoru 'Henge gamaki' ni tsuite" (On the "Painted Scroll of Apparitions" by Hishikawa Moronobu and his pupils), in *Hishikawa Moronobu ten*, 12–15. Several photographs of the scrolls may be found on the website of the Museum of Fine Arts, Boston.

28. The artist, Furuyama Moroshige, was a neighbor of Buzaemon in Hasegawachō (the old name for the Negimachi theater district). *Shika no makifude* got Buzaemon into trouble with the authorities; a facetious anecdote and illustration in it about an aspirant actor playing a kabuki horse was deemed offensive, and he was obliged to flee to the Izu Peninsula for several years. For the complete text and illustrations, see Asakura Haruhiko, ed., *Enseki jisshu* (Ten kinds of Mount Yan gemstones) (Tokyo: Chūō Kōronsha, 1980), vol. 6, 213–54.

29. In his 1683 preface, Anke says in flowery language that Moronobu copied "hand traces of the Three Houses, in the manners depicted in Japanese painting." It is not immediately obvious who the Three Houses (*sanke*) are, though two must be Tosa and Kano. For the third House, Kobayashi posited the Hasegawa branch of Tosa, the Sesshū line, the Edo branch of Kano or the line descending from Iwasa Matabei. See Kobayashi, *Moronobu to shoki ukiyo-e* (Moronobu and the first period of ukiyo-e), in Nihon no bijutsu (Arts of Japan) 363 (Tokyo: Shibundō, 1996), 22; also Kobayashi, in *Hishikawa Moronobu ten*, 7. However, *sanke* was a stereotyped expression, and these are not Moronobu's own words, so we need not read too much into them.

30. In Kyoto, he may well have seen paintings by Kano and other artists depicting the life of the city, especially the so-called *Rakuchū Rakugai zu* (Paintings in and around the capital). In Edo he probably saw works belonging to vassals of the shogun and to Buddhist monasteries. Even without these, he would have been familiar with printed illustrations in books of the period in such classics as *Tales of Ise* (*Ise monogatari*); in light fiction; and in the texts of plays about Sakata Kintoki and other swashbuckling heroes. He would certainly have been familiar with the woodcut illustrations of his Osaka counterpart, Yoshida Hanbei (act. c. 1660–92), and with the works of Asai Ryōi and Ihara Saikaku. Other readily available material included the so-called *Nara ehon* (colored picture books and handscrolls used by storytellers and others); handscroll versions of *otogi-banashi* (bedtime stories); miscellaneous kinds of illustrated-tale literature; sets of portraits of famous poets, done in a Tosa style and often displayed at Shinto shrines; and sets to illustrate occupations. Such pictorial material is now more readily available in modern editions.

31. For a good description of the painting, with further references, see *An Important Collection of Japanese Ukiyo-e Paintings* (New York: Christie's, 27 Oct., 1998), sale 9044, no. 42.

32. For the Yoshiwara, see Cecilia Segawa Seigle, *Yoshiwara: The Glittering World of the Japanese Courtesan* (Honolulu: University of Hawai'i Press, 1993). Over the long history of the Yoshiwara its customs and fashions constantly changed. Care must be taken to distinguish it from its counterparts in Kyoto and Osaka, which are depicted in several paintings from the late 16th century onward. The earliest depictions of the New Yoshiwara are in two anonymous albums, both from the 1660s: *Yoshiwara Pillow* (*Yoshiwara makura*) and *Yoshiwara Mirror* (*Yoshiwara kagami*). The former contains erotic prints in an ukiyo-e style, while the latter is a detailed guide that includes a street plan with names and addresses, followed by detailed descriptions and portraits of individual girls (and a poem about each), an early example of a *Yoshiwara saiken* (detailed Yoshiwara guide). These guidebooks were published thereafter at regular intervals, notably by Urokogataya, one of Moronobu's main publishers; the earliest guide to the original Yoshiwara was *Azuma monogatari* (Tales of the east, 1642). Urokogataya Sanzaemon began his publishing business in about 1660, and it was continued by his descendants until the late 18th century. The publisher Tsutaya Jūzaburō (1750–1797) started his career in 1773 by selling Urokogataya guidebooks at the entrance to the Yoshiwara (see the essay by Julie Nelson Davis in this volume).

33. See Asakura Haruhiko, ed., *Edo meishoki* (Record of famous places in Edo) (Tokyo: Meicho Shuppan, 1976), 237–44. It happens that 1662 was the year in which Moronobu's father died.

34. Saitō Gesshin, *Zōtei Bukō nenpyō*, vol. 1, 79.

35. See Helen Mitsu Nagata, "Reading a Pictorial Narrative: A Study of the Illustrations Attributed to Hishikawa Moronobu in *Yoshiwara koi no michibiki* (A Guide to Love in the Yoshiwara, 1678)" (Ph.D. diss., Stanford University, 2000), passim. This useful work includes a complete transcription and translation of the book.

36. According to legend, Asakusadera (formal name Sensōji) was founded in the early 7th century as a shrine to Kannon, the most compassionate of bodhisattvas, and in 942 the Kannon-dō was rebuilt by Taira no Kinmasa (dates unknown), the then Lord of Awa, who also dedicated an image in the Komagata-dō. These pious acts were recollected in 1662 by Asai Ryōi in *Edo meishoki*. The Kannon-dō existing in Moronobu's day was erected in 1649. The present Kannon-dō is a reinforced concrete replica of this, most of Asakusadera having been destroyed in World War II.

37. Nagata, "Reading a Pictorial Narrative," Appendix C, 226, gives a list. The name of this publisher, at Tōri Aburachō, simply means "book distributor." *Yoshiwara koi no michibiki* was his last known title.

38. In 1682–83, Yamagataya, also at Tōri Aburachō, published five illustrated books and three sets of album prints by Moronobu; and in 1684, two books illustrated by Sugimura Jihei. See Asano, "Hishikawa Moronobu," 33–34. There is a complete set of *Yoshiwara no tei* in the Tokyo National Museum. See *Tokyo Kokuritsu Hakubutsukan zuhan mokuroku/Illustrated Catalogues of Tokyo National Museum: Ukiyo-e Prints* (Tokyo: Tokyo Bijutsu, 1971), vol. 1, nos. 1–12.

39. I am grateful to John C. Weber for his hospitality and for allowing me a leisurely viewing of the entire scroll. I am grateful also to Julia Meech for assistance and encouragement and for providing documentary material. In Toronto, Jack Howard (Royal Ontario Museum) and other library staff helped me to track down obscure titles.

40. For a long handscroll of about 1700 by Furuyama Moromasa, which covers the same ground as the Weber Moronobu scroll, see Gian Carlo Calza, *Ukiyo-e* (London: Phaidon Press, 2005), pl. V.14. The scroll, in the Museé Stibbert, Florence, is more detailed and of considerable historical, if not artistic, value.

41. After Taira no Kinmasa (see note 36 above), the province of Awa changed hands many times and was subdivided. In 1638, southwest Awa was granted to Yashiro Tadamasa (1594–1662), who had served both the first Tokugawa shogun Ieyasu (1542–1616) and Tadanaga (1606–1633), second son of his successor Hidetada (1579–1632). He was rewarded with the Hōjō (or Tateyama) fief in Awa, and the title Etchū no kami. As I have suggested, Tadamasa may have invited Moronobu's father to Awa, and he may have facilitated Moronobu's own move to Edo. After Tadamasa's death, the succession passed to his adopted son Tadaoki (1619–1663), whose real father Asakura Nobumasa had also served Tadanaga, and subsequently the shogun Iemitsu. Tadaoki too lacked a male heir, and falling dangerously ill in 1662 he adopted his nephew, the eldest son of his real elder brother Asakura Nobusue. The Asakura family, from Echizen, had been crushed in battle in 1570 by Oda Nobunaga (1534–1582) but retained influence and wealth.

42. Tadataka was technically a *fudai daimyō*, one of a class of hereditary retainers who directly served the shogun, had relatively small official stipends (starting at 10,000 *koku*) but might wield considerable power and earn substantial bonuses. He had senior and junior wives, and he fathered six sons and six daughters. Between

1656 and 1710, the Yashiro family was regularly listed in the *bukan*, "martial mirror," a kind of Debrett's Peerage for the samurai class. The entries for 1705 and 1710 even indicate distances from Edo to Awa by land and by sea. See Hashimoto Hiroshi, ed., *Daibukan* (Great martial mirror) (Tokyo: Meicho Kankōkai, 1965), vol. 1, 103, 110, 118, 140, 166, 193, 229, 252, 298, 362, 398. Takashōchō was so named in 1641, because originally falconers lived there; the name was changed to Ogawamachi in 1693. See Saitō Gesshin, *Zōtei bukō nenpyō*, vol. 1, 39, 95.

43. In fact, the income from the domain amounted to 10,300 *koku*. The main primary source on the *Mangoku sōdō* is the anonymous *Mangoku sōdō nichiroku* (Diary of the 10,000-*koku* disturbance), compiled in the early 1740s. This has been reprinted in Aoki Kōji et al., eds., *Nihon shomin seikatsu shiryō shūsei* (Collection of historical materials on the daily life of the people of Japan) (Tokyo: San'ichi Shobō, 1968–84), vol. 6, 17–31. For a briefer account in the semiofficial chronicle *Tokugawa jikki* (True record of the Tokugawa), see Kuroita Katsumi and Kokushi Taikei Henshūkai, eds., *Tokugawa jikki* (Tokyo: Yoshikawa Kōbunkan, 1976), vol. 7, 235–36; as well as summaries in modern Japanese secondary sources. There are several other references to Tadataka in the *Tokugawa jikki*: for his 1682 visit to Nikkō, see vol. 5, 444–45. His partner for the latter was Yagyū Muneari, Lord of Taima, from the family of hereditary fencing teachers to the shogun.

44. The German doctor Engelbert Kaempfer (1651–1716), who encountered Makino during audiences in 1691, describes him as a rather proper person. For Kaempfer, see the recent translation by Beatrice M. Bodart-Bailey, *Kaempfer's Japan: Tokugawa Culture Observed* (Honolulu: University of Hawai'i Press, 1999), 356–57.

45. The kitchen scene in *Yoshiwara no tei* is simpler and does not include the large serving dishes depicted in the Weber scroll. The kitchen scene in *Yoshiwara koi no michibiki* (1678) shows large dishes apparently being used for the preparation of food, rather than for serving it. Early sources on *fucha ryōri* are quoted in Jingū Shichō, ed., *Koji ruien* (Garden of similarities of ancient matters) (Tokyo: Koji Ruien Kankōkai, 1931), vol. 51, 131–34. See also Amanda Mayer Stinchecum, "Fare of the Country: Japan's Fucha Ryori, A Meal Fit for a Monk," *New York Times*, 6 April 1986 (available online), describing the modern Tokyo restaurant "Bon." Another explanation of the word *fucha* might be "tea of Putuoshan," in reference to the holy mountain island in Zhejiang province where Yinyuan, the founder of Ōbaku, had spent some time before coming to Japan.

46. This unsigned screen was perhaps originally part of a handscroll. The scenes relate closely to the final portion of the Weber scroll, which it seems to antedate by a few years. See *Hishikawa Moronobu ten*, 32–33. A version of the *dokuryū* screen, partly obscured by a stylized cloud, is included also in an *ageya* scene in a Yoshiwara screen by Moronobu in the Museum of Fine Arts, Boston; see Timothy Clark et al., *The Dawn of the Floating World*, 66–67.

47. Li's edition of *Shuihu zhuan*, with its woodcut illustrations, was one of the two best-known versions of this work and came to have considerable influence in Japan. It was partially translated by the Confucian scholar Okajima Kanzan (1674–1728); further translations and adaptations followed, by Santō Kyōden among others. The outlaws of the Water Margin were equated in the popular mind with the story of the "Forty-seven Ronin," whose exploits in 1703 caught everyone's imagination.

48. Quoted by Jin Jiang, "Heresy and Persecution in Late Ming Society: Reinterpreting the Case of Li Zhi," *Late Imperial China* 22, no. 2 (2001): 14.

49. I owe this suggestion to Wang Kangmei, Royal Ontario Museum, Toronto.

50. For further information about *O-ie-ryū*, see, for example, Horie Tomohiko, "Edo jidai no shofū" (Calligraphy styles of the Edo period), in *Edo*, vol. 6 of Sho no Nihon (Japanese history in calligraphy) (Tokyo: Heibonsha, 1975), 40–41.

51. For a very different interpretation by John T. Carpenter, in collaboration with Professor Ikezawa Ichirō, see Melanie Trede with Julia Meech, eds., *Arts of Japan: The John C. Weber Collection* (Berlin: Museum of East Asian Art, National Museums in Berlin, 2006), 161. Another six-panel screen of exactly the same type, perhaps the pair to it, is depicted on the small screen in the Nara Prefectural Museum (see note 46 above). Even some of the same characters as on the Weber scroll are repeated on it. At one stage in his difficult life, Li Zhuowu took refuge at Huangboshan, the parent monastery in China of the Ōbaku school. He remained a controversial figure long after his death, and his ideas are still much debated by Chinese scholars. It is known that Cangshu and other works by him made their way into the shogun's library as well as the libraries of powerful daimyo such as the Maeda of Kaga and the Owari Tokugawa of Nagoya. They would also have been available in Chinese monasteries in Nagasaki; at Ōbaku monasteries in Uji, Edo and Settsu; and at the Seidō, the Confucian shrine in Edo, which was reestablished by Tsunayoshi on a large new site in the Yushima district in 1690 and became an important center for the education of young samurai.

52. The Ōbaku school was introduced into Japan in 1654 when Yinyuan Longqi (J. Ingen Ryūki; 1592–1673) came to Nagasaki at the invitation of local Chinese monks. He was preceded in 1651 by Daozhe Chaoyuan (J. Dōsha Chōgen; 1602–1662), who returned home after Ingen's arrival. Both monks were from Fujian (Li Zhuowu's province), and specifically from Huangboshan (J. Ōbaku-san). In Japan they attracted followers from the Sōtō school of Zen, and from the great Rinzai Zen monastery of Myōshinji, in Kyoto. After initial difficulties, Ingen obtained backing from Emperor Go-Mizunoo and other men at court, as well as from the shogun, and brought disciples from China. His monastery of Manpukuji, at Uji, did not originally represent a distinct school, and continued to influence other schools, particularly at Myōshinji; but it became the center for Ōbaku Zen. Ingen lectured in Edo to the shogun Ietsuna; he established a branch monastery in Settsu province (Fumonji); and his disciple Mu-an Xingtao (J. Mokuan Shōtō; 1611–1684) founded other monasteries, including Zuishōji (1670), the headquarters of Ōbaku in Edo. Mass ordinations were conducted there, and Mokuan's successor, Tetsugyū (1628–1712), a Japanese convert, gave a series of lectures to the shogun Tsunayoshi in 1694–95. For a recent study of Ōbaku, see Helen Baroni, *Obaku Zen: The Emergence of the Third Sect of Zen in Tokugawa Japan* (Honolulu: University of Hawai'i Press, 2001). For Japanese sources, see Ōtsuki Mikio, Katō Shōshun and Hayashi Yukimitsu, *Ōbaku bunka jinmei jiten* (Biographical dictionary of Ōbaku culture) (Kyoto: Shibunkaku Shuppan, 1988); Okuda Yukio, Suzuki Ryūshu and Hayashi Yukimitsu, eds., *Obaku iboku chō* (Portfolio of Ōbaku autographs) (Uji: Ōbaku-san Manpukuji, 1967); Hayashi Yukimitsu, ed., *Ōbaku bunka* (Ōbaku culture) (Uji: Ōbaku-san Manpukuji, 1972).

53. Hans Bjarne Thomsen, in Amy Reigle Newland, ed., *The Hotei Encyclopedia of Woodblock Prints* (Amsterdam: Hotei Publishing, 2005), vol. 1, 88, citing *Andon* 20, vol. 5 (1985): 80. Ming erotic prints were to be an influence on the *beni-zuri-e*, or "red-printed pictures," (the red-and-green color prints of the early 18th century; see fig. 53 in this volume).

54. A single spotted dog is included in the kitchen scenes of Moronobu's *Yoshiwara koi no michibiki* (1678) and *Yoshiwara no tei* (1682–83).

55. Quoted by Kuwata Tadachika, *Tokugawa Tsunayoshi to Genroku jidai* (Tokugawa Tsunayoshi and the Genroku era) (Tokyo: Akita Shoten, 1975), 161.

56. Muro Kyūsō was a follower of Arai Hakuseki (1657–1725), a close adviser to the new shogun Tokugawa Ienobu (1663–1712). His fiscal and other recommendations were based on the theories of Zhuxi (1130–1200), rather than on the Old Learning (*kogaku*) school of Ogyū Sorai (1666–1726) and the Wang Yangming school of Hosoi Kōtaku (1658–1735), who had both been supported by Yoshiyasu. In retrospect, the differences between these Neo-Confucian teachers seem personal as much as philosophical.

57. He inscribed each, kept one for himself and presented the other two to Pure Land monasteries in the province of Kai. At least one of these portraits has survived, as has a wooden portrait sculpture at Erinji, a branch montastery of Myōshinji in Yamane Prefecture, which he supported.

58. For Yoshiyasu, the sources consulted include Morita Giichi, *Yanagisawa Yoshiyasu* (Tokyo: Jinbutsu Ōraisha, 1975). *Matsukage nikki*, of which there are many manuscripts, was not printed until modern times; I have relied on the modern Japanese translation by Masubuchi Katsuichi, *Yanagisawa Yoshiyasu sokushitsu no nikki: Matsukage nikki* (The diary of Yanagisawa Yoshiyasu's secondary wife: "Shadow of the pines" diary) (Tokyo: Seiunsha, 1999). The title word *Matsukage*, meaning "shadow of the pine," suggests that Tsunayoshi permitted Yoshiyasu to use the aristocratic family name Matsudaira.

59. Masubuchi, *Yanagisawa Yoshiyasu sokushitsu no nikki*, 19.

60. See especially Beatrice M. Bodart-Bailey, *The Dog Shogun: The Personality and Policies of Tokugawa Tsunayoshi* (Honolulu: University of Hawai'i Press, 2006).

61. Meech, in Trede with Meech, *Arts of Japan*, 158.

The Original Source
(Accept No Substitutes!)
Okumura Masanobu

SARAH E. THOMPSON

Okumura Masanobu (1686–1764) began his career with an album of courtesan pictures, published in 1701 when he was only fifteen. For over fifty years he continued to work as a printmaker, book illustrator and painter and, from 1719 on, also as his own publisher. Masanobu was a leader in the introduction and development of new formats, compositional techniques, coloring methods and subject matter for woodblock prints. His extraordinary versatility makes it difficult to single out any one aspect of his work as a crowning achievement, an irony that may have contributed to the relative paucity of scholarship on Masanobu, despite his widely recognized importance.[1]

Masanobu's long-lasting success in the competitive commercial world of ukiyo-e was due not only to his artistic ability but also to his skill at promoting himself and his products. Many of the prints issued by his firm, the Okumuraya, include lengthy inscriptions featuring the word *kongen* (source, origin, originator), often paired with warnings that the works from this original source are being pirated by unscrupulous persons, and that discriminating customers should look for "the true signature of Masanobu" and the red gourd seal of the Okumuraya. *Kongen* appears in the publisher's trademarks, signatures and in some titles; its possible meanings in various contexts will be discussed in detail below, together with considerations of the validity of Masanobu's claims to be the "originator" of such innovations as pillar prints (*hashira-e*), perspective prints (*uki-e*) and even early color printing (*benizuri-e*, literally "red-printed pictures," using two to four colors). Whether or not these claims were true, the frequent repetition of *kongen* as a self-description suggests that it was an effective advertising ploy.

This essay examines a selection of innovations associated with Masanobu, both those that he explicitly claimed and those that he did not, within a chronological framework. As Robert Vergez outlined, Masanobu's career may be broadly divided into three periods: the early period, from 1701 to 1718, when he illustrated books, albums of prints and single-sheet prints for various publishers; the middle period, from 1719 to about 1739, when he operated his own publishing house; and the late period, the 1740s and early 1750s, when

Figure 53 (detail)

Figure 33
Okumura Masanobu
The Courtesan Koyoshi, **from the album**
Beautiful Courtesans of the Northern Quarters
(*Hokkaku bigichō*)
1701. Woodcut. Plate 18.8 x 26.7 cm. Honolulu
Academy of Arts, Gift of James A. Michener,
1991, 31105B

he concentrated on the development of new types of prints, having turned over at least some of the publishing business to his successor, Okumura Genroku (act. c. 1718–64).[2] The question of Masanobu's originality will be considered in light of works he produced during each period.

Courtesans, Parodies and Picturebooks: 1701–18

No record has survived of Masanobu's studies with a teacher, and a lack of affiliation with any particular school of art would be in keeping with the independence that he displayed throughout his career. He may have been largely self-taught, initially influenced by Hishikawa Moronobu (1630/31?–1694) and Torii Kiyonobu I (1664–1729). As with most ukiyo-e artists, no personal details of Masanobu's biography are known.[3] His career must be reconstructed on the basis of dated inscriptions, together with prints depicting kabuki performances, when the dates of these are known (although the latter method requires caution, since there are a few cases of retrospective prints issued years after the performances; for example, one of Masanobu's famous perspective prints shows a performance at the Nakamura Theater in 1740 but was apparently published in 1745). Mutō Junko's comprehensive survey of 184 datable actor prints by Masanobu indicates that he was active as an artist from 1701 to 1756.[4] Other research has determined that Masanobu signed his prints with over fifty-eight different signatures and used more than twenty-two different publisher's marks.[5]

Masanobu's debut work, an album of courtesan pictures known variously as *Beautiful Courtesans of the Northern Quarters* (*Hokkaku bigichō*), and *Genroku-era Courtesans in Opposing Mirrors* (*Genroku tayū awase kagami*), was printed on the final page with the artist's signature, the publisher's name, Kurihara Chōemon, and the date, eighth month of Genroku 14 (1701) (fig. 33). The pictures were closely inspired by, though not (with a single exception) directly copied from, an album of courtesans by Torii Kiyonobu I that was first published by Hangiya Shichirobei in Genroku 13 (1700) and subsequently reissued, in what was apparently a pirated edition using recut blocks, in the sixth month of Genroku 14 by the same Kurihara Chōemon. One can imagine how pleased Chōemon must have been to find a teenaged prodigy who could imitate the seasoned Torii master.[6]

Masanobu continued to produce accomplished images of courtesans throughout the first two decades of his career. His paintings and prints of stately beauties in elaborately decorated robes, set off by a plain background, continue a tradition inherited from the anonymous masters of the Kanbun era (1661–73) through Moronobu (see fig. 24). The strong similarities in format and composition among Masanobu's prints (fig. 34) and paintings (fig. 35) of the 1710s indicate that he conceived the latter as multiples of the former, as did the contemporary artists of the Torii and Kaigetsudō schools. The combination of graceful composition, believable three-dimensional forms and elegantly rendered kimono patterns that made young Masanobu one of the major artists of the early eighteenth century is especially apparent in his painting of a standing courtesan (fig. 35), whose colorful outer robe with a design of rice sheaves contrasts with a delicate inner robe showing scenes from classical court literature drawn in delicate monochrome. The latter motif also hints at Masanobu's strong interest in the classical literary tradition, a major source of inspiration for him.

The works in which Masanobu's startling originality is first apparent are the horizontal black-line series (*sumizuri-e*) that he designed for assorted publishers during the same period (figs. 36, 38, 41). These were issued in sets, usually of twelve prints, although the number could vary, with the artist and publisher identified only on the final sheet. They are most often found in the form of albums called *orihon*, made by folding each print in half and gluing the outer edges, or as individual prints with traces of a centerfold indicating that they were removed from such albums. They are also occasionally mounted as handscrolls, or may never have been mounted at all. Masanobu appears to have designed over thirty series of prints, although not all of them have survived in their entirety.[7] The subjects include scenes of the Yoshiwara pleasure quarter, the theater, processions, cityscapes and so on. In addition to the straightforward depictions of contemporary life, over half of these sets include parodies or allusions to serious subjects such as religion or classical literature.

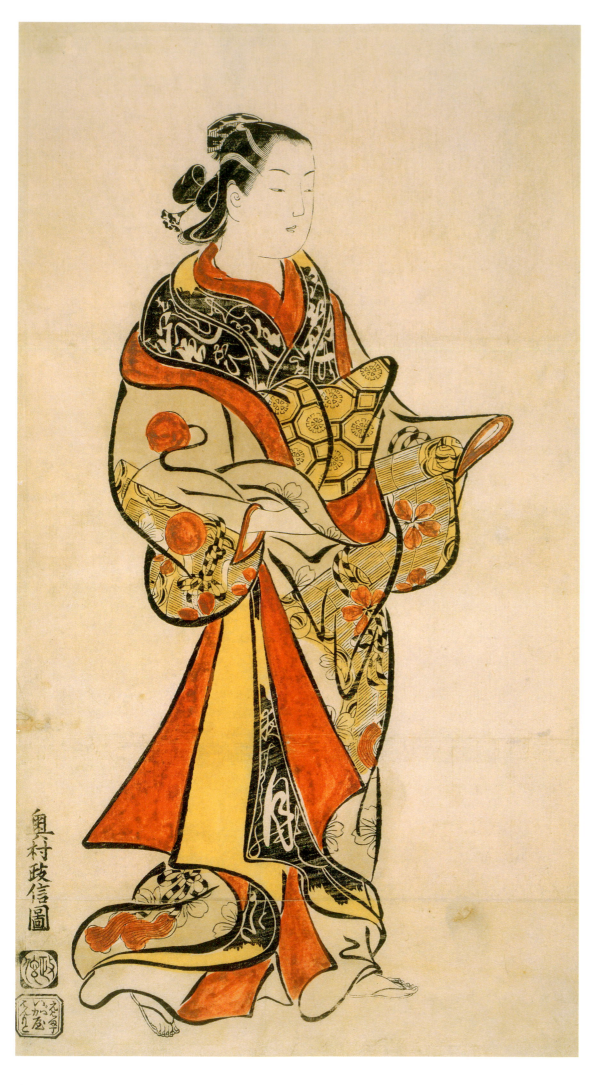

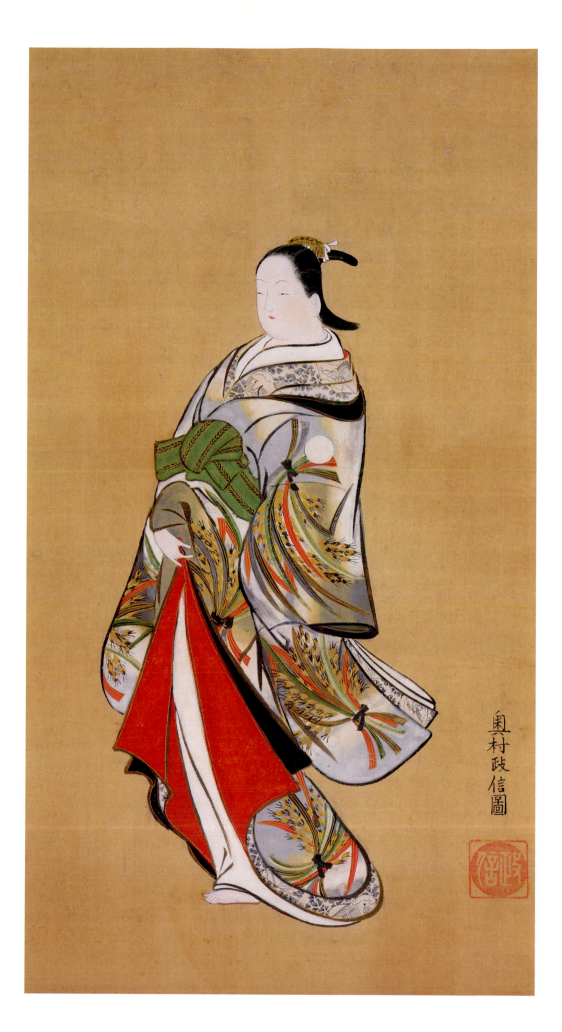

Opposite: Figure 34
Okumura Masanobu
Courtesan in Robe Decorated with Calligraphy
1710s. Woodcut, handcolored. 54 x 29.3 cm.
Clarence Buckingham Collection, The Art Institute
of Chicago, 1925.1744

Figure 35
Okumura Masanobu
Courtesan
1710s. Hanging scroll; ink, color and gold on silk.
47.8 x 27.4 cm. John C. Weber Collection

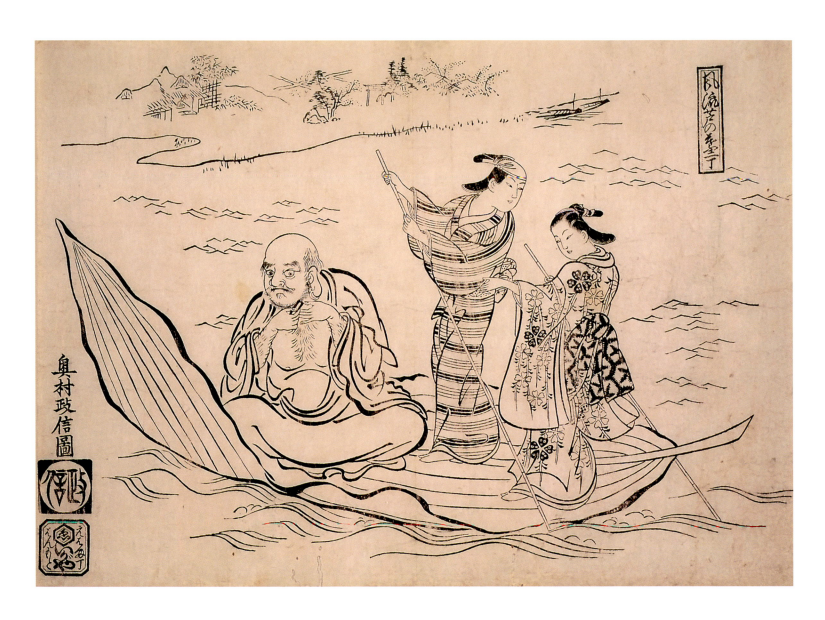

Figure 36
Okumura Masanobu
Two Elegant Reed Leaves (Fūryū ashi no ha nichō)
c. 1710. Woodcut. 28.8 x 40.1 cm. Museum of
Fine Arts, Boston, Gift of Mrs. Jared K. Morse in
memory of Charles J. Morse, 53.2922

One of Masanobu's most important contributions to the world of ukiyo-e was
never the subject of a *kongen* claim, if only because there was no single word for it at the
time. This was his extensive use of the witty literary allusions and parodies now known as
mitate (or *mitate-e*, "*mitate* pictures," to distinguish graphic uses of the technique from
written ones). In general, *mitate* means "selection" and signifies imagery that combines
at least two completely different subjects, often drawn from the high culture and the pop-
ular culture respectively: for example, a scene from classical literature reenacted by fash-
ionably dressed contemporary figures.[8] A few designs that qualify as *mitate-e* predate
Masanobu, but he developed the convention more than any other artist of his time, creat-
ing a stock of devices that themselves would be appropriated by ukiyo-e artists until the
mid-nineteenth century.

Within the broad category of polysemic images called *mitate-e*, Masanobu used sev-
eral different methods of combining his disparate subjects. One technique introduces fig-
ures from the divine realm or the legendary past into the contemporary world, particularly

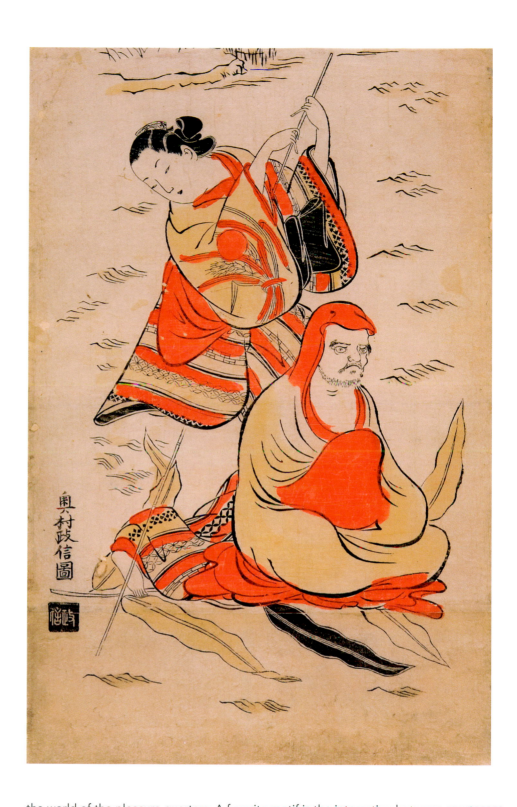

Figure 37
Okumura Masanobu
Courtesan Poling Daruma on a Reed Boat
Early 1710s. Woodcut, handcolored. 48.9 x 29.8 cm.
Asian Art Museum of San Francisco, Gift of the
Grabhorn Ukiyo-e Collection, 2005.100.8

the world of the pleasure quarters. A favorite motif is the interaction between courtesans and Daruma, or Bodhidharma, the legendary founder of Zen Buddhism. The visual joke was originated by the artist Hanabusa Itchō (1652–1724), who was said to have painted a female Daruma in response to the witty remark of a real-life courtesan: she claimed to be more enlightened than the patriarch who sat in meditation for nine years because she herself had sat on display in the brothel for ten.[9] At least two of Masanobu's horizontal album sheets show Daruma and a courtesan each wearing the costume of the other. In two others Masanobu reworks the legend of the patriarch's crossing the Yangtze River on a reed by adding a courtesan and a handsome actor-prostitute as boatmen who pole the reed across the Sumida River (fig. 36).[10] A large print handcolored in orange pigment of the courtesan poling Daruma combines *mitate* with the generic beauty picture (fig. 37). The beauty has pulled down the right sleeve of her striped outer robe, the better to pole the boat. The same pattern of rice sheaves and moon-shaped medallion visible on her inner sleeve also appears on the robe of Masanobu's courtesan in figure 35.

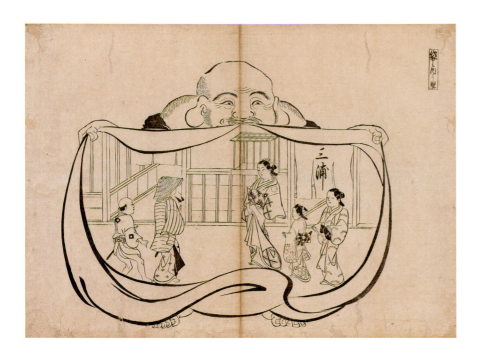

Another favorite theme brings the Seven Gods of Good Fortune into the world of ukiyo-e. In one example, the god Hotei opens his treasure bag to display a miniature street scene in the Yoshiwara magically contained within it (fig. 38). In a large handcolored print, the gods Ebisu and Daikoku perform as *manzai* dancers celebrating the New Year (fig. 39). Like the pairing of Daruma and the courtesan, however, the trope of the Gods of Good Fortune predates Masanobu: a unique album leaf attributed to Sugimura Jihei (act. c. 1681–98), for example, shows two of the gods partying with courtesans.[11]

The most intellectually interesting of all Masanobu's early prints are the *mitate-e* of Noh plays, which add humorous details to updated pictures to create true parodies. Most of these Noh parodies are album pages, but one example, *A Floating World Version of* The Potted Trees (*Ukiyo hachi no ki*), seems to be a stand-alone design, since it is larger than the customary album pages and is handcolored (fig. 40). In the Noh play *The Potted Trees* (*Hachi no ki*), an impoverished samurai burns his three precious bonsai trees to warm a guest; in Masanobu's parody, the host and guest are replaced by a courtesan and her client, gazing fondly at each other over a brazier heating a kettle of sake. (For the subsequent updating of this theme by Suzuki Harunobu, see exh. no. 23). A branch of plum from the tree in the garden, recalling the bonsai plum of the play, and the courtesan's fan serve as fuel for the charcoal fire. In the painting alcove behind the courtesan are three treasures identified by labels imitating the lofty language of the play: "Though damaged, a calligraphy by Teika" (Fujiwara Teika, 1162–1241); "Though torn, the pillow of Komachi" (Ono no Komachi, 834–900, poet and renowned beauty); "Though broken, the samisen of Ōiso Tora" (a legendary twelfth-century courtesan). These objects parallel the three items kept by the samurai in the Noh play—broken armor, a rusty spear, an emaciated horse—because they might some day be needed in the service of his lord.[12] Teika, Komachi and Tora appear also in kabuki plays and thus are doubly appropriate for a floating world parody. The "calligraphy by Teika" transcribes an appropriate poem from Teika's *One Hundred Poems by One Hundred Poets* (*Hyakunin isshu*) that describes the watchfire of the imperial guards, burning like the fire of love in the poet's heart.[13]

Figure 38
Okumura Masanobu
Inside the Bag, the Pleasure Quarters (*Fukuro no uchi ni sato*), **from the album** *Okumura Masanobu's Picture Copy Book* (*Okumura Masanobu edehon*)
1710s. Woodcut. Plate 27 x 37 cm. Museum of Fine Arts, Boston, Gift of Mrs. Jared K. Morse in memory of Charles J. Morse, 2007.315

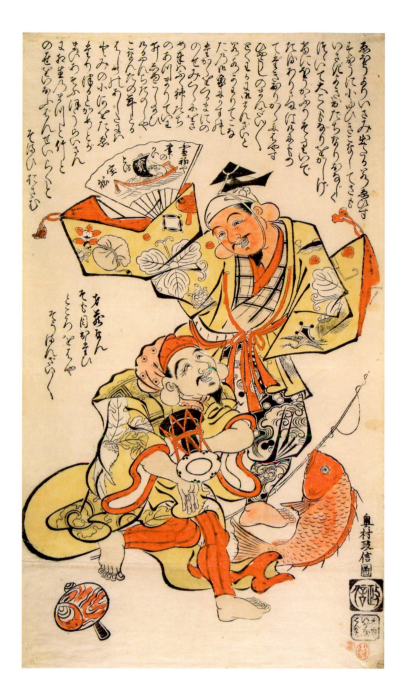

Figure 39

Okumura Masanobu

Ebisu and Daikoku Performing a Manzai Dance at New Year

Late 1710s. Woodcut, handcolored. 56.4 x 31.5 cm. Collection of Harlow N. Higinbotham

The text is a type of recitation that might be spoken or sung by *manzai* dancers, street performers who went door-to-door on New Year's Day and whose auspicious words brought good luck to the homes where they were invited in to entertain. By purchasing this print, customers could enjoy the benefits of a *manzai* dance performed by two of the Gods of Good Fortune. The text reads, in part:

> From a lucky direction comes young Ebisu, handsomely dressed, posing heroically. Next comes Daikoku, equally elegant, a scarf around his face, on this festive occasion beating the time of the tune for *manzai* dancing.

On Ebisu's fan:

> New Year calligraphy! The brushes are the oars of The Ship of Treasures.

In the happy ending of the play, the guest proves to be the regent of Japan, the very lord that the poor but loyal samurai is prepared to serve as best he can. The regent restores the lost fortune of his onetime host, substituting three fiefs for the three sacrificed trees. The young man who is the guest of Masanobu's courtesan holds the libretto for the play. Does this portend that her fortune will soon be restored as well, and she will be able to repair her battered treasures and buy a new fan?

Another Potted Trees parody appears as the final sheet of a set of twelve album prints based on Noh plays (fig. 41). Here, the romantic element introduced by Masanobu is a homoerotic one, as the host chops up his precious bamboo flute to light a fire for an attractive young man. The three treasures seen in the picture alcove, again described by labels that parody the wording of the play, are a fashionable striped jacket, a hanging lacquer inro and a courtesan painting signed by Moronobu, here advertised as items essential to the host's status as a man-about-town.

Masanobu's amusing parodies of classical stories are related to his avocation as a *haikai* poet, one of the many pupils of Tachiba Fukaku (1662–1753). Masanobu's alternate names, Hōgetsudō, Bunkaku and Baiō, resemble Fukaku's names, Shōgetsudō, Fukaku and Sen'ō, suggesting that they may have been given to Masanobu by his poetry teacher.[14] Fukaku was a leader of the *haikai* world in Edo after the death of the great master Matsuo

Figure 40
Okumura Masanobu
A Floating World Version of the Noh Play
The Potted Trees (*Ukiyo hachi no ki*)
1710s. Woodcut, handcolored. 31.1 x 54.3 cm.
The Mann Collection, Highland Park, IL

Bashō (1644–1694). He was one of the founders of a radical offshoot of the Danrin school of *haikai* known as the Weird-Bird Style (*Kechō-fū*), which focused on wordplay and puzzle-poems to an even greater extent than the rival Joke Style (*Share-fū*) practiced by the mainstream *haikai* poets of the early eighteenth century.[15] None of the poets of the period immediately following Bashō has fared well in the estimation of later critics. Donald Keene remarks that Fukaku "wrote many verses of notable silliness during the course of a long lifetime."[16]

Scholarly discussions of *mitate-e* devote considerable attention to the terminology used in print titles, particularly words that signal parodic intent: *ukiyo, fūryū, fūzoku, yatsushi, mitate* and so on.[17] Masanobu uses these terms sparingly, but, as in *A Floating World Version of* The Potted Trees (fig. 40), he uses *ukiyo* (floating world) and *fūryū* (fashionable) sometimes to signify an updating of an old story. I have not found *fūzoku* (customs and manners), *yatsushi* (informal) or *mitate* in his print titles. Most often Masanobu labels his parodies with a double title that indicates the source, as in *The Bamboo Flute and the Potted Trees* (*Shakuhachi hachi no ki*) (fig. 41). This convention may derive from the "Eight Views" titles, in which eight scenic sights (Night Rain, Sunset Glow and so on) originally associated with the Xiao and Xiang Rivers in China, were applied to similar sights in Japan in the vicinity of Lake Biwa in Ōmi province and later to many other subjects.[18] Masanobu's album *Eight Views in the Yoshiwara*, with individual titles such as *Night Rain on the Shared Umbrella* (*Aigasa no yau*) and *Sunset Glow at the Great Gate* (*Ōmon no sekishō*), is an early example of this very popular *mitate* theme and titles combining a contemporary and classic theme.

Masanobu as Publisher and Publicist: 1719–39

With the establishment in 1719 of his own publishing firm, the Okumuraya, in Tōrishiochō in Edo, Masanobu began to self-publish all of his single sheets. The earliest datable work identifying him as publisher as well as artist is a handcolored print depicting the actor Sanogawa Mangiku as Ohatsu, a waitress at the Fuji teahouse, from a performance at the Nakamura Theater in the fourth month of Kyōhō 4 (1719) (fig. 42). The actor's obi is decorated with the crest of his costar, Ichikawa Danjūrō II. The "famous Fuji teahouse at Asakusa" advertised on the hanging lantern and with its signature vines (*fuji* means "wisteria") was a real establishment operating during a special viewing of icons (*kaichō*) at the Sensōji temple at Asakusa, near the Yoshiwara, in the third to fifth months of Kyōhō 4.[19]

Sanogawa Mangiku as Ohatsu was one of the new "red pictures" (*beni-e*), so-called for their handcoloring in red or rose-pink pigment (*beni*), derived from safflower. Many *beni-e*, as this one, include a faux-lacquer finish made by combining black ink with deer glue (*nikawa*); since the 1790s they have been known as "lacquer pictures" (*urushi-e*).[20] There is no evidence of a transition to more complex coloring in the twenty-five-odd years in which the *beni-e* technique was used. Rather, *beni-e* employed an assortment of red, blue, purple and brown colors in addition to the orange and yellow colors of the earlier *tan-e*, and special features such as the "lacquer" black, embossing, and sprinkled brass filings to imitate powdered gold.

The publisher credited for *beni-e* is identified as Izumiya Gonshirō by the standard source, the 1844 *Zōho ukiyo-e ruikō* (*Some considerations of ukiyo-e, revised and supplemented*) by Saitō Gesshin (1804–1878), based on earlier versions by five other authors dating back to about 1790.[21] It is not possible to confirm this statement, since some half-dozen publishers produced actor prints of the *beni-e* type datable to 1717 and 1718. Only Izumiya Gonshirō, however, proclaims himself "the originator of *beni-e*" (*beni-e kongen*). This appellation appears, together with the address of the Izumiya, Dōbōmachi in the Asakusa Mitsuke district, in a jar-shaped seal on several prints by Okumura Toshinobu (act. c. 1716–51), one an actor print dateable to the first month of Kyōhō 3 (1718) (fig. 43). Izumiya Gonshirō's *kongen* designation appears repeatedly on prints he published but not on those of his contemporaries; apparently they respected his claim.

The advertising potential of the Izumiya claim may have inspired Masanobu to try something similar when he himself went into business as a publisher. *Sanogawa Mangiku as Ohatsu* (fig. 42) has at the lower left, below Masanobu's signature, a round seal containing

Figure 41

Okumura Masanobu

The Bamboo Flute and the Potted Trees (*Shakuhachi hachi no ki*)

1710s. Woodcut. 27 x 36.8 cm. Clarence Buckingham Collection, The Art Insitute of Chicago, 1925.1892

the word *kongen* written horizontally across the top, his shop address, *Tōrishiochō*, his name, *Okumura Masanobu*, and the word *hanmoto* (publisher) in three vertical lines from right to left. This seal is Masanobu's first to include the word *kongen*. Unlike Izumiya Gonshirō's acknowledged claim for an invention, Masanobu's is ambiguous; there is no indication of what, exactly, he has originated. In this case it is clearer to interpret the word *kongen* in a more general sense, as "source," "origin" or even "original" rather than "originator." It is also significant that Masanobu relates *kongen* to his role as publisher, not as artist, by placing it within the publisher's seal, not within his signature.

An expanded version of the *kongen* claim that appears on Masanobu's prints of the 1720s is more difficult to translate. Like other publishers of the period, Masanobu combined the artist's signature and the publisher's name and/or mark in a horizontal cartouche extending across the lower edge of the print. One signature in this form reads: *Nihon gakō ukiyoe ichiryū kongen Okumura Shinmyō Masanobu shōhitsu*, with the expression *rui nashi* (without equal) written in kana on either side of the red gourd seal (the trademark of the Okumuraya) between the names Shinmyō and Masanobu (fig. 44). It is more accurate to interpret *ichiryū* not as "one school" (as suggested by some early translations) but as "the number one, the best, the finest" (compare the modern Japanese expression *ichiryū shakai*, "the highest level of society").[22] It functions as a vague superlative similar to "without equal." In this reading the full signature comes closer to a reasonable claim: "The true brush of Okumura Shinmyō Masanobu, Japanese artist of ukiyo-e, the finest, the original, without equal." Masanobu's adoption of *kongen* also may have the intent of his frequent warnings against imposters: "This is the original source, accept no substitutes." The warning against forgeries appeared early in Masanobu's publishing career and may have been a response to a specific incident of forgery.[23]

Masanobu's new publishing business was a success. It was part of a boom in printmaking at the beginning of the Kyōhō era (1716–36) that is attributable to the great success of the gorgeous *beni-e*. These were generally in the narrow, vertical *hosoban* format, printed three to one *ōban* sheet. The large vertical format used for Masanobu's *tan-e* (handcolored, featuring orange pigment) courtesan prints disappeared completely after 1718 (figs. 34, 37). The dearth of large prints over the next twenty years may relate to the government calls for austerity known as the Kyōhō Reforms, but edicts specifically directed to the publishing industry did not begin until 1721. It is more likely that the discontinuation of large prints was a matter of fashion and economics: customers who could afford a large print could buy several small ones, and those who could not afford a large print could buy a single small one. The boom also suggests that prints had become a commodity of their own, not a substitute for expensive paintings. The commercial success of *beni-e* may even have contributed to the censorship edicts of 1721 and 1722 by bringing the flourishing publishing industry to the attention of authorities who had previously ignored it.

Masanobu's pupils Okumura Toshinobu and Okumura Genroku both appeared on the scene in 1718, designing prints for various publishers. The timing of their debuts, just as Masanobu was about to open his own publishing house, is no coincidence. Mutō Junko suggests that after Masanobu decided to publish his own work, he responded to publishers seeking his services as an illustrator by recommending one of his pupils instead.[24] Toshinobu was especially talented, creating many designs comparable to the works of his teacher; Genroku was competent but made his real mark when he took over the business end of the Okumuraya from Masanobu.[25]

When Genroku took over the management of the Okumuraya is unclear. The first work naming him as publisher is a book issued in 1728, after the firm had been operating for nine years. Mutō conjectures that Masanobu may have decided to separate the functions of publisher and chief artist as a precaution, in view of the stricter regulation of the publishing industry under the Kyōhō Reforms of the 1720s.[26] At around the same time, Okumura Toshinobu, who previously had only designed for other publishers, began to work primarily in-house, another indication of a change in the direction (and probably success) of the organization. However, the earliest known single-sheet print listing the publisher Okumura Genroku at the sign of the red gourd in Tōrishiochō is much later, dating from 1743. Masanobu would then have been fifty-seven, an appropriate age for semi-retirement.[27] It was also precisely

Figure 42
Okumura Masanobu
Sanogawa Mangiku as the Waitress Ohatsu at the Fuji Teahouse
1719. Woodcut, handcolored. 30.2 x 14.9 cm.
Clarence Buckingham Collection, The Art Institute of Chicago, 1935.405

Above: Figure 44
Okumura Masanobu
Ichikawa Danjūrō II as Ike no Shōji
1725. Woodcut, handcolored. 31.8 x 15.9 cm.
Clarence Buckingham Collection, The Art Insitute
of Chicago, 1925.1830

Right: Figure 43
Okumura Toshinobu
Ichimura Takenojō as Koshō Kichisaburō
1718. Woodcut, handcolored. 33.6 x 15.8 cm.
Museum of Fine Arts, Boston, William Sturgis
Bigelow Collection, 11.19107

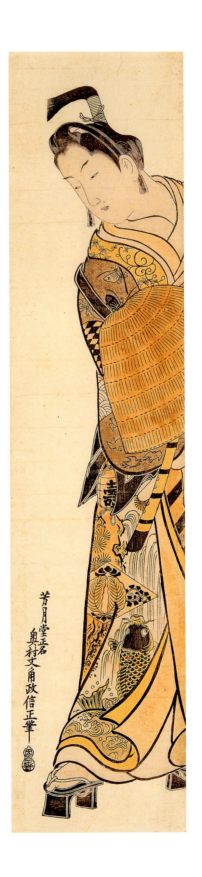

Figure 45
Okumura Masanobu
Onoe Kikugorō as Soga no Gorō
c. 1747–50. Woodcut, handcolored. 69.2 x 25.6 cm.
Museum of Fine Arts, Boston, William Sturgis
Bigelow Collection, 11.13339

Figure 46
Okumura Masanobu
Onoe Kikugorō as Soga no Gorō
c. 1747–50. Woodcut, handcolored. 62.5 x
14.2 cm. Honolulu Academy of Arts, Gift of
James A. Michener, 1991, 23301

the time when Masanobu was concentrating on innovations such as perspective prints, pillar prints and color printing, and one can imagine that he may have wanted to give up the day-to-day management of the business. He may have retained control of some of the Okumuraya's publications himself; Masanobu's perspective and color prints of the 1740s identify Genroku as their publisher, but his pillar prints do not.

During this middle period of his career, 1719–39, there was no one invention that Masanobu could claim explicitly, as Izumiya Gonshirō had claimed the invention of beni-e. His originality was to some extent subordinated to the need to give the Okumuraya a firm business foundation by publishing works that were certain to sell. Over the twenty-year period, he built up a following of loyal customers who were appreciative of his remarkable skills and willing to pay a higher price for special, experimental prints. It was this customer base that made possible Masanobu's achievements of the 1740s and 1750s.

The Authentic Originator: Pillar, Perspective and Color Prints, 1740s–50s

The final third of Masanobu's print career began in the early 1740s when he brought out three important new lines: pillar prints (hashira-e); perspective prints (uki-e) that employed Western-style vanishing-point perspective; and color-printed images using red and green blocks (benizuri-e) in addition to the basic black key block. Masanobu began to apply the term kongen not just as a general claim of quality and (unspecified) originality, but to imply that he was indeed the inventor of these new images.

The pillar prints are most likely Masanobu's innovation. Many of them include the words hashira-e kongen (originator of pillar prints) in his signature, not in the publisher's seal. The only indication of the publisher is the gourd-shaped sign of the Okumuraya, which contains "Tanchōsai," another of Masanobu's art names. His intent probably was to make these prints resemble paintings, a return to the successful large-format prints of the 1710s at which he had excelled.

Most of Masanobu's pillar prints are not precisely datable, but a number of them depict the popular actors Sanogawa Ichimatsu I (1722–1762) and Onoe Kikugorō I (1717–1783), who arrived in Edo from Kyoto in 1741 and 1742 respectively (fig. 45). Ichimatsu and Kikugorō were ideal subjects for Masanobu, who preferred attractive, romantic leads to action heroes. The fame of these young stars, whose fans clamored for images of them, may have inspired him to bring back the large figure in a new guise.[28] The unusually beautiful and delicate handcoloring indicates that the pillar prints were deluxe productions.

Although many pillar prints of the early 1740s are quite wide and only slightly taller and narrower than the large vertical prints of the 1710s, a more exaggerated narrow format became standard by the end of the decade. A hint as to how this may have happened is a noticeable vertical streak in several of the wider prints, perhaps the result of the gradual warping of two joined printing blocks. There are also narrower impressions apparently printed from one half of the separated blocks (fig. 46).[29] The happy accident of cropped figures gives an exciting sense of the figure in motion. An especially amusing example of these effects is Masanobu's Korean stunt rider who stands in the stirrups of his galloping horse as he brushes the character for "tiger" (fig. 47). Korean embassies to Japan regularly gave displays of trick horsemanship; one of the tricks was to brush calligraphy while on horseback. This stunt rider was probably a member of the Korean embassy that visited Japan in 1748.[30]

The most spectacular of Masanobu's pillar prints is a group of three extra-tall, extra-narrow prints of three top celebrities of Edo: again, Sanogawa Ichimatsu; an elegantly dressed courtesan (or Onoe Kikugorō in the role of a courtesan, since the comb bears his crest, fig. 48), and the comic rakugo monologist Fukai Shidōken (1680?–1765). Louise Virgin believes the set may have been intended as a triptych, with the two icons of Edo-style beauty flanking the ugly but enormously popular presenter of ribald tales and bawdy sermons.[31] It seems that Masanobu had by now acquired a core group of devoted customers or patrons who were willing to pay for expensive novelties.

The designation uki-e kongen ("originator of perspective prints" or "original perspective prints") appears on at least seven prints designed by Masanobu that employ vanishing-point perspective (fig. 49). Uki-e literally means "floating picture." The origin of the term is

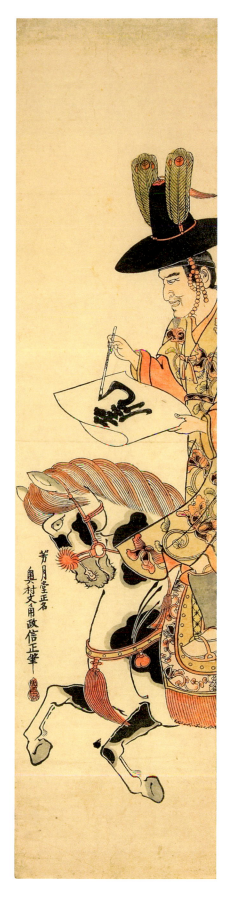

Figure 47
Okumura Masanobu
Korean Acrobatic Rider Inscribing Calligraphy While Standing in the Stirrups
c. 1748. Woodcut, handcolored. 71.8 x 16.8 cm. Asian Art Museum of San Francisco, Gift of the Grabhorn Ukiyo-e Collection, 2005.100.10

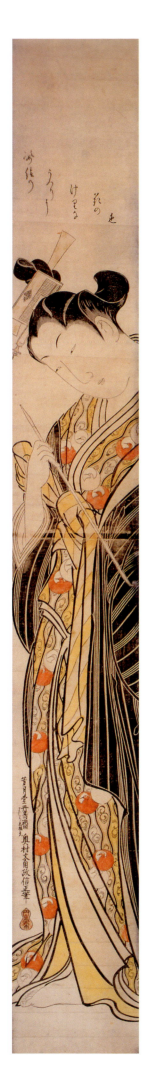

obscure, but it is generally assumed to refer to a picture seen as if floating in the lens of one of the mechanical viewing devices known collectively as *nozoki karakuri* (literally, peeping machines). Broadly speaking, these devices fall into two categories: those in which the image is viewed directly through a magnifying lens (the non-reflex type) and those in which the image is first reflected in a mirror and then viewed through a lens (the reflex type).[32] The lenses themselves were a Dutch import, but most of the viewing devices seem to have been constructed in Japan. The machines came in a variety of sizes, from small hand-held models to large carnival peepshows with multiple viewing ports into which one inserted a variety of colored printed images. A broadsheet dated 1739 lists "the prints of *uki-e*" as one of the nineteen newsworthy events of the year. The location of this entry between the sighting of a foreign ship and the return of Japanese sailors who had been shipwrecked on a desert island may indicate the exotic appeal of the foreign system of perspective.[33]

How knowledge of Western perspective reached Japan is uncertain.[34] One avenue is suggested by Masanobu's perspective print showing Chinese figures playing backgammon in a pavilion with landscape views on three sides, a composition directly copied from a large, anonymous Chinese woodcut (fig. 50).[35] Possibly a group of imported Chinese prints circulated among ukiyo-e artists in 1739 inspiring them to create similar views of Japanese scenes, much like the adaptation of the Eight Views theme, mentioned earlier. Direct influence from European pictorial art at this time is unlikely, because no Western stylistic characteristics other than the perspective itself are as yet evident.

Masanobu's Chinese scene is unique; nearly all other perspective pictures show the townspeople of Edo in urban settings such as theater interiors (seventeen known designs) and the main street of the Yoshiwara (ten known designs). A strong case has been made that Torii Kiyotada (act. c. 1720–50) was the true originator of *uki-e*; his interior view of the Ichimura Theater shows a performance staged in 1739.[36] At least seven other artists also designed early perspective prints. Whether or not he was the first to design them, Masanobu was the creator of the most spectacular surviving examples of *uki-e*. His set of six extra-large handcolored prints, made around 1745, shows famous scenes of Edo: four interior views, a kabuki theater, the dry goods store Echigoya, a room overlooking Ryōgoku Bridge and a parlor in the Yoshiwara (fig. 51); and two exterior views showing, respectively, the Yoshiwara entrance and the theater district (exh. no. 73). Each of the titles ends with the words *ō-uki-e* (large perspective picture).[37]

Like the pillar prints, the perspective prints of Masanobu and his contemporaries feature especially lavish handcoloring that enabled them to compete effectively with the printed-color designs becoming popular at just the same time. The development of color printing in Japan, accomplished through increasingly skillful use of the guide marks known as *kentō*, goes back at least to 1631, when a mathematical treatise was printed with diagrams in color.[38] In 1730, the great kabuki star Ichikawa Danjūrō II commissioned *Thanks to the Father* (*Chichi no on*) in memory of his father, Danjūrō I, with four illustrations in color.[39] Masanobu, with his own poetry connections, would surely have known of this book and of the imported Chinese color-printed books that inspired it.

The earliest datable color print so far known is a work by Masanobu, a pictorial calendar for the year 1742 depicting a young couple beside a tree of stacked pink sake cups representing the long and short months of the year.[40] Masanobu may or may not have been the first to print in color, but, again, he was probably the best up to his time. As in the case of the pillar prints, some of the *benizuri-e* show only Masanobu's signature and seal, no publisher's

Figure 48
Okumura Masanobu
Courtesan Holding a Pipe
Mid-1740s. Woodcut, handcolored. 128.2 x 16 cm.
Museum of Fine Arts, Boston, William Sturgis
Bigelow Collection, 11.13335

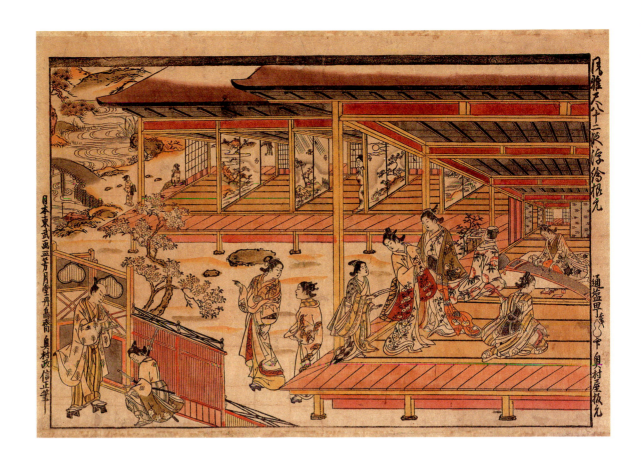

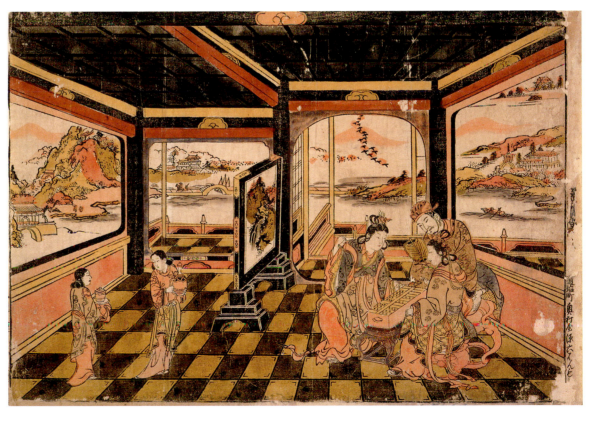

Top: Figure 49

Okumura Masanobu

Elegant Shakuhachi Version of Ushiwakamaru
Serenading Jōruri-hime, an Original Perspective
Print (Fūga shakuhachi jūnidan uki-e kongen)
1740s. Woodcut, handcolored. 32.1 x 45.7 cm.
Museum of Fine Arts, Boston, William S. and John
T. Spaulding Collection, 21.5772

Above: Figure 50

Okumura Masanobu

Chinese Figures in a Pavilion Playing Sugoroku
1740s. Woodcut, handcolored. 30.7 x 44.1 cm.
Museum of Fine Arts, Boston, William Sturgis
Bigelow Collection, 11.13347

Previous pages: Figure 51

Okumura Masanobu

Large Perspective Picture of a Second-story Parlor in the New Yoshiwara, Looking Toward the Embankment (Shin Yoshiwara nikai zashiki dote o mitōshi ō-uki-e)

c. 1745. Woodcut, handcolored. 42 x 65.7 cm. The Mann Collection, Highland Park, IL

Figure 52

Okumura Masanobu

Ukifune Chapter of The Tale of Genji *(Genji Ukifune)*

Mid-1740s. Woodcut, handcolored. 32.4 x 43.8 cm. Asian Art Museum of San Francisco, Gift of the Grabhorn Ukiyo-e Collection, 2005.100.9

The poem reads:

> Heavy snow
> settling in a drifting boat,
> my heart is filled with longing.

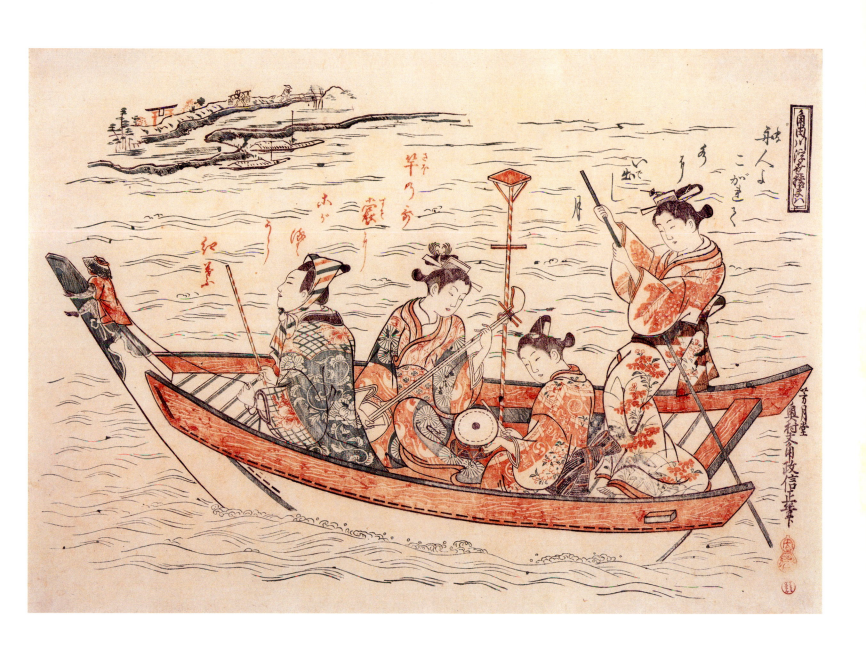

Figure 53

Okumura Masanobu

***A Floating World Monkey Trainer on the Sumida
River (Sumidagawa ukiyo sarumawashi)***

Late 1740s–early 1750s. Color woodcut. 32.3 x
44.7 cm. The Mann Collection, Highland Park, IL

Denizens of the floating world recite two poems:

Oh, boatman! The moon
has arisen in the
water as you row.

The song the boat pole
sings as my floating red leaf
is rowed by your skirt.

mark, so it is possible that he, rather than his successor Genroku, took responsibility for their production. Both parodic imagery and poetic inscriptions, infrequent in Masanobu's work during the 1720s and 1730s, now appear often over thirty years later. The wit that Masanobu displayed in his youth is showcased again during his semi-retirement. Though retired as a publisher, he was quite busy as an artist.

A comparison of a *beni-e* and *benizuri-e* from the 1740s shows Masanobu's mastery of the differing aesthetics of each technique. The former is represented by lovers in a boat, an irreverent homage to *Ukifune* (A boat adrift), one of the best-known episodes of *The Tale of Genji* (fig. 52). The floating world celebrity Sanogawa Ichimatsu beats a melody for his companion (possibly Onoe Kikugorō in the role of a courtesan), who has set aside her sake cup. Her tipsy tune is inscribed overhead:

yuki ya	Heavy snow
yuki ya	settling in a drifting boat,
mi wa Ukifune ni	my heart is filled with longing.[41]
tsumoru koi	

The delicate, elaborate handcoloring, using many different hues and subtle shading effects, is reminiscent of the coloring of the pillar prints, so *Ukifune* probably also dates from the mid-1740s.

A Floating World Monkey Trainer on the Sumida River, a *benizuri-e* of the late 1740s or early 1750s, shows a fashionable group setting off by ferry in the direction of Mimeguri Shrine (fig. 53). Here, the humor seems to be related not to a literary parody but instead to the replacement of humble figures such as monkey trainers and boatmen with young denizens of the floating world. The poems have been translated by Roger Keyes:

funabito yo	Oh, boatman! The moon
kogarete mizu ni	has arisen in the
ideshi tsuki	water as you row.
sao no uta	The song the boat pole
suso ni kogaruru	sings as my floating red leaf
uku beniha	is rowed by your skirt.

The boat pole is singing the sound ("swish, swish, swish") of a couple making love. With only red and green, Masanobu achieves the effect of far greater variety. The intricate textile patterns would have been extremely time-consuming to paint in by hand. Experienced both as an artist and as a publisher supervising the process of engraving and printing, Masanobu knew the strengths of both handcoloring and color printing.

During the 1740s, *benizuri-e* gradually replaced the labor-intensive (and expensive) handcolored *beni-e*. By 1748, for example, nearly all actor prints were printed in color. By about 1756 woodcuts were being printed in three colors (red, green and blue), with a fourth color (purple) introduced the following year.[42] Only one three-color print by Masanobu is known.[43] His last known actor print dates from 1756, and a painting of an actor, also datable to 1756, states that it was done in the artist's seventy-first year (by Japanese count).[44] In the last decade of his life, Masanobu seems to have retired as an artist. He died at seventy-eight in 1764, just on the cusp of the commercial appearance of full-color printing.

———

Masanobu's importance is perhaps best understood by considering his self-description, *kongen* (source, origin, originator), in the widest possible sense. In several *benizuri-e* trip-tychs dating from the late 1740s or early 1750s, at the end of his career, he substituted *ganso* (founder) for the more ambiguous *kongen* in his signature, labeling himself "best of

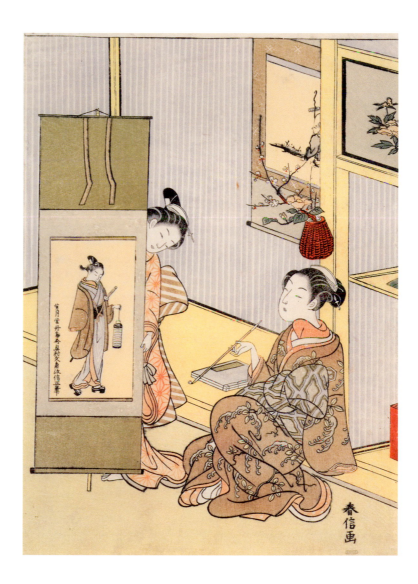

the founding fathers of Edo pictures" (*Edo ichiryū ganso*).[45] He was over sixty, had been in the field since the age of fifteen, and had surely earned the right to call himself a founder or ancestor. Whether as founder or developer, it was he more than any other single artist who was responsible for the changes in theme, format and technique that occurred in the first half of the eighteenth century. He was seen by later artists as the leading master of his time: Suzuki Harunobu, for example, shows a courtesan and her *kamuro* admiring a hanging scroll by Masanobu, either a painting or a wide pillar print of a young man carrying a lantern (fig. 54). Masanobu's artistic successors depicted his works within their prints as prized possessions conferring status on their lucky owners. Like Moronobu before him and Harunobu after him, Masanobu had enduring cachet.

Notes

1. The two monographs devoted entirely to Masanobu are: Miyatake Gaikotsu, *Okumura Masanobu gafu* (Collection of pictures by Okumura Masanobu) (Osaka: Fukuda Tomokichi, 1910); and Robert Vergez, *Early Ukiyo-e Master: Okumura Masanobu* (Tokyo, New York and San Francisco: Kodansha International, 1983). Masanobu and his work are extensively discussed in Suzuki Jūzō, "Ukiyo-e shoki hanga no seisaku shisei" (Early ukiyo-e prints from the standpoint of production), in *Shikago bijutsukan I/The Art Institute of Chicago I*, vol. 4 of Ukiyo-e shūka (Tokyo: Shōgakukan, 1979), 232–33; Timothy Clark, "Image and Style in the Floating World: The Origins and Early Development of Ukiyo-e," in Timothy Clark, Anne Nishimura Morse and Louise E. Virgin, with Allen Hockley, *The Dawn of the Floating World, 1650–1765: Early Ukiyo-e Treasures from the Museum of Fine Arts, Boston*, exh. cat. (London: Royal Academy of Arts, 2001), 26–31, and a biography of Masanobu, 51–52 (the volume is hereafter abbreviated as Clark et al., *The Dawn of the Floating World*); and several articles by Robert T. Paine to be cited individually below. Important unpublished work by Juliann Wolfgram has been presented in several lectures, notably "Marketing vs. Publicity: Okumura Masanobu and the Business of Woodblock Prints" (lecture, Seventh International Ukiyo-e Conference, Chiba City Museum of Art, Oct. 19–20, 2002).

2. Vergez, *Early Ukiyo-e Master*, 33–40. I have retained Vergez's periodization but have altered some of the specific dates in light of more recent research; for example, Vergez dates the founding of the Okumuraya to about 1721, rather than 1719.

3. Edo- and Meiji-period sources collated and analyzed in Miyatake, *Okumura Masanobu gafu*, generally agree that he died in 1764, on the eleventh day of the second month, in his seventy-ninth calendar year; his birth date would therefore be 1686.

4. Mutō Junko, *Shoki ukiyo-e to kabuki/ Early Ukiyo-e and Kabuki* (Tokyo: Kasama Shoin, 2005), 312; Mutō, "Okumura Masanobu no yakusha-e: Sakuga jiki to seisaki jōkyō o chūshin ni /Actor Prints by Okumura Masanobu—on the period of his works and the situation," *Ukiyo-e geijutsu/ Ukiyo-e Art* 133 (Oct. 1999): 4.

5. Aoki Takayuki, "Okumura Masanobu: Rakkan, hanmoto-in kara saguru sōsaku katsudō/ Okumura Masanobu: From his Signatures and Publisher's Seals," *Ukiyo-e geijutsu/Ukiyo-e Art* 133 (Oct. 1999): 20.

6. Clark et al., *The Dawn of the Floating World*, 108–14 (catalogue entry by Louise Virgin); Howard Link, *Primitive Ukiyo-e from the James A. Michener Collection in the Honolulu Academy of Arts* (Honolulu: The University Press of Hawaii, 1980), 89–90; Gunhild Avitabile, *Early Masters: Ukiyo-e Prints and Paintings from 1680 to 1750*, exh. cat. (New York: Japan Society Gallery, 1991), 52–55.

7. Fourteen such sets (excluding the early courtesan albums), not all of them complete, were published in Shibui Kiyoshi, "Masanobu no sumi-e/Sumiye (1688–1715) by Okumura Masanobu," *Ukiyo-e no kenkyū/The Ukiyoye no Kenkyu*, no. 23, vol. 6, no. 3 (Mar. 1929): 1–66. Wolfgram, in "Marketing vs. Publicity," notes that there are over thirty sets; and her estimate is supported by my own preliminary survey of unpublished material in the Museum of Fine Arts, Boston. There appear to be at least thirty-five sets, although in some cases it is unclear whether a single surviving design is or is not from a set.

8. There is vast and ever-increasing literature on *mitate* in both Japanese and English. A good starting point is Timothy T. Clark, "*Mitate-e*: Some Thoughts, and a Summary of Recent Writings," *Impressions* 19 (1997): 6–27, supplemented by Suwa Haruo, "Kenkyū shiryō: Ukiyoe no mitate/Research Material: *Mitate* in Ukiyo-e," *Kokka* 1213, vol. 102, no. 4 (Dec. 1996): 28–33. Other useful English-language articles include: Tadashi Kobayashi, "*Mitate-e* in the Art of the Ukiyo-e Artist Suzuki Harunobu," in Donald Jenkins, *The Floating World Revisited* (Portland, OR: Portland Art Museum, 1993), 85–91; David Waterhouse, "Some Confucian, Buddhist, and Taoist *Mitate-e* by Harunobu," *Impressions* 19 (1997): 28–47; Timothy Clark, "Prostitute as Bodhisattva: The Eguchi Theme in Ukiyo-e," *Impressions* 22 (2000): 36–53; and Nakamachi Keiko, translated and adapted by Henry Smith and Miriam Wattles, "Ukiyo-e Memories of *Ise Monogatari*," *Impressions* 22 (2000): 54–85.

9. Waterhouse, "*Mitate-e* by Harunobu," 36.

10. On the exchange of clothing, see Helen C. Gunsaulus, *The Clarence Buckingham Collection of Japanese Prints: The Primitives* (Chicago: The Art Institute of Chicago, 1955), 124, no. 25; and Clark, "*Mitate-e*: Some Thoughts," 25, fig. 18. On the reed boat, see Gunsaulus, *The Clarence Buckingham Collection*, 123, no. 20; and Clark et al., *The Dawn of the Floating World*, 158–59 (catalogue entry by Louise Virgin).

11. Narazaki Muneshige, ed., *British Museum III*, vol. 3 of Hizō Ukiyo-e taikan/Ukiyo-e Masterpieces in European Collections (Tokyo: Kodansha, 1988), pl. 173, with detailed commentary by Asano Shūgō on pp. 289–90; also cited in Clark, "Image and Style in the Floating World," 29.

12. Arthur Waley, *The Nō Plays of Japan* (London: G. Allen & Unwin Ltd., 1921), 142.

13. Joshua S. Mostow, *Pictures of the Heart: The Hyakunin Isshu in Word and Image* (Honolulu: University of Hawai'i Press, 1996), 287–89. The poem is by Ōnakatomi no Yoshinobu, no. 49 in the anthology.

14. Vergez, *Early Ukiyo-e Master*, 35; Mutō, "Okumura Masanobu no yakusha-e," 5.

15. Suzuki, "Ukiyo-e shoki hanga," 232–33; *Nihon koten bungaku daijiten* (Dictionary of Japanese classical literature) (Tokyo: Meiji Shoin, 1998), 384. Strictly speaking, *kechō* were monstrous, demonic birds; and the name was probably originally intended to be an insult. I have taken the translation "Weird Birds" from Clark, "*Mitate-e*: Some Thoughts," 8–9, where the title of the 1755 publication *Ehon mitate hyakkachō* (with the same two last characters as *kechō*) is rendered *Picture Book: Mitate of One Hundred Weird Birds*. In this book, the "weird birds" and the plants that accompany them are made up of inanimate objects such as dustpans; but it seems likely that some reference to *Kechō-fū haikai* is also intended.

16. Donald Keene, *World within Walls: Japanese Literature of the Pre-modern Era, 1600–1867* (New York: Random House, 1976), 339.

17. Clark, "*Mitate-e*: Some Thoughts," 8–15; Alfred Haft, "Harunobu and the Stylishly Informal: "*Fūryū Yatsushi*" as Aesthetic Convention," *Impressions* 28 (2006–2007): 23–39.

18. For a comprehensive study of the theme, see Judith Stubbs, "*Omi Hakkei*" (Ph.D. diss., University of Chicago, 1993).

19. Mutō, *Shoki ukiyo-e to kabuki*, 304. Yone Noguchi, *The Ukiyoye Primitives* (Tokyo: Privately published, 1933), 73, cites the same print as the first work published by Masanobu's shop but dates it to 1724; Gunsaulus, *The Clarence Buckingham Collection*, 159, no. 88, assigns it a date of around 1741 but does not explain the reason for this late date.

20. Mutō, *Shoki ukiyo-e to kabuki*, 356–59.

21. Mutō, *Shoki ukiyo-e to kabuki*, 357–58; Vergez, *Early Ukiyo-e Master*, 33. For additional pertinent references, see D. B. Waterhouse, *Harunobu and His Age: The Development of Colour Printing in Japan* (London: Trustees of The British Museum, 1964), 16–18.

22. The translation of *ukiyoe ichiryū kongen* as "originator of one school of ukiyo-e" appears in Laurence Binyon and J. J. O'Brien Sexton, *Japanese Colour Prints* (New York: Charles Scribner's Sons, 1923), 13, and is followed by Gunsaulus and Vergez as well.

23. Robert T. Paine, "Japanese Prints of Birds and Flowers by Masanobu and Shigenaga," *Oriental Art* 9, no.1 (Spring 1963): 22–34.

24. Mutō, *Shoki ukiyo-e to kabuki*, 382–83.

25. Robert Vergez noted that Genroku may have been Masanobu's son, a younger brother, nephew or pupil adopted as a son, but concluded that "the genealogical enigma remains unsolved." Vergez, "Okumura Genroku, Artist and Publisher," *Ukiyo-e geijutsu/Ukiyo-e Art* 49 (1976): ii.

26. Mutō, *Shoki ukiyo-e to kabuki*, 376–77.

27. Aoki Takayuki, "Okumura Masanobu," 23.

28. Mutō has suggested that the pillar prints deliberately avoided association with specific performances in order to give them longer-lasting appeal. Mutō, "Okumura Masanobu no yakusha-e," 5–6; also cited in Clark et al., *The Dawn of the Floating World*, 186.

29. A theory that the narrower versions were in fact the first was put forward in Robert Treat Paine, Jr., "Some Pillar Prints by Masanobu," *Bulletin of the Museum of Fine Arts, Boston* 53, no. 308 (1959): 41–47, and supported in Vergez, *Early Ukiyo-e Master*, 38. The more generally accepted view that the wider versions were the first is presented in Jacob Pins, *The Japanese Pillar Print: Hashira-e* (London: R. G. Sawers, 1982), and Clark et al., *The Dawn of the Floating World*, 30–31.

30. For Korean embassies and trick horsemanship, see David Waterhouse, "Korean Music, Trick Horsemanship and Elephants in Tokugawa Japan," in Tokumaru Yoshihiko and Yamaguchi Osamu, *The Oral and the Literate in Music* (Tokyo: Academia Music Ltd., 1986), 353–70.

31. Clark et al., *The Dawn of the Floating World*, 197.

32. The non-reflex version of the *nozoki karakuri* was known in Japan by 1685, when one appeared in a book illustration. See Julian Jinn Lee, "The Origin and Development of Japanese Landscape Prints: A Study in the Synthesis of Eastern and Western Art" (Ph.D. diss., University of Washington, 1977), 722, fig. 30. The second, more complicated machine (variously known as optical diagonal machine, zograscope, or, by its French name, *optique*) seems to have been introduced to Japan only around 1750 and is therefore not relevant to the very first record of *uki-e* in 1739, although it was influential in the second stage of the development of perspective prints from the 1760s on.

33. Kishi Fumikazu, *Edo no enkinhō: Uki-e no shikaku* (Perspective systems of Edo: The viewpoints of *uki-e*) (Tokyo: Keisō Shobō, 1994), 1–4.

34. In his 1977 dissertation on the development of Japanese landscape prints, Julian Jinn Lee suggested that the immediate source of inspiration was a Chinese book entitled *Shixue jingyun* (Detailed guide to the study of vision), that had been published in 1729 and reissued in 1735. Lee, "The Origin and Development of Japanese Landscape Prints," 223–43; Timon Screech, "The Meaning of Western Perspective in Edo Culture," *Archives of Asian Art* XLVII (1994): 59. Unfortunately, there is no direct evidence for the influence of this book; at least one copy is in a Japanese collection, but it is not clear when it was imported.

35. Kishi, *Edo no enkinhō*, 9; also reproduced in *Ukiyo-e geijutsu/Ukiyo-e Art* 133 (Oct. 1999): pls. A (the Masanobu print) and B (the Chinese print).

36. Lee, "The Origin and Development of Japanese Landscape Prints," 70–72; Kishi, *Edo no enkinhō*, 43–46.

37. The interior theater view, mentioned earlier, shows a production of 1740, but the crests of the actors on the hanging lanterns and other pictorial clues date the print to 1745. Apparently it was intended not as a souvenir of a specific performance, but as a generic view of notable sights of the city. Lack of specificity extended the sale potential. Kishi Fumikazu, "The Perspective System of Early *Uki-e*: Okumura Masanobu's Series of *O-uki-e*," *Aesthetics* 6 (Mar. 1994): 75.

38. Waterhouse, *Harunobu and His Age*, 18.

39. Roger S. Keyes, *Ehon: The Artist and the Book in Japan*, exh. cat. ([New York]: The New York Public Library; and Seattle and London: University of Washington Press, 2006), 72–77; also mentioned in Waterhouse, *Harunobu and His Age*, 19, and Aoki, "Okumura Masanobu," 24.

40. Roger S. Keyes, as cited in David Waterhouse, *Images of Eighteenth-Century Japan: Ukiyoe Prints from the Sir Edmund Walker Collection*, exh. cat. (Toronto: Royal Ontario Museum, 1975), 72–73; Aoki, "Okumura Masanobu," 24–25. Other evidence counters that Masanobu may not have been the first to apply the color technology developed for book illustrations to single-sheet prints. Several Edo-period sources ascribe the invention to Uemura Kichiemon of the Emiya publishing house; and *benizuri-e* actor prints were published in 1742 by the Nakajimaya. Waterhouse, *Harunobu and His Age*, 20; Mutō, *Shoki ukiyo-e to kabuki*, 360.

41. Translation by James Kenney from Julia Meech-Pekarik, "The Artist's View of Ukifune," in Andrew Pekarik, ed., *Ukifune: Love in The Tale of Genji* (New York: Columbia University Press, 1982), 208.

42. Mutō, *Shoki ukiyo-e to kabuki*, 360.

43. Vergez, *Early Ukiyo-e Master*, pl. 34.

44. Mutō, *Shoki ukiyo-e to kabuki*, 612 (the print) and 312 (the painting).

45. Gunsaulus, *The Clarence Buckingham Collection*, 168–70.

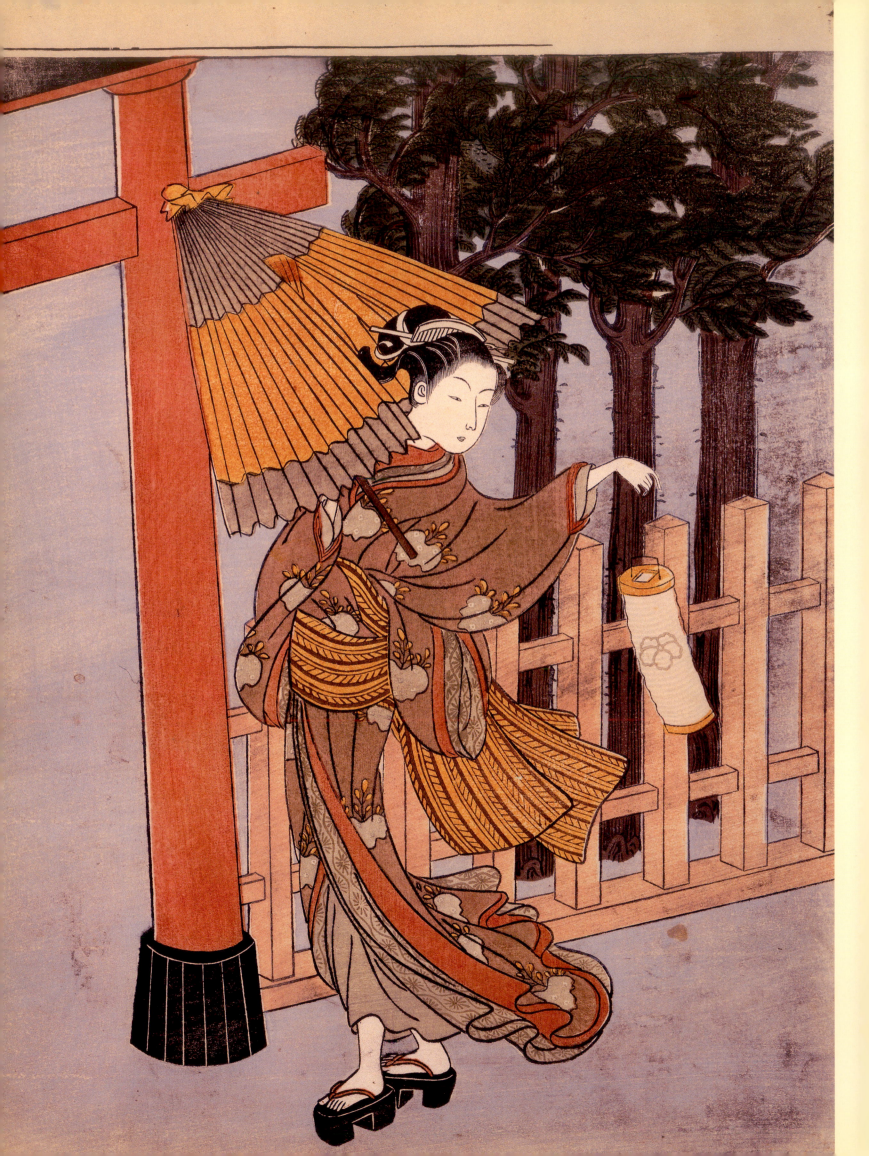

Suzuki Harunobu
The Cult and Culture of Color

ALLEN HOCKLEY

Figure 55
Suzuki Harunobu
Visiting a Shrine in Night Rain
Late 1760s. Color woodcut. 28.5 x 21 cm.
The Mann Collection, Highland Park, IL

If the number of monographs, articles and exhibition catalogues is any measure of importance, then Hokusai, Hiroshige and Utamaro must surely be the holy trinity of ukiyo-e artists. But with Japanese prints—an art so loved by so many—page count is more often an indicator of adulation than critical engagement. If polemics prove the better metric, then one hundred twenty-five years of modern scholarship suggest that Suzuki Harunobu (1725?–1770) deserves the Palme d'Or (fig. 55). The beauty, or rather the charm, of his prints, has certainly elicited more than their share of poetic responses, but Harunobu has also generated controversy like no other print designer before or after him, including the enigmatic Sharaku.

Harunobu's fortuitous association with the development of full-color printing garnered for him a high profile among early collectors and scholars in Europe and America. Japanese scholars generally followed this lead. His elite status in these constituencies endures. The catalogue of the 2002 landmark exhibition at the Chiba City Museum of Art suggests that color continues to dominate the thoughts and practices of Harunobu specialists. The Chiba catalogue entries rely extensively on color to differentiate among the many editions and states of Harunobu's designs. Hard science in the form of three-dimensional fluorescence mass spectroscopy was deployed to identify many of the fugitive vegetable pigments Harunobu's printers utilized, notably a pure-red (or pink) extract of safflower, dayflower blue and gamboge. An effort to recreate the original palette of Harunobu's early prints provided a benchmark against which the deterioration and fading of his prints can be measured.[1]

But color can also elicit far more subjective responses. The Chiba catalogue includes an effort by Roger S. Keyes, one of the most talented and trained eyes in the field, to ascribe emotional responses to the color combinations in Harunobu's prints. The essay is a delight to read, and its underlying premise seems sound: who would disagree that color has the potential to elicit powerful reactions? But the author offers no historical evidence to support his interpretations. We don't know how mid-eighteenth-century Japanese viewers reacted to color, and we wonder if Keyes is not forcing Eurocentric, or perhaps even personal, conceptions of color and emotion into his reading of Harunobu's prints.[2]

The fascination, even fixation on Harunobu and color is not new. One purpose of this essay is to document its earliest manifestations, since they appear to have had profound consequences for subsequent scholarship. They have, for example, induced scholars to examine the broader cultural milieu surrounding the advent of full-color printing. Harunobu's role in these developments is undeniable, but scholars now recognize that he was only one of several contributors and probably not the most important. Nonetheless, the primacy accorded Harunobu in early scholarship has resisted challenge. Habits of practice and thought continue to blind and bind scholars. Attempts at revisionism discussed herein have, for the most part, failed. There is, in other words, a tension that continues to animate Harunobu scholarship between the cult of color, meaning an obsessive rehashing of the advent of full-color printing, and attempts to assess the broader implications of this achievement. Taking up the challenge, this essay reexamines the small set of written documents central to our understanding of the events that brought about full-color printing. This evidence suggests that Harunobu's most important legacy may not have been his contributions to full-color printing but rather, his efforts to turn the products of this new technology into marketable commodities. Understanding what was and continues to be at stake where Harunobu and color are concerned provides insights into his prints, the print tradition in the mid-eighteenth century and, more important, to prejudices, both productive and not, in ukiyo-e scholarship.

Harunobu was one of several artists designing prints in the early 1760s. Like his most noteworthy peers Ishikawa Toyonobu (1711–1785) and Torii Kiyomitsu (1735–1785), his palette was restricted by the printing technology in use at the time. With each color requiring a separate woodblock, his prints typically used a key block to produce the black outlines and two additional blocks to add color. In 1764, he designed several prints illustrating classical poems. Most of these were upright, middle-sized (hosoban) prints called mizu-e (water pictures), precursors to full-color prints that utilized two or three blocks to produce light colors, with blue predominating. Most surviving mizu-e do not have key-block outlines, another distinguishing feature of this genre. Perhaps these delicately rendered prints prompted the members of popular-poetry clubs (kyōkaren) who commissioned Harunobu to design prints for exchange at their gatherings. These were calendar prints, known as daishō surimono or egoyomi. Elements of the calendar in use at the time were cleverly hidden somewhere in their designs.[3] They could include references to the era name (nengō), the sixty-year cycle (kanshi) or the order of long (dai) and short (shō) months.[4] Harunobu's depiction of a young woman performing a stair-climbing ritual (Ohyakudo), for example, has the year-cycle designation (kinoto tori) and the long months of the year 1765 (2, 3, 5, 6, 8 and 10) worked into the design of her obi (fig. 56).[5] Harunobu's calendar prints exhibit great variety in the calendrical markings they displayed. Some of them combine the era name for 1765, Meiwa ni—second year of the Meiwa era (1764–72)—with either the long or short months. Others display all three systems: the era name, the year cycle, as well as the long and/or short months. Gamesmanship among members of the poetry clubs seems to be the protocol behind these designs. One assumes that these secret calendars elicited great amusement when exchanged at their celebratory gatherings.

A desire among the poetry club members to produce especially sumptuous prints instigated experiments that led to the development of full-color prints, or nishiki-e (brocade pictures), a term adopted at that time or shortly thereafter. In Swallow Stone Journal (Enseki zasshi), published in 1811, the popular novelist Takizawa Bakin (1767–1848) offered an account of the technological innovations that facilitated full-color printing:

> About the year Meiwa 2 [1765], after studying the color prints of China, a certain wood-block cutter called Kinroku had a talk with a printer, Mr. X. They devised something which would fix the alignment on the wood-blocks, and for the first time produced printing in four or five colours. Kinroku himself said that in no time there would be publishing in several places.[6]

Accounts of these events varied from one writer to the next, however. Ōta Nanpo (1749–1823), an author of humorous prose and verse who knew Harunobu personally and may

Figure 56
Suzuki Harunobu
Ritual of Climbing the Stairs One Hundred Times
1765. Color woodcut. 27.2 x 19.5 cm. Museum of Fine Arts, Boston, William Sturgis Bigelow Collection, 11.19437

have participated in the *daishō* exchanges of 1765 and 1766, disagreed with Bakin: "This explanation is wrong. The *kentō* [guide mark] was devised in Enkyō 1 (1744) by Uemura Kichiemon of the Emiya. That which is now called the *kentō* was originally called the Uemura."[7] Evidently, the development of color printing was important enough to stimulate debate between two of the leading exponents of popular culture decades after the actual events took place. Hindsight, in other words, made it a seminal event in the history of the print tradition.

Prior to the development of *nishiki-e* technology, woodcuts were generally produced with only two or three colors, primarily pink and green, and occasionally yellow and blue. Overprinting, the application of one color over another, could extend this range somewhat. The color-printed portions of *benizuri-e*, "red-printed pictures" as these prints of the early 1740s were known, were often confined to the main motifs of the design, thus leaving substantial areas of the print uncolored. The new full-color prints of the 1760s not only used many colors, but also could be colored over their entire surface if desired.[8] As one of Bakin's informants predicted, *nishiki-e* superseded early forms of color printing and quickly became the preferred medium for designers and publishers of popular prints.

Late nineteenth-century European collectors and scholars were as fascinated with the technology of full-color printing as Bakin and Nanpo, but Harunobu's role in this development was a matter of debate, at least initially. In *Descriptive and Historical Catalogue of a Collection of Japanese and Chinese Paintings in the British Museum*, William Anderson (1842–1900), a British physician who began collecting prints while practicing medicine in Japan, noted that Harunobu "devoted himself chiefly to an early form of colour-print known as *Azuma Nishiki-ye* or *Surimono*, a kind of New Year's card, printed from five or six blocks, and sold in large numbers at the beginning of the year."[9] Anderson recognized Harunobu's connection to full-color prints but mistakenly assumed that the term referred only to the calendar prints he designed for the poetry clubs. The term *nishiki-e* does not appear in any of Anderson's later publications. In fact, several years elapsed before scholars recognized the real meaning and historical significance of the term.

There are several reasons for this lapse. Early Western collectors and scholars were enamored with the vivid applications of color in Japanese color woodblock prints, in part because Western artists working in woodcut and wood engraving media generally preferred monochrome prints produced from a single block. Multiblock processes were used in Europe since the early 1500s, but artists who were interested in tonal gradation produced chiaroscuro woodcuts, as they were known, which they achieved with a relatively narrow brown or black palette. Consequently, the fascination with Japanese printing technologies quickly became a fixation among those attempting to write histories of the print tradition, but not, as one might assume, on the advent of full-color printing. Rather, collectors and scholars were primarily concerned with the transition from handcoloring to color printing. Because technological improvements in the medium provided the framework on which early scholars in the West and later in Japan constructed their surveys of ukiyo-e, they vied with one another to fix the precise date when each new technique was introduced. All readily agreed on the developmental trajectory of printing technology: *sumizuri-e* (ink-printed pictures), through *tan-e* (hand-colored prints that utilized *tan*, an orange pigment, as their primary color, see fig. 37) and *benizuri-e* (red-printed pictures, see fig. 53), to full-color designs; but the dating of this framework was skewed from the outset by an essay written by Ernest Satow (1843–1929), a British diplomat stationed in Japan from the early 1860s to the 1880s.[10] Satow quoted a Japanese source who claimed to have seen a 1695 color-printed single-sheet design of the famous actor Ichikawa Danjūrō I (1660–1704). Anderson did not question Satow's judgment, perhaps because they had been colleagues in the small foreign community residing in Japan during the late nineteenth century, perhaps because Japanese expertise in traditional arts was a precious commodity at the time. As a result, Anderson's account of the print tradition—the earliest in any Western language—dated the transition from hand to block-printed coloring to the early 1700s and assigned this development to Torii Kiyonobu (1664–1729).[11] Anderson acknowledged that Harunobu, along with Torii Kiyonaga (1752–1815) and Katsukawa Shunshō (d. 1792), used more color blocks, but he saw this as nothing more than perfecting a technological advance that was introduced fifty years earlier.

All early scholars adapted Anderson's technology-based chronology to their own histories of Japanese prints with only minor modifications, but Harunobu's status was hotly debated.[12] Edward F. Strange (1862–1929), curator of Japanese art at the South Kensington Museum, supported Anderson's date for the inception of color printing but adamantly refused to consider what were obviously more informed opinions: "Such Japanese writers as have condescended to bestow any attention on the biographies or works of the colour-print designers, have attributed to Suzuki Harunobu the 'invention' of nishiki-ye. We have seen this to be entirely inaccurate."[13] Strange was willing to accord Harunobu some degree of recognition. He continues: "It is certain, however, that Harunobu made great improvements in the art of printing, and did a great deal to generally popularize the whole craft," but in publications issued as late as 1931, he still refused to acknowledge Harunobu's connection to nishiki-e.[14]

Ernest Fenollosa's 1896 exhibition catalogue, The Masters of Ukioye [sic]: A Complete Historical Description of Japanese Paintings and Color Prints of the Genre School, challenged Anderson's chronology and began the process of refocusing attention on Harunobu's relationship with the earliest nishiki-e. Like his predecessors, Fenollosa (1853–1908), the first curator of Japanese art at the Museum of Fine Arts in Boston, arranged his catalogue to reflect incremental improvements in printing technology. With each new technological development, he extended his catalogue entries from a single paragraph to several in which he described in detail the significance of the new printing processes. For the first two-color print appearing in his catalogue, a work by Okumura Masanobu (1686–1764) dated 1743, he wrote: "European critics have, without exception, made a great mistake in ascribing this change to the close of the seventeenth century. Block colored work by Kiyonobu is everywhere recently labelled of that date in exhibitions and collections. It is an error apparently borrowed from the uncritical conjectures of some English and French authorities. It was a most exciting chase of years, during my residence in Japan, to hunt down, narrowly encircle, and finally to capture this most important date."[15] Displaying his connoisseurial skills—trappings of the emerging discipline of art history—Fenollosa then described in detail how he compared fabric patterns and hairstyles in early benizuri-e prints with those in dated illustrated books to arrive at his discovery. He utilized the same method to date the first three-color print in his catalogue, an interior scene by Nishimura Shigenaga (1697?–1756), to 1759.[16] Using a vertical, oversized double-sheet print (which Fenollosa referred to as a kakemono-e) by Harunobu, dated to 1763, Fenollosa discussed the use of overprinting to extend the palette from three to nine colors.[17] A Harunobu design of the courtesan of Eguchi described as "Girl, as the Buddhist divinity Fugen, riding on a white elephant" that Fenollosa dated to 1765 is the first exhibit in the catalogue he refers to as a "color print." The term nishiki-e appears several entries later in a description of another Harunobu design: "Need we wonder that the name nishikiye, or embroidery painting, was now bestowed upon this new art?"[18] In the hyperbole that characterizes much of his writing, Fenollosa set the stakes for future discussions of Harunobu: "The year 1765, therefore, cuts like a knife through the ranks of the Ukioyeshi. The older leaders practically cease to produce, being distanced in the race What a sudden change in personalities! Who, then, are the new men, upon whom the future of Ukioye depends?"[19]

Once Harunobu's association with early nishiki-e was recognized, his status was upgraded in the eyes of collectors and scholars; he was quickly designated one of the elite artists of the ukiyo-e tradition—a position that has seldom been challenged since. The increased level of scrutiny Harunobu received because of scholars' focus on the inception of full-color printing gradually opened up a broader range of contextual issues surrounding his prints. But the elite status he had acquired also blinded scholars in ways that prevented full realization of this potential. The following examples serve to illustrate this point.

Many of the calendar prints Harunobu designed in 1765 and 1766 bear the names or seals of poetry-club members who commissioned them. Of those who can be identified, research indicates that they were either samurai or wealthy merchants. In other words, participants in the calendar exchanges were among the most literate members of eighteenth-century Japanese society. The creativity they invested in their calendar prints extended beyond the secreting of calendar information somewhere in the designs and the exploita-

tion of multiblock printing. Many of the poetry-club members also incorporated elaborate *mitate* into their conceptualizations. *Mitate* and *mitate*-pictures (*mitate-e*) have complex etymologies, highly varied applications (both historical and current) and the wide array of synonymous terms used by ukiyo-e artists in the titles of their works.[20] For the sake of expediency, *mitate* may be defined as creative or humorous reworkings of well-known subjects or themes. Most often, historical persons, mythical or religious figures or famous works of art were depicted in contemporary guise in a manner that ranged from innocently charming to transgressive and iconoclastic.

While not calendar prints per se, the set of *Eight Parlor Views* (*Zashiki hakkei*) designs in this exhibition exemplifies the new levels of cultural literacy associated with early *nishiki-e* (fig. 57a–h). These prints, designed by Harunobu but conceptualized by Okubo Jinshirō Tadanobu (1727–1777)—a shogunal retainer and the leader of the Kikuren poetry club—who used the name Kikurensha Kyosen, are *mitate* on the Eight Views of Xiao and Xiang Rivers, a theme first explored in eleventh-century Chinese poetry and landscape painting. In the early sixteenth century, the Eight Views were transposed to scenic places in Ōmi province located to the east of Kyoto. This reformulated version, Eight Views of Ōmi (*Ōmi hakkei*), became popular among Japanese landscape painters. Several ukiyo-e artists, including Harunobu, designed straightforward depictions of the scenes prior to the advent of full-color printing.[21] Kyosen reputedly reset the Eight Views of Ōmi theme as eight indoor scenes featuring contemporary beauties in which an element in each design is a *mitate* of the original landscape. *Evening Snow on Mount Hira* became *Evening Snow of the Floss Shaper* (*Nurioke no bosetsu*) in Kyosen's version (fig. 57); *Returning Sails at Yabase* became *Returning Sails of the Towel Rack* (*Tenuguikake no kihan*) (fig. 57f). The highly erudite individuals behind the calendar print exchanges not only embraced full-color printing, they also significantly expanded the thematic repertoire of the print tradition.

Harunobu's association with the poetry clubs bolstered his reputation as an elite artist among collectors and scholars, but arguing for his preeminence also obfuscated other important facets of his relationship with the poetry clubs. The original *Eight Parlor Views* set, which bears Kyosen's signature and seal, were packaged in a paper wrapper that bore the series title and a subtitle reading *Fashionable Picture Competition* (*Fūryū e-awase*). Like the calendar prints discussed above, the *Eight Parlor Views* was commissioned for exchange at poetry club gatherings. Kyosen's *Parlor Views* prints were initially produced for private use, but as with many of the calendar prints, they were subsequently reissued, often several times, for commercial distribution. Later editions were printed with the signature of Harunobu in place of Kyosen. Isoda Koryūsai (1735–1790) and Torii Kiyonaga borrowed liberally from Harunobu's designs for their versions of the Eight Parlor Views theme. This infusion of elite culture forever altered the trajectory of commercially produced ukiyo-e.[22] *Mitate* conceptualized by the poetry clubs in 1765 and 1766 became increasingly common in commercially produced designs, thus raising the level of cultural literacy of the entire print tradition.

Creative reuse of material from other artists was common in ukiyo-e, and as Harunobu's elite status led to more scrutiny scholars quickly realized that he was no stranger to this practice. He plagiarized liberally from his predecessors Sukenobu and Masanobu as well as his contemporaries Toyonobu and Kiyomitsu, but his association with early *nishiki-e* and the status this garnered isolated him from criticism. Plagiarism is a value-laden term in its present usage and perhaps inappropriate here in that many ukiyo-e artists borrowed from their predecessors and peers. It was, after all, an effective means to profit on popular designs. I use the term to emphasize the defensive posture taken by scholars invested in Harunobu's primacy when they attempt to account for his borrowing, which, compared to other artists, was considerable. In an effort to justify this practice, for example, Tanabe Masako contends that iconographic gamesmanship is what Harunobu intended all along—he invited his viewers to discover his borrowings.[23] On occasion, Harunobu seems to acknowledge his sources as, for example, his print showing two women looking at a hanging scroll signed by Okumura Masanobu (see fig. 54). But we need to be suspicious of such designs as they may be little more than efforts at self-promotion. Is Harunobu acknowledging Masanobu as the inspiration for his own work or is he providing a means to compare his design with that of his highly regarded predecessor?

Following pages: Figure 57a–h
Suzuki Harunobu
The Eight Parlor Views (*Zashiki hakkei*)
1766. Color woodcuts. 28.9 x 21.6 cm;
28.5 x 21.6 cm; 28.6 x 21.5 cm; 28.8 x 21.6 cm;
28.4 x 21.6 cm; 28.7 x 21.7 cm; 28.4 x 21.7 cm;
28.6 x 21.6 cm. Clarence Buckingham Collection,
The Art Institute of Chicago, 1928.896–903

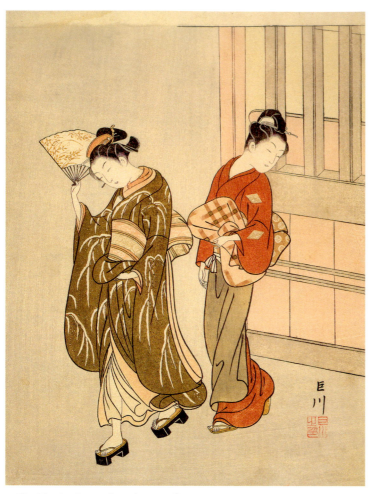

a. *The Clearing Breeze from the Fans (Ōgi no seiran)*

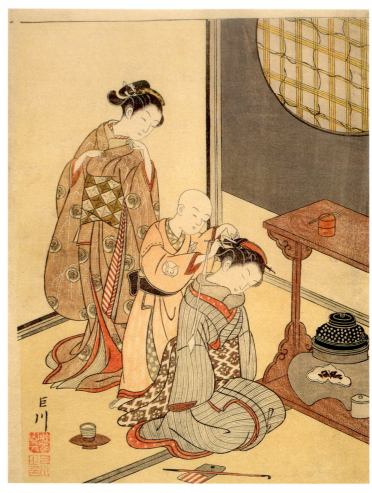

b. *Night Rain on the Heater Stand (Daisu no yau)*

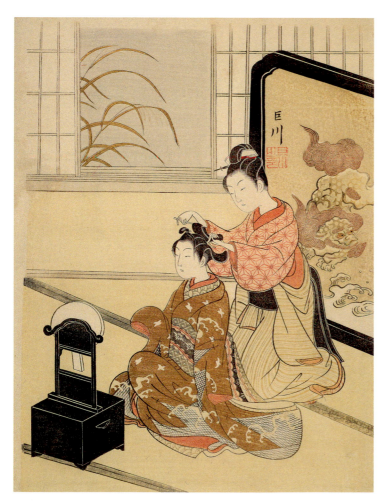

c. *The Autumn Moon in the Mirror Stand (Kyōdai no shūgetsu)*

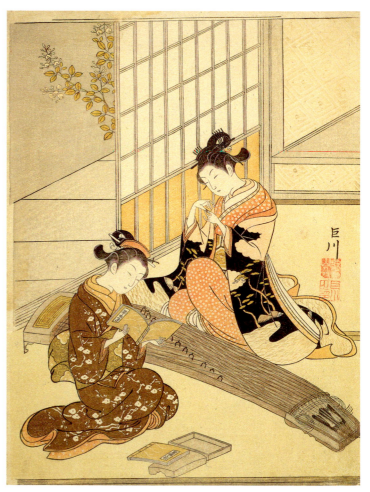

d. *Descending Geese of the Koto Bridges (Kotoji no rakugan)*

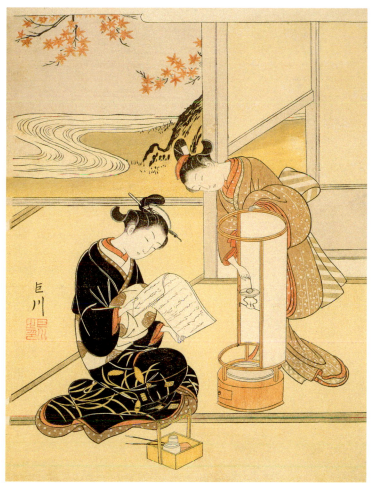

e. *The Evening Glow of the Lantern* (*Andō no sekishō*)

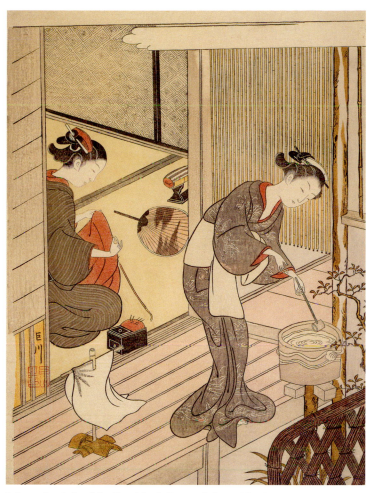

f. *Returning Sails of the Towel Rack* (*Tenuguikake no kihan*)

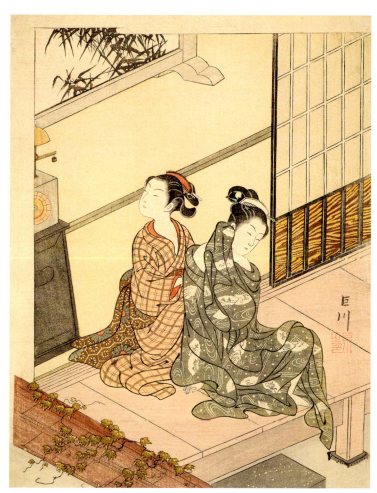

g. *The Evening Bell of the Clock* (*Tokei no banshō*)

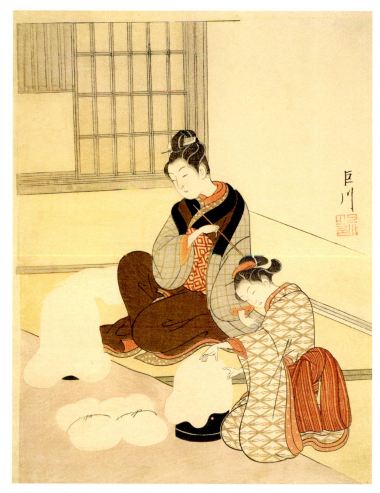

h. *Evening Snow on the Floss Shaper* (*Nurioke no bosetsu*)

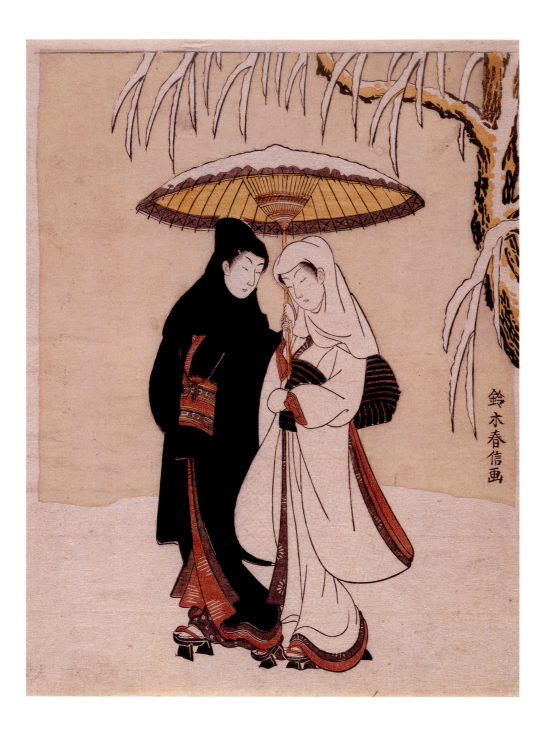

鈴木春信画

Accounts of Harunobu's plagiarism, or rather the spin given it by specialists, would not be objectionable if other artists (notably Koryūsai) had not been routinely and severely condemned for lifting motifs from their predecessors. But then, Koryūsai made the mistake of copying Harunobu—the primary deity of the cult of color—thus absolving Harunobu devotees past and present of any need to be concerned with double standards. In fact, what appears as plagiarism may not be the case at all. Koryūsai made several versions of *Lovers Sharing an Umbrella* and many resemble Harunobu's design (figs. 58, 59). Was Koryūsai plagiarizing Harunobu or was he simply conveying to his clientele an image they knew well from the work not only of Harunobu but of Okumura Masanobu before him? More to the point, when a subject acquires iconic status, how can its replication be considered plagiarism?

The great delight Harunobu specialists take in tracking down the sources he mined has become a scholarly game in and of itself. David Waterhouse has proven particularly adroit at identifying the sources Harunobu used for his designs. His insights are themselves regularly plagiarized by other scholars, whose work we often read for evidence of the sort of creative borrowing Harunobu himself practiced.[24]

Figure 58
Suzuki Harunobu
Lovers Sharing an Umbrella
1767. Color woodcut. 26.5 x 20 cm.
Private Collection, New York

Harunobu's premature death in 1770 at the height of his popularity prompted republication of many of his designs and widespread emulation of his style by his peers and followers. This response is to be expected in the competitive print market, but it also added significantly to Harunobu's cachet. He had the especially good fortune of being forged by someone who admitted to his transgressions in print. Shiba Kōkan (1747–1818) confessed to passing off forgeries immediately after Harunobu's death but, motivated by guilt, eventually began signing his imitations with the name Harushige.[25] Kōkan's print bearing the signature Harushige and depicting a young woman descending the stone steps of a temple (fig. 60) was likely inspired by Harunobu's calendar print noted above (see fig. 56). The discovery of Kōkan's confession generated much subsequent attention among ukiyo-e scholars, setting them on a quest for fakes.[26] Their odyssey took an unexpected turn in the late 1920s when Arthur Waley and Tomita Kōjirō debated whether Kōkan and Harushige were one and the same.[27] The publication of three comprehensive catalogues devoted to Harunobu in the 1960s and early 1970s forced their authors to revisit the issue of Kōkan's forgeries and designate their choice of likely candidates. The result was considerable overlap but no consensus.[28]

Evidently, the issue remained unsettled, as other scholars (including this author) took up the problem once again two decades later, by pointing out a flaw running through earlier assessments.[29] Kōkan's post-Harushige career led him to explore Western-style art. The fact that many of Kōkan's perspective prints exhibited similarities to Harunobu's designs led scholars to assume that any print with Western elements such as linear perspective must be a forgery. Kōkan's depiction of a courtesan and her two attendants (kamuro) rolling a large snowball (fig. 61), inscribed "Harunobu," was a frequently cited example in that it was clearly inspired by an image in Harunobu's posthumously published *Picture Book of the Brocades of Spring* (*Ehon haru no nishiki*) (fig. 62). To Harunobu specialists it seemed that Kōkan lifted this subject from Harunobu and set it against a background conceived in Western-style linear perspective. But in their relentless pursuit of forgeries, no one thought to ask the obvious question: Why would Kōkan add entirely new and completely foreign elements into prints he was trying to pass off as Harunobu originals? The short answer is he didn't—Harunobu must have also produced perspective prints. Harunobu's circle of acquaintances included Hiraga Gennai (1734–1779), a scholar of Dutch learning (rangaku), that is, European studies, who reputedly taught Western-style art to several of his associates.[30] Many of the perspective prints thought to be Kōkan forgeries also bear stylistic hallmarks attributable to Harunobu. One of Harunobu's designs depicting a harbor scene, moreover, clearly indicates that he was experimenting with linear perspective prior to the introduction of full-color printing.[31]

Some writers have pointed out obvious incongruities in Harunobu's supremacy, but seemingly to no avail. *Mitate-e* are certainly not unique to Harunobu. Artists working several decades before him, particularly Masanobu, were very adept at this form of visual play, as three examples in this exhibition attest (see figs. 36, 37, 52). In fact, many of Harunobu's most celebrated *mitate-e* are variations on prints from the oeuvres of his predecessors. Money L. Hickman discovered an Okumura Toshinobu (act. c. 1716–51) print in the Museum of Fine Arts, Boston (fig. 63), that incorporates all the imagery Kyosen and Harunobu used in their *Eight Parlor Views* series (fig. 57a–h). In fact, the Parlor Views concept first appeared in a humorous poem (kyōka) in 1739 and was subsequently worked into a kabuki play twenty-five years before Kyosen and Harunobu revisited it.[32] Despite the evidence provided by Toshinobu's print, the Kyosen/Harunobu series remains one of the most acclaimed examples of mid-eighteenth-century *mitate-e* owing, in part, to Harunobu's reputation as an "innovator."

In a similar attempt at revisionism, David Waterhouse documented examples of both calendar prints and multiblock color printing that predate Harunobu's calendar designs of 1765.[33] The evidence he cited should have elicited reassessment of the standard narrative on the development of color printing, but the implications of Waterhouse's findings were never fully explored in subsequent scholarship. It seems that attempts at revisionism that call into question Harunobu's revered status have had little effect.

Harunobu's association with the development of *nishiki-e*, his liberal use of motifs from the prints of his predecessors and peers, and the republication, emulation and forgery

Figure 59
Isoda Koryūsai
The Imperial Progress, Chapter 29, from the series *Fanciful Genji* (*Yatsushi Genji, Miyuki*)
1772. Color woodcut. 25.5 x 19 cm. William Sturgis Bigelow Collection, Museum of Fine Arts, Boston, 11.19547

Figure 60
Shiba Kōkan (signed Harushige)
Shimizu, from the series *Fashionable*
Seven Komachi (*Fūryū nana Komachi*)
c. 1770. Color woodcut. 28.5 x 21.1 cm. The British
Museum, Gift of E. W. Tuke, JA 1938.3.12.09

of his designs following his death, stimulated—perhaps even necessitated—a kind of scholarship that relied on meticulous visual scrutiny of his prints. Systematic comparisons of the many editions of Harunobu's prints and tracking of his influence on later artists have brought to light the sequences in which Harunobu's designs were commercialized, but his oeuvre has yet to be reframed in a manner that addresses changes in the market and viewer constituencies for his prints. This is not just an argument for a more recently fashionable form of art history. Rather, the documentary sources scholars frequently cite regarding the development of full-color printing suggest this very approach. Writing in *Dreams During a Nap* (*Karine no yume*) in 1825, the author Shuho Shichizaemon Raimu (dates unknown) offers the following account:

> In the beginning of Meiwa [i.e., the Meiwa era, 1764–72] there were very large numbers of *daishō surimono* and people started using different colours in the printing of woodblocks. Principally through the efforts of Ōkubo Jinshirō, a *hatamoto* [bannerman] from Ushigome who used the *haimyō* [pen name] Kyosen and of Abe Hachinoshin Shakei from the wharf in Ushigome, clubs were formed and *daishō* exchanged. Later there were big meetings in such places as the Yushima teahouse, but they ended within two years. From that time, *nishiki-e* were sold on a large scale through the bookshops.[34]

Like the accounts of Bakin and Nanpo, noted above, Shuho's does not mention Harunobu specifically. Instead, he highlights the roles played by Harunobu's associates in the development of full-color printing. How might we interpret this?

Undoubtedly, Harunobu's role in the production of early *nishiki-e* was common knowledge—Nanpo wrote on the subject often and frequently mentions Harunobu. In *Ukiyo-e ruikō* (Some considerations of ukiyo-e), a "lives of the artists" chronicle of ukiyo-e, begun by Nanpo in the 1790s and subsequently edited and expanded by later authors, he stated: "From the beginning of Meiwa he drew and put out *Azuma nishiki-e*, and was their originator at this time. This was the period when at the beginning of spring *daishō no surimono* [calendars showing the long and short months] were very popular, and appeared for the first time with five or six printings. With the acquisition of skill they became the present-day *nishiki-e*."[35]

Shuho wrote well after the events he described and had the advantage of hindsight. Much had happened in the print tradition in the intervening years. In particular, color printing had been thoroughly commercialized over the second half of the eighteenth century. Differences between the salon culture of the Meiwa *daishō* exchanges and common ukiyo-e had diminished considerably.

Right: Figure 61
Shiba Kōkan (inscribed Harunobu)
Courtesan, Two Kamuro *and a Giant Snowball*
1771. Color woodcut. 28.6 x 21.6 cm. Private
Collection

Below: Figure 62
Suzuki Harunobu
Courtesan, Two Kamuro *and a Giant Snowball,*
from *Picture Book of the Brocades of Spring*
(*Ehon haru no nishiki*)
1771. Color woodblock-printed book. Vol. 1, fols.
7v–8r. 21.7 x 14.6 cm each page. Private Collection

Figure 63
Okumura Toshinobu
Eight Parlor Views of Kanazawa Palace (Kanazawa no gosho zashiki hakkei): Segawa Kikunojō I as Kajiwara's Wife, Shizuya, and Sanjō Kantarō II as Mankō, the Widow of Kawazu
1733. Woodcut, handcolored and with deer glue. 31.7 x 15.6 cm. Museum of Fine Arts, Boston, William S. and John T. Spaulding Collection, 21.8116

But history of the sort Shuho authored spoke not only of the past, but also to the era in which it was written. Privately published and distributed prints called *surimono* were enjoying a renaissance if not a complete rebirth in the early nineteenth century when he wrote of Meiwa *nishiki-e*. Poetry-club culture was also reaching its apex. Designers and publishers of color prints, moreover, were pushing the medium to unprecedented levels of sophistication and nuance, superseding anything produced in the Meiwa era. Shuho's revisionism highlighted the roles of the poetry clubs in a manner similar to Bakin and Nanpo's foregrounding of those responsible for the technical achievements of *nishiki-e*. These early nineteenth-century writers were still invested in the cult of color but downplayed Harunobu's role in favor of a more balanced account of the advent of *nishiki-e*. But as revisionist as their efforts might seem, their accounts stand in marked contrast to other primary sources, particularly those more contemporary with the actual events of 1765.

Morishima Chūryō (1754–1808), disciple of Hiraga Gennai, covers much of the same material in those by Shuho, Bakin and Nanpo in his *The Waste Paper Basket* (*Hogokago*). Chūryō notes that "In Meiwa 2, the Monkey Year, *daishō* pictures were popular: much elegance was put into these abbreviated calendars, and their merits were appraised as if they were paintings. From this time began block-printing with seven or eight printings." But Chūryō assigned Harunobu a specific role in these events. He wrote: "It was from it and others that Suzuki Harunobu hit on the idea of putting out to various dealers in illustrated novels (*e-zōshiya*) the posters (*kanban*) known as *Azuma nishiki-e*, 'Brocade Pictures of the East,' and selling them. This was the origin of modern *nishiki-e*."[36] My point here is that Chūryō credits Harunobu not with the creation of *nishiki-e*, but with their subsequent commercialization. The preoccupation with Harunobu's link to calendar prints and their elite clientele may very well have prevented early nineteenth-century enthusiasts and their twentieth-century counterparts from exploring a more important relationship between Harunobu and commercial publishing.

The earliest accounts of multicolor printing raise another related issue. Shuho, Bakin and Nanpo used the term *nishiki-e* when they referred to the full-color prints of the mid-1760s. Earlier accounts, however, reveal a preference for *Azuma nishiki-e*. These include Chūryō's *Hogokago* and Nanpo's *Ukiyo-e ruikō*, noted above, as well as Nanpo's preface to Harunobu's 1769 illustrated book, *The Story of Dohei the Candy Vendor* (*Ameuri Dohei den*) and a 1767 *kyōshi* (humorous poem) published in *Literary Works of Master Groggy* (*Neboke sensei bunshū*).[37] The implications of this preference are worth more consideration.

Azuma means "the east" but was more specifically a reference to the city of Edo. It was a way of setting Edo in opposition to Kyoto, the historical capital, and for centuries the cultural heart of Japan. *Nishiki* (brocade) referred to textiles but was also used metaphorically in floating world literature, appearing often in the titles of Harunobu's illustrated books published both before and after 1765.[38] Jack Hillier notes that the term *nishiki-e* had been in use since the early 1700s, and that it referred to a popular Kyoto handicraft in which colored pieces of fabric were glued onto outline drawings. Hillier suggests that the term *Azuma nishiki-e* was probably chosen so as to distinguish the new printing technology from its Kyoto precedent.[39] A more aggressive interpretation suggests that *Azuma nishiki-e* was symptomatic of an emergent Edocentrism datable to the mid-eighteenth century.[40]

The correlation between references to *Azuma nishiki-e* from the late 1760s and a change in Harunobu's choices of themes at that time raises an important issue. Specialists uniformly agree that Harunobu began to depict subjects from his immediate surroundings in 1767.[41] He continued to produce *mitate-e* that harkened back to classical literature but began to populate his designs with identifiable Edo and floating world personalities, such as Osen, a young woman who operated a tea stall near the Kasamori Inari Shrine, Ofuji, who sold toothpicks and cosmetics in Asakusa, various Yoshiwara courtesans and the occasional actor. These people are not named, but were well known enough to be recognizable when they appeared in Harunobu's prints. His depiction of a courtesan standing on the veranda of a brothel, for example, shows a curtain (*noren*) suspended over the entrance bearing the name of the establishment: Motoya (fig. 64). While the identity of the courtesan is not immediately apparent, surely those among Harunobu's clientele who frequented the Yoshiwara would have known who she was. Even the client she attempts to seduce may

Figure 65
Suzuki Harunobu
***Sunset Glow at Ryōgoku Bridge (Ryōgokubashi
no sekishō), from the series Fashionable Eight
Views of Edo (Fūryū Edo hakkei)***
1768–69. Color woodcut. 27.3 x 20.4 cm.
Museum of Fine Arts, Boston, William Sturgis
Bigelow Collection, 11.19463

Opposite: Figure 64
Suzuki Harunobu
***Courtesan of the Motoya and Client
Disguised as an Itinerant Monk***
1770. Color woodcut. 28.9 x 21.6 cm.
Private Collection

The Motoya was a brothel on Nakanochō in
the Fukagawa district of Edo and was celebrated
for a girl called Oroku. Possibly she is the one
who is depicted here. A man wishing to visit a
brothel incognito might disguise himself as an
itinerant monk.

have been identifiable to a knowledgeable audience, despite his disguise as an itinerant
monk (*date komusō*). Harunobu and Kyosen's 1776 *Eight Parlor Views* collaboration was
intended for an elite clientele, but four years later, he spoke to a wider audience when he
created the series *Fashionable Eight Views of Edo* (*Fūryū Edo hakkei*), the designs of which
feature identifiable locales throughout the city. *Sunset Glow over Ryōgoku Bridge* (*Ryō-
gokubashi no sekishō*) shows two young beauties on a veranda before a backdrop of the
famous bridge that spans the Sumida River near Asakusadera, a popular temple located to
the north of the city center (fig. 65).

To devotees of the cult of color, Harunobu will always be the creative genius around
whom coalesced the talent and energy needed to advance woodblock-print technology.
Evidence contrary to this grand narrative will be ignored. Members of the poetry clubs,
along with the engravers and printers on which the entire *nishiki-e* enterprise relied, will be
acknowledged but relegated to the supporting cast as Harunobu continues to take center
stage. The cult of color is, after all, a cult of the artist—an enduring but highly problemati-
cal construct that often leaves other productive lines of inquiry unexplored.

Notes

1. The exhibition catalogue noted here is Chiba City Museum of Art and Hagi Uragami Museum of Art, eds., *Seishun no ukiyo-eshi Suzuki Harunobu—Edo no kararisuto tōjō/Suzuki Harunobu, Ukiyo-e artist of the springtime of youth: Entry on stage of the Edo colorist*, exh. cat. (Chiba and Hagi: Chiba City Museum of Art and Hagi Uragami Museum, 2002), hereafter abbreviated as *Seishun no ukiyo-eshi Suzuki Harunobu*. For the essay on mass spectroscopy in the Chiba catalogue, see Shimoyama Susumu, "Colorants employed in Suzuki Harunobu's prints 'Night Rain on the Daisu' and 'Ki no Tomonori'—A Report on a Non-destructive Analysis," 298–99; see Tanabe Masako, "The Enigma of Elegance—Colorants and Paper in the Woodblock Prints of Suzuki Harunobu," 310, for a discussion of Tachihara Inuki's efforts to duplicate the palette of Harunobu's prints.

2. Roger S. Keyes, "Harunobu's Color," in *Seishun no ukiyo-eshi Suzuki Harunobu*, 293–97.

3. Only publishers authorized by the Tokugawa shogunate were permitted to distribute printed calendars. *Egoyomi* produced for these poetry gatherings did not contravene any laws, because they were privately commissioned and intended only for club members.

4. Calendars used in the Tokugawa era had essentially three components: a *nengō* or era name, consisting of a two-character combination chosen for its auspicious meaning; a *kanshi* designation, drawn from a sixty-year cycle devised from astronomical and astrological symbols; and a *daishō* order, a sequence of long (*dai*, 30 day) and short (*shō*, 29 day) months, the order of which was altered by the government every year. Calendar print designers used one, two or all of these systems in their prints.

5. The *Ohyakudo* ritual involved climbing temple stairs one hundred times, usually to invoke good fortune.

6. D. B. Waterhouse, *Harunobu and His Age: The Development of Colour Printing in Japan* (London: Trustees of The British Museum, 1964), 15. Kobayashi, "Suzuki Harunobu—The Master of Youth," 292, in *Seishun no ukiyo-eshi Suzuki Harunobu*, provides a slightly different translation of this extract.

7. This passage appeared in *Ichiwa ichigen*, which was published in 1883 but written by Ōta Nanpo sometime between 1779 and 1820. See Waterhouse, *Harunobu and His Age*, 15.

8. It should be noted that the development of deluxe *hōsho* paper around this time also contributed to the advent of full-color printing in that it allowed for greater color saturation and gauffrage while being durable enough to withstand the multi-block printing process.

9. William Anderson, *Descriptive and Historical Catalogue of a Collection of Japanese and Chinese Paintings in the British Museum* (London: Longmans, 1886), 342. Anderson paraphrased this information from the 1844 edition of *Ukiyo-e ruikō*, one of the few extant primary sources to record the details of print artists' lives. Ōta Nanpo wrote *Ukiyo-e ruikō* in the 1790s. Other authors contributed new material to each of its many editions.

10. Ernest Satow, "On the Early History of Printing in Japan," *Transactions of the Asiatic Society of Japan* 10 (1881): 48–83.

11. See William Anderson, *Pictorial Arts of Japan*, (Boston and New York: Houghton, Mifflin and Company, 1886), 154. He lists 1700 as the beginning of three-block printing. In *Catalogue of Prints and Books Illustrating the History of Engraving in Japan* (London: Burlington Fine Arts Club, 1888), xvii–xviii, he provides a brief history of color printing that dates three-block prints (by Kiyonobu, Kiyomasu, Masanobu) to 1700, four-block prints (by Shigenaga) to 1720 and five- to six-block prints (by Harunobu, Kiyonaga, Shunshō) to 1765. In "Japanese Wood Engravings," *Portfolio* (1895): 23, Anderson assigns the beginning of color printing to Kiyonobu in 1710. He also notes improvements in color-printing technology in 1765 but does not use the term *nishiki-e* (pp. 31–32).

12. See, for example, Siegfried Bing, *Catalogue de l'exposition de la gravure japonaise à l'Ecole des Beaux-Arts* (Paris: Ecole des Beaux-Arts, 1890).

13. Edward F. Strange, *Japanese Illustration: A History of the Arts of Wood-cutting and Colour Printing in Japan* (London: George Bell and Sons, 1896), 29.

14. For example, "Harunobu, with several of the Japanese writers on the Ukiyoye School, has the credit of having invented *nishikye*. This is, of course, untrue, but it probably rests on the grounds that he certainly introduced many improvements into the process, and greatly popularised prints of this class; while it may be that the term *Adzuma Nishikiye* was first applied to the work from his studio. It is recorded that his prints were widely sought during the period Meiwa (A.D. 1764–1772), and that at the same time New Year *surimono*, with five or six printings, were first made, though we are not definitely told that this was done by Harunobu himself." Edward F. Strange, *Japanese Colour Prints* (London: Victoria and Albert Museum, 1931), 19.

15. Ernest F. Fenollosa, *The Masters of Ukioye: A Complete Historical Description of Japanese Paintings and Color Prints of the Genre School* (New York: W. H. Ketcham, 1896), 21. Fenollosa's polemic directed toward European scholars characterizes much of his writing on ukiyo-e. For a fuller account of this aspect of his work see Allen Hockley, *The Prints of Isoda Koryūsai: The Floating World and Its Consumers in Eighteenth-Century Japan* (Seattle and London: University of Washington Press, 2003), 24–31.

16. Fenollosa, *The Masters of Ukioye*, 37.

17. Fenollosa, *The Masters of Ukioye*, 40.

18. Fenollosa, *The Masters of Ukioye*, 46.

19. Fenollosa, *The Masters of Ukioye*, 43. "Ukioyeshi" (*ukiyo-eshi*) is a generic term used to refer to ukiyo-e artists.

20. For a full discussion of these issues, see Timothy T. Clark, "*Mitate-e*: Some Thoughts, and a Summary of Recent Writings," *Impressions* 19 (1997): 6–27. Sarah E. Thompson's essay in this volume also addresses the complexity of the term.

21. The other artists were Kiyomasu II, Shigenaga, Kiyonobu, Kiyomitsu and Shigemasa.

22. For a more thorough discussion of the commercialization of *mitate* and its implications, especially as regards *Zashiki hakkei* series, see Hockley, *The Prints of Isoda Koryūsai*, 41–86.

23. Tanabe Masako, "Suzuki Harunobu no zugara shakuyō: mitate no shukō to shite no saihyōka" (Design borrowings of Suzuki Harunobu: A reappraisal of *mitate* as a device) *Bijutsushi* (Art history) 127 (Feb. 1990): 66–86.

24. For examples, see David Waterhouse, "Harunobu in Chiba," *Impressions* 26 (2004): 118–26.

25. Roughly twenty extant prints bear Kōkan's Harushige signature.

26. Kōkan's confession, *Kōkan kōkaiki* (*Kōkan's record of his regrets*), was inserted into a longer essay titled *Shunparō hikki* (*Notes by Shunparō*). *Shunparō hikki* was first published in Ōtsuki Shūji, *Hyakka setsurin*, vol. 1 (Tokyo: Kōbunkan, 1892). For details, see David Waterhouse, "Suzuki Harunobu: Some Reflections on the Bicentenary of His Death," *Oriental Art* (1971): 353. Laurence Binyon provided the first comprehensive discussion of the Kōkan confession and forgeries in 1916, although it is clear from his comments that the issue had surfaced earlier among scholars working in both Europe and Japan. See Laurence Binyon, *A Catalogue of Japanese and Chinese Woodcuts Preserved in the Sub-Department of Oriental Prints and Drawings in the British Museum* (London: Trustees of the British Museum, 1916), xl–xlii.

27. See Arthur Waley, "Shiba Kōkan and Harushige not Identical," *Burlington Magazine* LII (1928): 178, 183. Waley's article initiated a subsequent exchange with Tomita Kōjirō. See Tomita Kōjirō, "Shiba Kōkan and Harushige Identical. I," *Burlington Magazine* LV (1929): 66–73; and Arthur Waley, "Shiba Kōkan and Harushige not Identical. II," *Burlington Magazine* LV (1929): 73–74.

28. The catalogues were: David Waterhouse, *Harunobu and His Age*; Margaret O. Gentles, *The Clarence Buckingham Collection of Japanese Prints, Volume II. Harunobu, Koryūsai, Shigemasa, their followers and contemporaries* (Chicago: The Art Institute of Chicago, 1965); and Jack Hillier, *Suzuki Harunobu: An Exhibition of his Colour-Prints and Illustrated Books, on the Occasion of the Bicentenary of His Death in 1770* (Philadelphia: Philadelphia Museum of Art, 1970). In a subsequent article occasioned by the publication of Hillier's catalogue, Waterhouse summarized in detail the debate surrounding the Kōkan forgeries as it had evolved to that point. See Waterhouse, "Suzuki Harunobu," 345–53.

29. See Higuchi Jō, "Shiba Kōkan (Harunobu gisaku) to Suzuki Harunobu kōkaiki ni tsuite no ni san no mondai" (Shiba Kōkan [forger of Harunobu] and Suzuki Harunobu: Problems with *Kōkan's records of his regrets*), *Bunka shigaku* (Cultural history) 42 (Nov. 1986): 22–41. My findings first appeared in a M.A. thesis written in 1987, parts of which were later published. See Allen Hockley, "Harunobu's Relationship with Hiraga Gennai," *Andon* 32 (1989): 149–59 and Allen Hockley, "Harunobu and the *Megane-e* Tradition," *Ukiyo-e geijutsu/Ukiyo-e Art* 95 (1989): ii–v. Typesetting errors in the latter article are the responsibility of *Ukiyo-e geijutsu*.

30. For a discussion of Gennai's circle, see Hiroko Johnson, *Western Influences on Japanese Art: The Akita Ranga Art School and Foreign Books* (Amsterdam: Hotei Publishing, 2005), 30–36. See Hockley, "Harunobu's Relationship with Hiraga Gennai," 149–59 for a detailed account of Gennai's influence on Harunobu.

31. This print, in the collection of the Portland Art Museum, is discussed in detail in Hockley, "Harunobu and the *Megane-e* Tradition," ii–v.

32. Money L. Hickman, *Bosuton bijutsukan* (Museum of Fine Arts, Boston), I, Ukiyoe shūka (The glory of ukiyo-e) (Tokyo: Shōgakkan, 1985), 134–35. In personal correspondence, David Waterhouse notes: "Money Hickman's version of the origin of Zashiki hakkei can be corrected and amplified. The individual titles derive from one or more *kyōka* by the Osaka author Yuensai Teiryū, written in 1722 and incorporated into a puppet play that year. Then, supposedly in 1725, a fourteen-year-old boy composed *tanka* about each of them, with titles corresponding to those of Kyosen's prints (as named on the wrapper for the set in the Riccar Art Museum). Though the manuscript containing this information was not published until modern times, Hayashi Yoshikazu thinks that the Zashiki hakkei must have become well-known at the time as a subject; and the Toshinobu print in Boston is evidence of that. The poems and their titles appear also in a miscellany covering the late Kyōhō and Genbun eras, in an entry for 1737."

33. Waterhouse, *Harunobu and His Age*, 18–20. See also Timothy Clark, "Image and Style in the Floating World: The Origins and Early Development of Ukiyo-e," in Timothy Clark, Anne Nishimura Morse and Louise Virgin, with Allen Hockley, *The Dawn of the Floating World 1650–1765: Early Ukiyo-e Treasures from the Museum of Fine Arts, Boston*, exh. cat. (London: Royal Academy of Arts, 2001), 29–30.

34. Matthi Forrer, *Egoyomi and Surimono: Their History and Development* (Vithoorn: J.C. Gieben, 1979), 5. Kobayashi Tadashi gives a slightly different translation of this passage and attributes it to the handwritten memoirs of Suwa Yoritake, dated 1821. See Kobayashi Tadashi, "Suzuki Harunobu—The Master of Youth," in *Seishun no ukiyo-eshi Suzuki Harunobu*, 289.

35. Waterhouse, *Harunobu and His Age*, 16.

36. Waterhouse, *Harunobu and His Age*, 17. Waterhouse corrects the first line of Chūryō's account; Meiwa 2 was the Bird, not the Monkey year.

37. Hillier, in *Suzuki Harunobu*, 10, renders the line from *Ameuri Dohei den* as "The black and white prints of earlier days are antiquated now, and the only thing people care for is the newly devised gorgeousness of *Azuma nishiki-e*." Kobayashi cited Nanpo's poem as: "*Azuma no nishiki-e o eizu, tachimachi Azuma nishiki-e to utsutte yori, ichimai no benizuri urezaru toki, Torii wa nannzō aete Harunobu ni kanawan, nannyo utsushi nasu tōsei no sugata.*" See Kobayashi, "Suzuki Harunobu—The Master of Youth," in *Seishun no ukiyo-eshi Suzuki Harunobu*, 289. Hillier provides an alternative explanation: "in the manner of taking impressions of prints everything is changed in the eastern capital, the sheets colored with *beni-e* no longer find a market. Harunobu depicts all sorts of men and women in the most elegant manner." See Jack Hillier, *The Japanese Print: A New Approach* (London: G. Bell and Sons, 1960), 62–63.

38. For example, see *Young Braves in Brocades of the Old Village* (*Wakamusha kokyō no nishiki*, 1761); *Picture Book of Bravery: The Sleeves of Brocade* (*Ehon buyū nishiki no tamoto*, 1767); and *Picture Book of Spring Brocades* (*Ehon haru no nishiki*, 1771). Only the last of these illustrated books (*ehon*) is actually printed in full color.

39. Hillier, *Suzuki Harunobu*, 12–13.

40. See Nishiyama Matsunosuke, *Edo Culture: Daily Life and Diversions in Urban Japan, 1600–1868*, translated and edited by Gerald Groemer (Honolulu: University of Hawai'i Press, 1997), 41–52. See also Hockley, *The Prints of Isoda Koryūsai*, 68–74, for a discussion of Edocentrism in mid-eighteenth-century print culture.

41. Waterhouse was the first scholar to explore this shift in subject matter. Since then, other scholars have pursued this further. See David Waterhouse, "New Light on the Life and Work of Suzuki Harunobu," *Impressions* 5 (1981): 1–6.

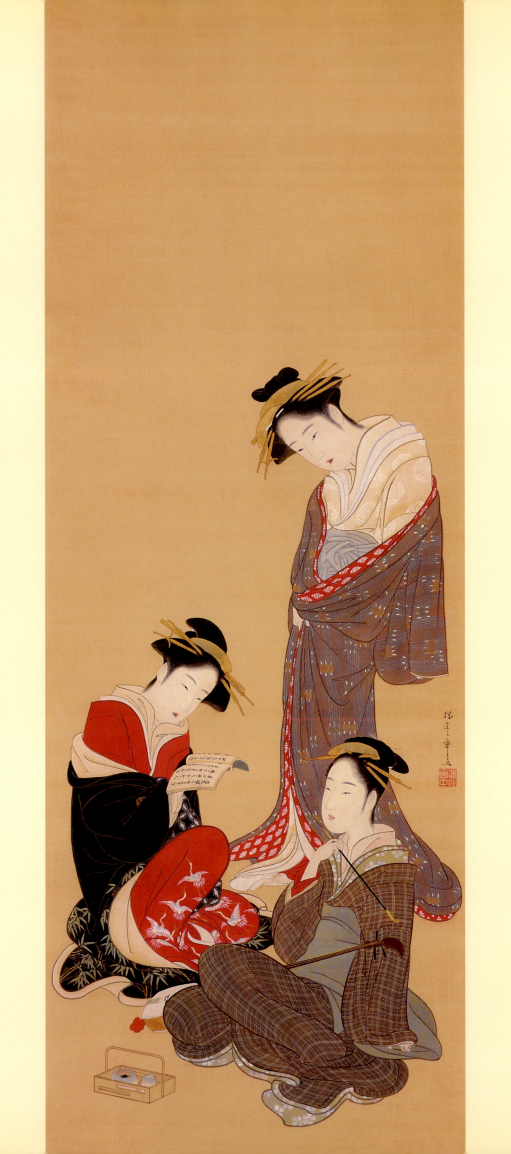

Katsukawa Shunshō

Ukiyo-e Paintings for the Samurai Elite

TIMOTHY CLARK

Katsukawa Shunshō (d. 1792) was one of the most accomplished painters of the eighteenth century, working almost exclusively in the genre of "pictures of beautiful women" (*bijinga*). Technically and in terms of their appeal, his paintings rank among the most significant ever produced in Japan, irrespective of period or school. There is a unique loveliness to his ideal of female beauty, and he often situates his figures within detailed settings or shows them in activities fascinating for their closely observed detail. As a colorist, Shunshō is unsurpassed.

Many of these elements come together in Shunshō's *Three Beauties* in the present exhibition, a painting that dates from the last few years of the artist's career (fig. 66). The composition skillfully balances the three figures: two courtesans and a geisha, who is seated with her samisen resting on her lap and holding a pipe. Before her on the floor is a plain smoking set. The seated courtesan appears to be studying a song book. The standing courtesan, her head bent forward in a pose often encountered in Shunshō's paintings, wears a luxurious outer robe (*uchikake*) with an unusual pattern of spools of thread amid stripes, over a white night robe tied with a sash at the front. Her feet are bare. The other costumes are similarly sumptuous. This informal scene in the private apartments of the courtesans perhaps shows the women relaxing after they have sent home the last client, and the standing courtesan's pose may even suggest her exhaustion. All of the faces share the same appealing, open expression, with eyebrows raised and lips slightly parted, that is frequently found in paintings from the artist's mature period.

Shunshō's masterwork in the medium of painting is the magnificent set of hanging scrolls *Pastimes of Women in the Twelve Months* in the MOA Museum of Art, Atami, designated as an Important Cultural Property. Two paintings from this set of twelve apparently were lost and replaced at a later date by Utagawa Kuniyoshi (1798–1861). But no one who has seen the remaining ten tall hanging scrolls by Shunshō displayed together can forget their cumulative impact. Each shows in intimate detail an idealized annual cycle of social customs of the twelve months enacted by beautiful, calm, exquisitely dressed women. His continuing empirical search for compositions that were richly plausible in terms of their

Figure 66
Katsukawa Shunshō
Three Beauties
c. 1789–92. Hanging scroll; ink, color and gold on silk. 94.6 x 34.1 cm. John C. Weber Collection

accumulation of motifs arranged in space and the carefully recorded actions of the protagonists—if not exactly naturalistic in a contemporary Western sense—is apparent in any detail we care to select from the *Pastimes of Women*. In a general comparison to European painting, it is as if Shunshō combines the genre and still-life strengths of the Dutch school with the admiration for female elegance of French painters.

Taking the example of the painting for the fifth month (fig. 67), if we follow an imaginary vertical line through the center of the composition we pass through an extraordinary complex of imagery: an incense burner with a tray of incense sticks; a lacquered table casually scattered with a book and writing implements; two women seated informally reading a volume of the same book by the light of caged fireflies; a standing woman holding a fan decorated with a picture of the kabuki actor Segawa Kikunojō III performing the dance *Maiden at Dōjōji Temple*; a veranda with a vase of iris and water plantain; and a hanging reed blind that fades into the evening shadows.[1]

The *Pastimes of Women* were once owned by Matsuura Seizan (1760–1841), lord of Hirado, who may indeed have commissioned them and, if so, may well have advised on their content. For Seizan, a member of the ruling elite which claimed to have created an ideal society governed by neo-Confucian relations between the classes and the sexes, Shunshō's cycle of sanctioned activities must indeed have been much savored for their sense of calm and order. Add this to the atmosphere of casual and informal intimacy with so many beautiful women, and the experience must have been—and still is—sensually quite overpowering.

Courtesan and Two Attendants by a Brazier in the Chiba City Museum of Art is the unique example of a painting of a beauty from early in Shunshō's career, in the early 1770s, while he was still influenced by the lingering style of the recently deceased Harunobu. Then most of a decade passes until the next surviving painting, a *Standing Courtesan*, formerly in the William Sturgis Bigelow Collection, which has recently reappeared in the art market. This scroll can be dated to about 1779–80 on the basis of the unusual form of the handwritten seal that follows the signature. *Standing Courtesan* builds stylistically on the courtesans drawn by Shunshō and Kitao Shigemasa (1739–1820) for the 1776 illustrated book, *Mirror of Yoshiwara Beauties Compared* (*Seirō bijin awase sugata kagami*) (figs. 68, 81).

Just around this time, there appears an intriguing reference to Shunshō's paintings in *Guide to Contemporary Women's Fashions* (*Tōsei onna fūzoku tsū*), a 1775 "book for [brothel] sophisticates" (*sharebon*), which is illustrated by him. The postscript opens with the phrase "A scroll by Shunshō costs one thousand gold pieces" (*Shunshō ippuku atai senkin*), a playful parody of a famous line by the Song poet Su Shi (1036–1101). What it implies is that Shunshō paintings were appreciated and expensive at the time, but we have no idea what the actual prices were. There is, in general, a frustrating lack of concrete information about the cost of ukiyo-e paintings, by Shunshō or anyone else.[2] The content of the postscript suggests that Shunshō's reputation as a painter must have been based on many more than two works, supporting the view that a high percentage has been lost.

The most complete listing of Shunsho's paintings made so far totals about one hundred works.[3] As I have suggested elsewhere, this must represent only a small fraction of those originally painted—possibly as little as 10 percent.[4] Given the high level of technical accomplishment of which he was capable and the length of a career that spanned more than a quarter century from the mid-1760s until his death, it is inconceivable that Shunshō made only one hundred paintings. The frequent destruction wrought on the city of Edo since his time is surely the main reason why many more works have not survived. Having said this, most of the paintings presently known seem to date from the last ten years or so of Shunshō's career, the Tenmei (1781–89) and the beginning of the Kansei (1789–1801) eras. At this time Shunshō designed many fewer of the hundreds of prints of kabuki actors with which he had launched and sustained his career. The inference is that he was gradually diverting his energies from designing woodblock prints and book illustrations to concentrate much more on painting commissions, increasingly from members of the top social strata. Production of actor and other prints was entrusted to his leading pupils: first to Katsukawa Shunkō (1743–1812), then to Katsukawa Shun'ei (1762–1819; see fig. 97, exh. nos. 100, 101) and others.[5]

Figure 67
Katsukawa Shunshō
The Fifth Month, from *Pastimes of Women in the Twelve Months*
c. 1783–84. One of a set of hanging scrolls; ink and color on silk. 115 x 25.7 cm. Important Cultural Property, MOA Museum of Art, Atami

Shunshō belongs to a lineage of teachers and pupils who were among the most active of ukiyo-e painters, including his immediate teacher, Miyagawa (later Katsumiyagawa) Shunsui (act. early 1740s–early 1760s). This lineage ran: Moronobu–Chōshun–Shunsui–Shunshō–Hokusai. Hishikawa Moronobu (1630/31?–1694) first consolidated the ukiyo-e "style" through his painted works; Miyagawa Chōshun (1682?–1752) apparently designed paintings only, no prints or illustrated books; Shunshō's pupil Katsushika Hokusai (1760–1849) was indisputably the greatest ukiyo-e painter of his time. Shunshō himself gives evidence of a familiarity with the important painted works of the Kyoto ukiyo-e artist Nishikawa Sukenobu (1671–1750) (fig. 69). Shunshō's *Beauty Reading a Letter* includes an inscription next to his signature saying that he was commissioned to do a work in the style of Sukenobu, but he is unsure of what should be the appropriate old fashions, claiming modestly that he is not up to the task (fig. 70). Who would be a likely person to commission such a painting? It might just have been Matsuura Seizan, mentioned above, who is known to have owned at least one painting by Sukenobu, *Courtesan with a Letter and Two Attendants*, in a private collection in Japan.[6]

Some of Shunshō's most interesting and inventive paintings fall into the category of so-called "parody pictures" (*mitate-e* or *yatsushi-e*), a genre earlier made popular by Okumura Masanobu (1686–1764), Suzuki Harunobu (1725?–1770) and others. These works typically present a contemporary beauty such as a Yoshiwara courtesan in the guise of a celebrated figure from "high culture" of the past. *Boat Prostitute at Asazuma*, a rare early painting by Shunshō, which carries his handwritten seal (*kaō*) used in the late 1770s, is a fine example (fig. 71). In the medieval period, Asazuma on the eastern shore of Lake Biwa was well-known for its boat prostitutes, who were even mentioned in classical poetry. In the Genroku era (1688–1704), the unorthodox Kano-school painter Hanabusa Itchō (1652–1724) adapted the subject to that of an Asazuma prostitute wearing the costume of a *shirabyōshi* dancer in a boat beneath a willow, as here, and gazing at the full moon. It was said that Itchō's lady lightly satirized the shogun Tsunayoshi's habit of playing the hand drum and chanting verse with his concubine Oden no kata in a boat on the lake in Fukiage Park in the shogun's castle compound in Edo (modern Tokyo). The theme was taken up by many subsequent ukiyo-e painters.

Figure 68
Katsukawa Shunshō and Kitao Shigemasa
Eguchi, Kaoru, Ninoaya and Tachibana of the Shinkanaya, from *Mirror of Yoshiwara Beauties Compared* (*Seirō bijin awase sugata kagami*)
1776. Color woodblock-printed book with mica embellishments, Vol. 3 of 3, fols. 3v–4r. Collection of Arthur Vershbow

Figure 69

Nishikawa Sukenobu

Woman Arranging Her Hair

c. 1716–36. Hanging scroll; ink and color on paper.
86.6 x 37.3 cm. Collection of Roger L. Weston

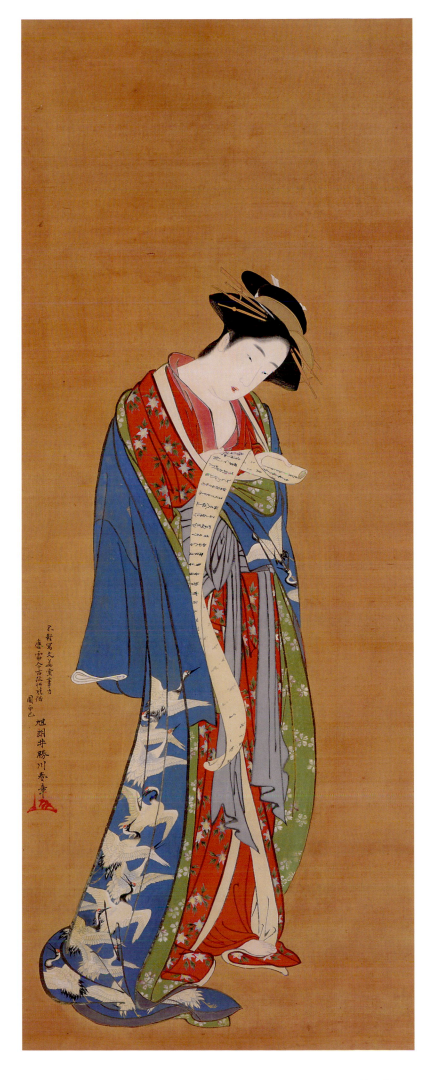

Figure 70
Katsukawa Shunshō
Beauty Reading a Letter
c. 1783–84. Hanging scroll; ink, color, gold
and silver on silk. 92.3 x 35 cm. John C. Weber
Collection

Shunshō includes an inscription above his
signature saying that he was commissioned to do
a work in the style of Sukenobu (see figure 69), but
he is unsure of what should be the appropriate old
fashions, claiming modestly that he is not up to
the task.

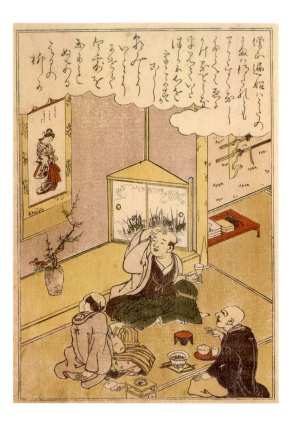

Figure 72
Katsukawa Shunshō
Admiring a Painting of a Beauty, from
*One Hundred Poems by One Hundred
Poets, Woven in Eastern Brocade*
(*Nishiki hyakunin isshu azuma-ori*)
1775. 1 vol., fol. 1r. Color woodblock-
printed book. 28 x 18.2 cm each page.
The British Museum, Bequeathed by
Sir A. W. Franks, JIB 110

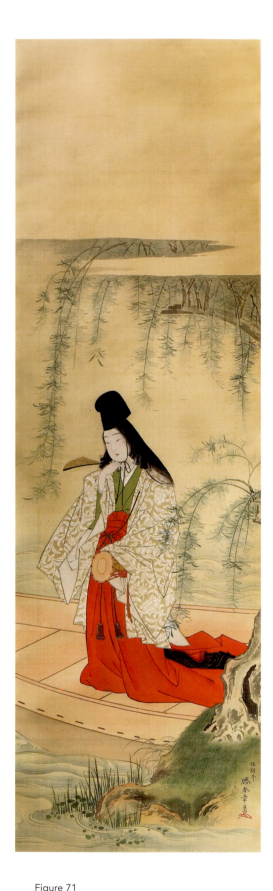

Figure 71
Katsukawa Shunshō
Boat Prostitute at Asazuma
Late 1770s. Hanging scroll; ink and color on silk.
90.8 x 27.9 cm. Collection of Roger L. Weston

How were Shunshō's paintings used? In what contexts were they appreciated? Once again, there is very little concrete information, although some newly discovered facts about his patrons have come to light. One Shunshō book illustration takes us into a suite of rooms where three men are enjoying food, wine and tobacco and admiring a painted scroll of a standing beauty that hangs in the display alcove (fig. 72). The picture is one of the frontispiece illustrations to Shunshō's book *One Hundred Poems by One Hundred Poets, Woven in Eastern Brocade* (*Nishiki hyakunin isshu azuma-ori*), which was published in Edo at the New Year of 1775. The room must be filled with the subtle fragrance of the branch of plum artfully arranged with a camellia in a vase beneath the painting. All three men seem to be actually looking at the scroll. One scratches his head (with slight embarrassment?); his companion points. It would be fascinating to know if they are talking about the woman, the painting or both—alas, the text gives no clues. Two of the three men wear single swords and two more swords hang in the wall rack in the adjoining room. Either they are merchants who have special permission to wear a single sword, or else they are samurai who have each taken off one of their customary pair of swords for comfort. If this were the Yoshiwara pleasure quarter, their swords would have been left with a special attendant at the Main Gate. So the scene may be a reception room in a brothel or restaurant in an unlicensed pleasure quarter, or simply a room in the private residence of one of the men. The man without a sword has a shaven head; he may be in retirement, or else a doctor or scholar. We might even imagine that these men are typical admirers of Shunshō, whom he portrays remarking on a work not unlike his own.

A recently rediscovered, key work which has opened many new perspectives on Shunshō's career is represented by the fragment *Peony,* from the handscroll *Secret Games in the Spring Palace* (*Shungū higi*) (fig. 73). This is one scene from a sequence of twelve paintings, originally mounted together in a large-format handscroll and one of the most spectacular painted erotic works to have survived. Nine of the paintings are presently mounted together in handscroll format; the other three, as here, are now mounted as separate hanging scrolls. All have been the subject of a detailed study by Naitō Masato.[7] After 1931, when the handscroll is believed to have been auctioned in its entirety, *Secret Games* went into hiding. Only when it turned up on the Japanese art market around 2000 did the mystery start to unravel.

The genesis of this work is quite complex. The handscroll has a preface by the *haikai* poet Baba Zongi (1703–1782), which gives his age as seventy-eight and is therefore

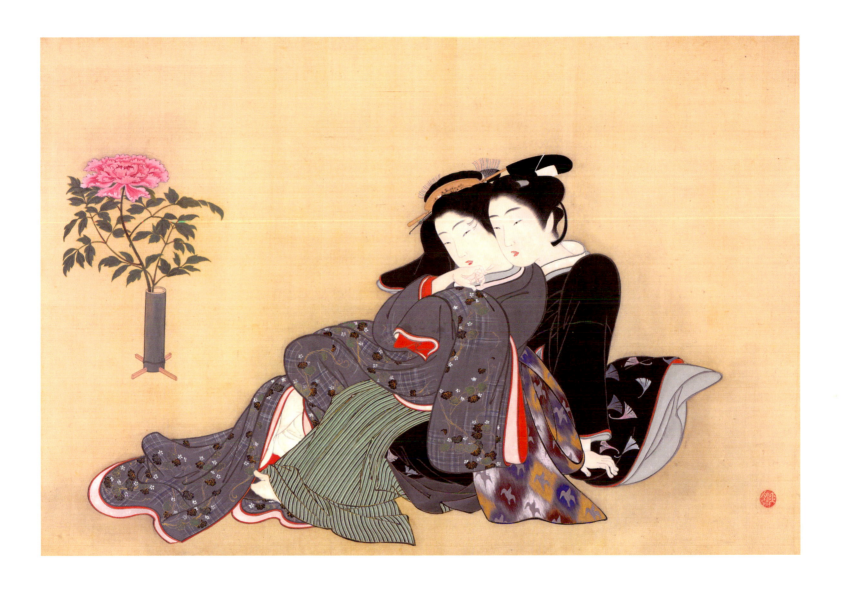

Figure 73
Katsukawa Shunshō
Peony, from the handscroll *Secret Games in the Spring Palace* (*Shungū higi*)
Late 1770s. Hanging scroll; ink and color on silk.
47 x 69 cm. John C. Weber Collection

thought to have been written in 1780. By that time, Shunshō seems to have finished the four scenes that are not explicitly erotic, including *Peony*. Stylistically, these look to be rare works of the late 1770s. Five or six years later, in the early 1780s, Shunshō added the remaining seven explicit scenes and an eighth of a young man admired by beauties at a flower-viewing party, now in the Ōta Memorial Museum, Tokyo.

The provenance of this erotic work is significant. It was passed down in the Higuchi family who were retainers of the Tokugawa family of Kii province, one of the three main branches of the shogunal family. Naitō has followed earlier scholars in conjecturing that it originally may have been painted by Shunshō specifically for the Tokugawa of Kii, perhaps at the introduction of Baba Zongi. A commission of this importance would account for the unusually grand dimensions and rich, jewel-like pigments of the paintings. Shunshō has previously been known as the artist of many erotic works in the printed-book or album format. Hayashi Yoshikazu published a list of some twenty erotic titles released between 1771 and 1790 that he attributed to Shunshō (some of the works are unsigned).[8] However, before the rediscovery of *Secret Games*, painted erotica by the artist had been curiously absent. Given Shunshō's large output of erotic books and skills as a painter, it was logical to assume

that painted erotica by him must have once existed. Now it has reappeared, represented by a magnificent work that fulfils all expectations.

Recently, evidence has also emerged for a close association between the artist and the retired lord of Kōriyama in Yamato province (modern Nara Prefecture), Yanagisawa Nobutoki (1724–1792), who must have been an almost exact contemporary (Shunshō's birth date is not presently known but is estimated to have been sometime in the 1720s). Lord Yanagisawa has long been known as a passionate fan of kabuki, as revealed by his *Diaries of Banquets and Pleasures* (*Enyū nikki*, 1773–85) and their sequel, *Shōkaku's Diaries* (*Shōkaku nikki*, 1786–92).[9] Shunshō's importance as an artist of the kabuki world is sufficient reason for the two to have been acquainted. However, their association extended further. Hanasaki Kazuo published notes to Lord Yanagisawa's very extensive diaries, which are otherwise un-indexed, that have pointed scholars to several significant references to Shunshō's erotica and paintings.[10] To summarize, Lord Yanagisawa was given copies of two of Shunshō's illustrated books, *Mirror of Yoshiwara Beauties Compared*, mentioned earlier, and *Actors Like Mount Fuji in Summer* (*Yakusha natsu no Fuji*), within days of their publication in 1776 and 1781, respectively. In 1788, he purchased a color woodblock copy of Shunshō's erotic masterpiece *Haikai Album of the Cuckoo* (*Haikai yobuko-dori*) through his friend, the block carver Okamoto Shōgyo (dates unknown) (fig. 74). Finally, Lord Yanagisawa commissioned Shunshō to paint some sliding-door panels of Mount Fuji, in 1787, and of waterbirds and reeds, in 1789. Although neither set of sliding doors apparently survives, it is interesting to note that the subjects were not of the floating world. Indeed, no similar subject has survived from Shunshō's brush in any format. Was this an unusual commission, or did the artist paint more imagery besides ukiyo-e? Nobutoki's purchase of Shunshō's printed erotica is intriguing, too, because just a couple of years later, in 1790, Senior Councillor Matsudaira Sadanobu (1759–1829) would ban completely the production and sale of erotic works as part of the shogunate's Kansei Reforms.

The discovery that Yanagisawa Nobutoki was an important patron during the last years of Shunshō's life suggested to Naitō an important new theory that relates to the largest hanging scroll painting by the artist currently known: *Beauties Looking at Paintings* in the Idemitsu Museum of Arts (fig. 75). In this horizontal tableau, eleven women are in a room near the garden of a grand mansion, with further rooms receding in perspective toward an extensive park in the background. On the far right, a beauty uses a special bamboo stick (*yahazu*) to place a hanging scroll of the lucky god Jurōjin in the display alcove. In the center, three of her companions admire an ink painting of cranes and bamboo that bears the minute signature of Kano Tan'yū (1602–1674), the leading artist of his generation

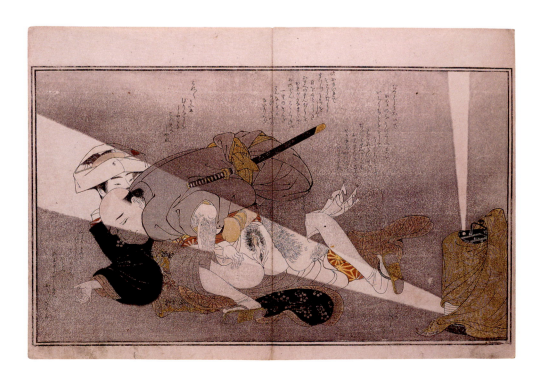

Figure 74
Katsukawa Shunshō
Encounter at Night, from *Haikai Album of the Cuckoo* (*Haikai yobuko-dori*)
1788. Color woodcut album, 1 vol., fols. 8v–9r.
Plate 25 x 36.4 cm. Private Collection, New York

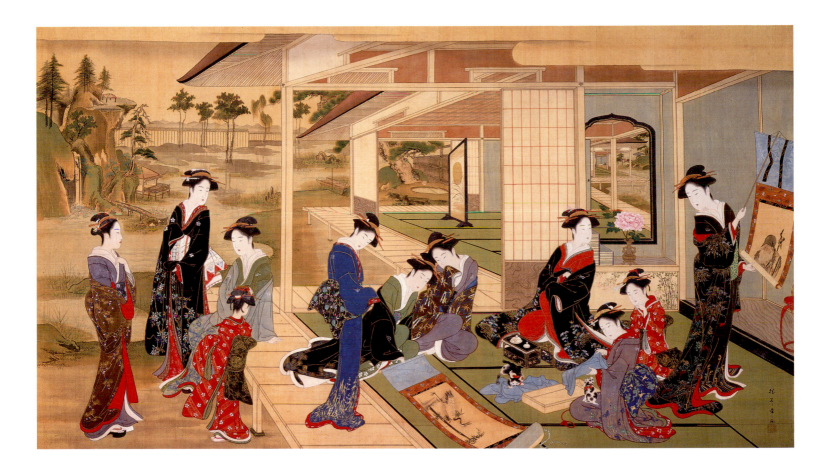

and painter-in-attendance (*oku eshi*) to the shogun. To the right, a woman is removing the silk wrapper from a third painting, to the delight of two cats. Three others converse at the veranda beside a young girl, whose attention seems to be caught by something to her right. Who are these women? The setting suggests that they are a high-ranking samurai lady (seated facing us, with a black- and gold-lacquer smoking set placed before her), who is surrounded by family members, servants and girls. And yet, if the scene were transposed to the Yoshiwara or one of the unlicensed pleasure quarters, then these might equally be courtesans, geisha and their young attendants. In general, Shunshō's beautiful women appear classless in the sense that their lovely costumes combine the fashions of courtesans, high-ranking samurai women and the wives and daughters of wealthy merchants. Perhaps a deliberate eliding is intended between the boundaries of these two very different worlds for the amusement of a high-ranking patron. Perhaps some subtle parody is even at work.

While there is no need to assume that this painting records an actual scene, scholars have questioned whether the distinctive features of the landscape might record the estate of a wealthy person, surrounded by a tall fence to deter thieves. Armed with the new knowledge of Shunshō's association with Lord Yanagisawa, Naitō began to wonder if the painting might relate to the lord's famous Rikugien Park, which still survives in the Komagome district of Tokyo. Using other paintings of Rikugien and modern photos of the garden, Naitō presents a convincing case for this location and for Shunshō's patronage by several leading samurai aristocrats in his final years.[11] The Rikugien estate is where the daimyo Yanagisawa Yoshiyasu (1658–1714) had his Edo mansion. Yoshiyasu is proposed as a patron of Hishikawa Moronobu in the essay by David Waterhouse in this volume.

Figure 75
Katsukawa Shunshō
Beauties Looking at Paintings
c. 1789–92. Hanging scroll; ink, color and gold on silk. 70 x 123 cm. Idemitsu Museum of Arts, Tokyo

Figure 76
Katsukawa Shunshō
Ichikawa Danjūrō V in the **Shibaraku**
(Stop Right There!) Role
Late 1780s. Folding fan; ink, color and gold
on mica-ground paper. 15.9 x 45.5 cm.
John C. Weber Collection

One more aspect of Shunshō's activities as a painter that remains to be fully explored is his paintings of kabuki actors. Shunshō was, of course, from the 1760s onward, a leader in developing a new, more searching realism in actor portraiture. This was primarily expressed in the medium of the color woodblock print. As with his erotica, Shunshō's prolific output of kabuki-related works in the media of prints and illustrated books argues for a larger number of kabuki-related paintings than survive. Maybe kabuki paintings were regarded more as ephemera, as exemplified by the portraits of actors that the artist is known to have done on folding fans in some quantity.[12] Included in the present exhibition are two rare portraits by Shunshō of the superstar Ichikawa Danjūrō V (1741–1806). The form of the artist's signature and hand-written seal on these two paintings suggests that they were both done about 1787 to 1788.[13] The first is a painting on a folding fan showing him in full costume for the Shibaraku (Stop Right There!) role (fig. 76). The fan also bears a poem, as yet undeciphered, inscribed by the leading Yoshiwara courtesan, Hanaōgi IV, who is herself pictured on a fan in this exhibition (see fig. 93). The second, a hanging scroll, shows his face reflected in a large round mirror (*sugatami*) of the type used in actors' dressing rooms (fig. 77). Danjūrō still wears the full makeup for the Shibaraku role, but now he is dressed in an informal cotton robe. Dyed into the fabric of the shoulder is a carp leaping up a waterfall that was one of the actor's personal crests. The seventeen-syllable humorous verse (*senryū*) inscribed with his poetry name, Sanjō (but which is not apparently in his hand), may be translated:

Kaomise ya	Showing his face!
suō no tataku	Voluminous robes that beat
sanzen ri	Three thousand leagues.

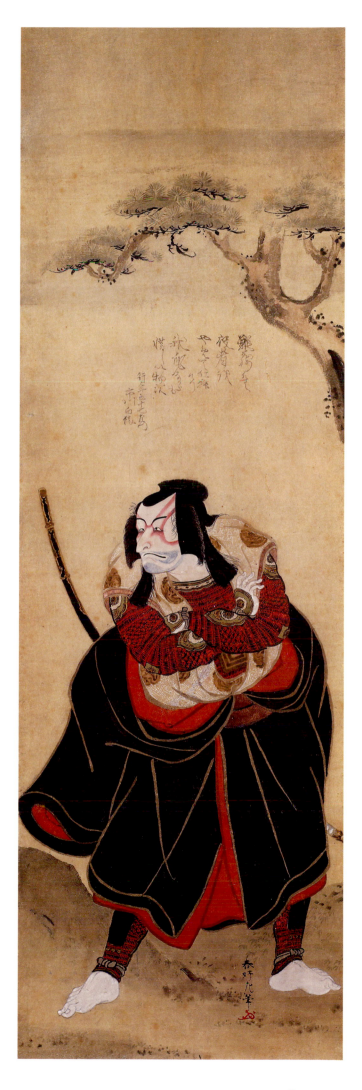

Right: Figure 77
Katsukawa Shunshō
*Ichikawa Danjūrō V in Kumadori Makeup
Seen in a Mirror*
Late 1780s. Hanging scroll; ink and color on silk.
79.2 x 12.1 cm. John C. Weber Collection

Far right: Figure 78
Katsukawa Shunkō
Ichikawa Ebizō IV (Danjūrō V) in the
Shibaraku (*Stop Right There!*) Role
c. 1797. Hanging scroll; ink and color on paper.
85.7 x 27 cm. Minneapolis Institute of Arts,
Bequest of Richard P. Gale, 74.1.114

The first line plays on the "face-showing" (*kaomise*) performances at the start of the season in the eleventh month and the actor's (and the artist's) showing us his face. "Voluminous robes" signifies the huge Shibaraku costume that requires three assistants to drape on the actor. Danjūrō's sharp cry of "Shibaraku," the heart-stopping moment of the scene that every kabuki fan waits for, must surely travel over a vast distance.

Danjūrō V had small eyes, closely set beside a large nose. The penetrating and intimidating, cross-eyed glare (*nirami*) seen in both these paintings was another speciality of the whole lineage of Ichikawa Danjūrō actors in their trademark "rough stuff" (*aragoto*) roles. A third painting in the exhibition, by Shunshō's pupil Shunkō, shows Danjūrō with arms crossed, staring down some unseen adversary (fig. 78). Here, the poem signed with Danjūrō's poetry name, Ichikawa Hakuen (White Monkey) "in his fifty-seventh year," signals Danjūrō's retirement from the stage in 1796 (he had used the name Ebizō since 1791). In fact, he continued to act occasionally after this, using the name Hakuen:

Ebizō wa Hearing that Ebizō is quitting,
yakusha o yamete even though he is myself,
shiman to ka I, too, will miss this actor.[14]
waga mi nagara mo
oshii mono ka na

———

Shunshō's complete activities have yet to be fully charted, but recent study of his paintings, his erotica and his patrons by Naitō Masato and others has opened up exciting new perspectives on the artist's career. The phenomenon of Shunshō painting for the samurai elite further challenges the once-popular characterization of ukiyo-e in terms of cheap and disposable, albeit spectacular, prints for the masses. Cultural interactions between samurai and townspeople, particularly in the 1770s and 1780s, were rich and complex.

Notes

1. Segawa Kikunojō III performed *Maiden at Dōjōji Temple* (*Musume Dōjōji*) at the Nakamura Theater, Edo, in the first month, and again in the fourth month, of Tenmei 3 (1783). This important piece of evidence dates the set to around 1783–84. Narazaki Muneshige and Tanaka Tatsuya, "Katsukawa Shunshō hitsu *Fūzoku jūni-ka-getsu zu*" (The paintings *Pastimes of Women in the Twelve Months* by Katsukawa Shunshō), *Shunshō*, vol. 4 of Nikuhitsu ukiyo-e (Ukiyo-e painting) (Tokyo: Shūeisha, 1982), 123.

2. Naitō Masato, *Ukiyo-e saihakken* (Rediscovering ukiyo-e) (Tokyo: Shōgakukan, 2005), 174–80, wherein he discusses the prices of ukiyo-e prints at various times but points out that there is almost no documentation about the prices of ukiyo-e paintings.

3. See Naitō Masato, "Katsukawa Shunshō no nikuhitsu bijinga ni tsuite" (Katsukawa Shunshō's paintings of beautiful women), *Bijutsushi* (Art history) 125 (Mar. 1989): 57–81. The list appears on pp. 71–74. It includes a number of paintings now only known as photographic illustrations in old publications. Conversely, quite a few hitherto unrecorded Shunshō paintings have appeared since the article was published in 1989, so the total extant must be about one hundred.

4. Timothy Clark, "Ukiyo-e painting: How much has survived?" (lecture, International Ukiyo-e Society Symposium, Edo-Tokyo Museum, Nov. 25–26, 2006).

5. For the largest published group of actor prints by Shunshō and his pupils, see Timothy Clark and Osamu Ueda, *The Actor's Image: Print Makers of the Katsukawa School* (Chicago: The Art Institute of Chicago; and Princeton: Princeton University Press, 1994).

6. Narazaki Muneshige, ed., *Sukenobu, Settei*, vol. 9 of Nikuhitsu ukiyo-e, no. 6.

7. Naitō Masato, "Shunshō no nikuhitsu shungakan *Shungū higi zukan*" (Shunshō's painted erotic handscroll *Secret Games in the Spring Palace*), in Gakushū Kenkyūsha, ed., *Katsukawa Shunshō nikuhitsu Shungū higi zukan* (A painting by Katsukawa Shunshō: The illustrated handscroll *Secret Games in the Spring Palace*) (Tokyo: Gakushū Kenkyūsha, 2003).

8. Hayashi Yoshikazu, *Edo makura-eshi shūsei: Katsukawa Shunshō* (Collected erotic artists of Edo: Katsukawa Shunshō) (Tokyo: Kawade Shobō Shinsha, 1991): 42–44.

9. For more on Lord Yanagisawa's passion for kabuki, see Timothy Clark, "Edo Kabuki in the 1780s," in Clark and Ueda, *The Actor's Image* (1994): 27–48, especially pp. 28–30.

10. Hanasaki's notes appear in Hanasaki Kazuo, *Yanagisawa Nobutoki nikki oboegaki* (Notes on Yanagisawa Nobutoki's diaries) (Tokyo: Miki Shobō, 1991). For a collation and commentary on those notes relating to Shunshō, see Naitō, *Ukiyo-e saihakken* (2005), 130–38.

11. Naitō, *Ukiyo-e saihakken*, 139–55.

12. For more on this point, see the references to Shunshō's painted actor portraits in Timothy Clark, "Ready for a Close-up: Actor 'Likenesses' in Edo and Osaka," in C. Andrew Gerstle with Timothy Clark and Akiko Yano, *Kabuki Heroes on the Osaka Stage, 1780–1830*, exh. cat. (London: The British Museum Press, 2005), 36–53, especially pp. 43–44.

13. This tentative dating follows the table of Shunshō's signatures given in Naitō, "Katsukawa Shunshō no nikuhitsu bijinga ni tsuite," 75–79, particularly p. 78. However, the form of the handwritten seal on the hanging scroll of Danjūrō V is slightly unusual: the final brushstroke that sweeps across the bottom of the seal from right to left appears to have been done in this instance with two separate strokes of the brush. This requires further study.

14. Translation by Matthew Welch.

Tsutaya Jūzaburō
Master Publisher

JULIE NELSON DAVIS

A traveler stops to take a closer look at the prints and books for sale at the Kōshodō and overhears the proprietor at the back in conversation with his samurai client (fig. 79). On display are stacks of new sheet prints showing kabuki actors and the folk-hero Kintarō the mountain boy. At the right, assistants assemble and trim the pages of a book, perhaps preparing the poetry anthologies advertised on the signboards hanging in front of the shop, *Collected "Mad Poetry"* and *Famous Places of the Eastern Capital at a Single Glance*, and the warrior story, *Loyal Retainers' Water Margin*. This is the shop of Tsutaya Jūzaburō (1750–1797), the publisher whose crest—the three peaks of Mount Fuji above an ivy leaf shown on the sign out front—became a trademark for quality and innovation in the late eighteenth century. The image by Katsushika Hokusai (1760–1849) commemorates both the shop, one of Edo's famous sources of ukiyo-e, and its founder, a man whose death two years earlier left the floating world's most accomplished artists and writers bereft of their champion.

Tsutaya Jūzaburō was more than just a publisher; he was an impresario at the center of a network of talent and capital. The story of how he created a house style, exploited the technology of woodblock printing to transform ukiyo-e into a new art form and made the artists and writers of his studio into famous names has not yet been fully disclosed. This essay reconstructs the career of Tsutaya, charting his astonishing progress over the course of twenty-two years from guidebook purveyor to master publisher.

A Storehouse of Talent

In 1949, Tijs Volker coined the term the "ukiyo-e quartet" to describe the cooperative enterprise of publisher, artist, printer and carver, with the publisher acting as the financial and aesthetic arbiter of the process.[1] These publishers developed, financed, directed and marketed the printed materials they produced in collaboration with illustrators, writers, artisans and others. The catchall term for their shops, *hon'ya*, or "book shop," served as a basic designation, but more specific terms demarcated specializations. Among these, the

Figure 79
Katsushika Hokusai
***A Shop for Illustrated Books (Ezōshiya)*,**
View of Tsutaya Jūzaburō's Shop,
the Kōshodō, from *Picture Book of the*
***Pleasures of the East* (*Ehon azuma asobi*)**
1802. Publisher: Tsutaya Jūzaburō. Color
woodblock-printed book. 22 x 15.2 cm.
Waseda University Library

shomotsuya was a shop for scholarly books, the *shōhon'ya* sold puppet theatre (*jōruri*) play-books and the *tōhonya* brokered books imported from China. Tsutaya's profession was that of a *jihondōiya*, seller of light books. He was also known for his prints and illustrated books; Hokusai labeled the picture of the Kōshodō an *ezōshiten*, using a variation of the term *ezōshiya*, meaning that this shop's specialty was illustrated books.[2]

Yet the most appropriate term in use in this period for the role of the publisher was *hanmoto*, literally "origin/source of the block," aptly positioning the publisher at the point of invention of his projects. The publisher's shop functioned as a corporate enterprise, and like other businesses it developed its own look, quality and brand identity. Few other publishers cultivated as many renowned floating world names as did Tsutaya.

Publishers developed inventory in several ways. They acted as distributors, copublishing or purchasing materials developed elsewhere. Sometimes they acquired woodblocks from others in order to produce a new version of a successful work. Commissions for advertisements from commercial clients or for poetry books from aesthetically minded patrons were another source of projects. Successful publishers took advantage of current interests and fads, responding to the moment, continually attentive to their clientele and to their niche markets. Some sought out emerging illustrators and writers and made them into famous names. Publishers occasionally appropriated (and even expropriated) their competitors' best-selling products by issuing copies under their own brand; it is apparent from cases brought before the guild concerning the rights to specific book titles that defining the difference between imitation and infringement could be contentious. Spotting talent and responding to trends was risky. When they misjudged their markets, publishers felt the losses.[3]

Commercial publishing was a cutthroat business. All ukiyo-e print publishers were members of the commercial booksellers' guilds that established standards, settled matters of perceived infringement and enforced censorship. By Tsutaya's time, books were part of everyday life, available for purchase or through the local book rental shops (*kashihon'ya*). Prints, produced in quantity and sold at low prices, were also widely available. As Kobayashi Tadashi has noted elsewhere, by the 1760s "*azuma nishiki-e*" (brocade prints of the East, i.e., Edo) became a common term for describing full-color woodblock prints. It signals an Edocentric view that these images surpassed the famous Kyoto fabrics in their beauty.[4] By the third quarter of the eighteenth century, 917 publishers were active in the city of Edo, nearly double the 493 reported at the start of the century; in Kyoto and Osaka those numbers declined over the same period, from 536 to 494 in Kyoto and 564 to 504 in Osaka.[5] While this marked shift in the trade to Edo was part of a larger movement of commercial enterprise to the shogun's city, the sheer number of publishers active in the city is striking evidence of how competitive the profession had become in Tsutaya's lifetime.

From period documents it is possible to ascertain that printing from multiple color blocks was regarded as superior to uncolored prints (*sumizuri-e*, or pictures printed in black ink) and prints with two to three colors, dilute forms of red, yellow and blue (*benizuri-e*, or "pictures printed with red"). The full-color print, in turn, was surpassed in quality (and no doubt in expense) by the special commissions of poetry groups for even more sumptuous albums and sheet prints (*surimono*, or "printed things"). And yet, the relative price of the color prints was not exorbitant. Some sold for a price equivalent to the cost of a double serving of soba noodles, according to one period report.[6]

To keep prices so modest, publishers needed to recoup their investments through sales or other funding strategies. Some printed materials were commissioned and paid for outright by patrons. Others may have been funded by clients using the completed materials as an advertisement for their businesses. The numbers of impressions produced must have been calibrated according to the cost and profit ratios, but it also seems likely that some publishers used the profits made from reliable bestsellers—how-to manuals, guidebooks, cheap novelettes and the like—to subsidize other projects. While little information is available about so-called "edition" sizes, clearly these varied in the late eighteenth century. Special productions were likely limited to tens or perhaps hundreds of impressions, while commercial prints seem to have ranged from releases of five hundred to two to three thousand impressions. Larger runs have been estimated at eight to ten thousand printings.[7]

Tsutaya's income was tied directly to profits made in marketing the licensed pleasure district, the Shin, or New, Yoshiwara (hereafter referred to as the Yoshiwara), located in the northeast quadrant of Edo. He was born in the quarter in the third year of the Kan'en era (1750); his mother, known by the surname Hirose and perhaps called Tsuyo, seems to have been employed in the district, while his father, Maruyama Jūsuke, came from the province of Owari. Between the ages of five and six, he was adopted by the Kitagawa family, owners of the Tsutaya teashop, and reared just outside the Great Gate of the Yoshiwara; from them he acquired the surname Kitagawa and the shop name Tsutaya (House of the Ivy).[8] This teashop was one of many such establishments where clients might take respite before passing through the gate, and it was clearly part of an extended network of enterprises that served the quarter.

Tsutaya's first professional project was a guidebook (saiken) for the licensed district, dated An'ei 3 (1774); he is listed in the colophon as co-publisher with Urokogataya Mago-bei. By 1777, he held the exclusive rights to produce such directories. Published twice annually, these catalogues listed each house and its ranked courtesans (yūjo) and were probably underwritten by the brothel owners' association. Tsutaya made innovations to the format by adding information about the local teashops and restaurants, and it seems likely that he would have received fees from these business owners in exchange. He also brought out cultural critiques (hyōbanki) and style books (sharebon) describing the social codes and practices of the district, and these served as how-to manuals for prospective clients. To enhance the appeal of these books, Tsutaya hired writers and illustrators well known in floating world circles, often playing off the writers' reputations as "sophisticates" (tsū) who had mastered the esoterica of the district. These printed works were sold from his shop, the Kōshodō, located just outside the Great Gate of the Yoshiwara, and visible on many of the maps included in the opening pages of his guidebooks (fig. 80).[9]

In 1776, Tsutaya drew on his Yoshiwara connections for two landmark projects. In both cases, he collaborated with established publishers in the Nihonbashi district, thus extending his market beyond the Yoshiwara; these partners had the right—not yet acquired by Tsutaya—to sell products in downtown Edo. Although no documentation remains about the financing for these projects, the images of courtesans, as others have suggested, may have been subsidized by the brothel owners and used as advertisements.[10] For both projects, Tsutaya and his colleagues hired top-ranked designers and craftsmen to produce prints featuring the finest techniques and full color. The first project, *Mirror of Yoshiwara Beauties*

Figure 80

Map of the area around the Great Gate of the Yoshiwara district, from *Guidebook to the New Yoshiwara* (*Shin Yoshiwara saiken*)

1783. Preface by Hōseidō Kisanji. Postscript by Ōta Nanpo. Publisher: Tsutaya Jūzaburō. Woodblock-printed book. 18.4 x 12.6 cm each page. Private Collection

Tsutaya's shop is the fifth, counting from right to left at the bottom of the right page; it is identified as "Guidebook publisher and book shop, Tsutaya Jūzaburō."

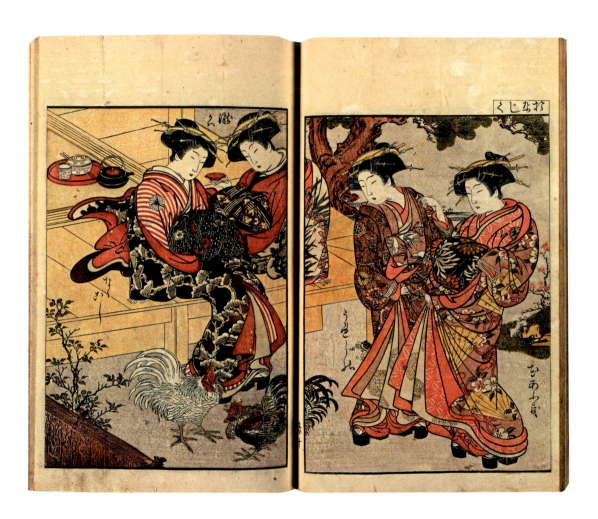

Figure 81

Katsukawa Shunshō and Kitao Shigemasa
Hanaōgi, Ureshino, Takigawa and Nanakoshi of the Ōgiya, from *Mirror of Yoshiwara Beauties Compared (Seirō bijin awase sugata kagami)*
1776. Publisher: Tsutaya Jūzaburō. Color woodblock-printed book. Vol. 1 of 3, fols. 10v–11r. 28 x 18 cm each page. Spencer Collection, The New York Public Library, Astor, Lenox and Tilden Foundations, Sorimachi 439

Compared (Seirō bijin awase sugata kagami), illustrated in three volumes the high- and middle-ranking courtesans of the quarter (fig. 81). It featured designs by the established ukiyo-e artists Kitao Shigemasa (1739–1820) and Katsukawa Shunshō (1726–1792). The colophon lists the names of both Tsutaya and Yamazaki Kinbei as publishers, but according to a later inventory, Tsutaya was the actual publisher and Yamazaki Kinbei the in-town distributor.[11]

For the second project, Tsutaya collaborated with the publisher Nishimuraya Yohachi, whose shop, the Eijudō, was a fixture in central Edo. The red seals of both publishers appear on the first ten prints of *Models of Fashion: New Designs Fresh as Spring Leaves (Hinagata wakana no hatsumoyō)*, designed by Isoda Koryūsai (1735–1790) (fig. 82). These images, too, were likely subsidized by brothel owners. The similarity between designs on some of the robes and those in popular pattern books (*hinagatabon*) might suggest sponsorship from textile producers, as well.[12] Yet by the autumn of that year, Nishimuraya assumed full control of the project. It became one of the longest-running series in the history of ukiyo-e, with 140 known designs issued over eight years, according to Allen Hockley's study of Koryūsai.[13] Nishimuraya retained Koryūsai as the designer through 1782, but subsequently employed Torii Kiyonaga (1752–1815) to continue the project through 1784 (fig. 83). Through the mid-1780s, the team of Nishimuraya and Kiyonaga dominated the market for full-color prints of beautiful women, and as Matthi Forrer's study of publishing trends and paper formats demonstrates, Nishimuraya became the leading producer of sheet prints in both the *ōban* and *chūban* formats in the Tenmei era (1781–88).[14]

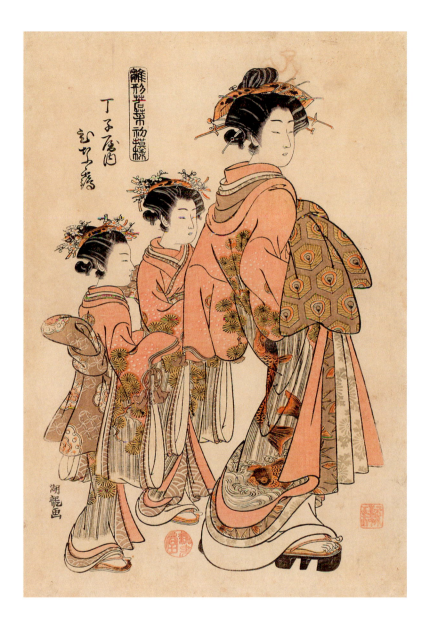

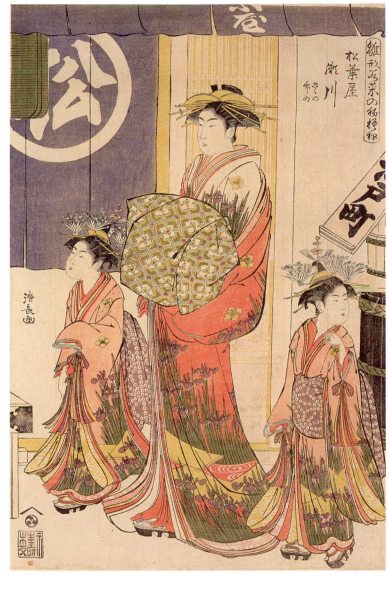

Figure 82
Isoda Koryūsai
Hinazuru of the Chōjiya (Chōjiya uchi Hinazuru),
from the series *Models of Fashion: New
Designs Fresh as Spring Leaves (Hinagata
wakana no hatsumoyō)*
1776. Publishers: Tsutaya Jūzaburō (Kōshodō)
and Nishimuraya Yohachi (Eijudō). Color woodcut.
37 x 26.2 cm. Museum of Fine Arts, Boston,
William S. and John T. Spaulding Collection,
1921, 21.8230

Figure 83
Torii Kiyonaga
*Segawa of the Matsubaya with her Kamuro
Sasano and Takeno (Matsubaya Segawa, Sasano,
Takeno)*, from the series *Models of Fashion:
New Designs Fresh as Spring Leaves (Hinagata
wakana no hatsumoyō)*
1783. Publisher: Nishimuraya Yohachi (Eijudō).
Color woodcut. 37 x 25 cm. Collection of
Cecilia Segawa Seigle

The two projects of 1776 enabled Tsutaya to learn from his more established colleagues and to piggyback his reputation off their success. The collaboration also provided him with the opportunity to distribute through shops in central Edo. His next business venture mimicked the recent achievements of his associate, the publisher Urokogataya Magobei, in the field of popular literature. In 1775, Urokogataya had brought out *Mr. Glitter-n-Gold's Dreams of Glory* (*Kinkin Sensei eiga no yume*) by the samurai writer Koikawa Harumachi (1744–1789). This comic *kibyōshi* (literally, yellow booklet) transformed the genre of the popular illustrated novelette. The story lambastes the "pretender" (the *hanka-tsū*, or "half-sophisticate") known as Mr. Glitter-n-Gold and his "dream of splendor" in the licensed quarter.[15] Urokogataya went on to issue four more Harumachi titles in 1776 and promoted another samurai author, Hōseidō Kisanji (1735–1813), with seven *kibyōshi* in 1777.[16]

Taking his cue from Urokogataya, Tsutaya collaborated with the two authors, Harumachi and Kisanji, to produce new stories illustrated by Kitao Shigemasa and his student Kitao Masanobu (1761–1816). Shigemasa, who had begun working for Tsutaya in 1774, remained a mainstay of the publisher's stable throughout his career and became one of the most prolific book illustrators of this period, designing some 250 titles. His style for female figures also became a template for artists such as Masanobu, Kiyonaga and Kitagawa Utamaro (1753?–1806). Masanobu, in turn, worked for Tsutaya first as an illustrator and later as a writer under the pen name Santō Kyōden (see fig. 110). In 1781, the samurai and cultural critic Ōta Nanpo (1749–1823) included Tsutaya on his list of the top eight publishers of popular fiction. Although Tsutaya was listed last, simply being included on the list manifests his emerging stature in the field; the others—in order, Tsuruya, Murataya, Okumuraya, Matsumuraya, Nishimuraya, Iseya and Iwatoya—were, after all, established shops in the city proper. Shigemasa and Masanobu, Tsutaya's artists, were also featured by Nanpo as among the best of the day.[17]

Tsutaya's expansion into the field of illustrated fiction was supported by the contacts he made through the writers and poets known as the Yoshiwara Circle (Yoshiwara-ren). These men of letters lived in or near the quarter and came together through the practice and appreciation of a style of literary expression known as *gesaku* (vernacular playful writing). The owner of the Daimonjiya brothel, Murata Ichibei (1754–1828), also known by his poetry name Pumpkin Stem (Kabocha no Motonari), led the group. Other members included the Yoshiwara proprietors: Suzuki Uemon (1744–1810), known as Splendid View from the Top of the Roof (Muneage no Takami) of the Ōgiya brothel; and Mallet of Good Fortune (Tawara no Kozuchi) of the Daikokuya. Courtesans, including Utahime of the Matsubaya, Hanaōgi III of the Ōgiya and Tagasode and Hatamaki of the Daimonjiya, are known to have been in attendance at some special events, but whether they came as guests, participants or as entertainers has not been established. It was through these luminaries that Tsutaya became affiliated with Nanpo (the leader of the Yomo poetry group), as well as with the samurai-born *kyōka* ("crazy verse," or "mad poetry") poets, Akera Kankō (1740–1800) and Yadoya no Meshimori (1753–1830), and the celebrated kabuki actor Ichikawa Danjūrō V (1741–1806) (see figs. 76–78, 96).[18]

Nanpo kept a scrapbook (now known only in facsimile) throughout this period. One page has a handwritten entry by Tsutaya describing his roles as a collector of a "storehouse of talent," and as a publisher of "Yomo Sensei" (Nanpo) and Yoshiwara guidebooks, with a shop located at the Great Gate. He adds his shop logo and his poetry name, Entwined in the Ivy (Tsuta no Karamaru).[19] Nanpo's diary of the same years describes an event Tsutaya hosted at the Daimonjiya brothel in 1782. Guests included the writers Nanpo, Kankō and Harumachi and the Kitao artists Shigemasa, Masayoshi and Masanobu, testament to the publisher's emerging position at the center of this network of talent. Nanpo also records a party, held at the Ōgiya just after the New Year of 1783, that included Tsutaya, Nanpo, Kankō and the owner of the Daimonjiya.[20] These entries document the publisher and his cronies—including some of his writers and illustrators—cavorting at parties in the Yoshiwara together with brothel proprietors and courtesans. Still, there are no records that document the artists drawing courtesans from life or taking commissions for realistic representations of the floating world. Floating world images are, after all, pictures of an idealized, fantasti-

cal world; more to the point, the practices of representation in place for the depiction of the Yoshiwara precluded realistic treatment of the quarter in text and image.[21]

These associations provided Tsutaya with new ventures. In 1781, he published a comic novel by Shimizu Enjū, *Short History of the Fashion God* (*Minari daitsū-jin ryaku engi*). As illustrator, he chose the as-yet-unknown Utamaro. Thus began one of the most important collaborations of their careers. Utamaro's teacher, Toriyama Sekien (1712–1788), a book illustrator and painter, was part of the extended web of poets, and he likely brought the publisher and young designer together.[22] Tsutaya introduced Utamaro as a new talent; his advocacy extended to having him as a lodger from about the spring of 1783 through the spring of 1788.[23]

In 1783, the *Anthology of Ten Thousand Mad Poems* (*Manzai kyōka shū*) set off what would become a boom in "mad poetry." Edited by Nanpo, this title included selections by Tsutaya and many of the associates mentioned above. The mad poetry genre became so popular that it necessitated publication of a Who's Who of poets. Tsutaya and Utamaro had their reputations burnished as members of Nanpo's elite Yomo group in the 1783 *Know-All-About Kyōka* (*Kyōka shittari furi*); there, both are listed by their poetry names with Utamaro using the sobriquet Slip of the Brush (*Fude no ayamaru*).[24] Tsutaya is also shown hobnobbing with Nanpo, Kankō and others in Harumachi's 1784 *Meeting of the Yoshiwara Great Sophisticates* (*Yoshiwara daitsū-e*) (fig. 84). The poets are dressed up in parodic costumes: Nanpo with a funnel for a hat and Kankō as the classical poet Michizane wearing a black hood and holding a plum branch. In front, Harakara no Akindo (Nakai Tōdō, 1758–1821) a member of the Honchō-ren poetry circle, holds out a tray of brushes. Tsutaya, seated at the lower right with his back to the viewer, says, "Why don't we write a *kyōgen* play together to commemorate the occasion?" Utamaro, too, makes an appearance as a party guest on one of the book's later pages.[25]

In a Yoshiwara guidebook for the New Year of 1783, Tsutaya had announced his most ambitious project to date: one hundred double-*ōban* illustrations of the most elite courtesans of the Yoshiwara, with an example of each woman's calligraphy. He selected Kitao Masanobu as the designer. Actually realized in seven diptychs in 1783, then combined into an album in 1784, this project is acknowledged as one of the publisher's masterpieces. The album, *New Mirror Comparing the Handwriting of the Courtesans of the Yoshiwara* (*Yoshiwara keisei shin bijin awase jihitsu kagami*), included a preface by Nanpo and an afterword by Kankō (fig. 85; see also fig. 10). The courtesans' poems were purported to be replicas of their own calligraphy. True or not, some Yoshiwara proprietors did bring in calligraphy teachers, and it is known that the Ōgiya courtesans received lessons from the calligrapher

Right: Figure 84
Koikawa Harumachi
The Meeting of the Yoshiwara Great Sophisticates (*Yoshiwara daitsū-e*)
1784. Publisher: Iwatoya. Woodblock-printed book, *kibyōshi*. 18 x 13 cm approx. each page. Kaga Collection, Tokyo Metropolitan Central Library

Poets from the Yoshiwara Circle are shown here. Rear, left to right: Sakamori Nyūdō Jōseki, shown with bald head; Ohara Kuchii, with packet on his head; Ki no Sadamaru (1760–1842, nephew of Akara [Nanpo] and government retainer), with whisk on his head; Akera Kankō in black hood; Moto no Akuami (1724–1811), with his hand to his head; Yomo no Akara (Nanpo), with a funnel on his head; Tegara no Okamochi ("Carrying Merit on a Tray," 1735–1813, author of a 1786 guidebook for Tsutaya); and Ōya no Urazumi ("Living behind the Big Shop"). Front, left to right: Hezutsu Tōsaku (1726–1789, owner of a tobacco shop, an early member of Edo *kyōka* circles and discoverer of Nanpo); Harakara no Akindo, with tray of brushes; Kabocha no Motonari (the proprietor of the Daimonjiya), with veil; and Tsuta no Karamaru ("Entwined in the Ivy," Tsutaya), with his back to the viewer.

Following pages: Figure 85
Kitao Masanobu
The Courtesans Hanaōgi and Takigawa of the Ōgiya (*Hanaōgi, Takigawa*), from the album *New Mirror Comparing the Handwriting of the Courtesans of the Yoshiwara* (*Yoshiwara keisei shin bijin awase jihitsu kagami*)
1784. Publisher: Tsutaya Jūzaburō. Color woodcut, diptych. 37.8 x 51 cm. Private Collection

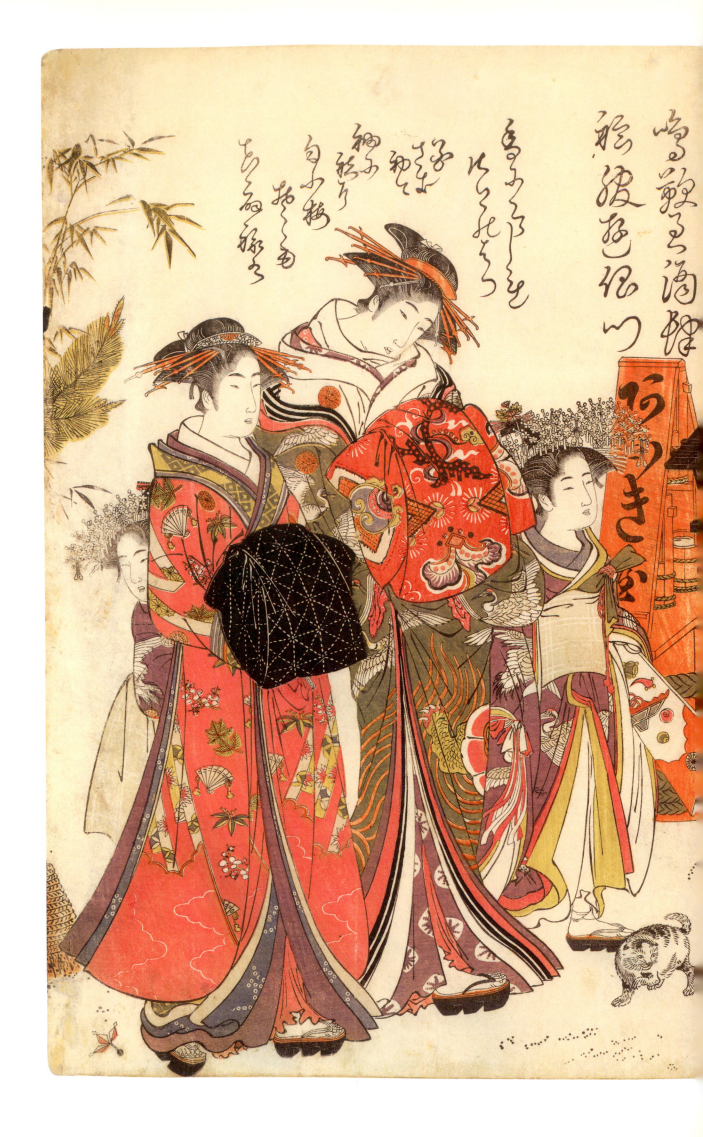

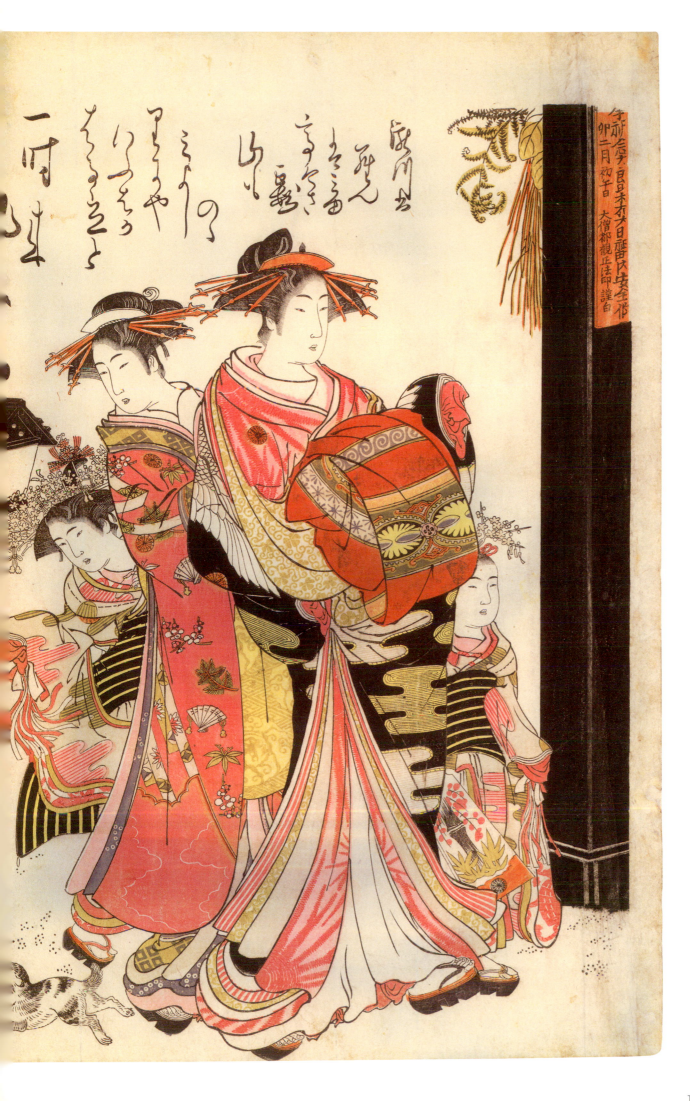

Figure 86
Santō Kyōden
Self-Portrait, from ***Grilled and Basted Edo-Born
Playboy*** (***Edo-umare uwaki no kabayaki***)
1785. Publisher: Tsutaya Jūzaburō. Woodblock-
printed book, *kibyōshi*. 18 x 13 cm approx. each
page. Gift of Martin A. Ryerson, The Art Institute
of Chicago, 3-3-06

Sawada Tōkō (1732–1796).[26] The fact that some poems were made in specific calligraphic styles suggests that the project was coordinated, and perhaps subsidized, by the Yoshiwara proprietors.

Tsutaya's next professional venture reveals his determination to become one of Edo's top-ranked producers of prints and books. In 1783, he expanded his business by buying out the publisher Moriya Kohei in the Toriaburachō neighborhood of the Nihonbashi district of downtown Edo. With a shop in this veritable publisher's alley, Tsutaya was now on a par with his previous collaborators, Yamazaki Kinbei and Nishimuraya Yohachi. It also gave him the right to sell materials within the city, making it unnecessary for him to distribute his works through partnerships as he had done previously.[27] Tsutaya then began a concerted effort to promote the authors and artists in his stable. In 1785, for example, he published the comic novel that launched Kitao Masanobu's new persona as the writer Santō Kyōden, *Grilled and Basted Edo-Born Playboy* (*Edo-umare uwaki no kabayaki*) (fig. 86). The novel became a best seller, so popular that the protagonist's name, "Enjirō," became a synonym for misguided conceit, and the bulbous nose of the aspiring dandy became known as the "Kyōden nose" after Kyōden illustrated himself in this book with the same feature.[28]

After Kyōden left printmaking, Tsutaya selected Utamaro as his lead artist for thirteen poetry albums and a number of erotic books published between 1786 and 1790.[29] Some of these also promoted the publisher and his artist as floating world sophisticates. The erotic album *Poem of the Pillow* (*Utamakura*), although unsigned, includes tongue-in-cheek references to artist and publisher that make its attribution indisputable. The anonymous preface names the volume and puns on the artist's name in the final lines: "and even suggesting the name of the painter, I call it *Ehon Utamakura* (Picture book of the Poem of the Pillow)."[30] In the opening sheet the man wears a garment with a crest similar to Tsutaya's ivy leaf, and through this identifying mark, the work serves a metaphorical portrait of the publisher (fig. 87). Thus, although Utamaro and Tsutaya are not named explicitly, both text and image allude to their expertise in the erotic world the book describes.

Three albums from 1789 to 1790 demonstrate Tsutaya's commitment to pushing the technical and artistic limits of the medium. *The Silver World* (*Gin sekai*), *Moon-mad Monk* (*Kyōgetsubō*) and *Statue of Fugen* (*Fugenzō*) were commissioned as a set on the popular theme of snow, moon and flowers (*setsugekka*). Utamaro's accompanying illustrations display a painterly elegance paralleling that of the poetry (fig. 88; exh. nos. 123, 124). In all three, subtle monochrome variations, saturated areas of color and bronze dusting signify the highly refined aesthetic sensibility of the poets, the skill of the painter's hand and the judicious attention of the publisher working closely with the finest block carvers and printers.

Opposite above: Figure 87
Kitagawa Utamaro
***Lovers in the Private Second-Floor Room
of a Teahouse,*** from the album ***Poem of
the Pillow*** (***Utamakura***)
1788. Publisher: Tsutaya Jūzaburō. Color woodcut.
Plate 25.5 x 37 cm. The Mann Collection,
Highland Park, IL

The poem on the fan by Yadoya no Meshimori
(1753–1830) speaks of a snipe that cannot rise
up because its bill is firmly caught in a clam—
an autumn evening.

Opposite below: Figure 88
Kitagawa Utamaro
Moon over a Mountain and Moor, from the
album ***Moon-mad Monk*** (***Kyōgetsubō***)
1789. Publisher: Tsutaya Jūzaburō. Color woodcut
album with metallic powders. Plate 25.5 x 38 cm.
Private Collection

Ki no Sadamaru, the compiler of this album,
appears in the gathering shown in Figure 84. The
embossed moon of the title appears in the upper
center of the right panel.

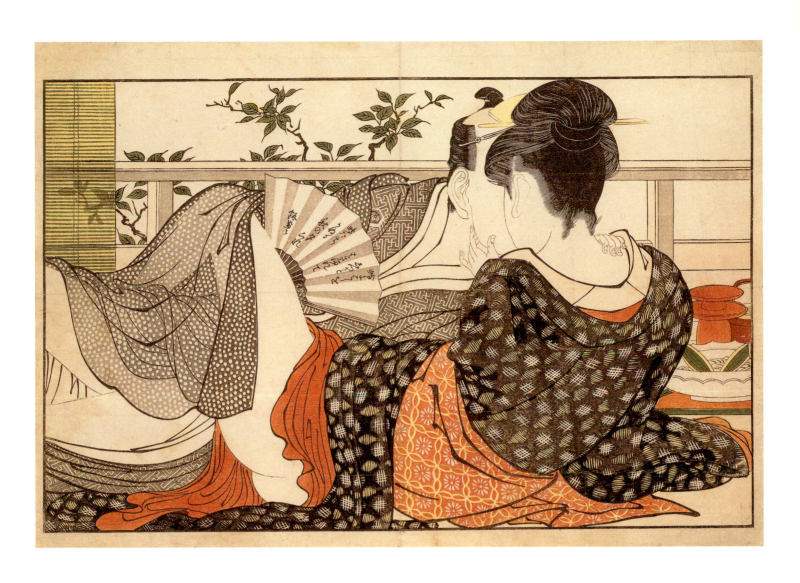

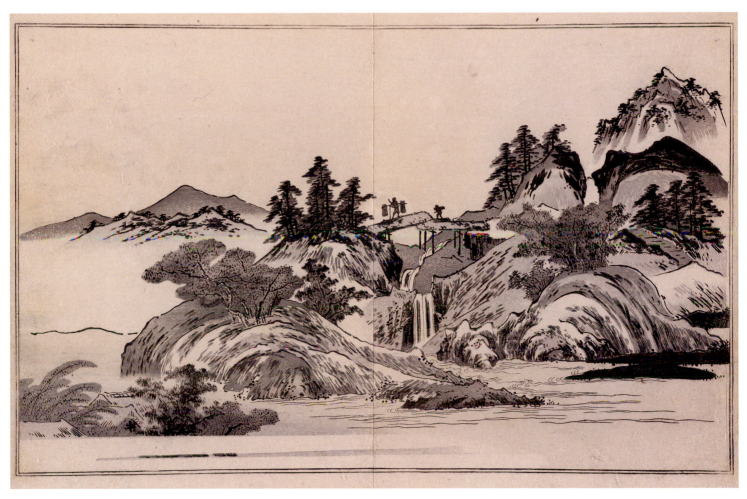

Reforms and Reinvention

In 1790, while Tsutaya and his associates were engaged in producing sumptuous albums, dazzling sheet prints and amusing light fiction, the political landscape of Edo was changing. In 1787, Matsudaira Sadanobu (1759–1829) had been appointed councillor to the shogun Tokugawa Ienari (1773–1841), and soon policies were instituted with the purpose of regulating morality by stressing economy, thrift and a return to the "scholarly" (*bun*) and the "military" (*bu*). Those of samurai rank in Tsutaya's circle retrenched under the new regime. Nanpo departed from *kyōka* circles to take up activities more visibly suited to a man of his status as a lower-ranking samurai. Two of Tsutaya's other writers, Kisanji and Harumachi, of higher rank as samurai, stopped writing comic novels. Kisanji may have returned to his home domain. Harumachi, who had satirized the previous regime, was to be called in for official review in 1789, but he died before the appointed day (widely rumored to have committed suicide).[31]

One of the goals of Sadanobu's regime was to reestablish control over floating world publishing. Regulations announced in 1790 signaled the shogunate's intention to monitor and punish offences. They compelled guild-level censorial examination of manuscripts and

Figure 89

Kitagawa Utamaro

The Light-hearted Type (also called ***The Fancy-Free Type***) (***Uwaki no sō***), **from the series *Ten Types in the Physiognomic Study of Women* (*Fujin sōgaku juttai*)**

c. 1792–93. Publisher: Tsutaya Jūzaburō. Color woodcut with mica ground. 37.8 x 25.1 cm. Asia Society, Mr. and Mrs. John D. Rockefeller 3rd Collection of Asian Art, 1979.219

sketches prior to seeking approval at the magistrate's office; the "real names" of authors and artists were also required. Current topics, erotica and "vulgar and offensive matters" were banned, as were frivolous and luxurious works. To report rumors in manuscript and make them available through the lending libraries was also forbidden, as was the practice of using the past as a pretext to report on the present. An edict issued several months later dictated inclusion of a seal reading "certified" (kiwame) on the recto of sheet prints. The seal signified that sketches had cleared review at both the guild and city magistrate level. Representatives of the publishers' guilds were charged with ensuring compliance, and they, along with the artist and publisher, were to be held responsible for violations of prohibited topics. The edict thus put into place a system of self-censorship.[32]

In the seventh month of 1790, Tsutaya published three style books by Kyōden. By the end of the year, the books were banned from sale, their publisher and writer under investigation.[33] Although approved by guild representatives, the books were found to be in violation after they went on the market. One featured an Edo playboy who, after taking the shogunate exhortations on efficiency to heart, was transformed into a joyless automaton obsessed with time management; the book ends with the protagonist realizing the folly of his venture, making a pointed satire of the shogunate's policies.[34]

The investigation proceeded, and two months later the city magistrate handed down a guilty verdict against all three titles. Tsutaya had to pay half his net worth in fines, Kyōden was manacled for fifty days, and the guild representatives who had approved the publications were banished to the provinces. Making examples of Tsutaya and Kyōden was designed as a public act demonstrating the right of the government to enforce its prohibitions. Ironically, Tsutaya served his own two-month term as guild censor later in the same year, and no doubt put his bitter experience into practice.[35]

The record of inquiry from the investigation provides concrete evidence of the financial relationship between author and publisher. Kyōden received payment upon submission of his manuscript to the publisher, but he was also expecting royalties based on sales, according to an agreement that had apparently been in place for five to six years.[36] Kyōden's arrangement offers an insight into the relationship between this author and his publisher, and it demonstrates that Kyōden could by now bank on royalties. How illustrators were compensated is as yet unknown, but it seems within the realm of probability that a similar system of advance payment and royalties was also in place for Tsutaya's top producers.

After the trial, Tsutaya must have suffered from his financial and professional losses. With Nanpo in retirement from the floating world, there were no commissions coming in for sumptuous books or other special projects for the Yomo Group. Tsutaya's output shows that he reinvested in a vigorous program of producing popular books and full-color sheet prints. Most notably, he backed Utamaro in a sequence of pictures of beauties (bijinga) that employed the technical achievements of the poetry albums in the medium of sheet prints. While other projects were also brought out in this key period of their collaboration, one of the most important is surely the set of full-color prints on the theme of the "physiognomic" aspects of women from 1792 to 1793. These boldly manipulated text, image and material to promote Utamaro and to appeal to the connoisseurship skills of Yoshiwara sophisticates.

The first two prints issued in the set are titled Ten Types in the Physiognomic Study of Women (Fujin sōgaku juttai) and signed "Drawn by Utamaro the physiognomist" (Sōmi Utamaro ga). Subtitled The Light-hearted Type (Uwaki no sō) and The Engaging Type (Omoshirokisō), and with the figures set against a reflective surface, the prints employ text and image that serve to persuade the viewer that these individuals have been observed, diagnosed and catalogued by Utamaro according to physiognomic precepts (figs. 89, 90). Four additional prints were issued under the same title and signature, and although they do not include subtitle designations, the mode of representation and the distinctions of hairstyle, costume and gesture attest to Utamaro's categorizing gaze (exh. nos. 127–130).[37]

The conceit of the images is that these designs "captured" moments that revealed specific types through Utamaro's spectacular physiognomic talent. The term sō used in all titles designates these as "aspects" or "types," and cites the Chinese art of divining the features of the body as physical manifestations of character and destiny. Likewise, Utamaro's signature rhetorically positions him as possessing the skill of discriminating among

female types. The innovative presentation of the figures in a medium close-up (called *ōkubi-e*, literally "large-neck pictures") reinforces the impression that these images were drawn from close observation, in a visual rhetoric that asserts these are portraits, reflective (like their mica-enhanced grounds) of what the artist saw. These were part of the collaborative strategy of promoting Utamaro through the manipulation of authorial codes.[38]

Tsutaya spared no costs in production, hiring highly skilled carvers and printers and employing sumptuous materials to make these technical masterworks. Care was taken to retain Utamaro's brushed line, indicating the hand of the artist, and to make a visual association between the mica surface and the polished metallic surfaces more often seen in the gold ground of painting. In spite of their assertions to naturalism, there is nothing specific about these representations to demonstrate that Utamaro indeed drew the women from life. It is also unlikely that he was referring to physiognomy manuals or was trained in that art of divination, for although such manuals were in circulation—and Maruyama Ōkyo (1733–1795) as well as other artists employed them in their painting practices—no connection may be made between Utamaro's images and the discipline. Instead, as I have argued elsewhere in more detail, the images refer to forms of comparison used in popular compatibility and style books, wherein such-and-such "type" was said to show specific characteristics and would be a "good match" to another type (not unlike similar designations used in matchmaking today).[39]

Readers of Tsutaya-published books may have recognized other floating world sources of Utamaro's compositions: *The Light-hearted Type* and *The Engaging Type* were inspired by Santō Kyōden's 1786 stylebook, *The Mirror of the Punter's Pluck (Kyakushu kimo kagami)*. *The Engaging Type* closely adapts the Kyōden illustration of a "riverbank" type (*kashi*), one of the lowest ranks of prostitutes, peering into a mirror as she blackens her teeth (fig. 91).[40] Utamaro's two sheet prints, the first issued in the set, assume that punters could discriminate among the lower ranks of the sex trade within and beyond the Yoshiwara. Informed readers would surely have made the connections between the "physiognomic" tropes used in Utamaro's sheet prints and Kyōden's guide. Utamaro's prints thus hid in plain sight an alternate typology of social distinctions.

The publisher continued to back Utamaro in a series of magnificently printed sets, triptychs and individual sheet prints throughout the early 1790s. Other artists, including Toyokuni, began imitating Utamaro's style, underscoring its commercial success. In about 1793 to 1794, Tsutaya produced Utamaro designs showing the three renowned beauties of Edo, Naniwaya Okita, Takashima Ohisa and Tomimoto Toyohina. While courtesans of the Yoshiwara were held to be paragons of glamour, women in other professions also achieved renown for their beauty. Often this attention focused on Yoshiwara geisha like Toyohina. Women who worked in Edo shops, like Ohisa and Okita, were known as *kanban musume* or "signboard girls." They functioned as product representatives similar to the models or actresses associated with designer merchandise today. As David Pollack has proposed, business owners likely sponsored these images.[41] Many became lesser celebrities, discussed in period guidebooks.

Three Beauties of the Present Day is one of Utamaro's most famous designs (fig. 92). The teahouse waitress Okita is at the lower right, the rice-cracker shopgirl Ohisa at the lower left and the Yoshiwara geisha Toyohina at the top. Mimicking familiar representation of such famous triads as the three vinegar tasters or the Buddha flanked by bodhisattvas, the grouping implies that the "beauties of Edo" had likewise achieved iconic status. Equaling the effects in the physiognomy series, the silver mica background suggests a reflective surface that contrasts with the figures' skin. The delicate lines used for the hair and the facial features attest to the high level of craftsmanship of Tsutaya's carvers and printers. The features of the three women are slightly different, but like all *bijinga*, where idealization to a prototype was more important than individualization, these do little to suggest Utamaro drew their faces from life.

Tsutaya's development of the larger format, full-color single-sheet print (*ōban nishiki-e*) as a major product line demonstrates his competitive stature in the publishing field. Through about 1794, he and Utamaro remained close collaborators, producing many acclaimed sets, multiple panel scenes and single-sheet prints. Thanks to Tsutaya, Utamaro

Figure 91
Kitao Masanobu
Riverbank Type (Kashi), from *The Mirror of the Punter's Pluck (Kyakushu kimo kagami)*
1786. Publisher: Tsutaya Jūzaburō (Kōshodō). Woodblock-printed book, *sharebon*. 18 x 13 cm approx. each page. Kaga Collection, Tokyo Metropolitan Central Library

Opposite: **Figure 90**
Kitagawa Utamaro
The Engaging Type (also called *The Interesting Type*) (*Omoshiroki sō*), from the series *Ten Types in the Physiognomic Study of Women (Fujin sōgaku juttai)*
c. 1792–93. Publisher: Tsutaya Jūzaburō. Color woodcut with mica ground. 38.3 x 25.2 cm. Private Collection

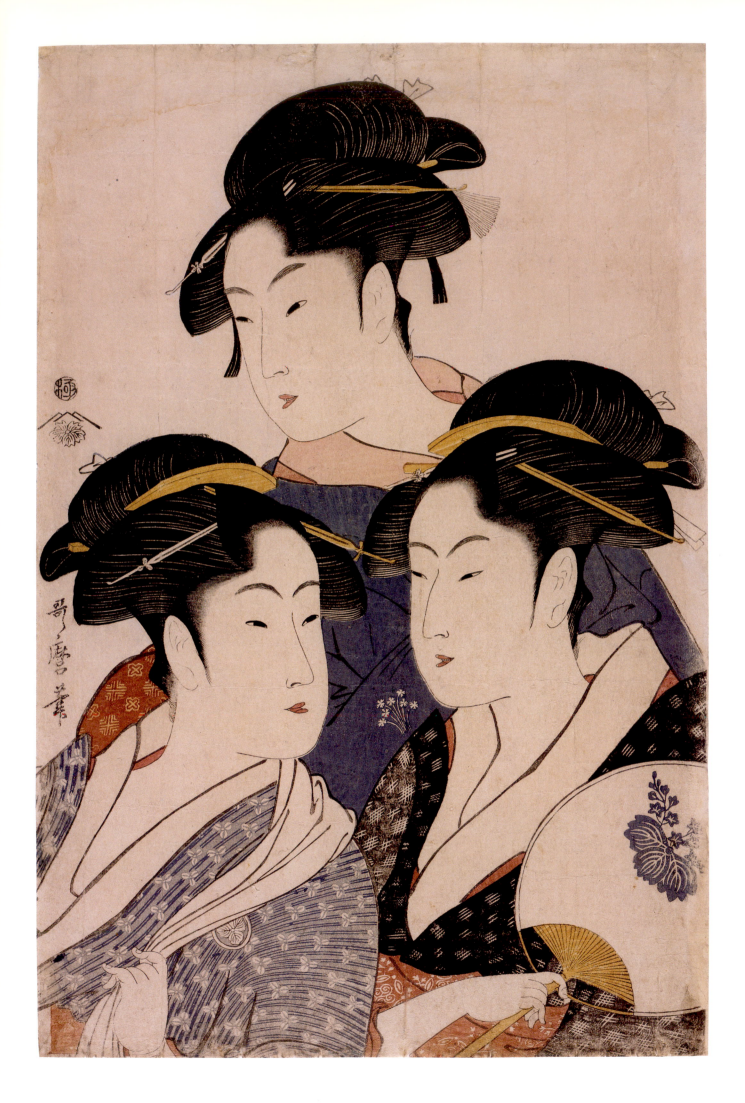

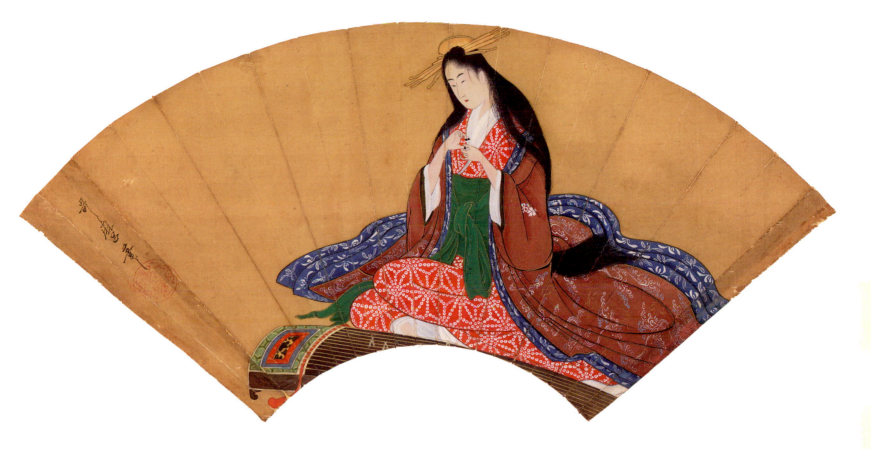

Figure 93
Kitagawa Utamaro
Hanaōgi IV of the Ōgiya
1794–95. Folding fan; ink, color and gold on silk.
20.9 x 52.7 cm. John C. Weber Collection

Opposite: Figure 92
Kitagawa Utamaro
Three Beauties of the Present Day
c. 1793. Publisher: Tsutaya Jūzaburō. Color
woodcut with mica ground. 38.2 x 25.5 cm.
Private Collection

had achieved name brand or bankable status. Through 1797, Tsutaya produced more prints by Utamaro than any other publisher, although Tsuruya Kiemon, Ōmiya Gonkurō, Yama-guchiya Chūsuke and Nishimuraya Yohachi also sponsored significant numbers of Utamaro-signed images.[42] While the latter are often exceptional and stunning images, overall, one has the impression that Utamaro's designs for other publishers are less innovative than they had been during his crucial developmental period with Tsutaya.

Sometime between 1794 and 1796, Utamaro painted Hanaōgi IV of the Ōgiya on the surface of a folding fan (fig. 93). Hanaōgi IV made her debut in 1787, and by the mid-1790s she had achieved the highest status as *yobidashi sancha* (by appointment only) at the exclu-sive Ōgiya.[43] While she had long been appreciated for her beauty and skill as a calligrapher and koto player, she became even more famous after a failed attempt to elope in 1794.[44] This fan painting was probably made after she resumed work in the Yoshiwara.

Ōgi means fan, and the format itself thus refers to both the courtesan and her house. Utamaro rose to the challenge posed by the shape of the fan by placing the figure at the center, her robes arranged around her in bands of color and pattern against a gold ground. Her koto acts as a stabilizing horizontal element at the base of the composition. The artist's attenuated signature and round seal at left counterbalance the riot of colorful garments flowing toward the right side of the fan. Paintings were more valuable objects than prints, and, as Kobayashi Tadashi has proposed, this fan was a highly prized possession likely com-missioned by a Yoshiwara sophisticate.[45]

Hanaōgi is shown putting the picks on her fingers in preparation to play the koto. Her freshly washed hair trails down her back. Yoshiwara courtesans typically washed their hair once a month, often on the twenty-seventh, and their usual daytime occupations were

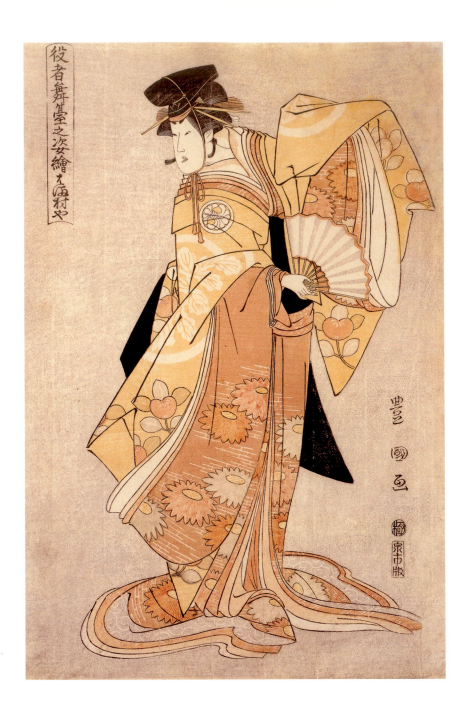

suspended for the occasion; they resumed their duties once more in the evening when the district opened for business. Hanaōgi, being one of the highest ranking courtesans of the house, would have been attended to early in the day; then she would have a rare opportunity, as seen here, to pursue her own interests.[46] Her expression is pensive as she prepares to play the instrument, her features idealized in the manner Utamaro often used to represent these paragons of beauty.

In the early 1790s, the premier position of Tsutaya and his artists was being challenged. Utagawa Toyokuni (1769–1825) in particular was advanced by other publishers as an alternative. Although Toyokuni had worked previously with Tsutaya, the sponsorship of the publishers Nishimuraya Yohachi and Izumiya Ichibei transformed Toyokuni into a leading designer. Nishimuraya issued beauty pictures by Toyokuni, while Izumiya produced Toyokuni's widely imitated full-length studies of actors against a color ground, the *Pictures of Actors on Stage* (*Yakusha butai no sugata-e*) (fig. 94).[47] Was it coincidence that shortly after Izumiya began releasing Toyokuni's actor prints in 1794, Tsutaya embarked upon his boldest venture to date, a group of twenty-eight prints signed "Tōshūsai Sharaku" in the fifth month of Kansei 6 (1794), timed to capitalize on the late spring kabuki calendar (figs. 95, 96)? These prints were a daring new approach to the genre, showing the actors close up, with exaggerated features set against a glistening dark mica ground (exh. nos. 92, 94, 96–98).

Figure 94
Utagawa Toyokuni
Segawa Kikunojō III (Hamamuraya) as the Shirabyōshi *Dancer Hisakata,* from the series *Pictures of Actors on Stage* (*Yakusha butai no sugata-e*)
1794. Publisher: Izumiya Ichibei. Color woodcut. 36.9 x 25.2 cm. Arthur M. Sackler Gallery, Smithsonian Institution, Washington, D.C., The Anne van Biema Collection, S2004.3.84

Opposite: Figure 95
Tōshūsai Sharaku
Sanogawa Ichimatsu III as the Courtesan Onayo of Gion, in the Kabuki Play The Iris Soga of the Bunroku Era (*Hanashōbu Bunroku Soga*)
1794. Publisher: Tsutaya Jūzaburō. Color woodcut with mica ground. 38.9 x 25.8 cm. The Mann Collection, Highland Park, IL

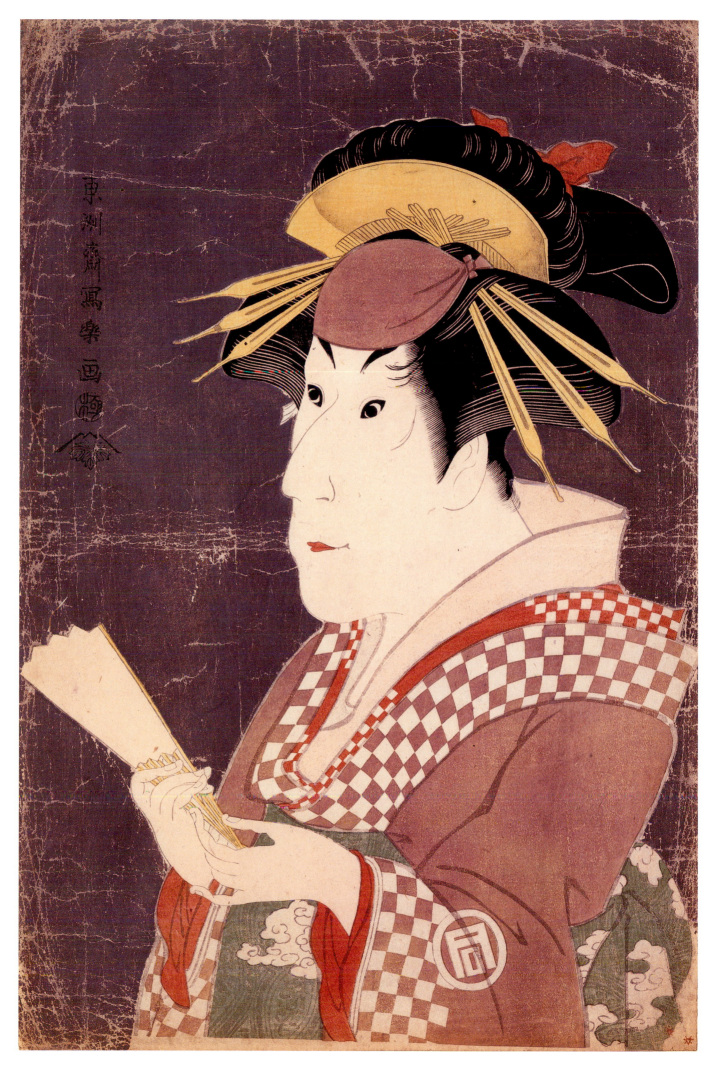

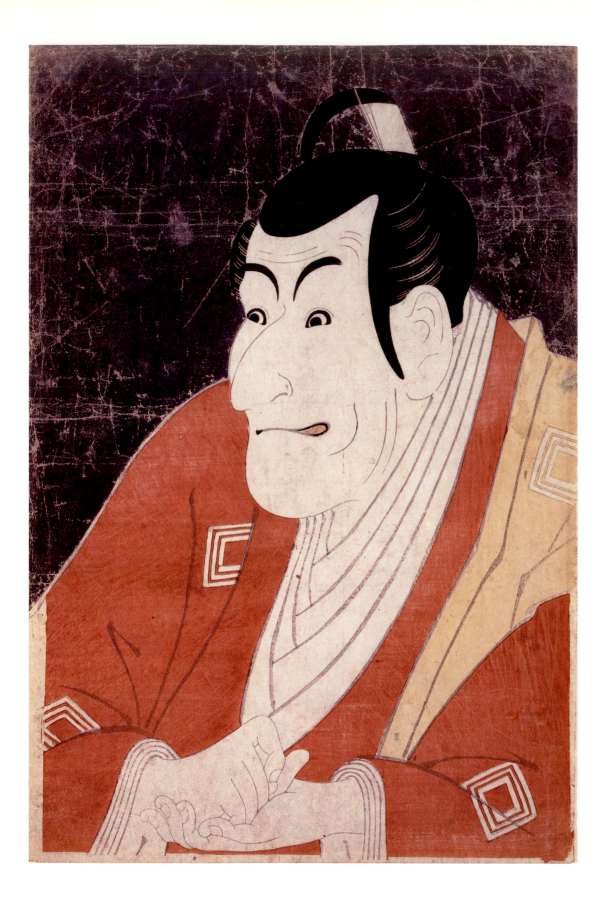

Figure 96
Tōshūsai Sharaku (act. 1794–95)
Ichikawa Ebizō IV (Danjūrō V) as Takemura
Sadanoshin, a Noh Performer Driven to Suicide
by his Daughter's Disgrace, in the Kabuki Play
The Beloved Wife's Particolored Reins (*Koi*
nyōbō somewake tazuna)
1794. Color woodcut with mica ground. 38.3 x
25.9 cm. The Mann Collection, Highland Park, IL

In this play, the lovers Yosaku and Shigenoi engage
in a forbidden liaison and have a child while in the
service of Lord Saemon. Shigenoi's father, Sada-
noshin, commits suicide because of his daughter's
disgrace. Ebizō IV appeared in the role of Sada-
noshin at the Kawarazaki Theater in Edo in the fifth
month of Kansei 6 (1794). In the Danjūrō line,
the holder of the name often changed his name
to Ebizō after his "prime" and once a successor in
the line was "ready." For paintings of Danjūrō V/
Ebizō IV see figures 76–78.

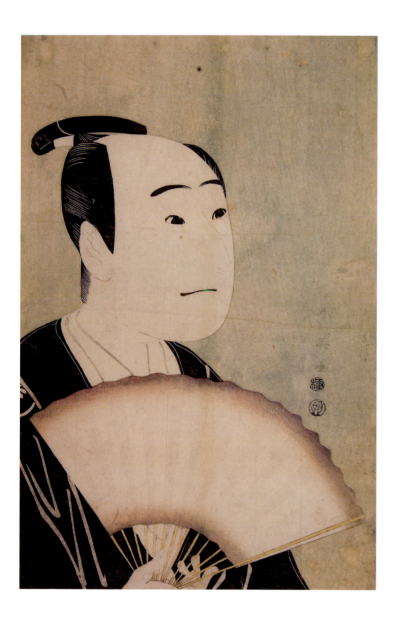

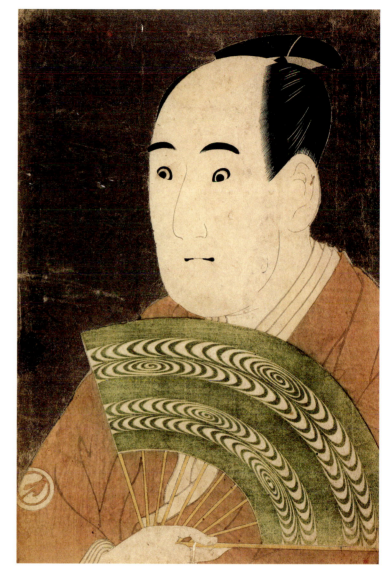

The collaboration between publisher and designer lasted only ten months. Tōshūsai Sharaku (act. 1794–95) is one of ukiyo-e's most enigmatic figures, and his identity has not yet been established with certainty. A brief report in the *Ukiyo-e kōsho* (Research on ukiyo-e) of 1802 states that Sharaku may have been the Noh actor Saitō Jūrōbei, in the service of the Awa daimyo.[48] As there are no works signed "Sharaku" that date before 1794, it is apparent that Sharaku did not train first as a book illustrator and then rise up in the ranks in the usual trajectory for ukiyo-e designers. Instead, his sudden appearance in the field seems to have been a calculated assault by Tsutaya on the actor print market.

Over ten months Tsutaya produced 145 actor and 10 sumo prints by Sharaku. Those issued in the fifth month of Kansei 6 are the most prized, on account of their dramatic intensity, fine technique and lavish materials. The actor print market, like that of beautiful women, was fiercely contested. Print buyers were attentive to the differences individual artists brought to their renditions of favorite stars. Katsukawa Shun'ei (1762–1819) and Sharaku illustrated Sawamura Sōjūrō III in the same play (figs. 97, 98), making it possible for us to

Left: Figure 97
Katsukawa Shun'ei
Sawamura Sōjūrō III as Ōgishi Kurando,
in the Kabuki Play The Iris Soga of the Bunroku
Era (Hanashōbu Bunroku Soga)
1794. Publisher: Tsuruya Kiemon. Color woodcut.
37.5 x 25 cm. Private Collection

Right: Figure 98
Tōshūsai Sharaku
Sawamura Sōjūrō III as Ōgishi Kurando,
in the Kabuki Play The Iris Soga of the Bunroku
Era (Hanashōbu Bunroku Soga)
1794. Publisher: Tsutaya Jūzaburō. Color
woodcut with mica ground. 36.3 x 24.2 cm.
David R. Weinberg Collection

compare their approaches. Both artists emphasize the actor's long, oval-shaped face, beady eyes and serious expression, but Shun'ei's Sōjurō is attractive and relaxed, Sharaku's is sharp and clever. While Sharaku's are among the most compelling actor prints of the period, one senses that they are edging dangerously close to being caricatures. It was said at the time that Sharaku worked "too hard telling the truth" (*amari ni shin o egakan tote*), suggesting he showed too much, even unflattering features.[49]

Why Sharaku's career came to a sudden close is not known. It is possible that he had to resume duties as a Noh actor or return to service for the daimyo. It may have also been the case that his prints did not yield sufficient profit. Asano Shūgō argues that the prints issued in the first half of the Tsutaya-Sharaku partnership display the kinds of luxurious materials consistent with private commissions. These early works may have been funded by theater or print aficionados, with additional impressions produced for sale to the broader public. The decrease in extravagant effects in the second half of the collaboration may indicate that the publisher was not able to maintain the private sponsorship that had been in place for the earlier prints.[50] Although this interpretation must remain hypothetical, it is supported by the fact that the format sizes also shrank. The group of 28 prints that marked Sharaku's debut was issued solely in the larger *ōban* format. Over the remaining period, only 12 of the total 117 were *ōban*; the remaining 105 designs were in smaller, less expensive formats (87 *hosoban* and 18 *aiban*). In the final period of Sharaku's activity, in the first month of Kansei 7 (1795), none of the designs was produced as *ōban*; for these 15, all were in the smaller formats (5 were *aiban* and 10 *hosoban*).[51] Over time, Tsutaya decreased the size of the prints and used less sumptuous pigments, signaling a pattern of declining investment in Sharaku.

At the same time, Tsutaya was developing new talents. He added actor prints by Shun'ei and book illustrations and small-format actor prints by Shunrō (better known as Hokusai, 1760–1849) to his inventory. He also supported new directions in fiction with emerging writers Takizawa Bakin (1767–1848) and Jippensha Ikku (1765–1831). Both Bakin and Ikku temporarily lived with the publisher, as Utamaro had done, during what was no doubt a formative period of their collaboration. Bakin came into their circle about 1790 via a tutorial with Kyōden, and the notice of his first publication with Tsutaya appeared on the firm's book list in 1793. Many of Bakin's books were produced by Tsutaya, and he subsequently became one of the most famous writers of the early nineteenth century. Ikku arrived in Edo in 1794 after a short career writing plays for the Osaka puppet theater, and his first Tsutaya-sponsored project was a self-illustrated, yellow-backed novelette, the *Shingaku Passionflower* (*Shingaku tokeigusa*), published in 1795.[52] Like Bakin, Ikku became one of the best-selling fiction writers of the period, and his novel *Hoofing It Along the Tōkaidō* (*Tōkaidōchū hizakurige*, 1802–22) is a classic. As had been the case with Kyōden and Utamaro, Tsutaya's early sponsorship of Bakin and Ikku, not to mention Hokusai, helped establish their careers, demonstrating once more his uncanny ability to spot and nurture talent.

In the later 1790s, after turning Utamaro into a name brand for the Kōshodō, Tsutaya began to promote beauty prints by Eishōsai Chōki (act. c. 1790s–early 1800s). Chōki, like Utamaro, was a student of Toriyama Sekien, and no doubt met the publisher through these affiliations. Chōki's style clearly shows his appreciation for Utamaro, and while his most famous works depict Edo-style beauties, he also portrayed actors and Osaka courtesans and geisha.[53] Chōki's images often feature women enjoying the delights of the seasons—fireflies on a summer night, the red sunrise at the New Year, newly fallen snow—and evoke the kinds of poetic allusions employed in the period (fig. 99; exh. nos. 2, 3). Set against a mica ground, they emphasize the poignancy of the moment, and as usual demonstrate the publisher's commitment to high technical quality, strength of line and use of fine materials.

Tsutaya continued working with the authors and artists he had supported—including Utamaro, Kyōden, Bakin, Hokusai, Chōki and Ikku, among others—through the rest of his career. He also brought out some remarkable prints by Kiyonaga, an artist previously associated with the publisher Nishimuraya. After 1794, he returned to publishing commissions for poetry groups, this time specializing in *haikai*. Most of these poetry books were republications of works produced by others, but in 1796 he released his own compilation.[54]

Figure 99
Eishōsai Chōki
Catching Fireflies
c. 1794. Publisher: Tsutaya Jūzaburō. Color woodcut with mica ground. 38.1 x 24.8 cm. Private Collection

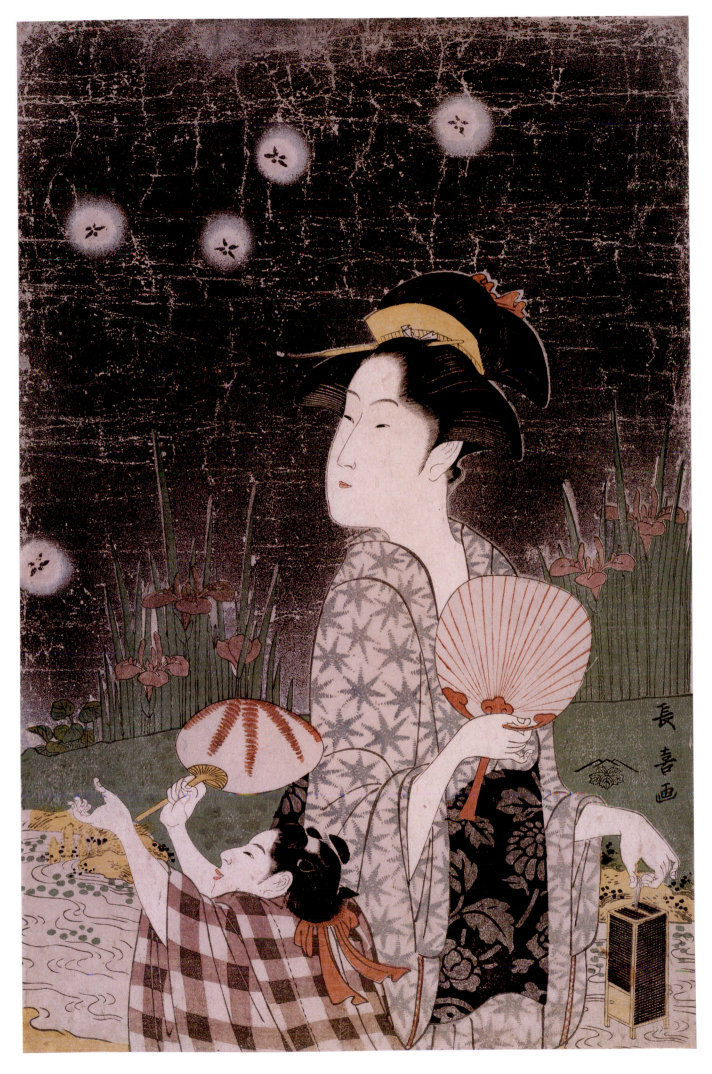

In the autumn of 1796, Tsutaya became ill with beri-beri, a disease caused by a diet deficient in thiamine, an element removed in the polishing of rice.[55] He died early in the summer of 1797.[56] For the artists, authors, carvers, printers and others who had been his collaborators, his death was more than the loss of their publisher—it meant they would be without their agent, producer, conspirator and friend. While the Kōshodō continued publishing right into the Meiji period, it never matched the quality or renown achieved during his lifetime.[57]

Over the course of his career, Tsutaya published approximately 545 books—including some of the genre's most important poetry albums, erotica and fiction—and several thousand designs for sheet prints. These impressive numbers alone would make him one of the leading publishers of his era, but Tsutaya's achievements are even more significant in the qualitative change he wrought in the milieu of commercial publishing. The books he produced on the Yoshiwara, from guidebooks to stylebooks, enlisted some of the most vaunted artists and authors, providing their audience, then and now, with invaluable information. Through his connections, he became an associate of the leading poets and writers and demonstrated his ability to marshal and direct his collaborators to exploit the print medium to its fullest. As a talent-spotter, Tsutaya supported the writers Harumachi, Kisanji, Kyōden, Ikku, Bakin and others, developing some of the most distinct voices of the period. He also created opportunities for some of ukiyo-e's most innovative designers—Shunshō, Shigemasa, Masanobu, Utamaro, Chōki, Sharaku and Hokusai.

———

In the year before Tsutaya died, Kyōden included a picture of him on the last page of *Pictures Cast by the Projector of the Human Heart* (*Hitogokoro kagami no utsushi-e*, 1796) (fig. 100). Authors often used the last page to make final remarks directed at the audience and many also included humorous caricatures of themselves, but here, Kyōden also included Tsutaya at the lower right. He shows himself seated at a table in the pose of a comic storyteller with his invented oval "heart lens." Kyōden's notion was that when this "lens" was held in front of an individual it would display the person's true self projected in a bubble on the torso. Here, that lens reveals his secret thoughts about patrons visiting his tobacco shop. The magic circle superimposed on Tsutaya's back shows the publisher concentrating on writing in what may be his account book.[58] Kyōden is sending up Tsutaya, recasting him as an accountant concerned with the bottom line. Tsutaya may well have been motivated by profit, but, if so, that drive was tempered by his dedication to challenging the technical limits of the medium, sponsoring emerging talent and producing many of the floating world's masterworks of art and literature.

Figure 100
Santō Kyōden
Self-Portrait, from Pictures Cast by the Projector of the Human Heart (Hitogokoro kagami no utsushi-e)
1796. Publisher: Tsutaya Jūzaburō. Woodblock-printed book, *kibyōshi*. 18 x 13 cm approx.
National Diet Library

Notes

1. Tijs Volker, *Ukiyo-e Quartet: Publisher, Designer, Engraver and Printer*, Mededelingen van het Rijksmuseum voor Volkenkunde, vol. 5 (Leiden: E. J. Brill, 1949).

2. Peter Kornicki, *The Book in Japan: A Cultural History from the Beginnings to the Nineteenth Century* (Leiden: E. J. Brill, 1998), 175.

3. See also, Chris Uhlenbeck, "Production Constraints in the World of Ukiyo-e: An Introduction to the Commercial Climate of Japanese Printmaking," in Amy Reigle Newland, ed., *The Commercial and Cultural Climate of Japanese Printmaking* (Amsterdam: Hotei Publishing, 2004), 13–18.

4. Kobayashi Tadashi, ed., *Nishiki-e no tanjō—Edo shomin bunka no kaika/The birth of nishiki-e—Full-color Woodblock Prints and Edo Popular Culture* (Tokyo: Tokyo Metropolitan Edo-Tokyo Museum, 1996), 13–14.

5. Moriya Katsuhisa, "Urban Networks and Information Networks," in *Tokugawa Japan: The Social and Economic Antecedents of Modern Japan*, Nakane Chie and Ōishi Shinzaburō, eds. (Tokyo: The University of Tokyo Press, 1990), 115–17.

6. An aside dated to 1805 as reported in Akai Tatsurō, "The Common People and Painting," trans. Timothy Clark, in *Tokugawa Japan*, Nakane and Ōishi, eds., 184.

7. See, among others, Matthi Forrer, "The Relationship between Publishers and Print Formats in the Edo Period," in Newland, ed., *The Commercial and Cultural Climate of Japanese Printmaking*, 178.

8. Tsutaya was born on the seventh day of the first month, Kan'en 3 (1750); Suzuki Toshiyuki, *Tsutaya Jūzaburō*, vol. 9 in the series Kinsei bungaku kenkyū sōsho (Research in early modern literature) (Tokyo: Wakakusa Shobō, 1998), 207 (the date here is incorrectly converted to 1751). See also, Matsuki Hiroshi, *Tsutaya Jūzaburō—Edo geijutsu no enshutsusha* (Tsutaya Jūzaburō—Director of Edo art) (Tokyo: Nihon Keizai Shinbunsha, 1974), 14; Kuramoto Hatsuo, *Tanbō Tsutaya Jūzaburō—Tenmei bunka o riido shita shuppanjin* (Inquiry on Tsutaya Jūzaburō: The publisher who led Tenmei culture) (Tokyo: Renga Shobō Shinsha, 1997), 36.

9. Suzuki Toshiyuki, *Tsutaya Jūzaburō*, 11 and 207. For a list of books published by Tsutaya, see Suzuki Toshiyuki, *Tsutajū shuppan shomoku* (Catalogue of Tsutajū's publications) in *Nihon shoshigaku taikei* (Japanese bibliography survey), vol. 77 (Musashimurayama-shi: Seishōdō Shoten, 1998). On Tsutaya's guidebooks, see Suzuki

Toshiyuki, "Tsutayaban saiken to sono daisai kōkoku" (Tsutaya-published *saiken* and their inserted advertisements) in Hiraki Ukiyo-e Foundation, *Edo bijin kurabe: Yoshiwara saiken* (Edo beauties compared: The Yoshiwara guidebooks) (Yokohama: Hiraki Ukiyo-e Foundation, 1995), 19. For an overview of the Yoshiwara, see Sone Hiromi, "Prostitution and Public Authority in Early Modern Japan," trans. Akiko Terashima and Anne Walthall, in *Women and Class in Japanese History*, Hitomi Tanomura, Anne Walthall and Wakita Haruko, eds. (Ann Arbor: Center for Japanese Studies, University of Michigan, 1999), 169–85.

10. Moriyama Yoshino, "Hanmoto no yakuwari to Tsutaya Jūzaburō no katsuyaku" (The role of the publisher and the active career of Tsutaya Jūzaburō) in Kobayashi Tadashi and Ōkubo Jun'ichi, eds., *Ukiyoe no kanshō kiso chishiki* (Knowledge of the fundamentals about and appreciation of ukiyo-e) (Tokyo: Shobundō, 1994), 206.

11. Suzuki Toshiyuki, *Tsutaya Jūzaburō*, 24–25.

12. Suzuki Toshiyuki, "The Publisher Tsutaya Jūzaburō and Ukiyo-e Publishing," in Amy Reigle Newland, ed., *The Hotei Encyclopedia of Japanese Woodblock Prints* (Amsterdam: Hotei Publishing, 2005), vol. 1, 175; Allen Hockley, *The Prints of Isoda Koryūsai: Floating World Culture and its Consumers in Eighteenth-Century Japan* (Seattle and London: University of Washington Press, 2003), 87–132.

13. Hockley, *The Prints of Isoda Koryūsai*, 108–12, 225–37.

14. Forrer, "The Relationship between Publishers and Print Formats," 176.

15. Haruo Shirane, ed., *Early Modern Japanese Literature: An Anthology, 1600–1900* (New York: Columbia University Press, 2002), 672–74; the tale, trans. James Araki, is included on pages 674–87.

16. Haruko Iwasaki, "The World of 'Gesaku': Playful Writers of Late Eighteenth Century Japan" (Ph.D. diss., Harvard University, 1984), 98–110, and 191.

17. Nanpo's remarks appear in *Kikujusō*; this text is included in Hamada Giichirō, ed., *Ōta Nanpo zenshū* (Collected works of Ōta Nanpo), vol. 7 (Tokyo: Iwanami Shoten, 1988), 227–35; see also, Matsuki, *Tsutaya Jūzaburō*, 43–45.

18. Cecilia Segawa Seigle, *Yoshiwara: The Glittering World of the Japanese Courtesan* (Honolulu: University of Hawai'i Press, 1993), 145.

19. *Shokusanjin hantori-chō* (Tokyo: Beisandō, 1928), n.p.; also reproduced in Suzuki Toshiyuki, *Tsutaya Jūzaburō*, 70.

20. Iwasaki, "The World of 'Gesaku,'" 183–95; Timothy Clark, "Utamaro and Yoshiwara: The 'Painter of the Green Houses' Reconsidered," in Asano Shūgō and Timothy Clark, *The Passionate Art of Kitagawa Utamaro*, exh. cat. (Tokyo: Asahi Shinbun; and London: The British Museum, 1995), text vol., 38.

21. Kyōden, having twice married apprentice courtesans (*shinzō*), knew many intimate details about the Yoshiwara, and, in later works, commented upon the hardships experienced by the women there employed in *The Other Side of the Brocade* (*Nishiki no ura*), 1790, and *Ten Years of the Bitter World of the Sex Hell* (*Kukai jūnen irojigoku jijo*), 1791.

22. Tsutaya published Sekien's *Tales of Valor Told in Pictures* (*Gazu seiyūdan*), in 1784; see also, Matsuki, *Tsutaya Jūzaburō*, 49–51; Suzuki Toshiyuki, *Tsutaya Jūzaburō*, 152. A small print in Nanpo's *Scrapbook* from about 1782 documents Utamaro's launch into Tsutaya's circle, probably at a party held by the publisher to promote his prodigy. Utamaro kneels with bent head in front of a screen naming the "great gods" who may have been present: the writers Nanpo, Kankō, Enjū, Nandaka Shiran (the *gesaku*, or "playful fiction" alias of the artist Kubo Shunman), Harumachi and Kisanji; the *kyōgen* actor Shiba Zenkō; and ukiyo-e artists identified as Kiyonaga, Kitao and Katsukawa. *Shokusanjin hantori-chō* (Tokyo: Beisandō, 1928), n.p., and Hamada Giichirō, "Shokusanjin hantei-chō" (Shokusanjin's scrapbook), *Ohtsuma Women's University Annual Report* (1970), 2: 99–113. Reproduced in Asano and Clark, *The Passionate Art of Kitagawa Utamaro*, text vol., 38, and Julie Nelson Davis, "Artistic Identity and Ukiyo-e Prints: The Representation of Kitagawa Utamaro to the Edo Public," in Melinda Takeuchi, ed., *The Artist as Professional in Japan* (Stanford: Stanford University Press, 2004), 125.

23. As reported in the 1802 *Ukiyo-e kōsho*, the earliest version of *Ukiyo-e ruikō* (Some considerations of ukiyo-e), begun by Ōta Nanpo, with additions by Sasaya Shinshichi and Santō Kyōden, see Hamada Giichirō, ed., *Ōta Nanpo zenshū* (Collected works of Ōta Nanpo), vol. 18 (Tokyo: Iwanami Shoten, 1988), 445; see also, Hayashi Yoshikazu, *Kitagawa Utamaro: Zoku* (Tokyo: Kawade Shobō Shinsha, 1993), 63, 72, 79, 88.

24. Fuguri Tsurikata, *Kyōka shittari furi* (Know-all-about *kyōka*) (Edo: Manmandō, 1783), n.p. (verso of page 11).

25. Koikawa Harumachi, *The Meeting of the Yoshiwara Great Sophisticates* (*Yoshiwara daitsū-e*) (Edo: Iwatoya, 1784); see also, Clark, "Utamaro and Yoshiwara," 40; Suzuki Toshiyuki, *Tsutaya Jūzaburō*, 73; and Iwasaki, "The World of 'Gesaku,'" 248–56.

26. Suzuki Toshiyuki, *Tsutaya Jūzaburō*, 142; see also, Suzuki Toshiyuki, "The Publisher Tsutaya Jūzaburō and Ukiyo-e Publishing," 177; Clark, "Utamaro and Yoshiwara," 39.

27. Suzuki Toshiyuki, *Tsutaya Jūzaburō*, 144; Suzuki Toshiyuki, "The Publisher Tsutaya Jūzaburō and Ukiyo-e Publishing," 177; Takao Kazuhiko, *Kinsei no shomin bunka* (Early modern mass culture) (Tokyo: Iwanami Shoten, 1997), 322.

28. Shirane, *Early Modern Japanese Literature*, 688.

29. Clark, "Utamaro and Yoshiwara," 40–41.

30. Translation adapted from Timothy Clark, "Utamaro's Erotic Album Utamakura," *Ukiyo-e hizō meihinshū: Utamakura* (Collected masterpieces of treasures of ukiyo-e: *Utamakura*) (Tokyo: Gakken, 1991), iii.

31. Iwasaki, "The World of 'Gesaku'," 358.

32. Uwabo Kuniyoshi, "Bunka gan-nen no shuppan tōsei o megutte—Taikōki no baai" (Taking another look at publishing regulations in the founding year of the Bunka era—the case of the *Taikōki*"), in Nihon daigaku bunri gakubu, *Mishima* (School of Humanities, University of Japan, Mishima) 27 (1978): 75–83; Kornicki, "*Nishiki no ura*," 157.

33. Kornicki, "*Nishiki no ura*," 157–58; Suzuki Toshiyuki, *Tsutaya Jūzaburō*, 229–32.

34. Minami Kazuo, *Edo no fūshiga* (Edo caricatures) (Tokyo: Kōbunkan, 1997), 73–76; see also, Eiko Ikegami, *Bonds of Civility: Aesthetic Networks and the Political Origins of Japanese Culture* (Cambridge and New York: Cambridge University Press, 2005), 319.

35. Kornicki, "*Nishiki no ura*," 157–58; see also, Matsuki, *Tsutaya Jūzaburō* 103–104; Suzuki Toshiyuki, *Tsutaya Jūzaburō*, 234

36. Kornicki, *The Book in Japan*, 239–40, citing Aeba Kōson, "Mukashi no sakusha no sakuryō oyobi shuppan busū" (Publishing circulation and fees for writers of the past), *Aoi* 4 (1910): 1–3.

37. Subsequent prints in the group retained the same formal elements and assertions to observation, but the titles and signatures were changed to *Ten Classes of Women's Physiognomy* (*Fujo ninsō juppon*) and "drawn by Utamaro according to physiognomic theory" (*sōkan Utamaro ga*), respectively; see also, Asano and Clark, *The Passionate Art of Kitagawa Utamaro*, text vol., 100–103.

38. See Davis, "Artistic Identity and Ukiyo-e Prints: The Representation of Kitagawa Utamaro to the Edo Public," 113–51.

39. See Julie Nelson Davis, *Utamaro and the Spectacle of Beauty* (London: Reaktion Books; and Honolulu: University of Hawai'i Press, 2007).

40. *The Light-Hearted Type* is patterned upon a figure called a "young dancer" (*odoriko*); in Kyōden's text she is not quite the lively entertainer the term implies, but is a prostitute passing in the *odoriko* costume. On the connections between Utamaro's sheet prints and Kyōden's book, see Yasui Masae, "Utamaro bijinga to Kyōden *Kyakushu kimo kagami*" (Utamaro's images of beauties and Kyōden's *Mirror of the Punter's Pluck*), *Bijutsushi* (Art history) 51, no. 1 (2002): 20–23; for translations of Kyōden's text on the *kashi* and *odoriko* types, see Davis, *Utamaro and the Spectacle of Beauty*.

41. Asano Shūgō, *Nishiki-e o yomu* (To read *nishiki-e*) (Tokyo: Yamakawa Shuppansha, 2002), 17–23; see also, David Pollack, "Marketing Desire: Advertising and Sexuality in Edo Literature, Drama, and Art," in Joshua S. Mostow, Norman Bryson and Maribeth Graybill, eds., *Gender and Power in the Japanese Visual Field* (Honolulu: University of Hawai'i Press, 2003), 71–88.

42. Matsuki, *Tsutaya Jūzaburō*, 157; Forrer, "Relationship between Publishers and Print Formats," 171–205.

43. Seigle, *Yoshiwara*, 186. The brothel was "classed as an *ōmagaki*, where the full lattice at the entrance went all the way to the ceiling," according to Asano and Clark, *The Passionate Art of Kitagawa Utamaro*, text vol., 127–28.

44. Donald Jenkins, *The Floating World Revisited*, exh. cat. (Portland, OR: Portland Art Museum; and Honolulu: University of Hawai'i Press, 1993), 121.

45. Kobayashi Tadashi, "Kitagawa Utamaro hitsu yūjo hikigotozu ōgimen/The Fan Painting *Courtesan Playing the Koto* Brushed by Kitagawa Utamaro," *Kokka* 1279 (2002): 1.

46. Kobayashi, "Kitagawa Utamaro hitsu yūjo hikigotozu ōgimen," 1.

47. Matsuki, *Tsutaya Jūzaburō*, 150–51.

48. Hamada, ed., *Ōta Nanpo zenshū*, vol. 18, 446; Suzuki Jūzō, *Sharaku*, trans. John Bester (Tokyo and Palo Alto: Kodansha International, 1968). Sharaku may have also been from Osaka, or aware of Osaka actor prints of the period; see John Fiorillo's summary of Sharaku biograpical information: http://spectacle.berkeley.edu/~fiorillo/texts/ukiyoetexts/ukiyoe_pages/sharaku3.html (accessed April 6, 2007).

49. Shun'ei's Sōjūrō, known only in two impressions, was printed with a light blue ground, but the fugitive color has now faded; see Timothy Clark in C. Andrew Gerstle, *Kabuki Heroes on the Osaka Stage 1780–1830* (London: British Museum Press, 2005), cat. no. 42. On Sharaku, see Hamada, ed., *Ōta Nanpo zenshū*, vol. 18, 446, and Suzuki Jūzō, *Sharaku*.

50. Asano Shūgō, "Sharaku no dai-ikki yakusha-e o megutte" (Taking another look at the first period of Sharaku's actor prints), in Asano Shūgō and Yoshida Nobuyuki, eds., *Sharaku*, vol. 3 of *Ukiyo-e o yomu* (To read ukiyo-e) (Tokyo: Asahi Shinbunsha, 1998) 43–47.

51. See the chart included in John Fiorillo's essay on Sharaku cited in note 48 above, (accessed 7 February 2007).

52. Tanaka Yūko, "Tsutaya Jūzaburō no nettowaaku" (Tsutaya Jūzaburō's network), *Tsutaya Jūzaburō no shigoto* (The work of Tsutaya Jūzaburō), *Bessatsu Taiyō*, 89 (Spring 1995): 74–76; see also, Suzuki Toshiyuki, *Tsutaya Jūzaburō*, 238.

53. Kobayashi and Ōkubo, eds., *Ukiyo-e no kanshō kiso chishiki*, 233.

54. Kornicki, *The Book in Japan*, 220.

55. Susan B. Hanley, *Everyday Things in Premodern Japan: The Hidden Legacy of Material Culture* (London: University of California Press, 1997), 161.

56. On the sixth day of the fifth month; see, Suzuki Toshiyuki, *Tsutaya Jūzaburō*, 201.

57. Suzuki Jūzō, *Ehon to ukiyoe: Edo shuppan bunka no kōsatsu* (Illustrated books and ukiyo-e: A study of the culture of Edo publishing) (Tokyo: Bijutsu Shuppansha, 1979), 455.

58. Timon Screech, *The Lens within the Heart: The Western Scientific Gaze and Popular Imagery in Later Edo Japan* (New York: Cambridge University Press, 1996).

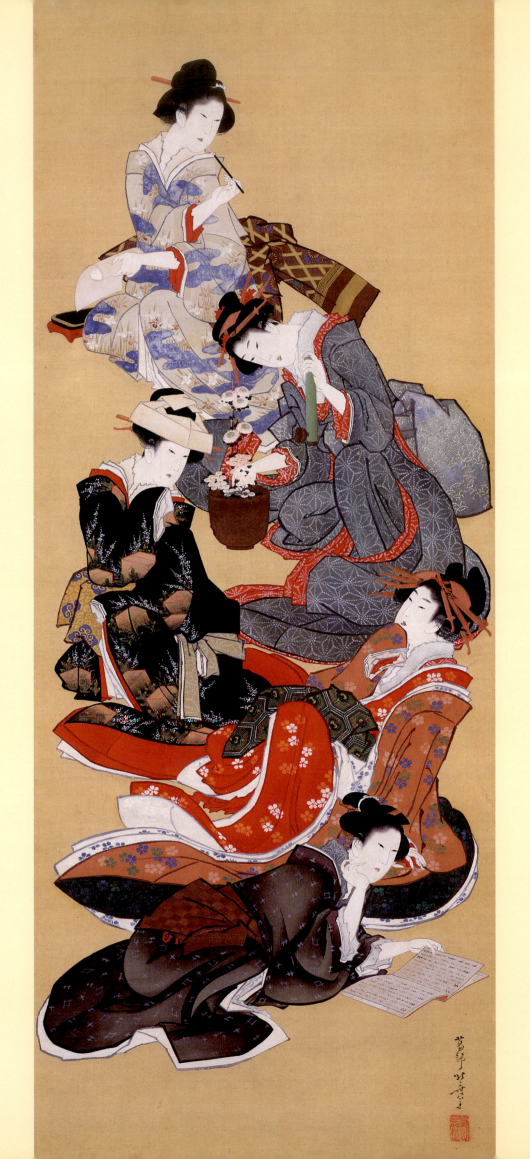

The Literary Network
Private Commissions for Hokusai and his Circle

JOHN T. CARPENTER

Hokusai, a household name in Japan in the artist's own day and worldwide within fifty years of his death, conjures up the iconic *"Great Wave," "Red Fuji,"* or humorous vignettes from *Hokusai Manga* (Random drawings by Hokusai). Rather than discuss these works made for public consumption, this essay focuses on special private commissions carried out by Katsushika Hokusai (1760–1849) and his circle: paintings and woodcuts with poems (*surimono*, literally "printed things"), created for a well-educated, wealthy and aesthetically discerning clientele.[1] In recent years, scholars have been giving greater attention to the sponsorship and enjoyment of ukiyo-e among the samurai stratum and even the imperial court of the late Edo period.[2] Many of the poets who wrote for privately published poetry anthologies and prints (and sometimes wrote verse for paintings) were well-off merchants and samurai who belonged to the same literary circles.

Capitalizing on his early success with deluxe commissions, Hokusai set out to establish a "franchise" based on luxury products much as a modern fashion conglomerate uses couture. The Hokusai studio or, perhaps more accurately, the Katsushika studio (the name the master shared with a number of close pupils) evolved around 1798 and was less formally structured than those of most other ukiyo-e artists of the day. Most of Hokusai's disciples—with the exception of certain female pupils, including his daughters—after a few years of apprenticeship were allowed or encouraged to set off on their own to produce expensive commissioned paintings (fig. 101), luxury *surimono* and lavish illustrated books.

The Hokusai imprimatur on a range of books and prints for wide commercial release was crafted from a reputation made on commissions from a select clientele and from calculated collaborations.[3] In his thirties, during the 1790s, Hokusai expanded into the market for illustrated poem-prints and albums. In the literary circles of this era, social standing meant less than the ability to compose impromptu witty poems, notably *kyōka* (literally, "mad verse").[4] *Kyōka* employed complicated wordplay and allusion to classical East Asian literature as a vehicle for sharing (or showing off) knowledge and wit.[5] The composing and decoding of these poems engendered a vibrant salon culture in which wealthy merchants

Figure 101
Katsushika Hokusai
Five Beauties
1805–13. Hanging scroll; ink and color on silk.
86.4 x 34.3 cm. Seattle Art Museum, Margaret E.
Fuller Purchase Fund, 56.246

and samurai mingled with professional writers and artists, kabuki actors and *rakugo* (humorous monologue) performers, not to mention geisha and courtesans of the various pleasure districts. Members of all social strata who were otherwise segregated could compete as equals with poems. Hokusai was part of this milieu.

As the *kyōka* movement exploded in the early nineteenth century, and as Hokusai's own reputation grew in tandem, it became impossible for him to keep up with private commissions for *surimono*, said to number above a thousand.[6] He was obliged to share his connections and commissions for paintings, books and prints with his closest assistants, including his daughters. Notwithstanding the talent of Hokusai's daughters and other associates, his studio functioned only while Hokusai lived. None of his pupils took on the mantle of heir. Part of the problem of creating a legacy might have been that Hokusai lived so long—to age eighty-nine—that many of his heirs apparent predeceased him or faded away without making a major mark. The Hokusai "label" needed a larger-than-life personality, and there was no one who could rise to the occasion after the master died.

Commissions for Paintings: Hokusai's Luxury Line

Representative of the quality painting that Hokusai offered his wealthiest clients is *Five Beauties* (fig. 101). The signature *Katsushika Hokusai* on this work is a combination of his studio name and art name found on works dating from around 1805 to 1810.[7] Painted on silk, the detailing of garment patterns, a trademark of deluxe ukiyo-e painting, uses expensive pigments made from powders of malachite for the greens, azurite or smalt (made from pulverized deep-blue glass) for the blues and cinnabar for the reds.[8] (The coarse grains of mineral pigments made them unsuitable for woodblock prints.)

The artist arranges a sinuous column of five women in an intriguing hierarchy. At the top, a woman in an elegant robe with iris-marsh motif, an allusion to the Heian-period *Tales of Ise*, is poised with writing brush in hand, symbolizing the importance of calligraphy for a woman of the courtier classes. Just below, the daughter of a wealthy merchant family arranges flowers in a wicker basket; her unplucked eyebrows and trailing *furisode* sleeves indicate that she is still unmarried. The woman with formal headwear (not that of a bride, as proposed by some commentators) is in the employ of a samurai family. Below her, a courtesan sits immodestly in her ostentatious attire. At the bottom, the widow of a merchant (with plucked eyebrows and narrow-sleeved robes of somber color) reads a book, symbolizing literacy. Why Hokusai represented this group—some have read it as representing the Neo-Confucian ideal of "five feminine virtues"—is unclear, but he shows women from various social strata, three of them engaged in artistic pursuits associated with skills expected of a good wife in elite Edo society: calligraphy, flower arrangement and literary interests.[9]

Another important early painting by Hokusai is an immense diptych of the Chinese mythological figure Yu Zhi (J. Gyokushi) gazing toward a dragon soaring through the clouds to bring her a magic, one-stringed zither (fig. 102).[10] Hokusai identified with the goddess as a symbol of artistic creativity; according to legend, when she played her instrument, myriad birds and beasts would flock to her performance. Hokusai impressed this painting with the seal *Shi zōka*, or "My master is creation," that is known from only a few surviving paintings and prints of 1798.[11]

The theme of Hokusai's painting was picked up years later in a *surimono* design by an artist from his circle, Yashima Gakutei (1786?–1868), a talented writer, poet and translator.[12] Here, however, Yu Zhi plays the one-stringed zither as the dragon encircles her (fig. 103). The Chinese immortal in the left panel is not identified in either of the accompanying poems, but he is probably Dong Feng (J. Tōhō), often depicted in Japan as a Chinese scholar-official with a pet tiger.[13] *Dragon and Tiger Diptych* (*Ryūko niban*) was commissioned by poets of the so-called Go (Five) Group, identified in the title cartouche by the archaic form of the Chinese character "five." The leader of the Go Group was Rokujuen (Ishikawa Masamochi, 1753–1830), a wealthy innkeeper, popular writer and poet, who earlier in his career collaborated with Tsutaya Jūzaburō on the production of deluxe poetry anthologies. He was also a noted scholar of National Learning (*Kokugaku*) studies and extremely knowledgeable of traditional Japanese literature.

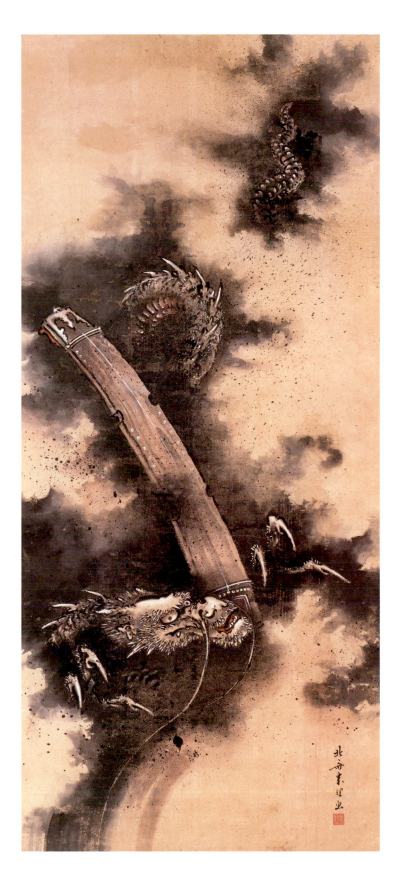

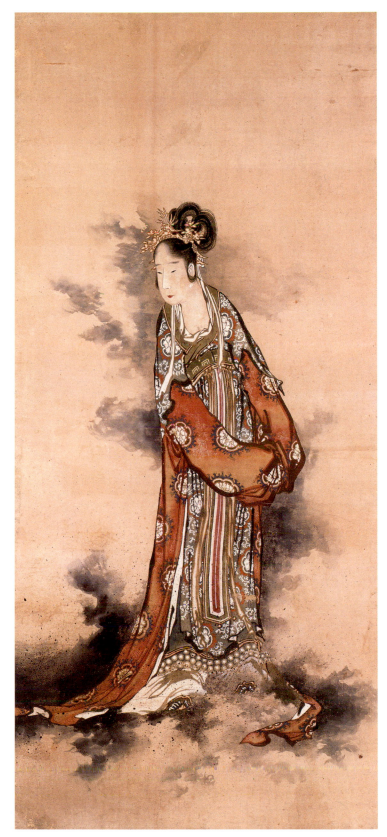

Figure 102
Katsushika Hokusai
The Chinese Immortal Yu Zhi
and a Dragon with Zither
1798. Pair of hanging scrolls; ink and color on
paper. 125.4 x 56.5 cm each. Private Collection

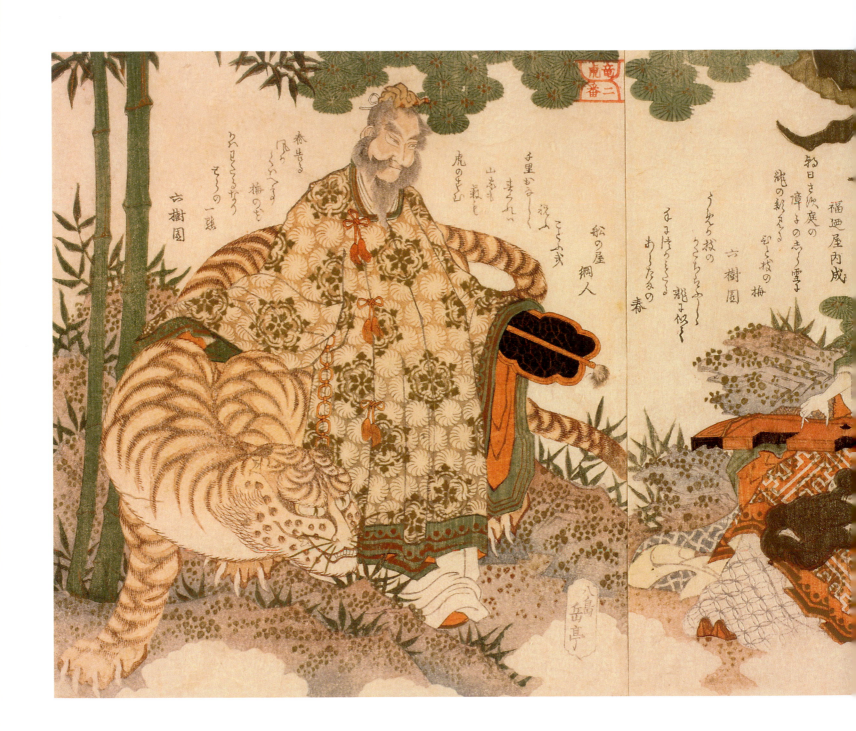

Figure 103
Yashima Gakutei
Dragon and Tiger Diptych (*Ryūko niban*)
[Yu Zhi and a Dragon with the Chinese
Immortal Dong Feng and a Tiger]
1830. Color woodcut, *surimono* diptych. 20.7 x
18.5 cm each. *Surimono* Collection of the
Becker Family

The poems on the right panel of the diptych link plum blossoms with dragon themes. The first is by Fukunoya Uchinari, one of Rokujuen's top disciples:

asahi sasu	As morning sunlight
niwa no shōji no	shines through paper doors
shirayuki ni	to a snow-covered garden,
ryū no kao miru	a branch of plum blossoms
hito-eda no ume	appears as the face of a dragon.
	Fukunoya Uchinari

The second poem is by Rokujuen, and speaks of the plum tree of Kameido Shrine in Edo famous for its gnarled trunk leaning so close to the ground that it was nicknamed the "Crouching dragon":

umegae no	The branch of plum
katachi wa fushishi	resembles the shape
ryū ni nite	of a crouched-over dragon,
te ni tsukamitaru	with a jewel of spring
aratama no haru	firmly clasped in its claws.
	Rokujuen

On the left sheet, the two poems shift to tiger themes, perhaps indicating that the set was issued in spring of Bunsei 13 (1830), a Tiger year. The first poem on the left sheet is read left to right, reverse of normal order:

tora no sumu	In groves where tigers dwell,
yabu mo sanka mo	in mountain retreats as well,
haru kureba	when spring arrives,
senri onajiku	everywhere, for a thousand miles,
iwau kotobuki	people celebrate good fortune.
	Funenoya Tsunahito

Rokujuen contributed the second poem referring to the legend of a mother tiger crossing a river carrying her cubs in her mouth. The verb *kuwaeru* means to "add on to" and to "clench in one's mouth":

haru tsuguru	Carried by the breezes
kaze ga kuwaete	announcing spring's arrival,
ume no hana	a plum blossom is wafted
kawa wataru nari	across the river
tora no itten	in the hour of the tiger.
	Rokujuen

Figure 104
Katsushika Hokusai
The Courtesan of Eguchi as the Bodhisattva
Fugen and the Monk Saigyō
c. 1810–11. Album leaf mounted as a framed
panel; ink and color on silk. 26.4 x 21.5 cm.
John C. Weber Collection

Another painting by Hokusai exemplary for both its brushwork and literary sophistication is *The Courtesan of Eguchi as the Bodhisattva Fugen and the Monk Saigyō* (fig. 104).[14] Viewers understood that this image refers to the legendary exchange between the monk-poet Saigyō (1118–1190) and a courtesan of the town of Eguchi (at the mouth of Yodo River in the Osaka area) who at first refuses to give him lodging for the night. In the Noh version of the episode, the courtesan of Eguchi appears as a ghost and reveals herself in the climax as a manifestation of Fugen. The bodhisattva appears mounted on a white elephant in various Buddhist scriptures and is so depicted in early iconographic manuals, grist for later parodic reworking by ukiyo-e artists.[15]

An eye-catching New Year's *surimono* by Totoya Hokkei (1780–1850) of the same theme, without the monk Saigyō, was commissioned around 1823 by the group of poets who called themselves the Hanazono-ren ("Flower Garden" Circle) (fig. 105).[16]

The three poems on this print make lighthearted allusions to the Noh play.[17] The first two parody the theme of the "temporary lodgings" (*kari no yado*) the courtesan reluctantly gave the traveler Saigyō; the third alludes to the transformation of the Buddhist deity into a beautiful courtesan:

utsukushiki
ume o mikakete
uguisu mo
kari no yadori o
tanomu naruran

haru no yo no
kari no yadori ni
ukareme no
sugata no yanagi
koto no ha no hana

utsukushi ya
hana no sugata no
fugen zō
asahi no beni no
niou kuchibiru

Will the warbler, too,
have to beg for
temporary lodgings
amidst plum blossoms
of enchanting beauty?
 Suikyōtei Umekage

On a spring night
in temporary lodgings,
a courtesan appears,
uttering flowery words,
elegant as leaves of willows.
 Renkidō Kazumasu

What elegance!
The flowery form
of the saintly Fugen,
with lips crimson
as the morning sun.
 Shun'yūtei Umeaki

Figure 105
Totoya Hokkei
***Eguchi*, from *A Series of Noh Plays for the
Hanazono Club* (*Hanazono yōkyoku bantsuzuki*)**
c. 1823. Color woodcut, *surimono* with silver
powder and embossing. 20.9 x 18.4 cm. Collection
of Joanna H. Schoff

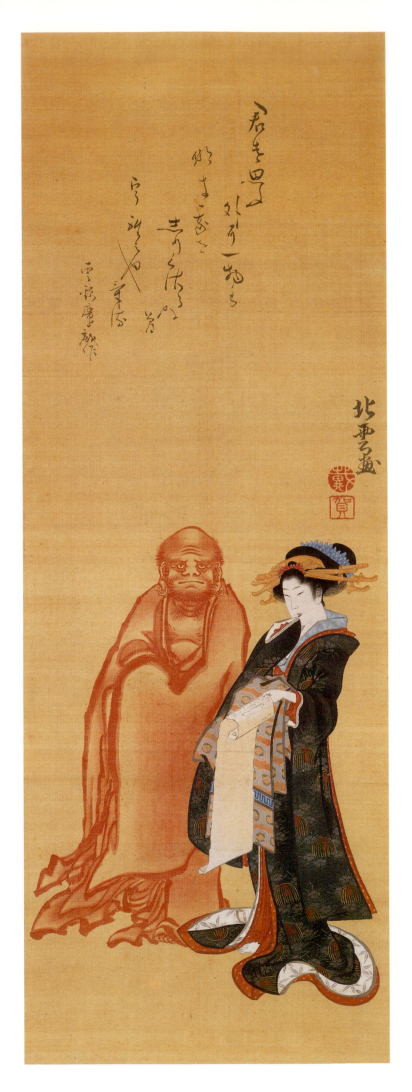

Figure 106
Katsushika Hokuun (act. 1804–44)
Courtesan and Daruma
1820s. Hanging scroll; ink and color on silk.
90.9 x 33.5 cm. Private Collection

Figure 107
Suzuki Harunobu (1725?–1770)
Konoharu of the Ietaya with Daruma Doll and Hanachō of the Iseya with Iris, from Picture Book of Collected Beauties of the Yoshiwara (Ehon seirō bijin awase)
Vol. 1 of 5, fols. 9v–10r. 1770. Color woodblock-printed book. 26.8 x 18 cm each page. Spencer Collection, The New York Public Library, Astor, Lenox and Tilden Foundations, Sorimachi 431

This witty transformation of saint and sinner in Edo popular culture had appeared in ukiyo-e prints by the early eighteenth century. The talented Hokusai assistant Katsushika Hokuun (act. 1804–44) created his own rendition of the theme (fig. 106).[18] He paired a courtesan with Bodhidharma (J. Daruma) in red monochrome in frontal pose with a conspicuously priapic contour. His companion holds an unrolled love letter and coyly raises her sleeve to her lips. In Edo parlance, courtesans were sometimes called *daruma* after the roly-poly dolls with Daruma face and torso that recall the legend of the master's loss of his legs during nine years of meditation. The idea was that a prostitute, after rolling around with a client, bounces up quickly just like a *daruma* doll, just as the one depicted beside a Yoshiwara courtesan in a Harunobu book illustration of 1770 (fig. 107).

The racy poem says that Bodhidharma not only lost his legs, he lost his *ichimotsu*, slang for penis. *Shiri-kusaru* is both "my ass has decomposed" and slang for knowing another person's intimate thoughts:

kimi o omou	As I meditate on nothing
hoka ni ichimotsu mo	other than you, I'm ashamed
naki ware o	that you know my real mind.
shiri kusaru koso	Alas, not only have I lost my prick
urami narikeru	but my ass has rotted away.
Unkin sekijō gesaku	Playfully composed by Unkin at a party

The signature brushed "at a party" (*sekijō*) informs us that social gatherings of writers and artists were hardly sedate, however illustrious the participants. Unkin is the pen name of Kamo no Suetaka (1752–1842), another prominent scholar in the National Learning movement who was also active in the poetry world.[19]

The Poetry Connection: Hokusai and Kyōden

One of the Edo literati with whom Hokusai and his circle worked closely was Santō Kyōden (1761–1816), a poet, popular writer and owner of a shop that specialized in pipes and smoking accessories, such as stylishly decorated paper tobacco pouches (fig. 110). A print of an outdoor scene drawn by Hokusai and Kyōden likely was issued in the spring of 1798, the Year of the Horse (fig. 108).[20] The *surimono* is in the large format (though with the text half now missing). The right foreground image, by Hokusai, shows women gathering spring herbs. The picture by Kyōden, on the left, shows a pair of peasant women from Ohara, north of Kyoto, who sold charcoal sticks for a living, with their packhorse. One woman conspicuously smokes a pipe, a reminder of Kyōden's main source of income.

Between 1795 and 1810, along with paintings in meticulous style, as described above, Hokusai made beauty paintings in a spontaneous, abbreviated mode for members of Edo literary circles.[21] Although the popular writers and ukiyo-e artists treated Chinese-inspired literary and artistic themes quite differently from their literati counterparts, they shared an interest in more intimately expressive paintings. Hokusai's courtesan leaning on a brazier dates from around 1800 (fig. 109).[22] The poem above her alludes to smoking, so we assume she holds a pipe. Her hair, rendered with comparatively rough, dry strokes, is knotted in a double-chignon in a Hyōgo coiffure popular among courtesans. Ink washes and pale red tints fill in the outlines.

The poem was written and inscribed by Kyōden. His text loosely takes the form of a Chinese poem that has been translated into Japanese. Kyōden assumes the voice of the courtesan:

sui-tsuke tabako no kumo to nari	Sometimes I turn into a cloud like smoke from tobacco I have lit,
itsuzuke biyori no ame to naru	other times I turn into rain, which makes a client linger a bit.
yogi no uchi, futon no ue	Atop a futon mattress, wrapped in quilted blankets,
isshō no kankai kore ippan	I while away my time like this: a lifetime of pleasant banquets. Seiseisai Kyōden and sealed Hasanjin

The verse cleverly exposes the material concerns of a man who made his living selling pipes and tobacco accessories in order to pay his enormous bills in the pleasure quarters (he married twice, both times to former courtesans). The juxtaposition of rain and clouds connotes

Figure 108
Katsushika Hokusai and Santō Kyōden
Gathering Spring Herbs and Brushwood
Peddlars from Ohara
Probably spring, 1798. Color woodcut, *surimono*.
19.6 x 53 cm. The Art Institute of Chicago,
Gift of Helen C. Gunsaulus, 1954.643

Figure 109
**Katsushika Hokusai, with
inscription by Santō Kyōden**
Reclining Courtesan
c. 1800. Hanging scroll; ink and light color
on paper. 29.2 x 44.8 cm. Collection of Peter
Grilli and Diana Grilli

sexual intercourse, a convention of classical Chinese poetry. The poet suggests that in the world of the Yoshiwara pleasure quarters, amorous affairs dissipate just as burnt tobacco turns to smoke, or as clear weather turns to rain. The ambiguous moral of the poem may underlie the attitude espoused by "floating world" aesthetics that the very transience of a sensuous experience is part of its pleasure.

It is well documented that Kyōden, who briefly worked as an ukiyo-e artist under the name Kitao Masanobu, made extra money at his shop inscribing and selling fans with his distinctive calligraphy and drawings. Alternatively, a painting such as this one by Hokusai might have been made during a calligraphy-painting gathering (*shogakai*). Most guests paid a fee to attend, and the host and/or guests remunerated artists and calligraphers for collaborative works.[23] The 1795 portrait of Kyōden by Chōkyōsai Eiri (act. 1790s–early 1800s) shows him holding a fan of the type he inscribed for clients in his shop (see fig. 110). The seventeen-syllable humorous verse (*senryū*) inscribed on the fan reads:

Saigyō mo	Even Saigyō
mada minu hana no	never saw such blossoms
kuruwa kana	as in the flowery pleasure quarters.
	Kyōden[24]

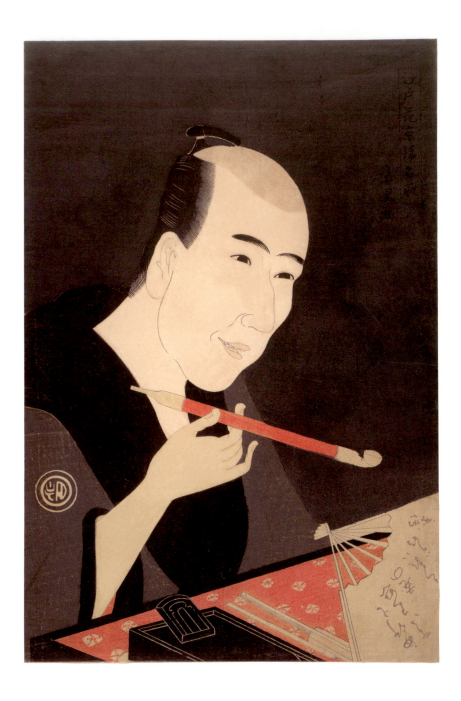

The verse recalls that the poet-monk Saigyō, featured in the Hokusai painting in figure 104, was famous for his fondness for cherry blossoms. It also teases that even though he may have encountered the beautiful courtesan of Eguchi, he could have never imagined the charming "flowers," or courtesans, of the Yoshiwara.

Kyōden regularly added witty Chinese and Japanese poems to paintings by prominent ukiyo-e artists. This was a means of "customizing" a painting for a special client. A *kyōka* in his distinctive hand appears on a painting by Utagawa Toyohiro (1773?–1828) of a geisha with a samisen pensively gazing out over a moonlit view of Edo Bay (fig. 111). The poem suggests the setting is a summer evening at a teahouse in Takanawa, in the southwest of the city (present-day Minato ward). Kyōden alludes to the ancient poetic expression of the "boat of the moon" (*tsuki no mifune*), to intimate that the moon is just setting sail, or rising, as sailboats retire:

suzushisa wa	As a place to enjoy refreshing coolness,
na ni Takanawa no	Takanawa has earned high esteem
natsu zashiki	for its reception rooms in summer,
tsuki no defune ni	when the breezes bring boats into harbor
kaze no irifune	as the boat of the moon sets sail.
	Santō Kyōden and sealed Hasanjin

Figure 110
Chōkyōsai Eiri
Flowers of Edo: The Master of Kyōbashi
(*Edo no hana Kyōbashi natori*)
c. 1795. Color woodcut with mica ground. 39.1 x 26 cm. The Metropolitan Museum of Art, The Howard Mansfield Collection, Purchase Rogers Fund, 1936, JP 2419

The master of Kyōbashi, the heart of Edo city, is the popular writer, artist and man-about-town Santō Kyōden (see also figs. 10, 85, 100, 108, 109, 111).

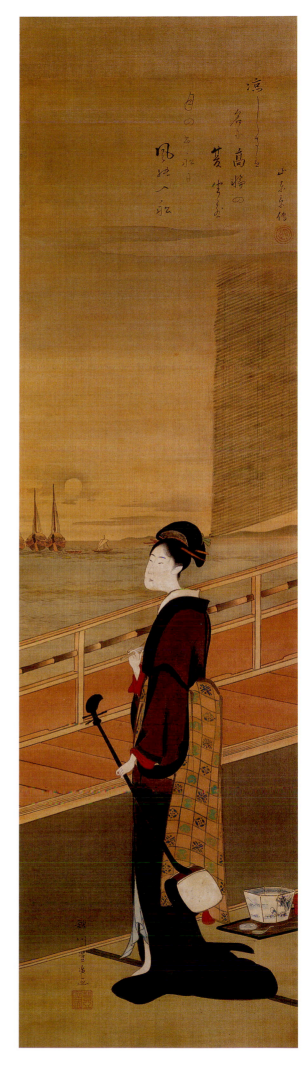

Figure 111
**Utagawa Toyohiro, with
inscription by Santō Kyōden**
Beauty Enjoying the Evening Cool
c. 1805. Hanging scroll; ink and color on silk.
99.5 x 27 cm. Gitter-Yelen Collection

Privately Published Prints by the "Man Mad about Drawing"

"Gakyōjin," literally "man mad about drawing," was one of the art names Hokusai started using around the turn of the century. Since "Gakyōjin Hokusai" is used almost exclusively on private commissions, it may be seen as the artist's first concerted attempt at the "branding" of his name and style at the upper end of the publishing market.[25]

An elegant but playful *surimono* signed *Gakyōjin Hokusai* of two Chinese boys watching a mother tiger transporting her cubs across a river celebrates the year of the tiger, 1806 (fig. 112). The surface of the water is patterned with rhythmic embossing that echoes the stripes on the tigers' fur. Chinese legend tells of three rambunctious "tiger" cubs, one of them spotted like a leopard as here, which always tried to attack the other two. The mother tiger had to devise a way to get all three across without leaving the miscreant cub alone with his siblings. She is said to have solved her dilemma by crisscrossing the river seven times by rotating the cubs. Hokusai's answer was simply to place the spotted cub on the mother's back. Here, he looks docile and terrified, as if his mother has threatened to toss him in the water if he does not behave.

The third of the three poems on the tiger print (far left) is by Shibanoya Sanyō (d. 1836), a prominent *kyōka* master who had been active since 1796 as a poetry judge (*hanja*) of the Yomo-gawa ("Four-directions" Group). The little hollow circle above his name in the sixth line from the left is probably a convention borrowed from *kyōka* anthologies to indicate that the poet was an honorary guest for a poetry compilation (and thus did not have to pay to be included). The first poem links the fragrance of plum blossoms to the legend of the tigers crossing the river:

mizu o oyogu	Before the tigers
tora yori saki e	can swim across the water,
saku ume no	the scent of plum
kawa mukō made	has drifted to the far shore,
watasu harukaze	carried by spring breezes.
	Sankyōtei Muraji[26]

The next poem alludes to the saying "the fox borrows the tiger's courage" (*tora no i o karu kitsune*), which refers to someone trying to claim for himself another person's glory. Here, it

Figure 112
Katsushika Hokusai
Chinese Boys Watching Tigers Cross a River
1806. Color woodcut, *surimono*. 14 x 19.3 cm.
The Frank Lloyd Wright Foundation, Scottsdale, AZ, 3002.102

Figure 113
Katsushika Hokusai
Chinese Boys Watching Tigers Cross a River
1806. Color woodcut, *surimono*. 18.5 x 14 cm.
Private Collection

suggests that plum does not need to pretend to be a warrior like Katō Kiyomasa (1562–1611), a general famous for his tiger-slaying exploits in Korea:

tora no i o	Plum blossoms need not
karade no ume wa	put on tiger skins,
mononofu no	pretending to be warriors,
yomo ni nioeru	to spread their scent everywhere,
haru no Kiyomasa	like a Kiyomasa in spring.
	Shingyokutei Toshinami

The final poem, by the above-mentioned Shibanoya Sanyō, conjures up an image of a large kite painted with a tiger in bamboo. The poem refers to another expression, "when the tiger roars, the winds howl" (*tora usobukeba kaze sawagu*). Early morning winds are said to rise up at the hour of the tiger, around four A.M. Continuing the complex wordplay, the expression *hyō hyō*, onomatopoeia for the sound of wind, reminds us that *hyō* means leopard in Japanese, a link to the spotted "tiger" cub of legend shown here on the mother tiger's back. Tigers and leopards were mistakenly thought to be male and female of the same species in premodern Japan. The poem reads:

karatake ni	A tiger, painted
tora o egakeru	amid Chinese bamboo
ōdako no	on a large kite,
hyō hyō to fuku	roars in the wind
kaze ni usobuku	as it howls and howls.
	Shibanoya Sanyō

The suitability of the image for a New Year's *surimono* in the year of the tiger made it possible for a fourth poet to reuse the image blocks for a second edition of the *Tigers* print by inserting a different text block (fig. 113). This second *Tigers* impression has a poem signed *Koshōrō Tsuru no Kegoromo*, an otherwise unknown poet.[27] Unlike the three rather clever poems—full of erudite wordplay—contributed by Shibanoya and his pupils, the single replacement poem comes across as a generic New Year's greeting, and would have worked with any image on a tiger theme:

kara yamato	Everywhere, for a thousand miles,
senri mo onaji	on the continent and in Japan,
onkoto ni	the blessings of the New Year
kakaru kasumi ya	of the tiger arrive,
tora no hatsu haru	wrapped in spring mists.
	Koshōrō Tsuru no Kegoromo

The poem compresses allusions to the Japanese sayings "the same winds blow across a thousand miles" (*senri dōfū*) and "the same wind brings blessings to all" (*dōfū onkoto*), both auspicious references. The phrase "a thousand miles" (*senri*) also calls to mind the expression "a tiger journeys a thousand leagues, and returns a thousand leagues" used to describe a strong-willed person who finishes what he or she starts—just like Hokusai's efficient mother tiger.

This delightful design of boys watching tigers on a spring day is just one of over a hundred *surimono* signed "Hokusai, the man mad about drawing," and just one of more than a thousand that the artist created in the course of his long life. Hokusai's early domination of the business of privately published woodblock prints, and the wide-ranging networks of clients in literary circles it helped generate, was the foundation of his subsequent success in mass-market printmaking and book illustration.

Hokusai's Daughters and the Katsushika Studio

Hokusai habitually used dual-name signatures, or a combination of former and current art names. He was known as Shunrō until 1795 at the age of thirty-five, when he broke ties with the Katsukawa studio and received the art name Sōri from a Rinpa master. Throughout his subsequent career, he adopted new names to mark turning points in his personal life: Hokusai, when he turned forty; Taitō just after he turned fifty; Iitsu (to become one again) when he crossed his sixtieth year, the year of the dragon when he was born; Manji, meaning eternity, when he was in his seventies and eighties, and several others. Yet Hokusai remained an enduring "brand name" that the artist held on to throughout his artistic career, and even when he adopted new names he commonly appended to his signature "formerly known as Hokusai" or "Hokusai, changed to. . .". The renowned "*Great Wave*" of around 1831 was signed "Drawn by Iitsu, changed from Hokusai" (*Hokusai aratame Iitsu hitsu*) (see fig. 127). Even after he stopped using Hokusai as his primary art name in 1810, publishers insisted that they be allowed to continue to use it to sell his woodcuts and books.

Hokusai took on many assistants, though only a few made names for themselves, and usually as painters or *surimono* designers.[28] They all helped promote the "couture" line of Hokusai products. At least five disciples inherited one of the master's full art names.[29] Over two hundred other pupils, many of whom must have been amateurs who had only temporary affiliation with the master, were granted art names incorporating the characters "Hoku," "Shin" (also pronounced "Tatsu," meaning dragon), "Tai," or "I," all characters from the art names the master had used at different stages of his career. "Hoku," the character for "North," was especially associated with the master's great popularity as the originator of *Hokusai Manga*.

Certain disciples—including Hokumei, Hokuun, Hokusai II, Taitō II, Iitsu II, Isai and his own daughters—were allowed to use "Katsushika" in their signatures. It seems to have been reserved for associates who had prolonged affiliation with the studio or who helped the master directly with illustration work and paintings. They were members of the Katsushika studio and an extended family of sorts for Hokusai.

Reliable biographical information of Hokusai's progeny is scarce, but some can be gleaned from *The Life of Katsushika Hokusai* (*Katsushika Hokusai den*), a biography of the artist published in 1893 by Iijima Kyoshin.[30] Hokusai had two sons, one by each of his two wives, but both were sent out for adoption, a common practice among plebeian families as a means of bringing in extra income (Hokusai himself was an adopted child). Neither was slated to follow in his father's footsteps. Instead, Hokusai turned to a daughter who signed her work "Tatsujo," or "daughter of the dragon."[31] Sometime in the 1810s Hokusai awarded

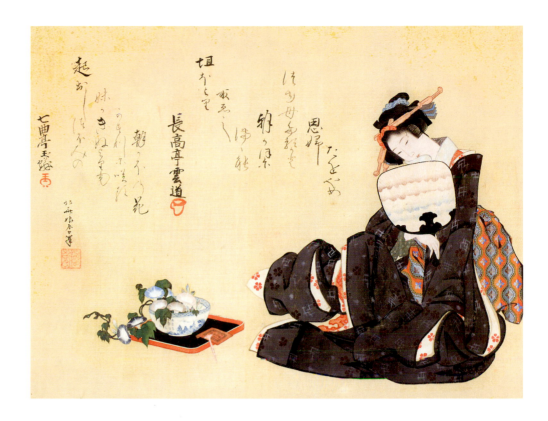

Figure 114
Katsushika Tatsujo
Woman with Morning Glories
c. early 1820s. Hanging scroll; ink and color
on silk. 34.2 x 44.8 cm. Los Angeles County
Museum of Art, Ernest Larsen Blanck Memorial
Fund, 58.26.1

her not one, but two, of his seals, *Yoshinoyama* (Mount Yoshino) and *Fumoto no sato* (Village at the foot of the mountain), which she used until the late 1820s.[32]

A painting of a young woman looking at a bowl of morning glories is signed "Painted by Tatsujo, daughter of Hokusai" and impressed with the *Fumoto no sato* seal (fig. 114). The two poems by Shichikyokutei Tamaari and Chōkōtei Kumomichi were probably added close to the time the painting was made, datable to the early 1820s. Read from left to right, reverse of normal order, the poems lead the eye toward the woman, rather than away from her. They use the metaphor of the *asa-gao* (literally, "morning face," or morning glory) to allude to the beauty of the young woman. In the first poem, *imo*, or "little sister," is a term of affection a man would use to refer to a young mistress or teenage courtesan. The second poem suggestively likens the maiden to a moist blossom that has been recently plucked. The poems read:

oki-ideshi	Still in the bud of youth,
tsubomi no imo ga	my "little sister" has just woken,
kinu yori mo	and on her silk robes,
kasuri ni sakeru	woven with splashed patterns,
asagao no hana	morning glories burst into bloom.
	Shichikyokutei Tamaari

kakiho yori	The young maiden
torieshi mama no	resembles a morning glory,
asagao ni	just now plucked
tsuyu motaru ka to	from the hedgerow,
omou taoyame	still moistened with dew.
	Chōkōtei Kumomichi

Other than a handful of paintings and book illustrations dating no later than the late 1820s, Tatsujo is a mystery.[33]

Katsushika Ōi (Ōei or Ei, c. 1800–c. 1866) was the youngest daughter from Hokusai's second marriage and appears to have lived and worked with her father in the last two decades of his life, the 1830s and 1840s.[34] Ōi had been married to an artist.[35] Not long after her

mother's death in 1828, she divorced her husband and returned to care for her aging father. Her art name Ōi incorporates the character "I" from Hokusai's art name, Iitsu, and literally means "being responsive to I[itsu]." There is no doubt that Ōi was instrumental in the maintenance of their artistic livelihood at a time when many of the early pupils had gone off on their own, retired or died. A *surimono* that many have taken to be a self-portrait of Hokusai as a fisherman dates to around the time Ōi returned to live with her father, and features *hokku* (seventeen-syllable poems) by father and daughter (fig. 115). The poem by Ōi reads:

kono haru wa　　　　　　This coming spring
tsuki no katsura o　　　　break off a branch
oru bakari　　　　　　　of the *katsura* tree in the moon.
　　　　　　　　　　　　　　Ei

The cryptic phrase "break off a branch of the *katsura* tree in the moon" derives from an ancient Chinese expression meaning to pass the civil service examination; in Japan, it took on the broader meaning of a young man "bringing honor to his family" by coming of age or getting married. It also calls to mind a famous thirty-one-syllable court verse (*waka*) with the identical phrase by the mother of Sugawara no Michizane (given name unrecorded; d. 872), written after her son's coming-of-age ceremony: "Now that you have broken the branch of the *katsura* tree in the moon, the winds will bring honor to our family." Ōi's poem references the ancient one, and suggests that she too is commemorating something that will bring happiness to the family, but she does not state what that might be.

The second poem, signed with Hokusai's poetry name "Manji," is equally cryptic:

hama suna ni　　　　　　On the sandy beach
omo mezurashiki　　　　admire the rarely-seen face
yomena kana　　　　　　of a "bride grass" aster.
　　　　　　　　　　　　　　Manji

Since "aster" is written with the characters for "bride grass," we assume that Hokusai refers to meeting an unidentified bride. This pair of poems may refer to the coming-of-age and marriage of one of Hokusai's grandsons, or an event of similar significance to the Katsushika household. Whatever the occasion, the collaboration on this *surimono* is symbolic of the close working relationship between father and daughter.

A memoir by Saitō Gesshin (1804–1878), an Edo city administrator, describes the Hokusai studio around 1848 and the significant role Ōi played in it:

> Katsushika Hokusai has used a number of names, including Raishin, Sōri, Shunrō, and Taitō; now it is Iitsu that he goes by.[36] This year, the first year of Kaei [1848], he turned eighty-nine [by Japanese count], but his health is good, and he walks without difficulty. He wears glasses when he draws. Even now he does very fine, detailed work. He has moved dozens of times, always to another small rented house. His youngest daughter Ei [Ōi] resembles her father—instead of washing the dishes after a meal, she just leaves them lying around without thinking twice about it. She was married to the ukiyo-e artist Nantaku [Minamizawa Tōmei], but divorced him and now lives with her father. She is about fifty years old. She paints and has done many designs for woodblock prints published under the name Iitsu.[37]

The revelation that Ōi was behind work signed "Iitsu" should serve as an incentive to future research on the issues surrounding collaboration on Hokusai prints. Hokusai evidently took credit for Ōi's work, the same way that Ralph Lauren may put his name or Polo emblem on clothes conceived of, and produced entirely by, assistants. Hokusai used the name "Iitsu" from 1820 to the mid-1830s—including on prints in the landmark series *Thirty-six Views of Mount Fuji*—but Ōi worked closely with her father from around 1829 until his death in 1849. She also traveled with him when he left Edo for trips to Obuse in what is now Nagano

Figure 115
Katsushika Hokusai
Fisherman Sitting on a Rock by the Sea
Early 1830s. Color woodcut, *surimono*. 21.3 x 18.4 cm. The Art Institute of Chicago, Gift of Helen C. Gunsaulus, 1954.625

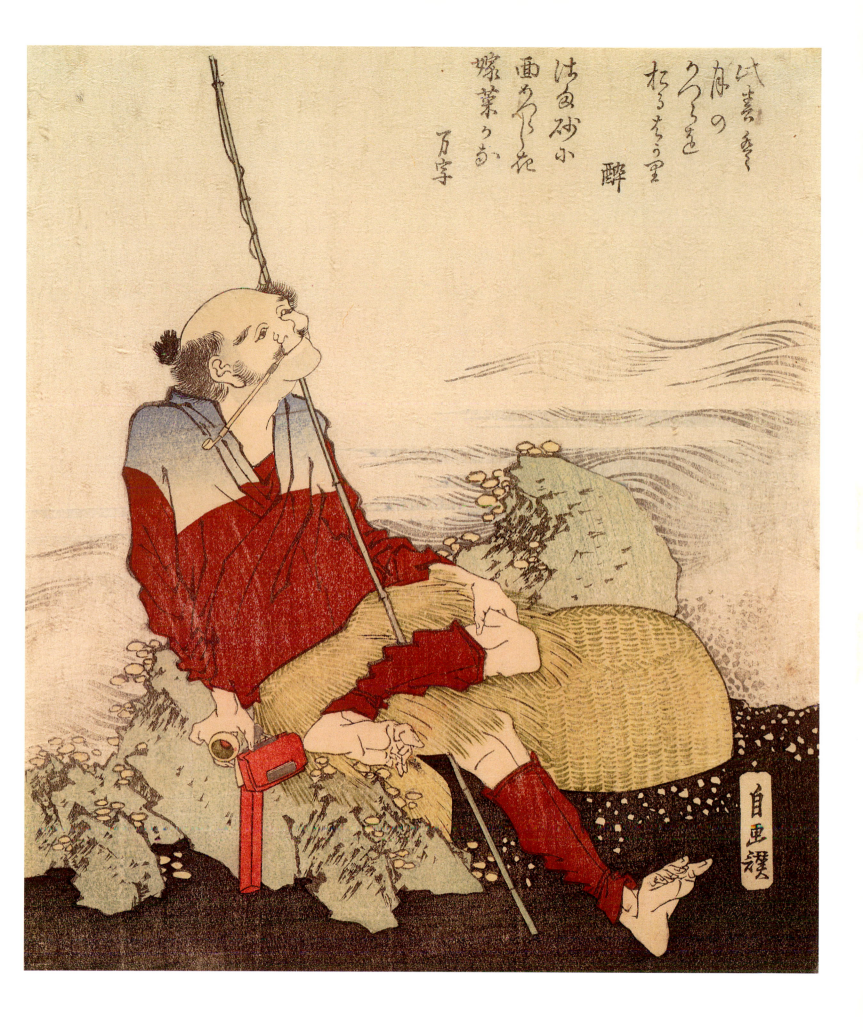

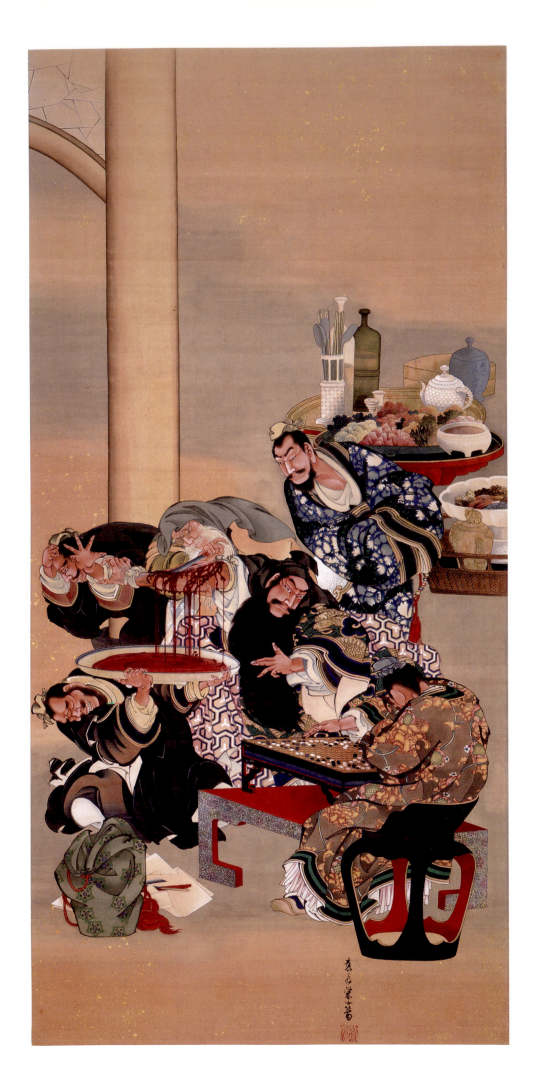

Figure 116
Katsushika Ōi
Operating on Guan Yu's Arm
1840s or early 1850s. Hanging scroll; ink, color
and gold leaf on silk. 140.2 x 68.2 cm. Cleveland
Museum of Art, Kelvin Smith Fund, 1998.178

Prefecture. There were short trips beginning in 1835 and longer visits at the end of his life in 1844 and 1845 on the invitation of Takai Kōzan, Hokusai's primary patron there.[38]

After Hokusai's death, Ōi continued painting to make a living for at least several years. A number of luxury-line paintings survive that are either signed by her or plausibly attributed to her. Among the most outstanding works with Ōi's signature are the meticulously detailed *Three Women Playing Musical Instruments* in the Museum of Fine Arts, Boston, and the gruesome *Operating on Guan Yu's Arm* in the Cleveland Museum of Art (fig. 116).[39]

A Happy Lion

A famous sketch of Hokusai's "temporary lodgings" made by his disciple Tsuyuki Iitsu II (d. 1893) some years after Hokusai died in 1849, shows the old master, kneeling under his futon, still painting, while Ōi looks on (fig. 117). Between the figures on the wall is a sign reading: "Under no circumstances will commissions for albums or fan paintings be accepted," signed *Miura Hachiemon*, the plebeian-sounding name Hokusai used at the end of his life. Both father and daughter were immersed in book illustration, including the later volumes of *Hokusai Manga*. Only in the late 1840s do we find Ōi signing her name to illustrated books.[40] We also presume that Hokusai's 1848 *Treatise on Coloring* (*Ehon saishiki-tsū*), a compendium of drawing and painting techniques, relied to a great extent on Ōi's input.[41] Hokusai is reputed to have said, "My paintings of beauties (*bijinga*) are no match for those by Ōi. She paints remarkably well, and is skilled in drawing methods (*gahō*)."[42]

Near the end of his life, from late 1842 through the end of the following year, Hokusai made hundreds of ink drawings of mythological Chinese lions and dancers costumed as lions as talismans against infirmity and old age. Over two hundred such drawings survive, most of which were originally collected together in an album known as the *Daily Exorcisms* (*Nisshin joma*). When one of Hokusai's clients, Miyamoto Shinsuke, called on the artist to

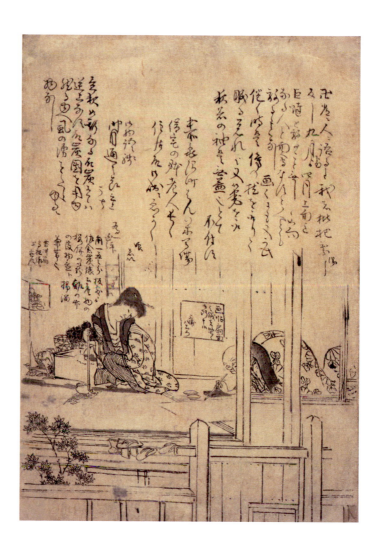

Figure 117
Tsuyuki Iitsu II
Hokusai and Ōi in their "temporary lodgings"
of the mid-1840s
Probably late 1880s. Ink on paper. 25 x 17 cm.
National Diet Library, Tokyo

Figure 118
Katsushika Hokusai
Crouching Lion, from *Daily Exorcisms*
(*Nisshin joma*)
1843. Ink on paper. 24.1 x 34.2 cm.
Private Collection

ask what had become of a painting he had commissioned, Ōi suggested that they present him with the album of lion drawings in lieu of the painting.[43] On the dedication page of the album, addressed to Kuninoya, a pseudonym of Miyamoto, Hokusai remarks: "I refer to these drawings, which I tossed off morning after morning, as my 'Daily Exorcisms.' Now that you, my esteemed patron, have accepted them as a commission, I worry that future generations will only be amused at my humble efforts." He signed this page *Miuraya Hachiemon* and sealed it *Katsushika*.

The dynamic lion drawings show the animals in various poses, many of them with anthropomorphic qualities. Almost all are dated with month and day—sometimes Hokusai did more than one on the same day—and several have inscriptions in the artist's hand. The drawing illustrated here (fig. 118), dated the twenty-fifth day of the twelfth month of Tenpō 14 (1843), the final drawing in the album as it survives today, is accompanied by a humorous poem punning on the word *shishi* (lion) that nicely sums up Hokusai's attitude in his final years:

ri ni mayou	At the year's end,
hito no shiwasu wa	those obsessed with profit
isoga-shishi	are busy lions, but I,
yoku o sutetaru	who have discarded greed,
ware wa tano-shishi	am a happy lion.

In the preparation of this essay I am deeply indebted for advice, as always, to Akama Ryō, Ikezawa Ichirō, Iwata Hideyuki, Kobayashi Fumiko, Kubota Kazuhiro and Sakai Gankow. Alfred Haft read through and commented on an earlier draft. I would also like to thank the Sainsbury Institute for the Study of Japanese Arts and Cultures for their support of research that contributed to this essay.

Notes

1. For more information on cultural contexts of *surimono* production, see Roger Keyes, *The Art of Surimono: Privately Published Japanese Woodblock Prints and Books in the Chester Beatty Library, Dublin* (London: Sotheby, 1985), vol. 1, 13–40; see also Asano Shūgō, trans. by Timothy T. Clark, "An Overview of Surimono," *Impressions* 20 (1998): 17–37.

2. Issues of elite patronage of ukiyo-e are addressed in Naitō Masato, *Ukiyo-e saihakken: Daimyō-tachi ga medeta ippin zeppin* (Rediscovering ukiyo-e: Masterworks admired by daimyo) (Tokyo: Shōgakukan, 2005). For a discussion of court patronage of ukiyo-e, including the circumstances behind the commissioning of a Hokusai painting now in the Sannomaru Shōzōkan (Museum of the Imperial Collections), see Imahashi Riko, *Edo kaiga to bungaku: "byōsha" to "kotoba" no Edo bunkashi* (The art of describing in Edo Japan: Painting and literature) (Tokyo: Tōkyō Daigaku Shuppankai, 1999).

3. The Hokusai name eventually extended to "mass-market" in his commercial landscape prints, how-to-draw manuals and illustrations for novels, but these aspects of the master's diverse and prolific career have been well covered in other studies. See Richard Lane, *Hokusai: Life and Work* (New York: E. P. Dutton, 1989); Matthi Forrer, with texts by Edmond de Goncourt, *Hokusai* (New York: Rizzoli, 1988); and John T. Carpenter, ed., *Hokusai and His Age: Ukiyo-e Painting, Printmaking and Book Illustration in Late Edo Japan* (Amsterdam: Hotei Publishing, 2005).

4. For a discussion of Tenmei literary salon culture and the *kyōka* movement, see Haruko Iwasaki, "The World of 'Gesaku': Playful Writers of Late Eighteenth-century Japan" (Ph.D. dissertation, Harvard University, 1984). See also John T. Carpenter, "*Kyōka* and Ukiyo-e Print Designers," in Amy Reigle Newland, ed., *The Hotei Encyclopedia of Japanese Woodblock Prints* (Amsterdam: Hotei Publishing, 2005), vol. 1, 170–74.

5. For a discussion of the literary aspects of *surimono*, see John T. Carpenter, "Ways of Reading Surimono: Poetry-Prints to Celebrate the New Year," in Joan B. Mirviss with John T. Carpenter, *The Frank Lloyd Wright Collection of Surimono*, exh. cat. (New York: Weatherhill; Phoenix, AZ: Phoenix Art Museum, 1995), 36–59; see also, Daniel McKee, "Leaves of Words: Examining the Art of Surimono as a Poetic Practice," in Daniel McKee, *Japanese Poetry Prints: Surimono from the Schoff Collection*, exh. cat. (Ithaca, NY: Herbert F. Johnson Museum of Art, 2006), 9–33.

6. See Kubota Kazuhiro, trans. John T. Carpenter, "The 'Surimono Artist' Hokusai in the Society of Edo Kyōka Poets," in Carpenter, ed., *Hokusai and His Age*, 181–82.

7. The seal reading *Kimō dasoku* (Fur on a turtle, legs on a snake) is associated with Hokusai's finest beauty paintings of his forties. See Naitō Masato, "Manipulation of Form in Hokusai's Paintings of Beauties," in Carpenter, ed., *Hokusai and His Age*, 73–74.

8. For pigments in early modern Japanese paintings, including some by Hokusai, see Elisabeth West Fitzhugh, John Winter and Marco Leona, *Studies Using Scientific Methods: Pigments in Later Japanese Paintings* (Washington, D.C.: Freer Gallery of Art, Smithsonian Institution, 2003). Ukiyo-e artists also used organic pigments in deluxe paintings. Hokusai and his studio used special coloring techniques in deluxe paintings, such as treating the reverse side of silk to create painterly effects; see Philip Meredith and Tanya Uyeda, "Mountings and Painting Techniques of Ukiyo-e Hanging Scrolls," in Anne Nishimura Morse, ed., *Drama and Desire: Japanese Paintings from the Floating World, 1690–1850*, exh. cat. (Boston: Museum of Fine Arts, 2007), 223–27.

9. Martie W. Young and Robert J. Smith, *Japanese Painters of the Floating World*, exh. cat. (Ithaca, NY: Andrew Dickson White Museum of Art, Cornell University; Utica, NY: Munson-Williams-Proctor Institute, 1966), no. 69.

10. The one-stringed zither (*ichigenkin*) in its present form was introduced to Japan from China in the third quarter of the seventeenth century. According to David Waterhouse, in "Chinese Music in Pre-Modern Japan," *Hanguk Umak-sa Hakpo/Journal of the Society for Korean Historico-Musicology*, vol. 11 (Dec. 1993): 521–76, it was popularized by Kakuhō (1729–1815), a learned monk from the Tendai monastery Kongōrinji in Kawachi province. The music was associated with the Ōbaku Zen movement, and it enjoyed daimyo, aristocratic and literati patronage. The two-stringed zither (*nigenkin*), on the other hand, is related to National Learn-ing; it was closely associated with Shinto, and there is nothing Chinese about its repertoire. Of course, as Waterhouse notes, in Edo urban society Buddhism and Shinto, elite and popular culture, National Learning and Chinese Learning were all intertwined.

11. Hokusai's erstwhile mentor Katsukawa Shunshō (d. 1792) used the seal *Zōka gachū*, or "Engaged in the creation of painting" at the end of his career (see *Three Beauties*, fig. 66 in this volume). Roger Keyes has written in detail on the *Yu Zhi* painting and on Hokusai's use of the *Shi zōka* seal in "The Dragon and the Goddess: Using Prints to Date, Identify and Illuminate Hokusai's Early Paintings," in Carpenter, ed., *Hokusai and His Age*, 17–31.

12. Gakutei learned the Hokusai style under the tutelage of Totoya Hokkei (1780–1850) and, like his teacher, studied *kyōka* under Rokujuen.

13. The tiger can be linked with various Chinese immortals, though Dong Feng seems to be closest in this case. The author thanks Joe Earle for his help with various queries related to iconography of immortals in *surimono* discussed in this essay.

14. Created around 1810 or 1811, the painting has the same *Katsushika Hokusai* signature and *Kimō dasoku* seal as *Five Women*. See the entries by Timothy Clark in *Arts of Japan: The John C. Weber Collection*, edited by Melanie Trede with Julia Meech, exh. cat. (Berlin: Museum of East Asian Art, National Museums in Berlin, 2006), no. 59; and in Ann Yonemura, *Hokusai*, exh. cat. (Washington, D.C.: Freer Gallery of Art and Arthur M. Sackler Gallery, Smithsonian Institution, 2006), vol. 2, no. 37. An unsigned preparatory drawing for this painting is in the collection of the Freer Gallery of Art; see Yonemura, *Hokusai*, vol. 2, no. 38.

15. For a thorough discussion of the depiction of the theme in prints and paintings, see Timothy Clark, "Prostitute as Bodhisattva: The Eguchi Theme in Ukiyo-e," *Impressions* 22 (2000): 37–53.

16. Hokkei was one of Hokusai's most successful and prolific protégés in *surimono* and book illustration. For an overview of Hokkei's contribution to the field of *surimono* design, see Jack Hillier, *The Japanese Print: A New Approach* (Rutland, VT and Tokyo: Charles E. Tuttle, 1975), 137–45. See also, Matthi Forrer, "Totoya Hokkei 1780–1850: A Preliminary Survey of His Life and Works," in G. C. Uhlenbeck, ed., *The Poetic Image: The Fine Art of Surimono* (Leiden: Hotei, 1987), 20–35.

17. Translations adapted from those I previously published in Joan B. Mirviss with John T. Carpenter, *Jewels of Japanese Printmaking: Surimono of the Bunka–Bunsei Era 1804–1830*, exh. cat. (Tokyo: Ōta Memorial Museum of Art; Nihon Keizai Shinbun, 2000), no. 47. For another set of translations, see McKee, *Japanese Poetry Prints*, no. 42.

18. Hokuun was apprenticed by Hokusai to work on illustrated books and, presumably, woodblock prints. His *Hokuun Manga* attempts to capitalize on the master's bestselling formula for drawing manuals. Both the "Tai" of *Taiga* in the upper of the two seals and the crinkled treatment of Daruma's undergarments in this painting relate to Hokusai's "Taito period" of the 1810s.

19. Several noted proponents of the National Learning movement, who usually focused their attention on the study of traditional Japanese literature or indigenous religious beliefs (Shinto), were also avid aficionados of ukiyo-e, and their witty poems are often found on *surimono* and deluxe paintings, as here. See John T. Carpenter, "Textures of Antiquarian Imagination: Kubo Shunman and the *Kokugaku* Movement," in Amy Reigle Newland, ed., *The Commercial and Cultural Climate of Japanese Printmaking* (Amsterdam: Hotei Publishing, 2004), 77–113.

20. For another example of a collaborative *surimono*, see Keyes, *The Art of Surimono*, vol. 1, 170.

21. See Carpenter, "Painting and Calligraphy of the Pleasure Quarters: Interaction of Image and Text in Hokusai's Early *Bijinga*," in Carpenter, ed., *Hokusai and His Age*, 33–61.

22. See Carpenter, "Hokusai and Kyōden: Portrayals of Courtesans in Painting and Poetry," in Calza, ed., *Hokusai Paintings*, 91–116.

23. See Andrew Markus, "*Shogakai*: Celebrity Banquets of the Late Edo Period," *Harvard Journal of Asiatic Studies* 53, no. 1 (June 1993): 135–67. For a study of *shogakai* in the first half of the nineteenth century, see Robert Campbell, "Tenpō-ki zengo no shogakai" (Calligraphy and painting gatherings around the time of the Tenpō era," *Kinsei bungei* (Literary arts of early modern Japan) 47 (1987).

24. Adapted from Carpenter, "Hokusai and Kyōden," 95.

25. Hokusai was probably paying the bills with work in more lucrative, mass-market book illustrations that he signed with the obscure alias Tokitarō Kakō. Around this time, Hokusai proudly signed his illustrations in upscale *kyōka* books for private (or very limited commercial) release with various combinations of "Sōri" and/or "Hokusai." He chose the obscure alias "Tokitarō Kakō" to sign the several *kibyōshi* novelettes—which were published for the mass market—that he illustrated between 1798 and 1804. For Hokusai's output in illustrated popular fiction of this time, see Lane, *Hokusai: Life and Work*; see also, Nagata Seiji, *Katsushika Hokusai nenpu* (Chronology of Katsushika Hokusai) (Tokyo: Sansaishinsha, 1985). From 1798 to 1804, almost all Hokusai *kibyōshi* are signed with variations of the art name Kakō.

26. The translation of this poem and two that follow are adapted from my work in Joan B. Mirviss with John T. Carpenter, *The Frank Lloyd Wright Collection of Surimono*, no. 32.

27. Because the first character of his pen name can also be read "Tsubo," meaning "jug," he probably had something to do with the Tsubo-gawa ("Jug" Group, known by this name for its jug-shaped emblem). The Tsubo-gawa was also known as the Asakusa-gawa (Asakusa Group, a poetry circle in the Asakusa neighborhood, where Hokusai lived at the time), headed by Asakusaan Ichindo (1755–1820), a pawnbroker by trade.

28. Other than his daughters, among the closest or most talented pupils were the following, listed in approximate order of receiving a new art name from the master: Sōri III, Shinsai, Hokuba, Hokuitsu, Hokutai, Hokuju, Hokuga (later Gosei), Hokkei (1780–1850) and his pupil Gakutei (1786?–1868), Hokumei, Hokuun, Hokusai II, Taito II, Iitsu II (Tsuyuki Kōshō, d. 1893) and Isai (1821–1880).

29. Sōri III (Hishikawa Sōji; act. 1790s–c. 1818); Kukushin II (a female pupil, Hokumei, whose family name was Inoue; act. early 1810s–1820s), Hokusai II (family name Suzuki, act. early 1810s–1826); Taito II (family name Kondō, act. 1810s–1853); and Iitsu II (there was also another Iitsu II in Nagoya).

30. See Iijima Kyoshin, annotated by Suzuki Jūzō, *Katsushika Hokusai den* (The Life of Katsushika Hokusai) (Tokyo: Iwanami Shoten, 1999).

31. To confirm the pronunciation of her name (which many scholars have rendered as "Tokijo"), there is an illustration of ivy vines in the *kyōka* book *Poetic Treasures* (*Hōkashū*) signed "Tatsujo" (with 'Tatsu' written in *kana*, and *jo*, a female name suffix in *kanji*), accompanied by a seal reading *Fumoto no sato*. This volume was published in 1828, perhaps the last verifiable date of Tatsujo's artistic output. The volume in the Library of Congress, Washington, D.C., is mentioned in the checklist of Sandy Kita et al., *Floating World of Ukiyo-e: Shadows, Dreams*

and Substance (New York: Harry N. Abrams in association with the Library of Congress, 2001), but the name is misread as "Tatsumo" rather than "Tatsujo." Standard biographical accounts do not mention a Tatsujo, but we can hypothesize that this was an alternative art name bestowed on one of Hokusai's daughters who died young or could not continue to work with her father. Some have thought that it might be a daughter named Otetsu, who Iijima suggests "excelled at painting," or another daughter for whom we have no records at all (not an uncommon occurrence during this period, especially for the progeny of a commoner). See Iijima, *Katsushika Hokusai den*, 308. Richard Lane speculates that Otetsu and Tatsujo were possibly the same in *Hokusai: Life and Work*, 97.

32. Since both seals are difficult to read, scholars have proposed other readings. Some read the *Yoshinoyama* seal as *Fuji no yama* (Mount Fuji). The issue is complicated by the fact that the Osaka artist Shunkōsai Hokushū (act. 1802–32), who worked briefly for Hokusai assisting with illustration work, was given permission to use (or simply started using) a seal reading *Yoshinoyama* carved to replicate the one given Tatsujo. Hokushū used it about a dozen times between 1818 and 1830. See Matsudaira Susumu, "Hokusai to Kamigata ukiyo-e" (Hokusai and ukiyo-e in Osaka), *Hokusai kenkyū* (Hokusai studies) 21 (Sept. 1996): 23–25. Hokushū also impressed this seal on a deluxe painting of the early 1820s showing the actor Nakamura Utaemon III (Shikan) as a courtesan holding an unrolled love letter (see fig. 134 in this volume; for a description, see C. Andrew Gerstle, with Timothy Clark and Akiko Yano, *Kabuki Heroes on the Osaka Stage: 1780– 1830*, exh. cat. (London: The British Museum Press, 2005), no. 186.

33. Another version of the painting in figure 114, unsigned but with the character "Tatsu" on the maiden's fan, is reproduced in *Nikuhitsu ukiyoe ten* (Exhibition of ukiyo-e paintings) (Tokyo: Itabashi-ku Museum of Art, 1989) and *Edo no natsu* (Summer in Edo) (Tokyo: Edo-Tokyo Museum, 1994), no. 54. The painting was sold in Tokyo in 1998, and was listed in the annual catalogue of the Ukiyo-e Dealers Association of Japan (Nihon ukiyoe shō kyōdō kumiai), 38.

34. For Ōi's career, see Kobayashi Tadashi, translated and adapted by Julie Nelson Davis, "The Floating World in Light and Shadow: Ukiyo-e Paintings by Hokusai's Daughter Ōi," in Carpenter, ed., *Hokusai and His Age*, 93–95; see also, Patricia Fister, *Japanese Women Artists, 1600– 1900*, exh. cat. (Lawrence, KS: Spencer Museum of Art, 1988). More details can be found in Japanese publications, including Kubota Kazuhiro, "Hokusai musume—Ōi Ei-jo ron: Hokusai nikuhitsuga no daisaku ni kansuru ichi kōsatsu" (A Study of Hokusai's daughter Ōi Ei-jo: An inquiry

into Hokusai paintings she did in his stead), *Ukiyo-e geijutsu/Ukiyo-e Art* 117 (1995): 12–25; and Yasuda Gōzō, "Hokusai no musume: Ōi Ei-jo zenden" (Hokusai's daughter: The biography of Ōi Ei-jo), *Kikan ukiyo-e* (Ukiyo-e quarterly) 86 (1981): 32–44.

35. Both trained as painters under the guidance of Tsutsumi Tōrin (c. 1743–1820). Information about Ōi is given in Iijima, *Katsushika Hokusai den*, 308–309.

36. By 1848, Hokusai was using art names other than Iitsu, but commercial prints featuring this signature probably continued to be widely available and we can assume that the public associated the master with the Iitsu signature of the Mount Fuji landscapes and bird-and-flower prints.

37. Translated by Carol Morland, from Kobayashi Tadashi, "The Real Hokusai: Artist 'Mad about Painting,'" in Yonemura, ed., *Hokusai*, vol. 2, 11. The original quotation is found in Saitō Gesshin, *Suiyo sōko* (Literary pursuits upon awakening), 1862.

38. See Segi Shinichi, "Hokusai Paintings in Obuse: Realms of the Genuine and the Spurious," in Calza, ed., *Hokusai Paintings*, 247–59.

39. For *Three Women Playing Musical Instruments*, see Morse, ed., *Drama and Desire*, no. 69.

40. Books illustrated and signed by Ōi with her own signature include *Illustrated Handbook for Daily Life for Women* (*E-iri nichiyō onna chōhō-ki*, 1847), compiled by Takai Ranzan, and *A Concise Dictionary of Sencha* (*Sencha tebiki no tane*, 1848). As pointed out in Kobayashi, "The Floating World in Light and Shadow," 95, it was no doubt seen as a useful marketing ploy to have a female illustrator with a connection to a famous artist associated with such volumes.

41. For Ōi's collaboration on the compilation of *Ehon saishiki-tsū*, see Carolina Retta, "Hokusai's Treatise on Coloring: *Ehon saishiki-tsū*," in Calza, *Hokusai Paintings*, 243.

42. Iijima, *Katsushika Hokusai den*, 309–10.

43. For this album, see Taki Setsuan (Sei'ichi), "'Daily Exorcisms': The Latest Discovery of Hokusai's Original Drawings," *The Kokka* (International edition) 17, no. 198 (Nov. 1906): 483–93.

Designed for Pleasure
Ukiyo-e as Material Culture

DAVID POLLACK

Display, sex, fashion and marketing were inseparably intertwined quantities from the very start of early modern urban life in Japan. Ukiyo-e were commercial objects, among the most visible extant examples of a dynamic and flourishing world of signs connecting money, goods and aesthetics. The discussion here intends to help provide an understanding of this remarkable art form in the context of the Edo-period culture of spectacle and desire, entertainment and information and, in general, the phenomenal growth of material culture, consumerism and advertising that sired and supported these.

We speak familiarly about "material culture," but the culture of Edo Japan was "material" in a quite literal sense.[1] Ukiyo-e is so much a part of developments in textile design and marketing that the floating world (ukiyo) itself can be thought of simply as "the world of fashion."[2]

Pattern Books and the World of Fashion

Understood as "the world of fashion," the word ukiyo signifies a world of constant change—by definition unpredictable and beyond man's control. Fashion was change made material. Merchants and the craftsmen whose work they commissioned and sold made the commercial discovery, so familiar to Madison Avenue, that while change may be fickle and impermanent, desire is constant, and desire can be manipulated to create and so control change. As in today's fashion world, potential consumers didn't need something until they were made to know they needed it; they had to be made to feel the urgency of not having it—especially when the beautiful and privileged were seen flaunting it.

Many ukiyo-e artists were involved in the production of hinagatabon (alternatively, hinakatabon, hiinagatabon), sample books of design patterns depicted on printed kimono outlines, a mainstay of seventeenth- and eighteenth-century publishing. Woodblock prints and paintings by Hishikawa Moronobu (1630/31?–1694; see Waterhouse essay in this volume) contain many of the elements of fashion—clothing, hairstyles, accessories, line, color

and gesture—that became central to ukiyo-e. In his work we find the automatic association of fabric and sexuality lying at the heart of later ukiyo-e art in which the woman herself appears to be the focus, but whose principal subject "is still her costume—its pattern, drape and flow."[3] The rise of *hinagatabon* catalogues in the Kanbun era (1661–73) parallels that of women's manuals describing customs and costumes. The 1660 *Etiquette Rules for Women* (*Onna shoreishū*), as one example, contains the broad range of information required to run a large upper-class household, and the first volume begins with examples of kimono patterns appropriate to each of the twelve months (fig. 119). The nouvelle riche might buy whatever she liked, but she was concerned not to buy the wrong dress.

The numerous illustrators of the printed pattern books are largely anonymous, aside from a few, including Moronobu's son, Hishikawa Morofusa (act. 1685–1703), who gave up printmaking for the presumably more lucrative and prestigious trade of textile dyeing, Yoshida Hanbei (act. 1660–92) and Nishikawa Sukenobu (1671–1751). In Sukenobu's 1718 *Nishikawa's Design Patterns* (*Nishikawa hinagata*), three women make selections from a pattern book, exclaiming: "What an unusual design," "Find one you like" and "I think I'll have this one" (fig. 120).[4]

The artists who illustrated pattern books inevitably discovered the commercial appeal of depicting attractive men and women dressed in the clothes for sale. And with the rapid rise of the two great Edo-period focal points of popular desire, the "entertainment quarters" and the theaters, these generic models were soon embodied in the figures of courtesans and actors, identified by name, crest, handwriting and other features. Again we find the nexus of material and fashion, desire and information, at play.

The long and varied careers of modern fashion and portrait photographers like Cecil Beaton and Irving Penn offer a suggestive parallel to those of many Edo ukiyo-e artists; and the careers of star models resemble those of the popular women pictured in ukiyo-e prints. Beaton's iconic portrait of Marilyn Monroe in 1956, for example, resembles nothing so much as one of the lovely female types by Kitagawa Utamaro (1753?–1806), both of them portrayed as shimmering confections of gauzy fabric and gossamer hairdo (figs. 121, 122).

Some of the effects perfected by Utamaro and Torii Kiyonaga (1752–1815) are intimately related to textile design—for example, the relationship of modulated line to ornamental pattern (or, significantly, pattern without outlines), the use of overlapping moirélike

Figure 119
Anonymous
***Robe designs**, from Etiquette Rules for Women* (*Onna shoreishū*)
1660. Woodblock-printed book, vol. 1 of 6, fols. 11v–12r. 27 x 18 cm double-page. The New York Public Library, Spencer Collection, Astor, Lenox and Tilden Foundations, Sorimachi 301

Examples of designs for the second and third months hanging on clothing racks: right; "Second month: scattered cherry blossoms and dandelions; left, "Third month: willows of various colors and cherry-blossoms."

Figure 120
Nishikawa Sukenobu
Women Choosing Textile Patterns, from
Nishikawa's Design Patterns (*Nishikawa hinagata*).
1718. Woodblock-printed book, vol. 1 of 5, fols. 1v–2r. 22 x 29 cm double-page. Spencer Collection, The New York Public Library, Astor, Lenox and Tilden Foundations, Sorimachi 390

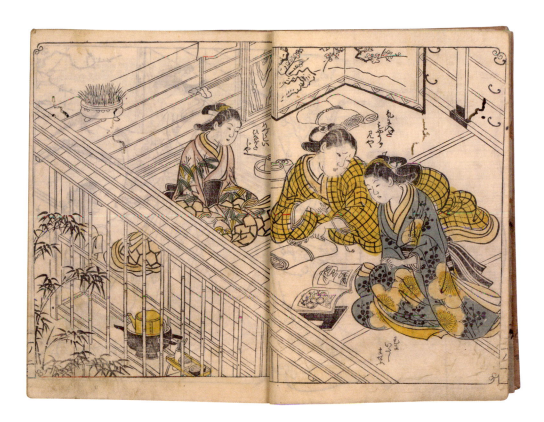

passages in cloth and hair and voiles. This delight with textile effects was a central theme of ukiyo-e paintings and prints. An ukiyo-e artist was popular to the extent that his "look" captured, or perhaps even created, the fashion sense of his age. Suzuki Harunobu (1725?–1770), Utamaro and Kiyonaga began to focus extensively not just on the public's desire for extraordinary courtesans and entertainers, but on perfectly ordinary (if extraordinarily beautiful) women and men decked out in fashions that could be purchased and worn (see figs. 1, 55, 92).

Marketing's Virtues and Vices

Japan's fashion industry dates from the 1660s, when wealthy women of the merchant class supplanted women of the samurai elite as the majority of fashion consumers. Increasing mercantile pressures toward economies of scale and volume during the eighteenth century had the inevitable effect of cheapening the product.[5] Kimono fabrics followed an entirely predictable modern spiral from fabulously expensive *haute couture*, to less expensive *prêt-à-porter* carried in fashionable shops, and, finally, to mass-market knockoffs. It should be noted that "pictures of the floating world," ukiyo-e, span the same commercial spectrum, from expensive one-off paintings to less, but still expensive, luxury editions of prints (*gōka-ban*), and on from less lavish, full-color prints (*nishiki-e*, or "brocade pictures") to mass-market, poorly printed monochrome, or *sumizuri-e*, editions of famous prints and illustrated books. Edo marketing had many of modern marketing's virtues and vices.[6]

Materials in the Genroku era (1688–1704) followed two trends: the vogues for sumptuous hand-dyed *yūzen* fabrics, and "for clothes conveying a feeling less of opulence than of lightness and wit."[7] Artists of the Kaigetsudō school of the early 1700s were obsessed with the colors, designs and textures of gorgeous fabrics, while Harunobu, around 1765 to

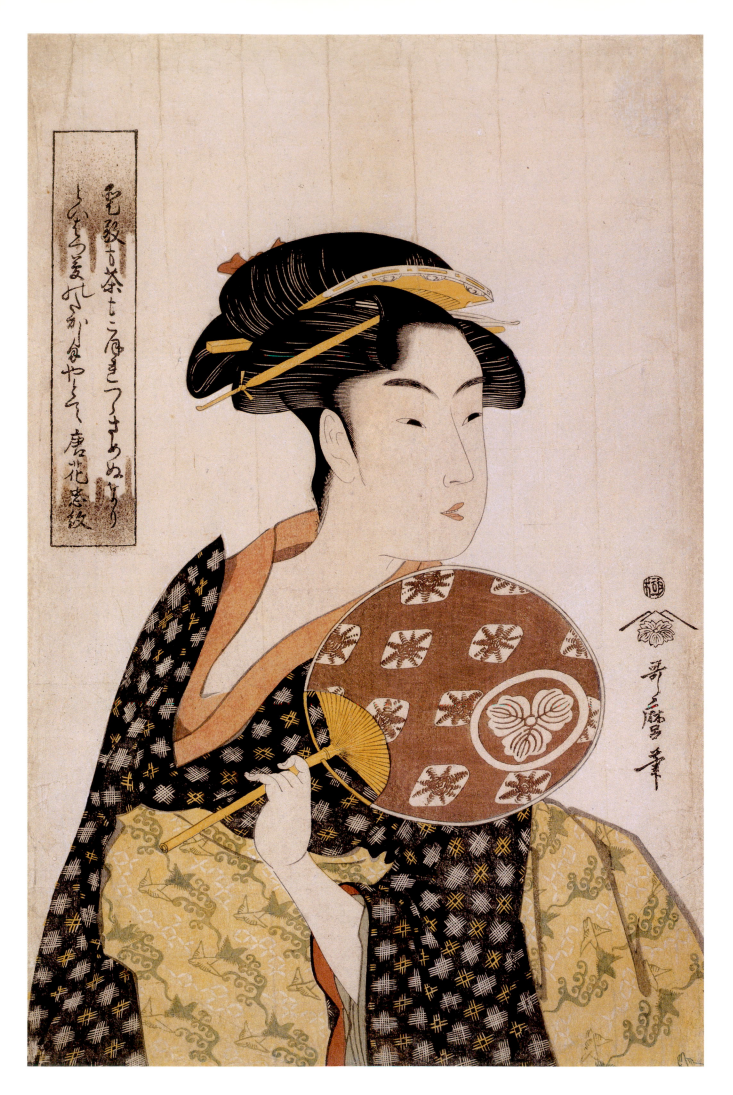

1770 chose more subdued ones; for example, his use of the dark yellow-brown known as *rokōcha* that became popular from 1766 (exh. no. 23). Harunobu's work perpetuates the striking use of classical allusion, or *mitate*, both in thematic images pictured on kimonos and in the poems reproduced on the prints, which was characteristic of earlier kimono design (see fig. 35).[8]

Fashion Plates in an Age of Information

Along with entertainment, information was a mainstay of Edo publishing, evidenced in the prodigious production of guidebooks to every aspect of the life of the city (*annai-bon*), to famous actors and courtesans (*hyōbanki*) and to the Yoshiwara (*saiken*). Information also took the form of kimono pattern books and other product catalogues, testimonials by famous people (*kōjō*), advertising flyers (*hikifuda*), promotional items (*keibutsu*), shop and product signboards (*kanban*), decals (*senjafuda*), books of crests (*monchō*) and the like, all of which figure in ukiyo-e to one degree or another.

The public domain was filled with visual and aural information of every sort. We are familiar with the kabuki theater as a place of sophisticated music, song and speech, but we are perhaps less familiar with the fact that popular actors were paid handsomely to deliver advertising pitches from the stage, and that novelists regularly planted paid advertising copy in their stories. Information spanned the broad gamut from the highly literate to the illiterate: the traveling salesmen who wandered the cities, each with his own cry, are a staple of literature and drama. Hucksters known as *yashi* (generally written with the characters for "masters of perfumery") flogged goods and services at open-air markets, shrines and temple fairs, part of the wildly variegated crowd of popular reciters and showmen who catered to the semiliterate and illiterate public. The attractive "billboard girls" (*kanban musume*) so frequently pictured by Harunobu, Utamaro and others—Ohisa of the Takashi-maya (fig. 122) and Okita of the Naniwaya (see figs. 1, 92; exh. no. 134), for example—offer a romanticized version of today's trade-show "product models."[9]

The population of Edo-period Japan did not think of commerce and entertainment as separate realms. While hucksters may have been far down the economic ladder from professional actors (who shared, however, their low social standing in the official status system), both lived and worked within the broad spectrum of "infotainment." Those at both ends of that spectrum used spectacle and speech, song and action, to draw their audiences in. Even among the *Eighteen Famous Plays* (*Kabuki jūhachiban*) of the Ichikawa acting family, *The Oil-Seller* (*Uirō-uri*) is based on a huckster's patter for a popular throat balm that is still sold today in a reconstruction of the original Edo-period shop in Odawara, while *Sukeroku* would quickly become permanently associated in the minds of city commoners with a particular combination sushi platter (the name of the play's female character, Agemaki, is parsed as the *age* in *abura-age*, a kind of fried tofu, and the *maki* in *norimaki*, or seaweed-roll)—not to mention the fact that its well-known single stage set amounted to an oversized advertisement for the Miuraya brothel at Kyōmachi-itchōme in the Yoshiwara district.

The publisher's work of raising the capital, commissioning the writers and artists, paying skilled craftsmen to carve and print blocks and arranging for the wholesaling and even retailing of everything from leaflets and guidebooks to literature and art required extraordinary connections to every part of the information world. Publishers stood at the very center of this world, and among the best connected was Tsutaya Jūzaburō (1750–1797) (see Davis essay on Tsutaya in this volume). Poetry groups were Edo's primary cultural networks. Tsutaya, whose poetry name was Tsuta no Karamaru ("Entwined in the Ivy"), was at the center of the well-known Yoshiwara Circle that included his own publishing-house's collection of Edo's hottest stars of literature and art: the writers Hōseidō Kisanji (1735–1813), Koikawa Harumachi (1744–1789), Santō Kyōden (a.k.a. Kitao Masanobu, 1761–1816), Takizawa Bakin (Kyokutei, 1767–1848) and Jippensha Ikku (1765–1831); and the ukiyo-e artists Kitao Shige-masa (1739–1820), Utamaro, Katsukawa Shunchō (act. 1780–95), as well as Katsushika Hokusai (1760–1849) and Tōshūsai Sharaku (act. 1794–95). The Yoshiwara Circle was headed by Murata Ichibei (a.k.a Kabocha no Motonari, or "Pumpkin Stem," 1754–1828), owner of the Daimonjiya brothel. Like a chairman of the board, Murata's leadership was

Figure 122
Kitagawa Utamaro
Takashima Ohisa with Fan
c. 1793. Color woodcut with mica ground.
38.2 x 25.5 cm. Private Collection

likely due to his money, prestige and connections, not to mention his ownership of an attractive and popular meeting place, though this group did also include Muneage no Takami, owner of the equally successful Ōgiya brothel.[10] The all-important lineage affiliations of Edo can be traced through these networks; many members of the Yoshiwara Circle, for example, including Tsutaya himself, were present at the famous "treasure-matching poetry gathering" (*takara-awase kai*) of 1783 convened by Takesue no Sugaru (one of the art names of Morishima Chūryō, 1756–1808) at the Kawachiya in Yanagibashi, an event regarded as the culmination of the era's popular *kyōka* ("mad verse") gatherings that customarily resulted in the commission of lavish printed poetry albums.[11] These networks cut across social-class boundaries and formed the central-casting pool of talent for the several major publishing houses competing with Tsutaya's.[12]

In 1794, the nearly simultaneous publication by Tsutaya of Sharaku's startling "large-head" actor prints (figs. 95, 96, 98; exh. nos. 92, 94, 96, 97, 98) and by Izumiya Ichibei of *Pictures of Actors on Stage* (*Yakusha butai no sugata-e*) by Utagawa Toyokuni (1769–1825) seems less a coincidence than evidence of a clash of networks, a crucial moment in the history of both publishing and ukiyo-e (see fig. 94). Sharaku's mysterious and complete disappearance from the scene after some ten months of phenomenal production (and we must here pass over the endless speculation concerning Sharaku's identity) in effect left the field of actor images almost entirely to Toyokuni and his school, and Izumiya in a position of greatly increased strength. Toyokuni's new prominence seems to represent a turning away from an increasingly unacceptable idea of "realism" of the sort pioneered by Katsukawa Shunshō (d. 1792; see fig. 76), who had died only two years before, to a more acceptably conventional (and, not incidentally, a more economically viable) version. The lineup of opposing sides was already visible in the membership lists of Edo's literary salons.

Advertising Models

The kimono pattern book would continue to provide a model of fashionable information. In his 1790 *Elegant Chats on Small Motifs* (*Komon gawa*), Edo's most fashionable man (*tsū*), Santō Kyōden (see fig. 110) used clever *komon* or "small patterns," such as pairs of facing mouths making clever boy-girl talk, fanned playing cards and Danjūrō's famous *Shibaraku* face-paint (fig. 123; see also, figs. 76–78).[13] Kyōden organized these witty designs around a number of common patterns, including *Ichimatsu* ("chessboard," named after a pattern made popular by the actor Sanogawa Ichimatsu I; see fig. 95), *seigaiha* ("Waves of

Figure 123
Santō Kyōden
Designs, from *Elegant Chats on Small Motifs* (*Komon gawa*)
1790. Woodblock-printed book. From Tani Minezō, *Asobi no dezain: Santō Kyōden "Komon gawa"* (Playful designs: Santō Kyōden's *Elegant Chats on Small Motifs*) (Tokyo: Iwasaki Bijutsusha, 1984), 205, fig. 2

Top right: pot lids; bottom right: fanned playing-cards; left: face-paint used by Ichikawa Danjūrō in the *Shibaraku* (Stop Right There!) role.

Kokonor"), *urokogata* ("fish scales") and so on. "Leaping mice" (*hane-nezumi*), based on the *seigaiha* motif, will show up again five years later on the padded, large-size kimono in Sharaku's print of *Onoe Matsusuke as the Lay Monk Magoroku Nyūdō*, suggesting that graphic, as well as textual, information circulated within poetry groups (fig. 124).[14]

One of the earliest Edo guidebooks to the brothel areas, *Illustrated Guide to the Yoshiwara* (*Yoshiwara saiken zu*), published by Surukaya Ichibei between 1684 and 1688, contains a schematic map and the names of brothels with the notation "updated monthly." *Night-calling Birds* (*Yagoe no tori*), published by Genkin'ya Hachizō in 1739, was the first guidebook to include pictures of the women along with the text, and it also incorporated the women's lantern-crests indicating the brothel where they worked. Tsutaya Jūzaburō's own profitable 1774 *Birds with Pretensions* (*Hitokidori*, written literally as "Birds that come to men"), was a guidebook innovation in the form of a handy folding booklet that could easily be carried in the kimono. Guidebooks to the pleasure quarter became the models for the kabuki guidebooks that provided similarly detailed and ready information on Edo's other great destination of popular fascination.[15]

In 1800, Utagawa Kunisada (1786–1865) illustrated a promotional brochure (*keibutsu*) for a perfume oil manufactured by Yorozuya Shirokei. *Gate of Immortality, a New Year's Water for Cosmetics* (*Oi senu kado keshō no wakamizu*), with text by the popular writer Takizawa Bakin, was given out as a New Year's gift to the manufacturer's regular buyers.[16] Keisai Eisen (1790–1848) and Kunisada were among the many artists who supplemented their incomes by placing Edo's most popular cosmetic, Bi'en Sennyokō (or Senjokō), or "Beautiful Fairy Maiden Fragrance," in their prints.[17] Like today's elegant ads featuring famous, but unnamed, stars (or their look-alikes) wearing name-brand watches, participation in such barefaced advertising likely contributed to an artist's popularity and provided useful evidence of it.

As with the most popular writers and illustrators garnering lucrative income from their work in advertising, the phenomenally popular Shikitei Sanba (1776–1822) and Kyōden were also able to supplement their revenues by staging or attending calligraphy and painting parties (*shogakai*). These proceedings were not unlike today's celebrity parties or famous-model photo-shoots; Andrew Markus has called them "autograph parties."[18] They were held at the famous restaurants located at Yanagibashi in Ryōgoku, at the scenic confluence of the Sumida and Kanda Rivers (see figs. 14, 129). Income derived from these occasions was referred to euphemistically as "brush-moistening fees" (*junpitsuryō*) or "talent-demonstration fees" (*kigōryō*).

The epochal joint publication by Tsutaya and Nishimuraya Yohachi, *Models of Fashion: New Designs Fresh as Spring Leaves* (*Hinagata wakana no hatsumoyō*) (see figs. 82, 83), featuring 139 illustrations by Isoda Koryūsai (act. c. 1764–88) and 11 by Torii Kiyonaga, also connected the "worlds" of the Yoshiwara brothels and the Nihonbashi clothing emporiums.[19] Allen Hockley proposes that the words *hinagata* and *moyō* (both meaning a pattern or design) in the title suggest a possible relationship between the brothel owners and the fabric merchants. Perhaps they contributed to the production costs of the prints; it is difficult to understand how else these enormously expensive works would have been financed even with publishers joining forces and brothel owners subsidizing production. Small crests on some of the garments worn by the courtesan advertising "models" in this series may even be those of the garment or fabric merchant.[20] It is no coincidence that the first *hinagatabon* published in color, the anonymous *Colorful Models of Ninefold Brocades* (*Saishiki hinagata kokonoe nishiki*), also appeared in 1784.[21]

But works like *Models for Fashion*, showing elaborate kimono designs on robes worn by courtesans of the highest rank, could scarcely have been intended to sell materials and patterns to ordinary women, to whom the law forbade such lavish costumes, which at any rate would not have been available in stores and would have to have been made up specially at enormous expense. An extreme example of such fantastic robes can be seen in a daunting *Hell Courtesan* by Utagawa Kuniyoshi (1798–1861) (fig. 125). It seems far more likely that it was Utamaro's and Kiyonaga's gorgeous but plausibly ordinary women, with their gorgeous but plausibly ordinary clothing, that achieved this valuable commercial connection. *Models for Fashion* can be seen as the first to unite the two modes of display,

Figure 124
Tōshūsai Sharaku
Onoe Matsunosuke I as the Lay Monk Magoroku in the Kabuki Play Kagurazuki Iwai no iroginu
1794. Color woodcut. 32.3 x 15.1 cm. Museum of Fine Arts, Boston, William Sturgis Bigelow Collection, 11.16484

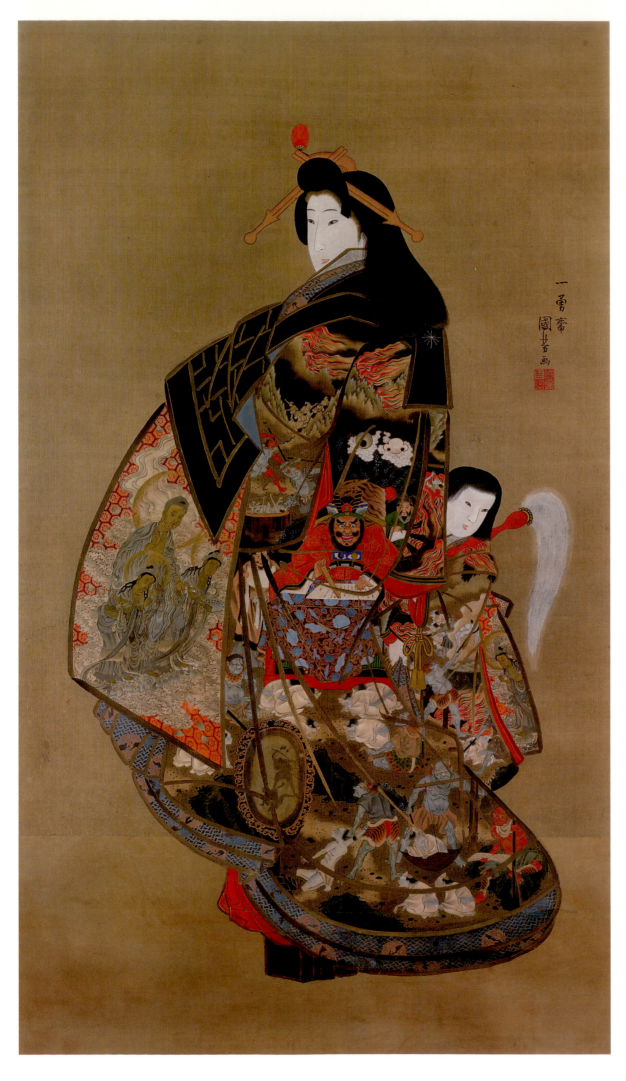

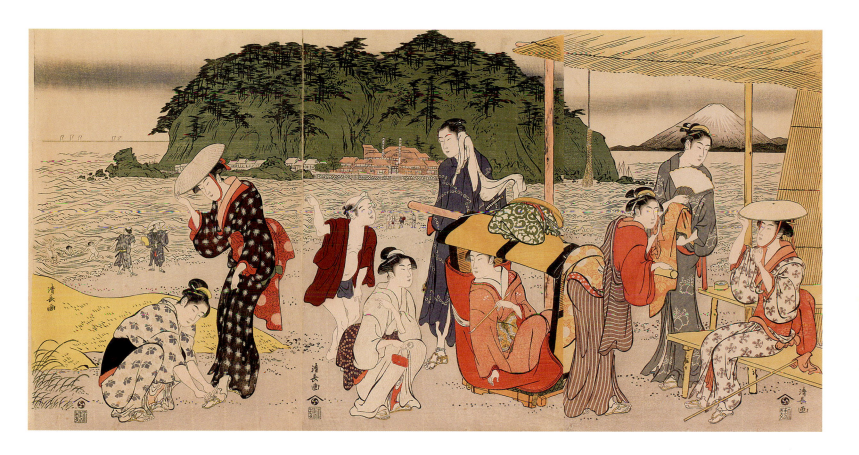

Figure 126
Torii Kiyonaga
Pilgrimage to Enoshima
c. 1789. Color woodcut triptych. 39.1 x 78.2 cm.
Museum of Fine Arts, Boston, William S. and
John T. Spaulding Collection, 21.7344-6

Opposite: Figure 125
Utagawa Kuniyoshi
Hell Courtesan
c. 1850. Hanging scroll mounted as a framed
panel; ink, color and gold on silk. 140.3 x 81.9 cm.
John C. Weber Collection

The Hell Courtesan is linked with the eccentric Zen
priest Ikkyū (1304–1481), abbot of the Kyoto tem-
ple Daitokuji. As a tribute to their relationship, she
wears the everyday, abbreviated form of a black
surplice, or *kesa*, attached to a halter draped
around her neck. Her attendant holds the fly whisk
that is emblematic of a Zen abbot. Ikkyū claimed
to have spent ten years in the brothels of Sakai, a
port bordering on Osaka. Legends recount that he
befriended a prostitute there named Jigoku (Hell).
The design on her robe shows the King of Hell
seated in judgment of the damned, who are sub-
jected to brutal torture.

followed immediately in 1784 by *New Mirror Comparing the Handwriting of the Courtesans
of the Yoshiwara* (*Yoshiwara keisei shin bijin awase jihitsu kagami*) (see figs. 10, 85). The
addition of poems in the various women's own handwriting simply added one more piece
of information that could be fetishized and commercially exploited.

In such images, "unique physical qualities" reside not in the person, but in the cloth-
ing and other elements; for example, the poems written in each woman's calligraphy in the
Handwriting series. This coding of identity follows a line that runs from Nishikawa Suke-
nobu's 1723 book *One Hundred Women Arranged by Class* (*Hyakunin jorō shinasadame*) as
the first work to depict the dress appropriate to each particular social group—empress to
streetwalker—to the next-generation Katsukawa "likeness pictures" and to the sets of vari-
ous classes and "types" of women by Utamaro and Masanobu of the 1790s. The "realism"
of actor portraits by Sharaku and Shunshō and of Utamaro's "physiognomies" proved to be
interesting but relatively unproductive dead-ends; what *was* productive were commercially
viable robe designs and easily reproducible facial types generated by the Utagawa-school
artists. The need for speed and cost-cutting was one reason; the public reaction to what we
might term the "Diane Arbus" nature of these more novel visions was another.

From Fashion Scene to Landscape Scene

During the last two decades of the eighteenth century, ukiyo-e attained an almost perfect
balance between the human figure and its setting. This achievement is epitomized in the rise
of wide-format triptych prints, which typically feature a number of large foreground figures
arrayed against a broad backdrop of familiar town and country settings. This development

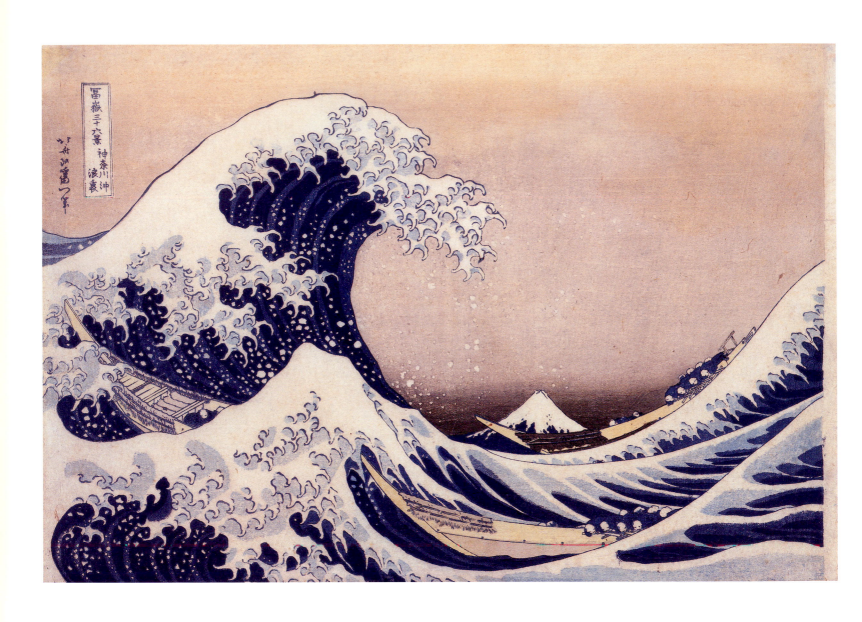

Figure 127
Katsushika Hokusai
Under the Well of the Great Wave Off
Kanagawa (Kanagawa oki nami ura),
from the series ***Thirty-six Views of Mount***
Fuji (Fugaku sanjūrokkei)
c. mid-1831. Color woodcut. 26.1 x 38.6 cm.
The Mann Collection, Highland Park, IL

can be related to contemporary changes in ways of seeing that began in the many scenes produced in the 1740s showing the interiors of theaters, brothels and restaurants under the influence of imported Western ideas of perspective, with up to a dozen foreground figures staged against a variety of urban backdrops. The "perspective prints" (uki-e) of Okumura Masanobu (1686–1764), discussed in the Thompson essay in this volume (see figs. 50, 51), and others were naïve exercises in single-point perspective, their main subject the drama of perspective itself as much as their ostensible subject matter.[22] The small figures at the focal point of a Masanobu uki-e, after all, occupied only a relatively modest, and rather hard-to-see, area at the center of the work. It is perhaps a version of this interpretation of perspective that results in Hokusai's "Great Wave" and others in his Thirty-six Views of Mount Fuji series, where the ostensible focal point, the illustrious Mount Fuji, is often reduced to an inconspicuous far-off triangle dwarfed by the enormous drama of its foreground frame. The new triptych format, with its broad foreground and sides to be filled with interesting large characters of every sort, paid more attention to the crowds arrayed in front of the great gate of the Yoshiwara than to the women inside. In this "stage-set" format we are treated to a broad close-up view of foreground figures engaging one another in complex exchanges, as in Kiyonaga's women on the beach with a distant view of Enoshima behind them (fig. 126). The effect of such works is to increase the sense of both objectivity and intimacy, offering at once a sweeping view and a close-up that in combination makes the viewer an intimate part of the scene.

The dominant subject of the triptych is stylish cityfolk in stylish settings of urban and suburban temples and shrines, fields and hills and roadside or riverside scenes. It is not much of a leap from such broad scenes of beautiful people set against panoramic backgrounds, to the famous landscape scenes like Hokusai's Thirty-six Views of Mount Fuji (fig. 127) or Hiroshige's Fifty-three Stations of the Tōkaidō Road that appear a few decades later, featuring the sorts of common people one might encounter in any public place.

A number of plausible reasons can be proposed to explain the sudden popularity of landscapes in the nineteenth century. The crackdown on public morality that was one result of the Tenpō Reforms of 1842–43 was responsible for a severe dropoff in actor prints—Kunisada's many series of actor prints, for example, fall into two distinct groups: those before 1843 and those after 1852.[23] As his experience shows, such subjects did not entirely disappear, and eventually returned to as great a demand as ever; but, in the meantime, publishers had come to find landscapes a safer and equally profitable alternative. A burgeoning genre of travel literature (which we can think of as a form of landscape narrative) reached its zenith of popularity in Jippensha Ikku's comic series of 1802–09, Hoofing It Along the Tōkaidō (Tōkaidōchū hizakurige)—about the same time that the panoramic triptych made its appearance—and the public demand for illustrated versions resulted in Hiroshige's popular Fifty-three Stations of the Tōkaidō. The enormously successful original "Hōeidō edition"[24] gave rise to many later editions and variations, including one thought to have been the best-selling series ever published, the 1852 version of the same title by Kunisada that combined the two leading genres of actor prints and landscapes by posing famous actors at each station—perhaps seen as a relatively safe way to reintroduce actors under the rubric of "landscape." The great success of the Kunisada set led to the 1857 Fifty-three Stations of the Tōkaidō by Twin Brushes (Sōhitsu gojūsan tsugi) by Hiroshige and Kunisada together, which posed a wide variety of Kunisada's figures against local landscapes by Hiroshige at each station.

The economics of production and consumption appear to have made large and infinitely reproducible series of "famous places" (meisho) cheaper and more lucrative to produce than one-off prints showing the latest of the myriad incarnations of popular actors or courtesans dressed in fashions so outlandishly sumptuous that they could not be worn even by the wealthiest potential customers for fear of violating sumptuary laws.[25] Publishers, for their part, despite effecting economies of scale, materials and labor, were likely being increasingly squeezed by fees charged by popular actors and courtesans, many of whom owned shops selling their own branded goods and images, and who were increasingly concerned with protecting their lucrative image rights. Toyokuni, for example, shows Danjūrō V onstage as a night watchman advertising dental hygiene products while Iwai

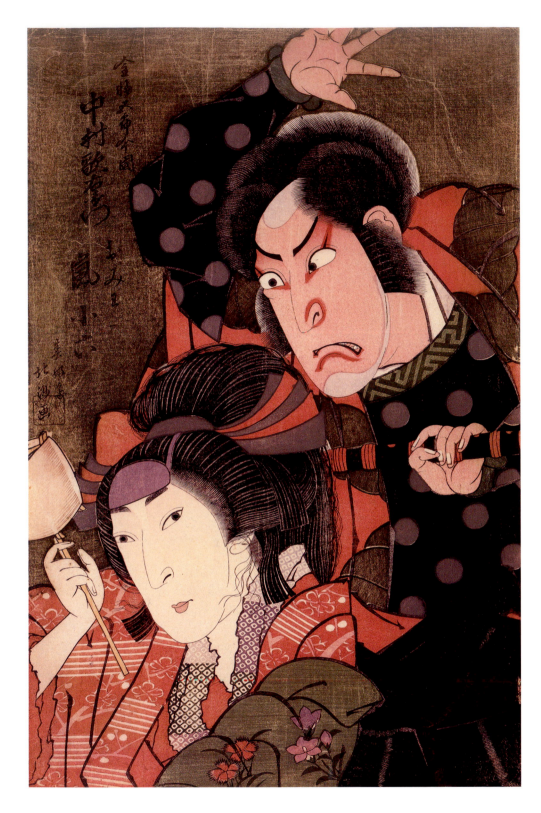

Figure 128
Shunkōsai Hokushū (act. 1802–32)
Nakamura Utaemon III as Kanawa Gorō
Imakuni and Arashi Koroku IV as Omiwa in
the Kabuki Play Mounts Imo and Se: Exemplary
Women's Virtues (*Imoseyama onna teikin*)
c. 1821. Color woodcut with gold ground with
silver and copper powders. 39.3 x 26.3 cm.
The Mann Collection, Highland Park, IL

Omiwa, below, holds a spool of thread she has
used to track the man she loves. In a case of
mistaken identity in a typically convoluted kabuki
plot, Kanawa Gorō Imakuni stabs and kills her.

Opposite: Figure 129
Utagawa Hiroshige
Fireworks, Ryōgoku Bridge (*Ryōgoku hanabi*),
from the series *One Hundred Views of Famous*
Places of Edo (*Meisho Edo hyakkei*)
1858. Color woodcut. 36.1 x 23.5 cm. Brooklyn
Museum, Gift of Anna Ferris, 30.1478.98

Murasakiwaka in the role of a wife helpfully brandishes a signboard emblazoned with the product's brand name and the shop's address.[26] Prints issued first as limited luxury items, including the use of mica and metallic powders (fig. 128), were followed later by larger and cheaper runs that dispensed with the careful hand-shading (*bokashi*) of colors that required enormous care and skill by the printer (exh. no. 26). This sort of retailing resembles today's distinction between hardcover and mass-market paperback-book editions.

The rise of landscapes (fig. 129) thus suggests two important things: from the point of view of publishers and artists, landscapes were often safer and more profitable subjects than beauties and actors; and from the point of view of the public, landscape prints were relatively inexpensive ways to gratify a desire for novel and less hidebound visions of the world—especially as they might incorporate Western techniques of shading and coloration (chiaroscuro, Prussian blue) and perspective in ways that the more conventional genre of

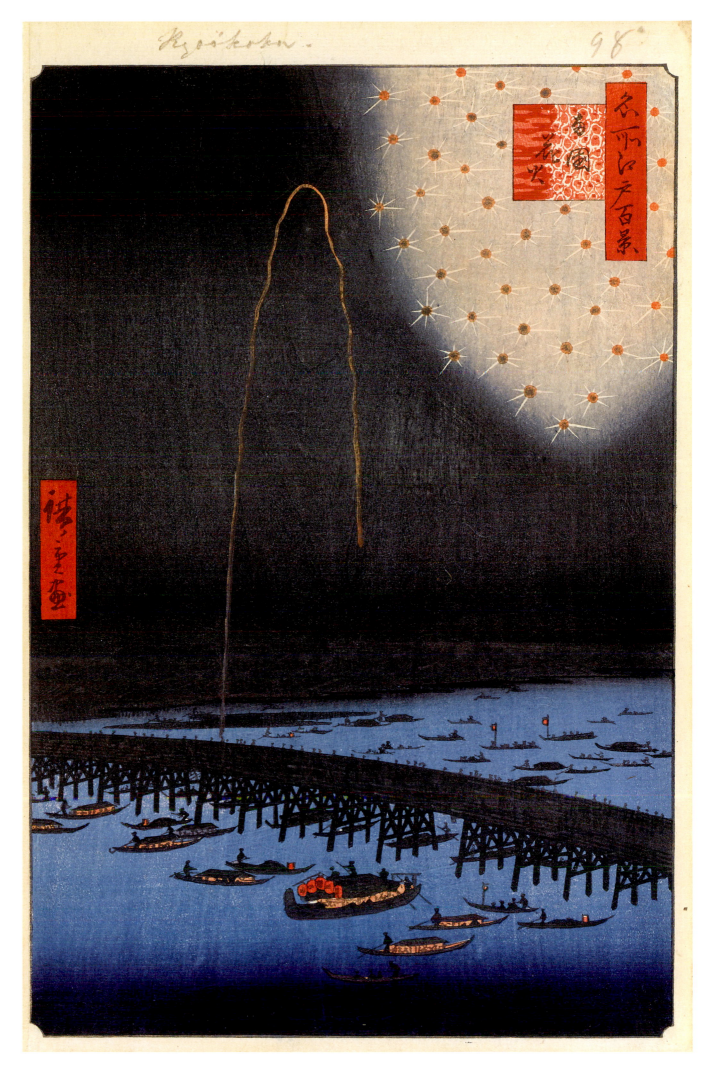

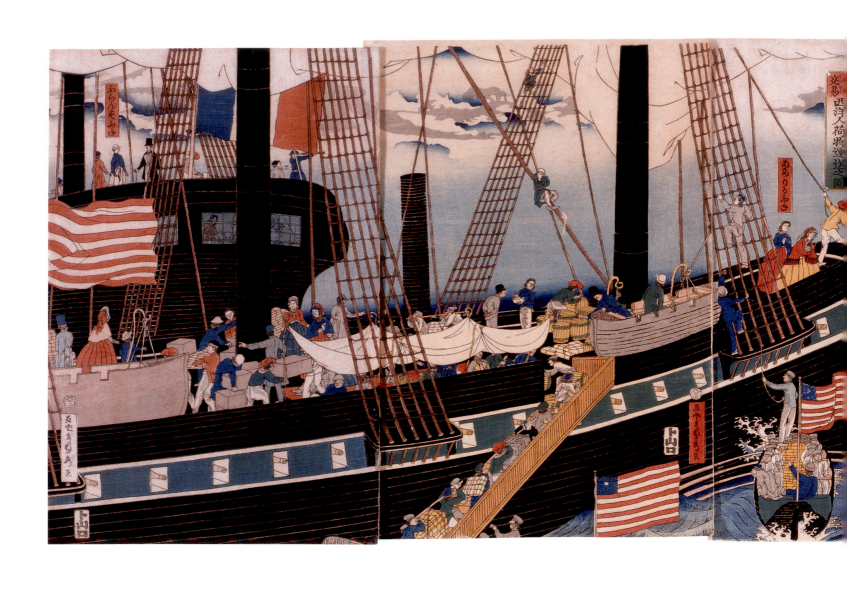

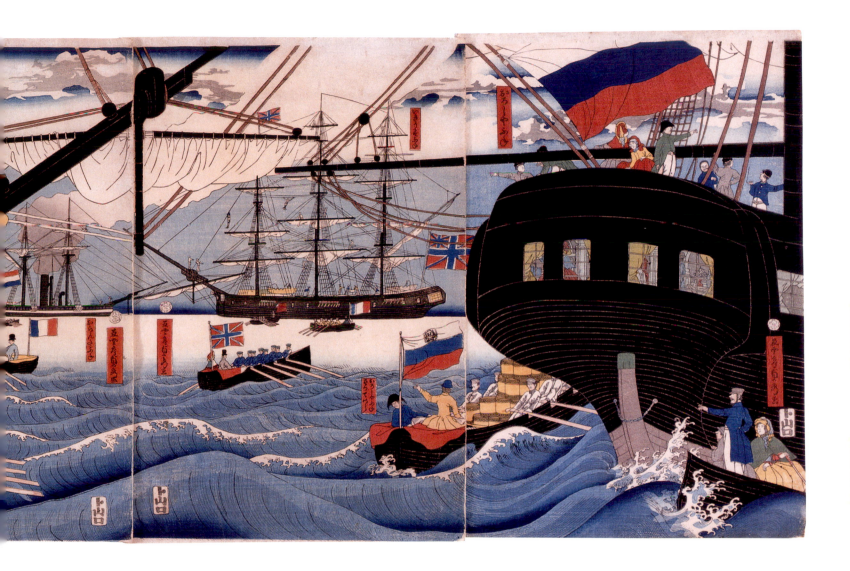

actor prints could not. At shops where major roads met the city limits, landscape views were sold to customers needing suggestions about famous places to visit or looking for a souvenir to replace the more problematic sorts of materials that could have had the wife asking, "and just who is this pretty young thing?"

Also to be considered is the cheaper and more profitable flourishing mass market for illustrated fiction. Publishers could do just as well or even better by churning out books of popular fiction illustrated with cheap black-and-white block prints as they could with the far more expensive full-color actor and courtesan prints. For one thing, they wouldn't have had to keep paying fees or royalties to the many popular idols who were in a position to demand them. Also, while actor prints required a constant stream of new and unique designs for each actor's appearance in a different play or even scene (though publishers were always exploring ways around this problem), the images for fictional stories were far more stable and less variable—and, when names were forbidden, far less risky. These considerations coincide with the publishers' turn from prints of actors and women to landscape and other series. The Utagawa school's continued profitable production of actor prints, which amounted to a monopoly, demonstrates the successful economies of scale of a tightly organized and controlled production-line approach that could continue to be profitably tied

Figure 130
Hashimoto Sadahide (1807–1878/79)
Yokohama Trade: Picture of Westerners Shipping Cargo (Yokohama kōeki seiyōjin nimotsu unsō no zu)
1861. Color woodcut pentaptych.
37.5 x 127 cm. Geoffrey Oliver

Yokohama became a designated open port for trade with Westerners in July 1859. An American ship in the left foreground loads cargo from smaller boats. Women observe the busy scene through the glass windows of a nearby French ship. To the far right the lavish interior furnishings of a Russian ship are visible through its windows. In the distance we see a Dutch steamer and a British sailing ship.

(and in turn to lend support) to the ever-popular theater world. (Kabuki theater posters are still produced today by Torii Kiyomitsu IX, the female head of the venerable Torii school that from its inception held a monopoly on this profitable genre.)

This brings us to a surprising juncture: the arrival of Commodore Matthew Perry's "black ships" in Uraga Bay in 1853–54. This event signaled the start of a virtual tidal wave of Western influence (fig. 130) which, much like Hokusai's "*Great Wave*," was at once fascinating and terrifying. It should be remembered that Hiroshige's *One Hundred Views of Famous Places of Edo* (see fig. 129), remarkable for its innovative vision of Edo and the novelty and freshness of its framing devices, is also essentially a conservative vision in its resolute nostalgia for the good old days. But this foreign intrusion, as reflected by other late-Edo and early Meiji-period print artists, had the contradictory effect of promoting a backlash of conservative nationalism even as it fostered a fascination with the new and the foreign. Utagawa Kuniyoshi's striking triptych of the legendary swordsman Miyamoto Musashi battling an enormous whale (fig. 131) is one of many such views of a traditional Japan depicting famed warriors engaged in spectacular and often nobly suicidal battle. Kuniyoshi has Musashi dressed appropriately, but a close look at his whale suggests that the great beast's mottled skin was modeled on a traditional kimono fabric known as "dappled fawn tie-dye" (*kanoko shibori*), seen for example in the underrobe of the woman on the right in Harunobu's *Observing Lovers from the Doorway* (exh. no. 15). Kuniyoshi's very chic whale appears to have succeeded in knotting this material casually under its chin, and perhaps even in securing it with a red *obijime* sash cord, just as has Utamaro's beauty smoking in her bathrobe (exh. no. 130).

Here we might mention the Utagawa-school quilted cotton fireman's jacket painted on the inside with an image taken from a Kuniyoshi print (fig. 132). The Edo fireman or *tobi*, an icon of courage and prowess, was the urban commoner's version of the noble samurai, a class that effectively ceased to exist after the wearing of swords was outlawed in 1876. These charismatic figures were essentially rowdy ruffians whose work was almost entirely destructive, consisting as it largely did in tearing down Edo's wood-and-paper buildings during conflagrations to provide firebreaks. Like their later epigones, the modern-day *yakuza* gangsters, they liked to think of themselves as men of honor who were protectors of the little people, and their favorite images, endlessly reproduced in prints and on their jacket linings, were of the beloved 108 popular heroes of the Chinese novel *Water Margin Classic* (Ch. *Shuihuzhuan*, J. *Suikoden*).

Figure 131
Utagawa Kuniyoshi
The Warrior Miyamoto Musashi Subduing a Whale
c. 1847–52. Color woodcut triptych. 36.8 x 73.7 cm.
Geoffrey Oliver

The famous swordsman Miyamoto Musashi (1583–1647) is plunging his sword into a giant whale off the coast of Higo (present-day Kumamoto Prefecture). There are many stories about Musashi's exploits as a swashbuckler. He is known also as a poet and as the painter Niten.

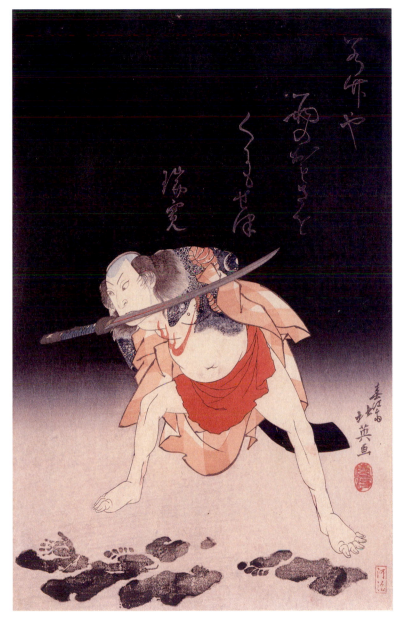

Figure 132

Artist unknown

Fireman's Coat with design of the brigand Rōrihakuchō Chōjun

Mid-19th century. Cotton with paste-resist painting. 120.5 x 119.5 cm. John C. Weber Collection

The fierce, tattooed brigand, sword clenched between his teeth, has forced his way through the bars of a castle water gate beneath an ornamental roof tile designed as the face of an ogre. Bells are attached by ropes to the gate to ward off intruders. The textile artist copied the design from Kuniyoshi's series of around 1828–30 depicting the heroes of the *Water Margin Classic* (*Suikoden*).

Figure 133

Shunkōsai Hokuei (act. 1824?–37)

The Osaka Actor Arashi Rikan II as Danshichi Kurobei in the Night Murder Scene of the Kabuki Play Mirror of Naniwa [Osaka]: The Summer Festival (*Natsu matsuri Naniwa kagami*)

1832. Poem signed *Rikan*. Color woodcut. 37.2 x 24 cm. The Mann Collection, Highland Park, IL

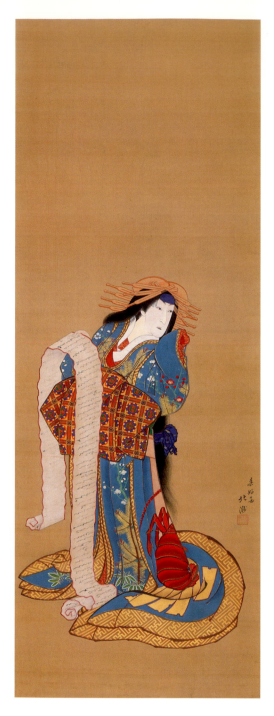

The best ukiyo-e is characterized by a tension—we might liken it to that of the frozen *mie* pose of the kabuki drama—of human form and of composition in terms of line and volume, color and pattern, content and ornament, essence and accident. While actors are depicted in the dynamic stasis of their exciting *aragoto* or "tough" poses (fig. 133), beautiful women, actors in the roles of beautiful women (fig. 134) and young men-about-town strike *wagoto*, or seductive poses. In either case, vibrant line is anchored and reinforced by the pattern, color and volume of the textiles in which line is literally fleshed out. What this means is that in ukiyo-e, an eroticism of flesh is essentially replaced by one of material. This is nowhere clearer than in the enormous Edo-period output of pornography, in which the strenuously dramatic performances of actors in the bedroom, at once *wagoto* and *aragoto*, can no more be stripped of their defining material context than could those of actors performing on the stage be stripped of theirs. In Japanese art, the entirely naked body alludes to the mundane sociality of the bath and the family, not the erotic individuality of the bed—a polarity with which an artist like Utamaro is constantly playing, in bodies shown peek-a-boo emerging from the bath or the bed. Indeed, Utamaro regularly depicts female breasts, but he does so to suggest a fetching state of casual domestic negligé—a woman emerging from the bath, dressing or undressing, even nursing a child—not something sexual. The "physiognomy" of a lower-class housewife smoking her pipe is announced as much by the beautifully rendered thin, tie-dyed robe loosely secured around her hips by a crimson sash as by her facial features and attitude. A charming painting of a near-naked couple by Utagawa Toyohiro (1773?–1828), *Enjoying the Evening Cool under a Gourd Trellis*, evokes a powerful sense of conjugal tranquility, not of sexuality (fig. 135). In Japanese erotic and nonerotic art, bodies are of themselves uninteresting; what makes them interesting is their clothing. Ukiyo-e was, along with its most striking subject matter, a completely material art. Ukiyo-e were thus more or less blatant advertising for women and their brothels, actors and their theaters, and their kimonos and the shops that sold them, as well as for cosmetics, accessories, medicines, books, shops, restaurants—in other words, for just about anything that might be for sale in Edo.

Figure 134
Shunkōsai Hokushū (act. 1802–32)
Nakamura Utaemon III as a Courtesan
c. 1820. Hanging scroll; ink, color and gold on silk.
103.8 x 38.1 cm. John C. Weber Collection

The Osaka actor Utaemon III (Shikan) in a dance role as a courtesan holds a love letter and wears a costume with designs of New Year festivities.

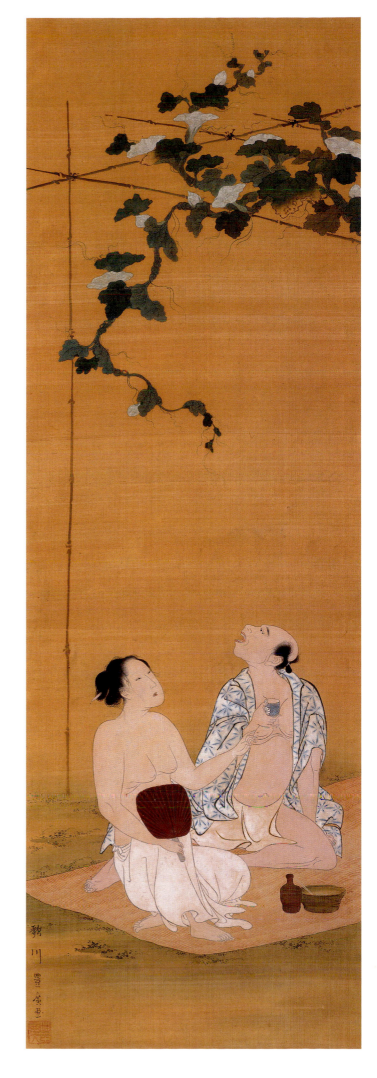

Figure 135

Utagawa Toyohiro

Enjoying the Evening Cool under a Gourd Trellis

Early 19th century. Hanging scroll; ink and color
on silk. 84.4 x 28 cm. The Metropolitan Museum of
Art, The Harry G. C. Packard Collection of Asian
Art, Gift of Harry G. C. Packard and Purchase,
Fletcher, Rogers, Harris Brisbane Dick and Louis V.
Bell Funds, Joseph Pulitzer Bequest and The
Annenberg Fund Inc., Gift, 1975.268.129

Notes

1. Eiko Ikegami has observed that the transformation of Japan's agrarian economy of 1600 to a booming commercial economy a century later resulted from the production and consumption of cotton, silk and linen fabrics. Eiko Ikegami, *Bonds of Civility: Aesthetic Networks and the Political Origins of Japanese Culture* (New York: Cambridge University Press, 2005), 246.

2. Art in Japan was always closely associated with the textile crafts. Silk was, of course, the most highly valued of all clothing materials, and a dense and vigorous interchange between the media of textiles and painting has long been characteristic of Japanese culture.

3. Margot Paul, "A Creative Connoisseur: Nomura Shōjirō," in Amanda Mayer Stinchecum, *Kosode: 16th–19th Century Textiles from the Nomura Collection*, exh. cat. (New York: Japan Society; and Tokyo: Kodansha International, 1984), 18.

4. Nagasaki Iwao, "Designs for a Thousand Ages: Printed Pattern Books and Kosode," trans. Amanda Mayer Stinchecum, in *When Art Became Fashion: Kosode in Edo-Period Art*, edited by Dale Carolyn Gluckman and Sharon Sadako Takeda (New York and Tokyo: Weatherhill; and Los Angeles: Los Angeles County Museum of Art, 1992), 99.

5. Nagasaki Iwao summarizes the case for a subsequent decline in kimono innovation or taste in the years prior to 1800 in three points: (1) stagnating, formulaic design and dyeing techniques made pattern books redundant; (2) concentration of the patterned area of the garment made for less variation in design; and (3) the sumptuary laws of the period made it difficult to wear gorgeously decorated robes and led to more restrained taste such as stripes and small allover patterns. See Nagasaki, "Designs for a Thousand Ages," 105. The last point, the importance of sumptuary laws in creating the famous Edo *iki* (smart, stylish, chic) aesthetic, has often been noted. Monica Bethe, in "Reflections on *Beni*: Red as a Key to Edo-Period Fashion," in *When Art Became Fashion*, 133–53, summarizes the idea on pages 136–39, but goes on to note the unexpected popularity during the 18th century of *beni* reds (143 ff.), which satisfied "the sense of a need for restrained suggestiveness . . . embodied in the idea of *iki*" (147).

6. One of its vices was the effect that new technologies could have on older established ones. While the 1678 pattern book *Genji hinagata* had listed twenty-six specific types of dyeing, nearly all of these would vanish a few decades after the advent of innovative drawing with rice-paste resist, known as *yūzen* dyeing for a fan painter named Miyazaki Yūzen (act. late 16th–early 17th c).

7. Stinchecum, "Kosode: Techniques and Designs," in Stinchecum, *Kosode*, 53.

8. See Sharon Sadako Takeda, "Clothed in Words: Calligraphic Designs on Kosode," in *When Art Became Fashion*, 154–79.

9. See David Pollack, "Marketing Desire: Advertising and Sexuality in the Edo Arts," in *Gender and Power in the Japanese Visual Field*, ed. Norman Bryson et al. (Honolulu: University of Hawai'i Press, 2003), 71–88.

10. Tanaka Yūko, *Edo wa nettowaku* (Edo as network) (Tokyo: Heibonsha, 1993), 144–45.

11. Other major poetry groups spawned by those who attended this seminal gathering included the Yamanote Group of Yomo no Akara (Ōta Nanpo), the Yotsuya Group of Karagoromo Kisshū, the Sakaimachi Group of Ichikawa Danjūrō and the Shiba Group of Hamabe Kurohito (Mikawaya Hanbei).

12. These publishers included Tsutaya Jūzaburō, Izumiya Ichibei, Nishimuraya Yohachi, Tsuruya Kiemon, Iseya Ichibei, Murataya Jirōbei, Iwatoya Kisaburō and others. See Konta Yōzō, "Edo no shuppan shihon" (Publishing capital in the Edo period) in *Edo chōnin no kenkyū* (Studies in Edo townsman culture), ed. Nishiyama Matsunosuke, vol. 3 (Tokyo: Yoshikawa Kōbunkan, 1973), 9.

13. Kyōden's idea of "pattern books" of witty textile designs based on familiar ideas and objects followed his 1784 *Small Patterns* (*Komonzai*), which, in the course of a century, would spawn some dozen different works published along the lines of this popular model. Tani Minezō, *Asobi no dezain: Santō Kyōden "Komon gawa"* (Playful designs: Santō Kyōden's *Elegant Chats on Small Motifs*) (Tokyo: Iwasaki Bijutsusha, 1984), 205, fig. 2.

14. Tani, *Asobi no dezain*, 167 (fig. 139), 207.

15. See Yagi Keiichi and Niwa Kenji, *Yoshiwara saiken nenpyō* (A chronology of Yoshiwara guidebooks) (Tokyo: Seishōdo, 1996).

16. Sebastian Izzard, *Kunisada's World*, exh. cat. (New York: Japan Society, in collaboration with the Ukiyo-e Society of America, 1993), 20.

17. See Ellis Tinios, "The Fragrance of Female Immortals: Celebrity Endorsement from the Afterlife," *Impressions* 27 (2005–2006): 43–51.

18. Andrew Markus, *The Willow in Autumn: Ryūtei Tanehiko, 1783–1824* (Cambridge, MA: Council on East Asian Studies, Harvard University, 1992), 139–40.

19. *Models of Fashion: New Designs Fresh as Spring Leaves* amounted to the creation of a new "world" (*sekai*), a technical term used in the theater world to connote an established nexus of events and characters in dramatic scripts. It is not hard to imagine why collaborative publishing was more successful than direct competition. Tsutaya, with his house just outside the gate of the Yoshiwara, had the rights to the guidebook "world" of the brothels and their women; Nishimura had the financial clout and human resources at his downtown Nihonbashi location. See Allen Hockley, *The Prints of Isoda Koryūsai: The Floating World and Its Consumers in Eighteenth-century Japan* (Seattle and London: University of Washington Press, 2003), 116–17.

20. Hockley, *The Prints of Isoda Koryūsai*, 124.

21. Nagasaki, "Designs for a Thousand Ages," 113, n. 5. One might speculate that the success of lavish series such as *Models of Fashion: New Designs Fresh as Spring Leaves*, completed by Kiyonaga around 1784, led publishers to issue even the formerly inexpensive pattern books in color. The increased expense would likely have driven many publishers of *hinagatabon* out of the business or forced them to collaborate just as Tsutaya and his colleagues were doing. Expensive series like the one by Koryūsai that used this expanded informational format are the late 18th-century descendants of the earlier *hinagatabon*, and the increase in their artistic quality cannot be separated from the increased value of their commercial information.

22. See Kishi Fumikazu, *Edo no enkinhō: ukiyoe no shikaku* (Perspective in the Edo period: The optical angle of ukiyo-e prints) (Tokyo: Keisō Shobō), 1994.

23. The best-known victims of the Tenpō Reforms in the early 1840s were the popular writers Ryūtei Tanehiko (1783–1842), author of the wildly successful "Rustic Genji" burlesque of the classic *The Tale of Genji*, featured in numerous triptychs by Kunisada, who died after the blocks for the book were confiscated, and Tamenaga Shunsui (1790–1843), who died a year after having been imprisoned for writing pornography.

24. Popularly known as the "Hōeidō Tōkaidō," the series of fifty-five prints in *ōban* format was a joint publication by Takenouchi Magohachi (Hōeidō) and Tsuruya Kiemon (Senkakudō) issued from around 1833 to 1834.

25. That landscape souvenir series had become a best-selling product also suggests that publishers may have begun to find the earlier reliable support of the large fabric retail houses more problematic. Perhaps that factor prompted Utamaro and Kiyonaga to depict not only the customary actors and courtesans, but also beautiful merchant-class and samurai women and men dressed in fashionable fabrics that were sold in the great emporiums like the Mitsui Echigoya that not coincidentally often appeared in prints, and that could actually be worn in public (private consumption was never at issue).

26. Pollack, "Marketing Desire," 84. The two actors shown together onstage in an advertising "announcement," or *kōjō* pose in this print, do not seem to have appeared together in the same play. Ichikawa Danjūrō VII, in the role of the Night Watchman Kichiroku, appears in the play *New Year's Soga: All's Fine in Yoshiwara* (*Ehō Soga yorozu Yoshiwara*, 1819), while Iwai Murasakiwaka as Otsuna figures in *Tears of Love: An Uprooted Mooring Line* (*Koi no nada nebiki tomozuna*, 1838).

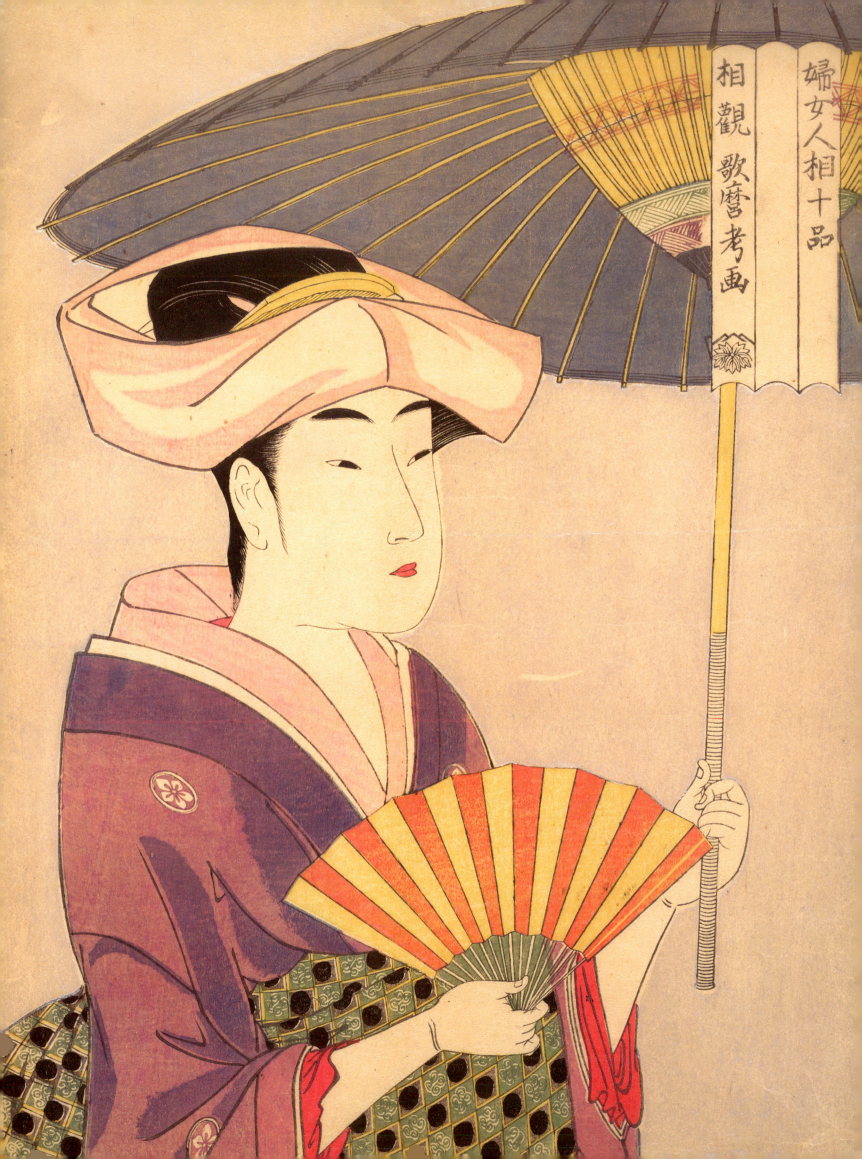

婦女人相十品
相觀 歌麿考画

Works in the Exhibition

The following list is in alphabetical order by the artist's given name. Eishōsai Chōki (exh. no. 1), for example, is alphabetized as Chōki. The Japanese title is given only when it appears on the work. Works illustrated in the catalogue essays are indicated by their figure numbers. The exhibition number ("exh. no." as abbreviated in the catalogue essays) precedes the artist's name.

Exhibition number 127 (detail)

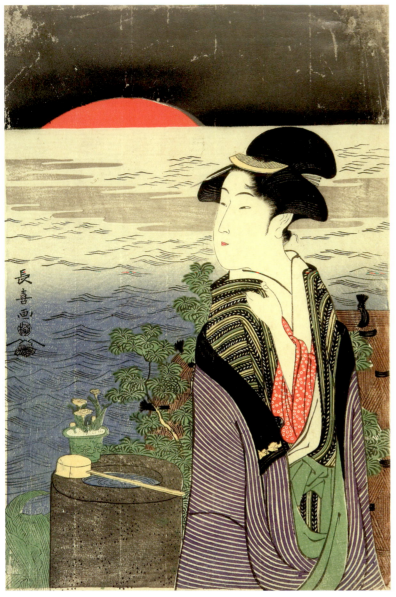

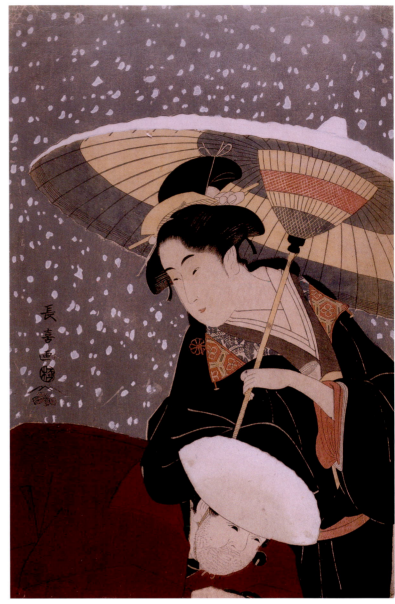

2

3

1. **Eishōsai Chōki** (act. c. 1790s–early 1800s). *Catching Fireflies.* c. 1794. Signed *Chōki ga.* Publisher: Tsutaya Jūzaburō. Color woodcut with mica ground, *ōban.* 38.1 x 24.8 cm. Private Collection Fig. 99

2. **Eishōsai Chōki** (act. c. 1790s–early 1800s). *New Year Sunrise.* c. 1794. Signed *Chōki ga.* Publisher: Tsutaya Jūzaburō. Censor's seal *kiwame* (certified). Color woodcut with mica ground, *ōban.* 38.1 x 25.1 cm. Asian Art Museum of San Francisco, Gift of the Grabhorn Ukiyo-e Collection, 2005.100.84

3. **Eishōsai Chōki** (act. c. 1790s–early 1800s). *Snow.* c. 1794. Signed *Chōki ga.* Publisher: Tsutaya Jūzaburō. Censor's seal *kiwame* (certified). Color woodcut, *ōban.* 37.5 x 24.8 cm. Private Collection

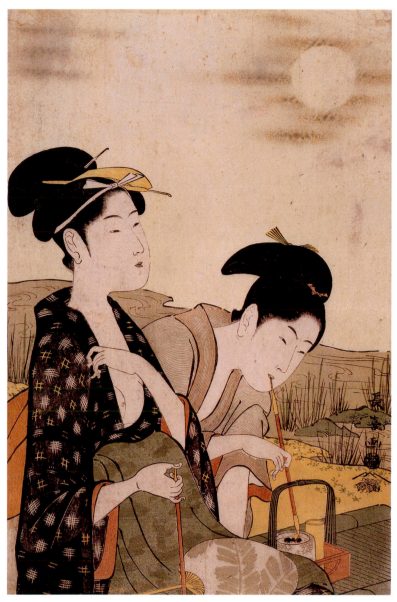

4

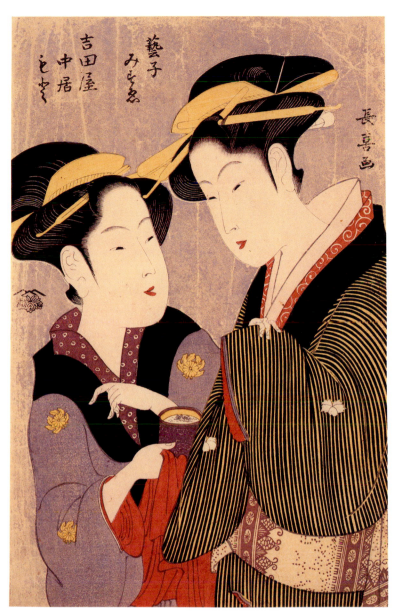

5

4. **Eishōsai Chōki** (act. c. 1790s–early 1800s). *Moon Viewing*. c. 1794. Signed *Chōki ga*. Publisher: Tsutaya Jūzaburō. Censor's seal *kiwame* (certified). Color woodcut, *ōban*. 36.9 x 24.5 cm. Private Collection

5. **Eishōsai Chōki** (act. c. 1790s–early 1800s). *Moto, Maidservant of the Yoshidaya in Shinmachi, Osaka, and Mizue, a Geisha*. c. 1794. Signed *Chōki ga*. Publisher: Tsutaya Jūzaburō. Color woodcut with mica ground, *ōban*. 37.3 x 24.8 cm. The Mann Collection, Highland Park, IL

6. **Chōkyōsai Eiri** (act. 1790s–early 1800s). *Flowers of Edo: The Master of Kyōbashi (Edo no hana Kyōbashi natori)*. c. 1795. Signed *Eiri ga*. Color woodcut with mica ground, *ōban*. 39.1 x 26 cm. The Metropolitan Museum of Art, The Howard Mansfield Collection, Purchase, Rogers Fund, 1936, JP 2419 Fig. 110

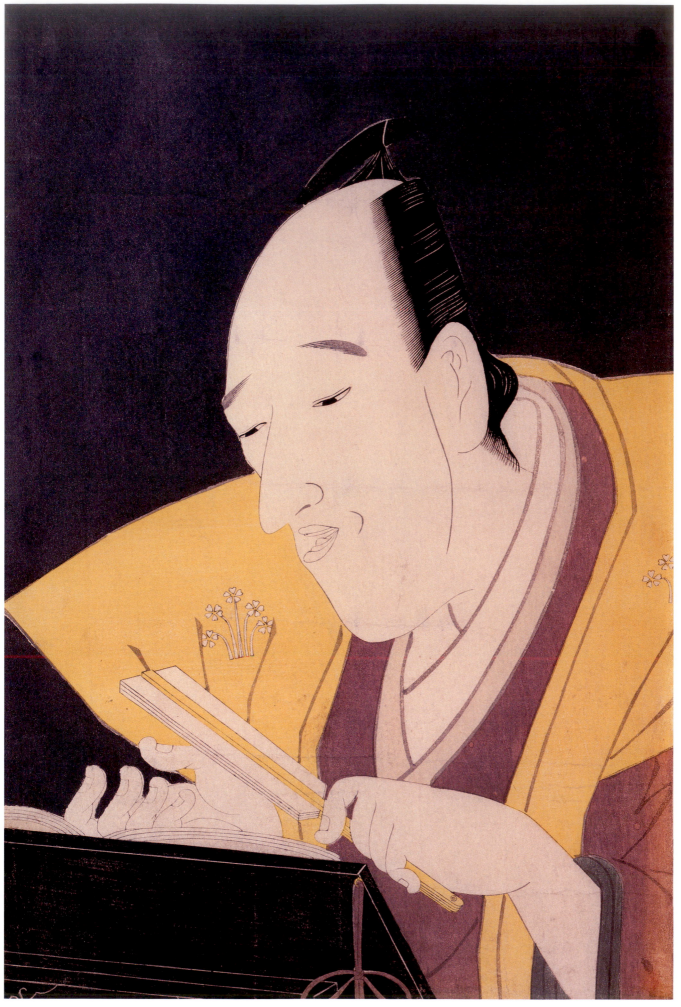

7

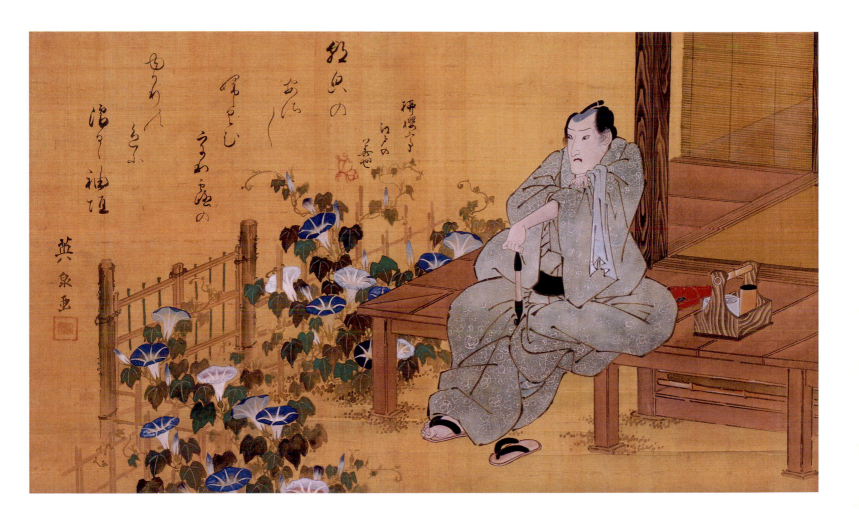

7. Chōkyōsai Eiri (act. 1790s–early 1800s). *Flowers of Edo: The Master of Yanagibashi* (*Edo no hana Yanagibashi natori*). c. 1795. Signed *Eiri ga*. Color woodcut with mica ground, *ōban*. 36.6 x 24.9 cm. The Mann Collection, Highland Park, IL

The master of the Yanagibashi district is the celebrated chanter Tomimoto Buzen Dayū II, here marking his place in the libretto with his fingers and beating time with his fan. The print is from the same set as Eiri's portrait of Santō Kyōden in exh. no. 6, fig. 110 and on the catalogue cover. Neither print has a publisher's mark or censor's seal.

8. Keisai Eisen (1790–1848). *Onoe Kikugorō III Offstage Relaxing in his Garden*. c. 1820. Signed *Eisen ga* and sealed *Keisai*. Inscription signed *Ryūōtei Edo no Hananari* and with butterfly emblem. Hanging scroll; ink and color on silk. 33.6 x 57.2 cm. Private Collection, New York

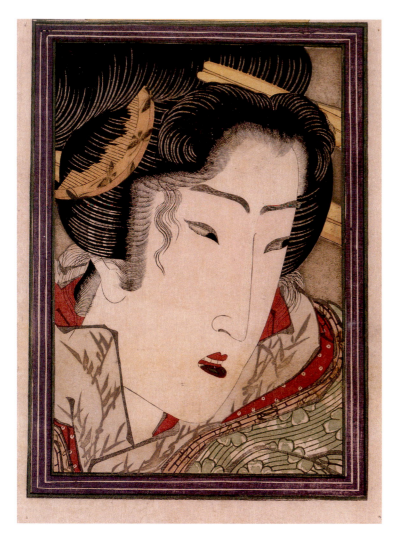
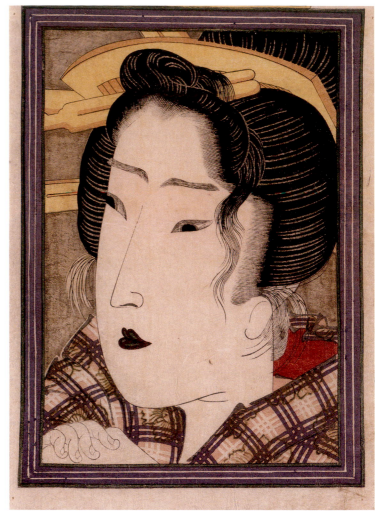

9

9. Keisai Eisen (1790–1848). *Two Beauties*. 1830s. Color woodcuts, *koban*. 19.7 x 13.6 cm each. Private Collection

10. Keisai Eisen (1790–1848). *Geisha*. Early 1830s. Signed *Keisai Eisen* and sealed *Eisen ga in*. Hanging scroll; ink, color, gold and silver on silk. 95.4 x 39.3 cm. Collection of Roger L. Weston Fig. 4

11. Yashima Gakutei (1786?–1868). *Dragon and Tiger Diptych* (*Ryūko niban*) [Yu Zhi and a Dragon with the Chinese Immortal Dong Feng and a Tiger]. 1830. Signed *Yashima Gakutei*. Color woodcut, *surimono* with silver and brass powders and embossing, *shikishiban* diptych. 20.7 x 18.5 cm each. *Surimono* Collection of the Becker Family Fig. 103

12a–h. Suzuki Harunobu (1725?–1770). *The Eight Parlor Views* (*Zashiki hakkei*): *The Clearing Breeze from the Fans* (*Ōgi no seiran*); *Night Rain on the Heater Stand* (*Daisu no yau*); *The Autumn Moon in the Mirror* Stand (*Kyōdai no shūgetsu*); *Descending Geese of the Koto Bridges* (*Kotoji no rakugan*); *The Evening Glow of the Lantern* (*Andō no sekishō*); *Returning Sails of the Towel Rack* (*Tenuguikake no kihan*); *The Evening Bell of the Clock* (*Tokei no banshō*); *Evening Snow on the Floss Shaper* (*Nurioke no bosetsu*). 1766. Signed *Kyosen* and sealed *Kyosen no in* and/or *Jōsei sanjin*. Color woodcuts, 8 *chūban*. 28.9 x 21.6 cm; 28.5 x 21.6 cm; 28.6 x 21.5 cm; 28.8 x 21.6 cm; 28.4 x 21.6 cm; 28.7 x 21.7 cm; 28.4 x 21.7 cm; 28.6 x 21.6 cm. Clarence Buckingham Collection, The Art Institute of Chicago, 1928.896–903 Fig. 57a–h

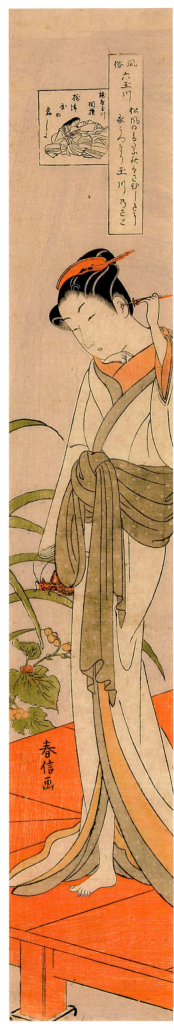

13. Suzuki Harunobu (1725?–1770). *Courtesan as the Poet Sagami at Tōi Jewel River, A Famous Place in Settsu Province* (*Tōi no Tamagawa Sagami Settsu no kuni no meisho*), from the series *Customs and Manners of the Six Jewel Rivers* (*Fūzoku Mutamagawa*). 1769–70. Signed *Harunobu ga*. Color woodcut, *hashira-e*. 68.6 x 11.4 cm. Asian Art Museum of San Francisco, Gift of the Grabhorn Ukiyo-e Collection, 2005.100.37

The poem in the title cartouche by Minamoto no Toshiyori (1055–1129) is typically associated with the Tōi (a.k.a. Kinuta or Mishima) River:

Matsukaze no	Autumn wind through the pines
oto dani aki wa	has a lonely sound;
sabishiki ni	melancholy, too,
koromo utsunari	the sound of fulling cloth
Tamagawa no sato	at Tamagawa.

13

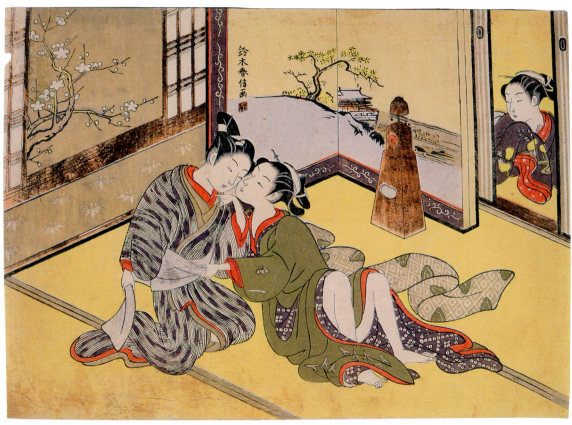

15

14. Suzuki Harunobu (1725?–1770). *Ritual of Climbing the Stairs One Hundred Times* [*Ohyakudo*]. 1765. Color woodcut, *chūban*. 27.2 x 19.5 cm. Museum of Fine Arts, Boston, William Sturgis Bigelow Collection, 11.19437 Fig. 56

15. Suzuki Harunobu (1725?–1770). *Lovers Observed.* 19th century from 1767–68 woodblocks. Color woodcut, *chūban*. 20.9 x 28.8 cm. Museum of Fine Arts, Boston, William Sturgis Bigelow Collection, 11.19714

16. Suzuki Harunobu (1725?–1770). *Courtesan with Love Letter and* Kamuro *Playing Blindfold with a Client.* c. 1768–69. Signed *Harunobu ga.* Color woodcut, *chūban*. 28.6 x 21.7 cm. Museum of Fine Arts, Boston, William Sturgis Bigelow Collection, 11.19511

17. Suzuki Harunobu (1725?–1770). *Courtesan of the Motoya and Client Disguised as an Itinerant Monk.* 1770. Signed *Suzuki Harunobu* ga. Color woodcut, *chūban*. 28.9 x 21.6 cm. Private Collection Fig. 64

18. Suzuki Harunobu (1725?–1770). *Picture Book of the Brocades of Spring* (*Ehon haru no nishiki*). 1771 (Meiwa 8.1). Sealed *Harunobu.* Publisher: Yamazaki Kinbei (Kinzandō), Edo. Block cutter: Endō Matsugorō. Preface signed *Heki-gyokudō.* Color woodblock-printed book, *fukurotojibon.* 2 vols. 21.7 x 14.6 cm. each page. Private Collection Fig. 62

19. Suzuki Harunobu (1725?–1770). *Courtesan and Hotei Smoking on a Veranda in Moonlight.* c. late 1760s. Signed *Suzuki Harunobu ga.* Color woodcut, *chūban*. 20 x 27 cm. Collection of Harlow N. Higinbotham Fig. 8

20. Suzuki Harunobu (1725?–1770). *Visiting a Shrine in Night Rain.* Late 1760s. Color woodcut, *chūban*. 28.5 x 21 cm. The Mann Collection, Highland Park, IL Fig. 55

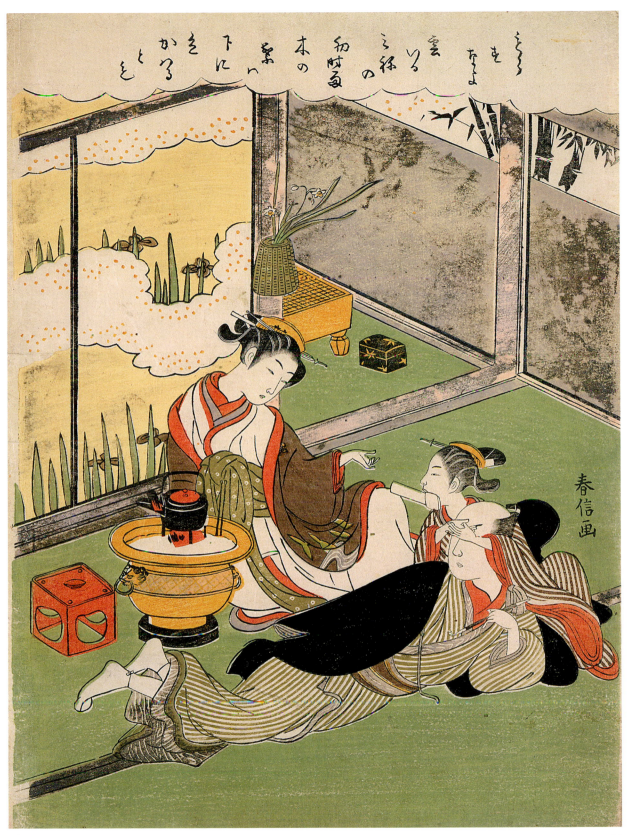

16

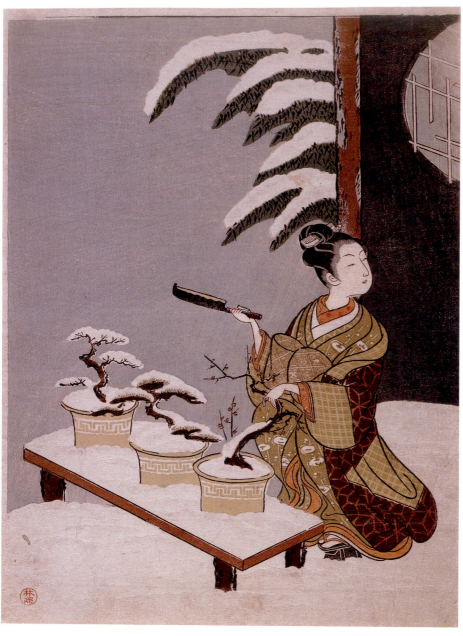

23

21. Suzuki Harunobu (1725?–1770). *Picture Book of Collected Beauties of the Yoshiwara* (*Ehon seirō bijin awase*). 1770 (Meiwa 7.6). Publishers: Funaki Kasuke, Koizumi Chūgorō and Maruya Jinpachi, Edo. Engraver: Endō Matsugorō. Preface listing Harunobu as artist signed *Tanakaan*. Frontispiece illustration of cherry blossoms with *haikai* poem by Kasaya Saren; poems on illustrations of courtesans also by Saren. Color woodblock-printed book, *fukurotojibon*. Vol. 1 ("Spring") of 5 on four seasons and moon. 26.8 x 18 cm each page. Spencer Collection, The New York Public Library, Astor, Lenox and Tilden Foundations, Sorimachi 431 Fig. 107

22. Suzuki Harunobu (1725?–1770). *Lovers Sharing an Umbrella.* 1767. Signed *Suzuki Harunobu ga.* Color woodcut, *chūban.* 26.5 x 20 cm. Private Collection Fig. 58

23. Suzuki Harunobu (1725?–1770). *Parody of the Noh Play* The Potted Trees. 1766. Seal of Hayashi Tadamasa (1853–1906). Color woodcut, left panel of calendar-print diptych, *chūban.* 27.6 x 20.3 cm. Private Collection

This is the left sheet of a diptych. The right sheet depicts a second girl sitting huddled on a verandah and watching what is going on. Compare the much earlier treatment of the Noh play by Okumura Masanobu (figs. 40, 41).

24. Suzuki Harunobu (1725?–1770). *Admiring a Picture of a Dandy by Okumura Masanobu.* 1768. Signed *Harunobu ga.* Masanobu scroll inscribed *Hōgetsudō Tanchōsai Okumura Bunkaku Masanobu shōhitsu* (Genuine brush of Hōgetsudō Tanchōsai Okumura Bunkaku Masanobu). Seal of Henri Vever (1854–1943). Color woodcut, *chūban.* 27.3 x 19.7 cm. Collection of Cecilia Segawa Seigle Fig. 54

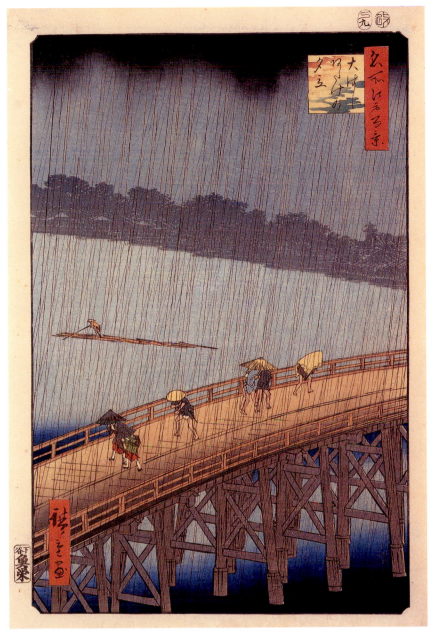

26

25. Utagawa Hiroshige (1797–1858). *Fireworks, Ryōgoku Bridge* (*Ryōgoku hanabi*), from the series *One Hundred Views of Famous Places of Edo* (*Meisho Edo hyakkei*). 1858. Signed *Hiroshige ga*. Publisher: Uoya Eikichi. Censor's seal *aratame* (inspection) with date seal 8th month, Year of the Horse. Color woodcut, *ōban*. 36.1 x 23.5 cm. Brooklyn Museum, Gift of Anna Ferris, 30.1478.98 Fig. 129

26. Utagawa Hiroshige (1797–1858). *Sudden Shower at Ōhashi Bridge, Atake* (*Ōhashi Atake yūdachi*), from the series *One Hundred Views of Famous Places of Edo* (*Meisho Edo hyakkei*). 1857. Signed *Hiroshige ga*. Publisher: Uoya Eikichi. Censor's seal *aratame* (inspection) with date seal 9th month, Year of the Snake. Color woodcut, *ōban*. 36.3 x 24.9 cm. The Mann Collection, Highland Park, IL

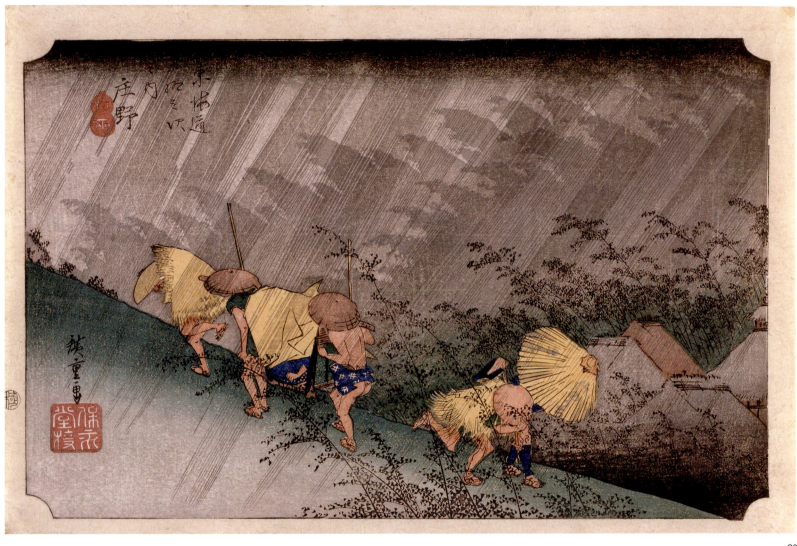

27. Utagawa Hiroshige (1797–1858). *Poem by Bai Juyi*, from the series *Chinese and Japanese Verses for Recitation* (*Wakan rōeishū*). c. 1840–41. Signed *Hiroshige hitsu* and sealed *Ichiryūsai*. Publisher: Jōshūya Kinzō. Censor's seal *kiwame* (certified). Color woodcut, *ōban*. 37.5 x 25.8 cm. The Mann Collection, Highland Park, IL Fig. 11

28. Utagawa Hiroshige (1797–1858). *Driving Rain, Shōno* (*Shōno hakuu*), from the series *The Fifty-three Stations of the Tōkaidō* (*Tōkaidō gojūsan tsugi no uchi*). c. 1833. Signed *Hiroshige ga*. Publisher: Takenouchi Magohachi (Hōeidō). Censor's seal *kiwame* (certified). Color woodcut, *ōban*. 24.7 x 37.2 cm. Private Collection, New York

29. Utagawa Hiroshige (1797–1858). *Bird and Loquats*. Early 1830s. Signed *Hiroshige hitsu*. Publisher: Sanoya Kihei (seal *Kikakudō sei* in red cartouche below artist's signature; seal *Sanoya* in red gourd-shaped seal below censor's round seal). Censor's seal *kiwame* (certified). Rectangular red seal to right reading *Tenpō shinchō* (newly printed from the Tenpō era). Color woodcut, block carved in reverse to simulate Chinese-style stone rubbings (*ishizuri-e*), *ō-tanzaku*. 38 x 17.3 cm. Museum of Art, Rhode Island School of Design, Providence, Gift of Mrs. John D. Rockefeller, Jr., 34.282

The Chinese poem may be translated: The day fresh green leaves spring from bamboo shoots is the time for gathering in my basket the gold studding the trees.

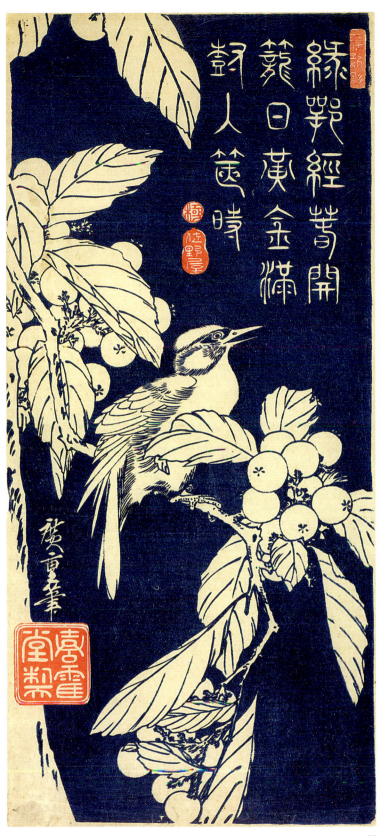

29

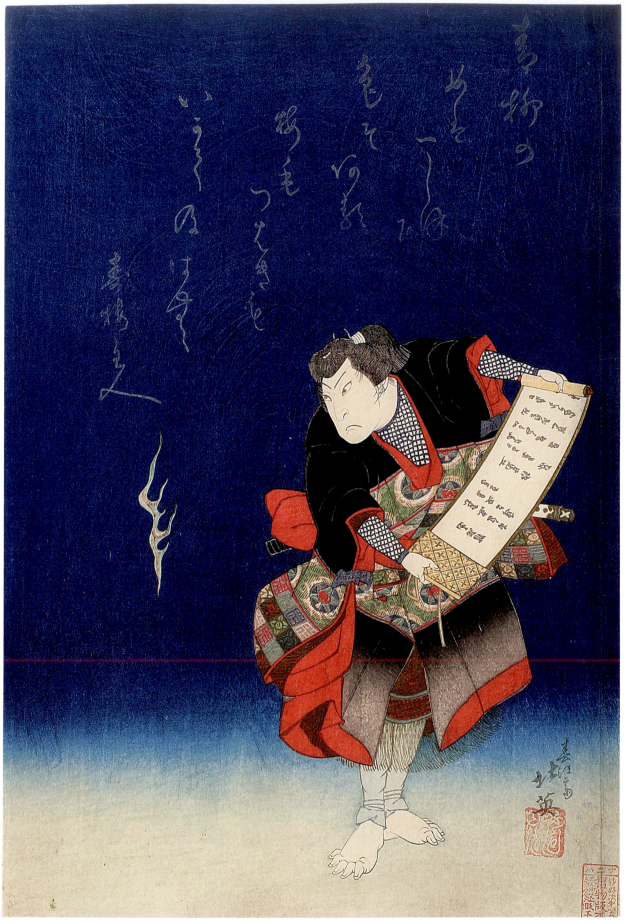

31

30. Totoya Hokkei (1780–1850). *Eguchi* [The Courtesan of Eguchi as the Bodhisattva Fugen from the Noh play, *Eguchi*], from *A Series of Noh Plays for the Hanazono Club* (*Hanazono yōkyoku bantsuzuki*). c. 1823. Signed *Hokkei*. Color woodcut, *surimono* with silver powder and embossing, *shikishiban*. 20.9 x 18.4 cm. Collection of Joanna H. Schoff Fig. 105

31. Shunkōsai Hokuei (act. 1824?–37). *The Osaka Actor Arashi Rikan II as Sōma Tarō before a Spirit Flame*. 1832. Signed *Shunkōsai Hokuei* and sealed *Fumoto no ume* (Plum tree in the foothills). Poem signed *Jubai Shujin*. Color woodcut *surimono* with silver powder, *ōban*. 37.2 x 25.1 cm. Collection of Dr. and Mrs. Martin Levitz

As Tarō unrolls a scroll of spells to use to avenge the death of his father, the wizard-general Masakado, he senses the spirit of his parent, manifested as a silver flame.

32. Shunkōsai Hokuei (act. 1824?–37). *The Osaka Actor Arashi Rikan II as Danshichi Kurobei in the Night Murder Scene of the Kabuki Play* Mirror of Naniwa [Osaka]: The Summer Festival (*Natsu matsuri Naniwa kagami*). 1832. Signed *Shunkōsai Hokuei* and sealed *Shunkō*. Engraver: Kasuke. Poem signed *Rikan*. Color woodcut, *ōban*. 37.2 x 24 cm. The Mann Collection, Highland Park, IL Fig. 133

No longer able to withstand the ridicule of his father-in-law, Kurobei makes bloody tracks in the snow after murdering him. The play *Natsu matsuri Naniwa kagami* was performed at the Chikugo Theater in Osaka in 1832. The poem,

signed by the actor, likens Kurobei to young bamboo shoots that can withstand the severest storm:

wakatake ya	Even in heavy rain,
ame no omosa o	the young bamboo
ku ni mo sezu	does not suffer.
	Rikan

Translation by John T. Carpenter

33. Katsushika Hokusai (1760–1849). *The Chinese Immortal Yu Zhi* (J. Gyokushi) *and a Dragon with Zither*. 1798. Dragon painting signed *Hokusai Sōri ga* and sealed *Shi zōka* (My master is creation). Pair of hanging scrolls; ink and color on paper. 125.4 x 56.5 cm each. Private Collection Fig. 102

34. Katsushika Hokusai (1760–1849). Inscription by Santō Kyōden (1761–1816). *Reclining Courtesan*. c. 1800. Signed *Gakyōjin Hokusai ga* and sealed *Kimō dasoku* (Fur on a turtle, legs on a snake). Inscription signed *Seiseisai Kyōden* and sealed *Hasanjin*. Hanging scroll; ink and light color on paper. 29.2 x 44.8 cm. Collection of Peter Grilli and Diana Grilli Fig. 109

35. Katsushika Hokusai (1760–1849). *Five Beauties*. 1805–13. Signed *Katsushika Hokusai hitsu* and sealed *Kimō dasoku* (Fur on a turtle, legs on a snake). Hanging scroll; ink and color on silk. 86.4 x 34.3 cm. Seattle Art Museum, Margaret E. Fuller Purchase Fund, 56.246 Fig. 101

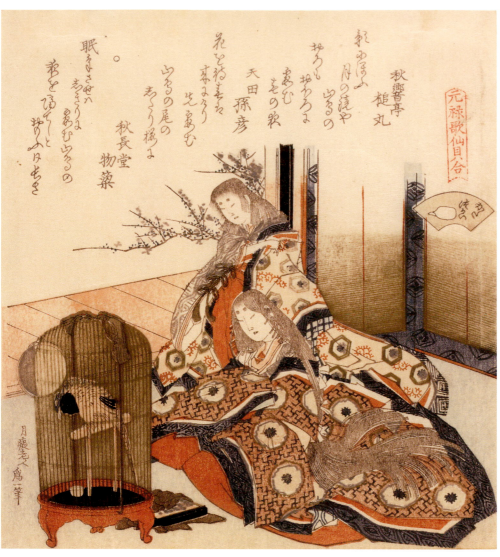

36

36. Katsushika Hokusai (1760–1849). *Univalve Shell* (*Katatsukai*), from the series *Genroku Immortal Poets Shell Matching Contest* (*Genroku kasen kai awase*). 1821. Signed *Getchirōjin Iitsu hitsu*. Poems signed *Shūkyōtei Tsuchimaru, Amada no Magohiko* and *Shūchōdō Monoyana* [see exh. no. 113 note]. Color woodcut with brass and silver powders and embossing, *surimono*, *shikishiban*. 19.3 x 17.8 cm. *Surimono* Collection of the Becker Family

37. Katsushika Hokusai (1760–1849) **and Santō Kyōden** (Kitao Masanobu, 1761–1816). *Gathering Spring Herbs and Brushwood Peddlers from Ohara*. Probably 1796 or 1797. Signed *Hokusai Sōri ga* and sealed *Kanchi*. Ohara peddlers signed *Santō Kyōden ga* and sealed *Hasanjin*. Seal of Wakai Kenzaburō (1834–1908). Color woodcut, *surimono*, *ōbōsho zenshiban* (large *hōsho*, complete sheet), lower half text portion removed. 19.7 x 53.1 cm. The Art Institute of Chicago, Gift of Helen C. Gunsaulus, 1954.643 Fig. 108

38. Katsushika Hokusai (1760–1849). *Fisherman Sitting on a Rock by the Sea*. Early 1830s. Signed *Jigasan*, contraction of *jiga jisan* (drawn and inscribed by myself). Poem (left) by Hokusai signed *Manji*. Poem (right) by Hokusai's daughter, Katsushika Ōi (c. 1800–c. 1866), signed *Ei*. Color woodcut, *surimono* with brass and silver powders, *shikishiban*. 21.3 x 18.4 cm. The Art Institute of Chicago, Gift of Helen C. Gunsaulus, 1954.625 Fig. 115

39. Katsushika Hokusai (1760–1849). *Birds of the Capital* (*Miyakodori*). c. 1802. Signed in colophon *Gakyōjin Hokusai hitsu*. Color woodcut album of *kyōka* ("mad verse") poems with 6 plates, *aiban*. 23 x 35 cm covers open. The Art Institute of Chicago, Martin A. Ryerson Collection, 4-1-49.

Parents and children make a pilgrimage to Masaki Inari Shrine on the west bank of the Sumida River to partake of an annual Shinto ritual, an end-of-summer purification rite held on the last day of the sixth month. Visitors pass through a large hoop made of *chigaya* grass tied with paper to symbolically exorcise spiritual impurity. The album was privately commissioned by the Nogawa poetry club.

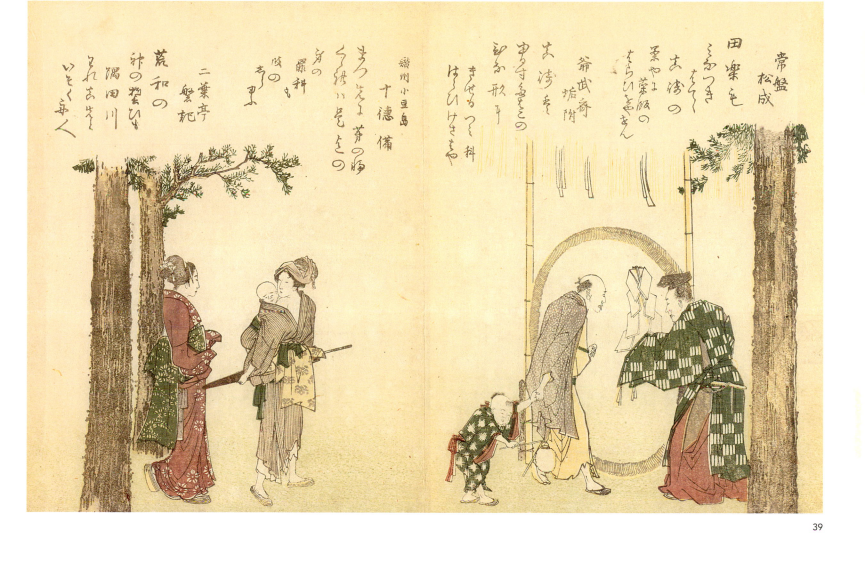

40. Katsushika Hokusai (1760–1849). *Printer and Engraver*. c. 1825. Signed *Hokusai aratame Iitsu hitsu* (drawn by Iitsu, changed from Hokusai). Poems signed as below. Color woodcut, *surimono* with brass and silver powders and embossing, *shikishiban*. 21.4 x 18.7 cm. *Surimono* Collection of the Becker Family Fig. 9

The headnote and first two poems are by Settei Nanzan, identified from the address next to his signature as a poet from Hagi in Nagato province (part of present-day Yamaguchi Prefecture), who wrote the poem in late spring while in Edo:

Tori ga naku Ōedo ni haru o mukaete

Greeting the spring in Great Edo, where the birds sing out.

haru tatsu to	Not only when spring comes,
iu ni kagirazu	but even this morning
Musashino no	layers of mist can be seen
ie wa kasumite	trailing over houses
kesa mo miekeri	on the plains of Musashi.

yo wa hana no	Everywhere we see cherries,
ō no shōgatsu	famous as the "king of flowers,"
kotoba o mo	and into its wood are carved
sakuragi ni horu	New Year's greetings
ōmikuni-buri	in the custom of our sacred land.

The third and final poem is by Kyōkadō (Hall of Mad Poetry), an alternative poetry name used by Yomo no Utagaki Magao (1753–1829), head of the Yomo poetry group. Here he lavishes praise on the calligraphic and carving skills of Settei, whose second name, Nanzan (Southern Mountain), is inscribed on the standing screen behind the figures. Settei probably paid Magao to engage Hokusai for the design and to write the poem, a distinctive feature of these "non-commercial" prints. Magao's poem reads:

sakuragi ni	In a *surimono*
kotobuku haru no	for this felicitous spring,
surimono mo	the characters "Southern Mountain"
minami no yama no	are carved into cherry wood
kakezu kuzurezu	in a formal style, without a flaw.

Translations and commentary by John T. Carpenter

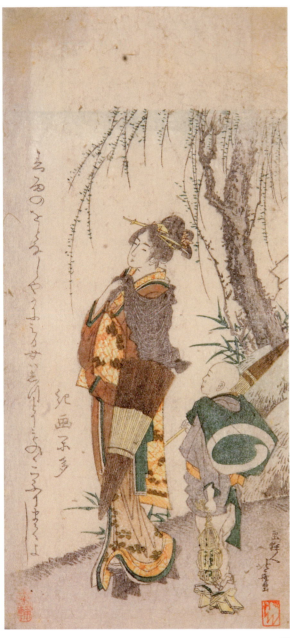

41

41. Katsushika Hokusai (1760–1849). *Girl with Umbrella Walking with a Boy.* c. 1802. Signed *Gakyōjin Hokusai ga.* Seals illegible. Color woodcut, *surimono, jūnigiriban.* 19.5 x 9.3 cm. Private Collection

The poem reads:

> *harusame no* A maiden appears
> *otonashiyaka ni* in the spring drizzle,
> *miru onna wa* so gentle and quiet—
> *shittori mono no* her petite body, now moist,
> *koburi made yoshi* seems all the more alluring.
> Kiga Rakuda

Translation by John T. Carpenter

42. Katsushika Hokusai (1760–1849). *Chinese Boys Watching Tigers Cross a River.* 1806. Signed *Gakyōjin Hokusai ga.* Color woodcut, *surimono, kokonotsugiriban.* 18.5 x 14 cm. Private Collection Fig. 113

43. Katsushika Hokusai (1760–1849). *Fine Wind, Clear Weather* (*Gaifū kaisei*) [*"Red Fuji"*], from the series *Thirty-six Views of Mount Fuji* (*Fugaku sanjūrokkei*). 1830s. Signed *Hokusai aratame Iitsu hitsu* (Drawn by Iitsu, changed from Hokusai). Publisher: Nishimuraya Yohachi (Eijudō). Censor's seal *kiwame* (certified). Color woodcut, *ōban.* 25.5 x 38.1 cm. Private Collection, New York Fig. 2

44. Katsushika Hokusai (1760–1849). *Under the Well of the Great Wave Off Kanagawa* (*Kanagawa oki nami ura*) [*"Great Wave"*], from the series *Thirty-six Views of Mount Fuji* (*Fugaku sanjūrokkei*). 1830s. Signed *Hokusai aratame Iitsu hitsu* (Drawn by Iitsu, changed from Hokusai). Publisher: Nishimuraya Yohachi (Eijudō). Censor's seal *kiwame* (certified). Color woodcut, *ōban.* 26.1 x 38.6 cm. The Mann Collection, Highland Park, IL Fig. 127

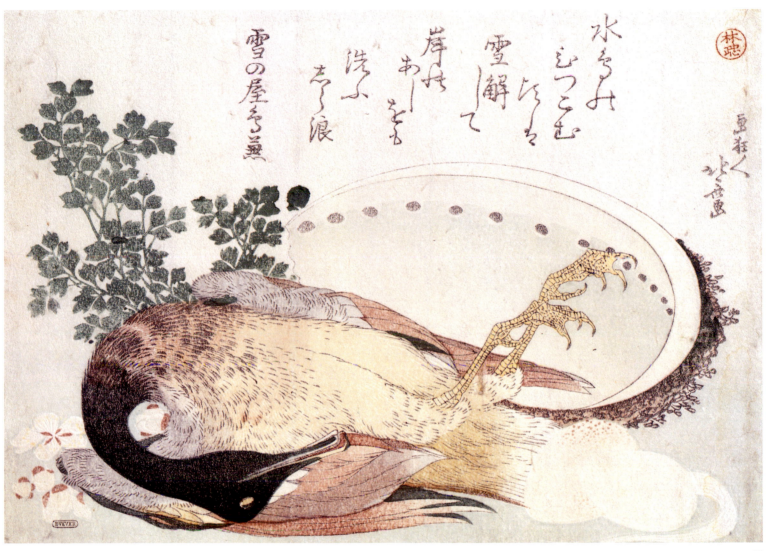

45

45. Katsushika Hokusai (1760–1849). *Dead Mallard with Abalone Shell and Stew Ingredients*, 1805–10. Signed *Gakyōjin Hokusai ga*. Seal of Hayashi Tadamasa (1853–1906). Seal of Henri Vever (1854–1943). Color woodcut, *surimono, yatsugiriban*. 13.9 x 19.3 cm. Collection of Stephen W. Rozan and Marie Rozan

The poem reads:

mizutori no	Just when water birds
hikkomu koro wa	are returning north again,
yukige shite	the snow starts to thaw,
kishi no ashi o mo	and reeds along the bank
arau shiranami	are washed by white-capped waves.
	Yukinoya Torikane

Translation by John T. Carpenter

46

46. Katsushika Hokusai (1760–1849). *Ceramics from Sōma (Sōmayaki)*, from the series *All Variety of Horses (Uma zukushi)*. 1822, Year of the Horse. Signed *Fusenkyo Iitsu hitsu*. Color woodcut, surimono with metallic powders, *shikishiban*. 20.7 x 18.8 cm. Collection of Joanna H. Schoff

A pottery tea cup from Sōma with a silhouette of a horse refers to the year and title of the set, Hokusai's thirty *surimono* for the Yomo Group and two of its subgroups, the Shūchōdō Shachū and Manji-ren. Beside it are an Arita porcelain tea caddy and an iron kettle partly covered by a wrinkled cloth, possibly "Sōma cloth," another famous product from that district in northern Japan. The syllable "ma" in Sōma is written with the character for "horse." In the poem, *Hatsu-mukashi* (old and new) tea was a special blend made for the shogun and an expression for the outgoing year at New Year's:

kusa no me mo
fuku kagen yoki
awayuki no
naka no aomi ya
cha no hatsu-mukashi

Just when it is warm enough
for grasses to push up
green through a dusting of snow,
it's the best time
for *hatsu-mukashi* tea.
 Shūfūen Hananushi

Translation and commentary by John T. Carpenter

47. Katsushika Hokusai (1760–1849). *The Courtesan of Eguchi as the Bodhisattva Fugen and the Monk Saigyō*. c. 1810–11. Signed *Katsushika Hokusai ga* and sealed *Kimō dasoku* (Fur on a turtle, legs on a snake). Album leaf mounted as a framed panel; ink and color on silk. 26.4 x 21.5 cm. John C. Weber Collection Fig. 104

48

48. Shunkōsai Hokushū (act. 1802–32). *Ichikawa Ebijūrō I as Tōken "China Dog" Jūbei, in the Kabuki Play* Benimurasaki ai de someage. c. 1822. Signed *Shunkōsai Hokushū.* Color woodcut, *ōban.* 39.4 x 26 cm. Collection of Dr. and Mrs. Martin Levitz

The poem reads:

Saohime mo	Even Saohime, Goddess of Spring,
nabiki ya suran	cannot help but be won over
hōrai no	by the "prawn," Ebijūrō,
ebi wa rippa na	the pièce de résistance
haru no hanagata	of the New Year's offering
	in this fine spring season.
	Hōrai Sanjin

Hōrai, the traditional abode of the immortals in East Asian mythology, is also an alternative name for the decorative arrangement (*kuitsumi*) of various comestibles prepared for the New Year, which are consumed by guests one by one, until only a large prawn, the most impressive ingredient, remains. *Hanagata* in the last line means both "star piece" and "kabuki star," suggesting that the *ebi*, or "prawn," referring to Ebijūrō, excels in a New Year's performance. The poem on the original print, therefore, made it suitable for reissue as a New Year's greeting card, independent of the original performance it commemorated in 1816. The poet's pen name literally means "Recluse of the Abode of Immortals."

Translation and commentary by John T. Carpenter

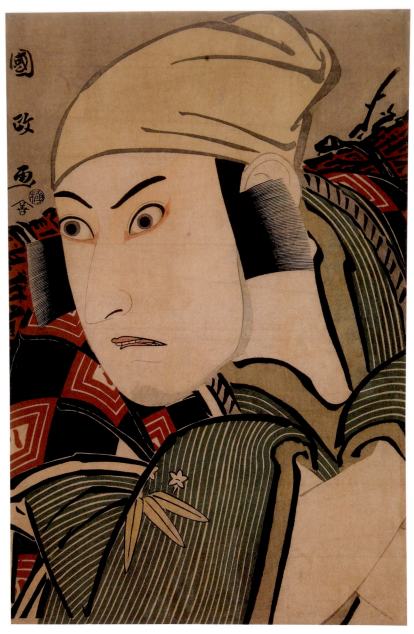

56

49. Shunkōsai Hokushū (act. 1802–32). *Ichikawa Ebijūrō II as Ki no Haseo, Nakamura Utaemon III as Kujaku Saburō and Fujikawa Tomokichi II as Kōbai hime, in the Kabuki Play* Tenmangū aiju no meiboku. *1828. Signed Shunkōsai Hokushū and sealed Yoshinoyama. Color woodcut triptych with metallic powders and embossing, ōban. 37.2 x 76.2 cm. Collection of Dr. and Mrs. Martin Levitz Fig. 6*

The play was performed at the Kado Theater as the New Year's premiere in 1828, when Ichikawa Ichizō II assumed the name Ebijūrō II. The deluxe printing and the lack of publisher's mark and labels of actors and roles may mean this was a private commission.

50. Shunkōsai Hokushū (act. 1802–32). *Nakamura Utaemon III as a Courtesan. c. 1820. Signed Shunkōsai Hokushu and sealed Yoshinoyama. Hanging scroll; ink, color and gold wash on silk. 103.8 x 38.1 cm. John C. Weber Collection Fig. 134*

51. Shunkōsai Hokushū (act. 1802–32). *Nakamura Utaemon III as Kanawa Gorō Imakuni and Arashi Koroku IV as Omiwa, in the Kabuki Play* Mounts Imo and Se: Exemplary Women's Virtues (*Imoseyama onna teikin*). *c. 1821. Signed Shunkōsai Hokushū ga and sealed Yoshinoyama. Color woodcut with gold ground with silver and copper powders, ōban. 39.3 x 26.3 cm. The Mann Collection, Highland Park, IL Fig. 128*

This is the first state of the print with elaborate metallic embellishments and seal. Here, in a case of mistaken identity, Gorō stabs Omiwa, who vows with her blood to help overthrow their adversary, Iruka. The play was performed in Osaka in 1821.

52. Katsushika Hokuun (act. 1804–44). *Courtesan and Daruma. 1820s. Signed Hokuun ga and sealed Taiga. Hanging scroll; ink and color on silk. 90.9 x 33.5 cm. Private Collection Fig. 106*

57

53. Attributed to Sugimura Jihei (act. c. 1681–98). *Lovers Behind a Screen.* 1690s. Woodcut, *sumizuri-e*, handcolored, *ōban*. 26.6 x 36.2 cm. The Mann Collection, Highland Park, IL Fig. 18

54. Attributed to Sugimura Jihei (act. c. 1681–98). *Family Outing on Boy's Day.* 1680s. Monogram seal of Edwin M. Grabhorn (1889–1968) and illegible seal. Woodcut, *sumizuri-e*, handcolored, *ōōban*. 59.7 x 29.8 cm. Asian Art Museum of San Francisco, Gift of the Grabhorn Ukiyo-e Collection, 2005.100.1 Fig. 17

55. Toyohara Kunichika (1835–1900). *Onoe Kikugorō V as Igami no Gonta* (*Igami no Gonta Onoe Kikugorō*), from the series *Fashionable Modern Clothing* (*Tōseigata zokuizoroi*). 1885. Signed *Toyohara Kunichika hitsu* and with *toshidama* seal. Publisher: Kodama Matashichi. Engraver: Horiko Mori. Color woodcut, *ōban*. 38.1 x 24.9 cm. Private Collection Fig. 13

56. Utagawa Kunimasa (1773–1810). *Ichikawa Yaozō III as Watanabe no Tsuna, in the Kabuki Play* Seiwa nidai ōyose Genji. 1796. Signed *Kunimasa ga*. Publisher: Tamariya Zenbei. Censor's seal *kiwame* (certified). Color woodcut, *ōban*. 37 x 25 cm. Private Collection

57. Utagawa Kunisada (1786–1865). *Onoe Matsusuke II* [Kikugorō III, 1784–1849] *as the Carpenter Rokusaburō* (*Daiku Rokusaburō*), from the series *Great Performances* (*Ōatari kyōgen*). c. 1815. Signed *Gototei Kunisada ga*. Publisher: Kawaguchiya Uhei (Fukusendō). Censor's seal *kiwame* (certified). Color woodcut with mica ground, *ōban*. 37.2 x 25.4 cm. Private Collection

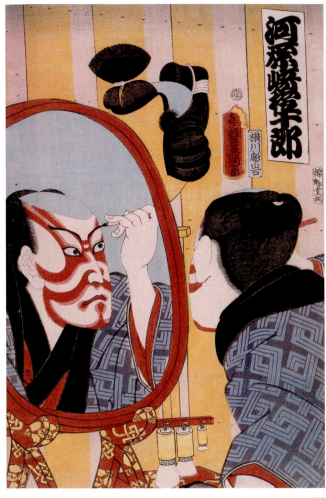

59

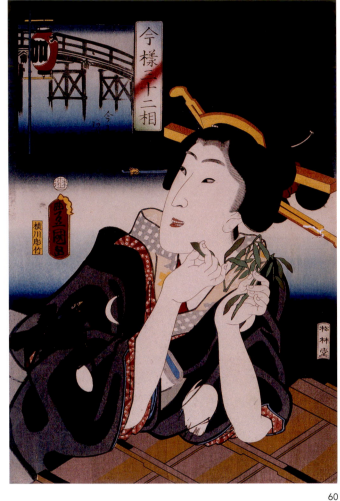

60

58. Utagawa Kunisada (1786–1865). *Nakamura Utaemon III as the Monkey Trainer Yojirō* (*Yojirō*), from the series *Great Performances* (*Ōatari kyōgen*). c. 1815. Signed *Gototei Kunisada ga*. Publisher: Kawaguchiya Uhei (Fukusendō). Censor's seal *kiwame* (certified). Color woodcut with mica ground, *ōban*. 39.3 x 26.8 cm. The Mann Collection, Highland Park, IL Fig. 3

59. Utagawa Kunisada (1786–1865). *Kawarazaki Gonjūrō* (*Ichikawa Danjūrō IX*) *Painting His Eyebrow in a Mirror*, from an untitled series of actors backstage. 1861. Signed *Ki-ō* (old man of seventy-seven) *Toyokuni ga*. Publisher: Tsujiya Yasubei (Kinkaidō). Engraver: Yokogawa Iwa. Censor's seal *aratame* (inspection) with date seal 12th month, Year of the Rooster. Color woodcut, *ōban*. 35 x 24.2 cm. Private Collection

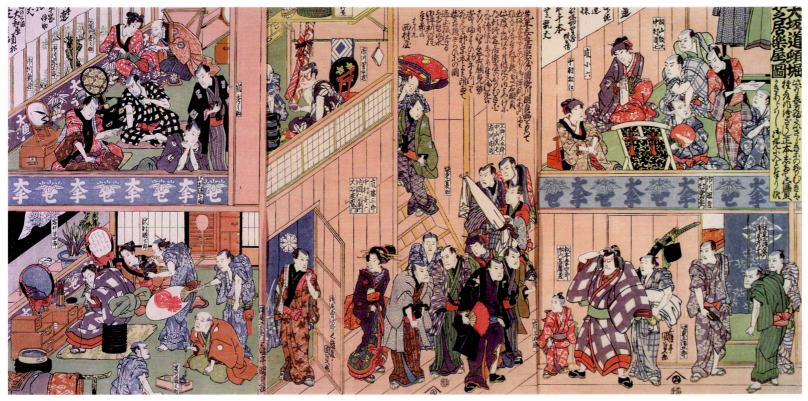

61

60. **Utagawa Kunisada** (1786–1865). *The Excitable Type (Ima ni agari sō),* from the series *Modern Thirty-six Types (Imayō sanjuniso).* 1859. Signed *Toyokuni ga.* Publisher: Fujiokaya Keijirō (Shōrindō). Engraver: Yokogawa Takejirō. Censor's seal *aratame* (inspection) with date seal 12th month, Year of the Goat. Color woodcut, *ōban.* 36.2 x 24.8 cm. Private Collection

61. **Utagawa Kunisada** (1786–1865). *View of the Dressing Rooms in a Theater in Dōtonbori, Osaka (Ōsaka Dōtonbori shibai gakuya no zu).* Spring, 1821. Signed *Gototei Kunisada ga.* Publisher: Nishimuraya Yohachi. Censor's seal *kiwame* (certified). Color woodcut triptych, *ōban.* 36 x 75 cm approx. Worcester Art Museum, Worcester, Massachusetts, Harriet B. Bancroft Fund, 2003.115

In the early spring of 1821, a number of leading Edo actors traveled to Osaka for special guest appearances. Kunisada included both Osaka and Edo actors in this triptych, a fanciful souvenir of the event. The Osaka actor Nakamura Utaemon III (Shikan), seen in costume in figures 3, 128 and 134, kneels in front of a mirror holding a fan in the room on the upper level on the right sheet.

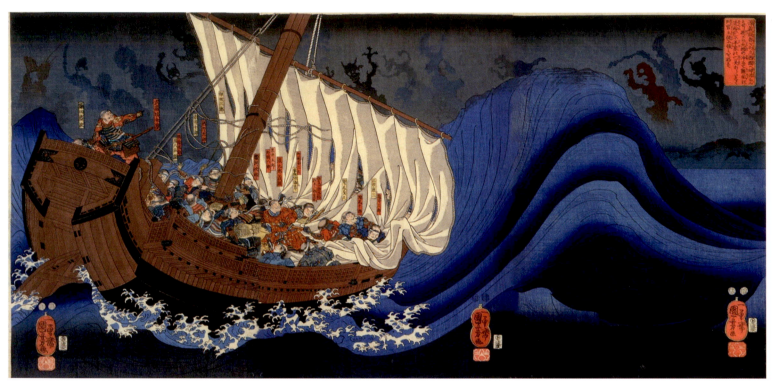

62

62. Utagawa Kuniyoshi (1798–1861). *Benkei and Yoshitsune at the Battle of Dannoura.* 1849–52. Signed *Ichiyūsai Kuniyoshi* ga and with paulownia seal. Publisher: Enshūya Hikobei. Censors' seals of Fukushima Wajūrō and Muramatsu Genroku. Color woodcut, *ōban* triptych. 36 x 75 cm approx. Merlin C. Dailey & Associates, Inc

63. Utagawa Kuniyoshi (1798–1861). *Black Carp.* c. 1847. Signed *Ichiyūsai Kuniyoshi* ga and sealed *Ichiyūsai.* Publisher: Tsujiokaya Bunsuke. Color woodcut, *ōtanzaku.* 37.5 x 12.7 cm. Geoffrey Oliver

64. Utagawa Kuniyoshi (1798–1861). *The Warrior Miyamoto Musashi Subduing a Whale.* 1847–52. Signed *Ichiyūsai Kuniyoshi* ga. Publisher: Kawaguchiya Shōzō (Kawashō). Color woodcut, *ōban* triptych. 36.8 x 73.7 cm. Geoffrey Oliver Fig. 131

65. Utagawa Kuniyoshi (1798–1861). *Hell Courtesan.* c. 1850. Signed *Ichiyūsai Kuniyoshi* ga and with unidentified seal. Hanging scroll remounted as a framed panel; ink, color and gold on silk. 140.3 x 81.9 cm. John C. Weber Collection Fig. 125

66. Kitao Masanobu (Santō Kyōden, 1761–1816). *New Mirror Comparing the Handwriting of the Courtesans of the Yoshiwara* (*Yoshiwara keisei shin bijin awase jihitsu kagami*). 1784. Two plates entitled *A Collection of Handwriting of Famous Courtesans of the Yoshiwara* (*Seirō meikun jihitsu shū*), with Tsutaya's

imprint and lacking address above emblem of new premises in Ōmonguchi as of autumn, 1783. Signed *Kitao Rissai Masanobu* ga and sealed *Soseki.* Publisher: Tsutaya Jūzaburō (Kōshodō). 2-page preface signed *Yomo Sanjin* [Shokusanjin, Ōta Nanpo, 1749–1823]. Postscript signed *Akera Kan Shujin* [Akera Kankō, 1736–1799]. Seal of Tony Straus-Negbaur. Color woodcut album, 7 *ōban* diptychs. Plates 37.8 x 51 cm. Private Collection Figs. 10, 85

67. Okumura Masanobu (1686–1764). *Courtesan in Robe Decorated with Calligraphy.* 1710s. Signed *Okumura Masanobu zu* and sealed *Masanobu.* Publisher: Igaya Kanemon (seal *hanmoto Igaya motohamachō*). Woodcut, handcolored, *ōōban.* 54 x 29.3 cm. Clarence Buckingham Collection, The Art Institute of Chicago, 1925.1744 Fig. 34

68. Okumura Masanobu (1686–1764). *Courtesan Poling Daruma in a Reed Boat.* Early 1710s. Signed *Okumura Masanobu zu* and sealed *Masanobu.* Woodcut, handcolored with orange pigment (*tan-e*), *ōōban.* 48.9 x 29.8 cm. Asian Art Museum of San Francisco, Gift of the Grabhorn Ukiyo-e Collection, 2005.100.8 Fig. 37

69. Okumura Masanobu (1686–1764). *Korean Acrobatic Rider Inscribing Calligraphy While Standing in the Stirrups.* 1740s. Signed *Hōgetsudō shōmyō Okumura Bunkaku Masanobu shōhitsu* and sealed *Tanchōsai.* Woodcut, handcolored, *beni-e, hashira-e.* 71.8 x 16.8 cm. Asian Art Museum of San Francisco, Gift of the Grabhorn Ukiyo-e Collection, 2005.100.10 Fig. 47

70. Okumura Masanobu (1686–1764). *Ukifune Chapter of* The Tale of Genji (*Genji Ukifune*). Mid-1740s. Signed *Hōgetsudō Tanchōsai Okumura Masanobu ga* and sealed *Tanchōsai*. Monogram of Edwin M. Grabhorn (1889–1968). Woodcut, handcolored, *beni-e, ōōban*. 32.4 x 43.8 cm. Asian Art Museum of San Francisco, Gift of the Grabhorn Ukiyo-e Collection, 2005.100.9 Fig. 52

71. Okumura Masanobu (1686–1764). *Courtesan Holding a Pipe*. Mid-1740s. Signed *Hōgetsudō Tanchōsai hashira-e kongen Okumura Bunkaku Masanobu shōhitsu* (Genuine brush of Hōgetsudō Tanchōsai originator of the pillar picture Okumura Bunkaku Masanobu) and sealed *Tanchōsai*. Woodcut, handcolored, *beni-e*, extra-long *hashira-e* of 2 joined sheets. 128.2 x 16 cm. Museum of Fine Arts, Boston, William Sturgis Bigelow Collection, 11.13335 Fig. 48

This impression with poem is unique among the three known designs of this print. The unsigned poem, which repeats elements of a famous poem by Ono no Komachi (834–900), probably was composed by Masanobu, an aficionado of poetry, and likens the colors of the "flower," that is, the courtesan, to the lush colors of his image of her:

Sugata-e no	Marvellously
utsurinikeri na	mirrored in an image,
hana no iro	the colors of a flower.

72. **Okumura Masanobu** (1686–1764). *Okumura Masanobu's Picture Copy Book* (*Okumura Masanobu edehon*). 1710s. Signed in four places in the album: *Yamato eshi* (Japanese master) *Okumura Masanobu zu* and sealed *Masanobu* and another seal; *Okumura Masanobu zu* and sealed on 4th and 19th plates; *Tōbu Yamato gakō Okumura Masanobu zu* and sealed on 20th plate. Publisher: Rikura Kihei. Woodcut album with twenty plates, *sumizuri-e*, *ōban*. Plates 27 x 18.5 cm. Museum of Fine Arts, Boston, Gift of Mrs. Jared K. Morse in memory of Charles J. Morse, 2007.315 Fig. 38

73. **Okumura Masanobu** (1686–1764). *Large Perspective Picture of the Kabuki Theater District in Sakaichō and Fukiyachō.* c. 1745. Signature and publisher's name in margin trimmed. Woodcut, handcolored, *beni-e*, *ōban*. 43.8 x 64.5 cm. Museum of Fine Arts, Boston, William Sturgis Bigelow Collection, 11.19687

74. **Okumura Masanobu** (1686–1764). *Ebisu and Daikoku Performing a Manzai Dance at New Year.* Late 1710s. Signed *Okumura Masanobu zu* and sealed *Masanobu*. Publisher: Egaya Kanemon. Seals of Wakai Kenzaburō (1834–1908) and Hayashi Tadamasa (1853–1906). Woodcut, handcolored with orange pigment (*tan-e*), *ōban*. 56.4 x 31.5 cm. Collection of Harlow N. Higinbotham Fig. 39

75. **Okumura Masanobu** (1686–1764). *Large Perspective Picture of a Second-floor Parlor in the New Yoshiwara, Looking Toward the Embankment* (*Shin Yoshiwara nikai zashiki dote o mitōshi ō-uki-e*). c. 1745. Signed left margin *Tōbu Yamato gakō Hōgetsudō shōmyō Okumura Bunkaku Masanobu shōhitsu* and sealed *Tanchōsai*. Publisher's name right margin: Okumuraya hanmoto. Woodcut, handcolored, *beni-e*, *ōōban*. 42 x 65.7 cm. The Mann Collection, Highland Park, IL Fig. 51

76. **Okumura Masanobu** (1686–1764). *A Floating World Version of the Noh Play* The Potted Trees (*Ukiyo hachi no ki*). 1710s. Signed *Okumura Masanobu zu* and sealed *Masanobu*. Publisher: Komatsuya. Woodcut, handcolored, *beni-e*, *ōōban*. 31.1 x 54.3 cm. The Mann Collection, Highland Park, IL Fig. 40

77. **Okumura Masanobu** (1686–1764). *A Floating World Monkey Trainer on the Sumida River* (*Sumidagawa ukiyo sarumawashi*). Late 1740s–early 1750s. Signed *Hogetsudō Okumura Bunkaku Masanobu shōhitsu* and sealed *Tanchōsai*. Seal of Henri Vever (1854–1943). Color woodcut, *benizuri-e*, *ōōban*. 32.3 x 44.7 cm. The Mann Collection, Highland Park, IL Fig. 53

78. **Okumura Masanobu** (1686–1764). *Courtesan.* c. 1716–36. Signed *Okumura Masanobu zu* and sealed *Masanobu*. Hanging scroll; ink, color and gold on silk. 47.8 x 26.4 cm. John C. Weber Collection Fig. 35

79. Attributed to Hishikawa Moronobu (1630/31?–1694). *A Guide to Love in the Yoshiwara* (*Yoshiwara koi no michibiki*). 1678 (Enpō 6.3). Publisher: Hontoiya at Tōriaburachō [Edo] (*Tōriaburachō Hontoiya kaihan*). Woodblock-printed book, *sumizuri-e*, handcolored, *fukurotojibon*. 1 vol. Plates 28 x 33 cm. Museum of Fine Arts, Boston, Gift of William S. and John T. Spaulding, 2000, 2000.1257 Fig. 27

80. Hishikawa Moronobu (1630/31?–1694). *A Visit to the Yoshiwara.* Late 1680s. Inscribed *Yamato-e Hishikawa Moronobu ga* and sealed *Moronobu* and *Hishikawa*. Handscroll; ink, color and gold on paper. 54.1 x 1,761.4 cm. John C. Weber Collection Figs. 15, 30–32

81. Hishikawa Moronobu (1630/31?–1694). *Watching a Courtesan and Her Client From Behind a Screen.* c. 1680. Woodcut, *sumizuri-e, ōban.* 27.2 x 38.3 cm. Kate S. Buckingham Endowment, The Art Institute of Chicago, 1973.645.9 Fig. 20

82. Hishikawa Moronobu (1630/31?–1694). *Lovers Beside a Screen.* c. 1680. Woodcut, *sumizuri-e, ōban.* 27.2 x 38.4 cm. Kate S. Buckingham Endowment, The Art Institute of Chicago, 1973.645.1 Fig. 21

83. Hishikawa Moronobu (1630/31?–1694). *Lovers By a Screen.* c. 1680. Woodcut, *sumizuri-e, ōban.* 27.1 x 38.4 cm. Kate S. Buckingham Endowment, The Art Institute of Chicago, 1973.645.4 Fig. 22

84. Hishikawa Moronobu (1630/31?–1694). *Standing Beauty.* c. 1690. Signed *Yamato-e Hishikawa Moronobu zu* and sealed *Hishikawa* and *Moronobu*. Hanging scroll; ink and color on silk. 68.6 x 31.2 cm. Collection of Richard Fishbein and Estelle Bender Fig. 24

85. Hishikawa Moronobu (1630/31?–1694). *Couple Seated by Autumn Flowers.* 1680s. Woodcut, *sumizuri-e, ōban.* 29.2 x 34.3 cm. The Metropolitan Museum of Art, Harris Brisbane Dick Fund and Rogers Fund, 1949, JP 3069 Fig. 19

86. Hishikawa Moronobu (1630/31?–1694). *Yoshiwara Street Scene,* from the series *Aspects of the Yoshiwara* (*Yoshiwara no tei*). 1682–83. Publisher: Yamagataya Ichirōemon. Woodcut, *sumizuri-e, ōban.* 25.7 x 38.6 cm. The Metropolitan Museum of Art, Gift of the Estate of Samuel Isham, 1914, JP 809 Fig. 28

87. Hishikawa Moronobu (1630/31?–1694). *Entertainers in a House of Assignation,* from the series *Aspects of the Yoshiwara* (*Yoshiwara no tei*). 1682–83. Publisher: Yamagataya Ichirōemon. Woodcut, *sumizuri-e, ōban.* 25.7 x 38.6 cm. The Metropolitan Museum of Art, Gift of the Estate of Samuel Isham, 1914, JP 812 Fig. 29

91

88. Hishikawa Moronobu (1630/31?–1694). *The Various Occupations of Japan, Exhaustively Portrayed: A Picture Book Mirror of Various Occupations* (*Wakoku shoshoku ezukushi: shoshoku ehon kagami*). 1685. Signed *Hishikawa Morono-bu* and sealed *Hishikawa*. Seal of Hayashi Tadamasa (1853–1906). Woodblock-printed book, *fukurotojibon*. 4 vols. bound as 3. 26.7 x 18.5 cm each page. Collection of Arthur Vershbow Fig. 16

89. Hashimoto Sadahide (1807–1878/79). *The American Merchant Eugene Van Reed.* 1860s. Signed *Dai Nihon Edo Hashimoto Gyokuransai Sadahide ga* and with *toshidama* seal. Framed painting; ink and color on silk. 102.9 x 35.6 cm. Asian Art Museum of San Francisco, Transfer from the Fine Arts Museums of San Francisco, Gift of Mrs. Noble T. Biddle, 2001.8 Fig. 12

90. Hashimoto Sadahide (1807–1878/79). *Yokohama Trade: Pictures of West-erners Shipping Cargo* (*Yokohama kōeki seiyōjin nimotsu unsō no zu*). 1861. Signed *Gountei Sadahide ga.* Publisher: Yamaguchiya Tōbei. Color woodcut, *ōban* pentaptych. 37.5 x 127 cm. Geoffrey Oliver Fig. 130

91. Hashimoto Sadahide (1807–1878/79). *Foreign Trading Establishments in Yokohama* (*Yokohama ijin shōkan urimono no zu*). 1861. Signed *Gountei Sadahide ga.* Publisher: Sanoya Kihei. Color woodcut, *ōban* hexaptych. The upper triptych 37.5 x 76.5 cm; the lower triptych 36.2 x 76.2 cm. Private Collection, New York

92. Tōshūsai Sharaku (act. 1794–95). *Nakamura Konozō as the Homeless Boatman Kanagawaya no Gon and Nakajima Wadaemon as Bōdara ("Dried Codfish") Chōzaemon, in the Kabuki Play* A Medley of Tales of Revenge (*Kata-kiuchi noriaibanashi*). 1794. Signed *Tōshūsai Sharaku ga.* Publisher: Tsutaya Jūzaburō. Censor's seal *kiwame* (certified). Seal of Henri Vever (1854–1943). Color woodcut with mica ground, *ōban.* 37.5 x 25.4 cm. Asia Society, Mr. and Mrs. John D. Rockefeller 3rd Collection of Asian Art, 1979.220

The play was presented at the Kiri Theater in Edo in the fifth month of Kansei 6 (1794) and was a composite drawn from two tales of revenge. Konozō and Wadaemon's relationship to the kabuki narrative is not clear. This is one of the best impressions to have survived, with Wadaemon having a red band of makeup over his eyes and Konozō wearing a slight body tint.

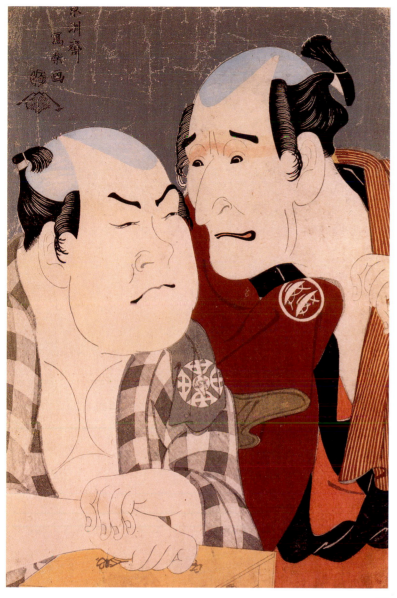

92

94

93. Tōshūsai Sharaku (act. 1794–95). *Ichikawa Ebizō IV as Takemura Sada-noshin, a Noh Performer Driven to Suicide by his Daughter's Disgrace, in the Kabuki Play* The Beloved Wife's Particolored Reins (*Koi nyōbō somewake tazuna*). 1794. Signed *Tōshūsai Sharaku ga*. Publisher: Tsutaya Jūzaburō. Censor's seal *kiwame* (certified). Color woodcut with mica ground, *ōban*. 38.3 x 25.9 cm. The Mann Collection, Highland Park, IL Fig. 96

94. Tōshūsai Sharaku (act. 1794–95). *Matsumoto Kōshirō IV as the Fishmonger Gorōbei from Sanya, in the Kabuki Play* A Medley of Tales of Revenge (*Kataki-uchi noriaibanashi*). 1794. Signed *Tōshūsai Sharaku ga*. Publisher: Tsutaya Jūzaburō. Censor's seal *kiwame* (certified). Color woodcut with mica ground, *ōban*. 37.3 x 24.9 cm. The Mann Collection, Highland Park, IL

95. Tōshūsai Sharaku (act. 1794–95). *Sanogawa Ichimatsu III as the Courtesan Onayo of Gion, in the Kabuki Play* The Iris Soga of the Bunroku Era (*Hanashōbu Bunroku Soga*). 1794. Signed *Tōshūsai Sharaku ga*. Publisher: Tsutaya Jūzaburō. Censor's seal *kiwame* (certified). Seal of Henri Vever (1854–1943). Color wood-cut with mica ground, *ōban*. 38.9 x 25.8 cm. The Mann Collection, Highland Park, IL Fig. 95

96

97

96. Tōshūsai Sharaku (act. 1794–95). *Sakata Hangorō III as Fujikawa Mizu-emon, Villain of the Kabuki Play* The Iris Soga of the Bunroku Era (*Hanashōbu Bunroku Soga*). 1794. Signed *Tōshūsai Sharaku ga.* Publisher: Tsutaya Jūzaburō. Censor's seal *kiwame* (certified). Color woodcut with mica ground, *ōban.* 38.5 x 26 cm. Private Collection

97. Tōshūsai Sharaku (act. 1794–95). *Ōtani Tokuji as the Manservant* (yakko) *Sodesuke, in the Kabuki Play* The Iris Soga of the Bunroku Era (*Hanashōbu Bunroku Soga*). 1794. Signed *Tōshūsai Sharaku ga.* Publisher: Tsutaya Jūzaburō. Censor's seal *kiwame* (certified). Color woodcut with mica ground, *ōban.* 36.2 x 24.7 cm. Private Collection, New York

98. Tōshūsai Sharaku (act. 1794–95). *Morita Kanya VIII as the Palanquin-bearer Uguisu no Jirosaku, in the Kabuki Play* A Medley of Tales of Revenge (*Katakiuchi noriaibanashi*). 1794. Signed *Tōshūsai Sharaku ga.* Publisher: Tsutaya Jūzaburō. Censor's seal *kiwame* (certified). Seal of Hayashi Tadamasa (1853–1906). Seal of Henri Vever (1854–1943). Color woodcut with mica ground, *ōban.* 36.8 x 25.4 cm. David R. Weinberg Collection

99. Tōshūsai Sharaku (act. 1794–95). *Sawamura Sōjūrō III as Ōgishi Kurando, in the Kabuki Play* The Iris Soga of the Bunroku Era (*Hanashōbu Bunroku Soga*). 1794. Signed *Tōshūsai Sharaku ga.* Publisher: Tsutaya Jūzaburō. Censor's seal *kiwame* (certified). Seal of Henri Vever (1854–1943). Color woodcut with mica ground, *ōban.* 36.3 x 24.2 cm. David R. Weinberg Collection Fig. 98

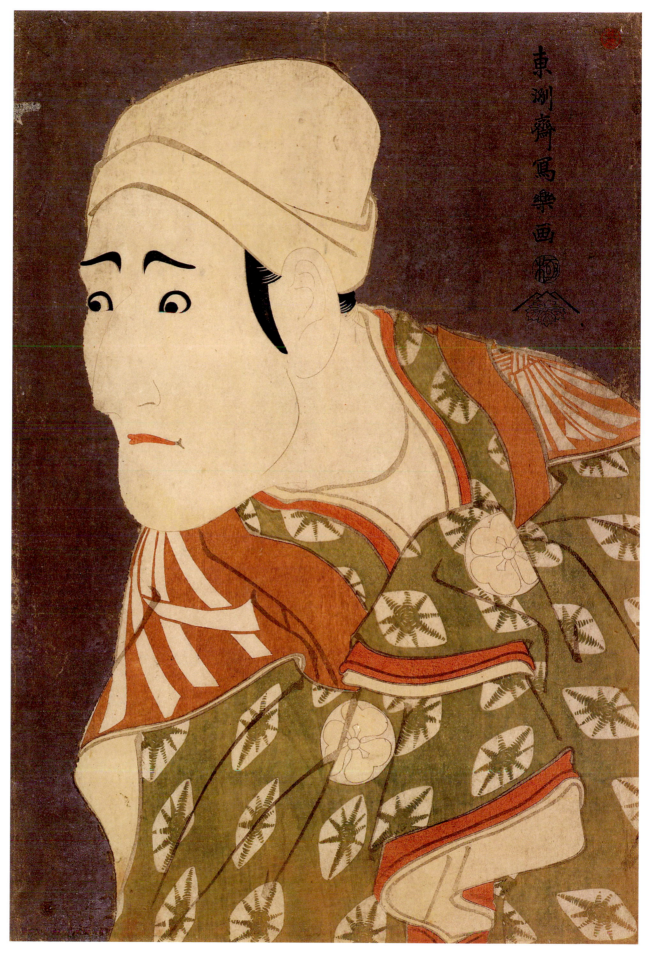

98

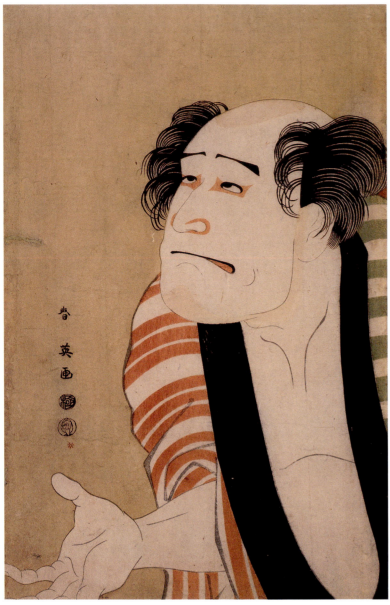

100

100. Katsukawa Shun'ei (c. 1762–1819). *Arashi Ryūzō as a Manservant* (yakko). 1794. Signed *Shun'ei ga*. Publisher: Tsuruya Kiemon. Censor's seal *kiwame* (certified). Seal of Henri Vever (1854–1943). Color woodcut, *ōban*. 36.8 x 24.1 cm. Asia Society, Mr. and Mrs. John D. Rockefeller 3rd Collection of Asian Art, 1979.221

101. Katsukawa Shun'ei (c. 1762–1819). *Sanogawa Ichimatsu III as Onayo, in the Kabuki Play* The Iris Soga of the Bunroku Era (*Hanashōbu Bunroku Soga*). 1794. Signature indistinct. Publisher: Emiya Kichiemon. Censor's seal *kiwame* (certified). Seal of Henri Vever (1854–1943). Color woodcut with mica ground, *aiban*. 32.5 x 22.5 cm. Private Collection.

For the Sharaku print of the actor in the same role see exh. no. 95.

102. Katsukawa Shun'ei (c. 1762–1819). *Sawamura Sōjūrō III as Ōgishi Kurando, in the Kabuki Play* The Iris Soga of the Bunroku Era (*Hanashōbu Bunroku Soga*). 1794. Signed *Shun'ei ga*. Publisher: Tsuruya Kiemon. Censor's seal *kiwame* (certified). Color woodcut, *ōban*. 37.5 x 25 cm. Private Collection Fig. 97

103. Katsukawa Shunkō (1743–1812). *Ichikawa Ebizō IV (Danjūrō V) in the Shibaraku* (Stop Right There!) *Role*. c. 1797. Signed *Shunkō sahitsu* (painted with the left hand) and with handwritten seal (*kaō*). Hanging scroll; ink and color on paper. 85.7 x 26.9 cm. Minneapolis Institute of Arts, Bequest of Richard P. Gale, 74.1.114 Fig. 78

104. Katsukawa Shunshō (d. 1792) **and Kitao Shigemasa** (1739–1820). *Mirror of Yoshiwara Beauties Compared* (*Seirō bijin awase sugata kagami*). 1776. Signed *Kitao Karan Shigemasa* and sealed *Kitao Shigemasa no in* and *Katsukawa Yūji Shunshō* and sealed *Katsukawa Shunshō*. Preface signed *Kōshodō Shujin* [Tsutaya Jūzaburō]. Publisher: Tsutaya Jūzaburō (Kōshodō). Block cutter: Inoue Shinshichi. Edo distributor: Yamazaki Kinbei. Color woodblock-printed book. 3 vols., *fukurotojibon*. 28.1 x 18.7 cm each page. Collection of Arthur Vershbow Fig. 68

105. Katsukawa Shunshō (d. 1792). *Haikai Album of the Cuckoo* (*Haikai yobuko-dori*). 1788. Color woodcut album. 1 vol., *orihon*, *ōban*. Plates 25 x 36.4 cm. Private Collection, New York Fig. 74

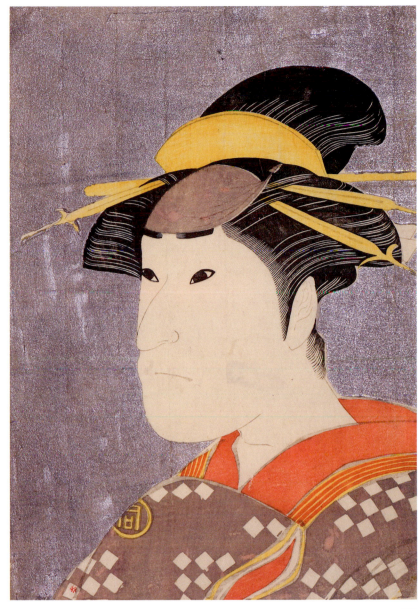

101

106. Katsukawa Shunshō (d. 1792). *Woman in Black Robe.* 1783–89. Signed *Katsu Shunshō ga* and with handwritten seal (*kao*). Hanging scroll; ink, color and gold on silk. 85.1 x 28.5 cm. Mary and Jackson Burke Foundation Fig. 7

107. Katsukawa Shunshō (d. 1792). *Ichikawa Danjūrō V in the* Shibaraku *(Stop Right There!) Role.* Late 1780s. Signed with handwritten seal (*kaō*). Unread poem signed *Hanaōgi* [Hanaōgi IV of the Ōgiya; see exh. no. 137]. Folding fan; ink, color and gold on mica-ground paper. Fan 15.9 x 45.5 cm. John C. Weber Collection Fig. 76

108. Katsukawa Shunshō (d. 1792). *Ichikawa Danjūrō V in* Kumadori *Makeup Seen in a Mirror.* Late 1780s. Signed *Shunshō ga* and with handwritten seal (*kaō*). Hanging scroll; ink and color on silk. 79.2 x 12.1 cm. John C. Weber Collection Fig. 77

109. Katsukawa Shunshō (d. 1792). *Beauty Reading a Letter.* c. 1783–84. Signed *Kyokurōsei Katsukawa Shunshō* and with handwritten seal (*kaō*). Inscribed *Bunkadō no hitsuryoku o utsusu ni tai sezu, motome ni ōjite konko*

ryūkō no fūzoku o zu suru nomi (Though requested to make a painting in the manner of Bunkadō [Nishikawa Sukenobu, 1671–1750] I cannot match the power of his brush so I have worked in the customs of today and earlier). Hanging scroll; ink, color, gold and silver on silk. 92.3 x 35 cm. John C. Weber Collection Fig. 70

110. Katsukawa Shunshō (d. 1792). *Three Beauties.* c. 1789–92. Signed *Katsu Shunshō ga* and sealed *Zōka gachū* (Engaged in the creation of painting). Hanging scroll; ink, color and gold on silk. 94.6 x 34.1 cm. John C. Weber Collection Fig. 66

111. Katsukawa Shunshō (d. 1792). *Peony,* from the handscroll *Secret Games in the Spring Palace (Shungū higi).* Late 1770s. Collector's (?) seal *Sōshū.* Hanging scroll; ink and color on silk. 47 x 69 cm. John C. Weber Collection Fig. 73

112. Katsukawa Shunshō (d. 1792). *Boat Prostitute at Asazuma.* Late 1770s. Signed *Kyokurōsei Katsu Shunshō ga* and with handwritten seal (*kaō*). Hanging scroll; ink and color on silk. 90.8 x 27.9 cm. Collection of Roger L. Weston Fig. 71

113. Hishikawa Sōri III (Tawaraya Sōji, act. late 1790s–late 1810s). *Reception Room with Paintings and Objects Associated with the Seven Gods of Good Fortune.* c. 1805. Signed on the hanging scroll *Hishikawa Sōri ga.* Color woodcut, *surimono* with silver and brass powders, large format *ōbōsho zenshiban* (large *hōsho*, complete sheet). 42.5 x 56.1 cm. *Surimono* Collection of the Becker Family

This *surimono* was probably commissioned around 1805 by a *kyōka* poet who signed his name Shōryūtei Tadataka Nijimori on the occasion of a gathering that was apparently to commemorate a ceremony to expel "unlucky gods." The preface is by the preeminent poet Yomo no Utagaki Magao (1753–1829). Nijimori's poem reads:

yakujin ni	To overcome unlucky gods
kachite kabuto no	don a warrior's helmet
maetate ya	to protect one from ahead,
shichifukujin o	and rely on the seven lucky gods
ushiro tate nite	to stand guard from behind.

It must have been quite an affair, since the roster of those who contributed poems is a veritable Who's Who of Edo literary salons: Magao; Ryūsai Chimata; Danjūrō (Utei) Enba (1743–1822); Ichikawa Hakuen (Danjūrō V, 1741–1806); Sakuragawa Jihinari (1762–1833); Santō Kyōden (1761–1816); Kyōkabō Komendo; Shūchōdō Monoyana (1761–1830); and Sōshūrō Kinrachi, among many others.

The artist inherited the name Sōri from Hokusai in 1798, and for several years continued to create *surimono* and book illustrations in a style so close to his teacher's that it is sometimes hard to distinguish them.

Translation and commentary by John T. Carpenter

114. Nishikawa Sukenobu (1671–1750). *Woman Arranging Her Hair.* c. 1716–41. Signed *Nishikawa Ukyō Sukenobu* [*kore o*] *egaku* and sealed *Nishikawa uji* and *Nishikawa kore* [*o*] *zu* [*su*]. Hanging scroll; ink and color on paper. 86.6 x 37.3 cm. Collection of Roger L. Weston Fig. 69

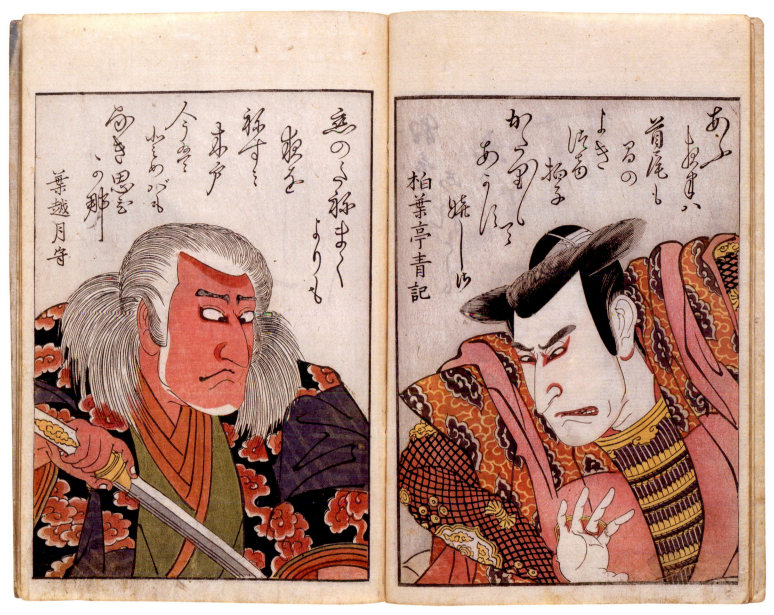

115. Katsushika Tatsujo (act. 1818–28). *Woman with Morning Glories*. c. early 1820s. Signed *Hokusai musume Tatsujo hitsu* (painted by Tatsujo, daughter of Hokusai) and sealed *Fumoto no Sato* (Village at the foot of the mountain). Hanging scroll; ink and color on silk. 34.2 x 44.8 cm. Los Angeles County Museum of Art, Ernest Larsen Blanck Memorial Fund, 58.26.1 Fig. 114

116. Utagawa Toyoharu (1735–1814). *Spring Concert*. 1780s. Signed *Ichiryūsai Utagawa Toyoharu ga* and sealed *Ichiryusai* and *Masaki no in*. Two-panel folding screen; ink and color on silk. 67.4 x 178.8 cm. Collection of Robert and Betsy Feinberg Fig. 5

117. Utagawa Toyohiro (1773?–1828). Inscription by Santō Kyōden (1761–1816). *Beauty Enjoying the Evening Cool*. c. 1805. Signed *Utagawa Toyohiro ga* and sealed *Toyohiro*; signed also *Santō Kyōden* and sealed *Hasanjin*. Hanging scroll; ink and color on silk. 99.5 x 27 cm. Gitter-Yelen Collection Fig. 111

118. Utagawa Toyohiro (1773?–1828). *Enjoying the Evening Cool under a Gourd Trellis*. Early 19th century. Signed *Utagawa Toyohiro ga* and sealed *Toyohiro*. Hanging scroll; ink and color on silk. 84.4 x 28 cm. The Metropolitan Museum of Art, The Harry G. C. Packard Collection of Asian Art, Gift of Harry G. C. Packard and Purchase, Fletcher, Rogers, Harris Brisbane Dick and Louis V. Bell Funds, Joseph Pulitzer Bequest and The Annenberg Fund, Inc., Gift, 1975.268.129 Fig. 135

119. Utagawa Toyokuni (1769–1825). *Actors' Looks in Facing Mirrors* (*Yakusha sōbō kagami*). 1804. Text signed *Asakusa Ichibito*. Preface, vol. 1 signed *Koko Sanjin*; inscription vol. 2 signed *Ichikawa Hakuen* [poetry name of actor Ichikawa Danjūrō V; see exh. nos. 93, 103, 107, 108 and 113]. Publishers: Yamadaya Sanshirō and Banshundō. Seals of Sengen?; Emile Javal; Henri Vever (1854–1943). Color woodblock-printed book. 2 vols, *fukurotojibon*. 26.5 x 17.9 cm each page. Private Collection

Illustration: *Onoe Matsusuke*; poem signed *Kashibatei Aoki* (right page); *Bando Yasosuke*; poem signed *Hagoshi Tsukimori* (left page), vol. 2, fols. 6v–7r

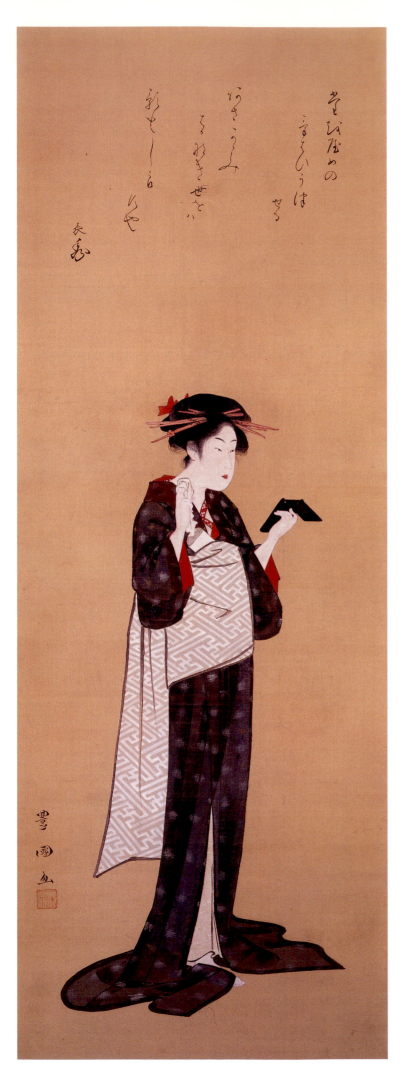

さらなめの
ますかひうは
うきこゝみ
さ好き世と
新もしら
かけ
長春

豊國画

120. **Utagawa Toyokuni** (1769–1825). *Beauty with Hand-mirror.* c. 1795. Signed *Toyokuni ga* and sealed *Ichiyōsai*. Hanging scroll; ink and color on silk. 93 x 34 cm. The Mann Collection, Highland Park, IL

The poem reads:

Taoyame no A mirror in the morning
kewai utsuseru reflects a young maiden
asa-kagami applying her makeup,
hakanaki yo oba but doesn't she see it also reveals
kage to shirazu ya an image of an evanescent world?
 Omohide (Hyōshū)

Translation by John T. Carpenter

Although the character on the mirror-case reads "tortoise," a symbol of long life, the poem is a more melancholy expression of the transience of life.

120

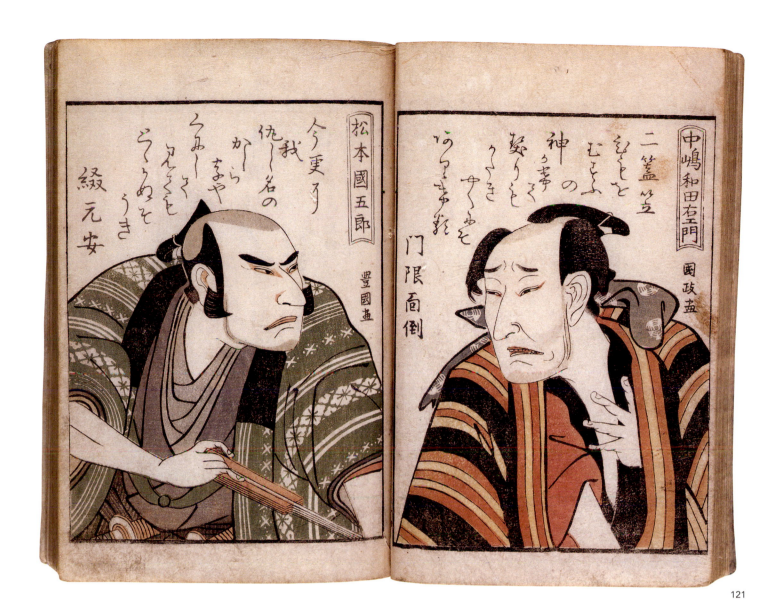

121. Utagawa Toyokuni (1769–1825), **Utagawa Kunimasa** (1773–1810) **and Kitagawa Utamaro** (1753?–1806). *A Connoisseur's Guide to Actors Behind the Scenes* (*Yakusha gakuya tsū*). 1799. Author: Shikitei Sanba (1776–1822). Preface and postscript signed *Shikitei Sanba*. Signed *Toyokuni ga* and *Kunimasa ga*; *Ichiryūsai Utagawa Toyokuni ga*; *Monjin Utagawa Kunimasa*. First double-page illustration signed *Utamaro hitsu*. Publisher: Jōshūya Tadasuke. Color woodblock-printed book. 1 vol., *fukurotojibon*, with later brocade wrappers over original paper covers. 17.9 x 12.5 cm each page. Private Collection

Illustration: *Nakajima Wadaemon and Matsumoto Kunigorō*, fols. 12v–13r
For another portrait of Wadaemon see exh. no. 92.

122. Kitagawa Utamaro (1753?–1806). *Lovers in the Private Second-Floor Room of a Teahouse*, from the album *Poem of the Pillow* (*Utamakura*). 1788. Publisher: Tsutaya Jūzaburō. Color woodcut, 25.5 x 37 cm. The Mann Collection, Highland Park, IL Fig. 87

123. Kitagawa Utamaro (1753?–1806). *Moon-mad Monk* (*Kyōgetsubō*). 1789. Signed *Kitagawa Utamaro* and sealed *Toyoaki no in* and *Utamaro*. Signed *Migi goyō Kitagawa Utamaro sei* (the preceding 5 leaves produced by Kitagawa Utamaro). Publisher: Tsutaya Jūzaburō (Kōshodō). Compiler: Ki no Sadamaru. Preface signed *Ki no Sadamaru*. Color woodcut album with metallic powders and embossing with 10 leaves; 5 plates and 72 *kyōka* ("mad verse") poems on the moon, *ōban*. Plates 25.5 x 38 cm. Private Collection Fig. 88

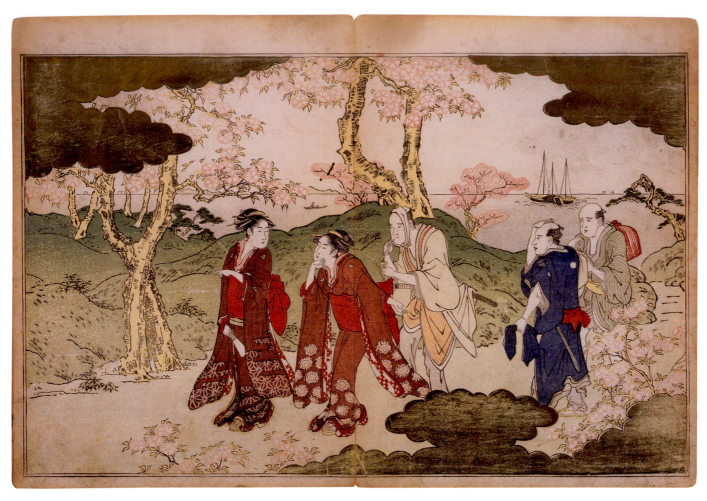

124

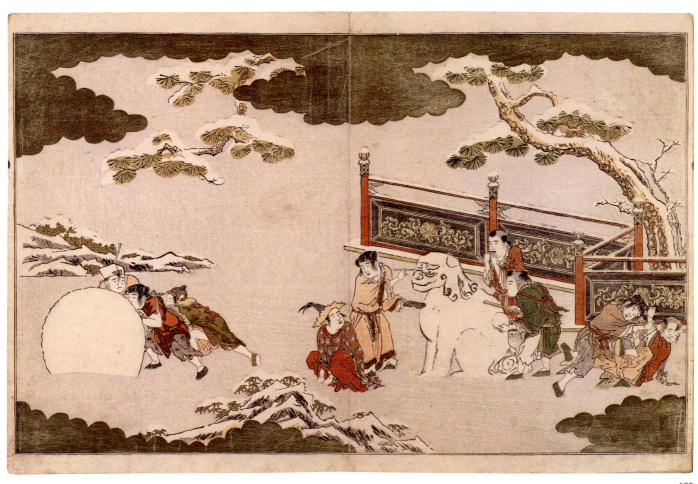

125

127

128

124. Kitagawa Utamaro (1753?–1806). *The Statue of Fugen* (*Fugenzō*). 1790. Signed *Kitagawa Utamaro*. Cyclically dated in preface; colophon undated. Publisher: Tsutaya Jūzaburō (Kōshodō). Color woodcut album with metallic powders and embossing, *orihon*, now divided into 9 separate leaves, comprising 3 of 5 original plates and 10 pp. of *kyōka* ("mad verse") by various poets, and covers, *ōban*. Plates 25.6 x 37 cm. Geoffrey Oliver

Illustration: *Viewing Cherry Blossoms at Gotenyama*

125. Kitagawa Utamaro (1753?–1806). *The Silver World* (*Ginsekai*). 1790. Sealed *Toyoaki no in* and *Utamaro*. Editor [publisher]: Tsutaya Jūzaburō (Kōshodō). Distributor: Yadoya no Meshimori. Preface signed *Yadoya Meshimori*. Color woodcut album with metallic powders and embossing with 5 illustrations of winter scenes followed by 8 pp. of *kyōka* ("mad verse"), *ōban*. Plates 25.5 x 38 cm. The Metropolitan Museum of Art, The Howard Mansfield Collection, Gift of Howard Mansfield, JIB 89

Illustration: *Children Making a Snow Sculpture*, fols. 6v–7r [details of lion face are later ink additions]

126. Kitagawa Utamaro (1753?–1806). *The Light-hearted Type* (also called *The Fancy-Free Type*) (*Uwaki no sō*), from the series *Ten Types in the Physiognomic Study of Women* (*Fujin sōgaku juttai*). c. 1792–93. Signed *Sōmi Utamaro ga* (Drawn by Utamaro the physiognomist). Publisher: Tsutaya Jūzaburō. Censor's seal *kiwame* (certified). Seal of Henri Vever (1854–1943). Color woodcut with mica ground, *ōban*. 37.8 x 25.1 cm. Asia Society, Mr. and Mrs. John D. Rockefeller 3rd Collection of Asian Art, 1979.219 Fig. 89

127. Kitagawa Utamaro (1753?–1806). *Woman Holding a Parasol*, from the series *Ten Types in the Physiognomic Study of Women* (*Fujo ninsō juppon*). c. 1792–93. Signed *Sōkan Utamaro kōga* (Thoughtfully drawn by Utamaro the physiognomist). Publisher: Tsutaya Jūzaburō. Color woodcut with mica ground, *ōban*. 38.1 x 25.7 cm. The Metropolitan Museum of Art, The Howard Mansfield Collection, Purchase, Rogers Fund, 1936, JP 2730

129

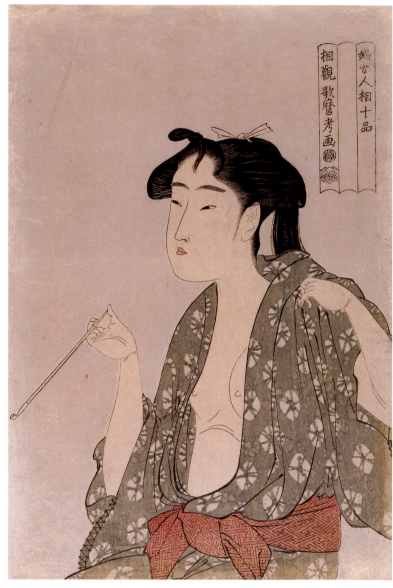

130

128. Kitagawa Utamaro (1753?–1806). *Woman Blowing a Glass Toy* (popen), from the series *Ten Types in the Physiognomic Study of Women* (Fujo ninsō juppon), c. 1792–93. Signed *Sōkan Utamaro kōga* (Thoughtfully drawn by Utamaro the physiognomist). Publisher: Tsutaya Jūzaburō. Censor's seal *kiwame* (certified). Color woodcut with mica ground, *ōban*. 38.9 x 27.5 cm. The Metropolitan Museum of Art, H. O. Havemeyer Collection, Bequest of Mrs. H. O. Havemeyer, 1929, JP 1662

129. Kitagawa Utamaro (1753?–1806). *Woman with Round Fan*, from the series *Ten Types in the Physiognomic Study of Women* (Fujin sōgaku juttai), c. 1792–93. Signed *Sōmi Utamaro ga* (Drawn by Utamaro the physiognomist). Publisher: Tsutaya Jūzaburō. Censor's seal *kiwame* (certified). Seal of Wakai Kenzaburō (1834–1908). Color woodcut with mica ground, *ōban*. 38.3 x 25.2 cm. Private Collection

130. Kitagawa Utamaro (1753?–1806). *Woman Exhaling Smoke from a Pipe*, from the series *Ten Types in the Physiognomic Study of Women* (Fujo ninsō juppon). c. 1792–93. Signed *Sōkan Utamaro kōga* (Thoughtfully drawn by Utamaro the physiognomist). Publisher: Tsutaya Jūzaburō. Censor's seal *kiwame* (certified). Color woodcut with mica ground, *ōban*. 36.9 x 25 cm. Private Collection

131. Kitagawa Utamaro (1753?–1806). *The Engaging Type* (also called *The Interesting Type*) (Omoshiroki sō), from the series *Ten Types in the Physiognomic Study of Women* (Fujin sōgaku juttai). c. 1792–93. Signed *Sōmi Utamaro ga* (Drawn by Utamaro the physiognomist). Publisher: Tsutaya Jūzaburō. Censor's seal *kiwame* (certified). Color woodcut with mica ground, *ōban*. 38.3 x 25.2 cm. Private Collection Fig. 90

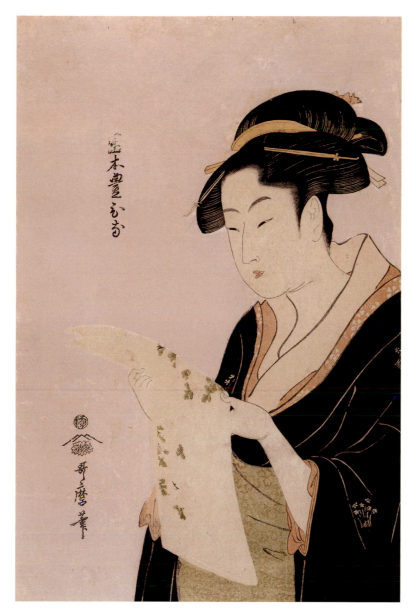

133

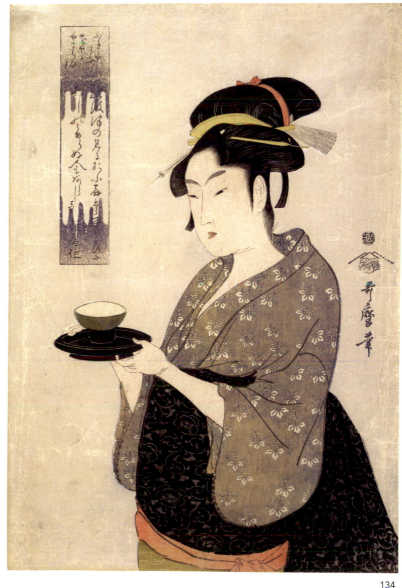

134

132. Kitagawa Utamaro (1753?–1806). *Woman, Possibly Naniwaya Okita, Adjusting Her Coiffure in a Mirror*, from the series *Seven Women at Their Toilettes in Front of* Sugatami *Mirrors* (*Sugatami shichinin keshō*), c. 1792–93. Signed *Utamaro ga*. Publisher: Tsutaya Jūzaburō. Censor's seal *kiwame* (certified). Seal of Hayashi Tadamasa (1853–1906). Color woodcut with mica on mirror glass, *ōban*. 37.1 x 24.4 cm. Private Collection Fig. 1

133. Kitagawa Utamaro (1753?–1806). *Tomimoto Toyohina*. c. 1792–93. Signed *Utamaro hitsu*. Publisher: Tsutaya Jūzaburō. Censor's seal *kiwame* (certified). Color woodcut with mica ground and embossing. 40 x 25.4 cm. Private Collection, New York

Here, the celebrated geisha Tomimoto Toyohina is reading a *surimono*. The blind-embossed lines of the print show how *surimono* of the time were folded first horizontally, then in three.

134. Kitagawa Utamaro (1753?–1806). *Naniwaya Okita with Tray*, c. 1793. Signed *Utamaro hitsu*. Publisher: Tsutaya Jūzaburō. Censor's seal *kiwame* (certified). Color woodcut with mica ground, *ōban*. 35.9 x 25.1 cm. The Metropolitan Museum of Art, The Howard Mansfield Collection, Purchase, Rogers Fund, 1936, JP 2734

135. Kitagawa Utamaro (1753?–1806). *Takashima Ohisa with Fan*. c. 1793. Signed *Utamaro hitsu*. Publisher: Tsutaya Jūzaburō. Censor's seal *kiwame* (certified). Color woodcut with mica ground, *ōban*. 38.2 x 25.5 cm. Private Collection Fig. 122

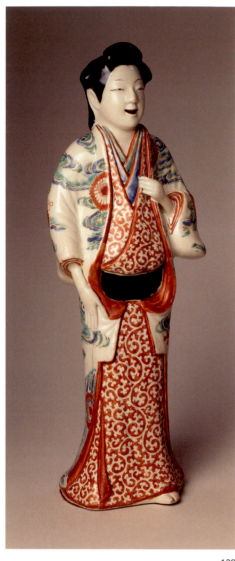

139

136. Kitagawa Utamaro (1753?–1806). *Three Beauties of the Present Day.* c. 1793. Signed *Utamaro hitsu.* Publisher: Tsutaya Jūzaburō. Censor's seal *kiwame* (certified). Color woodcut with white mica ground, *ōban.* 38.2 x 25.5 cm. Private Collection Fig. 92

137. Kitagawa Utamaro (1753?–1806). *Hanaōgi IV of the Ōgiya.* 1794–95. Signed *Utamaro hitsu* and sealed *Utamaro.* Folding fan; ink, color and gold on silk. 20.9 x 52.7 cm. John C. Weber Collection Fig. 93

138. Seated Female Figure. Japan, Arita ware, Kakiemon style. c. 1670–90. Porcelain with enamels and traces of gilt. H. 26.7 cm. Asia Society, Mr. and Mrs. John D. Rockefeller 3rd Collection of Asian Art, 1979.241 Fig. 25

139. Standing Female Figure. Japan, Arita ware, Kakiemon style. c. 1670–90. Porcelain with enamels and traces of gilt. H. 39.4 cm. Asia Society, Mr. and Mrs. John D. Rockefeller 3rd Collection of Asian Art, 1979.239 Fig. 25

140. Artist unknown. Fireman's Coat with design of the brigand Rōrihakuchō Chōjun. Mid-19th century. Cotton with paste-resist painting. 120.5 x 119.5 cm. John C. Weber Collection Fig. 132

141. Artist unidentified. Signed *Muneyoshi hitsu*. Fireman's Coat with design of demonic storm gods falling from bamboo scaffold in lightning storm. Mid-19th century. 92.4 x 116.9 cm. Cotton with paste-resist painting. John C. Weber Collection

Works in the Exhibition
出品目録

Compiled by Katsura Yamaguchi
山口　桂編

1. **栄松斎長喜**（生没年不詳・作画期：1790年代－1800年代初頭）
「蛍狩り」1794年頃
大判・錦絵：38.1 x 24.8 cm
署名：長喜画
版元：蔦屋重三郎　極印
個人蔵　**図版番号 99**

2. **栄松斎長喜**（生没年不詳・作画期：1790年代－1800年代初頭）
「初日の出」1794年頃
大判・錦絵：38.1 x 25.1 cm
署名：長喜画
版元：蔦屋重三郎　極印
サンフランシスコ・アジア美術館／グラブホーン浮世絵コレクション寄贈 (2005.100.84)

3. **栄松斎長喜**（生没年不詳・作画期：1790年代－1800年代初頭）
「雪の日」1794年頃
大判・錦絵：37.5 x 24.8 cm
署名：長喜画
版元：蔦屋重三郎　極印
個人蔵

4. **栄松斎長喜**（生没年不詳・作画期：1790年代－1800年代初頭）
「月見」1794年頃
大判・錦絵：36.9 x 24.5 cm
署名：長喜画
版元：蔦屋重三郎　極印
個人蔵

5. **栄松斎長喜**（生没年不詳・作画期：1790年代－1800年代初頭）
「芸子みずゑと吉田屋仲居もと」1794年頃
大判・錦絵：37.3 x 24.8 cm
署名：長喜画
版元：蔦屋重三郎
マーン・コレクション

6. **鳥橋斎栄里**（生没年不詳・作画期：1790年代－1800年代初頭）
「江戸花京橋名取（山東京伝）」1795年頃
大判・錦絵：39.1 x 26 cm
署名：栄里画
メトロポリタン美術館／ハワード・マンスフィールド・コレクション／ロジャース基金購入
(JP 2419)　**図版番号 108**

7. **鳥橋斎栄里**（生没年不詳・作画期：1790年代－1800年代初頭）
「江戸花柳橋名取（二世富本豊前太夫）」1795年頃
大判・錦絵：36.6 x 24.9 cm
署名：栄里画
マーン・コレクション

8. **渓斎英泉**（1790－1848）
「庭先の三世尾上菊五郎」1820年頃
絹本著色・一幅：33.6 x 57.2 cm
署名：英泉画　印章：渓斎
賛署名：柳櫻亭　江戸の花也（蝶文印）
個人蔵、ニューヨーク

9. **渓斎英泉**（1790－1848）
「二美人」1830年代
小判・錦絵：各19.7 x 13.6 cm
個人蔵

10. **渓斎英泉**（1790－1848）
「芸妓図」1830年代初頭
絹本著色・一幅：95.4 x 39.3 cm
署名：渓斎英泉　印章：英泉画印
ロジャー・L. ウェストン・コレクション　**図版番号 4**

11. **八島岳亭**（岳亭春信：1786?－1868）
「龍虎二番」1830年
色紙判・摺物二枚続：各20.7 x 18.5 cm
署名：八島岳亭
ベッカー家摺物コレクション　**図版番号 103**

12. **鈴木春信**（1725?－1770）
「坐敷八景」1766年
「扇の晴嵐」　　　中判・錦絵：28.9 x 21.6 cm
「台子の夜雨」　　中判・錦絵：28.5 x 21.6 cm
「鏡台の秋月」　　中判・錦絵：28.6 x 21.5 cm
「琴路の落雁」　　中判・錦絵：28.8 x 21.6 cm
「行燈の夕照」　　中判・錦絵：28.4 x 21.6 cm
「手拭掛の帰帆」　中判・錦絵：28.7 x 21.7 cm
「時計の晩鐘」　　中判・錦絵：28.4 x 21.7 cm
「塗桶の暮雪」　　中判・錦絵：28.6 x 21.6 cm
署名：巨川　印章：巨川之印または城西山人
シカゴ美術館／クラレンス・バッキンガム・コレクション (1928.896–903)
図版番号 57

13. **鈴木春信**（1725?－1770）
「風俗六玉川　擣衣の玉川　相模　摂津の国の名所」
柱絵判・錦絵：68.6 x 11.4 cm
署名：春信画
サンフランシスコ・アジア美術館／グラブホーン浮世絵コレクション寄贈
(2005.100.37)

14. 鈴木春信 (1725?－1770)
「御百度」1765年
中判・錦絵：27.2 x 19.5 cm
ボストン美術館／ウィリアム・スタージェス・ビゲロー・コレクション (11.19437)
図版番号 56

15. 鈴木春信 (1725?－1770)
「屏風と時計前の男女」1767－68年頃
中判・錦絵：20.9 x 28.8 cm
署名：鈴木春信画　印章：春信
ボストン美術館／ウィリアム・スタージェス・ビゲロー・コレクション (11.19714)

16. 鈴木春信 (1725?－1770)
「目隠し遊び」1768－69年頃
中判・錦絵：28.6 x 21.7 cm
署名：春信画
ボストン美術館／ウィリアム・スタージェス・ビゲロー・コレクション (11.19511)

17. 鈴木春信 (1725?－1770)
「もと屋の遊女と虚無僧」1770年
中判・錦絵：28.9 x 21.6 cm
署名：鈴木春信画
個人蔵　図版番号 64

18. 鈴木春信 (1725?－1770)
「絵本春の錦」1771年
彩色摺絵本・袋綴本二冊：各21.7 x 14.6 cm
印章：春信
版元：山崎金兵衛（金山堂）
個人蔵　図版番号 62

19. 鈴木春信 (1725?－1770)
「煙草を吸う遊女と布袋」1760年代後半
中判・錦絵：20 x 27 cm
署名：鈴木春信画
ハーロー・N. ヒギンボサム・コレクション　図版番号 8

20. 鈴木春信 (1725?－1770)
「雨の夜詣で」1760年代後半
中判・錦絵：28.5 x 21 cm
マーン・コレクション　図版番号 55

21. 鈴木春信 (1725?－1770)
「絵本青楼美人合」第一巻（五巻の内）1770年
彩色摺絵本・袋綴本一冊：26.8 x 18 cm
序文署名：田中菴のあるじ
版元：舟木嘉助、小泉忠五郎、丸屋甚八
ニューヨーク公立図書館／スペンサー・コレクション／アスター、レノックス＆チルデン
財団 (S. 431)「家田屋こ乃春とい勢や花てう」図版番号 107

22. 鈴木春信 (1725?－1770)
「雪中相合傘」1767年
中判・錦絵：26.5 x 20 cm
署名：鈴木春信画
個人蔵　図版番号 58

23. 鈴木春信 (1725?－1770)
「見立鉢ノ木」（二枚続の内）1765?年
中判・錦絵：27.6 x 20.3 cm
所蔵印：林忠正 (1853－1906)
個人蔵

24. 鈴木春信 (1725?－1770)
「掛軸を見る遊女」1768年
中判・錦絵：27.3 x 19.7 cm
署名：春信画
題賛署名等：芳月堂丹鳥斎奥村文角政信正筆（掛軸の落款）
所蔵印：アンリ・ヴェベール (1854－1943)
シシリア・セガワ・シーグル・コレクション　図版番号 54

25. 歌川広重 (1797－1858)
「名所江戸百景　両国花火」1858年
大判・錦絵：36.1 x 23.5 cm
署名：廣重画
版元：魚屋栄吉　改印
ブルックリン美術館／アナ・フェリス寄贈 (30.1478.98)　図版番号 130

26. 歌川広重 (1797－1858)
「名所江戸百景　大はしあたけの夕立」1857年
大判・錦絵：36.3 x 24.9 cm
署名：廣重画
版元：魚屋栄吉　改印
マーン・コレクション

27. 歌川広重 (1797－1858)
「和漢朗詠集」1840－41年頃
大判・錦絵：37.5 x 25.8 cm
署名：廣重筆　印章：一立斎
版元：上州屋金蔵　極印
マーン・コレクション　図版番号 11

28. 歌川広重 (1797－1858)
「東海道五拾三次ノ内　庄野」1833年頃
大判・錦絵：24.7 x 37.2 cm
署名：廣重画
版元：竹内孫八（保栄堂）　極印
個人蔵、ニューヨーク

29. 歌川広重 (1797－1858)
「枇杷に小禽」1830年代
大短冊判・錦絵：38 x 17.3 cm
署名：廣重筆　印章：佐野屋、喜霍堂製、天保新彫
版元：佐野屋喜兵衛（喜鶴堂）　極印
ロードアイランド・スクール・オブ・デザイン美術館／ジョン・D. ロックフェラー・Jr. 夫人
寄贈 (34.282)

30. 魚屋北渓 (1780－1850)
「花園謡曲番續　見立江口」1823年頃
色紙判・摺物：20.9 x 18.4 cm
署名：北渓
ジョアンナ・H. ショーフ・コレクション　図版番号 105

31. 春江斎北英（生没年不詳・作画期：1824?－37年頃）
「二世嵐璃寛の相馬太郎」1832年
大判・錦絵：37.2 x 25.1 cm
署名：春江斎北英　印章：ふもとのうめ
賛署名：寿梅主人
マーティン・レヴィッツ夫妻コレクション

32. 春江斎北英（生没年不詳・作画期：1824?－37年頃）
「夏祭浪花鑑　二世嵐璃寛の団七九郎兵へ」1832年
大判・錦絵：37.2 x 24 cm
署名：春江斎北英　印章：春江
賛署名：璃寛
マーン・コレクション　図版番号 133

33. 葛飾北斎 (1760－1849)
「玉巵弾琴図」1798年
紙本著色・双幅：各125.4 x 56.5 cm
署名：北斎宗理画　印章：師造化
個人蔵　図版番号 102

34. 葛飾北斎 (1760－1849)
「横たわる遊女」1800年頃
紙本著色・一幅：29.2 x 44.8 cm
落款：画狂人北斎画　印章：亀毛蛇足
賛署名：醒々斎京伝題（山東京伝：1761－1816）　賛印章：巴山人
ピーター＆ダイアナ・グリーリ・コレクション　図版番号 110

35. 葛飾北斎 (1760－1849)
「五美人図」1810年頃
絹本著色・一幅：86.4 x 34.3 cm
署名：葛飾北斎筆　印章：亀毛蛇足
シアトル美術館／マーガレット・E. フラー購入基金 (56.246)　図版番号 101

36. 葛飾北斎 (1760－1849)
「元禄歌仙貝合　かたつかい」1821年
色紙判・摺物：19.3 x 17.8 cm
署名：月癡老人爲一筆
狂歌署名：秋響亭槌丸、天田孫彦、秋長堂物築
ベッカー家摺物コレクション

37. 葛飾北斎（1760－1849）・山東京伝（北尾政演：1761－1816）
「春草摘みと大原女」1798年
大奉書全紙判・摺物：19.7 x 53.1 cm
署名：北斎宗理画、山東京伝画　印章：完知、巴山人
所蔵印：若井兼三郎（1834－1908）
シカゴ美術館／ヘレン・C.ガンソーラス寄贈（1954.643）　図版番号 109

38. 葛飾北斎（1760－1849）
「岩に座る漁師」1834－35年頃
色紙判・摺物：21.3 x 18.4 cm
署名：自画自賛
狂歌署名：応為　狂歌印章：卍
シカゴ美術館／ヘレン・C.ガンソーラス寄贈（1954.625）

39. 葛飾北斎（1760－1849）
「都鳥」1802年頃
彩色摺絵入狂歌本・一冊：23 x 35 cm（見開き）
署名：画狂人北斎筆
シカゴ美術館／マーティン・A.ライアソン・コレクション（4-1-49）

40. 葛飾北斎（1760－1849）
「絵師と摺師」1825年頃
色紙判・摺物：21.4 x 18.7 cm
署名：北斎改為一筆
狂歌署名：節亭南山、狂歌堂
ベッカー家摺物コレクション　図版番号 9

41. 葛飾北斎（1760－1849）
「傘持つ女と小僧」1802年頃
十二切判・摺物：19.5 x 9.2 cm
署名：画狂人北斎画　印章：不詳
狂歌署名：紀画楽多
個人蔵

42. 葛飾北斎（1760－1849）
「唐子川を渡る虎を見る図」1806年
九ッ切判・摺物：18.5 x 14 cm
署名：画狂人北斎画
個人蔵　図版番号 113

43. 葛飾北斎（1760－1849）
「冨嶽三十六景　凱風快晴」1830年代
大判・錦絵：25.5 x 38.1 cm
署名：北斎改為一筆
版元：西村屋与八（永寿堂）　極印
個人蔵、ニューヨーク　図版番号 2

44. 葛飾北斎（1760－1849）
「冨嶽三十六景　神奈川沖浪裏」1830年代
大判・錦絵：26.1 cm x 38.6 cm
署名：北斎改為一筆
版元：西村屋与八（永寿堂）　極印
マーン・コレクション　図版番号 127

45. 葛飾北斎（1760－1849）
「鴨と鮑」1805－10年頃
四ッ切判・摺物：13.9 x 19.3 cm
所蔵印：林忠正（1853－1906）、アンリ・ヴェベール（1854－1943）
スティーブン・W.ローザン＆マリー・ローザン・コレクション

46. 葛飾北斎（1760－1849）
「馬盡　相馬焼」1822年
色紙判・摺物：20.7 x 18.8 cm
署名：不染居為一筆
狂歌署名：秋風園花主
ジョアンナ・H.ショーフ・コレクション

47. 葛飾北斎（1760－1849）
「江口の君」1806－11年頃
絹本著色・額装：26.4 x 21.5 cm
署名：葛飾北斎画　印章：亀毛蛇足
ジョン・C.ウェバー・コレクション　図版番号 104

48. 春好斎北州（生没年不詳・作画期：1810年代－20年代）
「紅紫大坂潤　初世市川蝦十郎の唐犬重兵衛」1822年頃
大判・錦絵：39.4 x 26 cm
署名：春好斎北州
マーティン・レヴィッツ夫妻コレクション

49. 春好斎北州（生没年不詳・作画期：1810年代－20年代）
「天満宮花梅桜松　二世市川蝦十郎の紀ノ長谷雄、三世中村歌右衛門の孔雀三郎と
二世藤川友吉の紅梅姫」1828年
大判・錦絵三枚続：37.2 x 76.2 cm
署名：春好斎北州　印章：よしのやま
マーティン・レヴィッツ夫妻コレクション　図版番号 6

50. 春好斎北州（生没年不詳・作画期：1810年代－20年代）
「三世中村歌右衛門」1820年頃
絹本著色・一幅：103.8 x 38.1 cm
署名：春好斎北州　印章：よしのやま
ジョン・C.ウェバー・コレクション　図版番号 134

51. 春好斎北州（生没年不詳・作画期：1810年代－20年代）
「妹背山婦女庭訓　三世中村歌右衛門の金輪五郎今国と四世嵐小六のおみわ」1821
年頃
大判・錦絵：39.3 x 26.3 cm
署名：春好斎北州画　印章：よしのやま
マーン・コレクション　図版番号 128

52. 葛飾北雲（生没年不詳・作画期：1804－44年）
「美人と達磨」1820年代
絹本著色・一幅：90.9 x 33.5 cm
署名：北雲画　印章：戴賀
個人蔵　図版番号 106

53. 伝　杉村冶兵衛（生没年不詳・作画期：1681－98年）
「屏風のかげ」1690年代
大判・墨摺絵手彩色：26.6 x 36.2 cm
マーン・コレクション　図版番号 18

54. 伝　杉村治兵衛（生没年不詳・作画期：1681－98年）
「端午の節句」1680年代
大々判・墨摺絵手彩色：59.7 x 29.8 cm
所蔵印：エドウィン・M.グラブホーン（1889－1968）
サンフランシスコ・アジア美術館／グラブホーン浮世絵コレクション寄贈（2005.100.1）
　図版番号 17

55. 豊原国周（1835－1900）
「當世形俗衣揃　五世尾上菊五郎のいがみノ権太」1885年
大判・錦絵：38.1 x 24.9 cm
署名：豊原国周筆（年玉印）
版元：児玉又七
個人蔵　図版番号 13

56. 歌川国政（1773－1810）
「清和二代遨源氏　三世市川八百蔵の渡辺綱」1796年
大判・錦絵：37 x 25 cm
署名：国政画
版元：溜屋善兵衛　極印
個人蔵

57. 歌川国貞（1786－1865）
「大當狂言内　二世尾上松助の大工六三郎」1815年頃
大判・錦絵：37.2 x 25.4 cm
署名：五渡亭国貞画
版元：川口屋卯兵衛（福川堂）　極印
個人蔵

58. 歌川国貞（1786－1865）
「大當狂言内　三世中村歌右衛門の猿回しの与次郎」1815年頃
大判・錦絵：39.3 x 26.8 cm
署名：五渡亭国貞画
版元：川口屋卯兵衛（福川堂）　極印
マーン・コレクション　図版番号 3

59. 歌川国貞（1786－1865）
「楽屋で隈取する河原崎権十郎」1861年
大判・錦絵：35 x 24.2 cm
署名：喜翁豊国画
版元：辻屋安兵衛（錦魁堂）　改印
個人蔵

60. 歌川国貞（1786－1865）
「今様三十二相　今にあがり相」1859年
大判・錦絵：36.2 x 24.8 cm
署名：豊国画
版元：藤岡屋慶次郎（松林堂）　彫師：横川竹二郎　改印
個人蔵

61. 歌川国貞（1786－1865）
「大坂道頓堀芝居楽屋ノ圖」1821年
大判・錦絵三枚続：36 x 75 cm
署名：五渡亭国貞画
版元：西村屋与八　極印
ウーチェスター美術館／ハリエット・B．バンクロフト基金 (2003.115)

62. 歌川国芳（1798－1861）
「大物之浦平家の亡霊」1849－52年
大判・錦絵三枚続：36 x 75 cm
署名：一勇斎国芳画　印章：蔦印
版元：遠州屋彦兵衛
マーリン・C・デイリー社

63. 歌川国芳（1798－1861）
「真鯉図」1847年頃
大短冊判・錦絵：37.3 x12.7 cm
署名：一勇斎国芳画　印章：一勇斎
版元：辻岡屋文助
G．オリバー・コレクション

64. 歌川国芳（1798－1861）
「宮本武蔵と巨鯨」1847－52年
大判・錦絵三枚続：36.8 x 73.7 cm
署名：一勇斎国芳画
版元：川口屋正蔵（川正）
G．オリバー・コレクション　**図版番号 131**

65. 歌川国芳（1798－1861）
「地獄太夫」1850年頃
絹本著色・額装：140.3 x 81.9 cm
署名：一勇斎国芳画　印章：判読不明
ジョン・C．ウェバー・コレクション　**図版番号 125**

66. 北尾政演（山東京伝：1761－1816）
「吉原傾城新美人合自筆鑑」より「青楼名君自筆集」1784年
彩色摺絵本・一冊：37.8 x 51 cm
署名：北尾律斎政演画　印章：素石
序文：四方山人〔蜀山人：大田南畝（1749－1823）〕、朱楽管江（1736－1799）
版元：蔦屋重三郎
所蔵印：トニー・ストラウス＝ネグバウワー
個人蔵
丁字屋内雛鶴とちょうざん　**図版番号 10**
扇屋内花扇と瀧川　**図版番号 85**

67. 奥村政信（1686－1764）
「文字散らし紋の遊女」1710年代
大々判・墨摺絵手彩色：54 x 29.3 cm
署名：奥村政信圖　印章：政信
版元：伊賀屋勘右衛門
シカゴ美術館／クラレンス・バッキンガム・コレクション (1925.1744)
図版番号 34

68. 奥村政信（1686－1764）
「見立芦葉達磨」1710年代初頭
大々判・丹絵：48.9 x 31.7 cm
署名：奥村政信圖　印章：政信
サンフランシスコ・アジア美術館／グラブホーン浮世絵コレクション寄贈 (2005.100.8)
　図版番号 37

69. 奥村政信（1686－1764）
「朝鮮人曲馬の図」1740年代
柱絵・紅絵：71.8 x 16.8 cm
署名：芳月堂正名奥村文角政信正筆　印章：丹鳥斎
サンフランシスコ・アジア美術館／グラブホーン浮世絵コレクション寄贈 (2005.100.10)
　図版番号 47

70. 奥村政信（1686－1764）
「源氏浮舟」1740年代中頃
大々判・紅絵：32.4 x 43.8 cm
署名：芳月堂丹鳥斎奥村政信畫　印章：丹鳥斎
所蔵印：エドウィン・M．グラブホーン（1889－1968）
サンフランシスコ・アジア美術館／グラブホーン浮世絵コレクション寄贈 (2005.100.9)
　図版番号 52

71. 奥村政信（1686－1764）
「キセルを持つ美人」1740年代中頃
柱絵・紅絵竪二枚続：128.2 x 16 cm
署名：芳月堂丹鳥斎　柱絵根元　奥村文角政信正筆　印章：丹鳥斎
ボストン美術館／ウィリアム・スタージェス・ビゲロー・コレクション (11.13335)
図版番号 48

72. 奥村政信（1686－1764）
「奥村政信絵手本」1710年代
墨摺絵本・一冊：27 x 18.5 cm
署名：大和繪師奥村政信圖、東武大和畫工奥村政信圖　印章：政信、他
版元：利倉喜兵衛
ボストン美術館／ジェアード・K．モース夫人によるチャールズ・J．モース記念のための
寄贈 (2007.315)　**図版番号 38**

73. 奥村政信（1686－1764）
「境町葺屋町芝居町大浮絵」1745年頃
大々判・紅絵：43.8 x 64.5 cm
ボストン美術館／ウィリアム・スタージェス・ビゲロー・コレクション (11.19687)

74. 奥村政信（1686－1764）
「大黒と恵比寿」1710年代
大々判・丹絵：56.4 x 31.5 cm
署名：奥村政信圖　印章：政信
所蔵印：若井兼三郎（1834－1908）、林忠正（1854－1906）
ハーロー・N．ヒギンボサム・コレクション　**図版番号 39**

75. 奥村政信（1686－1764）
「新吉原二階座敷土手ヲ見通大浮絵」1745年頃
大々判・紅絵：42 x 65.7 cm
署名：東武大和畫工　芳月堂丹鳥斎　奥村文角政信正筆　印章：丹鳥斎
版元：奥村屋
マーン・コレクション　**図版番号 51**

76. 奥村政信（1686－1764）
「浮世鉢ノ木」1710年代
大々判・紅絵：31.1 x 54.3 cm
署名：奥村政信圖　印章：政信
版元：小松屋
マーン・コレクション　**図版番号 40**

77. 奥村政信（1686－1764）
「角田川浮世猿まハし」1740年代後半―50年代初頭
大々判・紅絵：32.3 x 44.7 cm
署名：芳月堂奥村文角政信正筆　印章：丹鳥斎
所蔵印：アンリ・ヴェベール（1854－1943）
マーン・コレクション　**図版番号 53**

78. 奥村政信（1686－1764）
「立美人図」1716－36年頃
絹本著色・一幅：47.8 x 26.4 cm
署名：奥村政信圖　印章：政信
ジョン・C．ウェバー・コレクション　**図版番号 35**

79. 伝　菱川師宣（1630/31？－1694）
「吉原恋乃道引」1678年
墨摺絵本手彩色・袋綴本一冊：28 x 33 cm（見開き）
版元：油町通本問屋
ボストン美術館／ウィリアム・S．＆ジョン・T．スポルディング寄贈 (2000.1257)
図版番号 27

80. 伝　菱川師宣 (1630/31？－1694)
「吉原風俗図巻」1680年代
紙本著色・一巻：54.1 x 1,761.4 cm
署名：日本繪菱川師宣書　印章：師宣、菱川
ジョン・C. ウェバー・コレクション　図版番号 15、30－32

81. 菱川師宣 (1630/31？－1694)
「無題組物」より「屏風のかげ」1673－81年頃
大判・墨摺絵：27.2 x 38.3 cm
シカゴ美術館／ケイト・S. バッキンガム遺贈 (1973.645.9)　図版番号 20

82. 菱川師宣 (1630/31？－1694)
「無題組物」より「衝立の側」1673－81年頃
大判・墨摺絵：27.2 x 38.4 cm
シカゴ美術館／ケイト・S. バッキンガム遺贈 (1973.645.1)　図版番号 21

83. 菱川師宣 (1630/31？－1694)
「無題組物」より「抱擁」1673－81年頃
大判・墨摺絵：27.1 x 38.4 cm
シカゴ美術館／ケイト・S. バッキンガム遺贈 (1973.645.4)　図版番号 22

84. 菱川師宣 (1630/31？－1694)
「立美人図」1690年頃
絹本著色・一幅：68.6 x 31.2 cm
署名：日本繪菱川師宣圖　印章：菱川、師宣
リチャード・フィッシュバイン＆エステル・ベンダー・コレクション　図版番号 24

85. 菱川師宣 (1630/31？－1694)
「無題組物」より「抱擁・菊」1680年代
大判・墨摺絵：29.2 x 34.3 cm
メトロポリタン美術館／ハリス・ブリスベイン・ディック基金及びロジャース基金
(JP 3069)　図版番号 19

86. 菱川師宣 (1630/31？－1694)
「よしはらの躰　散茶見世」1682－83年
大判・墨摺絵：25.7 x 38.6 cm
版元：山形屋市郎右衛門
メトロポリタン美術館／サミュエル・イシャム遺贈 (JP 809)　図版番号 28

87. 菱川師宣 (1630/31？－1694)
「よしはらの躰　揚屋大寄」1682－83年
大判・墨摺絵：25.7 x 38.6 cm
版元：山形屋市郎右衛門
メトロポリタン美術館／サミュエル・イシャム遺贈 (JP 812)　図版番号 29

88. 菱川師宣 (1630/31？－1694)
「和国諸職絵つくし絵本鑑」1685年
墨摺絵本・袋綴本四冊：各26.7 x 18.5 cm
所蔵印：林忠正 (1853－1906)
アーサー・ヴァーシュボー・コレクション　図版番号 16

89. 橋本貞秀 (1807－1878/79)
「アメリカ商人ヴァン・リード」1860年代
絹本著色・額装：102.9 x 35.6 cm
署名：大日本江戸橋本玉蘭斎貞秀画 (年玉印)
サンフランシスコ・アジア美術館／ノーブル・T. ビドル夫人寄贈 (2001.8)
図版番号 12

90. 橋本貞秀 (1807－1878/79)
「横浜交易西洋人荷物運送之図」1861年
大判・錦絵五枚続：37.5 x 127 cm
署名：五雲亭貞秀画
版元：山口屋藤兵衛
G. オリバー・コレクション　図版番号 129

91. 橋本貞秀 (1807－1878/79)
「横浜異人商館売物之図」1861年
大判・錦絵竪横六枚続：上三枚37.5 x 76.5 cm　下三枚36.2 x 76.2 cm
署名：五雲亭貞秀画
版元：佐野屋喜兵衛
個人蔵、ニューヨーク

92. 東洲斎写楽 (生没年不詳・作画期：1794－95)
「敵対乗合話・中島和田右衛門のぼうだら長左衛門と仲村此蔵の船宿かな川やの権」
1794年
大判・錦絵：37.5 x 25.4 cm
署名：東州斎寫楽画
版元：蔦屋重三郎　極印
所蔵印：アンリ・ヴェベール (1854－1943)
アジア・ソサエティー／ジョン・D. ロックフェラー三世夫妻アジア美術コレクション
(1979.220)

93. 東洲斎写楽 (生没年不詳・作画期：1794－95)
「恋女房染分手綱　四世市川蝦蔵 (五世市川団十郎) の竹村定之進」1794年
大判・錦絵：38.3 x 25.9 cm
署名：東洲斎寫楽画
版元：蔦屋重三郎　極印
マーン・コレクション　図版番号 96

94. 東洲斎写楽 (生没年不詳・作画期：1794－95)
「敵対乗合話　四世松本幸四郎の山谷の肴屋五郎兵衛」1794年
大判・錦絵：37.3 x 24.9 cm
署名：東洲斎寫楽画
版元：蔦屋重三郎　極印
マーン・コレクション

95. 東洲斎写楽 (生没年不詳・作画期：1794－95)
「花菖蒲文禄曾我　三世佐野川市松の祇園町白人おなよ」1794年
大判・錦絵：38.9 x 25.8 cm
署名：東洲斎寫楽画
版元：蔦屋重三郎　極印
所蔵印：アンリ・ヴェベール (1854－1943)
マーン・コレクション　図版番号 95

96. 東洲斎写楽 (生没年不詳・作画期：1794－95)
「花菖蒲文禄曾我　三世坂田半五郎の藤川水右衛門」1794年
大判・錦絵：38.5 x 26 cm
署名：東洲斎寫楽画
版元：蔦屋重三郎　極印
個人蔵

97. 東洲斎写楽 (生没年不詳・作画期：1794－95)
「花菖蒲文禄曾我　大谷徳次の奴袖助」1794年
大判・錦絵：36.2 x 24.7 cm
署名：東洲斎寫楽画
版元：蔦屋重三郎　極印
個人蔵、ニューヨーク

98. 東洲斎写楽 (生没年不詳・作画期：1794－95)
「花菖蒲思笄　八世森田勘弥の駕籠舁鶯の治郎作」1794年
大判・錦絵：36.8 x 25.4 cm
署名：東洲斎寫楽画
版元：蔦屋重三郎　極印
所蔵印：林忠正 (1853－1906)、アンリ・ヴェベール (1854－1943)
デビッド・R. ワインバーグ・コレクション

99. 東洲斎写楽 (生没年不詳・作画期：1794－95)
「花菖蒲文禄曾我　三世沢村宗十郎の大岸蔵人」1794年
大判・錦絵：36.3 x 24.2 cm
署名：東洲斎寫楽画
版元：蔦屋重三郎　極印
所蔵印：アンリ・ヴェベール (1854－1943)
デビッド・R. ワインバーグ・コレクション　図版番号 98

100. 勝川春英 (1762頃－1819)
「嵐龍蔵の奴」1794年
大判・錦絵：36.8 x 24.1 cm
署名：春英画
版元：鶴屋喜右衛門　極印
所蔵印：アンリ・ヴェベール (1854－1943)
アジア・ソサエティー／ジョン・D. ロックフェラー三世夫妻アジア美術コレクション
(1979.221)

101. **勝川春英** (1762頃−1819)
「花菖蒲文禄曾我　三世佐野川市松の祇園町白人おなよ」1794年
間判・錦絵：32.5 x 22.5 cm
署名：判読不明
版元：江見屋吉右衛門　極印
所蔵印：アンリ・ヴェベール (1854−1943)
個人蔵

102. **勝川春英** (1762頃−1819)
「花菖蒲文禄曾我　三世沢村宗十郎の大岸蔵人」1794年
大判・錦絵：37.5 x 25 cm
署名：春英画
版元：鶴屋喜右衛門　極印
個人蔵　**図版番号 97**

103. **勝川春好** (1743−1812)
「四世市川蝦蔵 (五世市川団十郎) の暫」1797年頃
紙本著色・一幅：85.7 x 26.9 cm
署名：春好左筆 (花押)
ミネアポリス美術館／リチャード・P. ゲイル遺贈 (74.1.114)　**図版番号 78**

104. **勝川春章** (?−1792)・**北尾重政** (1739−1820)
「青楼美人合姿鏡」1776年
彩色絵本・袋綴本三冊：各28.1 x 18.7 cm
署名：北尾花藍重政、勝川酉爾春章　印章：北尾、重政之印、勝川、春章
版元：山崎金兵衛、蔦屋重三郎
アーサー・ヴァーシュボー・コレクション　**図版番号 68、81**

105. **勝川春章** (?−1792)
「俳諧呼子鳥」1788年
彩色摺絵本・折本一冊：25 x 36.4 cm
個人蔵、ニューヨーク　**図版番号 74**

106. **勝川春章** (?−1792)
「黒衣の立美人図」1783−89年頃
絹本著色・一幅：85.1 x 28.5 cm
署名：勝春章画 (花押)
メアリー＆ジャクソン・バーク財団　**図版番号 7**

107. **勝川春章** (?−1792)
「五世市川団十郎の暫」1780年代後半
紙本著色・団扇絵・額装：15.9 x 45.5 cm
署名：(花押)
狂歌署名：花扇 (扇屋内四世花扇)
ジョン・C. ウェバー・コレクション　**図版番号 76**

108. **勝川春章** (?−1792)
「隈取する五世市川団十郎」1780年代後半
絹本著色・一幅：79.2 x 12.1 cm
署名：春章画 (花押)
ジョン・C. ウェバー・コレクション　**図版番号 77**

109. **勝川春章** (?−1792)
「文読む美人図」1783−84年頃
絹本著色・一幅：92.3 x 35 cm
署名：不對寫文華堂筆力　應需今古流行風俗　圖而己
旭朗井勝川春章 (花押)
ジョン・C. ウェバー・コレクション　**図版番号 70**

110. **勝川春章** (?−1792)
「三美人図」1789−92年頃
絹本著色・一幅：94.6 x 34.1 cm
ジョン・C. ウェバー・コレクション　**図版番号 66**

111. **勝川春章** (?−1792)
「春宮秘戯図巻　男女と牡丹図」1770年代後半
絹本著色・一幅：47 x 69 cm
所蔵印 (?)：爽州
ジョン・C. ウェバー・コレクション　**図版番号 73**

112. **勝川春章** (?−1792)
「浅妻舟」1770年代後半
絹本著色・一幅：90.8 x 27.9 cm
署名：旭朗井勝川春章画 (花押)
ロジャー・L. ウェストン・コレクション　**図版番号 71**

113. **三代菱川宗理** (俵屋宗二：生没年不詳・作画期：1790年代−1810年代後半)
「見立七福神」1800年頃
大奉書全紙判・摺物：42.5 x 56.1 cm
署名：菱川宗理画
ベッカー家摺物コレクション

114. **西川祐信** (1671−1750)
「髪結美人図」1716−41年頃
紙本著色・一幅：86.6 x 37.3 cm
署名：西川右京祐信畫之　印章：西川氏、祐信圖之
ロジャー・L. ウェストン・コレクション　**図版番号 69**

115. **葛飾辰女** (生没年不詳・作画期：1818−28)
「朝顔美人図」1820年代
絹本著色・一幅：34.2 x 44.8 cm
署名：北斎女辰女筆　印章：ふもとのさと
ロサンジェルス・カウンティ美術館／アーネスト・ラーセン・ブランク記念基金 (58.26.1)

図版番号 114

116. **歌川豊春** (1735−1814)
「春の調べ」1780年代
絹本著色・二曲一隻：67.4 x 178.8 cm
署名：一龍斎歌川豊春画　印章：一龍斎、昌樹之印
ロバート＆ベッツィー・ファインバーグ・コレクション　**図版番号 5**

117. **歌川豊広** (1773?−1828)
「美人納涼図」1805年頃
絹本著色・一幅：99.5 x 27 cm
署名：歌川豊廣画　印章：豊廣
画賛署名：山東京伝 (1761−1816)　画賛印：巴山人
ギッター・イエレン・コレクション　**図版番号 111**

118. **歌川豊広** (1773?−1828)
「夕顔棚納涼図」19世紀初頭
絹本著色・一幅：84.4 x 28 cm
署名：歌川豊廣画　印章：豊廣
メトロポリタン美術館／ハリー・G. C. パッカード・アジア美術コレクション／
フレッチャー、ロジャース、ディック、ベル、アネンバーグ基金及び
ジョセフ・ピューリッツァー遺産による購入 (1975.268.129)　**図版番号 135**

119. **歌川豊国** (1769−1825)
「役者相貌鏡」1804年
彩色摺絵本・二冊：26.5 x 17.9 cm
序署名：壺々山人 (上巻)、市川白猿 (五世市川団十郎：下巻)
版元：山田屋三四良、萬春堂
所蔵印：エミール・ジャヴァル、アンリ・ヴェベール (1854−1943)
個人蔵　図版番号、尾上松助と坂東八十助、狂歌署名：柏葉亭青記、葉越月守

120. **歌川豊国** (1769−1825)
「手鏡を持つ美人」1795年頃
絹本著色・一幅：93 x 34 cm
署名：豊国画　印章：一陽斎
マーン・コレクション

121. **歌川豊国** (1769−1825)・**歌川国政** (1773−1810)・**喜多川歌麿** (1753?−1806)
「俳優楽室通」1799年
彩色摺絵本・袋綴本一冊：17.9 x 12.5 cm
署名：豊国画、国政画；一竜斎歌川豊国画；門人歌川国政；歌麿筆
序及び跋文：式亭三馬 (1776−1822)
版元：上州屋忠助
個人蔵　図版番号、中島和田右衛門と松本国五郎

122. **喜多川歌麿** (1753?−1806)
「歌満くら」より「茶屋の二階座敷の男女」1788年
大判・錦絵：25.5 x 37 cm
版元：蔦屋重三郎
マーン・コレクション　**図版番号 87**

123. **喜多川歌麿** (1753?−1806)
「狂月坊」1789年
彩色摺絵入狂歌本・一冊：25.5 x 38 cm
署名：右五葉　喜多川歌麿製　印章：豊章之印、歌麿
選及び序：紀定丸
版元：蔦屋重三郎
個人蔵　**図版番号 88**

124. 喜多川歌麿（1753?－1806）
「普賢像」1790年
彩色摺絵入狂歌本・折本一冊：25.6 x 37 cm
署名：喜多川歌麿
版元：蔦屋重三郎
G．オリバー・コレクション

125. 喜多川歌麿（1753?－1806）
「銀世界」1790年
彩色摺絵入狂歌本・一冊：25.5 x 38 cm
印章：豊章之印、歌麿
版元：蔦屋重三郎（耕書堂）
メトロポリタン美術館／ハワード・マンスフィールド・コレクション／
ハワード・マンスフィールド寄贈（JIB 89）

126. 喜多川歌麿（1753?－1806）
「婦人相學十躰　浮気の相」1792－93年頃
大判・錦絵：37.8 x 25.1 cm
署名：相見歌麿画
版元：蔦屋重三郎　極印
所蔵印：アンリ・ヴェベール（1854－1943）
アジア・ソサエティー／ジョン・D．ロックフェラー三世夫妻アジア美術コレクション
（1979.219）　**図版番号 89**

127. 喜多川歌麿（1753?－1806）
「婦女人相十品　日傘をさす女」1792－93年頃
大判・錦絵：38.1 x 25.7 cm
署名：相觀歌麿考画
版元：蔦屋重三郎　極印
メトロポリタン美術館／ハワード・マンスフィールド・コレクション／ロジャース基金
購入（JP 2730）

128. 喜多川歌麿（1753?－1806）
「婦女人相十品　ポペンを吹く娘」1792－93年頃
大判・錦絵：38.9 x 27.5 cm
署名：相觀歌麿画
版元：蔦屋重三郎　極印
メトロポリタン美術館／H．O．ハヴマイヤー・コレクション／H．O．ハヴマイヤー
夫人遺贈（JP 1662）

129. 喜多川歌麿（1753?－1806）
「婦人相學十躰　団扇を持つ娘」1792－93年頃
大判・錦絵：38.3 x 25.2cm
署名：相見歌麿画
版元：蔦屋重三郎　極印
個人蔵

130. 喜多川歌麿（1753?－1806）
「婦女人相十品　タバコの煙を吹く女」1792－93年頃
大判・錦絵：36.9 x 25 cm
署名：相觀歌麿考画
版元：蔦屋重三郎　極印
個人蔵

131. 喜多川歌麿（1753?－1806）
「婦人相學十躰　団扇を持つ娘」1792－93年頃
大判・錦絵：38.3 x 25.2 cm
署名：相見歌麿画
版元：蔦屋重三郎　極印
個人蔵　**図版番号 90**

132. 喜多川歌麿（1753?－1806）
「姿見七人化粧」1792－93年頃
大判・錦絵：37.1 x 24.4 cm
署名：歌麿筆
版元：蔦屋重三郎　極印
所蔵印：林忠正（1853－1906）
個人蔵　**図版番号 1**

133. 喜多川歌麿（1753?－1806）
「富本豊ひな」1792－93年頃
大判・錦絵：40 x 25.4 cm
署名：歌麿筆
版元：蔦屋重三郎　極印
個人蔵、ニューヨーク

133. 喜多川歌麿（1753?－1806）
「姿見七人化粧」1792－93年頃
大判・錦絵：37.1 x 24.4 cm
署名：歌麿筆
版元：蔦屋重三郎　極印
所蔵印：林忠正（1853－1906）
個人蔵　**図版番号 1**

134. 喜多川歌麿（1753?－1806）
「富本豊ひな」1792－93年頃
大判・錦絵：40 x 25.4 cm
署名：歌麿筆
版元：蔦屋重三郎　極印
個人蔵、ニューヨーク

135. 喜多川歌麿（1753?－1806）
「高島おひさ」1793年頃
大判・錦絵：38.2 x 25.5 cm
署名：歌麿筆
版元：蔦屋重三郎　極印
個人蔵　**図版番号 122**

136. 喜多川歌麿（1753?－1806）
「当時三美人」1793年頃
大判・錦絵：38.2 x 25.5 cm
署名：歌麿筆
版元：蔦屋重三郎　極印
個人蔵　**図版番号 92**

137. 喜多川歌麿（1753?－1806）
「扇屋内四世花扇」1794－95年頃
絹本著色・団扇絵・額装：20.9 x 52.7 cm
署名：歌麿筆
印章：歌麿
ジョン・C．ウェバー・コレクション　**図版番号 93**

138. 有田窯柿右衛門様式（1670－90年頃）
「脇息打掛人形」一体
26.7 cm 高
アジア・ソサエティー／ジョン・D．ロックフェラー三世夫妻アジア美術コレクション
（1979.241）　**図版番号 25**

139. 有田窯柿右衛門様式（1670－90年頃）
「打掛人形」二体
各39.4 cm 高
アジア・ソサエティー／ジョン・D．ロックフェラー三世夫妻アジア美術コレクション
（1979.239–240）　**図版番号 25**

140. 水滸伝文様火消し装束（19世紀中頃）
120.5 x 119.5 cm
ジョン・C．ウェバー・コレクション　**図版番号 132**

141. 雷神図文様火消し装束（19世紀中頃）
92.4 x 116.9 cm
署名：宗芳筆
ジョン・C．ウェバー・コレクション

Index

Note: Page numbers in italics refer to illustrations.

Abe Hachinoshin Shakei, 92
acting: see aragoto; kaomise; kabuki; Noh; wagoto
actor prints (yakusha-e), 25, 29, 59, 67, 80, 81, 113n5, 132, 136, 141, 174, 179, 183–84
 backstage scenes, 214, 214, 215, 215
 censorship of, 179
 competition in, 135–36
 and image rights, 179–80
 kabuki theater posters, 184
 and landscapes, 179
 "large-head," 174
 realism in portraiture, 110, 177
Actors Like Mount Fuji in Summer (Yakusha natsu no Fuji), 108
Actors' Looks in Facing Mirrors (Yakusha sōbō kagami), 227, 227
Admiring a Picture of a Dandy by Okumura Masanobu (Harunobu), 79, 79, 87, 200
adoption, 37, 50, 53n17, 54n41, 81n25, 117, 158
advertising, 116, 117, 140n9, 173–74
ageya, 45–47, 49
ageya ōyose, 45
Ageya-cho, 45
aiban ("intermediate-size print," roughly 23.5 x 33 cm; between chūban and ōban), 136, 206, 224
Aigasa no yau (Night Rain on the Shared Umbrella) (O. Masanobu), 66
Akera Kankō (1740–1800), 120, 121, 121, 216
Akita domain, 99n30, 126
All Variety of Horses (Uma zukushi: Hokusai series), 210–11, 210
Amada no Magohiko, 206
American Merchant Eugene Van Reed, The (Sadahide painting), 28, 28, 29, 220
Ameuri Dohei den (The Story of Dohei the Candy Vendor), 95, 99n37
Anderson, William (1842–1900), 85–86, 98n9
Anke, 36, 39, 53n29
annai-bon, 173
Anthology of Ten Thousand Mad Poems (Manzai kyōka shū), 121

aragoto ("rough stuff": style of acting developed by Edo's first great kabuki actor, and contrasting with the softer wagoto style of Kyoto and Osaka), 23, 112, 186
Arai Hakuseki (1657–1725), 55n56
Arashi Rikan II, 185, 204, 205
Arashi Ryūzō, 224, 224
Arita ware, Seated and Standing Beauties, 42, 42, 234, 234
Art Institute of Chicago, The, 21, 40, 41, 60, 61, 67, 68, 69, 87, 88–89, 124, 152, 160, 196, 206, 216, 219
artistic training and transmission, 30, 42
Arthur M. Sackler Gallery, Smithsonian Institution, 132
Artist unidentified, signed Muneyoshi hitsu, Fireman's Coat with design of demonic storm gods falling from bamboo scaffold in lightning storm, 235, 235
Artist unknown, Fireman's Coat with design of the brigand Rōrihakuchō Chōjun, 48, 184, 185, 235
Asai Ryōi (1612?–1691), 53n30
 Record of Famous Places in Edo (Edo meishoki), 44, 44
 Tale of the Floating World (Ukiyo monogatari), 33
Asakura Nobumasa, 54n41
Asakura Nobusue, 54n41
Asakusa, 44–45, 50, 67, 95, 166n27
Asakusa Ichibito, 227
Asakusaan Ichindo (1755–1820), 166n27
Asakusadera, 44, 54n36, 97; see also Sensōji
Asakusa-gawa (Asakusa Group), 166n27
Asano Shūgō, 136
Asazuma, 51, 103, 106, 225
Asazumabune (The Boat at Asazuma), 51, 103, 106, 225
Asia Society (Mr. and Mrs. John D. Rockefeller 3rd Collection of Asian Art), 42, 126, 220, 224, 231, 234, 234
Asian Art Museum of San Francisco, 28, 38, 63, 71, 76, 192, 197, 213, 216, 217, 220
Aspects of the Yoshiwara (Yoshiwara no tei) (Moronobu), 45, 45, 47, 48, 219

Awa Province (Ashū), 135
Awa Province (Bōshū), 34–36, 47
awase ("matching": describing games and competitions), 25, 42, 59, 87, 102–03, 121, 151, 174, 206, 224
Azuma monogatari ("Tales of the East"), 54n32
Azuma nishiki-e ("brocade pictures of the East": referring to color prints from the Kantō region of Japan, with Edo as its metropolitan center), 23, 85, 91, 95, 116

Baba Zongi (1703–1782), 106, 107
Bai Juyi (772–846), 28, 202
Bakin, see Takizawa Bakin
Bamboo Flute and the Potted Trees, The (Shakuhachi hachi no ki), 66, 67, 67
Bandō Yasosuke, 227
Banshundō, publisher, 227
battle scenes, 29, 184, 216, 216
Beaton, Cecil, Marilyn Monroe, 168, 169, 170
Beauties Looking at Paintings (Shunshō painting), 108–9, 109
Beautiful Courtesans of the Northern Quarters (Hokkaku bigichō), 58, 59
beauty prints and paintings, see bijinga
Beauty Enjoying the Evening Cool (Toyohiro painting), 154, 155, 155
Beauty Reading a Letter (Shunshō painting), 103, 105, 105, 225
Beauty with Hand-Mirror (Toyokuni painting), 228, 228
Becker family, 24, 146, 196, 206, 207, 226
Beloved Wife's Particolored Reins, The (kabuki play), 132, 134, 135, 174, 221
beni-e ("safflower red pictures": black-and-white prints with carefully applied handcoloring in which beni, a extract of pink safflower, was the predominant color), 67, 68, 71, 78, 216, 217
Benimurasaki ai de someage (kabuki play), 211, 211

benizuri-e ("safflower red printed pictures": an early form of color printing developed in the early 1740s and using at first blocks in two colors, beni plus green or blue, in addition to the key block; in the late 1750s and earlier 1760s often with three or even four colors, especially beni, yellow and blue), 71, 72, 78, 85, 86, 116
Benkei and Yoshitsune at the Battle of Dannoura (Kuniyoshi), 216, 216
Bi'en sennyokō (senjokō: cosmetic), 175
Bigelow, William Sturgis (1850–1926; collector), 69, 70, 72, 73, 84, 91, 97, 102, 175, 198, 217, 218
bijinga ("pictures of beautiful people"), 29, 101, 102, 127, 129, 132, 136, 163, 170–71, 186
Binyon, Laurence, 99n26
Bird and Loquats (Hiroshige), 202, 203
Birds of the Capital (Miyakodori), 206, 207
Birds with Pretensions (Hitokidori), 175
Biwa, Lake, 66, 103
Black Carp (Kuniyoshi), 216, 217
black-line series, see sumizuri-e
block carver (hori-shi; block cutter), 25, 29, 37, 39, 53n24, 84, 86, 108, 124, 198, 224
Boat Prostitute at Asazuma (Shunshō painting), 51, 103, 106, 106, 225
Bodhidharma (J. Bodaidaruma), 63, 151; see also Daruma
bokashi (technique of gradated hand-shading in prints), 180
book sellers, see ezōshiten; ezōshiya; hon'ya; jihondōiya; kashihon'ya; shōhon'ya; shomotsuya; tōhon'ya
book types: see ehon; fukurotojibon; hinagatabon; gesaku; hyōbanki; kibyōshi; Nara ehon; orihon; saiken; sharebon; ukiyozōshi
British Museum, 92, 106
Brooklyn Museum, The, 180, 201
bu ("military" [as opposed to bun]), 126

Buddhism, 33, 35, 37, 39, 44, 47, 48, 50, 52n3, 52n7, 53n30, 80n8, 129; *see also* Bodhidharma; Buddhist monasteries; Daruma; *date komusō*; Fugen; Nichiren; Pure Land school, Saigyō; Shingon school; Zen Buddhism

Buddhist monasteries, *see* Asakusadera; Gokokuji; Hishikawa family monastery; Myōshinji; Rinkaisan Betsugan-in; Sensōji; Shōryūji; Zuishōji

Buke hyakunin isshu (One Poem Each by a Hundred Samurai), 36

bun ("civil, literary, scholarly" [as opposed to *bu*]), 126

bunjinga ("literati painting": Chinese-style painting practised by literati, especially in Kyoto; also known as *Nanga*), 28

Burke, Mary and Jackson, 19, *21*, 225

calendar prints (*daishō surimono* or *egoyomi*), 84, 85, 86–87, 91, 95, 98n3

calendars, 98n4

calligraphy, O-ie-ryū school of, 49

Cangshu (J. *zōsho*), 49, 55n51

Catching Fireflies (Chōki), 136, *137*, 192

censorship laws, 8, 25, 68, 108, 126–27, 179, 189n23; *see also* kiwame

Ceramics from Sōma (Sōmayaki) (Hokusai), 210–11, *211*

Chan Buddhism, 48; *see also* Zen Buddhism

Chiba City Museum of Art, 52n2, 80n1, 83, 93n1, 102

Chiba Prefecture, 34, 47, 52n7

Chichi no on (Thanks to the Father), 72

China and Chinese, 47, 49, 55n51, 55n52, 66, 72, 73, *73*, 84, 116, 156, 165n10, 211, *211*

Chinese and Japanese Verses for Recitation (Wakan Rōeishū), 28, 202

Chinese Boys Watching Tigers Cross a River (Hokusai), 156, *156*, 157, *157*, 208

Chinese Figures in a Pavilion Playing Sugoroku (O. Masanobu), 72, *73*, 179

Chinese Immortal Yu Zhi, The, and a Dragon with Zither (Hokusai), 144, *145*, 205

Chinese influences 28, 37, 42, 48–49, 72, 73, 81n34, 87, 127, 144, *145*, *146*, 152–53, 154, 156, 160, 163, 165n10, 165n13

Chinese names, 13

Chōjiya (Yoshiwara house), 119

Chōjiya Hinazuru, Chōzan (The Courtesans Hinazuru and Chōzan of the Chōjiya), from album *New Mirror Comparing the Handwriting of the Courtesans of the Yoshiwara (Yoshiwara keisei shin bijin awase jihitsu kagami)*, 25, *25*, 121, 177, 216

Chōkōtei Kumomichi, 159

Chōkyōsai Eiri (act. 1790s–early 1800s):
Flowers of Edo: The Master of Kyōbashi [Santō Kyōden] (*Edo no hana Kyōbashi natori*), 152, 153–54, 154, 193, 195
Flowers of Edo: The Master of Yanagibashi (*Edo no hana Yanagibashi natori*), *194*, 195

chōnin ("townsman"), 37

Chōzan, *25*

chūban (medium[-size] print, roughly 28 x 21 cm: size popular in the late 1760s and 1770s, and made by cutting a *hōsho* sheet into four; also used earlier to describe half an *ōban* sheet, and later to describe half an *aiban* sheet), 25, 198, 200

Cleveland Museum of Art, *162*, 163

clothing, *see* fireman, kimono, Nihonbashi, robes, textiles, *yūzen*

Collection of Handwriting of Famous Courtesans of the Yoshiwara, A (Seirō meikun jihitsu shū), 216

color printing:
cost and appeal of, 116
introduction of, 16, 18, 23, 25
overprinting in, 85, 86
transition from handcoloring, 85
see also nishiki-e, Okumura Masanobu, Suzuki Harunobu

Colorful Models of Ninefold Brocades (Saishiki hinagata kokonoe nishiki), 175

Compendium of Yamato-e (Yamato-e zukushi), 36

Confucianism, 49, 50, 55; *see also* Neo-Confucianism

Connoisseur's Guide to Actors Behind the Scenes, A (Yakusha gakuya tsū), 229, *229*

Cornell University, Andrew Dickson White Museum of Art, 19

Couple Seated by Autumn Flowers (Moronobu), 39, *40*, 219

Courtesan (O. Masanobu painting), 59, 61, 63, 172, 218

Courtesan and Daruma (Hokuun painting), *150*, 151, 212

Courtesan and Hotei Smoking on a Veranda in Moonlight (Harunobu), *22*, 198

Courtesan and Two Attendants by a Brazier (Shunshō painting), 102

Courtesan as the Poet Sagami at Tōi Jewel River, from series *Customs and Manners of the Six Jewel Rivers (Fūzoku Mutamagawa)* (Harunobu), 197, *197*

Courtesan Holding a Pipe (O. Masanobu), 71, *72*, 217

Courtesan of the Motoya and Client Disguised as an Itinerant Monk (Harunobu), 45, 95, 96, 97, 198

Courtesan in Robe Decorated with Calligraphy (O. Masanobu), *60*, 61, 68, 216

Courtesan Koyoshi, The, from album *Beautiful Courtesans of the Northern Quarters (Hokkaku bigichō)*, 58, 59

Courtesan of Eguchi, The, as the Bodhisattva Fugen and the Monk Saigyō (Hokusai painting), 148, *148*, 210

Courtesan Poling Daruma on a Reed Boat (O. Masanobu), 63, *63*, 216

Courtesan, Two Kamuro and a Giant Snowball (Shiba Kōkan, inscribed Harunobu), 91, 93, 198

Courtesan with a Letter and Two Attendants (Sukenobu painting), 103

Courtesan with Love Letter and Kamuro Playing Blindfold with a Client (Harunobu), 198, *199*

Courtesans Hanaōgi and Takigawa, The, of the Ōgiya, from album *New Mirror Comparing the Handwriting of the Courtesans of the Yoshiwara (Yoshiwara keisei shin bijin awase jihitsu kagami)*, 25, 121, 177, 216

Crouching Lion, from *Daily Exorcisms (Nisshin joma)* (Hokusai drawing), *164*, *164*

Customs and Manners of the Six Jewel Rivers (Fūzoku Mutamagawa) (Harunobu), 197, *197*

Daikoku, 64, *65*, 218

Daikokuya (Yoshiwara house), 120

Daily Exorcisms (Nisshin joma), 163, *164*

Daimonjiya (Yoshiwara house), 120–21, 173

daimyo, 19, 20, 23, 35, 47, 50, 52n11, 54n42, 55n55, 109, 135, 136, 165n10

daishō pictures, 95; *see also* calendar prints

Danjūrō (Utei) Enba (1743–1822), 226

Danjūrō line, *see* Ichikawa entries

Danrin school of *haikai*, 66

Daoism, 33, 48

Daozhe Chaoyuan (J. Dōsha Chōgen; 1602–1662), 55n52

Daruma, 62, 63, *63*, *150*, 151, *151*, 199, 212, 216; *see also* Bodhidharma

date komusō, 97

Dead Mallard with Abalone Shell and Stew Ingredients (Hokusai), 209, *209*

deer glue, *see* nikawa

Designs, from *Elegant Chats on Small Motifs (Komon gawa)* (Santō Kyōden), *174*, 174

Diary in the Shadow of the Pine (Matsukage nikki), 50, 55n58

"Dog shogun" (*Inu-kubō*), 50

dokuryū, 48

Dong Feng (J. Tōhō), 144, *146*

Doromachi, 120

Dreams during a Nap (Karine no yume), 92

Driving Rain, Shōno (Shōno hakuu), from series *The Fifty-Three Stations of the Tōkaidō (Tōkaidō gojūsan tsugi no uchi)* (Hiroshige), 202, *202*

Dutch influences and visitors, 72, 102, 183; *see also* Dutch learning; Nagasaki; *nozoki karakuri*; *uki-e*

Dutch learning (*Rangaku*: implying European studies), 91

dyeing, 34, 53n17, 53n25, 170, 188n5, 188n6; *see also* kon'ya

Ebisu and Daikoku Performing a Manzai Dance at New Year (O. Masanobu), 64, *65*, 218

edition sizes (of prints), 116

Edo:
advertising in, 173–74, 175, 189n6
Azuma as referring to, 95
censorship laws, 8, 25, 108, 126–27, 179
earthquake, fires and tsunami, 36, 37, 44, 53n16, 102
fashion world of, 169–77, 186
floating world and, 8, 10, 15, 28, 33
growth of, 33–34
poetry circles, 65–66, 87, 84, 121, 126, 143–44, 156, 165n4, 174
population of, 10, 23

shops, 45, 92, 115, 116, 117, 120, 129, 171, 175, 179, 183, 186
social changes, 25, 126
social classes in, 20, 37, 144, 177, 184
women's roles in, 144, 175, 177, 186
see also kabuki; Noh; publishers; ukiyo-e, Yoshiwara

Edo Bay, 154

Edo-e ("Edo pictures": old name for ukiyo-e prints; *cf. Azuma nishiki-e*), 23

Edo meishoki (Record of Famous Places in Edo), 44, *44*

Edo no hana Kyōbashi natori (Flowers of Edo: The Master of Kyōbashi [Santō Kyōden]), 152, 153–54, *154*, 193, 195

Edo no hana Yanagibashi natori (Flowers of Edo: The Master of Yanagibashi), *194*, 195

Edo period (1615–1868: when Edo, now Tokyo, first served as administrative capital of Japan), 20, 22, 49

Edo-umare uwaki no kabayaki (Grilled and Basted Edo-Born Playboy), 124, *124*

Egaya Kanemon, 218

egoyomi ("pictorial calendars"), *see* calendar prints

Eguchi (courtesan), 103, *103*, 108, 224

Eguchi, courtesan of, 86, 148, *148*, 154

Eguchi, from *A Series of Noh Plays for the Hanazono Club (Hanazono yōkyoku bantsuzuki)* (Totoya Hokkei), 148, *149*

Eguchi [The Courtesan of Eguchi as the Bodhisattva Fugen from the Noh play, Eguchi], from *A Series of Noh Plays for the Hanazono Club (Hanazono yōkyoku bantsuzuki)* (Totoya Hokkei), 204, 205

ehon ("picture book": illustrated book, especially one containing woodblock prints), 23, 37, *37*, 52n10, 52n11, 52n13, 53n19, 53n20, 53n30, 80n15, 81n39, 91, *93*, 99n38, *103*, 115, 118, 121, 124, 107, *107*, 139, 151, 163, 167n41, 170, 171, 176, 198, 200, 220, 229

Ehon haru no nishiki (Picture Book of the Brocades of Spring), 91, 93, *93*, 198

Ehon saishiki-tsū (Treatise on Coloring), 163

Ehon seirō bijin awase (Picture Book of Collected Beauties of the Yoshiwara), 151

Ehon Utamakura ("Picture Book of the Poem of the Pillow"), 124, *125*, 141n30, 229

Ei, *see* Katsushika Ōi

Eight Parlor Views of Kanazawa Palace (Kanazawa no gosho zashiki hakkei), 94

Eight Parlor Views (Zashiki hakkei), 21, 38–39, 87, 91, 94, 97, 98n22, 99n32, 196

Eight Views in the Yoshiwara (O. Masanobu), 66

Eight Views theme, 66, 72; *see also* Eight Parlor Views; Eight Views in the Yoshiwara; Eight Views of Ōmi; Eight Views of Xiao and Xiang Rivers; Fashionable Eight Views of Edo

Eight Views of Ōmi (Ōmi hakkei), 66, 80n18, 87

Eight Views of Xiao and Xiang Rivers (Shōshō hakkei), 66, 87

Eighteen Famous Plays (Kabuki jūhachiban) compiled by Ichikawa Danjūrō VII (1791–1859), 173

Eijudō publishing house (Nishimuraya Yohachi), 118, 119, 120, 131, 132, 136, 188n12, 208

Eishōsai Chōki (act. c. late 1790s–early 1800s), 138
 Catching Fireflies, 136, *137*, 192
 Moon Viewing, 193
 Moto, Maidservant of the Yoshidaya in Shinmachi, Osaka, and Mizue, a Geisha, 193
 New Year Sunrise, 136, *192*
 Snow, 136, *192*

Elegant Chats on Small Motifs (Komon gawa), 174

Elegant Shakuhachi Version of Ushiwakamaru Serenading Jōruri-hime, an Original Perspective Print (Fūga shakuhachi jūnidan uki-e kongen) (O. Masanobu), 71–72, *73*

embroidery, 34, 35, *37*, 52n7, 86

Emiya Kichiemon, 224

Emonzaka, 45

Endō Matsugorō, 198, 200

Engaging Type, The (also called *The Interesting Type*) *(Omoshiroi sō)*, from Utamaro series *Ten Types in the Physiognomic Study of Women (Fujin sōgaku juttai)*, 127, *129*, 233

"Enjirō," as synonym for "misguided conceit," 124

Enjoying the Evening Cool under a Gourd Trellis (Toyohiro painting), 186, *187*, 227

Enoshima, 177, 179

Enseki zasshi (Swallow Stone Journal), 84

Enshūya Hikobei, 216

Entertainers in a House of Assignation, from Moronobu series *Aspects of the Yoshiwara (Yoshiwara no tei)*, 45, *47*, 48, 219

"Entwined in the Ivy" (Tsuta no Karamaru: Utamaro's poetry name), 120, *121*

erotica, 46, 107–08, 110, 112, 127, 138, 186, 189n23; *see also* pornography

eshi ("painting master"), 33, 36, 52n12, 86, 98n19, 109, 218

Etiquette Rules for Women (Onna shoreishū), 170, *170*

Excitable Type, The (Ima ni agari sō), from series *Modern Thirty-Six Types (Imayō sanjunisō)* (Kunisada), *214*, 215

ezōshiten (variant of *ezōshiya*), 116, *see also* ezōshiya

ezōshiya ("picture leaves shop": shop selling illustrated books), 95, *114*, 115, 116

Family Outing on Boy's Day (attrib. to Sugimura Jihei), *38*, 39, 213

fan paintings, 39, 110, *110*, 131, *131*, 141n45, 163, 188n6, 225

Fanciful Genji (Yatsushi Genji) (Koryūsai series), 91

fashion, 22, 109, 169–77

Fashionable Eight Views of Edo (Fūryū Edo hakkei), 97, *97*

Fashionable Modern Clothing (Tōseigata zokuizoroi), 29, 213

Fashionable Picture Competition (Fūryū e-awase), 87

Fashionable Seven Komachi (Fūryū nana Komachi) (Shiba Kōkan, signed Harushige), 91, *92*

Feinberg, Robert and Betsy, 18–19, 227

Fenollosa, Ernest Francisco (1853–1908), *The Masters of Ukioye [sic]: A Complete Historical Description of Japanese Paintings and Color Prints of the Genre School*, 15–17, 18, 28, 30n1, 30n2, 86, 98n15–19

Ficke, Arthur Davison (1883–1945), *Chats on Japanese Prints*, 17

Fifth Month, The, from *Pastimes of Women in the Twelve Months* (Shunshō), 101–2, *102*

Fifty-Three Stations of the Tōkaidō by Twin Brushes (Sōhitsu gojūsan tsugi), 179

Fifty-Three Stations of the Tōkaidō, The (Tōkaidō gojūsan tsugi no uchi), 179, 202, *202*

Fine Wind, Clear Weather (Gaifū kaisei) ["Red Fuji"], from series *Thirty-Six Views of Mount Fuji (Fugaku sanjūrokkei)* (Hokusai), 15, 16, *16*, 171, 173, 208

fireman 184, 185, *185*, 235, *235*

Fireworks, Ryōgoku Bridge (Ryōgoku hanabi), from series *One Hundred Views of Famous Places of Edo (Meisho Edo hyakkei)* (Hiroshige), 180, *181*, 184, 201

Fishbein, Richard; and Estelle Bender, 43, 219

Fisherman Sitting on a Rock by the Sea, 160, *161*, 206

Five Beauties (Hokusai painting), *142*, 143, 144, 205

"floating world" (*ukiyo*), 8, 10, 15
 use of term, 28, 33
 see also ukiyo-e

Floating World Monkey Trainer on the Sumida River, A (Sumidagawa ukiyo sarumawashi) (O. Masanobu), 77, 78, 85, 218

Floating World Version of The Potted Trees, A (Ukiyo hachi no ki) (O. Masanobu), 64–65, 66, *66*, 218

Flowers of Edo: The Master of Kyōbashi [Santō Kyōden] (Edo no hana Kyōbashi natori), 152, 153–54, *154*, 193, 195

Flowers of Edo: The Master of Yanagibashi (Edo no hana Yanagibashi natori), 194, 195

Foreign Trading Establishments in Yokohama (Yokohama ijin shōkan urimono no zu), *220*, 220

Forrer, Matthi, 118

Frank Lloyd Wright Foundation, The, 156

Freer Gallery of Art, Washington D.C., 19

fucha ryōri, 47, 54n45

Fucha Tarōemon, 47–48,

fude ("brush of": i.e., painted by), 17

Fude no ayamaru ("Slip of the Brush": pen-name of Utamaro), 121

Fūga shakuhachi jūnidan uki-e kongen (Elegant Shakuhachi Version of Ushiwakamaru Serenading Jōruri-hime, an Original Perspective Print) (O. Masanobu), 71–72, 3

Fugaku sanjūrokkei (Thirty-Six Views of Mount Fuji) (Hokusai series), 15, 16, 16, 158, 160, 171, 173, *178*, 179, 184, 208

Fugen (Bodhisattva), 86, 124, 148, *148*, 149, *149*, 205, 210, 231

Fugenzō (Statue of Fugen), 124

Fuji, Mount, 15–16, *16*, 36, 53n16, 108, 115, 143, 160, 167n32, 167n36, 178, *178*, 179, 208

Fuji sanjūrokkei (Thirty-Six Views of Mount Fuji) (Hiroshige series), 53n16

Fujikawa Tomokichi II, 20, *20*, 212

Fujin sōgaku juttai (Ten Types in the Physiognomic Study of Women: Utamaro series), 127, *128*, 129, 233

Fujiokaya Keijirō (Shōrindō), 215

Fujiwara Teika (1162–1241), 35, 64
 One Hundred Poems by One Hundred Poets (Hyakunin isshu), 64

Fujo ninsō juppon (Ten Types in the Physiognomic Study of Women: Utamaro series), 127, *184*, *190*, 231, 231, 232, 233

Fukai Shidōken (1680?–1765), 71; *see also* rakugo

Fukiage Park, 103

Fukiyachō, 72, 218, *219*

Fukunoya Uchinari, 147

Fukuro no uchi ni sato (Inside the Bag, the Pleasure Quarters), from the album *Okumura Masanobu's Picture Copy Book (Okumura Masanobu edehon)*, 59, 64, 218

fukurotojibon ("book with bag-binding": the most common form of a traditional Japanese book, including illustrated books; with double pages folded over, stitched at the spine, with heavy paper covers of varying colors, and opening from the rear; usually with a title label pasted on the rear cover), 198, 200, 219, *220*, 224, 227, 229

Fukushima Wajūrō, 216

Fumoto no sato ("Village at the foot of the mountain": Hokusai seal), 166n31, 227

Funaki Kasuke, 200

Funenoya Tsunahito, 147

"Fur on a turtle, legs on a snake" (*Kimō dasoku*: Hokusai seal), 165n7, 205, 210

Furuyama Moroshige, 53n28
 Artist's Studio, from Shikano Buzaemon, *Shika's Paper-Wrapped Brush (Shika no makifude)*, 42, *42*

fūryū ("fashionable"), 62, 66, 80n17, 87, 92, 97, *97*

Fūryū ashi no ha nichō (Two Elegant Reed Leaves) (O. Masanobu), 59, *62*, *63*, 91

Fūryū e-awase (Fashionable Picture Competition), 87

Fūryū Edo hakkei (Fashionable Eight Views of Edo), 97, *97*

Fūryū nana Komachi (Fashionable Seven Komachi) (Shiba Kōkan, signed Harushige), 91, 92, *92*

fusa ryōri, 47

fūsha, 48

fūzoku ("customs and manners"), 66, 102, 113n1, 197, *197*, 225

Fūzoku Mutamagawa (Customs and Manners of the Six Jewel Rivers) (Harunobu), 197, *197*

gahō (drawing methods), 163

Gaifū kaisei (Fine Wind, Clear Weather) ["Red Fuji"], from series *Thirty-Six Views of Mount Fuji (Fugaku sanjūrokkei)* (Hokusai), 15, *16*, 171, 173, 208

Gakutei, 166n28

Gakyōjin Hokusai ("Hokusai, A Man Mad about Painting": art name used by the artist at turn of eighteenth and nineteenth centuries, mostly for private commissions), 156, 205, 206, 208, *208*, 209, *209*

Gale, Richard, 11, 19

games and competitions, *see* awase

ganso (founder), 78

Gaoquan Xingdong (J. Kōsen Shōton, 1633–1695), 50

Gate of Immortality, a New Year's Water for Cosmetics (Oi senu kado keshō no wakamizu), 124

Gathering Spring Herbs and Brushwood Peddlars from Ohara (Hokusai and Kyōden), 152, *152*, 206

Gazu seiyūdan (Tales of Valor Told in Pictures), 140n22

Geisha (Eisen painting), 17, *18*, 196

Genji hinagata (pattern book, 1678), 188n6

Genji, The Tale of, 76, 78, 81n41, 91, *91*, 189n23, 217; *see also* Genji Ukifune

Genji Ukifune (Ukifune Chapter of The Tale of Genji) (O. Masanobu), 76, 78, 91, 217

Genkin'ya Hachizō, pub.: *Night-calling Birds (Yagoe no tori)*, 175

Genroku era (1688–1704), 103, 171

Genroku-era Courtesans in Opposing Mirrors (Genroku tayū awase kagami), 59

Genroku Immortal Poets Shell Matching Contest (Genroku kasen kai awase), 206, *206*

Genroku kasen kai awase (Genroku Immortal Poets Shell Matching Contest), 206, *206*

Genroku tayū awase kagami (Genroku-era Courtesans in Opposing Mirrors), 59

gesaku ("playful composition": popular fiction, originally presented by samurai and intellectuals as parodies of Chinese classics), 120, 140n16, 140n20, 140n22, 141n25, 151, 165n4

Gin sekai (Silver World, The), 124

Girl with Umbrella Walking with a Boy (Hokusai), 208, *208*

Gitter-Yelen Collection, 155, 227

Go (Five) Group, 144

gōkaban (luxury printed editions), 171

Gokokuji, 50

Grabhorn, Edwin M. and Marjorie, 11, 213, 217

Grabhorn Ukiyo-e Collection, 38, 63, 71, 76, 192, 197, 213, 216, 217

Great Mirror of the Way of Love (Shikidō ōkagami), 47

Great Performances (Ōatari kyōgen), 17, 17, 213, *213*, 214

"Great Wave" (Hokusai), 143, 158, *178*, 179, 184, 208

Grilli, Peter and Diana, 153, 205

guide books, *see* saiken

Guide to Contemporary Women's Fashions (Tōsei onna fūzoku tsū), 102
Guide to Love in the Yoshiwara, A (Yoshiwara koi no michibiki), 44–45, 54n35, 54n37, 54n45, 55n54, 44, 219
guilds, 37, 116, 126–27
Guth, Christine M.E., 20

Hagi Uragami Museum of Art, 98n1
Hagoshi Tsukimori, 227
haikai ("playful [verse]": sequence of linked poems), 21, 47, 65–66, 80n16, 106, 108, 108, 136, 200, 224
Haikai Album of the Cuckoo (Haikai yobuko-dori), 108, 108, 224
Haikai yobuko-dori (Haikai Album of the Cuckoo), 108, 108, 224
Hakutei, see Ishii Hakutei
Hamabe Kurohito (Mikawaya Hanbei), Shiba Group of, 188n11
Hanabusa Itchō (1652–1724), 53n17, 63, 103
 The Boat at Asazuma (Asazumabune), 51
Hanaōgi III (courtesan), 102, 118, 120
Hanaōgi IV (courtesan), 110, 131–32, 131, 132, 225, 234
Hanaōgi IV of the Ōgiya (Utamaro painting), 110, 131–32, 131, 225, 234
Hanashōbu Bunroku Soga (The Iris Soga of the Bunroku Era: kabuki play title), 102, 132, 133, 135, 174, 221, 222, 222, 224, 225
Hanashōbu omoi no kanzashi (The Iris Hair-ornament of Remembrance): dance interlude in the kabuki play The Iris Soga of the Bunroku Era (Hanashōbu Bunroku Soga), 135
Hanazono-ren ("Flower Garden" Circle), 148
Hanazono yōkyoku bantsuzuki (A Series of Noh Plays for the Hanazono Club), 148, 149, 149, 204, 205
handcoloring, transition to color printing from, 85
hane-nezumi ("leaping mice") pattern, 175
Hangiya Shichirobei, 59
hanja (poetry judge), 156
hanka-tsū ("half-sophisticate": pretender), 120
hanmoto ("source/origin of the print/block": i.e., the publisher), 68, 80n5, 116, 140n10
Harakara no Akindo (Nakai Tōdō, 1758–1821), 121, 121
Harumachi, see Koikawa Harumachi
Harunobu, see Suzuki Harunobu
Harushige, see Shiba Kōkan
Hasanjin (seal of Santō Kyōden), 152, 154
Hashimoto Sadahide (1807–1878/79):
 The American Merchant Eugene Van Reed, 28, 28, 29, 220
 Foreign Trading Establishments in Yokohama (Yokohama ijin shōkan urimono no zu), 220, 220
 Yokohama Trade: Picture of Westerners Shipping Cargo (Yoko kōeki seiyōjin nimotsu unsō no zu), 182–83, 183, 184, 220

hashira-e ("pillar pictures": tall narrow prints, roughly 69–75 x 112–117 cm, said to have been mounted as a hanging scroll and displayed on a wooden pillar), 57, 71, 81n29, 197, 197, 216, 217
Hatakeyama Kizan (c. 1628–1704), 47
Hatamaki (courtesan), 120
hatsu-mukashi tea, 210
Hayashi Tadamasa (1853–1906), 200, 209, 218, 220, 222, 233
Hayashi Yoshikazu, 107
Hell Courtesan (Kuniyoshi painting), 175, 176, 177, 216
Hezutsu Tōsaku (1726–1789), 121
Hickman, Money L., 91
Hidetada (1579–1632), 54n41
Higinbotham, Harlow N., 22, 65, 198, 218
hikifuda, 173
Hillier, Jack, 95
Hinagata wakana no hatsumoyō (Models of Fashion: New Designs Fresh as Spring Leaves), 118, 119, 175, 189n19
hinagatabon [also hinakatabon, hiinagatabon] (pattern books), 118, 169–70, 173, 175, 188n5, 189n21
Hinazuru, 25, 119
Hinazuru of the Chōjiya (Chōjiya-uchi Hinazuru), 119
Hiraga Gennai (1734–1779), 91, 95
Hirose Tsuyo, 117
Hiroshige, see Utagawa Hiroshige
Hishikawa family monastery, 52n3
Hishikawa Kichibei, 36
Hishikawa Morofusa (act. 1685–1703), 36, 53
Hishikawa Moronobu (1630/31?–1694), 18, 33–55, 169–70
 birth and background, 34–35
 books illustrated by, 35–36, 39, 52n11
 Compendium of Yamato-e (Yamato-e zukushi), 36
 Couple Seated by Autumn Flowers, 39, 40, 40, 219
 death, 36, 52n3
 early life, 35–36
 Entertainers in a House of Assignation, from series Aspects of the Yoshiwara (Yoshiwara no tei), 45, 45, 47, 48, 219
 family and pupils, 36, 39, 53n17
 influence, 33, 36, 53n17, 103
 Guide to Love in the Yoshiwara, A (Yoshiwara koi no michibiki), 44–45, 54n35, 54n37, 54n45, 55n54, 44, 219
 Lovers beside a Screen, 39, 41, 41, 219
 Lovers by a Screen, 39, 41, 41, 219
 as master illustrator and painter, 37–42
 names used by, 34, 36, 52n3
 One Poem Each by a Hundred Poets on Mount Ogura (Ogurayama hyakunin isshu), 35–36
 One Poem Each by a Hundred Samurai (Buke hyakunin isshu), 36
 Origins of Yamato-e (Yamato-e no kongen), 52n1
 patrons, 46–47, 49–51, 109
 Portrait Eulogies of One Poem Each by One Hundred Poets (Hyakunin isshu zō sanshō), 36
 Standing Beauty, 42, 43, 43, 59, 219

Various Occupations of Japan, Exhaustively Portrayed, The: A Picture Book Mirror of the Various Occupations (Wakoku shoshoku ezukushi: shoshoku ehon kagami), 37, 37, 220
 as ukiyo-eshi, 33, 36
 Visit to the Yoshiwara (handscroll painting), 21, 33, 34, 34–35, 44–51, 46, 48–49, 51, 54n39, 54n40, 54n45, 55n46, 55n51, 219
Watching a Courtesan and Her Client from Behind a Screen, 39, 40, 40, 219
 and the Yoshiwara, 34, 34–35, 44–46, 51, 51
Yoshiwara Street Scene, from series Aspects of the Yoshiwara (Yoshiwara no tei), 45, 45, 219
Hishikawa Shichiemon, 34, 52n4
Hishikawa Sōri III (Tawaraya Sōji, act. late 1790s–late 1810s), Reception Room with Paintings and Objects Associated with the Seven Gods of Good Fortune, 226, 226
Hitogokoro kagami no utsushi-e (Pictures Cast by the Projector of the Human Heart), 138, 139, 139
Hitokidori (Birds with Pretensions), 175
Hockley, Allen, 12, 15, 18, 21, 83–99, 118, 175
Hoda, 34, 35, 47
Hōgetsudō Tanchōsai Okumura Bunkaku Masanobu signature (and variants), 65, 200, 216, 217, 218; see also Okumura Masanobu
Hokkaku bigichō (Beautiful Courtesans of the Northern Quarters), 58, 59
hokku (initial seventeen-syllable verse of a haikai sequence), 160
Hokuei, see Shunkōsai Hokuei
Hokuga (later Gosei) Hokkei (1780–1850), 166n28
Hokumei, 158, 166n28, 166n29
Hokusai and Ōi in their "temporary lodgings" of the mid–1840s (Iitsu II), 163, 163
Hokusai, see Katsushika Hokusai
Hokusai II (family name Suzuki, act. early 1810s–1826), 158, 166n28, 166n29
Hokusai Manga (Random Drawings by Hokusai), 143, 158, 163
Hokushū, see Shunkōsai Hokushū
Honchōren poetry circle, 121
Honolulu Academy of Arts, 58, 70, 160
Hontoiya (publisher), 45, 219
hon'ya (general name for a book shop), 115
Hoofing It along the Tōkaidō (Tōkaidō hizakurige, 1802–22), 136, 179
Hōrai Sanjin, 211
Horiko Mori, 213
Hōseidō Kisanji (1735–1813), 117, 120, 126, 138, 173
hōsho[gami] ("edict [paper]": fine-textured high-quality paper made with kōzo paper mulberry fiber, in small, medium or large size sheets): 98n8
hosoban ("narrow print," roughly 30 x 16 cm, made by cutting a hōsho or other sheet vertically into three or five pieces), 23, 68, 84, 136
Hosoi Kōtaku (1658–1735), 55n56
Hotei (god), 22, 64, 198
Hyakunin isshu (One Hundred Poems by One Hundred Poets), 64, 80n13

Hyakunin isshu zō sanshō (Portrait Eulogies of One Poem Each by One Hundred Poets), 36
Hyakunin jorō shinasadame (One Hundred Women Arranged by Class), 177
hyōbanki ("reputation record": published critiques of actors, courtesans and others), 117, 173
Hyōgo coiffure, 152

ichigenkin (one-stringed zither), 144, 145, 165n10
Ichikawa Danjūrō, Sakaimachi Group of, 188n11
Ichikawa Danjūrō, Shibaraku (Stop right there!) role, 110, 110, 111, 112, 174, 224, 225
Ichikawa Danjūrō I (1660–1704), 23, 72, 85
Ichikawa Danjūrō II (1689–1758), 67, 69, 72
Ichikawa Danjūrō II as Ike no Shōji (O. Masanobu), 68, 69
Ichikawa Danjūrō V (1741–1806), 110, 110, 111–12, 111, 120, 134, 134, 174, 179, 224, 225, 226, 227
Ichikawa Danjūrō V in Kumadori Makeup Seen in a Mirror (Shunshō), 110, 111, 120, 174, 225
Ichikawa Danjūrō V in the Shibaraku (Stop Right There!) Role (Shunshō), 110, 110, 120, 174, 225
Ichikawa Danjūrō VII (1791–1859), 189n26
Ichikawa Danjūrō IX (1839–1903), 214
Ichikawa Ebijūrō I, as Tōken "China Dog" Jūbei, in the Kabuki Play Benimurasaki ai de someage, 211, 211
Ichikawa Ebijūrō II (name adopted by Ichikawa Ichizō II in 1820), 20, 212
Ichikawa Ebijūrō II as Ki no Haseo, Nakamura Utaemon III as Kujaku Saburō and Fujikawa Tomokichi II as Kō hime, in the Kabuki Play Tenmangū aiju no meiboku, 18, 20, 212
Ichikawa Ebizō IV (name adopted by Ichikawa Danjūrō V in 1791), 111, 112, 134, 134, 221, 224, 225
Ichikawa Ebizō IV (Danjūrō V) as Takemura Sadanoshin, a Noh Performer Driven to Suicide by His Daughter's Disgrace, in the Kabuki Play The Beloved Wife's Particolored Reins, 132, 134, 135, 174, 221
Ichikawa Ebizō IV (Danjūrō V) in the Shibaraku (Stop Right There!) Role (Shunkō), 111, 224
Ichikawa Hakuen ("White Monkey," poetry name of Ichikawa Danjūrō V), 112, 226, 227
Ichikawa Ichizō II, 212
Ichikawa Yaozō III, 212, 213
Ichikawa Yaozō III as Watanabe no Tsuna, in the Kabuki Play Seiwa nidai ōyose Genji (Kunimasa), 212, 213
Ichimatsu pattern, 174
Ichimura Takenojō, 69
Ichimura Takenojō as Koshō Kichisaburō (O. Masanobu), 67, 69, 69
Ichimura Theater (Ichimuraza), 72
Ichiryūsai, 202, 227, 229
Ichiwa ichigen, 98n7
Ichiyōsai, seal, 228
Idemitsu Museum of Arts, 108, 109

iemoto (house source) system, 42
Ieyasu, see Tokugawa Ieyasu
Igaya Kanemon (seal hanmoto Igaya motohamachō), 216
Ihara Saikaku (1642–1693), 33, 53n30
 A Man with an Amorous Life (Kōshoku ichidai otoko), 52n1
Iijima Kyoshin, 158, 166n30, 167–68n31, 167n35
Iitsu (art-name used by Hokusai), see Katsushika Hokusai
Iitsu II (Tsuyuki Kōshō, d.1893), 158, 160, 163, 163, 166n28, 166n29
Iizuka Someko, 51
Ike Taiga (1723–1776), 28
Ikkyū (1304–1481), 177
Illustrated Guide to the Yoshiwara (Yoshiwara saiken zu), 175
Ima ni agari sō (The Excitable Type), from series Modern Thirty-Six Types (Imayō sanjunisō) (Kunisada), 214, 215
Imayō sanjunisō (Modern Thirty-Six Types), 214, 215
Imoseyama onna teikin (Mounts Imo and Se: Exemplary Women's Virtues) (kabuki play), 179–80, 180, 212
Imperial Progress, The, Chapter 29, from Koryūsai series Fanciful Genji (Yatsushi Genji, Miyuki), 90, 91, 91
Impressionism, 30
Impressions (the journal of the Ukiyo-e Society of America.; now the journal of the Japanese Art Society of America), 10–11, 80n8, 80n17, 98n20, 98n24, 99n41, 165n1, 165n15, 189n17
Inside the Bag, the Pleasure Quarters (Fukuro no uchi ni sato), from the album Okumura Masanobu's Picture Copy Book (Okumura Masanobu edehon), 59, 64, 64, 218
Inu-kubō ("Dog Shogun"), 50
Iris Hair-ornament of Remembrance, The (Hanashōbu omoi no kanzashi): dance interlude in the kabuki play The Iris Soga of the Bunroku Era (Hanashōbu Bunroku Soga)
Iris Soga of the Bunroku Era, The (Hanashōbu Bunroku Soga: kabuki play title), 102, 132, 133, 135, 174, 221, 222, 222, 224, 225
Isai (1821–1850), 158, 166n28
Iseya Ichibei, 120, 188n12
Ishii Hakutei (1882–1959), Yanagibashi, from series Twelve Views of Tokyo (Tōkyō jūnikei), 30, 30, 167n33, 175
Ishikawa Masamochi (Rokujuen; also known as Yadoya no Meshimori; 1753–1830), 144, 147, 165n12; see also Yadoya no Meshimori
Ishikawa Tomonobu (Ryūsen; act. 1680s–1710s), 53n17
Ishikawa Toyonobu (1711–1785), 53n17, 84
Isoda Koryūsai (1735–1790), 18, 87, 90, 91, 98n15, 98n22, 98n28, 98n40, 118, 119, 140n12, 140n13, 175, 189n20, 189n21
 Hinazuru of the Chōjiya (Chōjiya-uchi Hinazuru), from series Models of Fashion: New Designs Fresh as Spring Leaves (Hinagata wakana no hatsumoyō), 118, 119, 119, 175, 189n19, 189n21

The Imperial Progress, Chapter 29, from series Fanciful Genji (Yatsushi Genji, Miyuki), 90, 91, 91
Iwai Murasakiwaka, 179–80, 189n26
Iwai no tsubo ("Jar of Celebration"), 50
Iwasa Matabei (1578–1650), 16, 53n29
Iwasaki family, 35
Iwatoya Kisaburō, 120, 121, 141n25, 188n12
Izumiya Gonshirō, 67–68, 71
Izumiya Ichibei, 132, 174, 188n12
Izzard, Sebastian, 11, 20

Japanese Art Society of America (JASA), 3, 5, 7–11, 15, 30; see also Impressions; Ukiyo-e Society of America
Japanese Painters of the Floating World (1966 exhibition at Cornell University), 19, 165n19
Javal, Emile, 227
Jigoku ("Hell": name of prostitute), 175, 176, 177, 216n65
jihondōiya (seller of light books), 116
Jikudō Soban, 50
Jinshirō Tadanobu (1727–1777), see Kyosen, Kikurensha
Jippensha Ikku (1765–1831), 138, 173
 Hoofing It Along the Tōkaidō Road (Tōkaidōchū hizakurige), 179
 Shingaku Passionflower (Shingaku tokeigusa), 136
Joke Style (Share-fū) of poetry, 66
jōruri (puppet theatre), 116
Jōshūya Kinzō, 202
Jōshūya Tadasuke, 229
Journey to the West (C. Xiyuji; J. Saiyūki), 48
Jubai Shujin, 205
jūnigiriban ("print [sheet] cut into twelve": small print made from an ōbōsho sheet cut into twelve, once horizontally and six times vertically, roughly 20 x 10 cm), 208
junpitsuryō ("brush-moistening fees"), 175
Jurōjin, 50

Kabocha no Motonari ("Pumpkin Stem": poetry name of Murata Ichibei), 120, 121, 121, 173–74; see also Daimonjiya
Kabuki jūhachiban (Eighteen Famous Plays) compiled by Ichikawa Danjūrō VII (1791–1859), 173
kabuki theater:
 actors and plays, 15, 20, 23, 29, 39, 48, 53n19, 53n28, 59, 64, 72, 80n4, 91, 102, 108, 110, 112, 113n9, 113n12, 112, 113, 115, 120, 132, 134, 135, 141n49, 144, 167n32, 173, 175, 180, 185, 186, 205, 211, 212, 213, 218, 220, 221, 226, 224; see also individual actors and play titles
 guidebooks, 175
 mie pose, 186
 posters, 184
 "women's kabuki," 23
Kaempfer, Engelbert, 54n44
Kagurazuki Iwai no iroginu (kabuki play title), 175
kai-awase ("shell-matching") game, 42, 43, 206, 206; see also awase
Kaigetsudō group, 52n12, 53n17, 59, 171

kakemono-e ("hanging scroll picture": term sometimes used in older writing to describe prints in an extra-large format, resembling and perhaps mounted as hanging scrolls; including both the early ōōban prints and the later vertical ōban diptychs), 86
Kakuhō (1729–1815), 165n10
Kameido Shrine, 147
Kamo no Suetaka (pen-name Unkin, 1752–1842), 151
kamuro (child attendant on courtesan), 79, 79, 91, 91, 119, 119, 197, 199
kana (Japanese syllabic writing), 33, 68
Kanagawa oki nami ura (Under the Well of the Great Wave Off Kanagawa), 158, 178, 178, 179, 184, 208
Kanazawa no gosho zashiki hakkei (Eight Parlor Views of Kanazawa Palace), 94, 94
kanazōshi ("leaves written with kana syllables"), 33, 37
kanban (billboards, posters), 95, 129, 173
kanban musume ("billboard girls"), 129, 173
Kanbun era (1661–73: when anonymous figure paintings appeared, especially of beautiful women, foreshadowing development of recognized ukiyo-e paintings and prints in 1680s), 23, 42, 59, 170
Kanda River, 175
Kannon (Bodhisattva), 54n36
kanoko shibori (dappled fawn tie-dye), 184
Kano painting, 42, 103
 Rakuchū Rakugai zu, 53n30
Kano Tan'yū (1602–1674), 108–9
Kano Tsunenobu (1636–1713), 50
Kano Yoshinobu (1552–1640), 52n5
Kansei era (1789–1801), 102; Reforms, 108
kanshi (sexagenary cycle in Japanese calendar), 84, 98n4
kao (calligraphic seal-like flourish), 103, 224, 225
kaomise ("face-showing") performances, 110, 112
Kaoru (courtesan), 103, 103, 108, 224
Karagoromo Kisshū, Yotsuya Group of, 188n11
Karine no yume (Dreams during a Nap), 92
Kasamori Inari Shrine, 95
Kasaya Saren, 200
kashi (type of low-class prostitute), 129, 141n40
Kashi (Riverbank Type), from The Mirror of the Punter's Pluck (Kyakushu kimo kagami), 129, 129
Kashibatei Aoki, 227
kashihon'ya ("book rental shops"), 116
Kasuke (engraver), 205
Katakiuchi noriaibanashi (A Medley of Tales of Revenge: kabuki play), 132, 174, 221, 221
Katatsukai (Univalve Shell), from Hokusai series Genroku Immortal Poets Shell Matching Contest (Genroku kasen kai awase), 206, 206
Katō Kiyomasa (1562–1611), 157
Katsukawa Shunchō (act. 1780–95), 173
Katsukawa Shun'ei (1762–1819), 102, 136
 Arashi Ryūzō as a Manservant (yakko), 102, 224, 224

Sanogawa Ichimatsu III as Onayo, in the Kabuki Play The Iris Soga of the Bunroku Era (Hanashōbu Bunroku Soga), 102, 224, 225
Sawamura Sōjūrō III as Ōgishi Kurando, in the Kabuki Play The Iris Soga of the Bunroku Era (Hanashōbu Bunroku Soga), 102, 135–36, 135, 141n49, 224
Katsukawa Shunkō (1743–1812), 102, 112
 Ichikawa Ebizō IV (Danjūrō V) in the Shibaraku (Stop Right There!) Role, 111, 224
Katsukawa Shunshō (d. 1792), 18, 20, 85, 101–13, 138, 174, 177
 Actors Like Mount Fuji in Summer (Yakusha natsu no Fuji), 108
 Admiring a Painting of a Beauty, from One Hundred Poems by One Hundred Poets, Woven in Eastern Brocade (Nishiki hyakunin isshu azuma-ori), 106, 106
 artistic lineage and pupils, 102–03
 Beauties Looking at Paintings, 108–9, 109
 Beauty Reading a Letter, 103, 105, 105, 225
 Boat Prostitute at Asazuma, 51, 103, 106, 106, 225
 Courtesan and Two Attendants by a Brazier, 102
 Encounter at Night, from Haikai Album of the Cuckoo (Haikai yobuko-dori), 108, 108, 224
 The Fifth Month, from Pastimes of Women in the Twelve Months, 101–2, 102
 Guide to Contemporary Women's Fashions (Tōsei onna fūzoku tsū), 102
 Ichikawa Danjūrō V in Kumadori Makeup Seen in a Mirror, 110, 111, 111, 120, 174, 225
 Ichikawa Danjūrō V in the Shibaraku (Stop Right There!) Role, 110, 110, 120, 174, 225
 Ichikawa Ebizō IV (Danjūrō V) in the Shibaraku (Stop Right There!) Role, 111, 111, 112, 120, 134, 174, 224
 and kabuki, 108, 110, 112
 lost works and contemporary reputation, 102
 patrons and commissions, 102, 106, 108–9, 112
 Peony, from handscroll Secret Games in the Spring Palace (Shungū higi), 25, 106–8, 107, 225
 seal Zōka gachū ("Engaged in the creation of painting"), 165n11
 Standing Courtesan, 102
 Three Beauties, 100, 101, 165n11, 225
 Woman in Black Robe, 21, 225
Katsukawa Shunshō (d. 1792) and Kitao Shigemasa (1739–1820):
 Eguchi, Kaoru, Ninoaya and Tachibana of the Shinkanaya, from Mirror of Yoshiwara Beauties Compared (Seirō bijin awase sugata kagami), 102, 103, 108, 224
 Hanaōgi, Ureshino, Takigawa and Nanakoshi of the Ōgiya, from Mirror of Yoshiwara Beauties Compared (Seirō bijin awase sugata kagami), 102, 117–18, 118

Katsushika Hokusai (1760–1849), 83, 103, 136, 138, 143–67
assistants, disciples and studio, 143–44, 151, 158–60, 163, 165n16, 166n28, 166n29
biography of, 158
Birds of the Capital (Miyakodori), 206, 207
Ceramics from Sōma (Sōmayaki), from series All Variety of Horses (Uma zukushi), 210–11, 210
Chinese Boys Watching Tigers Cross a River, 156, 156, 157, 157, 208
The Chinese Immortal Yu Zhi and a Dragon with Zither, 144, 145, 145, 205
The Courtesan of Eguchi as the Bodhisattva Fugen and the Monk Saigyō, 148, 148, 210
Crouching Lion, from Daily Exorcisms (Nisshin joma), 164, 164
Daily Exorcisms (Nisshin joma), 163–64
daughters, 144, 158–60, 167n31
Dead Mallard with Abalone Shell and Stew Ingredients, 209, 209
Fine Wind, Clear Weather (Gaifū kaisei) ["Red Fuji"], from series Thirty-Six Views of Mount Fuji (Fugaku sanjūrokkei), 15, 16, 16, 171, 173, 208
Fisherman Sitting on a Rock by the Sea, 160, 161, 206
Five Beauties, 142, 143, 144, 205
Girl with Umbrella Walking with a Boy, 208, 208
Hokusai Manga (Random drawings by Hokusai), 143, 163
names used by, 144, 156, 158, 160, 163, 164, 165n3, 166n25, 166–67n31, 167n36, 206
and poetry, 143–44, 147, 148–49, 152, 153–54, 156–58, 164, 173, 206
portrait of, in sketch by Tsuyuki Iitsu, 163
Printer and Engraver, 23, 24, 24, 25, 207
private commissions, 143, 144–51, 156–58
Reclining Courtesan, with inscription by Santō Kyōden, 152, 153, 153, 205
reputation, 143–44
seal Fumoto no sato ("Village at the foot of the mountain"), 166n31
seal Kimō dasoku ("Fur on a turtle, legs on a snake"), 165n7, 205, 210
seal Shi zōka (My master is creation), 144, 205
A Shop for Illustrated Books (Ezōshiya), View of Tsutaya Jūzaburō's Shop, the Kōshodō, from Picture Book of the Pleasures of the East (Ehon azuma asobi), 114, 115
"Taito period," 166n18
Thirty-Six Views of Mount Fuji (Fugaku sanjūrokkei), 15, 16, 16, 158, 160, 171, 173, 178, 178, 179, 184, 208
Treatise on Coloring (Ehon saishiki-tsū), 163
Under the Well of the Great Wave Off Kanagawa ["The Great Wave"] (Kanagawa oki nami ura), from series Thirty-Six Views of Mount Fuji (Fugaku sanjūrokkei), 158, 178, 178, 179, 184, 208

Univalve Shell (Katatsukai), from series Genroku Immortal Poets Shell Matching Contest (Genroku kasen kai awase), 206, 206
see also surimono
Katsushika Hokusai (1760–1849) and Santō Kyōden (1761–1816), Gathering Spring Herbs and Brushwood Peddlars from Ohara, 152, 152, 206
Katsushika Hokuun (act. 1804–44), Courtesan and Daruma, 150, 150, 151, 158, 212
Katsushika Ōi (Ōei or Ei; c. 1800–c. 1866), 159–60, 163–64, 163
Operating on Guan Yu's Arm, 162, 162, 163
surimono by, 160, 161, 206
Three Women Playing Musical Instruments, 163
Katsushika Tatsujo, 158–59, 167n32
Woman with Morning Glories, 159, 159, 227
Kawaguchiya Shōzō (Kawashō), 216
Kawaguchiya Uhei (Fukusendō), 213
Kawai Tōzaemon, 47
Kawarazaki Gonjūrō (Ichikawa Danjūrō IX), 214, 214
Kawarazaki Gonjūrō (Ichikawa Danjūrō IX) Painting His Eyebrow in a Mirror, from an untitled series of actors backstage (Kunisada), 214, 214
Kawasaki Yoshirō, 34
Keene, Donald, 66
keibutsu, 173, 175
Keisai Eisen (1790–1848), 175
Geisha, 17, 18, 18, 196
Onoe Kikugorō III Offstage Relaxing in His Garden, 195, 195
Two Beauties, 196, 196
Keishōin, 50
kentō (guide mark for accurate registration of color blocks), 72, 85
key block (block from which the outlines of a picture are printed, usually in black, and to which the color blocks are keyed for accurate registration; sometimes called sumi-ita in Japanese), 71, 84
Keyes, Roger S., 16, 78, 83
kibyōshi ("yellow cover papers": facetious type of gesaku fiction, often illustrated by ukiyo-e artists), 120–21, 121, 124, 124, 136, 166n25
Kichizaemon Dōmo (d. 1662), 34–35
Kiga Rakuda, 208
kigōryō (talent-demonstration fees), 175
Kii Province, 107
Kikaku (1661–1707), 47
Kikugorō, see Onoe Kikugorō
Kikuren poetry club, 87
Kikurensha Kyosen (Tadanobu; 1727–1777), 87, 91, 97
Kimō dasoku ("Fur on a turtle, legs on a snake": Hokusai seal), 165n7, 205, 210
kimono, 23, 39, 42, 46, 59, 169–71, 173–75, 184, 186, 188n5; see also robes
Kinkin Sensei eiga no yume (Mr. Glitter-n-Gold's Dreams of Glory), 120
Kinokuniya Bunzaemon (?–1734), 47
Ki no Sadamaru (1760–1842), 121, 121, 124, 229
Kinryūzan, 44
Kintarō, 115
Kisanji, see Hōseidō Kisanji

Kitagawa family, 117
Kitagawa Utamaro (1753?–1806), 83, 120, 170–71, 173, 177, 186
collaboration with Tsutaya, 121, 124, 127, 129, 131, 136, 138, 175
The Engaging Type (also called The Interesting Type) (Omoshiroki sō), from series Ten Types in the Physiognomic Study of Women (Fujin sōgaku juttai), 127, 128, 129, 233
Hanaōgi IV of the Ōgiya, 110, 131–32, 131, 225, 234
The Light-Hearted Type (also called The Fancy-Free Type) (Uwaki no sō), from series Ten Types in the Physiognomic Study of Women (Fujin sōgaku juttai), 126, 126, 127, 129, 231
Lovers in the Private Second-Floor Room of a Teahouse, from album Poem of the Pillow (Utamakura), 124, 125, 229
Moon over a Mountain and Moor, from album Moon-Mad Monk (Kyōgetsubō), 124, 125, 229
Naniwaya Okita with Tray, 173, 232, 232
The Silver World (Ginsekai), 124, 230, 231
"Slip of the Brush" (Fude no ayamaru) as poetry name of, 121
The Statue of Fugen (Fugenzō), 124, 230, 231
Takashima Ohisa with Fan, 172, 173, 233
Three Beauties of the Present Day, 129, 130, 131, 171, 173, 234
Tomimoto Toyohina, 233, 233
Woman, Possibly Naniwaya Okita, Adjusting Her Coiffure in a Mirror, from series Seven Women at Their Toilettes in Front of Sugatami Mirrors (Sugatami shichinin keshō), 14, 15, 233
Woman Blowing a Glass Toy (popen), from series Ten Types in the Physiognomic Study of Women (Fujo ninsō juppon), 127, 231, 232
Woman Exhaling Smoke from a Pipe, from series Ten Types in the Physiognomic Study of Women (Fujo ninsō juppon), 127, 184, 232, 233
Woman Holding a Parasol, from series Ten Types in the Physiognomic Study of Women (Fujo ninsō juppon), 127, 190, 231, 231
Woman with Round Fan, from series Ten Types in the Physiognomic Study of Women (Fujin sōgaku juttai), 127, 232, 232
Kitagawa Utamaro (1753?–1806), Utagawa Toyokuni (1769–1825) and Utagawa Kunimasa (1773–1810): A Connoisseur's Guide to Actors Behind the Scenes (Yakusha gakuya tsū), 229, 229
Kitao Masanobu (1761–1816), 120, 173
A Collection of Handwriting of Famous Courtesans of the Yoshiwara (Seirō meikun jihitsu shū), 216
The Courtesans Hanaōgi and Takigawa of the Ōgiya, from album New Mirror Comparing the Handwriting of the Courtesans of the Yoshiwara (Yoshiwara keisei shin bijin awase jihitsu kagami), 25, 121, 122–23, 177, 216

The Courtesans Hinazuru and Chōzan of the Chōjiya (Chōjiya Hinazuru, Chōzan), from album New Mirror Comparing the Handwriting of the Courtesans of the Yoshiwara (Yoshiwara keisei shin bijin awase jihitsu kagami), 25, 26–27, 121, 177, 216
Riverbank Type (Kashi), from The Mirror of the Punter's Pluck (Kyakushu kimo kagami), 129, 129
as Santō Kyōden, 124, 124, 153
Kitao Shigemasa (1739–1820), 120, 138, 173
Kitao Shigemasa (1739–1820) and Katsukawa Shunshō:
Hanaōgi, Ureshino, Takigawa and Nanakoshi of the Ōgiya, from Mirror of Yoshiwara Beauties Compared (Seirō bijin awase sugata kagami), 102, 117–18, 118
Mirror of Yoshiwara Beauties Compared (Seirō bijin awase sugata kagami), 102, 103, 103, 117–18, 118, 224
kiwame ("certification" or "certified," "approval": type of official seal applied to prints, from 1790 onwards), 127, 192, 193, 202, 208, 213–15, 224, 231–34
Kiyonaga, see Torii Kiyonaga
Know-All-About Kyōka (Kyōka shittari furi), 121, 140n24
koban ("small print," roughly 20 x 14 cm, made by cutting a hōsho sheet into eight), 208
Kobayashi Tadashi, 116, 131
Kodama Matashichi, 213
kogaku (Old Learning) school, 55n56
Koikawa Harumachi (1744–1789), 126, 138, 173
The Meeting of the Yoshiwara Great Sophisticates (Yoshiwara daitsū-e), 121, 121, 124
Mr. Glitter-n-Gold's Dreams of Glory (Kinkin Sensei eigai no yume), 120
Koizumi Chūgorō, 200
kōjō, 173, 189n26
Kōkan, see Shiba Kōkan
Kōkan kōkaiki (Kōkan's record of his regrets), 99n26, 99n29
Kōkan's record of his regrets (Kōkan kōkaiki), 99n26, 99n29
kokonotsugiriban ("print [sheet] cut into nine": print made from an ōbōsho sheet cut three times each vertically and horizontally), 42
Koko Sanjin, 227
Kokugaku (National Learning), 144, 151, 165n10, 166n19
Komatsuya, publisher, 218
komon (small patterns), 174
Komon gawa (Elegant Chats on Small Motifs), 174, 174
Komonzai (Small Patterns), 188n13
kongen ("origin, source": word used especially in the print signatures of Okumura Masanobu), 52n1, 57, 62, 67–68, 71, 73, 73, 78, 81n22
kon'ya (indigo dyeing), 34
Korea and Koreans, 71, 71, 81n30, 157, 216
Korean Acrobatic Rider Inscribing Calligraphy While Standing in the Stirrups (O. Masanobu), 71, 71, 216
Kōriyama, Lord of, 108
Koryūsai, see Isoda Koryūsai
kōshi (grade of Yoshiwara courtesan), 45

Kōshodō (publishing house of Tsutaya Jūzaburō), 115, 117, 136, 138

Kōshoku ichidai otoko (A Man with an Amorous Life), 52n1

Koshōrō Tsuru no Kegoromo (poet), 157–58

koto (thirteeen-stringed zither), 88, 131, 141n45, 196

kuchi-e (woodblock frontispieces), 29

kuitsumi (food arrangement), 211

Kukai jūnen irojigoku jijo (Ten Years of the Bitter World of the Sex Hell), 140n21

kumi (family groups), 37

Kuninoya (Miyamoto Shinsuke), 164

Kunisada, *see* Utagawa Kunisada

Kurihara Chōemon, 59

Kyakushu kimo kagami (Mirror of the Punter's Pluck, The), 129, *129*, 141n40

Kyōden, *see* Santō Kyōden; Kitao Masanobu

"Kyōden nose," 124

kyōgen, 121, 140n22

Kyōgetsubō (Moon-Mad Monk), 124, *125*

Kyōhō Reforms, 68

kyōka ("mad Japanese verse": thirty-one-syllable poems using complicated word play, learned allusions and displays of wit), 19–20, 21, 91, 120, 121, 126, 143–44, 154, *155*, 156, 165n4, 166–67n31, 174, 207, 226, 229

Kyōkabō Komendo, 226

Kyōkadō (Hall of Mad Poetry), 207

kyōkaren (kyōka poetry clubs), 84, 126

Kyōka shittari furi (Know-All-About Kyōka), 121, 140n24

Kyosen, *see* Kikurensha Kyosen; Ōkubo Jinshirō Tadanobu

kyōshi ("mad Chinese poems": the equivalent of kyōka, composed in literary Chinese), 95

"lacquer picture," *see* urushi-e

landscape prints, 177–84
 and actor prints, 179
 history of, 28
 introduction of, 25, 30
 popularity of, 180–81
 souvenir series, 189n25
 "stage-set" format, 179
 travel literature, 179–80
 triptych format, 179

Lane, Richard (1926–2002), 17

Large Perspective Picture of a Second-Storey Parlor in the New Yoshiwara, Looking Toward the Embankment (Shin Yoshiwara nikai zashiki dote o mitōshi ō-uki-e) (O. Masanobu), 74–75, 76, 179, 218

Large Perspective Picture of the Kabuki Theater District in Sakaichō and Fukiyachō (Sakaichō Fukiyachō shibaimachi ō-uki-e) (O. Masanobu), 72, 218, *219*

Ledoux, Louis V. (1880–1948), 11, 17

Lee, Julian Jinn, 81n34

Levitz, Dr. and Mrs. Martin, *20*, 205, *211*, 212

Li Zhuowu (Li Zhi, 1527–1602), 48–49, 50, 55n51

Light-Hearted Type, The (also called *The Fancy-Free Type*) *(Uwaki no sō)*, from Utamaro series *Ten Types in the Physiognomic Study of Women (Fujin sōgaku juttai)*, 126, *126*, 127, 129, 231

Literary Works of Master Groggy (Neboke sensei bunshū), 95

Longhu ("Dragon Lake"), 48

Los Angeles County Museum of Art, 159, 227

Lovers behind a screen (attrib. to Sugimura Jihei), 39, *39*, 213

Lovers beside a Screen (Moronobu), 39, 41, *41*, 219

Lovers by a Screen (Moronobu), 39, 41, *41*, 219

Lovers in the Private Second-Floor Room of a Teahouse, from Utamaro album *Poem of the Pillow (Utamakura)*, 124, *125*, 229

Lovers Sharing an Umbrella (Harunobu), 90, *90*, 200

"mad poetry," *see* kyōka

Maiden at Dōjōji Temple (kabuki dance), 102, 113n1

Makino Narisada (1634–1713), 47, 49

"Mallet of [the Rice-Bale of] Good Fortune" (Tawara no Kozuchi), 120

Man with an Amorous Life, A (Kōshoku ichidai otoko), 52n1

Mangoku sōdō (peasant rebellion), 47

Manji (art-name of Hokusai), 158, 160

Manji-ren poetry group, 210

Mann, H. George, 9, 11, 12, *17*, 20, *28*, *39*, 66, 76, 77, *82*, 83, 124, 131, 132, *134*, *178*, *180*, *185*, *193*, 195, 198, *201*, 202, 205, 208, 212, 213, 214, 215, 221, *228*, 229

Manzai kyōka shū (Anthology of Ten Thousand Mad Poems), 121

manzai (type of New Year dance), 64–65, *65*, 218

Markus, Andrew, 175

Maruya Jinpachi, 200

Maruyama Jūsuke, 117

Maruyama Ōkyo (1733–1795), 129

Masanobu (pupil of Moronobu), 36

Masaki Inari Shrine, 206

Masanobu, *see* Kitao Masanobu; Okumura Masanobu

Masanojō, 36

Matsubaya (Yoshiwara house), 119, 120

Matsudaira Sadanobu (1759–1829), 108, 126

Matsukage nikki (Diary in the Shadow of the Pine), 50, 55n58

Matsumoto Kōshirō IV, 221, *221*, 229

Matsumoto Kōshirō IV as the Fishmonger Gorōbei from Sanya, in the Kabuki Play A Medley of Tales of Revenge (Katakiuchi noriaibanashi) (Sharaku), 132, 174, 221, *221*

Matsumuraya publishing house, 120

Matsuo Bashō (1644–1694), 65–66

Matsuura Seizan (1760–1841), 102, 103

Medley of Tales of Revenge, A (Katakiuchi noriaibanashi: kabuki play), 132, 174, 221, *221*

Meech, Julia, 11, 51, 54n39

Meeting of the Yoshiwara Great Sophisticates (Yoshiwara daitsū-e), 121, *121*, 141n25

Meiji period (1868–1912), 29

Meisho Edo hyakkei (One Hundred Views of Famous Places of Edo), 180, *181*, 184, 201, *201*

meisho (famous places), 179–80

Meiwa era (1764–72), 84, 92, 95

Metropolitan Museum of Art, 40, *45*, 154, *187*, 193, 219, 227, 231, *231*, 232

Michener, James, 11

Michizane, Sugawara no, 121, 160

Mimeguri Shrine, 78

Minamizawa Tōmei, 160

Minamoto no Toshiyori (1055–1129), 197

Minari daitsūjin ryaku engi (Short History of the Fashion God), 121

Ming banquet painting, 49

Minneapolis Institute of Arts, 111, 224

Mirror of Naniwa: The Summer Festival (Natsu matsuri Naniwa kagami) (kabuki play), 185, *185*, 186, 205

Mirror of the Punter's Pluck, The (Kyakushu kimo kagami), 129, *129*, 141n40

Mirror of Yoshiwara Beauties Compared (Seirō bijin awase sugata kagami), 102, *103*, 118, *118*, 224

mitate-e ("allusive pictures": originally a technical term in linked-verse composition, *mitate* is used in ukiyo-e to describe works in which a classical or other well-known theme is cleverly reinterpreted, often with a modish twist, and in a modern setting) 62–63, 64, 66, 87, 91, 95, 103, 173

Miura(ya) Hachiemon (art-name of Hokusai), 163, 164

Miuraya (Yoshiwara house), 173

Miyagawa (later Katsumiyagawa) Shunsui (act. early 1740s–early 1760s), 103

Miyagawa Chōshun (1682–1752), 53n17, 103

Miyakodori (Birds of the Capital), 206, *207*

Miyamoto Musashi (1583–1647), 184, *184*

Miyamoto Shinsuke, 163–64

Miyatake Gaikotsu (Miyatake Tobone, 1867–1955), 52n3

Miyazaki Yūzen (act. late 16th– early 17th c.), 188n6

Miyuki ("The Imperial Progress"), 91, *91*

mizu-e ("water pictures": early color prints using a grey instead of a black key block), 84

MOA Museum of Art, Atami, 101, *102*

Models of Fashion: New Designs Fresh as Spring Leaves (Hinagata wakana no hatsumoyō), 118, 119, *119*, 175, 189n19

Modern Thirty-Six Types (Imayō sanjunisō), 214, 215

monchō, 173

monks, 33, 50, 54n45, 55n52, 97, 124, 148, *148*, 154, 165n10, 175, *175*, 198, 210, 229; *see also* Buddhism; Zen Buddhism

Monroe, Marilyn, *168*, 169, 170

Moon-Mad Monk (Kyōgetsubō), 124, *125*

Moon over a Mountain and Moor, from album *Moon-Mad Monk (Kyōgetsubō)*, 124, *125*, 229

Moon Viewing (Chōki), 193, *193*

Morishima Chūryō (1754–1808): as Takesue no Sugaru, 174
 The Waste Paper Basket (Hogokago), 95

Morita Kanya VIII, 222, *223*

Morita Kanya VIII as the Palanquin-bearer Uguisu no Jirosaku, in the Kabuki Play The Iris Soga of the Bunroku Era (Hanashōbu Bunroku Soga), 132, 174, 222, *223*

Moriya Kohei, 124

Morofusa, *see* Hishikawa Morofusa

Moronaga, 36

Moronobu, *see* Hishikawa Moronobu

Moroyoshi, 36

Moto, Maidservant of the Yoshidaya in Shinmachi, Osaka, and Mizue, a Geisha (Chōki), 193, *193*

Moto no Akuami (1724–1811), 121

Motoya (Yoshiwara house), 95, 96

Mount Fuji, last recorded eruption of, 36

Mounts Imo and Se: Exemplary Women's Virtues (Imoseyama onna teikin) (kabuki play), 179–80, *180*, 212

moyō (pattern), 175

Mr. Glitter-n-Gold's Dreams of Glory (Kinkin Sensei eiga no yume), 120

Mu-an Xingtao (J. Mokuan Shōtō; 1611–1684), 55n52

Muneage no Takami, 120, 174

Muneyoshi (unknown artist), 235, *235*

Muramatsu Genroku, 216

Murata Ichibei (1754–1828: proprietor of Daimonjiya), 120, 173–74; *see also* Kabocha no Motonari

Murataya Jirōbei, 120, 188n12

Muro Kyūsō (1658–1734), 50

Museum of Fine Arts, Boston, 52n11, 53n27, 55n46, 69, 70, 72, 73, 86, 91, 94, 97, 119, 163, *177*, 198, *198*, 218, 219, *219*

music, 46, 48, *48*, 81n38, 163, 165n10, 167n39, 173; *see also* ichigenkin; koto; samisen; shakuhachi

Mutō Junko, 59, 68

Myōshinji, 50, 55n52

Nagasaki, 47, 55n51, 55n52

Naitō Masato, 19, 106, 107, 108, 109, 112

Nakai Tōdō (1758–1821), 121, *121*

Nakajima Wadaemon, 220, *221*, 229

nakama (guilds), 37

Nakamura Konozō, 220, *221*

Nakamura Konozō as the Homeless Boatman Kanagawaya no Gon and Nakajima Wadaemon as Bōdara ("Dried Codfish") Chōzaemon, in the Kabuki Play A Medley of Tales of Revenge (Katakiuchi noriaibanashi) (Sharaku), 132, 174, 220, *221*

Nakamura Theater (Nakamuraza), 59, 67, 113n1

Nakamura Utaemon III (Shikan), 17, *17*, 20, *20*, 167n32, 180, 186, *186*, 212, 214, 215

Nakamura Utaemon III as a Courtesan, 167n32, 186, *186*, 212

Nakamura Utaemon III as Kanawa Gorō Imakuni and Arashi Koroku IV as Omiwa in the Kabuki Play Mounts Imo and Se: Exemplary Women's Virtues (Imoseyama onna teikin), 179–80, *180*, 212

Nakamura Utaemon III as the Monkey Trainer Yojirō, from series Great Performances (Ōatari kyōgen) (Kunisada), 17, *17*, 214
Nakanochō, 45, 97
Nanakoshi (courtesan), 102, 117–18, *118*
Naniwaya Okita, *14*, 15, 129, 173, *233*
Naniwaya Okita with Tray, *233*
Nara ehon (manuscript picture books, illustrated in a popular Yamato-e style), 23, 53n30
Nara Prefectural Museum, 48
National Diet Library, *139*, *163*
National Learning, *see* Kokugaku
Natsu matsuri Naniwa kagami (Mirror of Naniwa: The Summer Festival) (kabuki play), 185, *185*, 186, 205
Neboke sensei bunshū (Literary Works of Master Groggy), 95
nengō (eras in Japanese calendar), 84
Neo-Confucianism, 48, 55n56, 102, 144
New Mirror Comparing the Handwriting of the Courtesans of the Yoshiwara (Yoshiwara keisei shin bijin awase jihitsu kagami) 25, 121, *122*, 177, 216
New Year Sunrise (Chōki), 136, 192, *192*
New York Public Library, *118*, *151*, *171*, 200
Nichiren (1222–1282), 35
Night Rain on the Shared Umbrella (Aigasa no yau) (O. Masanobu), 66
Nihon (name for Japan), 52n12
Nihonbashi ("Japan Bridge"), 117, 124, 175
Nihon giga ("Japanese playful paintings"), 52n12
Nihon-zutsumi, 45
nikawa ("deer glue": applied to prints to give lacquer-like gloss), 23, 67
Ninoaya (courtesan), 103, *103*, 108, 224
Nippon (name for Japan), 52n12
nirami (cross-eyed glare, in kabuki), 112
Nishikawa hinagata (Nishikawa's Design Patterns), 170, 171, *171*
Nishikawa Sukenobu (1671–1750), 103, 225
　Courtesan with a Letter and Two Attendants, 103
　Nishikawa's Design Patterns (Nishikawa hinagata), 170, 171, *171*
　One Hundred Women Arranged by Class (Hyakunin jorō shinasadame), 177
　Woman Arranging Her Hair, 104, *104*, 226
Nishikawa's Design Patterns (Nishikawa hinagata), 170, 171, *171*
nishiki (brocade), 95
nishiki-e ("brocade pictures": full-color prints), 23, 84–87, 91, 92, 95, 97, 98n11, 99n37, 116, 129, 171
Nishiki hyakunin isshu azuma-ori (One Hundred Poems by One Hundred Poets, Woven in Eastern Brocade), 106, *106*
Nishiki no ura (The Other Side of the Brocade), 140n21
Nishimura Shigenaga (1697?–1756), 86
Nishimuraya Yohachi (Eijudō: publisher), 118, 119, 120, 131, 132, 136, 188n12, 208
Nishina Yūsuke, 34, 35
Nisshin joma (Daily Exorcisms), 163, *164*
Niten (Miyamoto Musashi, 1583–1647), 184
Nogawa poetry club, 206

Noh, 50
　michiyuki (journeying) section of, 44
　mitate-e of, 64–65
　surimono references to, 148, 149
noren (entrance curtain, of cloth or rope), 95
nozoki karakuri (viewing devices), 72
nuihaku (silk embroidery), 34, 52n5

Ōatari kyōgen (Great Performances), 17, *17*, 213, *213*, 214
Ōbaku school, *see* Zen Buddhism
ōban ("large print," in vertical or horizontal format; the most common size of woodcut from the 1790s through the nineteenth century: in the first half of the 18th century, printed on a half sheet of Mino paper, roughly 45.7 x 33 cm, and from the 1760s on half of a smaller sheet, roughly 38.1 x 25.4 cm), 68, 118, 121, 129, 136, 189n24, 192, 193, 195, 201–02, 205, 208, 211–15, 218–22, 224, 229, 231–34
ōban diptychs, 216; triptychs, 179, 216
ōbōsho ("large edict [paper]": large format of *hōsho* paper, whose size varied from region to region and between makers; roughly two *ōban* sheets or three *ōtanzaku* sheets, and measuring roughly 42 x 58 cm; the uncut sheet being *ōbōsho zenshiban*, "large *hōsho*, complete sheet"), 206, 226
Observing Lovers from the Doorway (Harunobu), 184, 198, *198*
Obuse, 160
Oda Nobunaga (1534–1582), 54n41
Odawara, 72
odoriko (young dancer), 141n40
Ōei, *see* Katsushika Ōi
Ofuji, 95
ōgi (fan), 131
Ōgimachi Machiko (1676–1723), *Diary in the Shadow of the Pine (Matsukage nikki)*, 50, 51
Ōgiya (Yoshiwara house), 102, 117–18, *118*, 120, 121, 131, 173, 174, 225, 234
Ogurayama hyakunin isshu (One Poem Each by a Hundred Poets on Mount Ogura), 35–36
Ogyū Sorai (1666–1726), 55n56
Ohara, 152
Ohara Kuchii, 121, *121*
Ōhashi Atake yūdachi (Sudden Shower at Ōhashi Bridge, Atake), from series *One Hundred Views of Famous Places of Edo (Meisho Edo hyakkei)* (Hiroshige), 180, 201, *201*
Ohisa, *see* Takashima Ohisa
ohyakudo, 84
Ōi, *see* Katsushika Ōi
Oi senu kado keshō no wakamizu (Gate of Immortality, a New Year's Water for Cosmetics), 175
O-ie-ryū ("Honorable House School"), 49
Oil-Seller, The (Uirō-uri), 173
Ōiso Tora, 64
Okajima Kanzan (1674–1728), 55n47
Okamoto Shōgyo (dates unknown), 108
Okita, *see* Naniwaya Okita
oku eshi (painter-in-attendance), 109
ōkubi-e ("large–neck pictures": i.e., bust pictures), 129

Ōkubo Jinshirō Tadanobu (1727–1777), 87, 92
Okumura Genroku (act. c. 1718–64), 59, 68
Okumura Masanobu (1686–1764), 23, 57–81, 87, 138, 177
　artistic importance, 57, 71, 78–79
　The Bamboo Flute and the Potted Trees (Shakuhachi hachi no ki), 66, 67
　Chinese Figures in a Pavilion Playing Sugoroku, 72, 73, *73*, 179
　color prints (benizuri-e), 57, 71, 72, 78, 86
　Courtesan, 59, 61, *61*, 63, 172, 218
　Courtesan Holding a Pipe, 71, 72, 217
　Courtesan in Robe Decorated with Calligraphy, 60, 61, 68, 216
　The Courtesan Koyoshi, from album *Beautiful Courtesans of the Northern Quarters (Hokkaku bigichō)*, 58, *58*, 59
　Courtesan Poling Daruma on a Reed Boat, 63, *63*, 216
　Ebisu and Daikoku Performing a Manzai Dance at New Year, 64, 65, *65*, 218
　Eight Views in the Yoshiwara, 66
　Elegant Shakuhachi Version of Ushiwakamaru Serenading Jōruri-hime, an Original Perspective Print (Fūga shakuhachi jūnidan uki-e kongen), 71–72, 73, *73*
　A Floating World Monkey Trainer on the Sumida River (Sumidagawa ukiyo sarumawashi), 77, *77*, 78, 85, 218
　A Floating World Version of The Potted Trees (Ukiyo hachi no ki), 64–65, 66, 66, 218
　Genroku-era Courtesans in Opposing Mirrors (Genroku tayū awase kagami), 59
　as *haikai* poet, 65–66
　Ichikawa Danjūrō II as Ike no Shōji, 68, 69, 69
　Ichimura Takenojō as Koshō Kichisaburō, 67, 69, 69
　Inside the Bag, the Pleasure Quarters (Fukuro no uchi ni sato), from the album *Okumura Masanobu's Picture Copy Book (Okumura Masanobu edehon)*, 59, 64, 64, 218
　kongen ("original source") designation on works by, 57, 67–68, 71, 78–79
　Korean Acrobatic Rider Inscribing Calligraphy While Standing in the Stirrups, 71, *71*, 216
　Large Perspective Picture of a Second-Storey Parlor in the New Yoshiwara, Looking Toward the Embankment (Shin Yoshiwara nikai zashiki dote o mitōshi ō-uki-e), 74–75, 76, 179, 218
　Large Perspective Picture of the Kabuki Theater District in Sakaichō and Fukiyachō, 72, 218, *219*
　life and career, 57, 59, 71, 78
　mitate-e by, 62–63, 64, 66, 91, 103
　names and signatures used by, 57, 65, 68, 71, 78–79, 200, 217
　Night Rain on the Shared Umbrella (Aigasa no yau), 66
　Onoe Kikugorō as Soga no Gorō, 70, *70*, 71

as "original source" (kongen), 57
perspective prints (uki-e), 57, 71–72, 78, 179, 218
pillar prints (hashira-e), 57, 71, 78, 216, 217
print titles, 66
as publisher and publicist, 57, 67–68, 71, 78
pupil Toshinobu, 68; *see also* Okumura Toshinobu
Sanogawa Mangiku as Ohatsu, 67–68, 68
sumizuri-e series, 59
Sunset Glow at the Great Gate (Ōmon no sekishō), 66
Thanks to the Father (Chichi no on), 72
Two Elegant Reed Leaves (Fūryū ashi no ha nichō), 59, 62, *62*, 63, 91
Ukifune Chapter of The Tale of Genji (Genji Ukifune), 76, *76*, 78, 91, 217
warning against forgeries, 68
and Weird-Bird Style (Kechō-fū), 66
see also Okumuraya
Okumura Masanobu edehon (Okumura Masanobu's Picture Copy Book), 59, 64, 64, 218
Okumura Masanobu's Picture Copy Book (Okumura Masanobu edehon), 59, 64, 64, 218
Okumura Toshinobu (act. c. 1716–51), 67, 68, 91
　Eight Parlor Views of Kanazawa Palace (Kanazawa no gosho zashiki hakkei): Segawa Kikunojō I as Kajiwara's Wife, Shizuya, and Sanjō Kantarō II as Mankō, the Widow of Kawazu, 91, 94, *94*
Okumuraya publishing house, 57, 67–68, 71, 78, 120, 218
Old Learning (kogaku) school, 55n56
Oliver, Geoffrey, *183*, *184*, 216, 220, 231
Oliver, Jane, 20
ōmagaki, 141n43
Ōmi hakkei, *see* Eight Views of Ōmi
Ōmiya Gonkurō, 131
Omohide Hyōshū, 228
Ōmon no sekishō (Sunset Glow at the Great Gate) (O. Masanobu), 66
Omoshiroki sō (The Engaging Type; also called The Interesting Type), from Utamaro series *Ten Types in the Physiognomic Study of Women (Fujin sōgaku juttai)*, 127, *128*, 129, 233
"one-corner" compositions, 28
One Hundred Poems by One Hundred Poets (Hyakunin isshu), 64, 80n13
One Poem Each by a Hundred Poets on Mount Ogura (Ogurayama hyakunin isshu), 35–36
One Hundred Poems by One Hundred Poets, Woven in Eastern Brocade (Nishiki hyakunin isshu azuma-ori), 106, *106*
One Hundred Views of Famous Places of Edo (Meisho Edo hyakkei), 180, *181*, 184, 201, *201*
One Hundred Women Arranged by Class (Hyakunin jorō shinasadame), 177
One Poem Each by a Hundred Samurai (Buke hyakunin isshu), 36
Onna shoreishū (Etiquette Rules for Women), 170, *170*
Ono no Komachi (834–900), 64, 217
Onoe Kikugorō as Soga no Gorō (O. Masanobu), 70, *70*, 71

Onoe Kikugorō I (1717–1783), 70, 70, 71, 78

Onoe Kikugorō III (1784–1849), 195, 195, 213

Onoe Kikugorō III Offstage Relaxing in His Garden (Eisen painting) 195, 195

Onoe Kikugorō V (1844–1903), 29, 29, 213

Onoe Kikugorō V as Igami no Gonta (Igami no Gonta Onoe Kikugorō), from series Fashionable Modern Clothing (Tōseigata zokuizoroi) (Toyohara Kunichika), 29, 29, 213

Onoe Matsunosuke I, 175, 175

Onoe Matsunosuke I as the Lay Monk Magoroku in the Kabuki Play Kagurazuki Iwai no iroginu (Sharaku), 175, 175

Onoe Matsusuke, 227

Onoe Matsusuke II (Kikugorō III), 213, 213

Onoe Matsusuke II [Kikugorō III, 1784–1849] as the Carpenter Rokusaburō (Daiku Rokusaburō), from the series Great Performances (Ōatari kyōgen) (Kunisada), 213, 213

ōōban ("extra-large print": a standard format for black-and-white and hand–colored prints, from about the 1640s to the mid–1710s; roughly 54.5–64.5 x 30.5–33cm; a smaller sheet of paper was pieced to the bottom of the print to extend its length, and close inspection will reveal a horizontal seam), 213, 214, 217, 218

Operating on Guan Yu's Arm (Ōi painting), 162, 162, 163

Origins of Yamato-e (Yamato-e no kongen), 52n1

orihon ("folding book": album of leaves folded and glued in accordion style), 59, 216, 224, 231

Osaka, 18, 23, 33, 34, 36, 37, 44, 47, 52n4, 53n30, 54n32, 99n32, 113n12, 116, 136, 141n48, 148n67, 167n32, 177, 185, 186, 193, 205, 212, 215

Osaka Actor Arashi Rikan II, The, as Danshichi Kurobei in the Night Murder Scene of the Kabuki Play Mirror of Naniwa: The Summer Festival (Natsu matsuri Naniwa kagami), 185, 185, 186, 205

Osaka Actor Arashi Rikan II, The, as Sōma Tarō before a Spirit Flame, 204, 205

Ōsaka Dōtonbori shibai gakuya no zu (View of the Dressing Rooms in a Theater in Dōtonbori, Osaka) (Kunisada), 215, 215

Osen, 95

Ōta Memorial Museum, Tokyo, 107

Otama, 35, 50, 51

Ōta Nanpo (1749–1823), 21, 25, 52n3, 84–85, 92, 95, 117, 126
 Anthology of Ten Thousand Mad Poems (Manzai kyōka shū) edited by, 121
 Ichiwa ichigen, 98n7
 scrapbook kept by, 120
 and Yomo poetry group, 120, 121, 127, 216
 and Yoshiwara Circle, 120
 see also Ukiyo-e ruikō, Yomo no Akara, Yomo Sanjin

Ōtani Tokuji, 222, 222

Ōtani Tokuji as the Manservant (yakko) Sodesuke, in the Kabuki Play The Iris Soga of the Bunroku Era (Hanashōbu Bunroku Soga) (Sharaku), 132, 174, 222, 222

ōtanzaku ("large tanzaku": a long narrow print type, roughly 38 x 16.5 cm), 202, 216

Other Side of the Brocade, The (Nishiki no ura), 140n21

otogi-banashi (bedtime stories), 53n30

ō-uki-e ("large perspective picture": designation appearing occasionally on prints by Okumura Masanobu), 72, 75, 76

Owari Province, 117

Ōya no Urazumi ["Living behind the Big Shop"], 121, 121

painting, see references under bunjinga, Kano, Tosa, ukiyo–e

paper, see hōsho[gami], ōbōsho, shikishiban, ōtanzaku, tanzaku; and print sizes

Parody of the Noh Play The Potted Trees (Harunobu), 64, 173, 200, 200

Pastimes of Women in the Twelve Months (Shunshō painting), 101–2, 102

patronage, 8, 12, 19, 20–21, 25, 46–51, 71, 106, 108–09, 112, 116, 138, 163–64, 165n2

pattern books, see hinagata-bon; komon

Penn, Irving, 170

Peony, from handscroll Secret Games in the Spring Palace (Shungū higi) (Shunshō painting), 25, 106–8, 107, 225

Perry, Commodore Matthew, 184

perspective prints, see uki-e

Picture Book of Collected Beauties of the Yoshiwara (Ehon seirō bijin awase), 151, 151

Picture Book of the Brocades of Spring (Ehon haru no nishiki), 91, 93, 93, 198

Pictures Cast by the Projector of the Human Heart (Hitogokoro kagami no utsushi-e), 138, 139, 139

Pictures of Actors on Stage (Yakusha butai no sugata-e), 132, 132, 174

pigments, 63, 67, 68, 83, 85, 107, 136, 144, 165n8

Pilgrimage to Enoshima (Kiyonaga), 177, 177, 179

pillar prints, see hashira-e; Okumura Masanobu

plagiarism, 87, 90; see also Suzuki Harunobu; Shiba Kōkan

"Plain of Good Fortune" (Yoshiwara), 44

"Plain of Reeds" (Yoshiwara), 44

pleasure quarters, 25, 33, 44; see also Yoshiwara

Poem by Bai Juyi, from series Chinese and Japanese Verses for Recitation (Wakan Rōeishū) (Hiroshige), 28, 28, 202

Poem of the Pillow (Utamakura), 123, 124, 141n30, 229

poetry groups or clubs, 20, 84, 85, 86–87, 95, 97, 116, 120, 121, 127, 136, 143, 148, 173–74, 188n11, 206–7

poetry judge (hanja), 156

poetry types: see haikai, hokku, kyōka, kyōshi, senryū, tanka

Pollack, David, 21–22, 129

popen (glass bobbin–shaped toy that makes a popping sound), 231, 232

pornography, 186, 189n23; see also erotica

Portland Art Museum, OR, 30

Portrait Eulogies of One Poem Each by One Hundred Poets (Hyakunin isshu zō sanshō), 36

print sizes: see aiban; chūban; hashira-e; hosoban; jūnigiriban; kakemono-e; koban; kokonotsugiriban; ōban; ōōban; ōtanzaku; shikishiban; yatsugiriban

print types: see Azuma nishiki-e; beni-e; benizuri-e; bijinga; Edo-e; egoyomi; mizu-e; nishiki-e; sumizuri-e; surimono; ōkubi-e; surimono; tan-e; uki-e; urushi-e; yakusha-e

Printer and Engraver (Hokusai), 23, 24, 25, 207

printer (suri-shi), 24, 24, 29, 37, 53n24, 83, 84, 97, 115, 124, 129, 138, 180, 207

prostitution, 15, 34, 45, 63, 140n9, 141n41, 151; see also Asazuma-bune, Daimonjiya, Equchi, Jigoku, kashi, Takashimaya, Yoshiwara

Prussian blue, 180

publishers:
 authors' financial arrangements with, 127
 censorship of, 8, 25, 68, 108, 126–27, 179
 collaborative publishing, 189n19, 189n21
 commercial activities of, 116–17, 138, 173–74
 edition sizes, 116
 information dispensed by, 173–74
 inventories, 116
 of poetry, 188n12, 207
 popular illustrated fiction, 183
 specialties of, 115–16

Pumpkin Stem (Kabocha no Motonari), as poetry name of Murata Ichibei, 120, 173–74

Pure Land school, 36

Rakuchū Rakugai zu, 53n30

rakugo ("clipped speech": kind of humorous monologue), 42, 71, 144; see also Fukai Shidōken

Random Drawings by Hokusai (Hokusai Manga), 143, 158, 163

rangaku ("Dutch learning": i.e., European studies), 91

Reception Room with Paintings and Objects Associated with the Seven Gods of Good Fortune (Hishikawa Sōri), 226, 226

Record of Famous Places in Edo (Edo meishoki), 44, 44

"Red Fuji" (Hokusai), 16, 143

"red pictures," see beni-e

Renkidō Kazumasu, 149

Rikugien (park) 50, 109

Rikura Kihei, 218

Rinkaisan Betsugan-in, 36

Rinzai school, see Zen Buddhism

Ritual of Climbing the Stairs One Hundred Times (Harunobu), 84, 84, 91, 198

Riverbank Type (Kashi), from The Mirror of the Punter's Pluck (Kyakushu kimo kagami), 129, 129

robes, 21, 42, 51, 59, 63, 101, 110, 112, 118, 131, 144, 159, 170, 170, 175, 177, 184, 186, 188n5, 216, 225; see also kimono; uchikake

rōjū ("elders"), 50

rokōcha (dark yellow-brown), 173

Rokujuen (Ishikawa Masamochi, 1753–1830), 144, 147

Romance of the Three Kingdoms (C. Sanguozhi yanyi; J. Sangokushi engi), 48

Rōrihakuchō Chōjun (brigand), 185, 185, 235

Russo-Japanese war (1904–05), 29

Ryōgoku Bridge, 44, 72, 97, 175

Ryōgoku hanabi (Fireworks, Ryogoku Bridge), from series One Hundred Views of Famous Places of Edo (Meisho Edo hyakkei) (Hiroshige), 180, 181, 184, 201

Ryūko, 48

Ryūkō (1649–1724), 50

Ryūsai Chimata, 226

Ryūsen (Ishikawa Tomonobu, act. 1680s–1710s), 53n17

Ryūtei Tanehiko (1783–1842), 189n23

Sadako (wife of Yoshiyasu), 50

Saigyō (1118–1190), 148, 148, 153, 153, 154, 210

Saikaku, see Ihara Saikaku

saiken ("looking in detail": guide-books of various kinds, e.g., to the Yoshiwara), 54n32, 117, 117, 140n9, 143, 173

Saishiki hinagata kokonoe nishiki (Colorful Models of Ninefold Brocades) 175

Saitō Gesshin (1804–1878), 36, 52n5, 160
 Zōho ukiyo-e ruikō (Some considerations of ukiyo-e, revised and supplemented), 67

Saitō Jūrōbei, 135

Saiyūki, see Journey to the West

Sakaichō Fukiyachō shibaimachi ō-uki-e (Large Perspective Picture of the Kabuki Theater District in Sakaichō and Fukiyachō) (O. Masanobu), 72, 218, 219

Sakamori Nyūdō Jōseki, 121, 121

Sakata Hangorō III, 222, 222

Sakata Hangorō III as Fujikawa Mizuemon, Villain of the Kabuki Play The Iris Soga of the Bunroku Era (Hanashōbu Bunroku Soga) (Sharaku), 132, 174, 222, 222

Sakata Kintoki, 53n30

Sakuragawa Jihinari (1762–1833), 226

samisen (in current usage, usually shamisen; three-stringed long lute), 64, 101, 154

samurai:
 and the Yoshiwara, 44–49
 as art patrons and clients, 21, 25, 86, 109, 112, 115, 143
 as officials, 21
 as writers, 21, 44, 120–21, 143–44
 education, 55n51
 loyalties and duties, 23, 25, 64–65, 84, 126
 social position and hierarchy, 37, 54n42, 64, 112, 126, 184
 women, 109, 144, 171, 189n25; see also sokushitsu

sancha (grade of Yoshiwara courtesan), 45, 131

Sangokushi engi, see Romance of the Three Kingdoms

Sanguozhi yanyi, see Romance of the Three Kingdoms

Sanjō (poetry name of Ichikawa Danjūrō V), 110, 112

Sanjō Kantarō II, 94, *94*

Sankyōtei Muraji, 156

Sanogawa Ichimatsu (1722–1762), 71, 78

Sanogawa Ichimatsu III, 132, *133*, 174, 221

Sanogawa Ichimatsu III as the Courtesan Onayo of Gion, in the Kabuki Play The Iris Soga of the Bunroku Era (Hanashōbu Bunroku Soga) (Sharaku), 132, *133*, 174, 221

Sanogawa Mangiku, 67, *68*

Sanogawa Mangiku as Ohatsu (O. Masanobu), 67–68, *68*

Sanoya Kihei, 202, 220

Santō Kyōden (1761–1816), 25, 52n3, 120, 127, 136, 173, 175, 226; *see also* Kitao Masanobu

Designs, from *Elegant Chats on Small Motifs (Komon gawa)*, 174, *174*

inscriptions on paintings, 152, 153, *153*, 154, 155, *155*

The Mirror of the Punter's Pluck (Kyakushu kimo kagami), 129

names used by, 124, 152, 153, 154, 173

The Other Side of the Brocade (Nishiki no ura), 140n21

Pictures Cast by the Projector of the Human Heart (Hitogokoro kagami no utsushi-e), 138, 139, *139*

portrayed, 153–54, *154*, 193

Self-Portrait, from *Grilled and Basted Edo-Born Playboy (Edo-umare uwaki no kabayaki)*, 124, *124*

Self-Portrait, from *Pictures Cast by the Projector of the Human Heart (Hitogokoro kagami no utsushi-e)*, 139, *139*

Small Patterns (Komonzai), 188n13

Ten Years of the Bitter World of the Sex Hell (Kukai jūnen irojigoku jijo), 140n21

Santō Kyōden (1761–1816) and Katsushika Hokusai, *Gathering Spring Herbs and Brushwood Peddlars from Ohara*, 120, 152, *152*, 154, 174, 206

Satow, Sir Ernest (1843–1929), 85, 98n10

Sawada Tōkō (1732–1796), 124

Sawamura Sōjūrō III, 135–36, *135*, 222

Sawamura Sōjūrō III as Ōgishi Kurando, in the Kabuki Play The Iris Soga of the Bunroku Era (Hanashōbu Bunroku Soga) (Sharaku), 135–36, *135*, 174, 222

Schoff, Joanna H., 169

Secret Games in the Spring Palace (Shungū higi) (Shunshō), 25, 106–8, *107*, 225

Segawa Kikunojō I, 94, *94*

Segawa Kikunojō III, 102, 132, *132*, 174

Segawa Kikunojō III (Hamamuraya) as the Shirabyōshi Dancer Hisakata, from series *Pictures of Actors on Stage (Yakusha butai no sugata-e)*, 132, *132*, 174

Segawa of the Matsubaya with her Kamuro Sasano and Takeno (Matsubaya Segawa, Sasano, Takeno), from series *Models of Fashion: New Designs Fresh as Spring Leaves (Hinagata wakana no hatsumoyō)* (Kiyonaga), 118, 119, *119*, 175, 189n21

seigaiha pattern, 174–75

Seigle, Cecilia Segawa, 79, 119, 200

Seirō bijin awase sugata kagami (Mirror of Yoshiwara Beauties Compared), 102, *103*, 118, *118*, 224

Seirō meikun jihitsu shū (A Collection of Handwriting of Famous Courtesans of the Yoshiwara), 216

Seiseisai Kyōden, 152

Seiwa nidai ōyose Genji (kabuki play title), 212, 213

sekai ("world": technical term in theater), 129n19

Sengen, seal, 227

senjafuda, 173

senryū (seventeen-syllable humorous verse), 110, 153

Sensōji, 54n36, 67; *see also* Asakusadera

Series of Noh Plays for the Hanazono Club, A (Hanazono yōkyoku bantsuzuki), 148, 149, *149*, 204, 205

setsugekka (theme of snow, moon and flowers), 124

Settei Nanzan, 207

Settsu Province, 36, 55n51, 55n52, 197

Seven Gods of Good Fortune, 64

Seven Women at Their Toilettes in Front of Sugatami Mirrors (Sugatami shichinin keshō), 14, 15, 233

shakuhachi (end-blown bamboo flute), 66, 67, *67*, 73, *73*

Shakuhachi hachi no ki (Bamboo Flute and the Potted Trees, The), 66, 67

Sharaku, *see* Tōshūsai Sharaku

sharebon ("joking books": slender storybooks set almost exclusively in the licensed quarters and presuming an insider's familiarity with its customs and personalities; flourished 1764–88), 25, 102, 117, 127, 129, 129

Share-fū ("joking style"), 66

Shi zōka ("My master is creation": Hokusai seal), 144, 205

Shiba Kōkan (1747–1818):

Courtesan, Two Kamuro and a Giant Snowball [inscribed Harunobu], 91, 93, *93*

Kōkan kōkaiki (Kōkan's record of his regrets), 99n26, 99n29

Shimizu, from the series *Fashionable Seven Komachi (Fūryū nana Komachi)* [signed Harushige], 91, 92, *92*

Shibanoya Sanyō (d. 1836), 156, 157

Shibaraku (Stop Right There!) kabuki role, 110, *110*, *111*, 112, 174, 224; *see also* Ichikawa Danjūrō

Shichikyokutei Tamaari, 159

Shijō-school painting, 28

Shikano Buzaemon (1649–1699), *Shika's Paper-Wrapped Brush (Shika no makifude)*, 42, 42

Shikidō ōkagami (Great Mirror of the Way of Love), 47

shikishiban ("colored paper sheet": square cut from an *ōbōsho* sheet, once horizontally and three times vertically; roughly 20 x 18 cm; and used, like *tanzaku*, for inscribing poems; a standard format for *surimono*), 196, 205, 206, 207

Shikitei Sanba (1776–1822), 175, 229

Shimizu Enjū, *Short History of the Fashion God (Minari daitsū-jin ryaku engi)*, 121

Shimizu, from series *Fashionable Seven Komachi (Fūryū nana Komachi)* (Shiba Kōkan, signed Harushige), 91, 92, *92*

Shimōsa Province, 47, 52n7,

Shingaku Passionflower (Shingaku tokeigusa, 1795), 136

Shingaku tokeigusa (Shingaku Passionflower, 1795), 136

Shingon school, 50

Shingyokutei Toshinami, 157

shin-hanga ("new prints"), 30

Shinkanaya (Yoshiwara house), 103, *103*, 108, 224

Shinmyō (personal name sometimes used by Okumura Masanobu), 68

Shinto (indigenous religion of Japan), 47, 50, 53n30, 78, *82*, 83, 95, 165n10, 166n19, 167, 179, 198; *see also* Shrines; Kokugaku

Shin Yoshiwara ("New Yoshiwara"), *see* Yoshiwara

Shin Yoshiwara nikai zashiki dote o mitōshi ō-uki-e (Large Perspective Picture of a Second-Storey Parlor in the New Yoshiwara, Looking Toward the Embankment) (O. Masanobu), 74–75, 76, 179, 218

shogakai (calligraphy-painting gathering), 153, 166n23, 175

shogunate, 19, 20, 127; *see also* Tokugawa shogunate

shōhon'ya (shop for puppet theatre [*jōruri*] playbooks), 116

shomotsuya (shop for scholarly books), 116

Short History of the Fashion God (Minari daitsūjin ryaku engi), 121

Shōryūji, 36

Shōryūtei Tadataka Nijimori, 226

shrines (Shinto), *see* Kameido Shrine, Kasamori Inari Shrine, Masaki Inari Shrine, Mimeguri Shrine

Shūchōdō Monoyana (1761–1830), 206, 226

Shūchōdō Shachū poetry group, 210

Shūfūen Hananushi, 210

Shuho Shichizaemon Raimu (dates unknown), *Dreams During a Nap (Karine no yume)*, 92, 95

Shuihuzhuan, *see* Water Margin Classic

Shūkyōtei Tsuchimaru, 206

Shungū higi (Secret Games in the Spring Palace) (Shunshō), 25, 106–8, *107*, 225

Shunkō, *see* Katsukawa Shunkō

Shunkōsai Hokuei (act. 1824?–37):

The Osaka Actor Arashi Rikan II as Danshichi Kurobei in the Night Murder Scene of the Kabuki Play Mirror of Naniwa: The Summer Festival (Natsu matsuri Naniwa kagami), 185, 186, 205

The Osaka Actor Arashi Rikan II as Sōma Tarō before a Spirit Flame, 204, 205

Shunkōsai Hokushū (act. 1802–32), 167n32

Ichikawa Ebijūrō II as Ki no Haseo, Nakamura Utaemon III as Kujaku Saburō and Fujikawa Tomokichi II as Kō hime, in the Kabuki Play Tenmangū aiju no meiboku, 18, 20, 212

Ichikawa Ebijūrō I as Tōken "China Dog" Jūbei, in the Kabuki Play Benimurasaki ai de someage, 211, *211*

Nakamura Utaemon III as a Courtesan, 167n32, *186*, 212

Nakamura Utaemon III as Kanawa Gorō Imakuni and Arashi Koroku IV as Omiwa in the Kabuki Play Mounts Imo and Se: Exemplary Women's Virtues (Imoseyama onna teikin), 179–80, *180*, 212

Shunrō (early art-name used by Hokusai, 1760–1849), 136

Shunshō, *see* Katsukawa Shunshō

Shun'yūtei Umeaki, 149

Silver World, The (Gin sekai), 124

single-sheet prints, 34, 53n17, 53n21, 57, 68, 129

Sino-Japanese war (1894–95), 29

"Slip of the Brush" (*Fude no ayamaru*: pen-name of Utamaro), 121

Small Patterns (Komonzai), 188n13

Smith, Robert J., 19

smoking, 22, *22*, 101, 109, 152, 184, 186, 198; *see also* tobacco

Snow (Chōki), 136, 192, *192*

sō (physiognomic aspects or types), 127, 129

Sōhitsu gojūsan tsugi (Fifty-Three Stations of the Tōkaidō by Twin Brushes), 179

sokushitsu ("side rooms": secondary wives), 50

Sōmayaki (Ceramics from Sōma) (Hokusai), 210–11, *210*

Some considerations of ukiyo-e, revised and supplemented (Zōho ukiyo-e ruikō), 67

Sōri (art-name of Hokusai), 158

Sōri III (Hishikawa Sōji, act. 1790s–1818), 166n29

Sōshū, seal, 225

Sōshūrō Kinrachi, 226

Sotheby Parke Bernet, 11

Sōtō school, *see* Zen Buddhism

South Kensington Museum, 86

Splendid View from the Top of the Roof (Muneage no Takami), poetry name of Suzuki Uemon, 120

Spring Concert (Toyoharu painting), 18, *18*–19, 19, 227

Standing Beauty (Moronobu painting), 42, 43, *43*, 59, 219

Standing Courtesan (Shunshō painting), 102

Statue of Fugen, The (Fugenzō), 124

Stern, Harold P., 19

storm gods, 235, *235*

Story of Dohei the Candy Vendor, The (Ameuri Dohei den), 95

Strange, Edward F. (1862–1929), 86

Straus-Negbaur, Tony, 216

Su Shi (1036–1101), 102

Sudden Shower at Ōhashi Bridge, Atake (Ōhashi Atake yūdachi), from series *One Hundred Views of Famous Places of Edo (Meisho Edo hyakkei)* (Hiroshige), 180, 201, *201*

Sugatami shichinin keshō (Seven Women at Their Toilettes in Front of Sugatami Mirrors), 14, 15, 233

Sugawara no Michizane (d. 872), 160

Sugimura Jihei (act. c. 1681–98):

attrib. to, *Family Outing on Boy's Day*, 38, 39, 213

attrib. to, *Lovers behind a screen*, 39, 39, 213

single-sheet prints introduced by, 53n17

Suikoden, *see* Water Margin Classic

Suikyōtei Umekage, 149

Sukeroku, 173

Sumida River, 63, 175

Sumidagawa ukiyo sarumawashi (*A Floating World Monkey Trainer on the Sumida River*) (O. Masanobu), 77, *77*, 78, 85, 218

sumizuri-e ("picture printed in black ink": an uncolored print), 59, 85, 116, 171, 213, 218, 219

Sunset Glow at Ryōgoku Bridge (*Ryōgokubashi no sekishō*), from series *Fashionable Eight Views of Edo* (*Fūryū Edo Hakkei*) (Harunobu), 97, *97*

Sunset Glow at the Great Gate (*Ōmon no sekishō*) (O. Masanobu), 66

surihaku (gold and silver foil used in textiles), 34

surimono ("printed thing": woodblock print generally of small square format, roughly 20 x 18 cm, or in a long horizontal format; usually accompanied by poems, and often commissioned privately in a limited de luxe edition): characterization and uses, 21, 85, 95, 116, 165n1, 165n5, 166n19, 233 and Hokusai, 12, 21, 23, 143, 144, 146–47, 148, 149, 152, 156–58, 160, *161*, 164, 206–10

see also calendar prints

Surukaya Ichibei, pub.: *Illustrated Guide to the Yoshiwara* (*Yoshiwara saiken zu*), 175

Suzuki Harunobu (1725–1770), 18, 64, 83–99, 171, 173

Admiring a Picture of a Dandy by Okumura Masanobu, 79, *79*, 87, 200
and "Brocade Pictures of the East," 95
calendar prints by, 84, 85, 86–87, 91, 95
Courtesan, Two Kamuro and a Giant Snowball, from *Picture Book of the Brocades of Spring* (*Ehon haru no nishiki*), 91, 93, *93*, 198
Courtesan and Hotei Smoking on a Veranda in Moonlight, *22*, 198
Courtesan as the Poet Sagami at Tōi Jewel River, from series *Customs and Manners of the Six Jewel Rivers* (*Fūzoku Mutamagawa*), 197, *197*
Courtesan of the Motoya and Client Disguised as an Itinerant Monk, 45, 95, *96*, 97, 198
Courtesan with Love Letter and Kamuro Playing Blindfold with a Client, 198, *199*
death and aftermath, 91–92, 102
Eight Parlor Views (*Zashiki hakkei*), 21, 25, 87, *88–89*, 91, 97, 196
forgeries of, 91–92
full-color printing, 84–87, 91, 92, 95, 97
influence and legacy, 84, 91–92
innovation and plagiarism, 90–91
Konoharu of the Ietaya with Daruma Doll and Hanachō of the Iseya with Iris, from *Picture Book of Collected Beauties of the Yoshiwara* (*Ehon seirō bijin awase*), 151
Lovers Sharing an Umbrella, 90, *90*, 200
mitate-e, 91, 95, 103
mizu-e prints, 84
Observing Lovers from the Doorway, 184, 198, *198*
Parody of the Noh Play The Potted Trees, 64, 173, 200, *200*
and poetry clubs, 84, 85, 86–87, 95, 97

Ritual of Climbing the Stairs One Hundred Times, 84, *84*, 91, 198

The Story of Dohei the Candy Vendor (*Ameuri Dohei den*), 95

Sunset Glow at Ryōgoku Bridge (*Ryōgokubashi no sekishō*), from series *Fashionable Eight Views of Edo* (*Fūryū Edo Hakkei*), 97, *97*

Visiting a Shrine in Night Rain, 82, 83, 171, 198

Suzuki Uemon (1744–1810), 120

Swallow Stone Journal (*Enseki zasshi*), 84

Tachiba Fukaku (1662–1753), 65–66

Tachibana (courtesan), *103*, 108, 224

Tadanaga (1606–1633), 54n41

Tadaoki (1619–1663), 54n41

tagasode, 120

Taira no Kinmasa (dates unknown), 54n36

Taitō (art-name used by Katsushika Hokusai), 158

Taitō II (family name Kondō, act. 1810s–1818), 158, 166n29

Takai Kōzan, 163

Takanawa, 154

takara-awase kai (treasure-matching poetry gathering), 174

Takashima Kiyozaemon, 34

Takashima Ohisa, 129, *172*, 173, 233

Takashima Ohisa with Fan, *172*, 173, 233

Takashō-chō ("Falconers' Quarter"), 47

Takenouchi Magohachi (Hōeidō), 202; and Tsuruya Kiemon (Senkakudō), "Hōeidō Tōkaidō," 189n24

Takesue no Sugaru (Morishima Chūryō), 174

Takigawa (courtesan), 102, 117–18, *118*

Takizawa Bakin (1767–1848), 138, 173, 175
Hoofing It Along Tōkaidō (*Tōkaidōchū hizakurige*), 136
Swallow Stone Journal (*Enseki zasshi*), 84, 85, 92, 95

Tale of the Floating World (*Ukiyo monogatari*), 33

Tales of Ise, 144

Tales of Valor Told in Pictures (*Gazu seiyūdan*), 140n22

Tamariya Zenbei, 213

Tamenaga Shunsui (1790–1843), 189n23

Tanabe Masako, 87

Tanaka Kisaku, 35

Tanchōsai (art-name used by O. Masanobu), 71

tan-e (hand-colored prints emphasising *tan* orange pigment), 67, 85

Tang Yin (1470–1523), 49

tanzaku ("short slip" of paper for inscribing poems): *see ōtanzaku*

Tatsujo, *see* Katsushika Tatsujo

Tawara no Kozuchi ("Mallet of [the Rice Bale of] Good Fortune"), 120

Tawaraya Sōji (act. late 1790s–late 1810s), 226

tayū (high-ranking courtesan), 45

Tegara no Okamochi ["Carrying Merit on a Tray"], 174

Ten Types in the Physiognomic Study of Women (*Fujo ninsō juppon*: Utamaro series), 127, 184, *190*, 231, *231*, 232, 233

Ten Types in the Physiognomic Study of Women (*Fujin sōgaku juttai*: Utamaro series), 127, *128*, 129, 233

Ten Years of the Bitter World of the Sex Hell (*Kukai jūnen irojigoku jijo*), 140n21

Tenmangū aiju no meiboku (kabuki play), 18, 20, *20*, 212

Tenmei era (1781–88), 118

Tenpō era (1830–43), 202; reforms (1842–43), 179, 189n23

Tetsugyū (1628–1712), 55n52

textiles, 35, 78, 95, 118, 169–71, 175, 185, *185*, 186, 188n2, 188n3, 188n13; *see also* clothing, dyeing, embroidery, *hane nezumi* pattern, Ichimatsu pattern, kimono, *komon*, *kon'ya*, *nuihaku*, robes, *urokogata* pattern, *yūzen*

Thanks to the Father (*Chichi no on*), 72

theater, *see* kabuki, Noh

Thirty-Six Views of Mount Fuji (*Fugaku sanjūrokkei*) (Hokusai series), 15, 16, *16*, 158, 160, 171, 173, 178, *178*, 179, 184, 208

Thirty-Six Views of Mount Fuji (*Fuji sanjūrokkei*) (Hiroshige series), 53n16

Three Beauties (Shunshō painting), 100, 101, 165n11, 225

Three Beauties of the Present Day, 129, *130*, 131, 171, 173, 234

Three Women Playing Musical Instruments (Ōi painting), 163

tiger, 71, *71*, 144, 146, *146*, 147, 156, *196*, 157, *157*, 158, 165n13, 196, 208

tobacco, 106, 121, *138*, 152, 153; *see also* smoking

tobi (fireman), 184; *see also* fireman

tōhonya (shop for books imported from China), 116

Tōkaidō gojūsan tsugi no uchi (*The Fifty-Three Stations of the Tōkaidō*), 179, 202, *202*

Tokitarō Kakō (Hokusai), 166n25

Tokugawa Ienari (1773–1841), 126

Tokugawa Ienobu (1663–1712), 55n56

Tokugawa Ieyasu (1542–1616), 23, 54n41

Tokugawa Mitsukuni, 50

Tokugawa shogunate, 22, 23, 47, 54n41, 98n3, 107

Tokugawa Tsunayoshi (1646–1709), 47, 49–51, 103

Tokuju-in, 36

Tokyo Art School, 30

Tokyo Metropolitan Central Library, 121, 129

Tomimoto Buzen Dayū II, *194*, 195

Tomimoto Toyohina, 129

Tomimoto Toyohina, 233, *233*

Tomita Kōjirō, 91

tomobeya, 46

Tomofusa, 36

Torii Kiyomitsu (1735–1785), 84

Torii Kiyomitsu IX, 184

Torii Kiyonaga (1752–1815), 85, 87, 120, 136, 170–71
Pilgrimage to Enoshima, 177, *177*, 179
Segawa of the Matsubaya with her Kamuro Sasano and Takeno (*Matsubaya Segawa, Sasano, Takeno*), from the series *Models of Fashion: New Designs Fresh as Spring Leaves* (*Hinagata wakana no hatsumoyō*), 118, 119, *119*, 175, 189n21

Torii Kiyonobu (1664–1729), 23, 59, 85, 86

Torii Kiyotada (act. c. 1720–50), 72

Torii school, 59

Tōrishiochō, 67–68, 124

Toriyama Sekien (1712–1788), 121, 136
Tales of Valor Told in Pictures (*Gazu seiyūdan*), 140n22

Tosa painting, 42

Tōsei onna fūzoku tsū (Guide to Contemporary Women's Fashions), 102

Tōseigata zokuizoroi (Fashionable Modern Clothing), 29, *29*, 213

Toshihide, *see* Utagawa Toshihide

Tōshūsai Sharaku (act. 1794–95), 17, 138, 173, 177
Ichikawa Ebizō IV (Danjūrō V) as Takemura Sadanoshin, a Noh Performer Driven to Suicide by His Daughter's Disgrace, in the Kabuki Play The Beloved Wife's Particolored Reins, 132, 134, *134*, 135, 174, 221
Matsumoto Kōshirō IV as the Fishmonger Gorōbei from Sanya, in the Kabuki Play A Medley of Tales of Revenge (*Katakiuchi noriaibanashi*), 132, 174, 221, *221*
Morita Kanya VIII as the Palanquin-bearer Uguisu no Jirosaku, in the Dance Interlude The Iris Hair-ornament of Remembrance (*Hanashōbu omoi no kanzashi*) in the Kabuki Play The Iris Soga of the Bunroku Era (*Hanashōbu Bunroku Soga*), 132, 174, 222, *223*
Nakamura Konozō as the Homeless Boatman Kanagawaya no Gon and Nakajima Wadaemon as Bōdara ("Dried Codfish") Chōzaemon, in the Kabuki Play A Medley of Tales of Revenge (*Katakiuchi noriaibanashi*), 132, 174, 220, *221*
Onoe Matsunosuke I as the Lay Monk Magoroku in the Kabuki Play Kagurazuki Iwai no iroginu, 175, *175*
Ōtani Tokuji as the Manservant (yakko) Sodesuke, in the Kabuki Play The Iris Soga of the Bunroku Era (*Hanashōbu Bunroku Soga*), 132, 174, 222, *222*
Sakata Hangorō III as Fujikawa Mizuemon, Villain of the Kabuki Play The Iris Soga of the Bunroku Era (*Hanashōbu Bunroku Soga*), 132, 174, 222, *222*
Sanogawa Ichimatsu III as the Courtesan Onayo of Gion, in the Kabuki Play The Iris Soga of the Bunroku Era (*Hanashōbu Bunroku Soga*), 132, *133*, 174, *221*
Sawamura Sōjūrō III as Ōgishi Kurando, in the Kabuki Play The Iris Soga of the Bunroku Era (*Hanashōbu Bunroku Soga*), 135–36, *135*, 174, 222

Totoya Hokkei (1780–1850), 148, 165n12, 165n16
Eguchi, from *A Series of Noh Plays for the Hanazono Club* (*Hanazono yōkyoku bantsuzuki*), 148, 149, *149*
Eguchi [The Courtesan of Eguchi as the Bodhisattva Fugen from the Noh play, *Eguchi*], from *A Series of Noh Plays for the Hanazono Club* (*Hanazono yōkyoku bantsuzuki*), 204, 205

Toyohara Kunichika (1835–1900), *Onoe Kikugorō V as Igami no Gonta (Igami no Gonta Onoe Kikugorō)*, from series *Fashionable Modern Clothing (Tōseigata zokuizoroi)*, 29, 29, 213
Toyoharu, *see* Utagawa Toyoharu
Toyohina (geisha), 129, 130
Toyohiro, *see* Utagawa Toyohiro
Toyokuni, *see* Utagawa Toyokuni
Treatise on Coloring (Ehon saishiki-tsū), 163
triptych format, 179, 216
tsū ("sophistication": vogue term from 1770s), 102, 117, 120, 121, 121, 131, 161n25, 163, 167n41, 174, 229, 229
Tsubogawa ("Jug" group), 166n27
tsubone (grade of Yoshiwara courtesan), 34, 34, 45
Tsujiokaya Bunsuke, 216
Tsujiya Yasubei (Kinkaidō), 214
Tsuruya Kiemon, 120, 131, 188n12, 224
Tsuta no Karamaru ("Entwined in the Ivy": poetry name of Tsutaya Jūzaburō), 120, 173
Tsutaya ("House of the Ivy": shop name of Tsutaya Jūzaburō), 117
Tsutaya Jūzaburō (1750–1797), 21, 25, 115–41, 144, 173–74, 192, 193, 216, 220, 221, 222, 229, 231, 232, 233, 234
 actor and sumo prints published by, 132, 135–36, 173, 174
 and author–publisher relationship, 127
 Birds with Pretensions (Hitokidori) published by, 175
 birth and background of, 117
 book shop of, 114, 115, 124
 and censorship laws, 126–27
 and commercial publishing, 116–17, 129, 131–32
 crest of, 115, 124
 death of, 138
 Grilled and Basted Edo-Born Playboy published by, 124
 guidebooks published by, 117, 120, 121
 house style created by, 115
 influence of, 136, 138
 "mad poetry" published by, 120, 121, 174, 188n12
 Mirror of Yoshiwara Beauties published by, 117–18, 118
 Models of Fashion published by, 18, 119
 Mr. Glitter-n-Gold series published by, 120
 Poem of the Pillow published by, 124
 portrayed in *Pictures Cast by the Projector of the Human Heart (Hitogokoro kagami no utsushi-e)*, 138, 139, 139
 reputation of, 120, 121
 Sharaku as collaborator with, 132, 135–36, 138
 Short History of the Fashion God published by, 121
 Utamaro as collaborator with, 121, 124, 127, 129, 131, 136, 138, 175
 and Yoshiwara Circle (*Yoshiwara-ren*), 120–21, 121, 124, 127
Tsutsumi Tōrin (c. 1743–1820), 167n35
Tsuyuki Iitsu II (d. 1893), *Hokusai and Ōi in their "temporary lodgings" of the mid–1840s*, 163, 163
Twelve Views of Tokyo (Tōkyō jūnikei) (Ishii Hakutei), 30, 30, 167n33, 175

Two Beauties (Eisen), 196, 196
Two Elegant Reed Leaves (Fūryū ashi no ha nichō) (O. Masanobu), 59, 62, 62, 63, 91
two-color printing, introduction of, 23

uchikake (outer robe), 101
Uemura Kichiemon, 81n4, 85
Uirō-uri (The Oil-Seller), 173
uji, 36
uki-e ("floating picture": term of uncertain origin, to refer to picture with receding perspective, seen as if floating in lens of a *nozoki karakuri*, "peeping machine"), 57, 71–72, 73, 76, 78, 81n32, 81n33, 81n37, 179, 218
uki-e kongen ("source/originator of perspective prints"; in signatures of Okumura Masanobu), 71, 73, 73
Ukifune Chapter of The Tale of Genji (Genji Ukifune) (O. Masanobu), 76, 76, 78, 91, 217
ukiyo, *see* floating world
Ukiyo hachi no ki (A Floating World Version of The Potted Trees) (O. Masanobu), 64–65, 66, 66, 218
Ukiyo monogatari (Tale of the Floating World), 33
ukiyo-e:
 censorship of, 8, 68, 116, 126–27; *see also* kiwame
 collecting of, 11, 18–19, 83–86
 creative reuse of material in, 87, 90–91, 186
 in Edo, 8, 10, 15, 19, 22–23, 30, 143
 erotica, 17, 39, 42, 46, 49, 53n21, 54n32, 55n53, 65, 106–08, 112, 113n7, 124, 127, 138, 141n30, 186
 expansion of, 25, 28
 forgeries, 19, 68, 91
 history of, 16, 18, 22–23, 25
 and illustrated fiction, 37, 120, 126, 136, 138, 166n25, 183–84
 landscape prints, 25, 28, 30, 81n32, 81n34, 177–83, 189n25
 marketing of, 21, 23, 25, 80n1, 84, 91–92, 99n37, 115–18, 127, 135, 156, 158, 165n3, 166n25, 167n40, 169–72, 183, 188n9
 nakedness in, 186
 painting, 10–12, 15–21, 21, 23, 25, 28, 28–31, 32, 33–34, 34–35, 36, 39, 42, 43, 44, 46–54, 48–49, 51, 59, 61, 64–65, 68, 71, 78, 79, 100, 101–13, 102, 104, 105, 106, 107, 109, 110, 111, 129, 131, 131, 142, 143–44, 145, 148, 148, 150, 152–54, 153, 155, 158–59, 159, 162, 163–67, 164, 176, 186, 187, 195, 228
 and poetry, 154; *see also* surimono
 samurai as patrons of, 25, 165n2
 subject matter of, 21, 25, 29, 33, 57, 99n41, 179, 186
 studies, 17, 19–20, 21, 30
 tension in, 186
 use of term, 15, 22, 52n1
 woodblock-print technology, 85, 95, 97, 110, 115; *see also* block carver; book types; color printing; key block; printer; print sizes; print types
Ukiyo-e kōsho (Research on ukiyo–e), 135, 140n23
"ukiyo-e quartet," 115, 140n1

Ukiyo-e ruikō (Some considerations of ukiyo-e), 52n3, 52n12, 53n24, 67, 95, 98n9, 140n23
ukiyo-eshi (master of ukiyo-e), 33, 36
Ukiyo-e Society of America, 10–11, 15; *see also* Japanese Art Society of America; *Impressions*
ukiyozōshi (leaves written about the floating world), 33
Uma zukushi (All Variety of Horses: Hokusai series), 210–11, 210
Under the Well of the Great Wave Off Kanagawa (Kanagawa oki nami ura), 158, 178, 178, 179, 184, 208
Univalve Shell (Katatsukai), from Hokusai series *Genroku Immortal Poets Shell Matching Contest (Genroku kasen kai awase)*, 206, 206
Unkin, *see* Kamo no Suetaka
Uoya Eikichi, 201
Ureshino (courtesan), 102, 117–18, 118
urushi-e ("lacquer picture": hand-colored print with faux-lacquer finish made by combining black ink with *nikawa*, deer glue; term dating from the 1790s), 67
urokogata pattern, 175
Urokogataya Magobei, 117, 120
Urokogataya Sanzaemon, 54n32
urushi-e ("lacquer pictures"), 67
Utagaki Magao (1753–1829), 207; *see also* Yomo no Utagaki
Utagawa Hiroshige (1797–1858), 9, 11, 28, 31n7, 53n16, 83, 179, 184
 Bird and Loquats, 202, 203
 Driving Rain, Shōno (Shōno hakuu), from series *The Fifty-Three Stations of the Tōkaidō (Tōkaidō gojūsan tsugi no uchi)*, 202, 202
 Fifty-Three Stations of the Tōkaidō Road, 179
 Fireworks, Ryōgoku Bridge (Ryōgoku hanabi), from series *One Hundred Views of Famous Places of Edo (Meisho Edo hyakkei)*, 180, 181, 201
 Poem by Bai Juyi, from series *Chinese and Japanese Verses for Recitation (Wakan Rōeishū)*, 28, 28, 202
 Sudden Shower at Ōhashi Bridge, Atake (Ōhashi Atake yūdachi), from series *One Hundred Views of Famous Places of Edo (Meisho Edo hyakkei)*, 180, 201, 201
 Thirty-Six Views of Mount Fuji (Fuji sanjūrokkei), 53n16
Utagawa Hiroshige (1797–1858) and Utagawa Kunisada (1786–1865): *Fifty-Three Stations of the Tōkaidō by Twin Brushes (Sōhitsu gojūsan tsugi)*, 179
Utagawa Kunimasa (1773–1810): *Ichikawa Yaozō III as Watanabe no Tsuna, in the Kabuki Play Seiwa nidai ōyose Genji*, 212, 213
Utagawa Kunimasa (1773–1810), Utagawa Toyokuni (1769–1825) and Kitagawa Utamaro (1753?–1806): *A Connoisseur's Guide to Actors Behind the Scenes (Yakusha gakuya tsū)*, 229, 229
Utagawa Kunisada (1786–1865), 189n23
 Gate of Immortality, 175
 Kawarazaki Gonjūrō (Ichikawa Danjūrō IX) Painting His Eyebrow in a Mirror, from an untitled series of actors backstage, 214, 214

Nakamura Utaemon III as the Monkey Trainer Yojirō, from series *Great Performances (Ōatari kyōgen)*, 17, 17, 214
Onoe Matsusuke II [Kikugorō III, 1784–1849] as the Carpenter Rokusaburō (Daiku Rokusaburō), from series *Great Performances (Ōatari kyōgen)*, 213, 213
The Excitable Type (Ima ni agari sō), from series *Modern Thirty-Six Types (Imayō sanjunisō)*, 214, 215
View of the Dressing Rooms in a Theater in Dōtonbori, Osaka (Ōsaka Dōtonbori shibai gakuya no zu), 215, 215
Utagawa Kunisada (1786–1865) and Utagawa Hiroshige (1797–1858), *Fifty-Three Stations of the Tōkaidō by Twin Brushes (Sōhitsu gojūsan tsugi)*, 179
Utagawa Kuniyoshi (1797–1861), 101, 184
 Benkei and Yoshitsune at the Battle of Dannoura, 216, 216
 Black Carp, 216, 217
 Hell Courtesan, 175, 176, 177, 216
 The Warrior Miyamoto Musashi Subduing a Whale, 184, 184, 216
Utagawa Toshihide (1863–1925), 29
Utagawa Toyoharu (1735–1814), 25
 Spring Concert, 18, 18–19, 19, 227
Utagawa Toyohiro (1773?–1828):
 Beauty Enjoying the Evening Cool, with inscription by Santō Kyōden, 154, 155, 155, 227
 Enjoying the Evening Cool under a Gourd Trellis, 186, 187, 187, 227
Utagawa Toyokuni (1769–1825), 129, 132, 174, 179
 Actors' Looks in Facing Mirrors (Yakusha sōbō kagami), 227, 227
 Beauty with Hand-Mirror, 228, 228
 Segawa Kikunojō III (Hamamuraya) as the Shirabyōshi Dancer Hisakata, from series *Pictures of Actors on Stage (Yakusha butai no sugata-e)*, 132, 132, 174
Utagawa Toyokuni (1769–1825), Utagawa Kunimasa (1773–1810) and Kitagawa Utamaro (1753?–1806): *A Connoisseur's Guide to Actors Behind the Scenes (Yakusha gakuya tsū)*, 229, 229
Utahime, 120
Utamakura (Poem of the Pillow), 123, 124, 141n30, 229
Utamaro, *see* Kitagawa Utamaro
Uwaki no sō (The Light-Hearted Type; also called *The Fancy-Free Type)*, from Utamaro series *Ten Types in the Physiognomic Study of Women (Fujin sōgaku juttai)*, 126, 126, 127, 129, 231

Van Reed, Eugene, 28, 220
Various Occupations of Japan, Exhaustively Portrayed, The: A Picture Book Mirror of the Various Occupations (Wakoku shoshoku ezukushi: shoshoku ehon kagami), 37, 37, 220
Vergez, Robert, 57
Vershbow, Arthur, 37, 103, 220, 224
Vever, Henri, 200, 209, 218, 220, 221, 222, 224, 227, 231

View of the Dressing Rooms in a Theater in Dōtonbori, Osaka (Ōsaka Dōtonbori shibai gakuya no zu) (Kunisada), 215, *215*

Virgin, Louise, 71

Visit to the Yoshiwara (Moronobu handscroll painting), 21, 33, 34, *34–35*, 44–51, *46*, *48–49*, *51*, 54n39, 54n40, 54n45, 55n46, 55n51, 219

Visiting a Shrine in Night Rain (Harunobu), *82*, *83*, 171, 198

Volker, Tijs, 115, 140n1

wagoto ("Japanese stuff": soft style of acting, favored in Kyoto and Osaka, and contrasting with aragoto), 23, 186

waka ("Japanese poems/songs": most general name for Japanese court poetry), 21, 160,

Wakai Kenzaburō (1834–1908), 206, 218, 232

Wakan Rōeishū (Chinese and Japanese Verses for Recitation), 28, *28*, 202

Wakoku shoshoku ezukushi: shoshoku ehon kagami (Various Occupations of Japan, Exhaustively Portrayed, The: A Picture Book Mirror of the Various Occupations), 37, *37*, 220

Waley, Arthur, 80n12, 91, 99n27

Wang Yangming (1472–1528), 48

Wang Yangming school, 55n56

Warrior Miyamoto Musashi Subduing a Whale, The (Kuniyoshi), 184, *184*, 216

Washburn, Gordon Bailey, 8

Watanabe Shōzaburō (1885–1962), 30, 52n3

Watching a Courtesan and Her Client from Behind a Screen (Moronobu), 39, 40, *40*, 219

Waterhouse, David, 90, 91, 99, 165

Water Margin Classic (Ch. Shuihuzhuan, J. Suikoden), 48, 55n45, 115, 184, *185*; see also Rōrihakuchō Chōjun

Weber, John C., 9, 12, 21, 33, 34, 44–51, *46*, *48–49*, *51*, 54n40, 54n45, 61, *101*, *105*, *107*, *110*, *111*, *131*, *148*, *176*, *185*, 186, *210*, *212*, 216, 218, 219, 225, 234, 235, *235*

Weber scroll, see Visit to the Yoshiwara (Moronobu handscroll painting)

Weinberg, David R., *135*, 222

Weird Bird Style (Kechō-fū: radical offshoot of Danrin school of haikai), 66, 80n15

Western collecting and interest, 17, 30, 85,

Western influences, 72, 85, 141n48, 179–80; see also Dutch influences; Dutch learning; uki-e

Westerners, 22, 29–30, *182–83*, 183–84; see also Perry, Commodore

Weston, Roger L., *18–19*, *104*, 106, 196, 225, 226

Woman Arranging Her Hair (Sukenobu painting), 104, *104*, 226

Woman Blowing a Glass Toy (popen), from Utamaro series Ten Types in the Physiognomic Study of Women (Fujo ninsō juppon), 127, *231*, 232

Woman Exhaling Smoke from a Pipe, from Utamaro series Ten Types in the Physiognomic Study of Women (Fujo ninsō juppon), 127, 184, *232*, *233*

Woman Holding a Parasol, from Utamaro series Ten Types in the Physiognomic Study of Women (Fujo ninsō juppon), 127, *190*, *231*, *231*

Woman in Black Robe (Shunshō painting), 21, *21*, 225

Woman, Possibly Naniwaya Okita, Adjusting Her Coiffure in a Mirror, from Utamaro series Seven Women at Their Toilettes in Front of Sugatami Mirrors (Sugatami shichinin keshō), 14, 15, 233

Woman with Morning Glories (Tatsujo painting), 159, *159*, 227

Woman with Round Fan, from Utamaro series Ten Types in the Physiognomic Study of Women (Fujin sōgaku juttai), 127, 232, *232*

women: see also samurai

Worcester Art Museum, *215*

Xiyuji, see Journey to the West

Xu Cangshu, 49

Yadoya no Meshimori (1753–1830), 120, 124, 231; see also Ishikawa Masamochi

yahazu, 108

yakko (manservant), 222, 224

Yakusha butai no sugata-e (Pictures of Actors on Stage), 132, *132*, 174

yakusha-e ("pictures of [kabuki] actors"), see actor prints

Yakusha gakuya tsū (A Connoisseur's Guide to Actors Behind the Scenes), 229, *229*

Yakusha natsu no Fuji (Actors Like Mount Fuji in Summer), 108

Yakusha sōbō kagami (Actors' Looks in Facing Mirrors), 227, *227*

Yamadaya Sanshirō, 227

Yamagataya Ichirōemon, 45, 219

Yamaguchiya Chūsuke, 131

Yamaguchiya Tōbei, 220

Yamato Province, 108

yamato-e (Japanese-style painting), 36, 52n1, 52n11, 52n12, 219

Yamato-e no kongen (Origins of Yamato-e), 52n1

Yamato-e zukushi (Compendium of Yamato-e), 36

Yamazaki Kinbei, 118, 124, 198, 224

Yanagibashi, from series Twelve Views of Tokyo (Tōkyō jūnikei) (Ishii Hakutei), 30, *30*, 167n33, 175

Yanagisawa Nobutoki (1724–1792), 25, 108, 113n10

Yanagisawa Yoshiyasu (1658–1714), 49–51, 55n58, 55n59, 109

Yangtze River, 63

Yaoya Oshichi, 37, 53n19

yashi (hucksters), 173

Yashima Gakutei (1786?–1868): Dragon and Tiger Diptych (Ryūko niban) [Yu Zhi and a Dragon with the Chinese Immortal Dong Feng and a Tiger], 144, *146*, *146–47*, 196

Yashiro Tadamasa (1594–1662), 35, 54n41

Yashiro Tadaoki (1619–1663), 54n41

Yashiro Tadataka (1647–1714), 47, 49

yatsugiriban ("print [sheet] cut into eight," from an ōbōsho sheet cut once horizontally and four times vertically; roughly 20 x 14 cm), *209*

yatsushi ("making shabby, disguising": as a prefix in ukiyo-e titles, suggestive of parody and informality), 66, 80n17, 91, 103

Yatsushi Genji (Fanciful Genji) (Koryūsai series), 91, *91*

Yinyuan Longqi (J. Ingen Ryūki; 1592–1673), 54n45, 55n52

yobidashi ("by appointment": used of certain courtesans), 131

yogi (bedding kimono), 46, 51, 152

Yoko kōeki seiyōjin nimotsu unsō no zu (Yokohama Trade: Picture of Westerners Shipping Cargo), *182–83*, 183, 184, 220

Yokogawa Iwa, 214

Yokohama, *182–183*

Yokohama ijin shōkan urimono no zu (Foreign Trading Establishments in Yokohama), 220, *220*

Yokohama Trade: Picture of Westerners Shipping Cargo (Yoko kōeki seiyōjin nimotsu unsō no zu), *182–83*, 183, 184, 220

Yomo-gawa ("Four-directions" Group), 156

Yomo no Akara (poetry name of Ōta Nanpo, 1749-1843), 121, *121*, 188n11; see also Ōta Nanpo

Yomo no Utagaki Magao (1753–1829), 207, 226

Yomo poetry group, 120, 121, 127, 207, 210

Yomo Sanjin (Shokusanjin), 216; see also Ōta Nanpo

Yorozuya Shirokei, 175

Yoshida Hanbei (act. c. 1660–92), 53n30, 170

Yoshinoyama ("Mount Yoshino": seal), 159, 167n32, *212*

Yoshiwara Circle (Yoshiwara-ren), 120–21, *121*, 173–74

Yoshiwara daitsū-e (Meeting of the Yoshiwara Great Sophisticates), 121, *121*, 141n25

Yoshiwara keisei shin bijin awase jihitsu kagami (New Mirror Comparing the Handwriting of the Courtesans of the Yoshiwara) 25, 121, *122*, 177, 216

Yoshiwara koi no michibiki (A Guide to Love in the Yoshiwara), 44–45, 54n35, 54n37, 54n45, 55n54, 44, 219

Yoshiwara no tei (Aspects of the Yoshiwara), 45, *45*, 47, 48, 219

Yoshiwara ("Plain of Reeds," "Plain of Good Fortune": Edo pleasure quarter):
 courtesans of, 95, 103, 120, 121, 129, 131–32, 151, 154; see also courtesan(s); kashi; kōshi; sancha; tayū; tsubone; yobidashi; yūjo; and under names of individual courtesans Daikokuya house, 120
 Daimonjiya house, 120, 173
 description and general references, 15, 21, 25, 33–34, 39, 44–51, 54n32, 54n35, 54n38, 59, 106, 117, 120–21, 140n9, 153–54, 170, 186
 Fucha Tarōemon, 47–48
 maps and guidebooks, 117, *117*, 120, 121, 173, 175, 189n19
 Ōgiya house, 120, 121, 131, 174
 Takashima house, 34
 Yoshiwara-ren (Yoshiwara Circle), 120–21, *121*, 173–74

Yoshiwara saiken zu (Illustrated Guide to the Yoshiwara), 175

Young, Martie W., 19, 165n9

Yu Zhi (J. Gyokushi), 63, 144, 145, *145*, 146, 146, 165n11, 196, 205

yūjo (general word for courtesans and prostitutes), 117

Yukinoya Torikane, *209*

yūzen dyeing, 171, 188n6; see also dyeing

Zashiki hakkei, see Eight Parlor Views

Zen Buddhism, 33, 48, 49, 63, 177; see also Bodhidharma; Daruma; Zuishōji
 Ōbaku school, 47, 49, 50, 55n52, 165n10
 Rinzai school, 50, 55n52
 Sōtō school, 55n52

Zhuxi (1130–1200), 55n56

Zoho Ukiyo-e ruikō (Some considerations of ukiyo-e, revised and supplemented), 67

Zōka ("creation": on seals used by Shunshō and Hokusai), 144, 165n11

Zōsho, see Cangshu

Zuishōji monastery, 55n52

Photography Credits